# THE
# COASTS
# OF CALIFORNIA

ALSO BY OBI KAUFMANN

*The Forests of California: A California Field Atlas* (2020)

*The State of Water:
Understanding California's Most Precious Resource* (2019)

*The California Field Atlas* (2017)

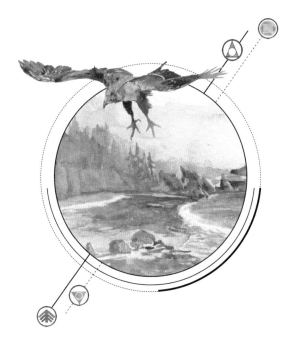

# THE
# COASTS
# OF CALIFORNIA

Written and Illustrated
by Obi Kaufmann

Heyday
Berkeley, California

Copyright © 2022 by William Kaufmann

All rights reserved. No portion of this work may be reproduced or transmitted in any form or by any means, electronic or mechanical, including photocopying and recording, or by any information storage or retrieval system, without permission in writing from Heyday.

Library of Congress Cataloging-in-Publication Data

Names: Kaufmann, Obi, author, illustrator.
Title: The coasts of California : a California field atlas / written and illustrated by Obi Kaufmann.
Description: Berkeley, California : Heyday, [2022] | Series: The California Lands Trilogy; 2 | Includes bibliographical references.
Identifiers: LCCN 2021032867 | ISBN 9781597145510
Subjects: LCSH: Coasts--California. | Coasts--California--Maps.
Classification: LCC G1527.C6G4 K38 2022 | DDC 912/.1916432--dc23
LC record available at https://lccn.loc.gov/2021032867

Cover Art: Obi Kaufmann
Cover Design: Ashley Ingram
Interior Design/Typesetting: Obi Kaufmann and Ashley Ingram

Published by Heyday
P.O. Box 9145, Berkeley, California 94709
(510) 549-3564
heydaybooks.com

Printed in China by Imago

10 9 8 7 6 5 4 3 2 1

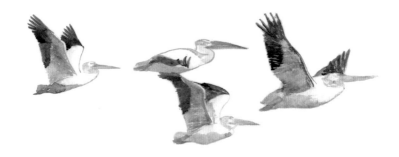

## *Ethical presumptions of* The Coasts of California:

A. Preserving humanity means preserving biodiversity; the best strategy against societal and ecological collapse is keeping intact the ecosystem functions and services that are universally strengthened by biological variety, complexity, and connectivity.

B. The world does not end; that is not the way nature works. The study of the natural world is the study of cycles within cycles—complex systems of stress and release that unfailingly transform but never wholly obliterate the underlying capacity of life to rebound anew.

C. Beauty can be a survival tool; our capacity to adapt and to respond to crisis, indeed our health, is bolstered by aesthetic appreciation, as is our capacity for empathy and reasonable thinking.

D. Art and science form a unity of knowledge that maximizes understanding; the humanities represent the values and aspirations of our society and the meaning we give to them; the scientific method is the key to unlocking universal truths, but those truths remain valueless without applied meaning.

E. For every point of despair, there is a point of hope. As the cascading feedback loops of the climate and extinction crises mount across the globe, so too do moments of insight and knowledge regarding responsibility, justice, and love; far from catastrophic failure as being already determined, the balance of the equation is just as likely to tip toward catastrophic success.

# CONTENTS

Introduction xv

*Keys and measures* xxv
00.01 The Geologic History of California's Coasts
00.02 Measurement Conversion Table
00.03 California and Earth's Grid System
00.04 Key to the Map Icons
00.05 The Coastal Counties of California
00.06 Conservation Status and Ranking: *Assigning special species designation*

01. Symmetry and Succession: *Perspectives on time and ecology* 1
    01.01 An Island of Diversity: *The living province of California*
    01.02 A Long History of Life: *California's ancient animals*
    01.03 Humanity Emerges: *Anthropogenesis in the Holocene*
    01.04 Accounting for the Most Vulnerable: *Endangered biodiversity*

02. Fault-Line Symphony: *The geomorphology of coastal California* 23
    02.01 How the Light Fades: *Ocean zones and marine classification*
    02.02 Where the Waves Break: *Beach profiles and shoreline structure*
    02.03 An Ancient Staircase: *Coastal terraces and their unique forests*
    02.04 Land's Westward Advance:
        *California's evolving coast through the ages*
    02.05 An Evolving Puzzle: *Pacific North America's tectonic configuration*
    02.06 Rocky Patterns in the Landscape:
        *North American terranes and continental structure*
    02.07 The Writhing Substrate: *Contemporary fault lines of California*
    02.08 The Land of the Sea: *The floor of the Pacific Ocean*
    02.09 Depth and Diversity: *Bathymetry off California's coast*
    02.10 Petrological Portrait: *California's coastal topography*
    02.11 Summits in Sight of the Sea:
        *Mountain provinces of coastal California*

03. Elemental Rhythms: *Energy, weather, and the cycles of wind and wave* 47
    03.01 Water and Gravity: *The astrophysical nature of the tides*
        03.01a Celestial Mechanics: *The spring and neap tides*
        03.01b Higher Highs and Lower Lows:
            *California's daily diurnal tidal patterns*

03.02 The Turning of the Ocean:
  *Current trajectories across the northern Pacific*
03.03 Delivering Life to the Coasts:
  *Habitat spaces of the California Current System*
03.04 Planetary Patterns and Local Effects:
  *El Niño, sea temperature, and wind*
03.05 The Ocean Machine: *Upwelling, oxygen, and temperature*
  03.05a Coastal Upwelling
  03.05b Coastal Downwelling
03.06 The Stirring of Life: *Chlorophyll concentrations*
03.07 Ocean Rain:
  *Storm cycles and atmospheric rivers in the eastern Pacific*
03.08 Between Flood and Drought: *California's Mediterranean climate*
03.09 Climate Disrupted: *Local climates and precipitation*
03.10 Fire Drivers:
  *The desert winds of Northern and Southern California*
03.11 Raging through Canyons: *The Santa Ana winds of Los Angeles*
03.12 The State of Fire: *Where, how, and why coastal California burns*
03.13 Deviation from the Norm:
  *The fire return interval departure of Southern California*
03.14 The Power of Renewal: *Fire regime and ecology in California*

04. Sand and Rivers: *Littoral patterns and estuary types*  85

  04.01 River's End: *Estuary geography*
  04.02 Discrete and Distinct: *Watersheds*
  04.03 Moments of Safe Harbor: *California's bay geography*
  04.04 Inexpressible Fertility: *The Golden Gate and the Bay Delta*
  04.05 Central Coast Arborea: *Forests on- and offshore*
  04.06 Traditions Both Ancient and Modern:
    *The many faces of the Point Reyes coast*
  04.07 Marching Sands: *California's dunes and littoral drift*
  04.08 Dune City: *San Francisco's sandy core*
  04.09 California Dreaming: *The beaches of Southern California*
  04.10 Jade and Sea Stacks: *The beaches of Northern California*

05. As Above, So Below: *A survey of coastal habitat types*  123

  05.01 A Patchwork Shore: *Habitat types across coastal California*
    05.01.01 Big Trees of the North Coast
    05.01.02 The Lost Coast and the Mattole River
    05.01.03 Pygmy Forests and the Terraces of Mendocino
    05.01.04 Cypress Forests of the Sonoma Coast

   05.01.05 Tidal Flats of the Bolinas Lagoon and Estuary
   05.01.06 Southern Redwoods of Big Basin State Park
   05.01.07 Coastal Woodlands of the Ventana Wilderness
   05.01.08 Estuary Restoration on Morro Bay
   05.01.09 Mesas of the Gaviota Coast
   05.01.10 Coastal Riparian Forests of the Santa Clara River
   05.01.11 Biodiversity Reserves across Palos Verdes
   05.01.12 Mosaic of Santa Cruz Island
   05.01.13 Fresh-Brackish Marsh of Tijuana Slough
 05.02 The Terrestrial Coast:
   *The distribution of indicative plant communities*
 05.03 Underwater Forest: *The offshore quilt of kelp ecosystems*
 05.04 A World of Their Own: *Tide-pool zonation*
 05.05 Where Half of Life Lives: *The biodiversity of wetlands*
 05.06 The Prairie by the Sea: *California's coastal scrub land*
 05.07 Of Manzanita and Mountains:
   *Coastal California's chaparral blanket*
 05.08 Wildflower Wonderland:
   *Following the bloom through the grasslands*
 05.09 Inside the Oak Woodland: *California's hardwood habitat*
 05.10 Forests on the Shore: *Coastal arboreal diversity*
 05.11 The Great Icon: *Old growth in the kingdom of the redwood*
 05.12 Specific Stressors: *Areas of Special Biological Significance*

06. All Creatures Great and Small: *Coastal biodiversity*  193

 06.01 Food Web in the Waves: *Biodiversity and ecosystems*
 06.02 The Microscopic Basis for Oceanic Life: *Plankton*
 06.03 From Bacteria to Sea Grass:
   *Regional primary producers of the kelp forests*
 06.04 From Suspension Feeders to Grazers:
   *Primary consumers of the kelp forests*
 06.05 From Predatory Snails to Otters:
   *Secondary consumers of the kelp forests*
 06.06 Fish Who Eat Fish Who Eat Fish:
   *Tertiary consumers of the kelp forests*
 06.07 Life on the Edge: *California's coastal endangered species*
 06.08 Biosurvey 01: *Amphibians*
 06.09 Biosurvey 02: *Nonmarine fish*
 06.10 Biosurvey 03: *Pinnipeds*
 06.11 Biosurvey 04: *Shorebirds and waterfowl*
 06.12 Biosurvey 05: *Sea turtles*
 06.13 Biosurvey 06: *Sharks*

06.14 Biosurvey 07: *Raptors and owls*
06.15 Biosurvey 08: *Dolphins and porpoises*
06.16 Biosurvey 09: *Pelagic seabirds*
06.17 Biosurvey 10: *Crustaceans and mollusks*
06.18 Biosurvey 11: *Whales*
06.19 Biosurvey 12: *Anadromous fish*

07. A Good, Long Walk: *The California Coastal Trail*   251

    07.01 A Many-Faceted Diamond: *The twenty-four coasts of California*
    07.02 Of Salmon and Spruce: *The Del Norte coast*
        07.02a Stewarding Trees: *North coast forest restoration*
    07.03 Of Shade and Scale: *The redwood coast*
        07.03a As Diverse as It Gets:
            *Invertebrate species of northern tide pools*
        07.03b Sue-meg State Park
    07.04 Of Old Growth and Oysters: *The Humboldt coast*
        07.04a Wastewater and Wildlife: *A new approach in Arcata*
    07.05 Of the Remote and the Rugged: *The Lost Coast*
        07.05a Rebuilding the Mattole River:
            *North coast estuary and riparian restoration*
        07.05b King Range National Conservation Area
    07.06 Of Steppe and Solitude: *The Sinkyone coast*
        07.06a Plants That Don't Use the Sun:
            *The fungus flowers of the Mendocino coast*
    07.07 Of Tide Pools and Tall Trees: *The Mendocino coast*
        07.07a All the Tough Little Trees:
            *Stories from the terraced dune forest*
        07.07b Van Damme State Park
    07.08 Of Lighthouses and Long Views: *The Point Arena coast*
        07.08a Saving Elk Creek: *Data in the service of restoration*
        07.08b Stornetta Public Lands
    07.09 Of Wine and Wildflowers: *The west Sonoma coast*
        07.09a Pathogen Incognita:
            *The mysterious tragedy of sea star wasting disease*
    07.10 Of Pasture and Poetry: *The Point Reyes coast*
        07.10a Of Cows, Elk, Deer, and Oysters:
            *Conflicts of conservation at Point Reyes*
    07.11 Of Peaks and Peninsulas: *The Golden Gate coast*
        07.11a An Elite Class of Diversity:
            *The Golden Gate Biosphere Reserve*
    07.12 Of Inlets and Inroads: *The Half Moon Bay coast*

07.12a The Connected Forest:
    *The Santa Cruz Mountains Stewardship Network*
  07.12b San Bruno Mountain State and County Park
07.13 Of Seals and Sage: *The Año Nuevo coast*
  07.13a Save the Pollinators, Save the Plants:
    *Endangered bees of the Santa Cruz Mountains*
  07.13b Año Nuevo Coast Natural Preserve
07.14 Of Monarchs and Marshlands: *The Monterey coast*
  07.14a Pickleweed: *Being a succulent in the salt marsh*
  07.14b Garrapata State Park
07.15 Of Cliffs and Condors: *The Big Sur coast*
  07.15a Andrew Molera State Park
07.16 Of Castles and Castilleja: *The San Simeon coast*
  07.16a Piedras Blancas Light Station Outstanding Natural Area
07.17 Of Barnacles and Beaches: *The Estero Bay coast*
  07.17a Of People and Pollutants: *Protecting Morro Bay*
  07.17b Montaña de Oro State Park
07.18 Of Dunes and Daisies: *The San Luis Obispo Bay coast*
  07.18a Of Oil Fields and Dune Fields:
    *Cleaning up the Santa Maria River Estuary*
07.19 Of Oaks and Ocean: *The Point Conception coast*
07.20 Of Sandstone and Sky: *The Santa Barbara coast*
  07.20a Of Streams and Steelhead:
    *Restoration of the Santa Barbara salmon*
07.21 Of Sycamores and the Santa Clara: *The Ventura coast*
  07.21a Lessons Not Learned:
    *The legacy of oil in the Santa Barbara Channel*
  07.21b Point Mugu State Park
  07.21c A Holdout for Diversity:
    *Habitat types at Mugu Lagoon*
  07.21d Malibu Creek State Park
07.22 Of Canyons and Creeks: *The Santa Monica coast*
  07.22a Saving the Mountain Lion:
    *Connectivity at Liberty Canyon*
  07.22b Topanga State Park
07.23 Of Cities and Sagebrush: *The San Pedro Bay coast*
  07.23a Rethinking Wastewater:
    *The key to Los Angeles's future*
07.24 Of Valleys and Vistas: *The San Clemente coast*
  07.24a Torrey Pines State Natural Reserve
07.25 Of Cactus and Clouds: *The San Diego coast*
  07.25a A Mixed Blessing:
    *The promise and the reality of desalination*
  07.25b La Jolla Cove Walk

08. Each a Character: *The islands of California*   423
    08.01 Santa Rosae
    08.02 The Islands of California
    08.03 Santa Catalina Island
    08.04 San Clemente Island
    08.05 San Miguel Island
    08.06 Santa Rosa Island
    08.07 Anacapa Island
    08.08 Santa Cruz Island
    08.09 Santa Barbara Island
    08.10 San Nicolas Island
    08.11 Angel Island
    08.12 The Farallon Islands

09. Policies and Protections: *Stewardship of the land and sea*   459
    09.01 How We Got Here and What Our Strategy Is Now
    09.02 Within Sight of the Sea: *Coastal parks and monuments*
    09.03 Enforcement and Enhancement:
        *Protections and the agencies responsible*
    09.04 North Coast Marine Protected Areas
    09.05 North Central Coast Marine Protected Areas
    09.06 Central Coast Marine Protected Areas
    09.07 South Coast Marine Protected Areas
    09.08 Coastal Wilderness Areas
    09.09 The Nature Conservancy
    09.10 Wildlife Areas and Ecological Reserves
    09.11 National Wildlife Refuges (NWRs)
    09.12 Coastal Land Trusts

10. Navigating a Chaotic Sea: *Modeling hope and peril*   499
        Facing West, part one: *View from the shore*
    10.01 The Path of Renewal: *The nature of disturbance*
        Facing West, part two: *Starting with the end*
    10.02 Feedback Cascades: *The drivers of climate breakdown*
        Facing West, part three: *Revolutions and paradigm shifts*
    10.03 The Effects of Pollution: *Vectors of climate-based ocean stress*
        Facing West, part four: *Growth, unbounded and costly*
    10.04 Poisoning the Sea: *Proportions and pollutants*
        Facing West, part five: *The cresting wave*
    10.05 Nothing Is Disposable: *Plastic's insidiousness*

    Facing West, part six: *The bottleneck and the inflection point*
10.06 The Sea's Harvest: *Monitoring human predation*
    Facing West, part seven: *Navigating the future*
10.07 The Rights of Rivers: *Polluted water, polluted bodies*
    Facing West, part eight: *Circular time, space, and mind*
10.08 An Infinite Supply: *Prospects and problems of desalination*
    Facing West, part nine: *Secrets of the arrow*
10.09 A Contentious Plan:
    *How the delta tunnel project would affect the bay*
    Facing West, part ten: *The arrow misses its mark*
10.10 Justice and Nature: *Human connectivity*
    Facing West, part eleven: *Reckoning day*
10.11 For the Love of Justice: *Biodiversity's future*
    Facing West, part twelve: *The circular economy*
10.12 Future California 001: *Keeping the circuit open*
    Facing West, part thirteen: *The tide of revolution*
10.13 Future California 002: *Unrecognizable*
    Facing West, part fourteen: *The innovation of memory*
10.14 Future California 003: *Islands in deep time*
    Facing West, part fifteen: *This is where we begin*

Acknowledgments 553
Glossary 555
Notes 559
Selected Bibliography 627
About the Author 639

# INTRODUCTION
## *Two Things at Once: Polarities and Dualities*

This is a time capsule.

The coasts of California that I have spent my life exploring are not what they were one hundred years ago, and they are not what they will be one hundred years from now. Through the fog-laden, forested grottos of the tallest trees in the world, over oak-dotted coastal bluffs where the desert touches the sea, and along salt-marsh estuaries where birds in tremendous numbers darken the sky, I've spent decades wandering, lamenting what washes away, and observing what remains.

This book contains a very personal collection, an inventory of what is rare, what is important, what needs to be remembered, and what needs to be saved. As the seasons roll by and the effects of climate breakdown due to global warming become ever more acute, my ever-growing affection for the greater entity of California so too focuses. When I describe the trails of California, whether coastal or inland, physical or philosophical, geographic or ecological, spatial or temporal, I remember the path I took to get to understanding my place in the world. I always wish to be more from here, as if the capacity to truly identify with being from somewhere is directly proportional to the responsibility one takes to learn about the natural character of that place. By endeavoring to better understand the natural world of California, I make a home for California in my heart as it has been a home for me.

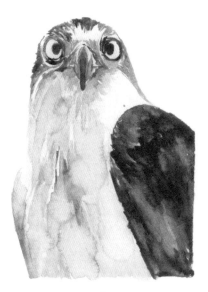

Osprey
*Pandion haliaetus*
(G5/S4)

California's heartbeat is the pounding of the tide on the beach. Where the salt currents of the sea meet the fresh nutrients from the inland rivers, a pulse drives the seasons across coastal habitats, and the climatic rhythm of the ages defines eras of ecological glut and famine. This story of the coasts of California is of a living system, as resilient as it is vulnerable and as enduring as it is endangered. Inside the dynamic force of each wave as it moves through me, a thousand notes, paintings, and maps spring to mind in the liminal space between the land and the sea.

The narrative pulse of this story oscillates between a scientific perspective and an artistic disposition. The basis of the work is the line between the measurable data and my own craft. By exploring the relationships that make up a healthy and biodiverse coastal ecosystem, and by taking a multidisciplinary approach, we can pull a thread from a working model of ethical stewardship to a deeper understanding of ourselves. The thread we pull between the data and the desire, the information and the image, and the research and the romance defines this book. The coasts (with their polymorphous nature, I refer to the length of California's shoreline in the plural) are as ecologically delicate as they are poetically inexhaustible.

The marginal space between two ecosystems often presents more niche resources for a greater amount of biodiversity than either of the ecosystems it bridges. In these spaces, living beings can access a greater range of habitats, and as a result the adjacent ecosystems often become more biologically complex and ecologically stable. So it is with the philosophical substrate of this work. There is a transitional space between any two concepts that have a relationship with each other, where the meaning of both is amplified. When we acknowledge that two things can be true at once, we can exit our intellectual silos, join one another, and draw new meaning from the study of ecology.

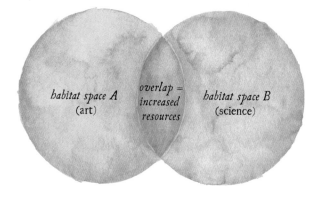

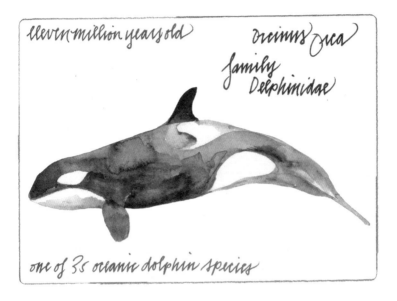

*eleven million years old*  
*Orcinus orca*  
*family Delphinidae*  
*one of 35 oceanic dolphin species*

## Between this and that: *Gradients of meaning*

The themes of this book work as polarities, or as forces that interact and contrast with one another to form a deeper, holistic understanding of the subject. There are three organizing spheres guiding the art and science of this book: (1) geographic/physical/historical—aspects of cartography concerned with space and time; (2) biological/climatic/elemental—aspects of biogeography concerned with living beings and the ways they interact; (3) aesthetic/personal/philosophical—aspects of psychology concerned with storytelling and society. Each of the polarities within these organizational spheres exists on a gradient between being inseparably conjoined and discretely separate. While it may be that some of the dynamics listed here exist as meaningful in all three spheres, they are organized as distinct forces that helped guide the organization of this presentation.

In the world around us, these dualities interact in a profound multitude of ways, and this book seeks to make these dualities visible. The fact that the book is itself built on a duality—the fusion of science and art—means that it's sensitive to these dualities as they appear in nature. We can do more than understand these dualities in the abstract: we can begin to feel their presence.

*The Coasts of California* exists as a catalog of ecological variables, a referenceable inventory of components of what can be called a recipe for sustainability. California's coastal ecosystems operate on a spectrum between functions (how they serve themselves) and services (how they serve us); and the ability of an informed California citizenry to understand (through science) and to derive meaning (through art) from the complexity of this living system is a powerful tool to perpetuate the human and the more-than-human world.

## The calculus of sustainability: *Inflection points and bottlenecks*

In differential calculus, the mathematical study of curvilinear functions, an inflection point is where a graphed curve changes its concavity or convexity, given its variables and parameters. In conservation biology—the interdisciplinary study of extinction purposefully applied to the preservation of biodiversity—a bottleneck (a type of inflection point) occurs when a given population (or group of populations) sharply declines and experiences either recovery or extirpation/extinction. Together, inflection points and bottlenecks can be graphed to represent predictive trends of resource distribution within any ecosystem, from a small tide pool to the global biosphere. They can also be used to model a possible trajectory for human ecology, one that is either optimistic or dire, although too many variables (most notably human ingenuity) work to warp any reliable prediction.

*Land and sea*
*Past and future*
*North and south/east and west*
*Size and scale*
*Urban and rural*
*Intact and degraded*
*Fresh water and salt water*
*Wetland and dry land*
*Incremental and immediate*

*Geographic*
*Physical*
*Historical*

*Drought and flood*
*Native and exotic*
*Endemic and universal*
*Common and rare*
*Naturalized and invasive*
*Predator and prey*
*Normalized and chaotic*
*Fragmented and connected*

*Biological*
*Climatic*
*Elemental*

*Public and private*
*Colonizing and indigenous*
*Within and without*
*Traditional and innovative*
*Individual and community*
*Simple and complex*
*Linear and curvilinear*
*Microcosm and macrocosm*
*Protected and unprotected*

*Aesthetic*
*Personal*
*Philosophical*

Introduction

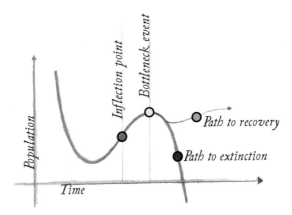

In writing this book, I made a decision to avoid using the term *climate change*. Instead, I use either *climate breakdown* or *climate disruption*, depending on the context. These phrases describe the shattering effects of anthropogenic (human-caused) global warming on long-term patterns of weather and on the boundaries of tolerance that acted as historical, normalizing parameters on those patterns. In terms of the waveform, climate breakdown refers to how the amplitudes describing the ebb and flow of functions and services grow increasingly chaotic in any given ecosystem. Climate disruption refers to how inflection points develop that didn't exist before because of the advent of a novel stressor or disturbance due to atmospheric anomalies from global warming. Climate breakdown due to global warming is possibly the greatest stress variable for any measurable waveform that describes any normalized regime within any of the world's ecosystems.

Ochre sea star
*Pisaster ochraceus*

This book describes the stretch of geography that divides California and the Pacific Ocean, but it has a much larger scope. Every map and every diagram describes a piece of a system whose influence extends far beyond the shore. Each amounts to a snapshot, an ephemeral account of this moment in history. By employing maps to describe places, and diagrams to describe systems, this kind of book—what I call a field atlas—is able to avoid heavy-handed predictions about the exact manifestation of chaotic phenomena that may emerge in the future. In this way, we leave open the powerful possibilities of stewardship and connectivity, not only between pieces of the natural world but between members of our own species.

The Coasts of California

Giant keyhole limpet
*Megathura crenulata*

The degree to which I leave out cultural information, human stories, and history may be alarming to some. The negative space of absent humanity in this field atlas is a character in the story, against which so many other characters are contrasted. At various points in the book, it is as if I am telling a story describing a scenario in which humans and their pernicious influence simply disappeared one day. The roads and cities are still there in my imagined California, as are the conservation issues tied to the creeping, feedback-riddled specter of climate breakdown. Yet it is quiet, and it is still. In real life, the human footprint covers these coasts like the opaque fog that socks it in. For tens of thousands of years, the natural world of California has been influenced by human society, but only in the past two hundred years has it been so terribly warped that even the word *natural* seems limited in usefulness. Although human evidence is everywhere, and its ubiquity can be blinding, building the story this way reveals a world that society has now hidden or works to destroy under a layer of concrete.

The coasts of California form a particular microcosm, a laboratory of inquiry into the much larger question of our continued place, and rank, in the biosphere. Every day, humanity navigates the labyrinth of moral action in regard to the decisions it has already collectively made and the negotiating required to sustain itself in the decades, centuries, and indeed millennia to come. It may be, and there is good evidence to suggest, that we are turning a corner (not unlike a hairpin turn on Highway 1) where we are compelled to face the other direction, away from old ideas about "using" nature, and are now equipping ourselves with the tools and the perspective to augment, feed, and replenish those aspects of our precious natural legacy that have been dismantled or destroyed.

Opaleye
*Girella nigricans*

# Introduction

## Notes on enjoying *The Coasts of California*:

Sea fingers
*Codium fragile*

1. This is a field atlas. This is not a field guide, nor is it a road atlas. The field atlas, a genre of my own invention, is not a visual encyclopedia of species or a reference tool detailing the exact geography of places with routes for getting there. The field atlas uses maps and inventories to show how nature works in—and between—specific places.

2. This is a reference book. It is meant to be referred to again and again, revealing something new every time. Although it is an excellent companion for a road trip up Highway 1, it doesn't present what traditional travel guides will. It's a layperson's introduction to the ecological processes of a huge breadth of habitat types. The invitation this book represents is to a journey through a geographically distinct area that is infinitely and uniquely complex.

3. This is primarily an art book. I work to be as transparent as possible when it comes to data sources and referenced research. I am not overly concerned with making sure the glossary at the back of the book is complete, but I am sure to cite ideas that are (1) good science and (2) not mine. I am an artist, not a research scientist. All of the art is data driven, but this is not a textbook. My search for meaning, for beauty, and for personal truth within the scientific sourcing proceeds without hesitation, and drips from every sentence.

4. This is a collection of unorthodox maps. These roadless, hand-painted maps tell different kinds of visual stories than do traditional road or topographic maps. These are nature-first maps where the effects of urbanization and infrastructure take a backseat to habitat connectivity and watershed proximity.

5. There are other books in this series. This book exists in the context of the others I've written, though they can be experienced in any order. The Field Atlas series began with my first book, *The California Field Atlas* (Heyday, 2017), and is (very loosely) several hundred hand-painted maps of how nature works around the state. The second book, *The State of Water* (Heyday, 2019), describes California's most

Two-spot octopus
*Octopus bimaculoides*

Purple olive snail
*Olivella biplicata*

precious resource and the infrastructure we've built for its conveyance, storage, and use. The third book, *The Forests of California* (Heyday, 2020), describes the complexity of California's arboreal habitats. In this, the fourth book of the series, I don't dwell too much on ground that I have covered before. In a few instances, I've reexamined and updated information and conclusions I've made in the past.

6. Each chapter addresses its subject differently. The first four chapters of the book revolve around temporal, abiotic, physical, and elemental forces that set the scene for life across California's coastal biomes. Chapters 5 and 6 focus on certain facets of contemporary biogeography and biodiversity, with specific reference to many iconic places and animal species along California's coasts. Chapter 7 is the biggest chapter of the book because it walks down the entire shoreline from Lake Earl near the Oregon border to the Tijuana Slough on the Mexican border. Chapter 8, which looks at the islands of California, is as set apart from the others as its subject, to address the unique evolutionary patterns found there. Chapters 9 and 10 are deep dives into humanity's impact on biodiversity and how the decisions we are making right now will affect the quality of life in the biosphere for centuries if not millennia to come.

Sea hare
*Dolabella auricularia*

7. This book is about more than the coasts. It is about becoming geographically and ecologically literate. It's about the complex nature of the coasts and the aspects of California nature influenced by them and the Pacific Ocean. You don't need to read this book from cover to cover. Like maps, photographs, or paintings, the story works in a nonnarrative space. The geographic scope of the book is generally the viewshed (what you can see) from California's shoreline up and down the state.

Obi Kaufmann
Oakland, California
2021

# Introduction

> This a story of hope. It assumes that our extractivist culture will soon transform, that the carbon-based economy will soon be replaced by a better solution to wealth and resources management. The wellspring of this hope is not some unrealistic, heroic view of what the myopic environmental movement might once have been but the capacity of the human mind to solve problems. In the next century, the world that exists as I write will be as unrecognizable to our great-grandkids as its current configuration might have been to our great-grandparents at the beginning of the twentieth century. We will have undone so many mistakes now still being perpetuated, or, more likely, they will have been undone for us.

Wavy turban snail
*Megastraea undosa*

# The Coasts of California

forever in love

California

Did I give you all the poetry you are worth?
Did I climb enough into your mountains
to see all the stars you needed me to see?
Was I a true enough friend to your children
— my more than human family,
to work honestly for the justice
deserved?
Did I find enough peace to recognize
what we do to your body, we do to
our own?
I have stood in this jeweled tide
deathless for a thousand years,
and it was barely enough time
to hear your single pulse,
barely enough time
to see you at all.

## KEYS AND MEASURES

| era | Period / Epoch | duration millions of years ago | | major events |
|---|---|---|---|---|
| Cenozoic | Quaternary | | | |
| | Holocene | present to 0.01 | | cycles of glaciation; major building of the coast ranges, the Transverse Ranges, and the volcanoes of the Cascade range |
| | Pleistocene | 0.01–3 | coastal range orogenies | |
| | Tertiary | | | |
| | Pliocene | 3–11 | | |
| | Miocene | 11–24 | | beginning of the coastal orogenies; origin of the San Andreas Fault |
| | Oligocene | 24–34 | | |
| | Eocene | 34–56 | | |
| | Paleocene | 56–70 | Nevada orogenies | |
| Mesozoic | Cretaceous | 70–135 | | major building of the Sierra Nevada, the Klamath Ranges, and the Peninsula Ranges |
| | Jurassic | 135–180 | | |
| | Triassic | 180–225 | | mountain building, and island arcs rise in shallow seas; |
| Paleozoic | Permian | 225–270 | Sonoma orogenies | California exists as small islands far from the Pangaean coast[1] |
| | Pennsylvanian | 270–305 | | |
| | Mississippi | 305–350 | | |
| | Devonian | 350–400 | | "Antler" orogeny[2]; proto-California ranges in the Eastern Pacific Ocean |
| | Silurian | 400–440 | | |
| | Ordovician | 440–500 | | |
| | Cambrian | 500–600 | | |
| | Late Precambrian | 600–1,800 | | Earliest California orogeny; California's oldest rocks[3] |
| | Early Precambrian | 1,800–2,700 | | |

00.01 The Geologic History of California's Coasts

*Source:* Data from D. Hornbeck and D. F. Fuller, *California Patterns* (Mountain View, CA: Mayfield, 1983), 12.

The Coasts of California

| US units | multiplied by | equal metric units |
|---|---|---|
| | LENGTH | |
| feet | 0.3048 | meters |
| inches | 2.5400 | centimeters |
| inches | 0.0254 | meters |
| inches | 25.4001 | millimeters |
| miles (statute) | 1.6093 | kilometers |
| miles (nautical) | 1.8532 | kilometers |
| yards | 0.9140 | meters |
| | AREA | |
| square feet | 0.0929 | square centimeters |
| square yards | 0.8361 | square meters |
| acres | 2.4710 | hectare |
| | VOLUME | |
| cubic inches | 16.3872 | cubic centimeters |
| cubic feet | 0.0283 | cubic meters |
| cubic yards | 0.7646 | cubic meters |
| gallons | 3.7854 | liters |
| fluid ounces | 29.5730 | milliliters |
| quarts | 0.9460 | liters |

## 00.02 Measurement Conversion Table

Introduction

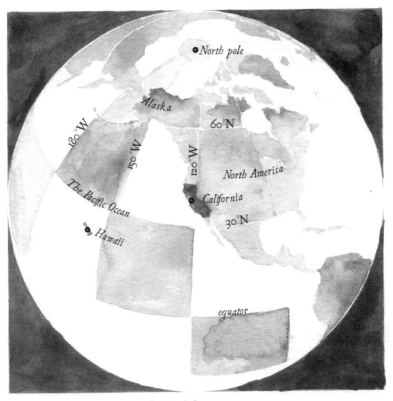

00.03 California and Earth's Grid System

*California's land area includes*

- More than 158,000 square miles
- 4,900 lakes and reservoirs
- 175 major rivers and streams
- 1,100 miles of coastline

The Coasts of California

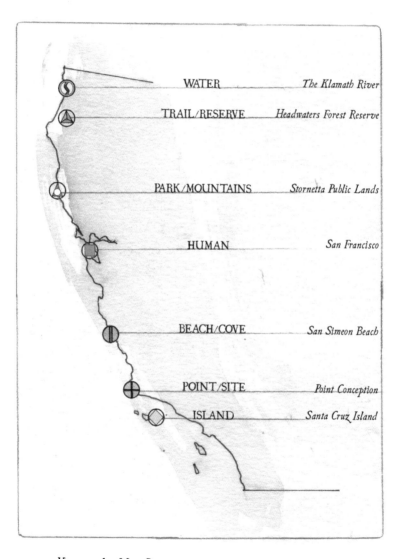

00.04 Key to the Map Icons

Introduction

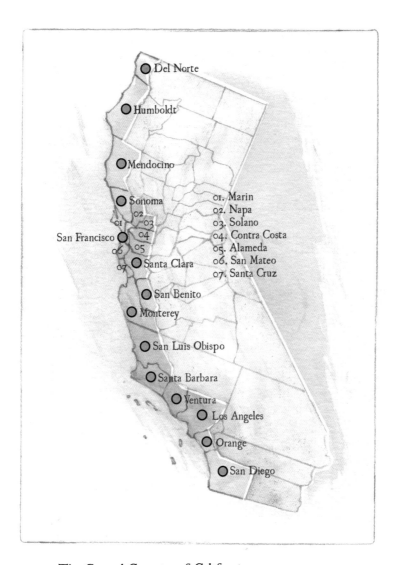

00.05 The Coastal Counties of California

## 00.06 Conservation Status and Ranking
*Assigning special species designation*

Throughout the book, animal species of special status are described by their common name, their taxonomic binomial, and their global and state conservation status according to the California Department Fish and Wildlife's California Natural Diversity Database.[1] If the named species is not followed by the applied code numbers, it is because it is not a species designated by either the State of California or the federal government as a species of special status. Plants are not included in this analysis as such, but may be described so as to emphasize their needed conservation with words like *rare*, *endemic*, or *endangered*.

To be ranked in the state's diversity database, a species is subject to at least one of these conditions: (1) listed or list-pending under the state and/or federal Endangered Species Act (ESA); (2) dependent on or associated with a declining habitat type; (3) peripheral to a larger population outside the state, but threatened with extirpation within California; (4) described as rare, restricted, declining, or threatened by a nongovernmental organization; (5) very restricted in distribution; (6) eligible for protection under the California Environmental Quality Act Guidelines;[2] or (7) listed by the California Department Fish and Wildlife as a species of special concern. This outline does not include the status of species that have been proposed as candidates for endangered status and await increased protections.

The species of special concern represent a critical swath of biodiversity in California, and the precariousness reflected in these designations cannot be overstated. Regarding the inhabitants of these varied ecosystems, the emphasis is on conservation, the restoration of their essential habitats, and the popular dissemination of research science across the state, working to maintain California's biodiversity from further decay.

Species listed are assigned global and state rankings that reflect rarity and threat of extinction. (This code system does not include level of protection under the federal ESA.) The following is the key to special conservation status wildlife:[3]

(G) Global ranking: indicates the conservation status of a species in its entire range, as distinct from the degree of threat of extinction within the state

(S) State ranking: indicates the conservation status of a species within California's state boundaries

(G1) Critically imperiled: at very high risk of extinction because of rarity, steep decline, loss of habitat, or other threats—often not more than five populations

(G2) Imperiled: at high risk of extinction because of restricted range, steep decline, loss of habitat, or other threats—often not more than twenty populations

(G3) Vulnerable: at moderate risk of extinction—often not more than eighty populations

(G4) Apparently secure: uncommon but not rare; a species of concern because of declines or other threats

(G5) Secure: common

(S1) Critically imperiled: at very high risk of extinction within the state because of rarity, steep decline, loss of habitat, or other threats—often not more than five populations

(S2) Imperiled: at high risk of extinction within the state because of restricted range, steep decline, loss of habitat, or other threats—often not more than twenty populations

(S3) Vulnerable: at moderate risk of extinction within the state—often not more than eighty populations

(S4) Apparently secure: uncommon but not rare; a species of concern in the state because of declines or other threats

(S5) Secure: common

Other symbols:

(T) Indicates the status of a subspecies only, in the global ranking.

(SNR) State–not ranked: as with the federal ESA, although populations may be low, declining, or in fact endangered, a species in this case has not been given protection under the state ESA as being under threat of extinction.

(TNR) Subspecies not ranked.

(?) Taxonomic questions remain that may influence exact designation.

(SH) Population is historical but possibly extirpated in the state—it hasn't been seen in twenty to forty years, although suitable habitat may remain.

(ESU) Evolutionarily significant unit.

(DPS) Distinct population segment.

# 01. SYMMETRY AND SUCCESSION
*Perspectives on time and ecology*

# The Coasts of California

Let's play a conceptual game. It will help us imagine our place in the grand history of life on earth, and from that place we can focus on California's wonderful shoreline. We'll set the game inside a series of rings that radiate out, like ripples in a pond, from the spot where we are standing. This spot is on top of an imaginary mountain with a perfect view in all directions. Everything we can see from our perfect vantage point is within what we will call a timeshed. A timeshed is like a watershed, but instead of a piece of space, the timeshed holds a piece of time. In this case, the timeshed of our game holds the past and the future history of life on earth.

Looking east, where the sun rises, you can see all the way back to the beginning of life on earth (05.a), deep in the Archean period of the Precambrian supereon, almost four billion years ago. Turning west, where the sun sets, you can see all the way to the very end of life on earth, when the core of our sun, through the processes of solar evolution, begins to shrink, brighten, and grow hotter, evaporating the oceans of planet earth and even all terrestrial bacteria. That too is roughly four billion years away from us. From this logic, it is reasonable to think that our species has found itself in the middle of the long history of life on this planet. And what a view it is!

In the timeshed game, the spot where we are standing represents right now. Our view of east and west looks out toward the past and the future. The further we can see in imaginary space, the further we can see into the history of life. As we lower our gaze to look at what is nearby, so too does the scale of the time horizon close. When we pull out our binoculars and examine a few symbolic miles to the east, call it ten million years ago (04.a), we find California just beginning to resemble its present geologic configuration. We find a landscape dominated by mammals that have since passed into extinction, and ecosystems where giant jaguars hunt giant camels across California's proto-grasslands. When we look west, we see what life will be like ten million years in the future (04.b) when, driven by the San Andreas fault, the peninsula of Baja has become an island. Recovering from the planet's sixth mass extinction, new predator species of these ecosystems hunt novel prey over landscapes as different from today's as those ancient grasslands are from what we know today.

*Previous page:*
Channel Islands flightless duck
*Chendytes lawi*
extinct 10,000 years ago

Fifteen thousand years ago (03.a) was when the world's only storytelling apes, *Homo sapiens*, discovered California's ripe hunting grounds for mammoth and a wealth of other megafauna. Fifteen thousand years from now (03.b) will again be a time

01. Symmetry and Succession

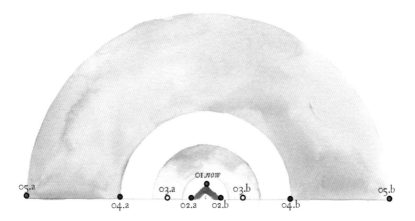

In the middle of a long story: *A timeshed of life on Earth*

Please note: the diagram is not to scale. The Precambrian period alone represents seven-eighths of earth's history.

when, recovering from a long age of warming, California's climate will be cooler, perhaps much cooler as the interglacial period ends and sea levels lower, exposing future humanity to a new set of conditions and resources.

Now let's finish the game by considering two hundred years ago (02.a), at the conceptual base of the mountain we now peer down from. In this extremely close horizon before Euro-American settlement, California was as different from what it is today as it will assuredly be two hundred years in the future (02.b). The mountain, at this scale, represents the carbon pulse, the robust modern economy, fed as it is from the power of fossil fuels. This horizon, bounded on both ends by the finite nature of the energy source extracted to begin the industrial era will, in the future, either transform (and form a ridgeline, to maintain the metaphor) or collapse. Two hundred years ago, many indigenous communities continued to flourish across California, and despite the centuries-long genocide that the Spanish had initiated and that the Americans were continuing, their culture of stewardship continued as a way of life as it had done for tens of thousands of years. Because so many native California cultures continue to grow and thrive in the twenty-first century despite the tragedies incurred since colonialization, when we look two hundred years into the future, we may be witness to a new, resurgent era of indigenous sovereignty.

North American Mammoth, Mammuthus columbi in California for two million years before extinction 13,000 to 10,000 years ago

The opportunity for this great moment of restorative justice to occur exists because of decisions we are all making right now and our courage to end the ongoing legion of legacy atrocities, rooted in colonial violence. For thousands of years, California's indigenous communities had been developing an ecological homeostasis with California's varied ecosystems, especially along its coasts, where, since the advent of the coming of humanity, the bounty of the sea has always provided for a relatively large population. Reckoning with its colonial past and respecting the strength of indigenous tradition, while engaging its seemingly endless capacity for innovation, seems to be the best road forward for California, whose near future is burdened by so many chaotic variables.

## 01. Symmetry and Succession

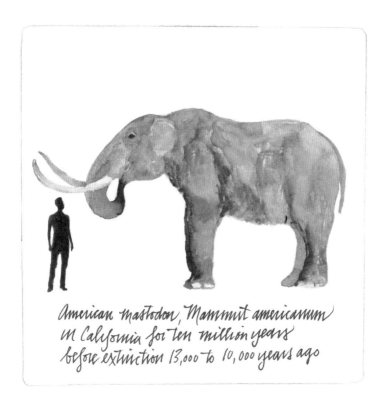

*American mastodon, Mammut americanum in California for ten million years before extinction 13,000 to 10,000 years ago*

Hope exists because despite the calamitous degradation of the natural world that has occurred across California, it still retains nearly its entire inventory of precolonial biodiversity. All of it is now grievously threatened, and every minute demands vigilance against its collapse; despite this, the extinction rate within California's floristic province remains extremely low. With that, our charge becomes clear: we bring about a new day of restorative justice by being more informed and more receptive to the natural world that sustains human society. There is no greater bellwether of our ability to reimagine and reengineer our home than along the coasts of California, where most of the human population of the state lives, and where its natural world is most threatened. When we mitigate damage to the coastal ecosystems, and when we understand how those systems function across time and space, we work toward realizing the potential of our species to be present for as much of the distant future as conceivably possible.

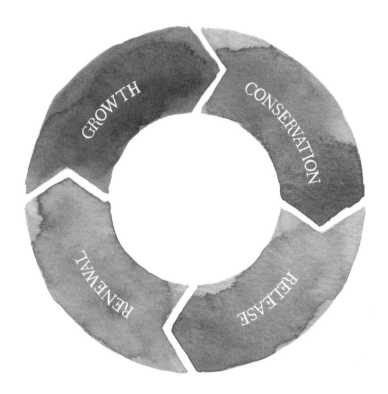

## The turning of life: *Introducing the adaptive cycle*

Nature works differently in California—that is both a true and a false statement. California is full of paradoxes where stated truths exist only at a certain scale or only from one perspective. For example, because of their isolation from the rest of North America, California's forests have evolved over ten of millions of years to use the regular return of fire as an agent of renewal that is wholly different from any other arboreal habitat in the world; it is also true that fire everywhere makes way ecologically for what comes next in a process called succession. The adaptive cycle is a model that generalizes each stage of succession in a pattern that all systems of life adhere to. From coastal, mixed-conifer forests to submerged, towering kelp forests, and from estuarine environments to chaparral-lined bluffs, all ecosystems exist in their own version of the adaptive cycle.

01. Symmetry and Succession

The complex character of an ecosystem is not unlike (and it can and perhaps should be argued that an ecosystem actually is) a living body. The body moves through stages in its life cycle and has a life span that resets periodically. Just as a young being moves to become a mature being in the prime of its life, a climax ecosystem is a mature ecosystem that has achieved stable populations of its constituent organisms for an extended period of time. This stability is called homeostasis or equilibrium. In the diagram, this is the conservation phase—the time when a system retains energy and reaches its greatest biological productivity.

Next comes the release phase, when an ecosystem absorbs and/or reacts to the effects of a disturbance event. If the disturbance event subscribes to a regular return interval, the adaptive cycle will reset, leading to greater amounts of bioproductivity within the ecosystem. A good example of this is an adaptive fire dependency that can be observed in the manzanita chaparral of California's coastal ranges. Some species of manzanita, *Arctostaphylos* sp. (90 percent of the world's fifty species are endemic to California), require temperatures provided by high-intensity, low-severity fire (240°F–260°F) for their seeds to germinate.[1]

looking up through the kelp forest

7

Purple urchin
*Strongylocentrotus sp.*

The undoing of the adaptive cycle results in a breakdown of the cycle of succession and leads to ecological conversion—for example, when a forest experiences too much severe fire and becomes a grassland. Anthropogenic (human-sourced) stressors and disturbances are threatening adaptive cycles within terrestrial and marine ecosystems around the globe and along the coasts of California. Often, some anthropogenic disturbance that occurred a long time ago will set off a cascading effect, a chain of causality that leads to, or assists in, the development of a situation we are witnessing today—not unlike the domino effect.

One such example is the devastation of the bull kelp forest off of California's northern coasts (see 04.05 and 05.03). With the overhunting of sea otters in the nineteenth and twentieth centuries, sea urchins, whose populations are kept in check by otters and who feed on kelp, began an unchecked rampage through the forest beneath the waves. It is widely thought that the sunflower sea star, *Pycnopodia helianthoides*, an invertebrate predator that also feeds on urchins, did its best to keep the urchin populations in check[2]—that is, until the mysterious sea star wasting disease (see 07.09.a) took hold and extirpated the species. It may take decades for the kelp forest to recover, if it can recover. Kelp forests around the world are threatened by a barrage of stressors in the devastating wake of the age of humanity.[3]

01. Symmetry and Succession

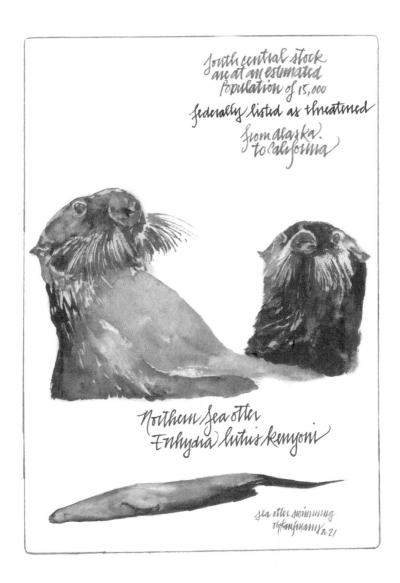

# The Coasts of California

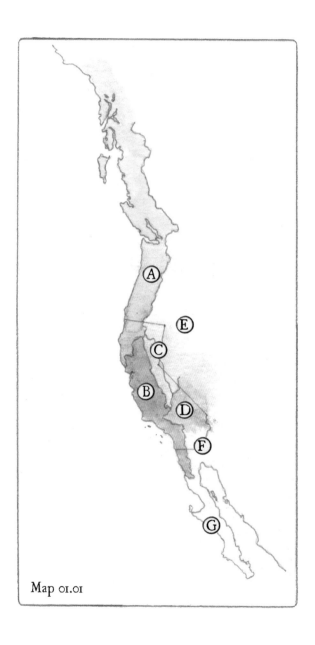

Map 01.01

## 01.01 AN ISLAND OF DIVERSITY
*The living province of California*

The wall that is the Sierra Nevada, a mountain range that rises nearly 15,000 feet over the course of tens of miles, has protected the isolation of California's botanical province for the entirety of the Cenozoic era, and in so doing has increased the province's island-like evolutionary qualities. California has more rare plants than most states have plants. This botanical isolation, coupled with California's globally rare Mediterranean climate, has built the state into one of thirty-six biodiverse hotspots on the planet.[4]

A. Pacific temperate rainforest—from California to Alaska; largest temperate rainforest in the world, with more biomass than any other; most timber produced of any other forest in the world and therefore, by many metrics, the most endangered.[5]

B. California Floristic Province—the island of California; isolated from the North American botanical provinces by the Sierra Nevada; 4% of the land area of North America, with over 35% of its total native flora and fauna;[6] over half of California's native plants are endemic, meaning they live nowhere else in the world.[7]

C. Sierra Nevada—North America's tallest and longest contiguous mountain range; the dominant topographic feature that defines California's ecological character.

D. Mojave Desert—in the rain shadow of the Sierra Nevada; almost entirely inside the political borders of the state of California.

E. Great Basin Desert—much of Nevada, Oregon, and parts of other states; expansive, arid region defined by no watersheds that drain directly to the sea.

F. Colorado Desert—piece of the Sonoran desert that extends into California.

G. Desierto y sierras de Baja California.

Yellow-faced bumblebee
*Bombus vosnesenskii*

# The Coasts of California

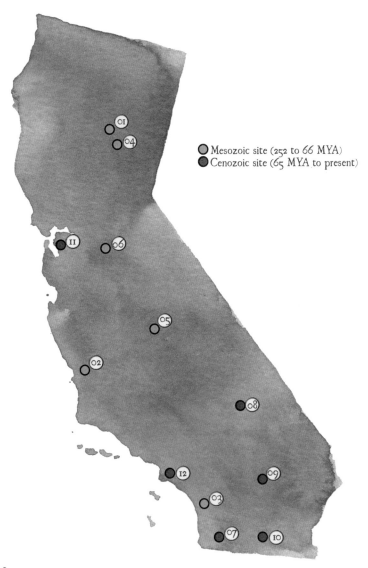

Map 01.02

## 01.02 A LONG HISTORY OF LIFE
*California's ancient animals*

Animal life has flourished in the geographic area that would become California since before the time of the dinosaurs. Map 01.02 depicts a few milestone discoveries in California paleontology. Each item in the list describes an exemplary Mesozoic species unearthed, or a group of the Cenozoic mammals present; the time frame involved expressed as MYA (millions of years ago); and, where applicable, the wealth of contemporary faunal diversity also excavated at the site.

01. *Thalattosaurus alexandrae*—marine reptile; 3 feet long (found with 3 other species of the same genus); Late Triassic Hosselkus Limestone in Shasta County (237–231 MYA); site includes 208 invertebrates[8] and 9 species of *Ichthyosaurus* (finned Mesozoic reptiles).[9]

02. *Plesiosaurus hesterus*—dolphin-size plesiosaurus; Late Jurassic rocks of the Franciscan Formation in San Luis Obispo County (160–145 MYA); dozens of plesiosaur sites have been discovered across California, with nearly as many species.[10]

03. *Aletopelta coombsi*—club-tailed, herbivorous ankylosaur; 25 feet long, weighing an estimated 4,500 pounds; Late Cretaceous Point Loma Formation, San Diego County (75 MYA).

04. *Ichthyornis* sp.—California's oldest bird; a toothed, gull-size bird; Chico formation in Butte County (83–72 MYA);[11] found near California's oldest modern (nontoothed) bird, a neognath (subclass *Neornithes*), of which there are nearly 10,000 species, from parrots to chickens.[12]

05. *Saurolophus* sp.—"duck-billed" hadrosaur; 40 feet long, bipedal; Late Cretaceous Moreno Formation in Fresno County (70 MYA).[13]

06. *Basilemys* sp.—terrestrial herbivorous turtle; Late Cretaceous formations in Nevada County (70 MYA).[14]

EOCENE (56–33 MYA). With most of California still under the sea, California during the second period of the Cenozoic (following the Paleocene, the first period after the Cretaceous extinction event that killed the dinosaurs) was already replete with a great variety of mammal diversity.

07. *Hypertragulus* (proto-deer), *Sespedectes* (insectivore, proto-hedgehog), *Procynodictis* (proto-opossum), *Phenacolemur* (proto-primate), lagomorph (proto-rabbit), tapiroids (proto-tapir), rodents, and camels; Sespe Formation in San Diego County.[15]

OLIGOCENE (34–24 MYA). As the San Andreas Fault began to emerge, a combination of aridity and cooling revealed more open land and grassland for California, greater speciation among the rodents, camels, and other herbivores continued.

08. *Miotylopus* (camels), *Rhinocerotid* (rhinoceros), and giant herbivores including Brontotheres, Uintatheres, Indricotheres, and Chalicotheres; Titus Canyon Formation, Death Valley in Inyo County.[16]

MIOCENE (23–5 MYA). Kelp forests begin to develop off the California coast, which begins to resemble its current configuration; the Great Basin Desert begins to develop; shrews and pikas arrive to California from Asia.

09. *Nothrotheriops*, *Megalonyx*, and *Paramylodon* (giant ground sloths); *Barbourofelis* (false saber-tooth cats); *Hipparion*, *Archaeohippus*, *Merychippus*, *Neohipparion*, *Scaphohippus*, *Pliohippus* (six genera of horse); *Plithocyon* (Hemicyoninae, dog-bears); the Barstow Formation in San Bernardino County; the North American land mammal age known as the Barstovian age, named for this formation, occurs between 16 to 13.3 MYA.[17]

PLIOCENE (5.3–2.6 MYA). The age of mammals follows the development of the isthmus of Panama and the following Great American Biotic Interchange when North and South America connect for the first time; age begins with the fossil evidence of the vole, *Mimomys* sp., in North America from Asia.[18]

10. *Nannippus* (horse), *Borophagus* (bear-dog), *Platygonus* (peccaries), *Euceratherium* (shrub ox), *Hemiauchenia*

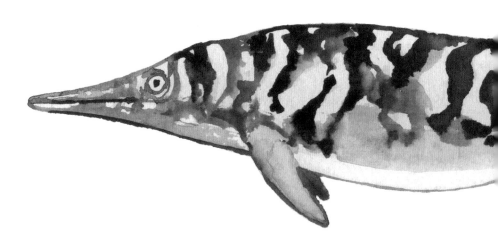

01. Symmetry and Succession

(camels), *Teleoceras* (rhinos), *Glyptotherium* (glyptodonts); Palm Springs Formation in Anza Borrego Desert State Park in San Diego County.[19]

PLEISTOCENE (2.6 MYA–11,700 years before present). As the glaciers retreat and the climate warms, the seas rise, and the wealth of mammalian diversity trembles at the coming of the age of humanity.

11. The Irvington fossil beds in Alameda County yield a trove of mammal fossils so rich that a North American land mammal age called the Irvingtonian (1.35–.28 MYA) is so named; the age is defined by the presence of mammoth for the first time in North America.[20]

12. The Rancho La Brea tar pits in Los Angeles County present a treasure of preserved terrestrial life so complete that another age, the Rancholabrean Land Mammal Age (280,000–11,000 years before present) is demarcated; this age is defined by the first appearance of bison in North America.[21]

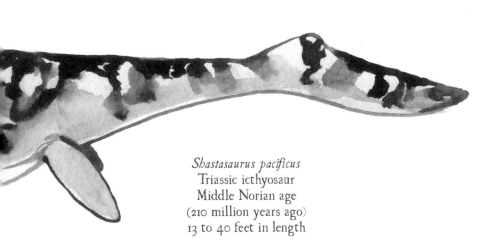

*Shastasaurus pacificus*
Triassic icthyosaur
Middle Norian age
(210 million years ago)
13 to 40 feet in length

The Coasts of California

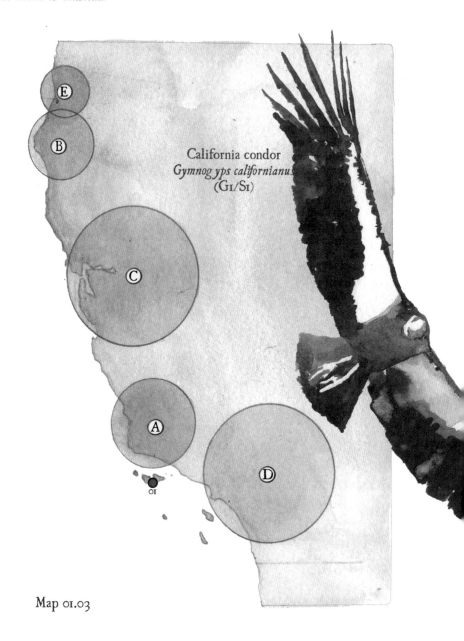

California condor
*Gymnogyps californianus*
(G1/S1)

Map 01.03

## 01.03 HUMANITY EMERGES
*Anthropogenesis in the Holocene*

01. Arlington Springs Man. Found on what is today Santa Rosa Island, perhaps the oldest skeletal remains of *Homo sapiens* found in North America are dated to 13,000 years before present (YBP);[22] humanity began to populate California in a much colder climate, when the sea level was much lower and the channel islands were fused as one large island called (by geologists) Santa Rosae (see 08.01); as the Quaternary extinction event of the late Pleistocene was under way, concurrent with the arrival of humanity to California, Arlington Springs Man and his people hunted an array of animals that no longer exist, including Channel Island pygmy mammoths (*Mammuthus exilis*), giant island deer mice (*Peromyscus nesodytes*), and flightless ducks (*Chendytes lawi*).[23]

A. Paleo-Coastal, Chumashan languages (13,000–10,000 YBP). During the Stone Age in Europe, Paleoindians across California were already widespread if not densely populated.

B. Paleo-Coastal, Yukian languages (13,000–10,000 YBP). In a time when elsewhere in the world cattle had yet to be domesticated, it may be that California was initially populated twice, by two culturally distinct Clovis Paleoindians.[24]

C. Hokan expansion, Penutian languages (10,000–3,000 YBP). With the establishment of the shellmounds near the San Francisco Bay, a hypermanagement of California's natural regimes by a growing population of humans begins to emerge; the sustaining, homeostatic quality of the ancient people of California toward their ecological community has been called by ethnologists "ecofunctionalism."[25]

D. Uto-Aztecan languages (3,000–1,500 YBP). Traditions of cultivation, harvesting, and pruning result in further ecomanagement of larger and larger tracts of landscape, all on a sustainable-yield basis, leading to deep and sophisticated ethnobotanical technologies across thousands of tribal groups.[26]

E. Athabaskan and Algic languages (1,500–700 YBP). In line with the Medieval Climate Anomaly (1,250–950 YBP), an event that spurred prolonged droughts in California. Fire continues as a regular pervading presence across the California Floristic Province;[27] it is a tool used for regeneration by Californians for thousands of years. The statewide regime of 4–6 million acres of burned land per year becomes the norm. The average burn area per fire averages roughly 500 acres each, preventing the regularized appearance of the megafires we see today.[28]

# The Coasts of California

Map 01.04

## 01.04 ACCOUNTING FOR THE MOST VULNERABLE
*Endangered biodiversity*

California's current species inventory includes the following. (All figures are approximations.)[29]
- 650 birds
- 220 mammals
- 100 reptiles
- 75 amphibians
- 70 freshwater fish
- 100 marine fish and mammals
- 6,500 native plants

1. Chinook salmon, *Oncorhynchus tshawytscha* pop. 30 (G1/S1S2)—upper Klamath and Trinity Rivers ESU (evolutionarily significant unit), one of six Chinook salmon ESUs in California; the removal of four dams on the Klamath River near the California-Oregon border by 2023 will work to increase habitat and reverse the trend toward extinction.[30]

2. Western snowy plover, *Charadrius alexandrinus nivosus* (G3T3/S2S3)—shorebird that lays eggs only on sandy beaches across California; 2020 population is roughly 2,500;[31] Sonoma County population 400;[32] populations across the state are rebounding since the statewide lockdown and the closing of beaches in response to the pandemic.[33]

3. Delta smelt, *Hypomesus transpacificus* (G1/S1)—a small fish that lives in the Sacramento–San Joaquin Delta, often near saltwater intake pumps for the California State Water Project; live for only one year and are susceptible to climate variance, and are thus indicators of ecological decline because of that susceptibility.[34]

4. Marbeled murrelet, *Brachyramphus marmoratus* (G3G4/S1)—a small seabird that nests only in redwood and Douglas fir trees that are both within two miles of the coast and over 150 years of age;[35] in 2017, the population in conservation zone 6, which includes the old growth of Big Basin Redwoods State Park (Santa Cruz County), was estimated at 650.[36]

5. Santa Cruz long-toed salamander, *Ambystoma macrodactylum croceum* (G5T1T2/S1S2)—the entire population of this subspecies of the long-toed salamander lives in the willow thickets that surround a few ponds within the Buena Vista Unit of the Ellicott Slough National Wildlife Refuge (Santa Cruz County).[37]

6. California condor, *Gymnogyps californianus* (G1/S1)—largest terrestrial bird in North America; 2020 world population 518, wild population 337; Ventana Wilderness population 63; lead poisoning remains the leading threat.[38]

7. Monarch butterfly, California overwintering population, *Danaus plexippus* pop. 1 (G4T2T3/S2S3)—precipitous decline in populations due to habitat and forage depletion across the range

of this iconic migratory butterfly; lowest-ever population recorded in fall 2020 at Pismo State Beach, regularly the largest wintering site in California.[39]

8. Mountain lion, *Puma concolor* (SNR, specially protected species[40])—the population of mountain lions in California is estimated at nearly 3,000 cats;[41] in Southern California, where they may have already crossed a threshold into what is called an extinction vortex, where a dwindling population and genetic isolation threaten the species, the population is closer to 300;[42] the wildlife crossing at Liberty Canyon, connecting the Santa Monica Mountains to the wildlands north of Highway 101, is crucial to maintaining the genetic diversity needed to sustain the local population.[43]

9. Tidewater goby, *Eucyclogobius newberryi* (G3/S3)—a small fish that lives in tributary wetlands across California; it has specific salinity, turbidity, and noncontamination requirements;[44] southernmost extent of its range is Agua Hedionda Lagoon (San Diego County).[45]

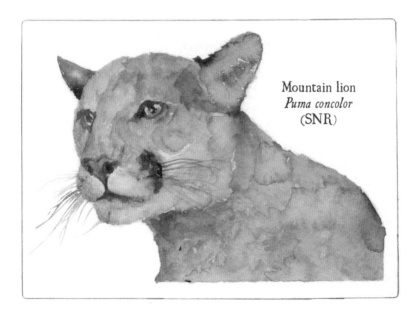

Mountain lion
*Puma concolor*
(SNR)

01. Symmetry and Succession

Every organism is a vehicle of its inherited genetic information. That information, recombined genetic code, adapts to dictate the drift of species and the ecosystems they interact with. This information is the currency of life. Its value is so absolute that its presentation can be said to be the purpose, if not the meaning, of life itself. What is a flower but a vehicle by which this information prepares to reproduce itself? Every flower carries its own universe of meaning.

Sticky monkeyflower
*Diplacus aurantiacus*

# 02. FAULT-LINE SYMPHONY
## *The geomorphology of coastal California*

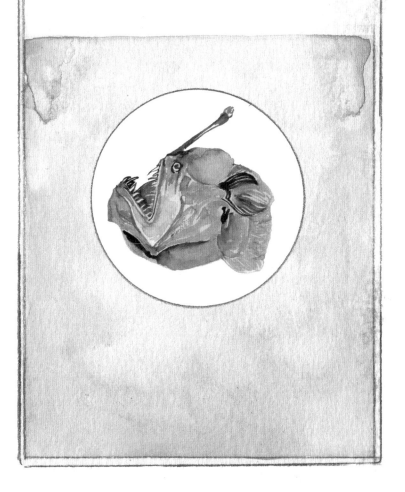

The theater of life in California is played out on a geologic stage. The restless, fractured earth between the continental and oceanic plates that constitutes California's borderland of terrestrial and marine ecology influences biogeography, or the distribution of life, more than any other physical factor. Understanding how the earth is dynamically roiling in space and time and how we categorize California's topographic morphology transcends geography and incorporates insights from the physical science of geology.

The grinding line between the North American Plate and the Pacific Plate, the network of fault lines that is the San Andreas Fault, is California's most infamous tectonic character. Responsible for so many of California's bigger coastal earthquakes, this dramatic line in the grand jigsaw puzzle that is the earth's surface is clearly visible. From an airplane, you can see it as an obvious suture on the landscape, running along the Diablo Range, the longest of California's coastal ranges. A hundred miles north, where the fault line leaves the land and heads out to sea at Tomales Bay, east of Point Reyes, you can see the difference in soil types between one side of the bay and the other. The Point Reyes side is deeply forested with bishop pine; on the inland side, the trees are replaced by rolling woodland. To understand how ecosystems work, we need to contextualize them in terms of the deep history of California's coastal topography and understand how the state, both above and below the waves, is built and has been building over the past several hundred million years.

## 02.01 HOW THE LIGHT FADES
*Ocean zones and marine classification*

GREEK: *eu-*"good"; *dis-*"difficult"; *pelagius-*"of the sea"; *neritos-*"shallow"; *epit-*"atop"; *mesos-*"in the middle"; *a-*"without"; *byssos-*"bottom"; *benthos-*"depth"; *littoral-*"of shore"; *sub-*"below"; *hades-*"underworld"

*Previous page:*
*Ceratioid* anglerfish
of the genus *Oneirodes*
Monterey Bay
Depth: 4,500 feet
Maximum size: 7 inches
37 species in genus
a deep sea predatory fish that
lures prey with luminscent fin ray

Marine environments form different conditions for habitats that are defined by access to light and by ocean depth. Most biological productivity takes place in the *euphotic zone* (01), which can extend to a depth of more than 600 feet. The *disphotic zone* (02) extends down to 1,800 feet, and although it is too dark for photosynthesis to occur, there is just enough light for vision to be a useful adaptation for pelagic

## 02. Fault-Line Symphony

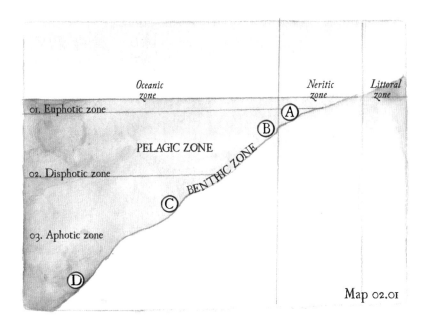

Map 02.01

animals. The *aphotic zone* (03) extends to the seabed below the disphotic zone, where no light can reach. Most of the world's ocean is in the disphotic zone.

The *pelagic zone* comprises the *neritic zone* and the *oceanic zone*—the division defines offshore marine space—what is nearby and what is further out at sea. The *benthic zone*, the ocean bottom, extends into the *littoral zone*, which includes the *intertidal zone* defined by high and low tide. Past the sublittoral zone lie four zones of unique physical environments determined by the depth of the continental shelf: (A) the mesopelagic zone, (B) the bathyal zone, (C) the abyssal zone, and, deepest of them all, (D) the hadal zone.

Sand louse
*Emerita sp.*

The Coasts of California

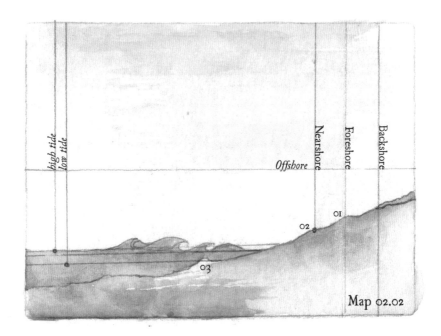

Map 02.02

## 02.02 WHERE THE WAVES BREAK
*Beach profiles and shoreline structure*

The profile of a beach is often temporary. With seasonal progression based on storms and wave force, the width and height of the beach comes and goes (see 04.07). The berm crest (01) usually marks the highest point where sand is deposited on a typical beach profile. The berm (02) runs parallel to shore and is the area where sediment (sand, granules, pebbles, and cobbles) are regularly deposited by wave and tidal action. Sandbars (03) can be exposed or submerged and are formed in response to changes in wave energy.

Brittle star
*Ophiuroidea*

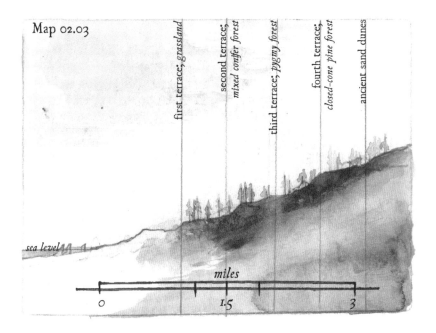

Map 02.03

## 02.03 AN ANCIENT STAIRCASE
*Coastal terraces and their unique forests*

Most of California's coastline is not sandy beach. More than 70 percent consists of seacliffs, and of that total, 60 percent (roughly 650 miles) are lower-relief bluffs, often eroded marine terraces formed by tectonic uplift half a million years ago.[1] Uplifted marine terraces appear along many stretches of California's coastline, and all support their own stratified ecology.

Over the past 500,000 years, uplift along Mendocino County's coast has produced a staircase of unique conditions for one of the world's most unique forest types: the Mendocino pygmy forest. Time is plainly laid out for the geologist across the pygmy forest (each of the four to five steps roughly and unevenly spaced out by approximately 100,000 years or more), but for the biologist, time works differently; because of the local, soil, and atmospheric conditions, the stressed coniferous trees grow more slowly here than they do elsewhere (see 05.01.03). A three-foot tree might be over one hundred years old and may belong to the one of two endemic species of pine: pygmy cypress, *Cupressus pygmaea*, and Bolander pine, *Pinus contorta* ssp. *bolanderi*.

The Coasts of California

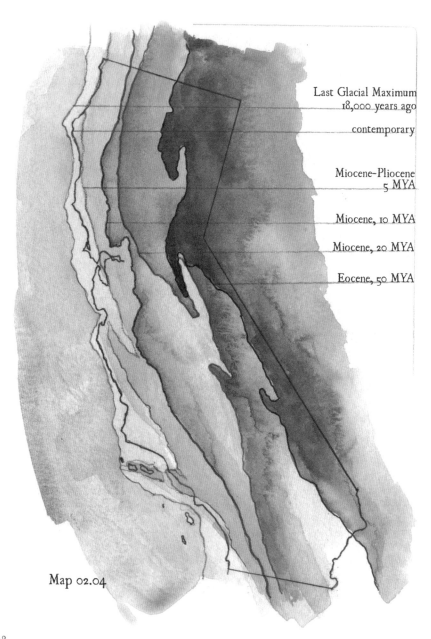

Last Glacial Maximum
18,000 years ago

contemporary

Miocene-Pliocene
5 MYA

Miocene, 10 MYA

Miocene, 20 MYA

Eocene, 50 MYA

Map 02.04

## 02.04 LAND'S WESTWARD ADVANCE
*California's evolving coast through the ages*

With the rise of the Sierra Nevada and the shifting of the tectonic plates into their current configuration, California evolved into its distinct ecological self, based on the geologic forces that molded it. The eastern coast of the Pacific Ocean retreated as what would be the California Floristic Province advanced west in the age after the dinosaurs.

During the Last Glacial Maximum, about 18,000 years ago, when global temperature was approximately 6°C (42°F) less on average than it is today, so much fresh water was locked in ice that the sea level off the California coast was approximately 130 meters lower than it is today.[2] When the sea level began to rise over the next several thousand years, certain populations of fish and other local organisms became isolated, and their genetic distinctiveness became and remains important in the study of how conservation biology is tied to geography. How ecosystems establish and benefit from refuge populations (or refugia, as biologists call it) is key in understanding how imperiled species survive and what stewardship they will require as sea levels rise and climates break down and evolve across the biosphere.

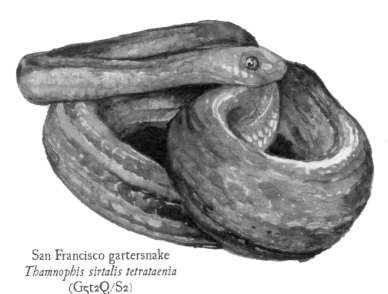

San Francisco gartersnake
*Thamnophis sirtalis tetrataenia*
(G5t2Q/S2)

# The Coasts of California

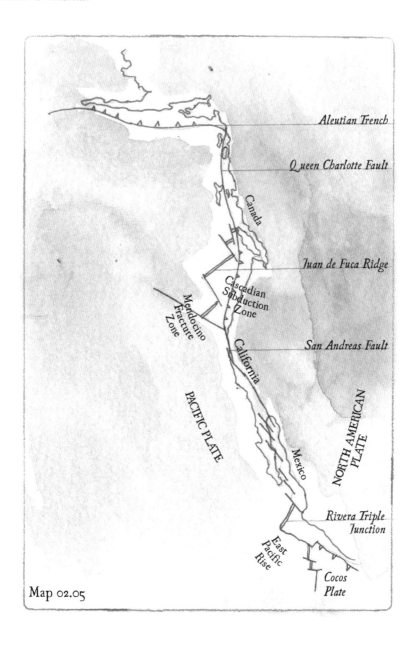

Map 02.05

## 02.05 AN EVOLVING PUZZLE
*Pacific North America's tectonic configuration*

The early Cenozoic era (65–20 MYA) was an important period of geologic time for California. During this time, two things happened: (1) the Farallon Plate, which once existed between the Pacific and the North American Plates, was subducted underneath the North American Plate, leaving only the Juan de Fuca Plate to the north and the Cocos Plate (east of the Rivera Transform Fault, as indicated on the map) to the south;[3] and (2) the San Andreas Fault began to resemble the transform plate boundary that it remains today.

The Late Cenozoic, the era we are still in, which began about 20 MYA, saw California's mountainous topography and shoreline configuration emerge as we know it today. During the westward migration of the North American Plate, it floated over a few hotspots in the earth's upper mantle. The hotspots caused the Rocky Mountains to rise at least a mile in elevation, and it was thought that these anomalies of mantle temperature also caused the Sierra Nevada to attain its modern height, but now there is substantial evidence that the Sierra Nevada achieved its present height in the mid-Cenozoic, approximately 40 MYA.[4] The Juan de Fuca plate system and the Mendocino Fracture Zone (the remnant of the Farallon Plate) was then south of the Bay Area.

Ten million years ago, the northward movement of the fracture zone caused extensive volcanism in what is now the San Francisco Bay Area, evidence of which you can still find at Sibley Volcanic Regional Preserve.[5] About 4 million years ago, the San Andreas took a left turn and helped form the only major east–west range in California, the Transverse Ranges of Southern California.[6]

Longhorn sculpin
*Myoxocephalus octodecemspinosus*

# The Coasts of California

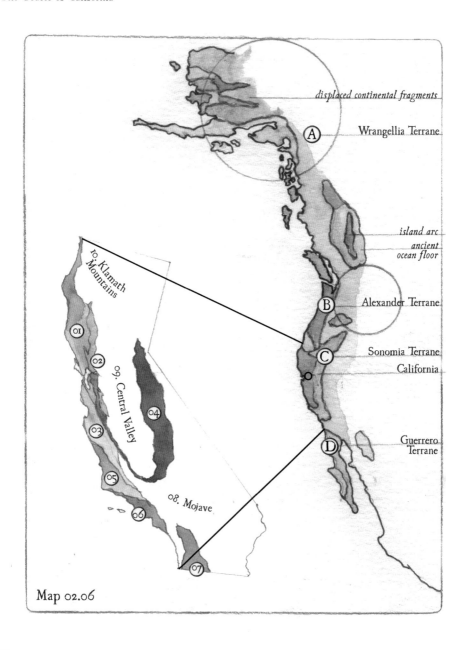

Map 02.06

## 02.06 ROCKY PATTERNS IN THE LANDSCAPE
*North American terranes and continental structure*

It is counterintuitive to think of continents themselves as having weight, but they certainly do, and it turns out that the tectonic plates that make up the continents are lighter in overall mineral composition than the oceanic plates. This is why oceanic plates always subduct under continental plates. The process of subduction is not a clean one, and over the course of tens of millions of years that these processes are ongoing, large bits of an oceanic plate will get sheared and squeezed across the continental plate that is overtaking it. These bits of the oceanic lithosphere, called *terranes*, can be hundreds of square miles of ocean plateaus, seafloor segments, and ancient island arcs that become part of many emergent continental orogenies.

A. Wrangellia Terrane—named for Alaska's Wrangell Mountains; extends down the western coast of Canada; basalt rock from a Jurassic ocean 250 million years ago moved northward to dock with the North American Plate by the Cretaceous period, 100 million years ago.[7]

B. Alexander Terrane; also, the Chugach Terrane—tied to the formation of the Wrangellia Terrane, although different enough in geologic character to be considered its own terrane.[8]

C. Sonomia Terrane—a microcontinent formed in the Late Permian that was geologically distinct and yet fated to at last be amalgamated by the North American Plate during the Triassic (200 MYA) and now only exists as remnant evidence across the Great Basin Desert.[9]

D. Guerrero Terrane—a composite terrane across Western Mexico primarily composed of cretaceous island arcs.[10]

01. North Coast Ranges, Franciscan Assemblage—geologic age, 150–200 million years[11]
02. Great Valley Sequence—Mesozoic sedimentary
03. Salinian Block—granitic rock, shares origin with Sierra, or maybe Mojave[12]
04. Sierra Nevada Batholith—Mesozoic granite rocks
05. San Luis Obispo County, Franciscan Assemblage
06. Santa Monica Mountains, Los Angeles Basin—Cenozoic fill
07. Southern California Batholith—Mesozoic granite rocks
08. Mojave Desert—Precambrian
09. Central Valley—Cenozoic fill
10. Klamath Mountains

# The Coasts of California

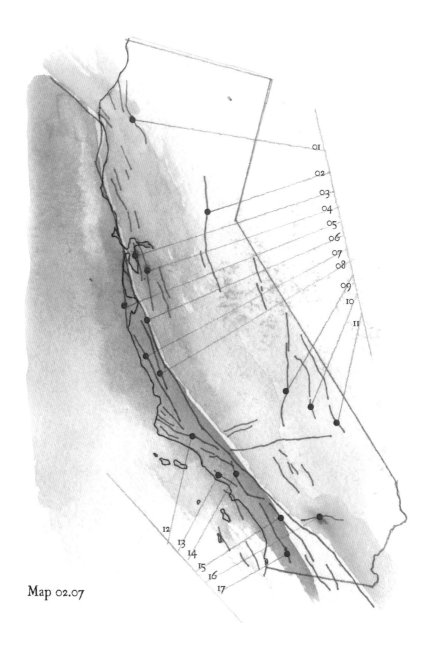

Map 02.07

## 02.07 THE WRITHING SUBSTRATE
*Contemporary fault lines of California*

California is a broken mosaic, a shattered layer of stone floating on the molten sea. There are more than 15,000 faults in California, over 500 of which are alive with tectonic energy, capable of unleashing an earthquake on a chaotic, lithospheric whim.[13] Ten recordable tremors occur every day in California, although, of the average 30,000 earthquakes that occur every ten years, only 30 are strong enough to be felt, and only a few are strong enough to cause damage.[14] The San Andreas Fault complex, the boundary between the Pacific Plate and the North American Plate and the largest fault in California, began to resemble its current configuration and to exhibit its current behavior about 28 million years ago.[15]

01. Coast Range Fault
02. Melones Fault
03. Hayward Fault
04. Calaveras Fault
05. San Gregorio Fault
06. San Andreas Fault
07. Sur-Nacimiento Fault
08. Rinconada Fault
09. Owens Valley Fault
10. Panamint Valley Fault
11. Death Valley Fault
12. Santa Ynez Fault
13. Santa Monica Fault
14. San Gabriel Fault
15. San Jacinto Fault
16. Pinto Mountain Fault
17. Elsinore Fault

Red columbine
*Aquilegia formosa*

The Coasts of California

Map 02.08

## 02.08 THE LAND OF THE SEA
*The floor of the Pacific Ocean*

The Pacific Ocean is the largest geographic entity on the planet. You could easily fit all the world's continents (57 million square miles) across its surface area (65 million square miles). The Pacific Ocean is also extremely deep. On its western boundary, it holds the deepest place on the planet (the Mariana Trench—36,201' deep). The trench is so deep that if you sunk the highest mountain into it (Mount Everest—29,032'), its peak would still be over a mile from the surface.

The average depth of the Pacific's abyssal plain is 12,000 feet. The abyssal plain is the largest geomorphic feature on the planet and extends out around the world's ocean to cover more than 50 percent of the earth's surface. If it weren't for the fracture zones, seamounts, and trenches that cover a not-insignificant amount of area, the abyssal plain would be a featureless expanse subject to sediment fall and millions of years of bacterial rain from the sunlit ecosystems miles above.

Of course, even where life seems impossible, there is life, and a great deal of it. It is estimated that more than 17,000 species of animal and animal-like creatures live in the aphotic realm, well beyond the reach of the sun's light on the abyssal plains of the world's ocean. Most of them are invertebrates, and many of them microscopic. Without primary producers, life in the deep sea depends on either nutrients from above drifting down or on an autotrophic technique called chemosynthesis, wherein the chemical nutrients found at geothermal vents along the oceanic ridgelines are biologically transformed into the basis for sun-free ecosystems. This is a wholly different world, one that may or may not be affected by our terrestrial woes of climate breakdown.

Because the biology of this world is so far removed from the world above, any survey of its biodiversity quickly delves into rich vocabulary of specialized taxonomy to describe the unique animals. The world's deep-sea ecosystems include more than 2,000 species of bacterium, 250 species of protozoan, 900 species of chiton (crustaceans in the class Polyplacophora), dozens of species of fish, and over 500 species of invertebrates that include polychaete worms (class polychaeta); nematode worms (phylum nematoda); peracarid crustaceans (superorder Peracarida); and monoplacophoran mollusks (superclass monoplacophora).[16] One of the strangest (and most beautiful because of it) creatures in the deep seas (and on the planet, for that matter) are the xenophyophores. The creatures, which in the eastern Pacific live at depths over 1,200 feet, grow to be about the size of a human fist, and are the largest single-celled organisms in the world. That's right, although their bodies contain many cellular nuclei, these creatures are unicellular.[17]

The Coasts of California

Map 02.09

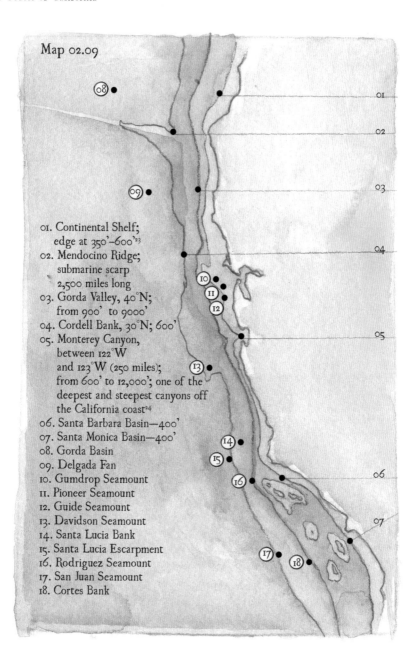

01. Continental Shelf; edge at 350'–600'[23]
02. Mendocino Ridge; submarine scarp 2,500 miles long
03. Gorda Valley, 40°N; from 900' to 9000'
04. Cordell Bank, 30°N; 600'
05. Monterey Canyon, between 122°W and 123°W (250 miles); from 600' to 12,000'; one of the deepest and steepest canyons off the California coast[24]
06. Santa Barbara Basin—400'
07. Santa Monica Basin—400'
08. Gorda Basin
09. Delgada Fan
10. Gumdrop Seamount
11. Pioneer Seamount
12. Guide Seamount
13. Davidson Seamount
14. Santa Lucia Bank
15. Santa Lucia Escarpment
16. Rodriguez Seamount
17. San Juan Seamount
18. Cortes Bank

## 02.09 DEPTH AND DIVERSITY
*Bathymetry off California's coast*

Of all the maps in this book, this is the only one that covers a topographic scale that includes every marine habitat type. Most of this book is occupied with terrestrial habitats and a few nearshore systems, but in terms of habitable space across three dimensions, the deep sea contains vast opportunity for ecosystems to develop complex food webs whose variety generally doesn't exist on land. The nearshore habitats include the littoral zone, the neritic zone, the intertidal zone, estuaries, seagrass meadows, and kelp forests. Further out to sea there are ocean banks, the continental shelf, the pelagic zone, the oceanic zone, seamounts, hydrothermal vents, cold seeps, the demersal zone (a transitional benthic zone between 700' and 3,300'), and the benthic zone (or the abyssal plain).[18]

Seamounts, undersea mountains that do not breach the surface, represent a huge and only barely understood habitat space. Off the California coast there are approximately sixty-three seamounts with an average distance from shore of 100 miles, each rising an average of 3,000 feet from the sea floor with an average summit depth of one mile beneath the surface.[19] The benthic seamount ecosystem is supported by an enormous breadth of biodiversity, and because of their relative isolation from one another, seamounts may have an endemism rate within their food web of 20 percent, meaning that one-fifth of all organisms found at any given seamount belong to species that exist nowhere else on the planet.[20]

The Davidson Seamount, one of California's largest seamounts, rises 7,500 feet from the sea floor and has a summit depth of 4,100 feet. Davidson is an archetypical Californian seamount in terms of how it creates its own current patterns with its own system of upwelling that attract an ecosystem of fish, sea turtles, seabirds, and marine mammals. The basis for this food web relies on the cold-water coral flourishing on the seamount far below.[21] The food web at the Davidson Seamount includes trophic interactions among over 250 species, including 25 species of cold-water coral and 15 recently discovered species: eight sponges, three corals, one ctenophore comb-jelly, one nudibranch gastropod, one polychaete worm, and one tunicate sea squirt.[22] Davidson Seamount is currently the only Californian seamount that is federally protected against exploitation and extraction. Given the robust nature of these essential and threatened pelagic habitats, the time for universal conservation of these precious places has come.

The Coasts of California

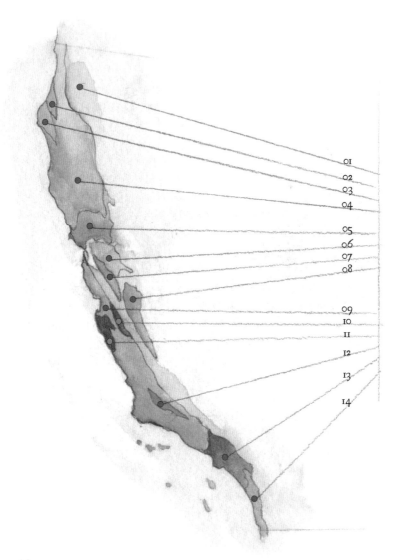

Map 02.10

## 02.10 PETROLOGICAL PORTRAIT
*California's coastal topography*

A survey of coastal bedrock geology leads us to some imaginative, deep-time thinking. In a geologic nutshell, the story of California's coastline begins when miles of sediment accumulated in the trench formed by the Farallon and the Pacific Plates as they were subducted beneath the North American Plate during the Paleozoic and the Mesozoic eras.[25] Since the era of the dinosaurs, the Sierra Nevada continued to grow and erode, and the deep patterns of convection inside the earth's mantle activated the San Andreas Fault, which then began to transport whole landscapes north on a slow walk from Mexico.

01. Cenozoic volcanic rocks
02. Cenozoic marine sedimentary rocks
03. Late Mesozoic sedimentary rocks
04. Late Mesozoic eugeosynclinal rocks
05. Cenozoic marine sedimentary rocks
06. Cenozoic volcanic rocks
07. Cenozoic nonmarine sedimentary rocks
08. Late Mesozoic eugeosynclinal rocks
09. Mesozoic sedimentary and volcanic rocks
10. Cenozoic volcanic rocks
11. Paleozoic sedimentary and volcanic rocks
12. Late Mesozoic sedimentary rocks
13. Cenozoic nonmarine sedimentary rocks
14. Cenozoic marine sedimentary rocks

As one example of the dynamism of the San Andreas Fault, once about 25 million years ago, an enormous volcano that was probably the topographic equivalent of Mount Shasta existed at what would be the southern end of the San Joaquin Valley. The newly formed San Andreas Fault ripped the volcano in half and began to drag it north, letting it erode over a total distance of 200 miles to become what we know today as Pinnacles National Park (site 11 on map 02.10).[26] In the present time, several hundred million years after the original deposit of what would become so much of California's marine sedimentary substrate, our coastal landscape is a tumbled and tossed, corduroy-like terrain of rocks made by sediment, by volcanic processes, and by a mixture of the two.

*Coastal coyote*

# The Coasts of California

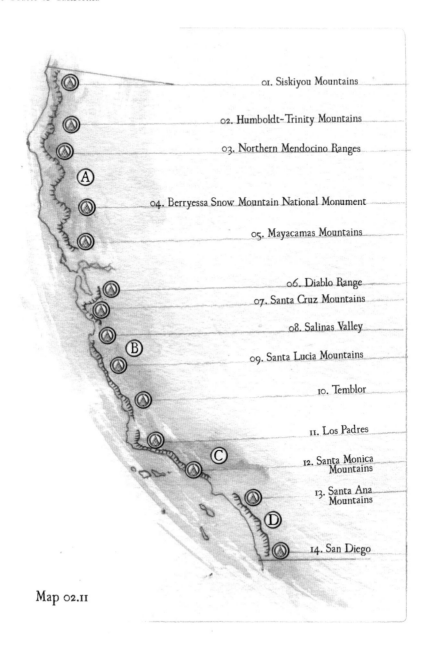

Map 02.11

## 02.11 SUMMITS IN SIGHT OF THE SEA
*Mountain provinces of coastal California*

Because of ancient volcanic activity and the contemporary configuration of the transform fault system that includes the San Andreas Fault, the collection of ridgelines that make up the coastal ranges generally runs roughly parallel to the coastline. Over the millennia, California's climate has influenced the morphology of California's coastal ranges. In the north, hundreds of thousands of years of heavy precipitation have cut deep, V-shaped valleys, including the Klamath River watershed. The picture is different in the dry coastal ranges of the south, which often harbor broad valleys where meandering rivers spread out in occasional moments of flood.

A—North Coast Ranges
B—Central Coast Ranges
C—Transverse Ranges
D—Peninsular Ranges

01. Siskiyou Mountains—three distinct provinces: the coastal belt, the Klamath oldland, and the Siskiyou upland;[27] these ranges hold some of the most diverse conifer forests in the world; primary watersheds include the Smith River and the Klamath River; tallest peak, Mount Ashland (Oregon, 7,533').

02. Humboldt-Trinity Mountains—a tangled roil of terranes that date back hundreds of millions of years; at nearly 400 million years old, the orogeny of the Klamath Mountains is the oldest in the state;[28] primary watersheds include the Trinity River and the Salmon River; tallest peak, Salmon Mountain (Humboldt County, 6,956').

03. Northern Mendocino Range; Mail Ridge; Yolla Bolly–Middle Eel Wilderness—the ranges cut by the south–north-running South Fork Eel River and the Eel River; tallest peak, Anthony Peak (Mendocino County, 6,954').

04. Berryessa Snow Mountain National Monument—inland ranges; headwaters of the Eel River; Cache Creek watershed; tallest peak, Snow Mountain (7,056'); Snow Mountain was an ancient seamount that was cleaved off of the subducting Pacific Plate over 150 million years ago.[29]

05. Mayacamas Mountains—mountain range that skirts the county line between Sonoma and Lake Counties; mostly Franciscan complex (150 MYA) in orogeny, although Sonoma volcanic period dates to the mid-Pliocene (2 to 5 MYA);[30] tallest peak, Cobb Mountain (Lake County, 4,720').

06. Diablo Range—at 150 miles, the longest of California's coastal ranges; it runs north–south from Carquinez Strait (Contra Costa County) to Polonio Pass (San Luis Obispo County); tallest

peak, San Benito Mountain (San Benito County, 5,267').

07. Santa Cruz Mountains—built on a fault anomaly in the San Andreas Fault called a reverse fault, the orogeny of the Santa Cruz Mountains is based in the transform fault (and how the fault bends, causing the mountains to buckle and rise), not the result of subduction as in most ranges;[31] major watersheds include San Lorenzo River (Santa Cruz County); tallest peak, Loma Prieta (Santa Clara County, 3,786').

08. Salinas Valley—the Salinas River runs 90 miles from south to north and separates the Santa Lucia Mountains to the west from the Gabilan Mountains to the east; tallest peak in the Gabilan Range, Fremont Peak (San Benito County, 3,455').

09. Santa Lucia Mountains—tallest peak, Santa Lucia Peak (also known as Junipero Serra Peak, Monterey County, 5,862').

10. Temblor—tallest peak, McKittrick Summit (San Luis Obispo County, 4,335').

11. Los Padres; Sierra Madre Mountains; San Rafael Mountains; Santa Ynez Mountains—tallest peak in the Los Padres National Forest, Mount Piños (Kern County, 8,831'); Sespe Wilderness; tallest peak in the Topatopa Mountains, Hines Peak (Ventura County, 6,704').

12. Santa Monica Mountains—volcanic activity between 24 MYA and 13 MYA lifted these mountains to a height of over 10,000 feet;[32] tallest peak, Sandstone Peak (Ventura County, 3,114').

13. Santa Ana Mountains—three major regions inside the peninsular batholith, the Bedford Canyon Formation, Santiago Peak Volcanics, and Woodson Mountains Granodiorite;[33] tallest peak, Santiago Peak (Orange County, 5,687').

14. San Diego—coastal peninsular ranges include San Ysidro Mountains, Jamul Mountains, El Cajon Mountain, and Aguanga Mountain; tallest peak, Cuyamaca Peak (San Diego County, 6,512').

02. Fault-Line Symphony

Figueroa Mountain
Santa Barbara County
looking south
toward the San Rafael Wilderness
Los Padres National Forest

# 03. ELEMENTAL RHYTHMS
*Energy, weather, and the cycles of wind and wave*

The planetary forces that shape California's natural world provide the spectrum of subjects covered in this chapter—the mechanical workings of the shoreline; the ocean's climate and current; and how terrestrial climate cycles are influenced by the sea, directing atmospheric wind patterns, which influence the nature of fire across the California landscape. This cursory survey presents several systems of astronomy, oceanography, climatology, and meteorology as a frame of reference for the far-ranging and impossible-to-be-understated influence of the ocean on all aspects of nature in California.

The California Current System (or, simply, the CCS) is one of the primary contributors to California's unique climate over the past several million years. Every single one of California's ecosystems depends on the continued functioning of the ancient machine that is the CCS, with its delivery of cold, nutrient-rich waters that govern thousands of food webs, watershed hydrology, and healthy forests across the state. Without the CCS, California would be a wholly different place.

This chapter begins with a survey of the physical components and patterns that built the CCS, from its local effects to its cosmic influencers. After we understand the basic mechanics of tides and waves, we examine how the atmosphere, the hydrosphere, and the biosphere interact both offshore and inland. Understanding the oceanographic, life-giving systems and observing how they are affected by climate breakdown (or climate disruption) are certainly essential pieces of the mystery to predicting our survivability in the centuries to come.

Señorita fish
*Oxyjulis californica*

*Previous page:*
Redwood orchid
*Calypso bulbosa*

48

This expansive chapter begins with the working of the tides and eventually moves to a discussion of climate breakdown and its relationship to California's megafires. The reasoning here is based on the platonic elements of water, earth, air, and fire. Where chapter 02 dealt with forces within the earth that shaped coastal topography, this chapter pulls a conceptual thread from oceanic patterns to inland ecological patterns. The interconnected influence of the coast touches every part of California.

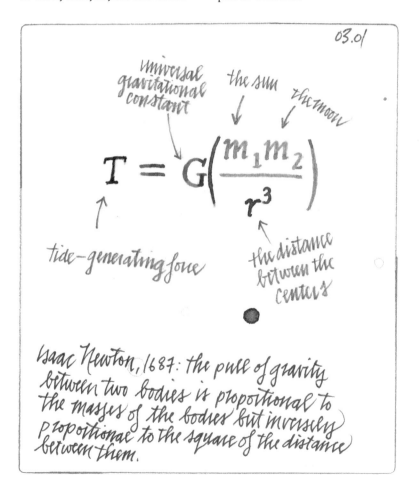

## 03.01 WATER AND GRAVITY
*The astrophysical nature of the tides*

The ebb and flow of the tides, from a planetary perspective, are a cosmologically elegant example of Newtonian physics. The gravitational effect on the tides from the moon as it revolves around the earth, and how both revolve around the sun in their elliptical symphony, can be expressed with two basic equations, here stated as sentences. One: the measure of gravity's pull between two objects is proportional to the masses of those objects, but inversely proportional to the distance between them. And two: the gravitational attraction is inversely proportional to the earth's distance from the moon and the sun, and the gravitational force of the moon and the sun on the ocean varies inversely with the cubed ratio of the distance from the center of the earth's mass to the center of mass between the sun or the moon. This math (see diagram for the algebraic equation) accounts for how even though the sun is so massive in comparison to the moon, it influences the tides only half as much as the moon because it is so far away.[1]

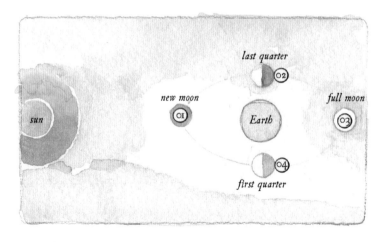

03.01a (above)

01. New moon, spring tide
02. Last quarter, neap tide
03. Full moon, spring tide
04. First quarter, neap tide

03.01b (opposite)

A. Ebb tide
B. Flood tide

## 03. Elemental Rhythms

### 03.01a Celestial Mechanics
*The spring and neap tides*

Spring tides (higher high tides and lower low tides) and neap tides (lower high tides and higher low tides) each occur roughly twice a month. King tides, the highest tides of the year, occur when the full or new moon is closest to the earth in what is called a perigean spring tide, and happen about three or four times a year. Although king tides are only a few inches higher than other high tides, they occasionally escort flood-like conditions to coastal communities.

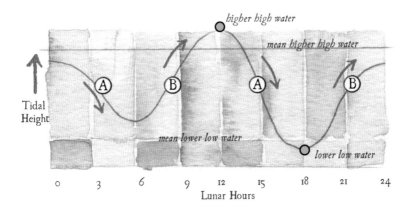

### 03.01b Higher Highs and Lower Lows
*California's daily diurnal tidal pattern*

A phenomenon of many personalities, the endless pulse of the shoreline wave can represent itself as a gentle lap combing a wide, shallow-angled beach, or it can be a thunderous symbol of the violent front between the eternally battling earth and sea. Because the globe is not a perfect sphere (the earth is a bit more than twenty-six miles wider at the equator than it is tall[2]) and because the world's continents disrupt wave patterns as they move through the ocean, California experiences two high tides and two low tides, both of different heights, every lunar day. This is called a mixed diurnal pattern.[3]

## WAVES

Waves in the open ocean are called *swells* or, when they are close to a storm center, are called *seas*. As long waves approach shore, they begin to refract when ocean depth is half their wavelength. Waves in sets will scatter depending on diverting obstacles that will either converge, focusing the eroding power of the wave (on a nearby cliff face, for example), or disseminate the waves' power. A plunging breaker wave, the wave that surfers seek, most often occurs when a steep wave hits a steep beach.

## RIP CURRENTS

When waves large enough to pass over an offshore sandbar crash on a beach and don't leave enough time for the next wave to exit the area, the built-up force may breach the sandbar and create a channel of powerful, outgoing water that can be hazardous to human swimmers because of the dragging and possibly submerging force it creates.

## TSUNAMIS

The largest of all waves is caused by and large through tectonic activity. A tsunami, a pulse of massive energy through the ocean, might have a wavelength of several hundred miles and can travel at a speed of more than five hundred miles per hour. The speed of the tsunami is equal to the depth of the water multiplied by the acceleration of (the square root of) gravity's constant (9.81 meters/second).[4] As the tsunami slams into a shallow coastal region, it loses its energy at a rate inversely proportional to its wavelength. The speed of the tsunami is related to water depth, yet the total energy of the wave remains constant; because of this mathematical imbalance, the overall height of the wave increases dramatically and extends far inland past the normal tide line. That is why you can't see a tsunami when it is out at sea, but when it finally slams into shore, it may be seventy-five feet tall. Generally, the threat of a massive tsunami in California is remote because of the narrow continental shelf, but smaller tsunamis are common. From 1950 to 2006, thirty-six tsunamis of varying intensity struck the West Coast.[5]

---

### Map 03.02 (opposite)

A. Kuroshio Current
B. Oyashio Current
C. Bering Current
D. North Pacific Current
E. Alaska Current/Alaskan gyre
F. California Current System
   (see 03.03 and 03.04)
G. North Equatorial Current
H. South Equatorial Current
I. Equatorial Counter Current

01. Hawaiian archipelago
02. Convergence zone; Pacific gyre
    (see 10.05)
03. California

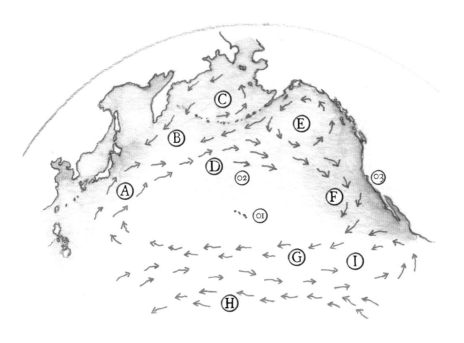

## 03.02 THE TURNING OF THE OCEAN
*Current trajectories across the northern Pacific*

*Source:* Adapted from L. Talley, G. Pickard, W. Emery, and J. H. Swift, *Descriptive Physical Oceanography: An Introduction* (London: Academic Press, 2011).

California's proximity to the Pacific Ocean is one of the primary drivers of its climate. Deep and complex patterns of circulation and climate within oceanic patterns, such as the El Niño–Southern Oscillation cycle (see 03.04) and the Pacific Decadal Oscillation[6] (a long-term shift of ocean temperatures that influences everything from precipitation to salmon propagation), govern the storm cycles and the health of pelagic ecosystems across the planet's biggest oceanic environment, the Pacific Ocean.

The complex of more than a dozen oceanic currents and gyres is based on patterns that have persisted in the northern Pacific Ocean for hundreds of thousands of years. The currents of the northern Pacific influence climate and ecosystems across North America,

Asia, and beyond. The emergent phenomena arising from this ancient and tremendously large movement of ocean water carry observable implications for the hydrosphere and the atmosphere. An atmospheric example of direct impact on California's climate is the cyclical generation of the North Pacific high-pressure system.[7] The seasonal strength of the system is determined by varying ocean temperatures and determines much of the summer and winter weather in California. The presence of this annual barometric pattern is one of the primary influencers of California's seasonal climate. It is strongest in the summer months, and it weakens in the winter months when northwesterly winds are able to push through and bring wet winter storms.[8]

Humboldt squid, Dosidicus gigas. 1.5 meters long

## 03.03 DELIVERING LIFE TO THE COASTS
*Habitat spaces of the California Current System*

Map 03.03 illustrates patterns within the California Current System (CCS) at the mesoscale, or an area of hundreds of square miles along the offshore coastline of the West Coast of North America from Mexico to Canada. This upwelling system is a primary source for nutrient delivery and is responsible for one of the largest, most complex ecosystems in the world. The three

03. Elemental Rhythms

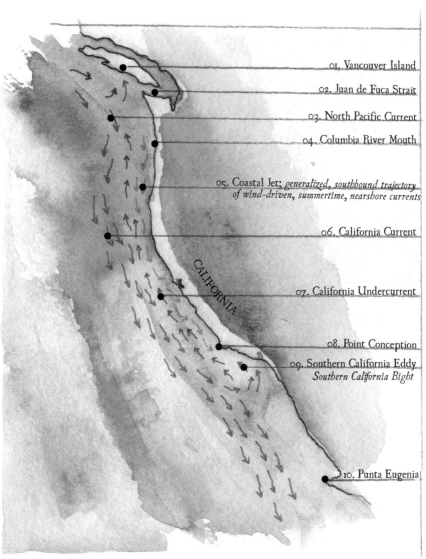

01. Vancouver Island
02. Juan de Fuca Strait
03. North Pacific Current
04. Columbia River Mouth
05. Coastal Jet; *generalized, southbound trajectory of wind-driven, summertime, nearshore currents*
06. California Current
07. California Undercurrent
08. Point Conception
09. Southern California Eddy
   *Southern California Bight*
10. Punta Eugenia

Map 03.03

zones of generalized habitat, arranged vertically within the water column, are the epipelagic (0–600'), the mesopelagic (600'–3,000') and the bathypelagic (depths greater than 3,000').[9]

Pelagic fish, such as anchovy, sardine, and mackerel, are primarily forage (food source) species that spawn in the Southern California Bight (09) but are found throughout the CCS.[10] Larger pelagic fish that together account for significant biomass in the ecosystem are Pacific bonito, *Sarda chiliensis*; Pacific hake, *Merluccius productus*; Pacific herring, *Clupea pallasii*; Pacific pompano, *Peprilus simillimus*; Pacific saury, *Cololabis saira*; and yellowtail, *Seriola lalandi*.[11] Perhaps the most important prey species, and certainly the most numerous species of squid in the CCS, is the market squid, *Doryteuthis* (formerly *Loligo*) *opalescens*.[12] There are over two dozen genera of mesopelagic fish, many of which are important prey species for the many predators that hunt these depths, including Humboldt squid, *Dosidicus gigas*.[13]

Important marine-fish predators in the CCS include adult salmon (coho and Chinook, see 06.19), seventy different species of rockfish, four species of tuna, and twenty-nine species of shark.[14] Nearly 150 species of seabird depend on the CCS, including Cassin's auklet, *Ptychoramphus aleuticus* (G4/S2S4). Other nonfish predators that hunt prey within the pelagic ecosystem are twenty-one species of whale (see 06.18), six species of pinniped (see 06.10), and at least four species of sea turtle (see 06.12).

## 03.04 PLANETARY PATTERNS AND LOCAL EFFECTS
*El Niño, sea temperature, and wind*

Because of the California Current System, the surface temperature of the ocean near California is cool, averaging 55°F north of Point Conception and, with seasonal and local variability, 55°F–72°F off the south coast.[15] There is an enormous push and pull of forces in the Pacific that affects the ocean temperature of California, and when the ocean temperature is affected, everything is affected. The El Niño–Southern Oscillation cycle, or ENSO, is a primary disruptor of ocean climate and thus California's atmospheric climate. There are three components that affect the mechanisms of El Niño and the coupled phenomenon La Niña: (1) heat content of the equatorial Pacific Ocean, (2) ocean surface temperature, and (3) trade winds, or the east–west winds that push warm water with them.[16]

Every two to seven years, during El Niño events, the trade winds that power the Walker circulation slow or

03. Elemental Rhythms

# The Coasts of California

even reverse, and warm water flows east toward Ecuador, and the winds and the warm water influence climate patterns as far away as (and further than) California.[17] This warming of the ocean near California can disrupt the upwelling that the offshore ecosystem depends on and can have devastating effects on all the associated marine life for the duration of the event. Although El Niño can bring above-average levels of precipitation to California, it is a complex system that doesn't have a direct, measurable correlation to how much rain or snow falls in any given year.[18] Conversely, La Niña events occur when trade winds keep ocean surface temperatures cool, and circulation patterns in the northern Pacific are altered, regularly leaving California with less than average precipitation totals.[19]

01. Non–El Niño year

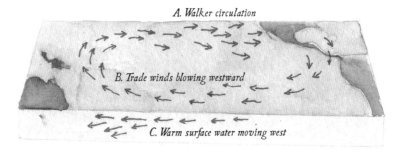

A. Walker circulation
B. Trade winds blowing westward
C. Warm surface water moving west

02. El Niño year

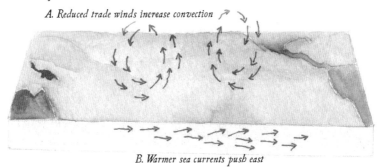

A. Reduced trade winds increase convection
B. Warmer sea currents push east

Map 03.04

03. Elemental Rhythms

## 03.05 THE OCEAN MACHINE
*Upwelling, oxygen, and temperature*

Cold water contains more usable oxygen than warm water. California's coastal waters brim with life because cold water is delivered to its ecosystems not only from the north by the CCS but from the deep by a process called upwelling. This system helps explain why the coastal ecosystems of California are as stable as they are. Diagram 03.05 depicts the hypothetical models of wind-induced upwelling and the distribution of water at different temperatures through the ecosystem.

# The Coasts of California

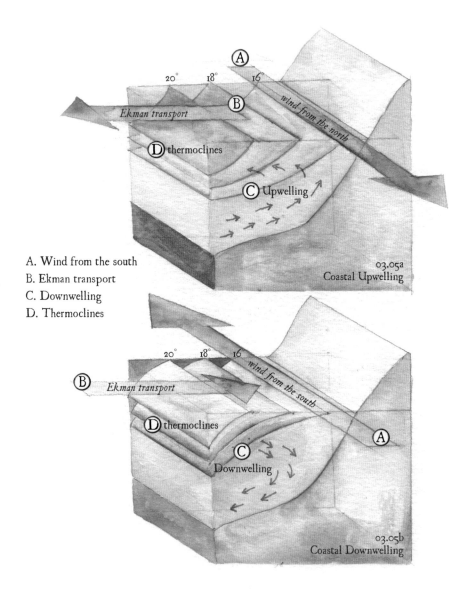

A. Wind from the south
B. Ekman transport
C. Downwelling
D. Thermoclines

3.05

## 03.05a Coastal Upwelling

A. Wind from the north; through a process called atmospheric forcing between stable regions of high and low pressure in the northern Pacific, the CCS generally moves south along the coast.[20]

B. Ekman transport—because of pressure differences between the North Pacific High (one of those stable anomalies in the northern Pacific) and the low pressure of the inland, a constant cross-shore presence produces wind and moves cold water in or out, depending on variables in seasonality;[21] this process of advance and retreat of colder and warmer water takes place within the Ekman flow, or the Ekman spiral, named for the scientist who first identified it.

C. Upwelling—the mechanism within the CCS that brings a highly variable amount of cold water and nutrients; vital for ecosystem functions in pelagic food webs; the effect of climate breakdown on the coastal circulation patterns is still debated; atmospheric temperature increase may result in rigid thermoclines that either increase upwelling productivity or decrease the system's efficacy, depending on the scale at which it is modeled.[22]

D. Thermoclines—stratified layers inside the water column created by sudden changes in water temperature.

## 03.05b Coastal Downwelling

The rounding of the cycle is downwelling; the transport of nutrient-depleted water from near the coast to the pelagic depths is the conveyor that maintains healthy epipelagic ecosystems; in the advent of climate breakdown, if thermoclines do become more rigid and less able to participate in current circulation, hypoxia (low dissolved oxygen concentration) could become an increased threat to offshore ecosystems;[23] artificial pumps to aid in the process are one proposed solution.[24]

# The Coasts of California

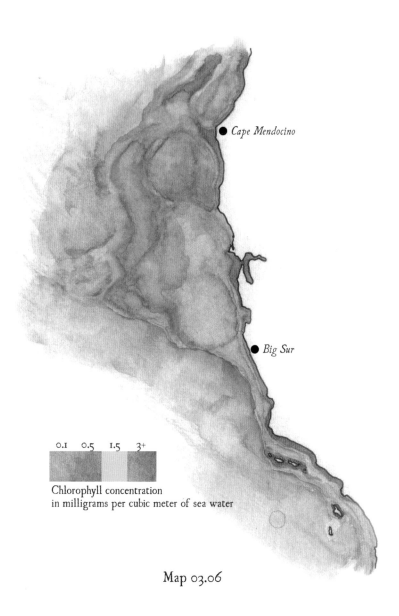

Map 03.06

## 03.06 THE STIRRING OF LIFE
*Chlorophyll concentrations*

Map 03.06 depicts a typical scenario where the concentration of chlorophyll (measured in milligrams per cubic meter of sea water) fans out from the California coast, indicating strong upwelling along the CCS.[25] Chlorophyll concentrations represent the available basis for primary production, the foundation of the oceanic food web; and it is by the reliable physical system of upwelling that the nutrient fuel source is supplied and sustains coastal marine life.

Upwelling season generally occurs off the coast of California in the early summer months, when the cold, upwelled water from the deep mixes with warm air to assist in producing seasonal fog.[26] A stress posed by climate breakdown may be the enlargement of hypoxic thermoclines (layers of oxygen-starved water). When these layers of warm water are pulled to the surface by upwelling, they can help manifest large dead zones in pelagic waters, but may also infiltrate estuary systems like San Francisco Bay and suffocate the ecosystem there.[27] Monitoring chlorophyll and sea surface temperature (SST) are two important, even fundamental measures of ocean health in the wake of climate breakdown. As dead zones become more common north of California along the coast of the Pacific Northwest, there is reason to think that the phenomenon may work its way south, and because of that, close watch is being kept on SST levels, which as of yet remain constant.[28]

California krill
Euphausiids
15 to 20 mm

# The Coasts of California

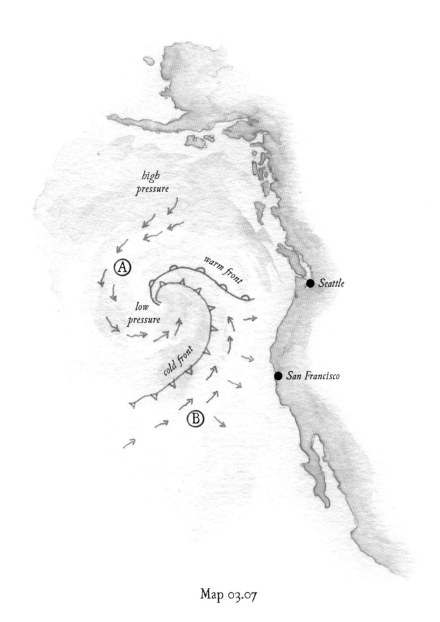

Map 03.07

## 03.07 OCEAN RAIN
*Storm cycles and atmospheric rivers in the eastern Pacific*

A. Southward influx of cold polar air
B. Northward influx of warm, moist, tropical air

Map 03.07 depicts the polar-front cyclonic pattern that develops just before California gets hit with a major winter storm.[29] In this situation, clouds that form in the warm tropical air are lifted on a cold front and drop rain and snow east of the warm front. This atmospheric belt, a system of pressure conveyance, is responsible for the "atmospheric rivers" that provide up to 50 percent of California's annual precipitation. Unfortunately, that precipitation is increasingly coming all at once in the form of "rain bombs," which are indicative of climate breakdown; they exacerbate flooding events and tend not to help alleviate long-term drought.[30] Atmospheric rivers bring moisture from the equatorial Pacific to the northern latitudes in narrow bands of low pressure that might be up to 1,000 miles long and only a couple of hundred miles wide.[31]

California Brown pelican
*Pelecanus occidentalis californicus*
(G4T3T4/S3)

# The Coasts of California

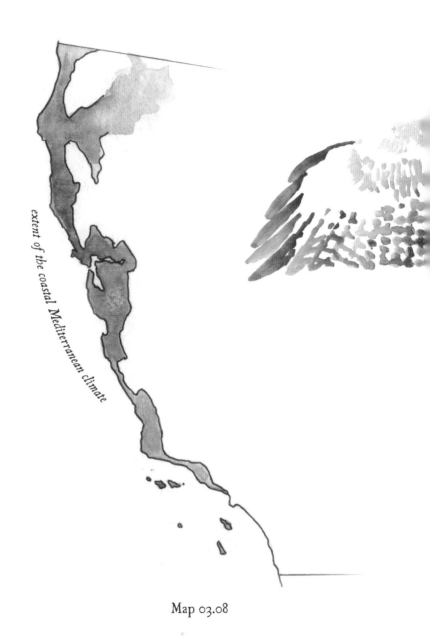

*extent of the coastal Mediterranean climate*

Map 03.08

# 03. Elemental Rhythms

## 03.08 BETWEEN FLOOD AND DROUGHT
*California's Mediterranean climate*

California's climate began to resemble its current pattern between four and seven million years ago when three major factors were set in place: (1) its topography of north–south coastal ranges that separate the coast from the inland valley; (2) its proximity to the cold Pacific Ocean and the circulation patterns of currents in the North Pacific; and (3) its long length of nearly 840 miles that cover 10° of latitude, or the resulting coastline drawn by contemporary tectonic forces.[32]

California's coastal climate type is as special as it is endangered. Mediterranean climates are characterized by warm-to-hot summers and cool, wet winters and exist in only five places on the globe: the Mediterranean basin, the west coast of Australia, central Chile, southwestern South Africa, and California. One defining aspect of California's coastal climate is the presence of summer fog. The fog generator is created by a pulling effect through coastal valleys (most notably through the Golden Gate) by the hot interior, creating a low-pressure zone along the coast.[33] Now that temperatures inland are rising, not only are there fewer days of fog on the coast, but the days that are foggy have lost almost 3.5 hours of fog.[34] This foggy type of Mediterranean climate is essential for coast redwood habitat, the world's tallest forest.

67

The Coasts of California

Map 03.09

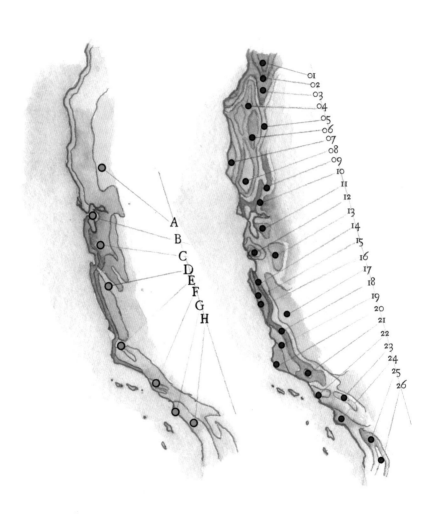

Climate                Precipitation

## 03.09 CLIMATE DISRUPTED
*Local climates and precipitation*

Map 03.09 samples eight localized climate types by coastal region (left) and average annual precipitation by locality (right). The eight climate types, keyed by letter, are each accompanied in this survey by a note regarding climate disruption and its effect on this climate type, either in the recent past or in the immediate future. The term *climate disruption*, instead of *climate breakdown*, *climate change*, or *global warming*, is used here to describe the potential impermanence of the effect should it be mediated by the curbing of mounting climate catastrophe.

A. Northern Valley Mediterranean. The Sacramento Valley is classified as a hot-summer Mediterranean climate; the San Joaquin Valley, the southern half of the Great Central Valley, is climatically classified as a desert.[35] *Climate disruption note:* The air temperature of the valley is expected to rise 6°F (3.3°C) by 2100;[36] where five days of over 100°F weather were recorded in Sacramento Valley in 2000, that number is expected to rise to an average of thirty-one days per year in 2036.[37]

B. North Coast Mediterranean. The climate of the coastal redwood forest from Big Sur to the Oregon border is characterized as a Mediterranean climate with a cool summer with fog.[38] *Climate disruption note:* Incidents of coastal fog, necessary for the health of the coastal redwood forest, have decreased 33% since the beginning of the twentieth century.[39]

C. North Coast Ranges Mediterranean. The northern mountains of the Shasta-Trinity, Six Rivers, and Mendocino National Forests are characterized by mild, dry summers and cool, wet winters. *Climate disruption note:* Tree ring data inside the Mendocino National Forest indicates that drought cycles of the past 10 years, specifically between 2010 and 2014, have been the most arid in at least 1,200 years.[40]

D. Semiarid steppe of the inland ranges. A semiarid climate receives less precipitation than the collective potential evapotranspiration of all the plant matter in the area, meaning that there is less water for plants than in wetter climates.[41] *Climate disruption note:* Since 1980, a significant decrease in long-term relative humidity has inversely affected the strength of the Diablo winds (see 03.10), increasing their ability to stoke fire.[42]

E. Central Coast Range Mediterranean. The Mediterranean climate of the Santa Lucia Mountains is also called dry-summer subtropical.[43] *Climate disruption note:* Since 1950, increased air temperature in the inland valleys has led to cooler onshore breezes, reducing average coastal temperatures south of Monterey for most months, although in summer months, days of extreme heat and aridity are becoming more common.[44]

F. Santa Monica Mountains Mediterranean. The coastal transverse mountains of Southern California experience warm, dry summers and wet winters. *Climate disruption note:* Anticipating further increases in temperature above those already measured, the Santa Monica Mountains National Recreation Area is one of seven parks involved in a massive project (the California Phenology Project) to study how the ecosystems are responding to climate breakdown.[45]

G. Los Angeles Mediterranean. Hot summers and cool, damp winters. *Climate disruption note:* Since 1895 (125 years ago), average temperatures across Los Angeles County have increased 4.1°F (2°C); it is predicted that by 2050, the number of days every summer when Los Angeles city temperatures will be higher than 95°F will triple.[46]

H. San Diego Mediterranean. Arid subtropical.[47] *Climate disruption note:* Particularly extreme; average temperatures across San Diego County are expected to increase between 5°F (2.7°C) and 10°F (5.5°C) by 2100.[48]

Average annual statewide total for precipitation is 22.5 inches. Seven of the ten years between 2009 and 2019 have been dry years when the state's average was not met.[49] California has the highest variability in precipitation averages of any state, and it receives 85 percent of its precipitation in the months between October and April.[50]

The following key corresponds to Map 03.09 and indicates average yearly precipitation across regional and specific localities.[51]

01. Gasquet—72"
02. Weitchpec—53"
03. Willow Creek—54"
04. Humboldt Redwoods State Park—72"
05. Yolla Bolly–Middle Eel Wilderness—60"
06. Round Valley—46"
07. Mendocino—41"
08. Healdsburg—42"
09. Lake Berryessa—25"
10. Napa Valley—25"
11. Fremont—16"
12. Santa Cruz—33"
13. Morgan Hill—21"
14. Salinas—15"
15. Big Sur—36"
16. San Simeon—20"
17. Coalinga—8"
18. Paso Robles—18"
19. Santa Maria—17"
20. Lompoc—16"
21. Ojai—19"
22. Oxnard—15"
23. San Bernardino—13"
24. Los Angeles—15"
25. Santa Ana Mountains—13"
26. Lake Cuyamaca—30"

03. Elemental Rhythms

Amaryllis belladonna
Amaryllis lily
South African
Common late-summer
North Coast California

# The Coasts of California

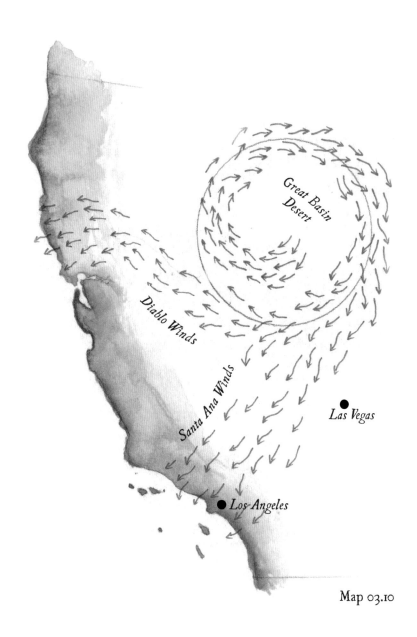

Map 03.10

## 03.10 FIRE DRIVERS
*The desert winds of Northern and Southern California*

Famous for exacerbating regional fires, the autumnal Diablo winds that rush through the canyons of Northern and Central California and the Santa Ana winds of Southern California are both created by the same process. In fact, there is no difference between the two; they are only named differently to represent regionality.[52] As atmospheric pressure builds in the high deserts of Nevada and eastern Oregon, a southwardly moving jet stream develops that propels the wind to low-pressure areas and lower elevations across and through the canyons of coastal California. On its way, the winds warm and increase speed, not only stoking fires that are already burning on the land but starting new ones by toppling power lines.[53]

*I burn with the forest*

# The Coasts of California

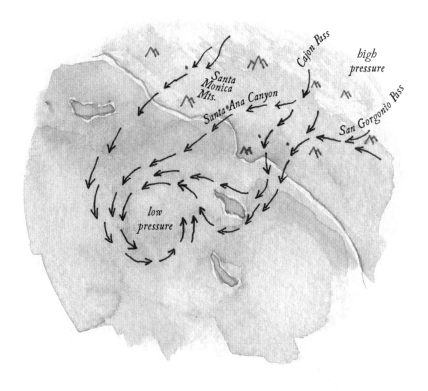

Map 03.11

03. Elemental Rhythms

## 03.11 RAGING THROUGH CANYONS
*The Santa Ana winds of Los Angeles*

The stoker of the flame, these desert winds blow off the high desert and pick up speed as they careen through the canyons of the south coast. They can arrive at any time of year, but do so most often in autumn when the air temperature is the highest, the soil is at its most arid point of the year, and the plant life is parched. The fastest speed ever measured of the Santa Ana winds came in 2011, when over Whitaker Peak (Los Angeles County), they were clocked at ninety-seven miles per hour.[54] With the advent of climate breakdown, the high-pressure zone over the Great Basin Desert that generates the Santa Anas might be dismantled, in which case, fewer wind events would occur, but those that would occur would do so later in the season, which might mean an extension of fire season into winter.[55]

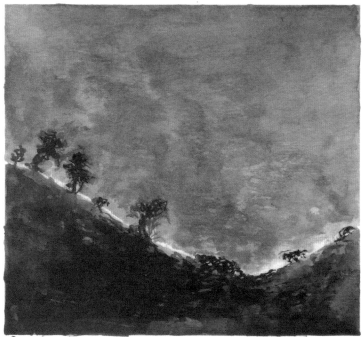

*the forest resets*

# The Coasts of California

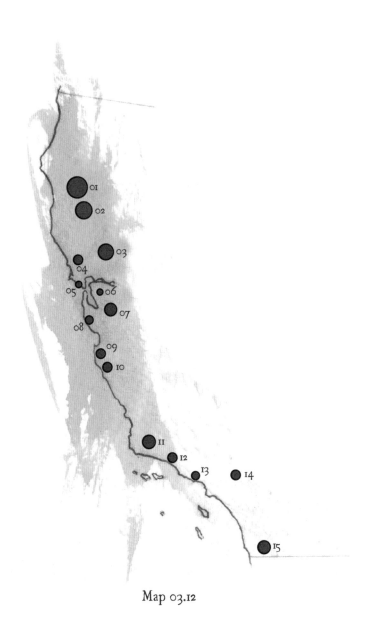

Map 03.12

## 03.12 THE STATE OF FIRE
*Where, how, and why coastal California burns*

Map 03.12 depicts many fires that took place within and along California's coastal ranges and coastal areas. The nature of fire in California is full of paradoxes. Among them: while each fire is unique with regard to its ignition, propagation, and severity, all these fires are the same with regard to the conditions, the policies, and the ecological mechanisms that triggered them.

Beginning the night of August 16, 2020, a lightning storm moved across northern California and delivered over twelve thousand lightning strikes across the arid summer landscape and sparked more than 650 individual fires.[56] Five of the twenty biggest fires in modern California history were sparked by the lightning storm, and five of the fires on this list were as well: August Complex (01), LNU Complex (03), Woodward (05), SCU Complex (07), and CZU Complex (08).

01. August Complex—1.03 million acres (1,600 square miles); August 2020; 38 separate fires that merged and together burned parts of six counties; the first gigafire in California's modern history;[57] one person died; cause: lightning

02. Mendocino Complex—.46 million acres (717 square miles); July 2018; two separate fires that merged and together burned parts of four counties; cause: machinery sparks

03. LNU Complex—.36 million acres (570 square miles); August 2020; six fires that merged and together burned parts of five countries; cause: lightning

04. Tubbs Fire—.037 million acres (58 square miles); one of eight fires that burned .245 million acres across Northern California in October 2017; one of the most destructive wildfires in history because of the devastation to the city of Santa Rosa; 22 people died; cause: either utility lines or personal equipment

05. Woodward Fire—.005 million acres (8 square miles); August 2020; Point Reyes National Seashore; the first fire inside this closed-cone pine forest in modern history; cause: lightning

06. Oakland Firestorm—.002 million acres (2.3 square miles); October 1991; in a historic eucalyptus plantation and suburban community; over 3,000 structures burned, and 25 people died; cause: incompletely extinguished grass fire

07. SCU Complex—.39 million acres (615 square miles); August 2020; many fires that together burned parts of six counties; cause: lightning

08. CZU Complex—.086 million acres (135 square miles); August 2020; Santa Cruz County; burned into the old-growth redwood forest of Big Basin State Park; cause: lightning

09. Soberanes Fire—.132 million acres (206 square miles); July 2016; Monterey County, Ventana Wilderness; cause: illegal campfire

10. Dolan Fire—.124 million acres (195 square miles); August 2020; Monterey County, Big Sur, Ventana Wilderness; cause: arson

11. Zaca Fire—.240 million acres (375 square miles); July 2007; Santa Barbara County, Los Padres National Forest; cause: machinery sparks

12. Thomas Fire—.282 million acres (440 square miles); December 2017; Ventura County; augmented by prolonged Santa Ana winds (see 03.11); cause: utility line

13. Woosley Fire—.096 million acres (152 square miles); November 2018; Santa Monica Mountains; three people died; cause: machinery

14. Bobcat Fire—.116 million acres (180 square miles); September 2020; San Gabriel Mountains; cause: utility line

15. Cedar Fire—.273 million acres (427 square miles); October 2003; Cuyamaca Mountains, San Diego County; 15 people died; cause: unintentional human mistake

Despite the list of fires, let's consider fire as a process instead of as a singular event. Fire needs trees, shrubs, and grass to burn; the drier the fuel, the more severe the fire. Climate breakdown, as manifested through global warming, is the primary driver of California's new era of megafire. The reason for this is the exponential increase of aridity inside woody plants due to the atmospheric vapor pressure deficit, a measure of how much humidity the air can hold. In the past fifty years, the air temperature of Northern California's forested lands has increased an average of 2.5°F (1.4°C) on hot days, inciting a spike in the vapor pressure deficit.[58]

## 03. Elemental Rhythms

The Thomas fire was advancing, spurred by the strongest Santa Ana wind event in years, at a rate of an acre a minute. The pitch in the pine trees exploded from the inside... It's not a fire but a maelstrom of burning air. The community of living beings that, just the day before, composed a forest, now were horrendous vapor. The stored beauty now spent and exchanged for ash petals in the wind across our terrible new kind of autumn. Our modern age is an age of fire.

It is not only the fire that remakes the mountains but also the mud. A month after the burn, when a half inch of rain fell in five minutes on the loose and ashy soil, the mountain came down. A fifteen-foot-tall wall of mud, now released, crashed into the seaside town of Montecito, burying twenty-one people in their homes. Despite our fatigue and our grief, the reset that the fire affords and demands is never over but exists in a cycle of give and take — the defining truth and challenge for us in this perilous place.

## 03.13 DEVIATION FROM THE NORM
*The fire return interval departure of Southern California*

Map 03.13 depicts the mean percentage fire return interval departure index (mean PFRID) from Monterey to San Diego, since 1910.[59] The mean PFRID represents how overburned the local area is. The departure index is expressed as a percentage of deviation from how often the area burned before Euro-American settlement. A zero percentage (0%) is a balanced fire regime, meaning that there is no deviation from premodern fire intervals. A negative percentage indicates the degree that overburning, or an increase in the return rate of fire on the land, has occurred in comparison to historical norms.

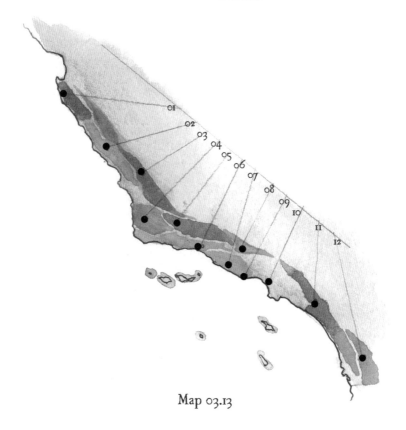

Map 03.13

## 03. Elemental Rhythms

01. Northern Monterey County:
    -34% to -17%
02. Big Sur and the San Simeon Coast:
    -17% to 0%
    *Note: data presented is pre-Soberanes (see 03.12.09) and pre-Dolan (see 03.12.10)*
03. Northern Los Padres National Forest:
    -34% to -17%
04. Santa Maria foothills:
    -17% to 0%
05. Southern Los Padres National Forest:
    -51% to -34%
06. Santa Ynez Mountains:
    -34% to -17%
07. Ventura County:
    urban-wildland interface, no data
08. Angeles National Forest:
    -51% to -34%
09. Santa Monica Mountain National Recreation Area:
    urban-wildland interface, no data
    *Note: with continuing events such as the Woosley fire (see 03.12.13), it may be that conditions for native chaparral regionally across the Santa Monica Mountains will not be suitable for fire return in less than 50 years without risk of ecotype conversion or the loss of chaparral to invasive, weedy grasses.*[60]
10. Los Angeles
11. Northern Cleveland National Forest:
    -34% to -17%
12. Southern Cleveland National Forest:
    -51% to -34%

This area, replete as its ridgelines and canyons are with fir forest, sage scrub, and chaparral, have seen shorter intervals between fire events than before the twentieth century. This means that Southern California has burned too much in the past century, and the native vegetation has not been able to respond and rebound as it would under a normalized regime without human development, invasive plants, and the advent of climate breakdown. Fire, in regular intervals as determined by the ecosystem, presents an opportunity, a disturbance that can lead to renewal. If we can normalize fire and heed the ecological function it serves—one that allows natural cycles to work as they should—the results will only serve humanity.

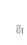

# The Coasts of California

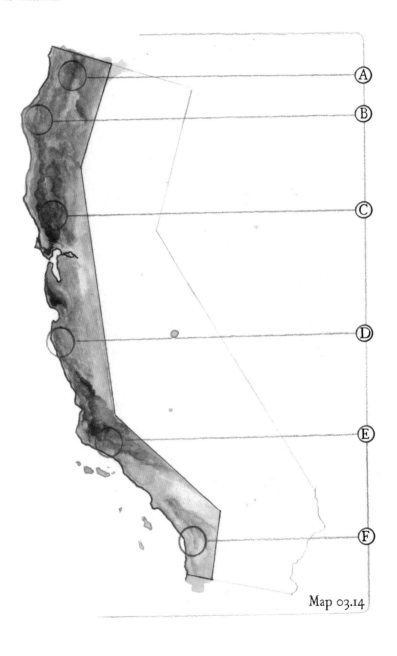

Map 03.14

## 03.14 THE POWER OF RENEWAL
*Fire regime and ecology in California*

It would be a mistake to underestimate the helpful role fire plays inside California's forests. For thousands of years prior to the Euro-American settlement, a sophisticated, anthropogenic fire regime was established across the entirety of the California Floristic Province. This regime, assisted as it was by lightning ignitions, was so complete that every arboreal habitat in the state evolved to become either adapted to or dependent on regular burning. A healthy California forest waits eagerly for high-intensity, low-severity fire to return. California forests are made not of trees but of fire, waiting to burn.

Map 03.14 represents sample forest types across California's coastal region and considers what a regularized fire return rate should be to maintain forest health and encourage biodiversity.

A. The Klamath Mountains, being among the most diverse habitats for conifer trees on the planet; fire return normalization rate between 8 and 19 years[61]

B. The old-growth redwoods of Humboldt Redwoods State Park, being the forests with the tallest trees in the world; fire return normalization rate between 26 and 50 years[62]

C. The northern chaparral of Berryessa Snow Mountain National Monument; now engaged in a deformed fire regime of less than 10 years, when the fire return normalization rate should be between 35 and 100 years[63]

D. The mixed-conifer (fir and redwood) communities of Big Sur and Monterey County, being the southern extent of the range of coast redwood; fire return normalization rate between 35 and 85 years[64]

E. The chaparral habitats of the Los Padres National Forest, being an endangered ecosystem due to too much fire and climate breakdown; fire return normalization rate between 30 and 150 years[65]

F. The herbaceous, sage scrub, chaparral, hardwood forest, and conifer forests of San Diego; fire return normalization rate between 40 and 150 years[66]

Another fire paradox in California is that over time, the more fire you have, the less damage it does. Most of Northern California is woefully fire deficient. Fire will have its day, and our failure to understand that truth is a major source of the ongoing and sorrowful calamity. One-third of the total land area that has burned since 1930 did so in the 120 days from the lightning storm of August 16, 2020 (see 03.12),[67] and another third of that total land area burned in the ten years

*fire renewal, fire reset*

between 2010 and 2020.[68] California was stewarded for thousands of years to burn at a rate of more than three million acres per year spread across thousands of fires, each about 500 acres in size—not four million acres spread across twenty fire complexes, each averaging 150,000 acres.[69] The difference between surviving fire and living with fire in California is the size of individual fire events. That is the salient factor.

The collective hand of colonialist violence—the hand that transformed landscape into property and arboreal habitat into timber—set in motion a series of cascading disturbances, and now California's forests are infirmed, simplified, fragmented, crowded, and stressed. The state's forests are also capable of being repaired, supported, restored, and reconnected, commensurate with the degree to which their human residents can muster the will to do the same inside themselves.

# 04. SAND AND RIVERS
*Littoral patterns and estuary types*

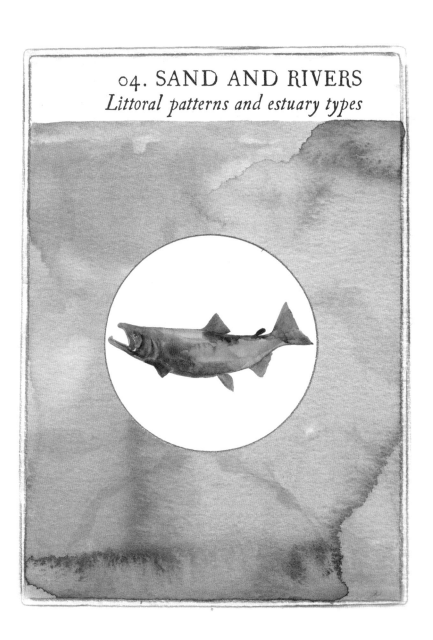

> *Every item on every list is wholly special and unique, a genus all its own, a unique evolutionary system that will never exist again in the same way as it does now.*

In chapters 02 and 03, we explored the geological patterns and weather systems that together shape California's coastal physiography. In this chapter, we take a dive that will last for the remainder of the book, into the physical organization of habitat spaces along California's coasts. In many ways, the rest of the book is hidden in this chapter. Focusing on places within three primary ecosystem networks—offshore; intertidal; and estuarine, including reserves, conservation areas, estuaries, watersheds, inlets, bays, sand dunes, and the beach communities California is famous for—a big picture develops. On a knife's edge, the systems that support this wealth of biodiversity still exist, yet threaten to collapse should we fail to attend to and acknowledge their existence and, therefore, their value.

*Previous page:*
Spawning coho salmon
*Oncorhynchus kisutch*
identifiable by the hooked beak

## 04.01 RIVER'S END
*Estuary geography*

Coastal watersheds are bookended by coastal habitat when the river meets the sea. The presence of salt changes the chemistry of the freshwater habitat, and a unique ecosystem develops. Across so many of California's smaller estuaries, the salt water only ever enters the watershed in seasonal doses. For most of the year, these smaller watercourses are blocked from the sea by sand hills. During the big-wave months of November through April, storm surges along the coast, mixed with river inflows from the watershed, can produce water levels several meters above the average maintained through the rest of the year.[1]

Water infrastructure, along with groundwater pumping that doesn't allow for appropriate recharge, significantly impacts the integrity of estuarine ecosystems across the state. Crucial to that integrity is estuarine circulation, the pattern of fresh water flowing out of the system on the top layer over heavier, saltier water coming in from the sea underneath. With-

out adequate inflow, the circulation patterns of fresh and salt water begin to break down and threaten the ecosystem.

Map 04.01 begins to describe the hundreds of localities that together represent over 45,000 acres of coastal wetland where estuarine habitats may be present.[2] The three geographic features include classic estuaries, lagoons, and river-mouth estuaries.[3] Classic estuaries are wetlands that are balanced between freshwater and saltwater inflows on a year-round, regular basis.[4] Lagoons are most often formed by a sand spit and regularly don't exist in the stream channel, but are usually isolated and located to the side of the river mouth where a shallow area of collected water, often hypersaline, can support tidal marshes and mudflats.[5] River-mouth estuaries are the most common type of estuary in California. Big river-mouth estuaries, such as the Russian and Navarro Rivers, are steep sided and have only a small bit of area available for eelgrass fields or other intertidal habitat types, but may be important corridors for anadromous fish returning to inland headwaters.[6]

*DEL NORTE COUNTY*

01. Yontocket Slough; Smith River
02. Lake Earl area
    Pebble Beach
03. Crescent City area
    Crescent City Harbor
    Wilson Creek
    Lagoon Creek
04. Klamath River

*HUMBOLDT COUNTY*

05. Redwood National Park area
    Johnson Creek
    Ossagon Creek
    Fern Canyon
    Squashan Creek
    Gold Bluffs
    Redwood Creek
    Stone Lagoon
    Big Lagoon
06. Eureka area
    Little River
    Clam Beach
    Widow White Creek
    Mad River Slough
    Humboldt Bay
07. Eel River
08. Mattole River area
    Guthrie Creek
    Bear River
    McNutt Gulch
    Mattole River

*MENDOCINO COUNTY*

09. Jackass Creek
10. Usal Creek; Cottaneva Creek
11. Wages Creek; Chadbourne Gulch
12. Fort Bragg/Mendocino area
    Ten Mile River
    Sandhill Lake and Inglenook Fen
    Lake Cleone
    Virgin Creek
    Pudding Creek
    Noyo River
    Caspar Creek
    Russian Gulch
    Big River
    Little River
    Albion River
    Little Salmon Creek
    Navarro River

# The Coasts of California

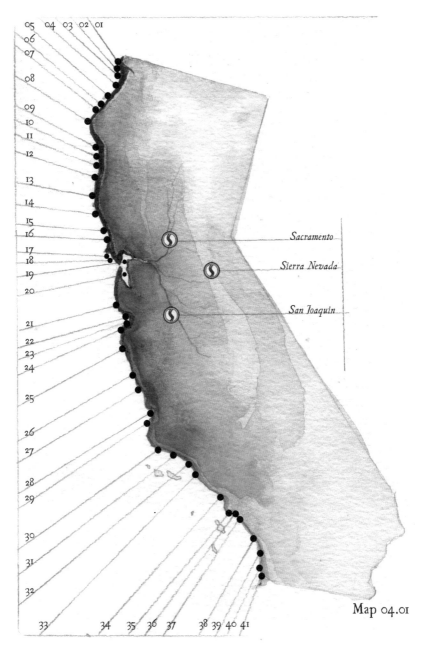

Map 04.01

04. Sand and Rivers

13. Point Arena area
    Greenwood Creek
    Elk Creek
    Irish Gulch
    Alder Creek
    Manchester
    Brush Creek
    Garcia River

*SONOMA COUNTY*

14. Gualala River
15. Russian River area
    Russian River
    Salmon Creek
    Bodega Bay

*MARIN COUNTY*

16. Tomales Bay area
    Estero Americano
    Estero de San Antonio
    Tomales Bay
17. Drakes Estero
18. Bolinas Lagoon
    Redwood Creek
    Tennessee Valley Lagoon
    Rodeo Valley Lagoon

*SAN FRANCISCO BAY*

19. San Pablo Bay
20. San Francisco Bay (and the San Mateo County coast)
    San Pedro Creek
    Half Moon Bay
    Airport Lagoon
    Frenchmans Creek
    Pilarcitos Creek
    Tunitas Creek
    San Gregorio Creek
    Pomponio Creek
    Pescadero Marsh
    Lake Lucerne
    Gazos Creek

*SANTA CRUZ COUNTY*

21. Southern Santa Cruz County coast
    Waddell Creek
    Scotts Creek Lagoon
    Baldwin Creek
    Lombardi Creek
    Dairy Gulch
    Wilder Creek
    Younger Lagoon
22. Santa Cruz area
    Neary Lagoon
    San Lorenzo River
    Santa Cruz Harbor
    Schwan Lagoon
    Corcoran Lagoon
    Moran Lake
    Soquel Creek
    Aptos Creek
    Pajaro River
    Elkhorn Slough

*MONTEREY COUNTY*

23. Salinas River
24. Carmel area
    Carmel River
    Joshua Creek
    San Jose Creek
    Malpaso Creek
    Soberanes Creek
25. Big Sur area
    Garrapata Creek
    Rocky Creek
    Bixby Creek
    Little Sur River
    Big Sur River
26. Flat Iron Creek

89

*SAN LUIS OBISPO COUNTY*

27. San Simeon coast
    San Carpoforo Creek
    Arroyo de la Cruz
    Arroyo del Corral
    Arroyo Laguna
    Arroyo del Puerto
    Little Pico Creek
    Pico Creek
    San Simeon Creek
    Santa Rosa Creek
28. Estero Bay area
    Villa Creek Lagoon
    Cayucos Creek Lagoon
    Old Creek
    Alva Paul Creek
    Toro Creek
    Chorro Creek
    Morro Bay
29. San Luis Obispo Bay
    San Luis Obispo Creek
    Pismo Creek Lagoon
    Santa Maria River
    Santa Ynez River
    (Santa Barbara County)

*SANTA BARBARA COUNTY*

30. Gaviota coast
    Honda Creek Lagoon
    Jalama Creek
    Canada de la Gaviota Creek
    Bell Canyon Creek
    Arroyo Hondo
31. Santa Barbara coast
    Devereux Slough
    Elwood Creek
    Campus Lagoon
    Goleta Slough
    Arroyo Burro Creek
    Mission Creek Lagoon
    Sycamore Creek
    Carpinteria Salt Marsh
    Carpinteria Creek

*VENTURA COUNTY*

32. Ventura area
    Ventura River
    San Buenaventura Beach
    Ventura Marina
    Santa Clara River
    Channel Islands Harbor
    Port Hueneme
33. Mugu area
    Ormond Beach
    Mugu Lagoon
    Trancas

*LOS ANGELES COUNTY*

34. Malibu area
    Dume Lagoon
    Malibu Lagoon
    Santa Monica Canyon
35. Los Angeles area
    Marina Del Rey
    Ballona Creek
    Cabrillo Marina
    Long Beach Harbor
    Los Angeles Harbor
    Los Angeles River
    Long Beach Marina

*ORANGE COUNTY*

36. Huntington Beach area
    Alamitos Bay
    San Gabriel River
    Anaheim Bay
    Muted Bolsa Bay
    Bolsa Chica
    Huntington Channel

04. Sand and Rivers

37. South Orange County coast area
    Newport Bay
    Aliso Creek
    San Juan Creek
    Dana Point Harbor

*SAN DIEGO COUNTY*

38. North San Diego coast area
    San Mateo Lagoon
    San Onofre Creek
    Las Pulgas Creek
    Las Flores Creek
    Aliso Canyon Creek
    French Lagoon
    Cockleburr Canyon

39. Greater Oceanside/Encinitas area
    Santa Margarita Lagoon
    Oceanside Harbor
    San Luis Rey Creek
    Loma Alta Slough
    Buena Vista Lagoon
    Agua Hedionda Lagoon
    Batiquitos Lagoon
    San Elijo Lagoon
    San Dieguito Lagoon
    Los Peñasquitos Lagoon

40. Mission Bay
    San Diego River

41. San Diego
    San Diego Bay
    Tijuana Slough

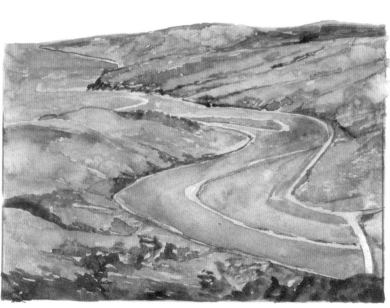

mouth of the Russian river, Sonoma county

The Coasts of California

Map 04.02

## 04.02 DISCRETE AND DISTINCT
*Watersheds*

California's coastal watersheds are physically different from those in other parts of the country. Where watersheds and their accompanying estuary wetlands on the East Coast might languidly spread out for hundreds or even thousands of square miles, California's coasts are geologically complex and dynamic, and because the watercourses emerge from deep canyons through steep mountains, they tend to only drain into much smaller basin areas. More than 70 percent of California's shoreline exists in what can be described as a high-relief profile—a terrain defined by cliffs, headlands, bluffs, and coast ridgelines that plunge into the sea.[7]

When isolated for a long enough period of time, the watershed can become a bounded, discrete island with ecosystems and organisms that express its unique characteristics.[8] Because of its unique ration of suspended nutrients and dissolved minerals, the watershed influences the health of the surrounding human ecology and how that society interacts with its environment.[9] The direct and indirect benefits from a healthy watershed are wide ranging, from mediating the effects of soil- and water-borne pollution; to water reliability and sustainability; to providing habitat for wildlife and a spectrum of services, from pest control to pollination, resources to recreation, and the less measurable, but vitally important, cultural and spiritual values.

01. Smith River
02. Klamath River
03. Redwood Creek
04. Maple Creek
05. Mad River and Little River
06. Lower Eel River
07. South Fork Eel River
08. Bear River
09. Mattole River
10. Lost Coast
11. Juan Creek
12. Ten Mile River
13. Noyo River
14. Big River
15. Navarro River
16. Russian River
17. Elk River
18. Garcia River
19. Gualala River
20. Sonoma coast
21. Salmon Creek
22. Point Reyes
23. Lagunitas Creek
24. Sacramento River
25. San Joaquin River
26. East Bay creeksheds
27. Santa Clara Valley
28. San Francisco Peninsula
29. San Mateo coast
30. San Lorenzo River
31. Pajaro River
32. Elkhorn Slough
33. Monterey Peninsula
34. Salinas River
35. Carmel River
36. Big Sur coast
37. San Simeon Creek
38. Santa Rosa Creek
39. Cayucos Creek
40. Morro Bay
41. Arroyo Grande
42. Santa Maria River
43. Santa Ynez River
44. Santa Barbara coast
45. Ventura River
46. Santa Clara River
47. Calleguas Creek
48. Santa Monica Mountains
49. Santa Monica coast
50. Los Angeles River
51. San Gabriel River
52. Santa Ana River
53. San Juan Creek
54. San Luis Rey River
55. Carlsbad coast
56. San Dieguito River
57. Peñasquitos coast
58. San Diego River
59. Otay River

## Estuaries
### the realm of grizzly's ghost

I was born with a bear-size hole inside me. The last California grizzly was killed fifty years before I was born, and I still miss the beautiful, precious being that she was. The fight against the simplification, the fragmentation, and the infirmity of our shared ecosystems, the habitat spaces we all rely on, is both the most joyful and the most painful thing I know. This philosophy is all wrapped up, draped in the raiments of what I aim to live, a self-examined life, focusing always on a better understanding of how to die. Only through that shadowed forest, punctuated with moments of the most exquisite beauty in light when I find my work in service to justice, can I come to grips with holding the gift of life at all.

# The Coasts of California

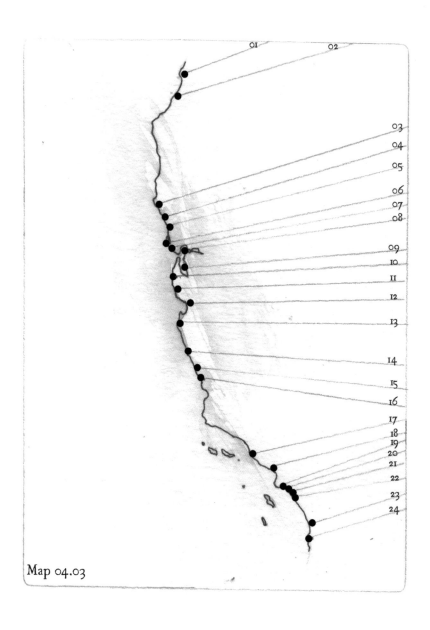

Map 04.03

## 04.03 MOMENTS OF SAFE HARBOR
*California's bay geography*

From the intertidal zone out to beyond where the light can reach but before the continental shelf drops away to the deep blue, the open ocean influences life in the epipelagic zone. The term *epipelagic zone* refers to the ecosystem that exists to a depth of 650 feet.[10] Because of California's narrow continental shelf (see 02.09), most of its bays are highly productive regions, subject to a robust upwelling system, the source of a significant phytoplanktonic biomass and the basis for a network of sublittoral ecosystems.[11]

This is where massive schools of bait fish, including anchovy, support a food web that includes not only dozens of species of fish but turtles, birds, and mammals, such as green sea turtles, *Chelonia mydas*; sooty shearwaters, *Ardenna grisea*; and harbor porpoise, *Phocoena phocoena*. Bays are essential foraging spots for many predators and are subject to regular and irregular chemical and temperature changes that affect their populations. Harmful (even poisonous) algal blooms and El Niño events (see 03.04), which can affect upwelling, setting off a trophic cascade due to an associated decrease in the primary production of phytoplankton.[12]

01. Crescent Bay
02. Humboldt Bay
03. Arena Cove
04. Fisherman Bay
05. Bodega Bay
06. Drakes Bay
07. Bolinas Bay
08. San Pablo Bay
09. San Francisco Bay

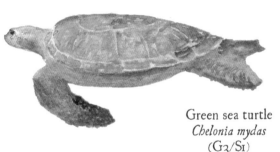

Green sea turtle
*Chelonia mydas*
(G3/S1)

10. Half Moon Bay
11. Año Nuevo Bay
12. Monterey Bay
13. Carmel Bay
14. San Simeon Bay
15. Morro Bay
16. San Luis Obispo Bay
17. Pierpont Bay
18. Santa Monica Bay
19. San Pedro Bay
20. Anaheim Bay
21. Newport Bay
22. Emerald Bay
23. La Jolla Bay
24. San Diego Bay

## 04.04 INEXPRESSIBLE FERTILITY
*The Golden Gate and the Bay Delta*

*In every direction, a different face of California's most precious jewel*

To describe the enormous array of life in the Bay Area, one early explorer used the words "inexpressible fertility."[13] Over a thousand species of animals still make their home here in this place that is now as ecologically compromised as it is fathomlessly beautiful. Metropolitan industry has over taken most of the bay, yet on its margins, hundreds of thousands of birds still recognize this essential landing spot on their annual migrations up and down the Pacific Flyway, and stop to rest and forage. Long after this modern society has washed away and transformed into what comes next, will the once-rich ecological niches not long ago filled by the extinct grizzly bear and the diminishing salmon be available again and occupied, perhaps by some new ursine predator and a resurgent population of anadromous fish?

In a time frame that coincides with the coming of humanity to the bay, about ten thousand years ago, the warming of the world's climate at the end of the last ice age filled the bay to its most recent maximum size.[14] Historically California's largest estuary, the San Francisco Bay Delta was the drain for a composite of watersheds that included more than 40 percent of California's total land area. Because of this massive river inflow, most of the original 850 square miles of bay lands (indicated by green on map 04.04) are classified as tidal wetland habitat.[15] The map describes the historical bay lands that, although severely damaged, still account for 77 percent of California's remaining perennial estuarine wetlands.[16]

Today, because of humanity's extensive extraction of river water, inflow conditions that represent the driest 20 percent of normal years occur 70 percent of the time.[17] In the upper regions of the Bay Delta complex, more than sixteen hundred miles of aqueous habitat existed only several decades ago, across an array of wetland ecosystems that included willow-fern communities, riparian forests, and dunes; now, 97 percent of that wetland network is lost.[18] The desiccating effect of ever-encroaching development across San Francisco Bay's largest subsections—South Bay, San Pablo Bay, and Suisun Bay—has resulted in a loss of 82.7 percent of the original 190,135 acres (298 square miles) of tidal wetland, to an existing total of 32,893 acres (51.4 square miles).[19]

04. Sand and Rivers

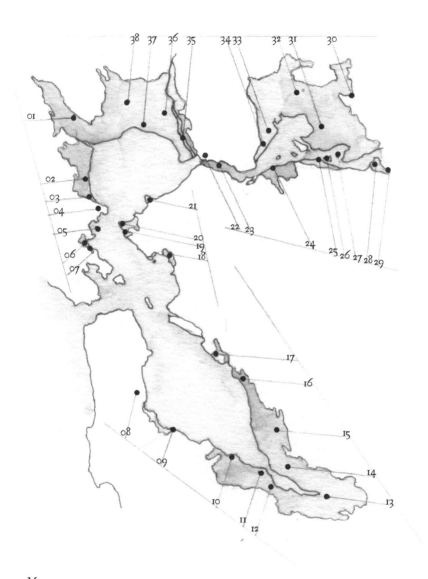

Map 04.04

Five wildlife refuges are positioned around the San Francisco Bay: Antioch Dunes, habitat for the Antioch Dunes anthicid beetle, *Anthicus antiochensis* (G1/S1); Don Edwards; Marin Islands; San Pablo Bay; and, further out, the Farallon Islands.

01. Petaluma Marsh Wildlife Area
02. Hamilton Air Force Base (closed)
03. John F. McInnis County Park
04. China Camp State Park
05. San Rafael Bay
06. Corte Madera Ecological Reserve
07. Ring Mountain Preserve
08. San Bruno Mountain State and County Park
09. Poplar Creek; Coyote Point
10. Bair Island
11. Ravenswood Preserve
12. Baylands Nature Preserve; Mountain View Shoreline Park
13. Guadalupe Slough; Alviso Slough; Coyote Creek
14. Don Edwards San Francisco Bay National Wildlife Refuge
15. Coyote Hills Regional Park; Alameda Creek
16. Hayward Regional Shoreline
17. Oyster Bay Regional Shoreline
18. Point Isabel Regional Shoreline
19. Miller/Knox Regional Shoreline
20. Point Molate Naval Fuel Depot (closed)
21. Point Pinole Regional Shoreline
22. Mare Island Strait
23. Carquinez Strait
24. Point Edith Wildlife Area
25. Bay Point
26. Chipps Island
27. Honker Bay
28. Lower Sherman Island Wildlife Area
29. Antioch Dunes National Wildlife Refuge
30. Little Honker Bay
31. Grizzly Island Wildlife Area
32. Rush Ranch Open Space
33. Grizzly Bay
34. Suisun Bay Marsh
35. Napa River
36. Napa-Sonoma Marshes Wildlife Area
37. San Pablo Bay National Wildlife Area
38. Skaggs Island Naval Communication Station (closed)

Black-necked stilt
*Himantopus mexicanus*

## 04.05 CENTRAL COAST ARBOREA
*Forests on- and offshore*

You'd be forgiven if at first glance you didn't see much difference between the towering forests on land and the vertical canopy of the submarine forests of kelp that exist as a quasi-arboreal habitat of their own. The submarine forest develops with different niche levels in which different trophic interactions occur, much as a terrestrial forest does, including a floor, an understory, an overstory, and a canopy. But kelp is not a tree at all. It isn't even a vascular plant. Kelp is an alga (see 05.03) and an ecosystem engineer much in the same way the redwood tree is, and although the two photosynthesizing species are much different botanically, their ecological effect is similar in a number of important ways.

Map 04.05 represents the biologically rich area from northern San Mateo County to Big Sur, an area whose kelp forests are legally protected at the heart of the Monterey Bay National Marine Sanctuary (see 09.02). Today, despite facing many stressors (see 05.12), the kelp forests continue to be

The Coasts of California

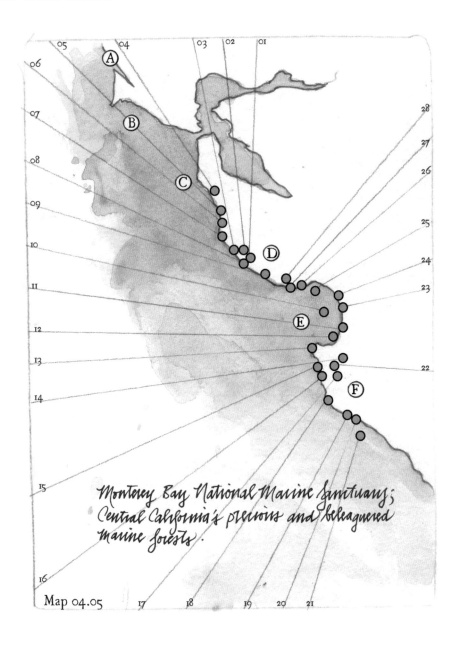

Monterey Bay National Marine Sanctuary; Central California's precious and beleaguered marine forests.

Map 04.05

04. Sand and Rivers

the ecosystem with the most complex food web in the California Current System; it counts in its number 650 macroalgal plant species, 500 fish species, 90 resident bird species, and 28 marine mammal species.[20]

A. Tomales Bay
B. Drakes Bay; Greater Farallones National Marine Sanctuary
C. Montara State Marine Reserve; Pillar Point State Marine Conservation Area
D. Santa Cruz Mountains
E. Monterey Bay National Marine Sanctuary
F. Ventana Wilderness

01. Big Basin Redwoods State Park
02. Butano State Park
03. Año Nuevo State Park
04. Montara Mountain
05. San Gregorio State Beach
06. Pescadero State Beach
07. Bean Hollow State Beach
08. Año Nuevo State Marine Conservation Area
09. Greyhound Rock State Marine Conservation Area
10. Soquel Canyon State Marine Conservation Area
11. Salinas River National Wildlife Refuge
12. Pacific Grove Marine Gardens State Marine Conservation Area
13. Asilomar State Marine Refuge
14. Carmel River State Beach
15. Point Lobos State Natural Reserve
16. Abalone Cove/Rocky Point
17. Garrapata State Park
18. Point Sur State Marine Reserve
19. John Little State Natural Reserve
20. Big Creek State Marine Conservation Area
21. Big Creek State Marine Reserve
22. Joshua Creek Canyon Ecological Reserve
23. Moss Landing
24. Pajaro River
25. Soquel Cove
26. Capitola
27. Santa Cruz
28. Henry Cowell Redwoods State Park

Elk kelp
*Pelagophycus porra*

# The Coasts of California

*Monterey Bay Aquarium, one of the world's foremost centers of marine research; Monterey, Calif.*

Southern sea otter, *Enhydra lutris nereis* (G4T2/S2), populations were decimated by the beginning of the twentieth century—along with beavers and northern fur seals, victims of the "fur rush," which predated the gold rush by several decades. The International Fur Seal Treaty of 1911, the first law of its kind, provided protection for the species, which saw an uptick in its population of 5 percent per year from 1930 to 1970.[21] Today, this important mammalian predator, who voraciously eats sea urchins and is thus a keystone species for the kelp forest, exists with a population of nearly 3,000 individuals (still down from a potential regional maximum of 16,000).[22]

## 04.06 TRADITIONS BOTH ANCIENT AND MODERN
*The many faces of the Point Reyes coast*

The Point Reyes peninsula itself is mostly a solid bedrock of granite that originated in the southern Sierra Nevada about 100 million years ago, in the early ages of that mountain range's orogeny,[23] and was pulled to its current location via the San Andreas Fault over the past 20 million years. The Point's variety of landscape and ecology is matched only by the controversy and debate that surrounds it. Whether addressing the deleterious effects of cattle on the landscape or the place of oysters in Drakes Estero, the question of how we can be both a steward to a natural system and a steward to an agricultural tradition is divisive (see 07.10).

Point Reyes feels ancient, with much of its old character still apparent, and although the undeniable modern forces of industry and climate are altering the natural conditions, there is a wealth of superlatives ascribable to this place out of time. Point Reyes remains the foggiest place on the planet, with fog gripping the peninsula more than two hundred days of the year.[24] Despite the gloomy weather report, Point Reyes is home to over 900 species of plants (including 50 rare, threatened, or endangered species and four species named for the peninsula), 480 species of birds (over half of all North American avifauna), and over 100 species of land vertebrates (and two endangered endemics: the Point Reyes mountain beaver, *Aplodontia rufa phaea* [G5T2/S2], and the Point Reyes jumping mouse, *Zapus trinotatus orarius* [G5T1T3?/S1S3]).[25] Not only does Point Reyes still have a higher percentage of intact wetlands than any other wetland-rich equivalent parcel in Northern California, but its extensive dune fields make up the largest network of its kind found regionally.[26]

# The Coasts of California

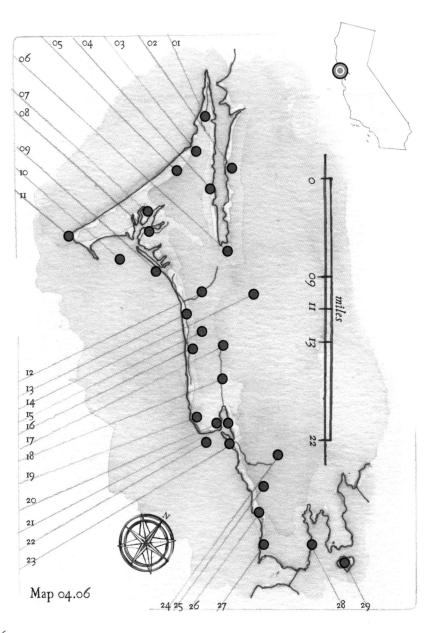

Map 04.06

04. Sand and Rivers

01. McClure's Beach
02. Marshall
03. Abbotts Lagoon
04. Tomales Bay State Park
05. Point Reyes Beach
06. Point Reyes Station
07. Drakes Estero
08. Estero Trail
09. Limantour Beach
10. Drakes Bay
11. Point Reyes
12. Bear Valley Trail
13. Coast Camp
14. Samuel P. Taylor State Park
15. Glen Camp
16. Wildcat Camp
17. Five Brooks Ranch
18. Olema Valley Trail
19. Agate Beach
20. Bolinas
21. Bolinas Lagoon
22. Duxbury Reef
23. Stinson Beach
24. Mount Tamalpais State Park
25. Muir Woods National Monument
26. Muir Beach
27. Rodeo Lagoon
28. Sausalito
29. Angel Island

Between agriculture and wildlife, we experiment with balancing our values, asking a question that has no single answer or solution about the nature of stewardship and the responsibility to support biodiversity.

# The Coasts of California

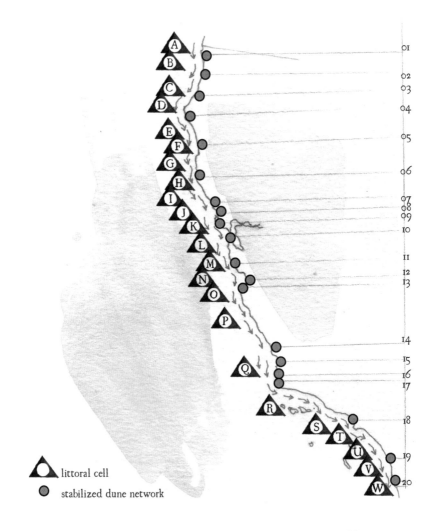

▲ littoral cell
● stabilized dune network

Map 04.07

## 04.07 MARCHING SANDS
*California's dunes and littoral drift*

Beach sand is the result when, in the endless milling of the waves, parent rocks (granite and chert, along with the minerals quartz and feldspar) are ground down to particles of less than 2 mm in size.[27] The beach sands of California don't stay put but are involved in two dynamic processes: (1) the littoral current and (2) littoral cells. Sand moves in generally a southern direction along the California coastline inside the littoral current, based on the angle of wave refraction as dictated by offshore currents. Between obstacles and boundaries—such as outcroppings, river mouths, dams, harbors, and reefs—littoral cells move sediment in discrete cycles.[28] These cycles of replenishment from sources (including river sediment and transport from other cells) to sinks (harbors and submarine canyons) are responsible for the quality and quantity of sand on the coast's beaches. Driving the littoral cells is the ceaseless action of waves that transport an incredibly large amount of sand: in Ventura County, the average displacement of beach sand is roughly about one million cubic yards, or 100,000 dump-truck loads of sand per year.[29]

A. Smith River cell
B. Klamath River cell
C. Eureka cell
D. Mattole River cell
E. Spanish Flat cell
F. Ten Mile River cell
G. Navarro River cell
H. Russian River cell
I. Bodega Bay cell
J. Point Reyes cell
K. Bolinas Bay cell
L. San Francisco cell
M. Santa Cruz cell
N. South Monterey Bay cell
O. Carmel River cell
P. Point Sur cell
Q. Morrow Bay cell
R. Santa Barbara cell
S. Santa Monica cell
T. San Pedro cell
U. Laguna cell
V. Oceanside cell
W. Mission Bay/Silver Strand cell

Brandt's cormorant
*Phalacrocorax penicillatus*

## Discontinuous sand dune communities

Dune communities begin humbly, yet become features of the strand landscape that can last for tens of thousands of years.[30] As onshore winds stockpile sand around a bit of beach debris, dunes begin to develop vegetation that is largely responsible for their long-term stability. Two types of sand dune biological communities exist in California: one north of Point Conception and one south; generally speaking, dunes in the northern part are more species rich than those in the south.[31]

Important dune plants include American dune grass, *Leymus mollis*; sagewort, *Artemisia* sp.; saltbush, *Atriplex* sp.; Lupine, *Lupinus* sp.; buckwheat, *Eriogonum* sp.; coreopsis, *Coreopsis* sp.; and heather, *Ericameria ericoides*.[32] Invasive plants that do so well across California's coastal dunes and tend to dominate over the natives, to the consternation of native plant pollinators, include European beachgrass, *Ammophila arenaria*, and iceplant, *Mesembryanthemum* sp. Because of their generalized isolation, plant species in this harsh and unstable environment that have evolved to survive the adaptive stress tend to become localized and endemic. Some localized target species for restoration at specific sites include Menzies's wallflower, *Erysimum menziesii*, at Lanphere-Christensen Dunes Preserve in Humboldt County (03 on Map 04.07);[33] and Nipomo Mesa Lupine, *Lupinus nipomensis*, at Guadalupe-Nipomo Dunes (15 on Map 04.07).[34]

01. Tolowa; Smith River; Lake Earl
02. Gold Bluffs Beach; Prairie Creek
03. Humboldt Bay; North Spit, South Spit; Buhne Point; Lanphere and Ma-l'el Dunes
04. Mattole River
05. Ten Mile River
06. Manchester Beach; MacKerricher
07. Bodega Bay; Salmon Creek; Bodega Dunes
08. Dillon Beach
09. Point Reyes; Limantour Spit; Abbotts Lagoon
10. San Francisco
11. Año Nuevo; Franklin Point
12. Salinas River; Marina Dunes; Marina State Beach
13. Monterey Peninsula; Asilomar Beach; Spanish Bay
14. Morro Bay
15. Guadalupe-Nipomo Dunes
16. Vandenberg Air Force Base
17. Santa Ynez River
18. Los Angeles; El Segundo
19. Santa Margarita River
20. San Diego

Menzies's wallflower
*Erysimum menziesii*

Nipomo Mesa lupine
*Lupinus nipomensis*

The Coasts of California

Map 04.08

## 04.08 DUNE CITY
*San Francisco's sandy core*

For the past two-and-a-half million years, a series of dune-scrub ecosystems fourteen square miles in total evolved and still exist under the concrete veneer of modern San Francisco.[35] With a Herculean campaign of reclamation over the past 150 years, modern Euro-American settlement dominated the geologically active, shifting dunes. That story of how we fight the sands is ongoing; it always will be. In the effort to build the city, we destroyed many species that only ever lived on this isolated peninsula, including the extinct Xerces blue butterfly, *Glaucopsyche xerces*. Either life is disposable to us or we're bewildered by our own responsibility in erasing evolution's networks.

Will we forever invest in fighting the intractable accretion of sand? Or, over the next several centuries, will we retreat from a rising sea level and watch the littoral creep of sand swallow Golden Gate Park? From our mortal perspective, it is difficult—maybe even tragic—to imagine our stubborn species acquiescing to the press of entropic planetary forces. It is also, I submit, beautiful: we are not the final word in nature; in fact, our mistakes seem to be as numerous as our accomplishments. The economic powerhouse of northern San Francisco is largely built on a substrate that liquefies in even a minor earthquake; is this a telling metaphor, a sober warning, or simply an engineering problem to be faced like any other challenge presented to us by the natural world?[36]

Dune tansy
*Tanacetum bipinnatum*

# The Coasts of California

Map 04.09

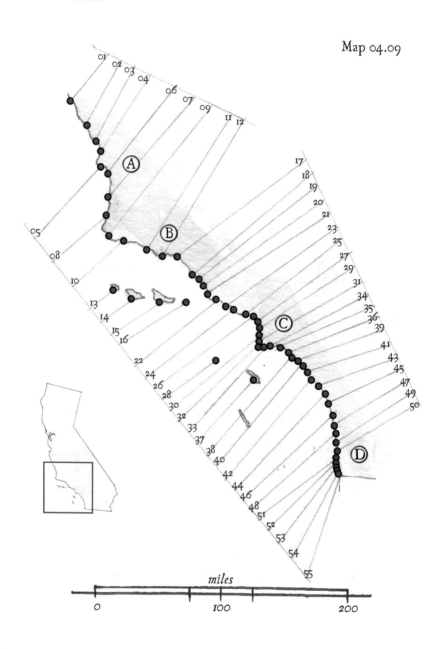

## 04.09 CALIFORNIA DREAMING
*The beaches of Southern California*

Never mind the clichés—there is a ton of good poetry waiting to be written here in the sunset-colored light. When I say *sunset color*, you know exactly what I mean. It is always amazing to me that the clash of two great elemental worlds, the sea and the land, can produce a place of such incomparable tranquility.

A — San Luis Obispo city area
B — Santa Barbara city area
C — Los Angeles city area
D — San Diego city area

01. Elephant Seal viewing area; William R. Hearst Memorial State Beach (San Luis Obispo)
02. San Simeon State Beach; Moonstone Beach (San Luis Obispo)
03. Estero Bluffs; Cayucos State Beach; Morro Strand State Beach (San Luis Obispo)
04. Morro Rock Ecological Reserve; Dunes Street Bluff; Morro Bay State Park; Morro Dunes Natural Preserve; Sweet Springs Nature Preserve (San Luis Obispo)
05. Port San Luis Pier and Beach; Avila State Beach (San Luis Obispo)
06. Pismo State Beach; Oceano Memorial County Park; Oceano Dunes Reserve; Oso Flaco Lake Natural Area (San Luis Obispo)
07. Rancho Guadalupe Dunes Preserve; Point Sal State Beach (Santa Barbara)
08. Ocean Beach County Park; Vandenberg Air Force Base beach access (Santa Barbara)
09. Jalama Beach County Park (Santa Barbara)
10. Gaviota State Park; Refugio State Beach; El Capitan State Beach (Santa Barbara)
11. Coal Oil Point Reserve; Isla Vista Beach; University of California; Goleta Beach County Park (Santa Barbara)
12. Arroyo Burro Beach County Park; One Thousand Steps Beach; Leadbetter Beach; West Beach; Chase Palm Park; Andree Clark Bird Refuge; Hammonds Beach; Miramar Beach (Santa Barbara)
13. San Miguel Island (Santa Barbara)
14. Santa Rosa Island (Santa Barbara)
15. Santa Cruz Island (Santa Barbara)
16. Anacapa Island (Santa Barbara)
17. Carpinteria Salt Marsh Nature Park; Carpinteria City Beach; Carpinteria State Beach; Carpinteria Bluffs Nature Park (Santa Barbara)
18. Rincon Beach County Park; La Conchita Beach; Seacliff Beach; Hobson Beach County Park; Rincon Parkway North (Ventura)
19. Faria Beach County Park; Solimar Beach; Emma Wood State Beach; Seaside Wilderness Park (Ventura)
20. Seaside Park; San Buenaventura State Beach; Santa Clara Estuary Natural Preserve (Ventura)
21. McGrath State Beach; Mandalay County Park; Mandalay State

Beach; Oxnard State Beach; Hollywood Beach; Silver Strand Beach; Port Hueneme Beach Park; Ormond Beach (Ventura)
22. Mugu Lagoon; Point Mugu Beach; Thornhill Broome Beach; Sycamore Cove Beach; County Line Beach (Ventura)
23. Staircase Beach; Leo Carrillo State Beach; Nicholas Canyon County Beach; El Pescador State Beach; La Piedra State Beach; El Matador State Beach; Lechuza Beach (Los Angeles)
24. Zuma Beach County Park; Point Dume State Beach; Point Dume State Preserve (Los Angeles)
25. Escondido Beach; Dan Blocker Beach; Malibu Bluffs Park (Los Angeles)
26. Malibu Lagoon State Beach; Las Tunas State Beach; Topanga State Beach (Los Angeles)
27. Will Rogers State Beach; Santa Monica State Beach; Santa Monica Municipal Pier; Venice City Beach (Los Angeles)
28. Aubrey E. Austin Jr. Memorial Park; Marina Del Rey Harbor (Los Angeles)
29. Dockweiler State Beach; El Segundo Beach; El Porto Beach; Manhattan County Beach; Hermosa City Beach (Los Angeles)
30. King Harbor; Redondo County Beach (Los Angeles)
31. Torrance County Beach; Point Vicente Park (Los Angeles)
32. Abalone Cove Beach; Royal Palms County Beach (Los Angeles)
33. Cabrillo Beach; Los Angeles Harbor (Los Angeles)
34. Long Beach City Beach; Belmont Shore; Alamitos Bay (Los Angeles)
35. Seal Beach; Surfside Beach; Sunset Beach (Orange)
36. Bolsa Chica State Beach; Huntington Beach (Orange)
37. Santa Catalina Island (Los Angeles)
38. Santa Ana River Mouth Beach; Newport Harbor Beaches (Orange)

*Laguna Beach, California*

## 04. Sand and Rivers

39. China Cove Beach; Corona Del Mar State Beach; Little Corona Del Mar Beach (Orange)
40. Crescent Bay Point Park; northern Laguna beaches; Main Beach; Aliso Beach (Orange)
41. West Street Beach Dana Point Harbor; Doheny State Beach (Orange)
42. Capistrano Beach Park; Poche Beach; San Clemente City Beach; San Clemente State Beach (Orange)
43. San Onofre State Beach (San Diego)
44. Oceanside City Beach; Buena Vista Lagoon Ecological Reserve (San Diego)
45. Carlsbad State Beach; South Carlsbad State Beach (San Diego)
46. Encinitas Beach; Beacon's Beach; Stone Steps Beach (San Diego)
47. San Elijo State Beach; Cardiff State Beach (San Diego)
48. Del Mar City Beach; Torrey Pines State Beach; Torrey Pines City Beach (San Diego)
49. Scripps Beach; La Jolla Shores Beach (San Diego)
50. Children's Pool Beach; Marine Street Beach; Windansea Beach (San Diego)
51. Mission Beach Park (San Diego)
52. Dog Beach; Ocean Beach City Beach (San Diego)
53. Point Loma Ecological Reserve (San Diego)
54. Coronado City Beach; Silver Strand State Beach (San Diego)
55. Imperial Beach; Tijuana River National Estuarine Research Reserve (San Diego)

*Grunion, the little fish that watches the moon*

*Grunion, Leuresthes tenuis and Leuresthes sardinas*

Grunion, *Leuresthes tenuis* and *Leuresthes sardinas*, are two species of small, silver fish that are not only endemic to southern and central California but are the only species of fish in the world that lays its eggs on land.[37] From March through August, just after the peak tides that follow the second, third, and fourth nights of the fourteen-day lunar cycle, hordes of grunion hoist themselves onto the beaches across the coast, and they deposit tens of thousands of eggs in the sand.[38] The eggs resulting from this particularly cosmological breeding pattern hatch fourteen days later and get carried to the sea by the waves. Grunion may be harvested by hand with a fishing permit.

The Coasts of California

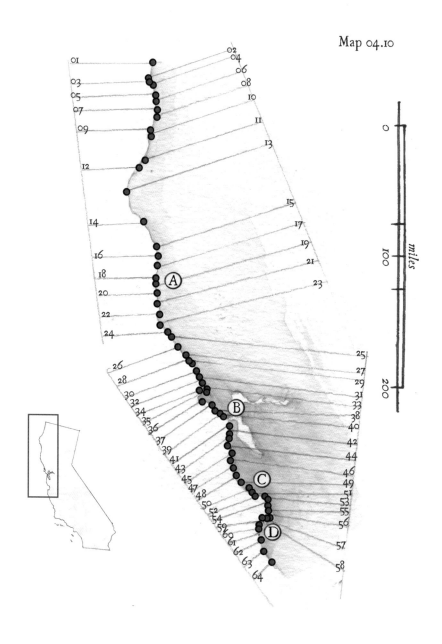

Map 04.10

## 04.10 JADE AND SEA STACKS
*The beaches of Northern California*

Watch the beaten coast; you can taste the salty erosion and nearly in human time see the sea cave turn into the arch and collapse. With the movement of tectonic plates, the Atlantic Ocean is getting larger and the Pacific Ocean will retreat from the spread, yet out here it seems that the sea has the upper hand. That's the illusion, isn't it? That these forces clash at all, when the only winner here is time, the ultimate agent. It isn't the waves that make the ocean jade soft to touch, but the crush of entropy and the playfully applied matrix of chemistry that make it all so beautiful.

A — Mendocino city area
B — San Francisco Bay Area
C — Santa Cruz city area
D — Monterey city area

01. Pelican State Beach; Clifford Kamph Memorial Park; Smith River County Park; Smith River (Del Norte)
02. Kellogg Beach Park; Tolowa Dunes State Park; Point St. George Beach; Radio Road Accessway (Del Norte)
03. Pebble Beach; Preston Island; Brother Jonathan Park; Crescent City Lighthouse; Beach Front Park; Crescent City Harbor; Crescent Beach (Del Norte, Crescent City)
04. Enderts Beach; Del Norte Coast Redwoods State Park (Del Norte)
05. Wilson Creek Beach (Del Norte)
06. Lagoon Creek; Klamath River; Flint Ridge (Del Norte)
07. Gold Bluffs Beach; Redwood National Park; Prairie Creek Redwoods State Park; Butler Creek Backpack Camp; Fern Canyon (Humboldt)
08. Orick Beach; Redwood Creek Beach; Freshwater Lagoon; Stone Lagoon; Dry Lagoon; Big Lagoon County Park (Humboldt)
09. Agate Beach; Sue-meg State Park (Humboldt)
10. Trinidad State Beach; Houda Point Beach; Little River State Beach; Clam Beach County Park; Mad River Beach County Park (Humboldt)
11. North Spit; Samoa Dunes (Humboldt)
12. Eel River; Centerville Beach (Humboldt)
13. Mattole Beach; King Range National Conservation Area; Shelter Cove (Humboldt)
14. Sinkyone Wilderness State Park (Mendocino)
15. Westport–Union Landing State Beach (Mendocino)
16. Wages Creek Beach; Westport Headlands; Chadbourne Gulch; Bruhel Point Bluff; Kibesillah Gulch (Mendocino)
17. Seaside Creek Beach (Mendocino)
18. MacKerricher State Park (Mendocino)
19. Glass Beach; Noyo Harbor; Mendocino Coast Botanical

The Coasts of California

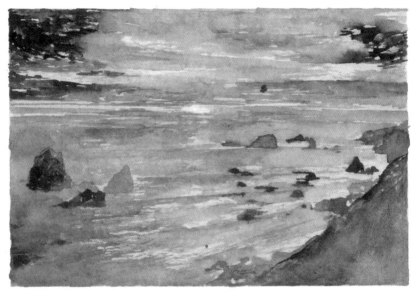

*the rocky Mendocino coast*

Gardens; Jefferson Way (Mendocino)
20. Jug Handle State Natural Reserve (Mendocino)
21. Caspar Headlands State Beach; Caspar Headlands State Natural Reserve; Point Cabrillo Light Station (Mendocino)
22. Russian Gulch State Park; Mendocino Headlands State Park; Van Damme State Park (Mendocino)
23. Dark Gulch Beach; Albion Flat; Navarro River Redwoods State Park; Mallo Pass Creek; Manchester State Beach (Mendocino)
24. Garcia River; Arena Cove; Bowling Ball Beach; Schooner Gulch State Beach; Hearn Gulch (Mendocino)
25. Fish Rock Beach; Collins Landing; St. Orres Creek (Mendocino)
26. Gualala River Beach (Mendocino/Sonoma)
27. Sea Ranch public access (Sonoma)
28. North Horseshoe Cove; Kruse Ranch; Fisk Mill Cove (Sonoma)
29. Stump Beach; Salt Point State Park; Ocean Cove Reserve (Sonoma)
30. Stillwater Cove Regional Park; Timber Cove Campground; Fort Ross State Historic Park; Fort Ross Reef Campground (Sonoma)
31. North Jenner Beaches; Goat Rock; Wright's Beach; Duncan's Landing (Sonoma)
32. Salmon Creek Beaches; Bodega Dunes Campground (Sonoma)

04. Sand and Rivers

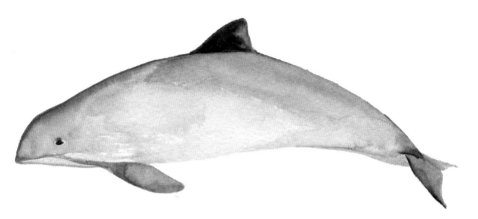

Harbour porpoise
*Phocoena phocoena*

33. UC Davis Bodega Marine Laboratory; Bodega Head; Doran Regional Park (Sonoma)
34. Dillon Beach (Sonoma)
35. Marshall Beach; Tomales Bay State Park (Sonoma)
36. Point Reyes beaches (Marin)
37. Agate Beach; Bolinas Beach; Bolinas Lagoon Preserve (Marin)
38. Seadrift Beach; Stinson Beach; Red Rock Beach; Steep Ravine Beach; Slide Ranch (Marin)
39. Muir Beach; Tennessee Valley (Marin)
40. Rodeo Beach (Marin)
41. Fort Point; Baker Beach; China Beach; Ocean Beach (San Francisco)
42. Fort Funston; Phillip Burton Memorial Beach (San Francisco)
43. Mussel Rock City Park; Sharp Park Beach and Pacifica Pier; Rockaway Beach; San Pedro Beach (San Mateo)
44. Gray Whale Cove State Beach; Montara State Beach; Fitzgerald Marine Reserve; Gray Whale Cove Trail (San Mateo)
45. Surfer's Beach; Dunes Beach; Venice Beach; Francis Beach; Arroyo Cañada Verde Beach; Cowell Ranch Beach (San Mateo)
46. Martin's Beach; San Gregorio State Beach; Pomponio State Beach; Pescadero State Beach (San Mateo)
47. Pebble Beach; Bean Hollow State Beach; Pigeon Point Lighthouse Hostel; Gazos Creek coastal access; Año Nuevo State Marine Reserve (San Mateo)

48. Waddell Creek Beach; Scott Creek Beach (Santa Cruz)
49. Davenport Beach (Santa Cruz)
50. Wilder Ranch State Park (Santa Cruz)
51. Red White and Blue Beach (Santa Cruz)
52. Natural Bridges State Beach; Cowell Beach; Santa Cruz Beach; Twin Lakes State Beach; Corcoran Lagoon Beach (Santa Cruz)
53. New Brighton State Beach; Seacliff State Beach (Santa Cruz)
54. Manresa State Beach; Sunset State Beach; Palm State Beach (Santa Cruz)
55. Zmudowski State Beach; Moss Landing State Beach; Salinas River State Beach (Monterey)
56. Marina State Beach (Monterey)
57. Monterey State Beach; Del Monte Beach (Monterey)
58. San Carlos Beach Park; Breakwater Cove; McAbee Beach; Lovers Point (Monterey)
59. Fanshell Beach; Pebble Beach; Carmel City Beach; Carmel River State Beach (Monterey)
60. Point Lobos State Natural Reserve; Garrapata State Park (Monterey)
61. Bixby Creek Bridge (Monterey)
62. Point Sur State Historic Park; Andrew Molera State Park (Monterey)
63. Pfeiffer Beach (Monterey)
64. Julia Pfeiffer Burns State Park; Esalen Institute; Limekiln State Park; Sand Dollar Beach; Jade Cove; Willow Creek picnic ground (Monterey)

# 05. AS ABOVE, SO BELOW
## *A survey of coastal habitat types*

Along the coast and between watersheds, there are vast differences in regional seasonality, soil chemistry, and local biodiversity. There is also a potentially equal number of parallel conditions of uniformity—common niche opportunities, nutrient delivery mechanisms, and functional dynamics—uniting the classifications of these ecosystems. If it weren't for the driving feature of biogeographic isolation, or that watersheds are separated by ridgelines and other dividing features, California would be a much more homogenous place.

This chapter paints habitat in broad strokes. The study of habitat employs the voice of the naturalist, the ecologist, and the philosopher. The naturalist is interested in studying the patterns of wildlife associations and how the mosaic of biogeography plays out across a given landscape. The ecologist is interested in the patterns of relationships between living and nonliving forces and what trends are present to influence a habitat's character. And the philosopher is interested in the ethics of categorization beyond scientific application, and questions the approach of analysis toward the natural world, when perhaps a synthesis (a joining together as opposed to a taking apart) of elements might reveal greater intrinsic value. The philosopher points out that if conservation, mediation, and restoration of the whole system is the goal, why would dividing it up,

*Previous page:*
Wildflower meadows across the coastal ranges of the Los Padres National Forest

---

*a working definition*
*Habitat —*

*the resource and spatial conditions that offer sufficient opportunity, based on a species' evolutionary requirements, for that species to sustain a viable population and its historical relationship with those specific conditions or conditions like it.*

a process that leads to an incorrect assumption about the interconnected holism of life itself, lead to anything but a fragmented view of what a habitat needs?

There are a few important and subtle truths to keep in mind as we take this multilayered approach to seeing living patterns in the landscape as they are presented in this chapter. (1) No habitat exists by itself, but rather is only classified by its contrasting qualities in relation to the habitats it is juxtaposed with. (2) The models presented in this chapter deal with large land areas; this is a survey of biogeography, not, for example, niche habitats by species.

(3) To maximize opportunities to access the greatest number of energy sources, most wildlife exists on the border between habitat types, inside the ecotone. Inside these marginal spaces, corridors of exceptional rarity and diversity develop. This survey is intended as a general guide to what the casual citizen might experience, and how that observer might differentiate and thereby understand larger patterns of life along the coast.

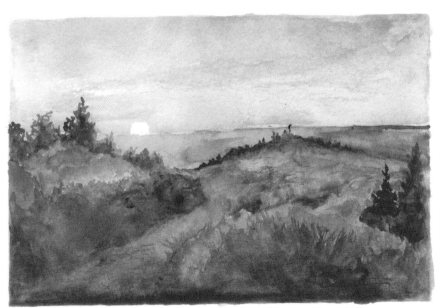

*Northern coastal chaparral of the Berryessa Snow Mountain National Monument*

## 05.01 A PATCHWORK SHORE
*Habitat types across coastal California*

Wild, and the act of wilding; to be wilded is to be soulfully variegated, multidimensionally adaptive, able to see the function of your system, and all of its challenges, from fundamentally different vantage points and to retain the agency to see those challenges not as sources of injury but as wells of opportunity.

You may think that the first and most obvious categorization is between aquatic and terrestrial habitats, but that wet-and-dry approach begins to break down when you examine estuarine habitat types across California, where often the effect of salt water versus fresh water can be just as differentiating as simply dividing the sea from the land. According to the California Department of Fish and Wildlife's (CDFW) California Wildlife Habitat Relationship system, there are twenty-five terrestrial habitat types common across California's coastal landscapes. The CDFW lists fifty-nine habitat types in total across the California Floristic Provence, and of those, thirty-four not included on the list here are twelve mountain, or montane, habitat types that can be mapped across inland elevations over 3,000 feet; eleven habitats that can be mapped across the Mojave, Sonora, and Great Basin Deserts; eight agricultural habitat types; and three remainders: marine, urban, and barren-type habitats.[1]

The following is a list of the CDFW's coastal habitat types—models that predict which particular vertebrate species might be present. The list doesn't work as a comprehensive mapping survey of vegetation types on either a regional or a local scale, as they disregard endemism and invasivity rates, to name a few shortcomings. The habitat types are listed here to describe alliance patterns, or trees of different species that regularly live together, in the natural and wild ecosystems along the coast. Included in the listing of each habitat type are a few of the most common plant and tree species that may be indicator species for that habitat type.

## DOUGLAS FIR
Douglas fir, *Pseudotsuga menziesii*
Tanoak, *Notholithocarpus densiflorus*
Madrone, *Arbutus menziesii*

## REDWOOD
Coast redwood, *Sequoia sempervirens*

## CLOSED-CONE PINE-CYPRESS
Cypress, *Cupressus* sp.
Pine, *Pinus* sp.

## MONTANE HARDWOOD-CONIFER
Oak, *Quercus* sp.
Fir, *Abies* sp.
Pine, *Pinus* sp.

## MONTANE HARDWOOD
Oak, *Quercus* sp.
Manzanita, *Arctostaphylos* sp.

## BLUE OAK WOODLAND
Blue oak, *Quercus douglasii*

## VALLEY OAK WOODLAND
Valley oak, *Quercus lobata*

## COASTAL OAK WOODLAND
Oak, *Quercus* sp.

## BLUE OAK–FOOTHILL PINE
Blue oak, *Quercus douglasii*
Gray pine, *Pinus sabiniana*

## EUCALYPTUS
Eucalyptus, *Eucalyptus* sp.

## MONTANE RIPARIAN
Black cottonwood, *Populus trichocarpa*
Red alder, *Alnus rubra*

## VALLEY FOOTHILL RIPARIAN
Black cottonwood, *Populus trichocarpa*
Western sycamore, *Platanus racemosa*

## MONTANE CHAPARRAL
Ceanothus, *Ceanothus* sp.
Manzanita, *Arctostaphylos* sp.

## MIXED CHAPARRAL
Oak, *Quercus* sp.
Manzanita, *Arctostaphylos* sp.

## CHAMISE-REDSHANK CHAPARRAL
Chamise, *Adenostoma fasciculatum*
Redshank, *Adenostoma sparsifolium*

## COASTAL SCRUB
Coyote brush, *Baccharis pilularis*
Lupine, *Lupinus* sp.

## ANNUAL GRASSLAND
Blue wildrye, *Elymus glaucus*
Purple needlegrass, *Nassella pulchra*

## PERENNIAL GRASSLAND
Danthonia, *Danthonia californica*
Festuca, *Festuca californica*

## WET MEADOW
Bentgrass, *Agrostis* sp.
Willow, *Salix* spp.

## FRESH EMERGENT WETLAND
Sedge, *Carex* sp.
Rush, *Juncus* sp.

## SALINE EMERGENT WETLAND
Cordgrass, *Spartina* sp.
Glasswort, *Salicornia* spp.

## PASTURE
Oats, *Avena* sp.
Rye, *Lolium* sp.

## RIVERINE
Cattails, *Typha* spp.
Willow, *Salix* spp.

## LACUSTRINE
Tule, *Schoenoplectus acutus*

## ESTUARINE
Alkali heath, *Frankenia salina*
Pickleweed, *Salicornia* spp.

# The Coasts of California

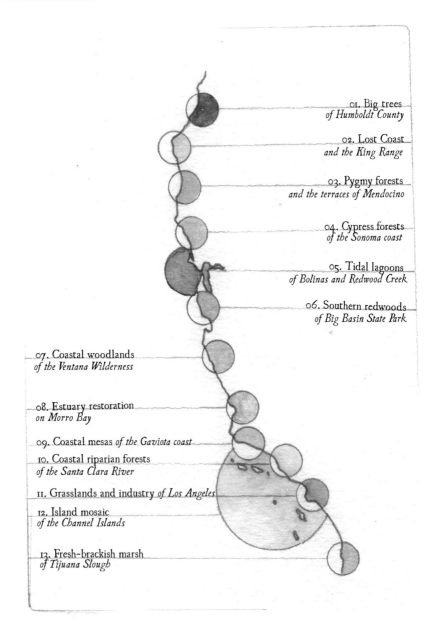

01. Big trees
of Humboldt County

02. Lost Coast
and the King Range

03. Pygmy forests
and the terraces of Mendocino

04. Cypress forests
of the Sonoma coast

05. Tidal lagoons
of Bolinas and Redwood Creek

06. Southern redwoods
of Big Basin State Park

07. Coastal woodlands
of the Ventana Wilderness

08. Estuary restoration
on Morro Bay

09. Coastal mesas *of the Gaviota coast*

10. Coastal riparian forests
of the Santa Clara River

11. Grasslands and industry *of Los Angeles*

12. Island mosaic
of the Channel Islands

13. Fresh-brackish marsh
of Tijuana Slough

# 05. As Above, So Below

Now we are going to examine the local reality of those habitat types and tree associations, and the wildlife that reside there, as they exist across thirteen iconic California landscapes. The second half of the chapter opens it back up to general trends of geographic distribution across marine and terrestrial habitats.

01. Big trees of Humboldt County

Along a coast where some of the largest remaining patches of old-growth redwood live, rare seabirds nest high above California's last salmon stronghold.

02. The Lost Coast and the King Range

A remote range takes the brunt of seaward weather, protecting a lonely river, giving it a character of its own.

03. Pygmy forests and the terraces of Mendocino

Exposed and beaten by salt wind and thin soil, old trees don't grow tall, but harbor their own secrets.

04. Cypress forests of the Sonoma coast

Over a pastured landscape on the bluff, pocket forests of closed-cone conifers become twisted monuments between the ridge and the sea.

05. Tidal lagoons of Bolinas and Redwood Creek

Protected by a wall of sand, brackish wetland makes for a nutrient-rich refueling station for birds on their long journey up and down the flyway.

Western spadefoot
*Spea hammondii*
(G3/S3)

06. Southern redwoods of Big Basin State Park

California's first state park still retains its old-growth character despite the ravages of fire and the modern world.

07. Coastal woodlands of the Ventana Wilderness

Big Sur's backcountry is home to some of the world's rarest trees and some of California's best wildflower fields.

08. Estuary restoration on Morro Bay

The struggle for responsible stewardship never ends, to protect the unique forms of life that have called this place home for thousands of years.

09. Coastal mesas of the Gaviota coast

The largest parcels of untouched coastal landscape in California whisper secrets of how California was and how it could be again.

10. Coastal riparian forests of the Santa Clara River

One of Southern California's largest and most dynamic watersheds provides a corridor for a wealth of ecosystems.

11. Grasslands and industry of Los Angeles

On the margins of California's biggest city, rare forms of life hang on to their ancestral habitat.

12. Island mosaic of the Channel Islands

The island biogeography of Channel Islands is a key mechanic in speciation, or how new species come into being, and is on full display across these remote places.

13. Fresh-brackish marsh of Tijuana Slough

It may be the southernmost corner of the state of California, but this wildlife stronghold is in the center of the California Floristic Provence.

05. As Above, So Below

north coast seastacks

The Coasts of California

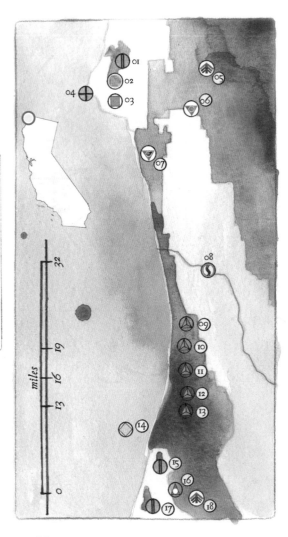

Map 05.01.01

## 05.01.01 Big Trees of the North Coast

Dominated by two rivers, the Smith and the Klamath, whose watersheds represent the largest remaining salmonid populations in the state, California's northwest forests also support habitat for the tallest trees in the world. Once thought of as zoological deserts for their lack of a shrub-filled understory, shady redwood forests are now known to be ecologically rich, supporting an enormous ecosystem at all levels of the trees' nearly 400-foot height.[2] It may be that there is as much subterranean carbon-based biomass as there is the forest body itself. The mycorrhizal networks, filament strands of fungus, connect the enormous trees with a wealth of nutrients in exchange for a steady dose of sugar supplied by the trees' photosynthetic processes.[3] Everything is alive in the redwood forest, include the soil.

01. Lake Earl
02. Lake Earl Wildlife Area
03. Crescent City
04. Point St. George
05. Stout Memorial Grove in Jedediah Smith Redwoods State Park
06. Myrtle Creek Botanical Area
07. Redwood National Park; Del Norte Coast Redwoods State Park
08. Klamath River
09. Rhododendron Trail
10. South Fork Trail
11. Cathedral Trees Trail
12. Trillium Falls Trail
13. Redwood Creek Trail
14. Humboldt Lagoons State Park
15. Stone Lagoon
16. Arco Grove of the Giants
17. Big Lagoon
18. Howard Libby Tree

Fly agaric
*Amanita muscaria*

# The Coasts of California

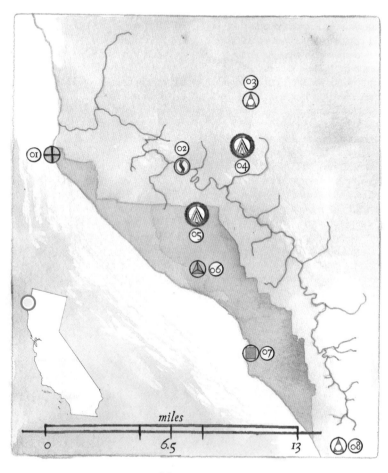

Map 05.01.02

## 05.01.02 The Lost Coast and the Mattole River

Behind the sublimely rugged, weather-beaten ridgeline that is the King Range National Conservation Area runs an injured river that needs a great deal of help. There are many rivers across California that are a mess, and the Mattole River is a textbook example. This remote watershed exists without the protection of large public designations—only one-third of the land in the 300-square-mile watershed is managed by a public/private mix of agencies and timber interests.[4] Before the middle of the twentieth century, the Mattole watershed was one of the most productive stretches of old-growth redwood forest in the region.[5] By 1987, in thirty years the timber industry had mowed more than 90 percent of the watershed's forest; coupled with massive flood events, decades of growing fire severity, and the intrusion of housing developments, the river is now the site of a major, citizen-led restoration effort.[6]

01. Punta Gorda
02. Mattole River
03. Humboldt Redwoods State Park
04. Elk Ridge
05. King Range
06. King Range National Conservation Area
07. Shelter Cove
08. Sinkyone Wilderness State Park

Brown bullhead
*Ameiurus nebulosus*

## The tallest trees of the tallest forests

Trees are listed here by maximum height, location, species, and approximate maximum age of common conifers in the coastal northwest forest—in ascending order of height.[7]

127' (Clackamas, Oregon); Engelman spruce, *Picea engelmannii*, 400 years
162' (La Pine, Oregon); ponderosa pine, *Pinus ponderosa*, 600 years
165' (Marble Mountains, California); incense cedar, *Calocedrus decurrens*, 400 years
187' (Clackamas, Oregon); western red cedar, *Thuja plicata*, 1,000 years
229' (Elk Creek, Oregon); Port Orford cedar, *Chamaecyparis lawsoniana*, 500 years
259' (Prairie Creek, California); western hemlock, *Tsuga heterophylla*, 400 years
273' (Yosemite, California); sugar pine, *Pinus lambertiana*, 400 years
315' (Vancouver Island, British Columbia); Sitka spruce, *Picea sitchensis*, 500 years
379' (Redwood National and State Parks, California); coast redwood, *Sequoia sempervirens*, 1,250 years, tallest living tree
415' (Vancouver, British Columbia—1902); Douglas fir, *Pseudotsuga menziesii*, 750 years; note: tallest living Douglas fir is 327' (Coos County, Oregon)

Hidden Trail Beach, Redwood National Park

## A hideaway of native grasses

As part of the Mattole Integrated Coastal Watershed Management Plan, a comprehensive recovery plan for the degraded ecosystem of the watershed, it was identified that despite the destruction of the forests, the grasslands of the Mattole still are more than 50 percent intact with their native constituent species.[8] Statewide, more than 90 percent of the native grasslands have been converted to nonnative alliances. Native species of the north coast ranges and coastal steppe include the following:[9]

Lemmon's needlegrass, *Stipa lemmonii*
California brome, *Bromus carinatus*
Leafy reed grass, *Calamagrostis foliosa*
California oatgrass, *Danthonia californica*
Tufted hairgrass, *Deschampsia cespitosa*
Blue wildrye, *Elymus glaucus*
Big squirreltail, *Elymus multisetus*
California fescue, *Festuca californica*
Idaho fescue, *Festuca idahoensis*
Junegrass, *Koeleria macrantha*
California melic, *Melica californica*
Tall trisetum, *Trisetum canescens*

*blue wild rye*

The Coasts of California

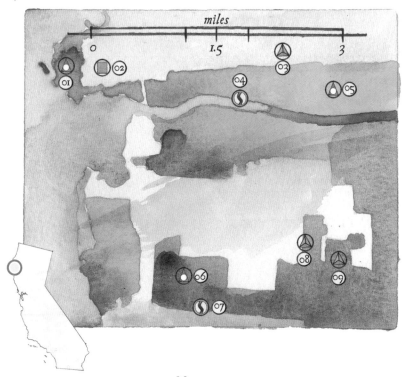

Map 05.01.03

## 05.01.03 Pygmy Forests and the Terraces of Mendocino

Under the acidic soil of the uplifted marine terraces of Mendocino County is a layer of clay that limits tree roots from accessing deep nutrients and water. The clay constrains their growth, keeping old trees small and creating a habitat of unique character.[10] Only about two thousand acres of this fragile habitat remain in existence. (Not represented on this map, but only a few miles north of Mendocino, is Jug Handle State Natural Reserve, where another pygmy forest survives.) The only suspected habitat for the federally listed endangered lotis blue butterfly, *Lycaeides idas lotis*, is one bog within the pygmy forest, although the butterfly hasn't been seen in over thirty years.[11]

01. Mendocino Headlands State Park
02. Mendocino
03. Jackson Demonstration Forest
04. Big River
05. Big River Unit of Mendocino Headlands State Park
06. Van Damme State Park; Beal Creek
07. Little River; Pygmy Forest Trail
08. Pygmy Forest; the Nature Conservancy
09. Hans Jenny Pygmy Forest Reserve, University of California Natural Reserve System

# The Coasts of California

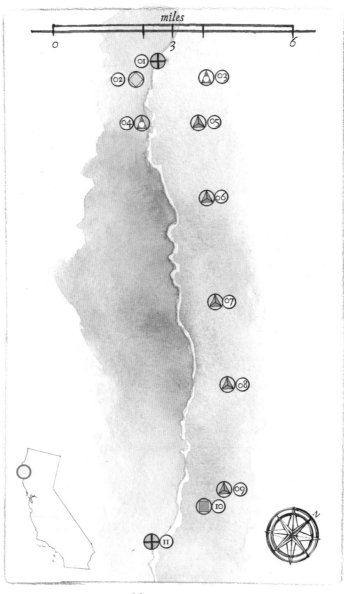

Map 05.01.04

05. As Above, So Below

Monterey cypress
*Hesperocyparis macrocarpa*

05.01.04 Cypress Forests of the Sonoma Coast

Along the Sonoma coast, a subtle shift occurs in the ecological character and makeup of the creekside coast ranges. Transitioning from the northern, temperate, coniferous rainforests of the Pacific Northwest—a kind of habitat that runs north from here all the way to Alaska—the riparian and bluff habitats south of here embrace a legacy of aridity, where coarse and well-drained soil often produces creek beds that are dry for most of the year. Spruce find it too dry south of here, and north of here, many songbirds find the darker forest unwelcoming.[12] A patchy network of similar, cypress-dominated arboreal communities extends all the way south to San Diego County, and the closed-cone forests of Sonoma and Marin Counties are part of the largest partition.

01. Gualala Point
02. Gualala Point Island
03. Gualala Point Regional Park
04. Del Mar Landing State Marine Reserve
05. Salal Trail
06. Walk On Beach Trail; Walk On Beach
07. Shell Beach Trail; Shell Beach
08. Stengel Beach Trail; Stengel Beach
09. Pebble Beach Trail; Pebble Beach
10. Sea Ranch
11. Black Point

The Coasts of California

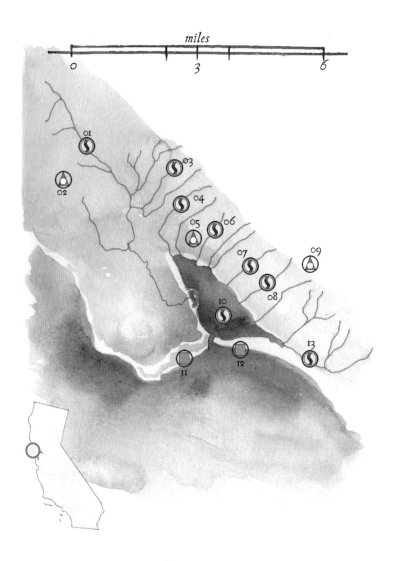

Map 05.01.05

## 05. As Above, So Below

California black rail
*Laterallus jamaicensis coturniculus*
(G3G4T1/S1)

## 05.01.05 Tidal Flats of the Bolinas Lagoon and Estuary

In the Bolinas Lagoon area, a compound of estuarine and riparian habitats supports an ecosystem of exceptional diversity that includes populations of many special-status species, from red-legged frogs to coho to endangered waterfowl, such as the California black rail, *Laterallus jamaicensis coturniculus* (G3G4T1/S1). Over the past several decades, the channelization of Easkoot Creek, the lagoon's major source of fresh water, along with the tidal input effect of the offshore riprap installed to protect the town of Stinson Beach and the extensive human development at the mouth of the lagoon, have cumulatively increased sedimentation and threaten the lagoon's sustainability.[13] Other challenges to restoration of this 1,100-acre wetland are a population density of invasive green crab, *Carcinus maenas*, that rivals any other on the West Coast[14] and the introduction of invasive grass onto the tidal shoal at the center of the lagoon, causing the grass to spread across the delicate dune ecosystem.[15] The ongoing restoration work to maintain the productivity of the lagoon integrates a vision of habitat connectivity, climate resiliency, and riparian/wetland enhancement.[16]

01. Pine Gulch Creek
02. Point Reyes National Seashore
03. Cronin Gulch
04. Lewis Gulch
05. Golden Gate National Recreation Area
06. Pike County Gulch
07. Morses Gulch
08. McKinnan Gulch
09. Mount Tamalpais State Park
10. Bolinas Lagoon
11. Bolinas
12. Stinson Beach
13. Easkoot Creek

## Fire brings life to the forest of tiny trees

Closed-cone conifers of four species dominate the arboreal mix of the pygmy forest where the trees rarely grow taller than six feet: bishop pine, *Pinus muricata*; Bolander pine, *Pinus contorta* ssp. *bolanderi*; pygmy (Mendocino) cypress, *Cupressus goveniana* ssp. *pigmaea*; and shore pine, *Pinus contorta* ssp. *contorta*. All closed-cone forests require a regular burn regime to propagate and to maintain their unique habitat quality. It may be that because of fire suppression, the overgrown pygmy forest has lost its ability to support the endangered butterflies that exist only here. In many cases, it isn't the heat and flame the forest needs to worry about; it is the lack of fire that kills.

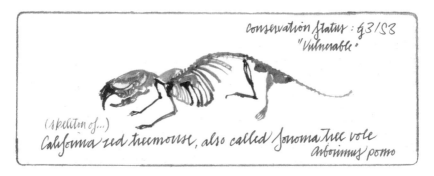

Conservation status: G3/S3 "Vulnerable"

(skeleton of...) California red tree mouse, also called Sonoma tree vole, *arborimus pomo*

## The small animals of the closed-cone forest

Cypress trees like soil that is rich in magnesium and nickel, such as the serpentine soils of Sonoma County. Certain animal species have evolved as endemic to places with this soil chemistry. For example, the Muir's hairstreak butterfly, *Callophrys muiri*, only lays its eggs on two species of tree: Sargent cypress, *Cupressus sargentii*, and McNab cypress, *Cupressus macnabiana*, on the coastal bluffs between Sonoma and San Luis Obispo Counties.[17] Most animals that depend on the cypress forest of the Sonoma coast are small and are able to get what they need from the sparse nutrients that the forest provides—think nuthatches and chickadees for birds, squirrels and wood rats for mammals; many are able to move between adjacent habitat spaces, including the local chaparral and vernal pool ecosystems.

05. As Above, So Below

## The Convention on Wetlands of International Importance

In 1971, an international convention of biologists and policymakers from 168 countries was held in Ramsar, Iran, to draft a treaty that designated twenty-two hundred sites across the globe, covering an area of more than 516 million acres (over 800,000 square miles), as biologically important wetland habitat.[18] These critically essential, imperiled sites were identified by their supporting a unique class of biodiversity, especially as waterfowl habitat for 20,000 or more birds and as supporting a significant percentage of the existing populations of indigenous fish species and other nonavian animals. Of Ramsar's twenty-two hundred sites, thirty-eight are in the United States; of those thirty-eight, six are in California; and of those six, four are on the Northern California coast:

Bolinas Lagoon (Marin County)
Tomales Lagoon (Marin County)
Laguna de Santa Rosa (Sonoma County)
San Francisco Bay Estuary (San Francisco Bay)

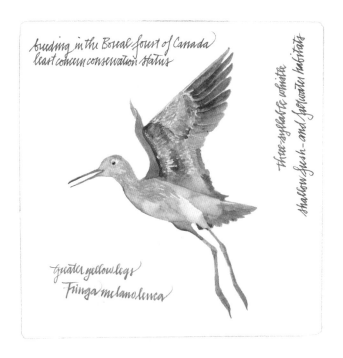

## 05.01.06 Southern Redwoods of Big Basin State Park

Waddell Creek is the biggest watershed with the most significant estuarine habitat in Big Basin State Park, California's first state park. The watershed includes the remaining forty-three hundred acres of the park's old-growth redwood forest.[19] From the ridgelines of the park, covered as they are with mixed chaparral, to the coastal brackish marsh near Año Nuevo, Big Basin is a repository of special-status animal species. These include, in the red alder riparian forest, the black swift, *Cypseloides niger* (G4/S2),[20] and, in the montane hardwood of the interior live oak forest, the sharp-shinned hawk, *Accipiter striatus* (G5/S4).[21] The wildfire that swept through San Mateo and Santa Cruz Counties in August 2020 scorched nearly eighty-seven thousand acres and significantly impacted all three watersheds in Big Basin State Park.[22]

01. Big Basin Redwoods State Park
02. Año Nuevo Bay/Waddell Creek estuary
03. Boulder Creek
04. Coast Dairies State Park
05. Fall Creek Unit of Henry Cowell Redwoods State Park
06. Henry Cowell Redwoods State Park
07. San Lorenzo River watershed
08. Santa Cruz
09. The Forest of Nisene Marks State Park
10. Wilder Ranch State Park

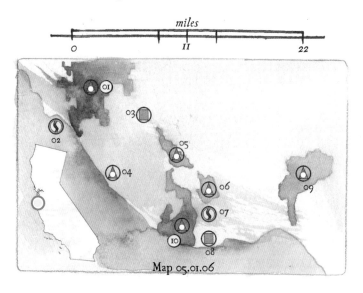

Map 05.01.06

05. As Above, So Below

## Insectivores and the big trees

The ecological principle of competitive exclusion states that complete competitors cannot coexist—that different species cannot compete for the exact same resources in the exact same manner. This means that every species has a slightly different niche inside the ecosystem.[23] Several dozens of species of insect-eating birds may use the vertical habitat of the redwood tree to forage for food, but each uses it in a slightly different way. At Big Basin, for example, the hermit warbler, *Setophaga occidentalis*, finds its food in the tree canopy, while the golden-crowned kinglet, *Regulus satrapa*, bounces around the shrubby understory looking for a meal, and leaves Wilson's warbler, *Cardellina pusilla*, to pick caterpillars out of the duff on the forest floor. Finding insects in the tree body, the pileated woodpecker, *Dryocopus pileatus*, digs insects out of the heartwood, while the hairy woodpecker, *Leuconotopicus villosus*, with its much smaller beak, can only extract its protein from shallower sources; meanwhile, the brown creeper, *Certhia americana*, pries back small pieces of bark to extract the meal waiting there.[24]

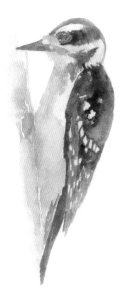

Hairy woodpecker

Pileated woodpecker

# The Coasts of California

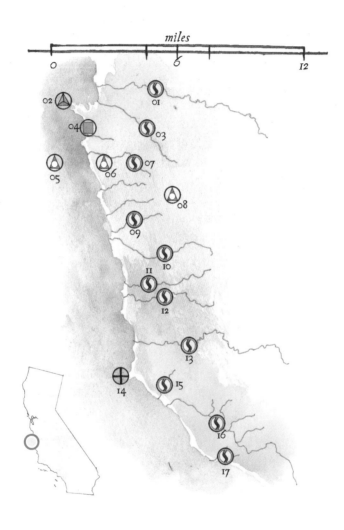

Map 05.01.07

## 05.01.07 Coastal Woodlands of the Ventana Wilderness

At nearly 237,000 acres (370 square miles), the Ventana Wilderness is the largest federally designated wilderness area on the coast. This map depicts the major, ecologically rich drainages on the western slope of the wilderness area. The eastern watersheds of the Ventana Wilderness are all tributaries of the Salinas River and drain into Monterey Bay. The 2020 wildfire in the area burned approximately 125,000 acres (195 square miles) across the southern portions of the Ventana Wilderness. Adding to that, the 2016 wildfire burned 132,000 acres (206 square miles) across the northern portion of the Ventana Wilderness and the greater coastal region south of Monterey.

01. Carmel River
02. Point Lobos State Natural Reserve
03. San Jose Creek
04. Carmel Highlands
05. California Sea Otter Game Refuge
06. Garrapata State Park
07. Soberanes Creek
08. Joshua Creek Canyon Ecological Reserve; Ventana Wilderness
09. Doud Creek
10. Garrapata Creek
11. Rocky Creek
12. Bixby Creek
13. Little Sur River
14. Point Sur; Point Sur State Historic Park
15. Swiss Canyon Creek
16. Big Sur Creek
17. Sycamore Canyon Creek

McWay Falls, Julia Pfeiffer Burns State Park, Big Sur

# The Coasts of California

white seabass
Atractoscion nobilis

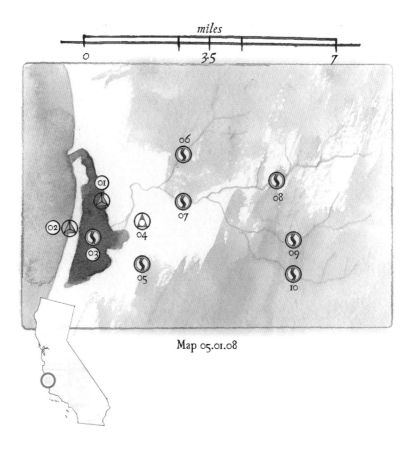

Map 05.01.08

## 05.01.08 Estuary Restoration on Morro Bay

Because of its size, the cumulative 48,000 acres (75 square miles) that make up the watershed of the 2,300-acre Morro Bay estuary support one of the central coast's largest and most productive ecosystems (mostly because of its size and its general isolation from urban industry). Although the watershed is large, the estuary itself is relatively small, and having been stressed by over a century of farmland and urban runoff, the ecosystem and its biodiversity are facing a precarious future. The Morro Bay National Estuary Program has identified seven negatively impacting factors on the region that have become remediation priorities, directing strategies of restoration: (1) sedimentation from urban development, (2) bacterial contamination from livestock and urban sources, (3) nutrient overenrichment from agricultural industry, (4) loss of freshwater flow during dry seasons due to human usage, (5) heavy metals and toxic pollutants from local industry, (6) habitat loss from urban sprawl and encroachment, and (7) steelhead loss from all of the preceding stressors.[25]

01. Morro Bay State Marine Recreational Management Area
02. Morro Dunes Nature Preserve
03. Morro Bay State Marine Reserve; Elfin Forest
04. Morro Bay State Park
05. Los Osos Creek watershed; Warden Creek
06. San Bernardo Creek
07. Chorro Creek
08. San Luisito Creek
09. Pennington Creek
10. Dairy Creek

Lingcod Ophiodon elongatus

## The return of the condor

This region is ground zero for recovery of the California condor, *Gymnogyps californianus* (G1/S1), which has bounced back from a low population of only 22 individuals in 1982 to a 2020 (world) population of 518—200 flying wild in California, 90 in the greater Big Sur area.[26] The condor, the largest terrestrial bird in North America, once enjoyed a range from California to New York State and south to Florida. Now there are small and increasing populations in California, Arizona, Utah, and Mexico. Although the genetic bottleneck could trigger its eventual extinction, the California condor is an iconic symbol of stewardship and emblematic of what good policy (including land management and reserves, along with the banning of lead ammunition, a primary factor in region-wide condor mortality) can do in the face of ecological degradation.

## Everywhere a home for endangered species

Within each of eight habitat types across sixteen designated Areas of Special Biological Significance, a threatened, endangered, or endemic species sustains a present population. (1) Brackish marsh: northern tidewater goby, *Eucyclogobius newberryi*. (2) Maritime chaparral: Morro manzanita, *Arctostaphylos morroensis*. (3) Coastal dune scrub: Morro shoulderband snail, *Helminthoglypta walkeriana*. (4) Coastal salt marsh: California seablite, *Suaeda californica*. (5) Sandy beach: western snowy plover, *Charadrius alexandrinus nivosus*. (6) Freshwater wetland: Chorro Creek bog thistle, *Cirsium fontinale* var. *obispoense*. (7) Riparian: California red-legged frog, *Rana draytonii*. (8) Riparian/aquatic: steelhead, *Oncorhynchus mykiss*.[27]

## 05. As Above, So Below

## Unlikely miracle along a wild coast

Around California's "elbow" (Point Conception), a pivot point in California's topography, the coastline shifts in orientation from north–south to east–west, and two ocean currents intersect to form an ecoregion replete with rare wildlife. If this landscape had been developed like any other in Southern California, all of this rich biodiversity would have been lost long ago, but instead an unexpected miracle occurred. Over the past three hundred years since Euro-American settlement, the Spanish land-grant system of selling large portions of land to individual families led ultimately to the Nature Conservancy's being donated one of these large, untouched parcels across the coast. The second aspect of unlikely preservation around the elbow was Vandenberg Air Force Base as (1) an area off-limits to the public or to private interests and (2) a wilderness area of sorts, stewarded in accordance with federal laws regarding endangered species and other environmental protections. These two pieces of an unexpected puzzle now exist as a connective landscape of close to 122,000 acres (190 square miles) and forty-three continuous miles of pristine shoreline that will never be developed.

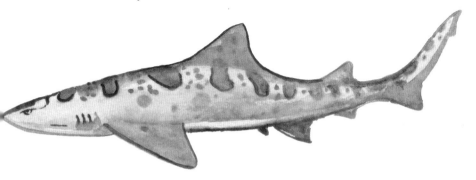

Leopard shark
*Triakis semifasciata*

# The Coasts of California

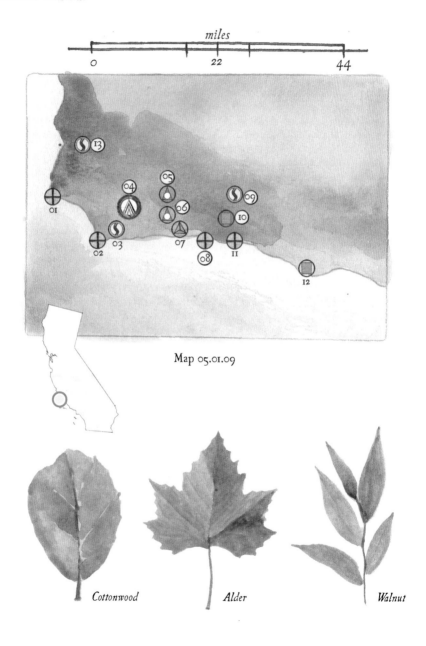

Map 05.01.09

*Cottonwood*  *Alder*  *Walnut*

## 05.01.09 Mesas of the Gaviota Coast

The coastal bluff between the shoreline and the Santa Ynez Mountains runs for over forty miles from Santa Barbara west to near the Jalama Creek watershed. Although nearly three-quarters of the land on the coastal bluff is monopolized by private agriculture, significant variety of native habitat still exists.[28] Protected tree species along the Gaviota coast are defined as mature trees of a particular species, or as trees that serve as nesting habitat for raptors or butterfly roosts. Those tree species include oak, *Quercus* sp.; sycamore, *Platanus racemosa*; willow, *Salix* sp.; California bay laurel, *Umbellularia californica*; cottonwood, *Populus* spp.; white alder, *Alnus rhombifolia*; and Southern California walnut, *Juglans californica*.[29]

01. Point Arguello
02. Point Conception
03. Jalama Creek watershed
04. Santa Ynez Mountains; Jualachichi summit (1,105')
05. Nojoqui Falls County Park
06. Los Padres National Forest
07. Arroyo Hondo Preserve; Tajiguas Ranch
08. Refugio State Beach
09. Lake Cachuma
10. El Capitan Ranch
11. El Capitan State Beach
12. Isla Vista
13. Santa Ynez River

*Oak*　　　*Sycamore*　　　*Willow*

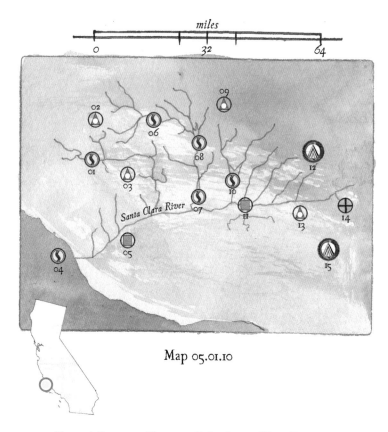

Map 05.01.10

## 05.01.10 Coastal Riparian Forests of the Santa Clara River

The Santa Clara River is a dynamic system—one of the last relatively intact, relatively free-flowing watersheds in Southern California. The braided, sandy floodplain winds through islands of riparian habitat, testament to how many now-channelized local rivers used to exist. In the upper reaches of its 1,600-square-mile watershed, four ecoregions of California converge: (1) the central coast, (2) the Great Central Valley, (3) the Mojave Desert, and (4) the south coast.[30] Throughout the greater area of the Santa Clara River, 138 endemic species of plant and animal still exist.[31] Six rare and local vegetation types that still hold acreage inside the watershed

## 05. As Above, So Below

are California walnut woodland, riverside alluvial fan sage scrub, southern willow scrub, valley needlegrass grassland, valley oak woodland, and Santa Clara wildflower field.³²

01. Sespe Creek
02. Sespe Wilderness
03. Sespe Condor Sanctuary
04. Pierpont Bay; Ventura
05. South Mountain Oil Field
06. Piru Creek
07. Lake Piru
08. Pyramid Lake
09. Angeles National Forest
10. Castaic Lake State Recreation Area
11. Santa Clarita
12. Sierra Pelona
13. Magic Mountain
14. Aviso Canyon
15. San Gabriel Mountains

Least Bell's vireo
*Vireo bellii pusillus*
(G5T2/S2)

## Conservation targets and endangered lives

The Nature Conservancy has identified eight conservation targets, defined as habitat types and animal groupings that together represent the priority work for ongoing restoration projects.³³ Seventeen species federally listed as endangered and threatened are associated with each of these conservation targets; in the following list, for each target, I've mentioned a single imperiled species that knows this home and no other.

1. Riparian forest
    Western yellow-billed cuckoo, *Coccyzus americanus occidentalis* (G5T2T3/S1)
2. Grasslands
    Slender-horned spine flower, *Dodecahema leptoceras*
3. Scrub communities
    Quino checkerspot butterfly, *Euphydryas editha quino* (G5T1T2/S1S2)
4. Woodlands
    Nevin's barberry, *Berberis nevinii*
5. Coniferous forest
    Arroyo toad, *Bufo californicus* (G2G3/S2S3)
6. Chaparral communities
    Least Bell's vireo, *Vireo bellii pusillus* (G5T2/S2)
7. Aquatic vertebrates
    Santa Ana sucker, *Catostomus santaanae* (G1/S1)
8. Wide-ranging terrestrial vertebrates
    California bighorn sheep, *Ovis canadensis californiana* (G4T2/S2)

The Coasts of California

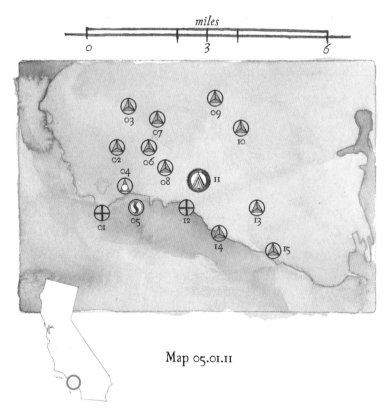

Map 05.01.11

## 05.01.11 Biodiversity Reserves across Palos Verdes

Twelve nature reserves that together create a largely continuous habitat space across the Palos Verdes Peninsula protect pockets of critically endangered vegetation. The peninsula that separates Santa Monica Bay from San Pedro Bay is an urbanized community that, despite its proximity to the city of Los Angeles, still manages to protect over fourteen hundred acres of coastal bluff and sage scrub, and riparian habitat along creek beds that are lined with cactus and areas of intact grassland.[34] Prickly pear, *Opuntia littoralis*; sage, *Artemisia* (sagebrush); *Salvia* (true sage); buckwheat, *Eriogonum*; and coyote bush, *Baccharis*, form the native matrix of plant life, and harbor in their scrubby habitats a wide abundance of endangered life.

01. Point Vicente
02. Three Sisters Reserve
03. Agua Amarga Reserve
04. Abalone Cove Shoreline Park
05. Abalone Cove
06. Filiorum Reserve
07. Vista del Norte Reserve
08. Portuguese Bend Reserve
09. Linden H. Chandler Preserve
10. George F. Canyon Preserve
11. Palos Verdes hills
12. Portuguese Bend
13. San Ramon Reserve
14. Ocean Trails Reserve
15. White Point Nature Preserve

*Peirson's morning-glory*

## Rare plants of Palos Verdes

Because of their relative isolation, peninsulas enable the development of unique biological associations and have a character all their own. The insulated zone between Southern cactus scrub and South Coast sage scrub present on the Palos Verdes peninsula is an ecologically marginalized, transitional zone that illustrates this point.[35] The rare plants that either presently inhabit or might even define this ecotone include the following:

Aphanisma, *Aphanisma blitoides* (CNPS list 1B)
Bright green dudleya, *Dudleya virens* (CNPS list 1B)
Catalina crossosoma, *Crossosoma californicum* (CNPS list 4)
Peirson's morning-glory, *Calystegia peirsonii* (CNPS list 4)
Santa Catalina Island desert-thorn, *Lycium brevipes* var. *hassei* (CNPS list 1B)
South Coast saltscale, *Atriplex pacifica* (CNPS list 1B)
Southern tarplant, *Centromadia parryi* ssp. *australis* (CNPS list 1B)
Woolly seablite, *Suaeda taxifolia* (CNPS list 4)
Lyon's pentachaeta, *Pentachaeta lyonii* (CNPS list 1B)—federally listed as endangered

California Native Plant Society list 1B—plants that are rare, threatened, or endangered in California and elsewhere

California Native Plant Society list 4—plants of limited distribution; a watch list

# The Coasts of California

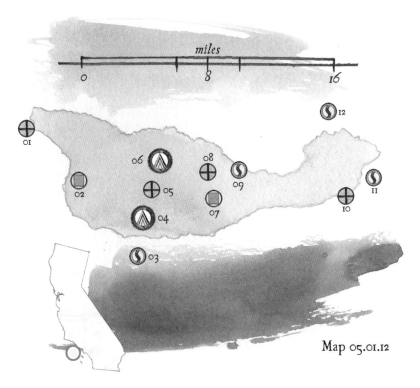

Map 05.01.12

## 05.01.12 Mosaic of Santa Cruz Island

Habitats on Santa Cruz Island, the largest of the Channel Islands, enjoy significant amplitudes of elevation gain and loss that contribute to a wide range of grassland and woodland types. Extensive grazing over the past century has degraded most of the native and riparian habitats throughout the island, but with the removal of sheep, livestock, and feral pigs, the vegetation should recover over the next several decades.[36] Endemic plant percentages are much higher on the island than on the mainland. In the northern Channel Islands, the rate of terrestrial endemism can be as high as 7 percent, whereas in the Santa Monica Mountains, it is less than 1 percent.[37]

01. Fraser Point
02. Christy Ranch
03. Gull Island Marine Reserve

05. As Above, So Below

04. Sierra Blanca (1,528')
05. Central Valley
06. Devil's Peak (2,450')
07. Main Ranch
08. Cañada del Puerto
09. Prisoners Harbor
10. Sandstone Point
11. Smuggler's Cove
12. Scorpion Marine Reserve

Santa Cruz Island live-forever

## An endemic species for every island habitat

Because Santa Cruz Island is so rich with endemic plants, its habitat associations (plants that grow together to form vegetation types), correspondingly include numerous examples of these plants that exist nowhere else.[38] The following are a few representatives:

Coastal sage scrub—Santa Cruz Island buckwheat, *Eriogonum arborescens*

Coastal bluff scrub—Santa Cruz Island live-forever, *Dudleya nesiotica*

Island chaparral—Santa Cruz Island manzanita, *Arctostaphylos insularis*

Island woodland—island ironwood, *Lyonothamnus floribundus* (not only an endemic species, but an endemic genus)

Southern oak woodland—island jepsonia, *Jepsonia malvifolia*

Closed-cone pine forest—Santa Cruz Island pine, *Pinus remorata*

Coastal strand—island goldenbrush, *Isocoma menziesii* var. *sedoides*

Coastal grasslands—island cream cup, *Platystemon californicus* var. *ornithopus*

# The Coasts of California

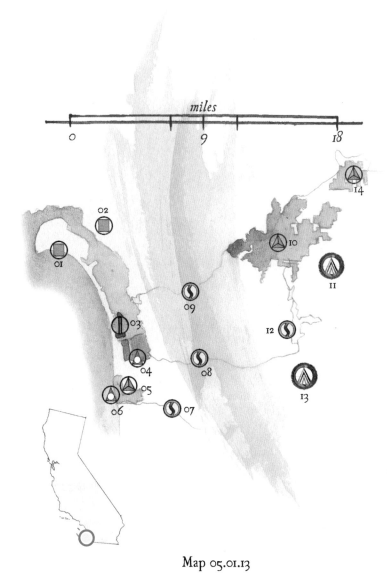

Map 05.01.13

## 05.01.13 Fresh-Brackish Marsh of Tijuana Slough

Over three million people live within a thirty-minute drive of the 2,500-acre Tijuana River estuary. The incredible urban crush on the delicate ecosystem presents enormous challenges to restoration and conservation. The estuary drains the Tijuana River's 120-mile watercourse, only five miles of which are inside the United States. The habitat network provides for hundreds of species of birds and dozens of species of mammals and reptiles, in a complex of sand dunes and beaches, open tidal channels and mudflats, salt marshes, fresh-brackish marshes, riparian corridors, coastal sage scrub, and vernal pools.

01. Coronado; San Diego Bay; Zuniga Shoal
02. San Diego
03. Silver Strand State Beach
04. South Bay National Wildlife Refuge
05. Tijuana Slough National Wildlife Refuge
06. Border Field State Park
07. Tijuana River
08. Otay River
09. Sweetwater River
10. San Diego National Wildlife Refuge; San Miguel Mountain (2,586')
11. Jamul Mountains; Rancho Jamul Ecological Reserve
12. Lower Otay Lake
13. San Ysidro Mountains; Otay Mountain (3,566')
14. San Diego National Wildlife Refuge; McGinty Mountain (2,183')

## A network of ecological requirements

The network of protected spaces around San Diego County is impressive in terms of acreage and specific habitat preserved, although much of this biodiversity is under threat from the long reach of urban pollution.[39] A few examples of the incessant stress on the habitat of the Tijuana Slough and beyond are listed here, as they apply to a handful of individual species:

Salt marsh bird's beak, *Cordylanthus maritimus*, requires native bees for pollination. Threat: insecticide pollution

California horn snail, *Cerithidea californica*, requires native algal mats, undisturbed by invasive plants. Threat: tamarisk and arundo invasion

Rove beetles, *Staphylinidae* spp., require noncompacted mud flats. Threat: off-road vehicles

Topsmelt silverside, *Atherinops affinis*, one of 29 fish species requiring high water quality, free of pollutants, in salt-marsh habitat. Threat: urban runoff

Pacific tree frog, *Hyla regilla*, requires functioning and connective riparian habitat. Threat: development

# The Coasts of California

Map 05.02

## 05.02 THE TERRESTRIAL COAST
*The distribution of indicative plant communities*

The remainder of this chapter is a survey of ecosystems, habitat types, and vegetative alliances that form the backdrop of California's biodiversity. To focus on the intrinsic value of the subject, the traditionally included utilitarian services of both recreation and cultural value have been intentionally left out.

Map 05.02 represents the locations of fifteen extraordinary terrestrial and wetland ecosystems; listed here are the keystone species that are necessary for the continued functioning of that ecosystem within its historical parameters—species without which the ecosystem would eventually become unrecognizable. These species, simply by engaging with their habitat, make resources and habitat for a significant number of other species.

> There is an important difference between an ecosystem and a habitat: an ecosystem is a network of forces that constitute the natural character of a given piece of landscape; habitat can be described as the phenomenological resources that are available to any given species within that ecosystem. Biogeography studies the ways ecosystems are distributed and how conditions of topography, climate, resources, and environmental stress determine the biodiversity therein.

01. The northern coastal forest of Six Rivers
    Chinook salmon, *Oncorhynchus tshawytscha*
02. The coastal mixed forest of the Mattole watershed
    Douglas fir, *Pseudotsuga menziesii*
03. The coastal steppe of Point Arena
    Mountain beaver, *Aplodontia rufa nigra*
04. The coastal prairie of Point Reyes
    Tule elk, *Cervus canadensis nannodes*
05. The salt marshes of San Francisco Bay
    Eelgrass, *Zostera marina*

The Coasts of California

06. The southern old growth of the Santa Cruz Mountains
    Redwood, *Sequoia sempervirens*
07. The cypress forest of Point Lobos
    Monterey pine, *Pinus radiata*
08. The mixed-evergreen forests and woodlands of Big Sur
    Mountain lion, *Puma concolor*
09. The oak woodlands of San Luis Obispo
    Acorn woodpecker, *Melanerpes formicivorus*
10. The dunes of Rancho Guadalupe
    Silver bush lupine, *Lupinus chamissonis*
11. The chaparral of the Santa Ynez Mountains
    Big pod ceanothus, *Ceanothus megacarpus*
12. The sage scrub of the Santa Monica Mountains
    Black sage, *Salvia mellifera*
13. The grasslands of Crystal Cove
    Costa's hummingbird, *Calypte costae*
14. The pines of San Diego County
    Torrey pine, *Pinus torreyana*
15. The strand communities of San Diego
    American dune grass, *Leymus mollis*

Giant kelp
*Macrocystis pyrifera*

## 05.03 UNDERWATER FOREST
*The offshore quilt of kelp ecosystems*

The kelp forests began to develop along the California coast approximately eleven million years ago, long before the California shoreline was arranged as it is now.[40] Today, eight hundred species of marine flora and fauna make their homes among these tall, shadowy, three-dimensional habitats that resemble arboreal ecosystems in their verticality and their structure, complete as they are with a forest floor, an understory, and a canopy. Off the coast of California, there are four primary types of canopy-forming kelp that overlap in range: giant kelp, *Macrocystis pyrifera*; dragon kelp, *Eularia fistulosa*; bull kelp, *Nereocystis luetkeana*; and elk kelp, *Pelagophycus porra*.[41] Giant kelp can grow at a rate of three feet per day and can reach heights of over one hundred feet from the ocean floor.[42]

The kelp forest, while resembling a terrestrial forest, is quite different in many key respects, and not just because it is under the waves; to describe the fecundity and variety of the kelp ecosystem, new vocabulary comes into play. The long trunk of the kelp body creates a *biogenic* (biologically created) habitat space for a host of *epiphytes* (algal organisms) and *epibionts* (invertebrates) that use the anchor and the tactical positioning of the kelp in the water column to access otherwise unattainable nutrients there, such as light and plankton.[43] For a deeper look at the kelp forest of Monterey Bay, see 04.05. For a trophic review of life in the kelp forest, see 06.03–06.06.

Kelp crab
*Pugettia producta*

# The Coasts of California

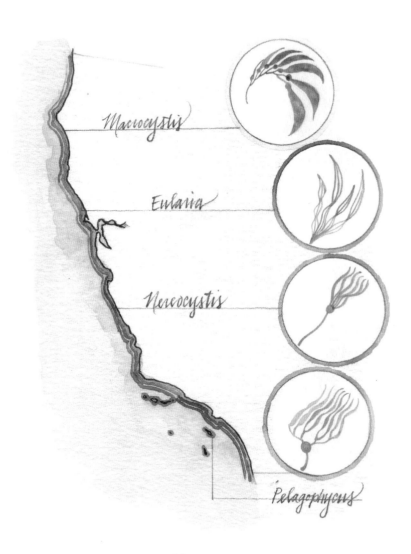

Map 05.03

## Services of the kelp forest

Kelp forests exist all over the globe, and together they store more carbon than all of the world's eelgrass, salt marsh, and mangrove habitats.[44] Kelp forests are capable of sequestering massive amounts of carbon dioxide, which not only is beneficial for keeping global atmospheric temperatures down but also lowers oceanic acidity, engineering a sustainable environment for the existing food web.[45] The wave-absorbing action of the forest also works to protect coastal habitats across California and will mitigate the effects of climate breakdown in the decades to come.[46] In addition, kelp forests are valuable for being productive fisheries, and the plant material itself is used in a number of products derived from this quickly replenishable source of aquiculture.

*Semicossyphus darwini*
Chilean sheephead

## Threats to the kelp forest

Thousands of acres of bull kelp have been destroyed since 2014—by some estimates, up to 90 percent of *Nereocystis* habitat has disappeared, and that number may be increasing.[47] The cause of this die-off is due to generalized marine warming, but is also exacerbated by a trophic cascade originating with sea star wasting disease (see 07.09a), which affects sea stars, the primary predator of purple urchins, who prey primarily on bull kelp.[48] Kelp forests survive because of the regular nutrient delivery involved with the process of upwelling (see 03.05), and the virulent effects of global warming threaten the reliability of this oceanic mechanism along the California Current.[49] In addition, the integrity of these important marine forests is continually compromised by exotic species of algae and invasive invertebrates, sewage discharge, coastal development, and sedimentation.[50] Statewide, only 22 percent of kelp forests exist inside Marine Protection Areas, and 14 percent of kelp forests exist inside of no-take reserves.[51]

The Coasts of California

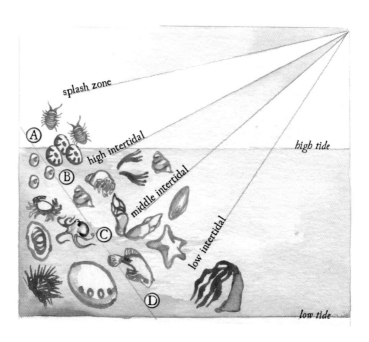

A. Splash zone
   Rock louse

B. High intertidal
   Blue-green algae
   Buckshot barnacle
   Periwinkle
   Sea lettuce
   Keyhole limpet
   Filamentous algae
   Acorn barnacle
   Rockweed
   Hermit crab
   Turban snail
   Aggregate anemone
   Striped shore crab

C. Middle intertidal
   Goose barnacle
   California mussel
   Chiton
   Dead man's finger
   Green anemone
   Sea urchin
   Ochre sea star
   Bat star
   Limpet
   Black abalone
   Tidepool sculpin
   Brittle star
   Sea cucumber

D. Low intertidal
   Sea palm
   Octopus
   Surf grass
   Feather duster worm

## 05.04 A WORLD OF THEIR OWN
*Tide-pool zonation*

Diagram 05.04 depicts the way plant and animal species are generally distributed along California's intertidal zone. Four times a day, this dramatic ecosystem transforms with the ebb and flow of the tide, between being an exposed and, subsequently, a submerged habitat space. The intertidal zone is an incredibly diverse and biologically rich environment, home to many unique organisms that evolved with strategies to thrive while enduring the endless exposure to pounding waves and daily intervals of desiccation. The individual species that make their habitat in the intertidal ecosystem include a total of 669 species of seaweed and more than 3,700 invertebrates.[52]

### Services of the intertidal zone

Not only is a rich and ecologically functioning intertidal zone essential for migrating and nesting bird species across California's coast, but the biologically diverse habitat also serves as a significant food source for local industry and economies. It also lessens the effects of damage and erosion from tidal forces on inland communities.

### Threats to the intertidal zone

The myriad of threats to this ecosystem from climate breakdown include disruptive increases in water temperature, increased rates of coastal erosion on the physical substrate the ecosystem depends on, increased ocean acidity disturbing most invertebrates at every stage of their phenology, and altered circulation patterns that govern the delivery of nutrients and oxygen.[53]

Gooseneck barnacle
*Pollicipes pollicipes*

# The Coasts of California

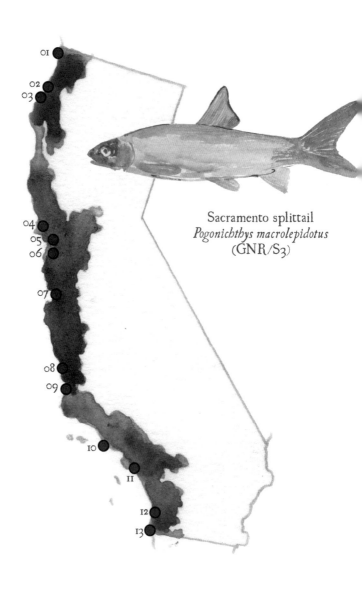

Sacramento splittail
*Pogonichthys macrolepidotus*
(GNR/S3)

Map 05.05

## 05.05 WHERE HALF OF LIFE LIVES
*The biodiversity of wetlands*

Map 05.05 depicts of some of the largest or most typical tidally dependent wetland habitats found along California's shoreline. The blue area on the map indicates the extent of the watersheds that feed fresh water to these wetlands. The notable exception here is the San Francisco Bay Delta. The watersheds of the Sacramento and San Joaquin Rivers are not mapped; rather, only the extent of the Bay Delta region including all its ancillary creeksheds is shown.

Wetland habitat types along coastal California include deep and shallow water estuarine habitats, tidal marshes, salt flats, tidal and nontidal freshwater fens, saline brackish marsh, beaches, dunes, lagoons, alkali meadows, riparian forest/scrub, and vernal pools. Because of the geography along the Pacific Flyway, the climate of the California Floristic Province, and the hydrology of California's watersheds, many coastal wetlands enjoy a huge spread of dense biodiversity, and have been designated as areas of international biological importance (see 05.01.05).[54]

There are generally four categories of salinity concentrations that define ecosystems within the coastal watershed boundary: (1) nontidal freshwater coastal wetlands, (2) inland extent of tidal influence, (3) tidal freshwater coastal wetlands, and (4) tidal saltwater coastal wetlands.[55] Because California's coastal wetlands vary so much in mechanical, topographic, and hydrological input, and because that input is so often linked to seasonality, there is no one common community type or uniting pattern across California's estuarine habitats.[56] It is estimated that within the subtidal and intertidal habitats of California's hundreds of estuaries, more than 80 percent of fish and shellfish species rely on these wetlands as habitat for at least some stage in their life.[57]

Belted kingfisher
*Megaceryle alcyon*

01. Lake Earl; Yontocket Slough; Smith River; Lake Tolowa

02. Humboldt Lagoons State Park

03. Humboldt and Arcata Bay; Eel River State Wildlife Area

04. Tomales Bay

05. San Pablo Bay; Suisun Bay; Grizzly Bay; Sacramento River; San Joaquin River

06. San Francisco Bay; Hayward Regional Shoreline; Don Edwards San Francisco Bay National Wildlife Refuge; Baylands Nature Preserve

07. Elkhorn Slough; Moss Landing State Wildlife Area; Ellicott Slough National Wildlife Refuge; Salinas River

08. Morro Bay

09. San Luis Obispo Bay; Oso Flaco Lake Natural Area; Santa Maria River

10. Mugu Lagoon; Calleguas Creek

11. Upper Newport Bay Ecological Reserve; San Diego Creek

12. Buena Vista Lagoon; Agua Hedionda Lagoon; Batiquitos Lagoon

13. Tijuana Slough; Tijuana River

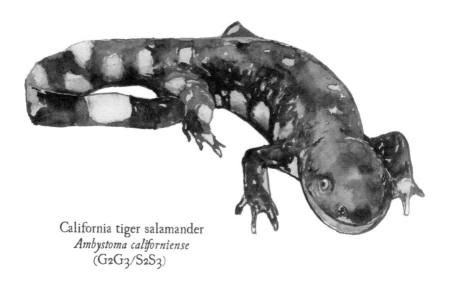

California tiger salamander
*Ambystoma californiense*
(G2G3/S2S3)

## 05. As Above, So Below

## Services of the coastal wetlands

The services that California's wetlands provide are many and tremendously important: habitat for hundreds of ecologically and commercially important fish and invertebrate species, significant carbon storage, flood buffering of local communities, and waste and pollution mitigation and assimilation through, among other processes, nitrification-denitrification—the process by which organic nitrogen is transformed into nitrogen gas.[58]

## Threats to the coastal wetlands

As varied and wide ranging as the services the wetlands provide, the threats they face are many in number, ranging from landscape transformation by urban encroachment, to biological invasion of over 235 individual species of exotic algae and invertebrates, to a panoply of chemical pollutants constantly disturbing the delicate chemistry within the estuarine habitat. The big one is sea-level rise. Because human water infrastructure has altered sediment input, thousands of remaining acres of wetlands may simply sink over the course of the next century.[59]

Suisun Marsh, San Francisco Bay Delta

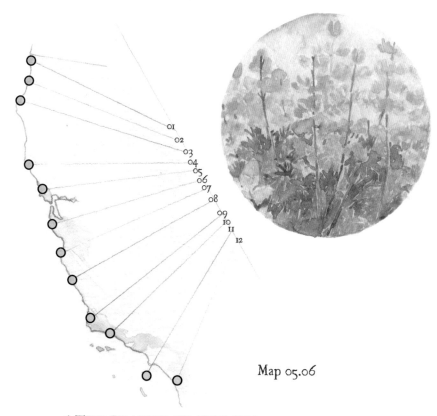

Map 05.06

## 05.06 THE PRAIRIE BY THE SEA
*California's coastal scrub land*

The north coastal scrub differs in many key ways from the southern sage scrub. In the north, primarily evergreen and often fragrant shrubs like yarrow, *Eriophyllum* sp., and pearly everlasting, *Anaphalis margaritacea*, make their home in lands covered by coyote brush, *Baccharis pilularis*; lupine, *Lupinus* sp.; and California buckwheat, *Eriogonum fasciculatum*.[60] In the south, drought-adapted shrubs such as California brittlebush, *Encelia californica*, make their habitat near succulents such as coastal agave, *Agave shawii*.[61] The letter $N$ represents nine grassland plant associations across twelve coastal ecosystems.

## 05. As Above, So Below

Northern coastal bluff scrub (N1)[62]
Principal plant: California sagebrush, *Artemisia californica*

California sagebrush scrub (N2)
Principal plants: sage, *Artemisia* (sagebrush) sp.; and *Salvia* (true sage) sp.

Coyote brush scrub (N3)
Principal plant: Coyote brush, *Baccharis pilularis*

Yellow bush lupine scrub (N4)
Principal plant: yellow bush lupine, *Lupinus arboreus*

Blue blossom chaparral (N5)
Principal plant: blue blossom ceanothus, *Ceanothus thyrsiflorus*

Coffeeberry scrub (N6)
Principal plant: coffeeberry, *Rhamnus californica*

Poison oak scrub (N7)
Principal plant: poison oak, *Toxicodendron diversilobum*

Hazel scrub (N8)
Principal plant: hazelnut, *Corylus cornuta*

Coastal prairie (N9)
Principal plants: fescue and oatgrass, *Festuca* and *Danthonia*

01. Lake Earl prairie and pasture, Del Norte County—N1, N3, N4, N6, N7

02. Prairie Creek Redwoods State Park, Humboldt County—N7, N8, N9

03. Fortuna prairie and pasture, Humboldt County—N1, N3, N4, N6, N7, N9

04. Point Arena, Mendocino County—N1, N3, N4, N6, N7, N8, N9

05. Bolinas Ridge, Marin County—N1, N3, N6, N7, N8, N9

06. San Gregorio prairies and pasture, San Mateo County—N1, N3, N6, N7, N9

07. Carmel Valley, Monterey County; Diablan Coastal sage scrub[63]—N2, N3, N5, N7, N9

08. Andrew Molera State Park, Monterey County; Diablan Coastal sage scrub—N2, N3, N5, N7, N9

09. Morro Bay State Park, San Luis Obispo County; Venturan Coastal sage scrub—N2, N5, N7

10. Santa Barbara Point, Santa Barbara County; Venturan Coastal sage scrub—N2, N5, N7

11. Santa Catalina Island, Los Angeles County—N2, N3, N4, N7, N9

12. Del Mar Mesa, San Diego County—N2, N5, N7

The Coasts of California

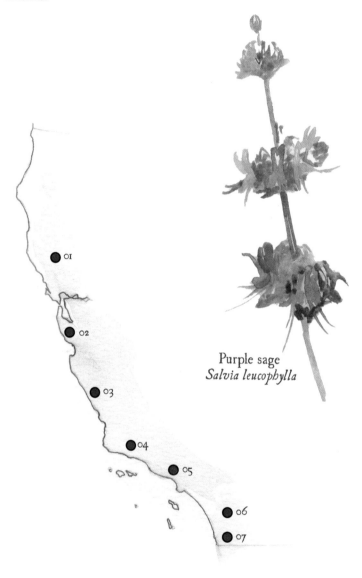

Purple sage
*Salvia leucophylla*

Map 05.07

## 05.07 OF MANZANITA AND MOUNTAINS
*Coastal California's chaparral blanket*

A sclerophyllous shrub is a plant that is typically Californian, meaning that it is a tough plant when subjected to the regular routines that it understands: the return of fire inside a regular regime, low water availability, and poor soil nutrients. The leaves of these slow-growing plants are small and have thick cuticles to minimize evapotranspiration, and the shrub covers the chaparral regions of California's coastal ridges.[64] The following are the most common evergreen sclerophyllous shrub and tree genera in California coast chaparral:[65]

Manzanita, *Arctostaphylos*
Chamise (northern) and redshank (southern), *Adenostoma*[66]
Oak, *Quercus*
Mountain mahogany, *Cercocarpus*
Ceanothus, *Ceanothus*
Sage, *Salvia*

01. Walker Ridge (3,400'), Berryessa Snow Mountain National Monument, Lake County; Northern maritime chaparral—including chamise, *Adenostoma fasciculatum*,[67] and bigberry manzanita, *Arctostaphylos glauca*, alliance

02. Montara Mountain (1,813'), San Mateo County; central coast chaparral—including brittle leaf, *Arctostaphylos crustacea*, and woolly leaf manzanita, *A. tomentosa*, alliance[68]

03. Cone Peak (5,155'), Santa Lucia Mountain, Monterey County; central coast chaparral—including chamise, *Adenostoma fasciculatum*, and black sage, *Salvia mellifera*, alliance[69]

04. Timber Peak (4,764'), Sierra Madre Mountains, Santa Barbara County; southern coast chaparral[70]—including bigberry manzanita, *Arctostaphylos glauca*, and buck brush, *Ceanothus cuneatus*, alliance[71]

05. Castro Peak (2,824'), Santa Monica Mountains, Los Angeles County; southern coast chaparral—including redshank, *Adenostoma*, and yerba santa, *Eriodictyon californicum*, alliance[72]

06. Rodriguez Mountain (3,886'), Hellhole Canyon County Preserve, San Diego County; southern coast chaparral—including chamise, *Adenostoma fasciculatum*, and white sage, *Salvia apiana*, alliance[73]

07. Lawson Peak (3,660'), Cleveland National Forest, San Diego County; southern coast chaparral—including chamise, *Adenostoma fasciculatum*, and mission manzanita, *Xylococcus bicolor*, alliance[74]

The Coasts of California

Map 05.08

## 05.08 WILDFLOWER WONDERLAND
*Following the bloom through the grasslands*

The grassland biome that is the coastal prairie from Oregon to Point Conception differs in many key respects from the grassland habitats of Southern California. In intact regions of the northern biome, native bunchgrasses such as blue bunchgrass, *Festuca idahoensis*, live beside introduced annual grasses such as barley, *Hordeum* sp., and introduced perennial grasses such as Bermuda grass, *Cynodon dactylon*.[75] In the south, coastal sage scrub and cactus scrub make up most of the intact scrubland biome.

Map 05.08 illustrates the locations of many of the most intense and beautiful wildflower blooms in California. Look for the poppies blooming in the south as early as January; in the north, you often have to wait until June to find the irises blooming on the edge of the redwood forest.

01. Lanphere Dunes (Humboldt)

02. Grizzly Creek Redwoods State Park (Humboldt)

03. Humboldt Redwoods State Park (Humboldt)

04. Russian Gulch State Park (Mendocino)

05. Van Damme State Park (Mendocino)

06. Manchester State Park (Mendocino)

07. Kruse Rhododendron State Natural Reserve (Sonoma)

08. Stillwater Cove Regional Park (Sonoma)

09. Abbotts Lagoon, Point Reyes National Seashore (Marin)

10. Ring Mountain Open Space Preserve (Marin)

11. Mount Diablo State Park (Contra Costa)

12. San Bruno Mountain (San Mateo)

13. Skyline Trail (Santa Cruz)

14. Santa Cruz Sandhills, Henry Cowell Redwoods State Park (Santa Cruz)

15. Pacific Grove coastline (Monterey)

16. Garrapata State Park (Monterey)

17. Andrew Molera State Park (Monterey)

18. Cone Peak Gradient Research Natural Area, Ventana Wilderness (Monterey)

19. Irish Hills Natural Reserve (San Luis Obispo)

20. Figueroa Mountain (Santa Barbara)

21. Burton Mesa Ecological Reserve (Santa Barbara)

22. South Hills Open Space (San Luis Obispo)

23. Romero Canyon (Santa Barbara)

24. Ojai-Ventura Bike Path (Ventura)

25. Sycamore Canyon, Point Mugu State Beach (Los Angeles)

26. Topanga Canyon, Santa Monica Mountains (Los Angeles)

27. Corral Canyon (Los Angeles)

28. Eaton Canyon Nature Center (Los Angeles)

29. Crystal Cove State Park (Orange)

30. Santa Catalina Island (Los Angeles)

31. Carlsbad Ranch (San Diego)

32. Torrey Pines State Reserve (San Diego)

33. Balboa Park (San Diego)

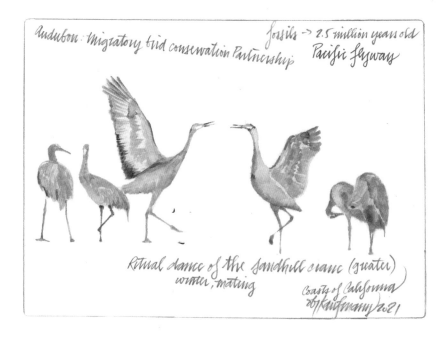

05. As Above, So Below

The Coasts of California

Map 05.09

## 05.09 INSIDE THE OAK WOODLAND
*California's hardwood habitat*

A woodland is not a forest. A woodland is a habitat where there is plenty of space between individual trees—defined as 20%–60% tree cover.[76] Although there are as many as twenty species of oak, *Quercus* sp., across California, there are five major types of foothill oak woodland communities that exist along the coastal ranges south of Mendocino National Forest

and along the west slope of the Sierra Nevada:[77] blue oak, *Quercus douglasii*; coast live oak, *Quercus agrifolia*; valley oak, *Quercus lobata*; Oregon oak, *Quercus garryana* (not generally a coastal species); and Engelmann oak, *Quercus engelmannii* (San Diego County).

Oak woodlands are biodiversity hotspots, but they have a relatively simple mix of tree species that shape the communities. Throughout California's oak woodlands—woodlands where oaks are regarded both as foundation species and as ecosystem engineers—thousands of understory and herb-layer plants support a community of over three hundred species of vertebrates and thousands of invertebrate species.[78]

## Services of the oak woodland

Oak woodlands store so much carbon that studies suggest that reforestation of destroyed oak habitat could sequester 1 percent of the state's current carbon emissions annually over the next seventy-five years.[79] Oak woodlands regulate groundwater and balance hydrology, promote soil fertility, and provide habitat to hundreds of game and nongame wildlife species.

## Threats to the oak woodland

California's oak woodlands are under threat from climate change (drought and fire regime disturbance); livestock grazing (woodland understory destruction); disease (massive die-off from sudden oak death and other pathogens); agricultural conversion (destruction for agriculture); and urban and residential development.[80]

Map 05.09 describes eight locations where the degree of variation in oak woodland is significant enough from the others to warrant their distinction.

01. Round Valley, location of the largest valley oak in the world[81]

02. Sonoma County, Trione-Annadel State Park, the site of twelve naturally hybridized oak species[82]

03. Ohlone Regional Wilderness, largest intact oak woodland in the East Bay Area[83]

04. Carmel Valley, Mitteldorf Preserve, 1,000 acres of oak woodland and redwood riparian habitat[84]

05. Los Osos Oaks State Natural Reserve, stunted, centuries-old oak woodland atop sand dunes[85]

06. Jack and Laura Dangermond Preserve, 24,000-acre coastal preserve of enormous and intact oak woodland

07. Lang Tree, Encino, site of a historic and massive valley oak that, after living for a thousand years, fell over in 1998; the city mourned[86]

08. San Diego County and Orange County, extent of Englemann oak habitat in California

# The Coasts of California

Map 05.10

## 05.10 FORESTS ON THE SHORE
*Coastal arboreal diversity*

The character of arboreal habitat along coastal California is as varied as it is in any montane habitat inside California's Floristic Province. Every tree species has a different way of handling fire, stress, reproduction, and its own ecological requirements. A tour of tree types from conifers to hardwoods along the coasts reveals how diverse arboreal habitats can be.

### Sitka spruce, *Picea sitchensis*

One of the world's largest conifers, the Sitka spruce is the defining tree of the bioregion called the Pacific Northwest temperate rainforest. Its southernmost extent is near Mendocino, and from there, its range extends north to Alaska.[87]

### Knobcone pine, *Pinus attenuata*

The seeds inside this closed-cone pine species will open only under the duress of extreme temperatures of fires, like those of many other pine and cypress species generally associated with this tree, which is generally known for topping out at a height of eighty feet.[88]

### Pacific madrone, *Arbutus menziesii*

One of five nonoak species susceptible to sudden oak death. This disease is caused by *Phytophthora ramorum*, a so-called wet mold related to a fungus that has wreaked havoc on California's coastal forests.[89] The pathogen has been so fast moving that it has killed over 50 million trees and infected four times that many in the last twenty years.[90]

### Coulter pine, *Pinus coulteri*

At a weight of up to four pounds, the spiny cone of the Coulter pine is the most massive pine cone in the world. The tree generally lives above 3,000 feet and is one of the tallest members of the chaparral vegetative alliance.

### Bigcone Douglas fir, *Pseudotsuga macrocarpa*

The distribution range of the Bigcone Douglas fir, one of the largest trees in Southern California, does not extend more than thirty-five miles north of the Transverse Ranges.[91] Look for its dark shape toward the ridgeline, its wild limbs twisted over a shrubby, riparian understory.

### Torrey pine, *Pinus torreyana*

The current population of what is arguably the rarest pine tree in the world is about 3,000 individuals on the San Diego coast (see 07.25) and about 2,000 (of what is probably the same species) on the eastern side of Santa Rosa Island.[92]

The Coasts of California

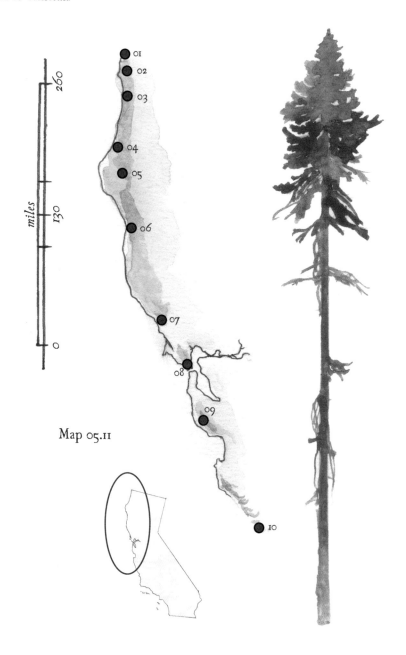

Map 05.11

## 05.11 THE GREAT ICON
*Old growth in the kingdom of the redwood*

How many ways can you describe a redwood tree? Most would start with the shape of the tree body itself. You see the trunk and the needles and the size of individual thing as one united entity, a whole unto itself. But then you adjust your scale. You can back up and see that the tree exists inside a forest-like habitat zone. You might see the soil, alive with ubiquitous mycorrhizae that reach out with ostensibly endless hyphae, forming a communication network of subterranean, arboreal chemicals connecting a galaxy of trees in one looping signal. You might see that the redwood exists in a thin climatic belt, a Goldilocks zone between the coast (never too close, as salinity would be detrimental) and never too far upslope, as coastal redwood cannot handle snow or the aridity that comes with inland elevation. You might see through time and look into and describe a genetic heritage that spans several hundred million years, before flowering plants, when redwoods were found across the primordial continent.

And then you can adjust your scale again and zoom in on the forest within the tree itself—spruce and huckleberry that have taken root in the canopy soil, salamanders and crustaceans that have evolved to live in this specific niche, hundreds of feet in the air. You may see the radiator-like technology that the redwood employs through billions of flat needles, creating, in essence, a breathing weather machine, biological climate control that, in a forest biomass greater than any other on earth, helps cool the planetary atmosphere. As you looked into the past, you might look into the future and see a tree that will live for a few thousand more years, survive fire, flood, pathogen, and even humanity. When you begin to describe the one tree, how could you not end up describing the whole world as it moves in living space and time?

Map 05.11 describes the range of the coast redwood, *Sequoia sempervirens*; the numbered items indicate where significant old-growth habitat remains.

01. Northernmost extent of the range of the California coastal redwood

02. Jedediah Smith Redwoods State Park—Stout Grove

03. Prairie Creek Redwoods State Park

04. Headwaters Forest Reserve

05. Humboldt Redwoods State Park

06. Jackson Demonstration State Forest

07. Russian River watershed

08. Muir Woods National Monument

09. Big Basin State Park

10. Southernmost extent of the range of the California coastal redwood

The Coasts of California

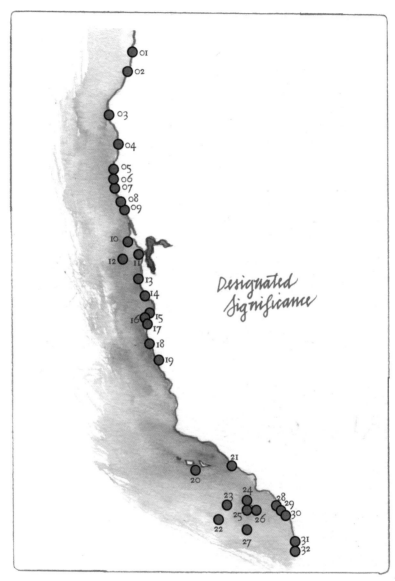

Map 05.12

## 05.12 SPECIFIC STRESSORS
*Areas of Special Biological Significance*

The agency whose responsibility it is to monitor and maintain water quality for human and so-called environmental use and to enforce surface water rights across the state is the State Water Resources Control Board, also called the State Water Board.[93] Its jurisdiction includes all the lakes, rivers, estuaries, bays, streams, and creeks inside the state along with the entirety of California's coastline.[94] By its analysis, coastal California has thirty-two Areas of Special Biological Significance[95] and State Water Quality Protection Areas, all of which are compromised or injured by a litany of stressors:

Agricultural runoff (including pollutants from livestock)
Altered water flows caused by infrastructure (dams and irrigation)
Camping waste
Contamination from shipping lanes
Fishing waste
Freshwater input caused by fluctuating river temperatures
Industrial contaminants
Nitrogen and pathogens from wildlife waste
Parking lot, road, and storm runoff
Removal of riparian vegetation
Sediment from past and present timber harvest
Septic leakage
Urban runoff (sewer discharge, treated sewage, heavy metals, and landscape drainage)
Year-round commercial fishing

Areas of Special Biological Significance

01. Redwood National Park
02. Trinidad Head
03. King Range
04. Jughandle Cove
05. Saunders Reef
06. Del Mar Landing
07. Gerstle Cove
08. Bodega
09. Bird Rock
10. Point Reyes Headlands
11. Duxbury Reef
12. Farallon Islands
13. James V. Fitzgerald
14. Año Nuevo
15. Pacific Grove
16. Carmel Bay
17. Point Lobos
18. Julia Pfeiffer Burns
19. Salmon Creek Coast
20. San Miguel, Santa Rosa, and Santa Cruz Islands
21. Laguna Point to Latigo Point
22. San Nicholas Island and Begg Rock
23. Santa Barbara Island and Anacapa Island
24. Northwest Santa Catalina Island
25. Western Santa Catalina Island
26. Southeast Santa Catalina Island
27. San Clemente Island
28. Robert E. Badham
29. Irvine coast
30. Heisler Park
31. San Diego-Scripps
32. La Jolla

# The Coasts of California

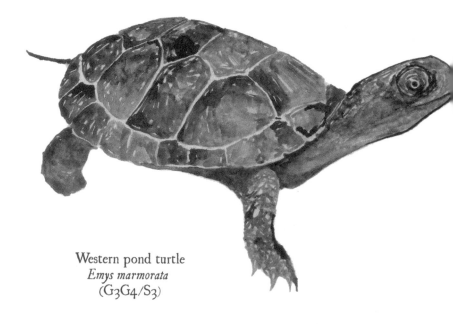

Western pond turtle
*Emys marmorata*
(G3G4/S3)

# 06. ALL CREATURES GREAT AND SMALL
*Coastal biodiversity*

In a strange game that I don't think we are aware of playing, we are testing how far California's ecosystems will stretch before they break. We watch the good numbers fall and the bad numbers rise. The metrics that are waning tragically, including population counts and total habitat area, together herald a dangerous trend of ecological simplification. The catastrophic waxing statistics include compounding environmental stressors and the rise of plastic-toxicity concentrations that insidiously work to destroy the biological complexity these ecosystems depend on.

There are some notable exceptions to this terrible trend; for example, many marine mammal populations are generally increasing, and we can attribute that to decades of good conservation policy and community activism at many scales. It is unclear whether successes such as the removal of several populations of humpback whale from the endangered species list or the rebounding of elephant seal populations over the past century are long lasting or whether, in the face of increased shipping traffic and marine pollution, we've only bought a little time and are still losing the long game.

*Previous page:*
North American beaver
*Castor canadensis*
Once common on the California coast, beaver ponds are known for the riparian biodiversity they support.

If fractious humanity could imagine itself playing the world's most dangerous game, where we envision victory as the establishment of abiding ecological complexity and where defeat is the collapse of the biosphere into a fragile state of simplified dysfunction, we might realize a path to success. We could conduct a win-win negotiation with nature, our false opponent. Regardless of the strategy we adopt, and even though we are one of the few species that has ever attained a social organization of global consequence, nature always wins. The way we join in this victory is to work at keeping all the pieces on the board, to help as many species as possible remain in their respective niches. Where species can continue to live, they can ensure that their surroundings remain ecologically complex, sustaining their ecosystems' functions. To understand what the rules of the game are, we study what pieces the game is played with, and as we endeavor to understand how and why biodiversity is important, we have to remember the relationships among the individual pieces.

This chapter is broken down into two basic parts. The first is a tour of the trophic strata within the food web of the kelp forest. Trophic strata are the organized layers of predator and prey relationships that extend to the primary sources of energy in the ecosystem, or the base of the food web. The now-endangered kelp forest is a common enough ecosystem that offers what might be the most robust

marine inventory of biodiversity for our trophic investigations. The second part of this chapter is a tour of some major animal categories: (1) animals listed as endangered, (2) amphibians, (3) nonmarine fish, (4) pinnipeds, (5) shorebirds, (6) sea turtles, (7) sharks, (8) raptors, (9) dolphins, (10) seabirds, (11) crustaceans, (12) whales, and (13) anadromous fish. What at first seems to be a motley collection of charismatic predators is in fact a list of popular animals, many of which are either keystone species, indicator species, or ecological engineers.

A keystone species performs a function within an ecosystem on which many other species depend and without which that ecosystem would be radically altered—an example includes orca and other apex predators (predators that are not preyed on themselves) that influence behavior at every trophic level from the top down. Another example is kelp, which provides habitat and food resources at every trophic level from the bottom up.

An indicator species serves as a bellwether of the health of its ecosystem, most often because of its physiological sensitivity to chemical disturbance, such as pollution. Examples include amphibians of many types, including the lungless salamander, which breathes through its skin.

Ecological engineers are species that, by nature of their behavior, create habitat niches within the ecosystem that can be occupied by other species; the beaver and its reservoir ponds are an excellent example of this engineering behavior.

Although the future is uncertain for the superlative biodiversity of the California Current ecosystem network, as it is home to more than thirty species of threatened and endangered animals, to our knowledge it continues to retain its entire complement of species. Although not a single extinction in its marine ecosystems has yet been recorded,[1] that time might be coming to an end. The fact that this is the case is either a truthful metric of hope and a good sign that the protections we've implemented are working, or it is a bitter testimony to the opaque nature of ecological truth—namely, that our data is incomplete and that it is very difficult and even dangerous for the conservation biologist to declare a species extinct. If you declare a species extinct, hope is lost, and with it, legislative protection.

For now, let us enjoy and study the grand parade of life and celebrate its complicated nature and ancient identity, from the plankton to the vertebrates that have evolved on the shoreline for half a billion years and longer. We can bear witness to this extant complexity and gather knowledge of its inventory. Every species and every niche is precious and worthy of its ageless legacy, an important piece in a very long game of evolution and interconnected survival.

# The Coasts of California

> I enjoy the scientific names of species. They sound poetic. I like to let them sit in my mouth and emerge slowly, like a lyrical phrase. The scientific name is so much better than the common name. There is information in the binomial nomenclature. The scientific name holds the taxonomy of the organism, and inside that taxonomy is the whole tree of life. By understanding the taxonomy, we acknowledge that organism's history and its inherent, interconnected value within the biosphere. Embedded in the sound is the witness of being.

Santa Lucia Mountains slender salamander
*Batrachoseps luciae*
(G2G3/S3)

## 06.01 FOOD WEB IN THE WAVES
*Biodiversity and ecosystems*

Taking a conceptual walk up (or down) the trophic ladder inside the kelp forest can be a tricky process. It doesn't quite work like its corresponding terrestrial analog. On land, the biomass pyramid is intuitive: grass and plants are the base, moving up to herbivores, through to predators, in a rational manner that follows the flow of energy through the system up to the apex. In a marine system, there is regularly more biomass, and thus energy, in zooplankton than there is in phytoplankton. That's because the animal-like character of zooplankton can be both herbaceous and predatory
—a nondiscriminatory class of filter feeders.

In the marine food web, the opportunity for energy does not restrict itself in terms of size or scale. The largest animals in the history of life on earth, the baleen whales, exclusively eat some of the smallest—most notably krill. It should also be noted that krill (specifically Antarctic krill, *Euphausia superba*) are individually small (25–30 mm), but together form the largest biomass of any single species on the planet.[2]

# The Coasts of California

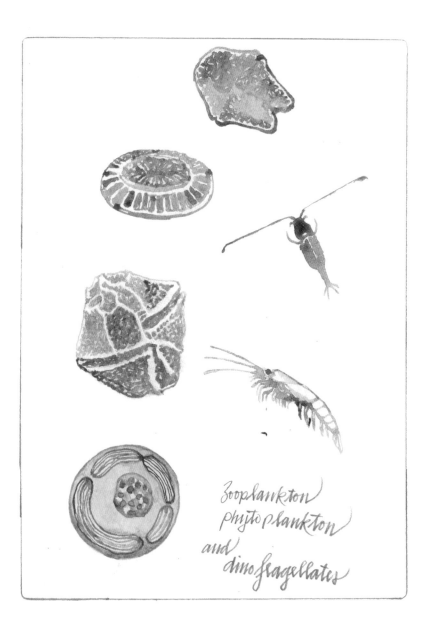

zooplankton phytoplankton and dinoflagellates

## 06.02 THE MICROSCOPIC BASIS FOR OCEANIC LIFE
*Plankton*

Even more than being the basis for all marine food webs, plankton may be responsible for the biosphere we all enjoy, not only because they continue to contribute more than half of the world's breathable air but also because of their ancient relationship to the atmosphere.[3] Five hundred million years ago, long before there was any land life, phytoplankton (single-celled plants, specifically cyanobacteria) cumulatively generated enough oxygen (the by-product of photosynthesis) to yield the relative balance of atmospheric chemistry of the modern world. It is reasonable to conclude, as the science seems to show, that if we understand how oceanic microbiology interacted with the paleoclimate, we might have a better understanding of what is happening with the earth's climate today.[4]

It would be too easy to state that plankton comes in two types—phytoplankton (plants) and zooplankton (animals). There is in fact a third type, the dinoflagellate. Dinoflagellates are self-mobile like animals, but are also autotrophic, like plants. *Lingulodinium polyedra* is a species of dinoflagellate that produces the red tide across Southern California when it blooms in the summer and fall, creating visible swaths that look like streaks of red on the waves and are moderately toxic to humans and marine life.[5] Another dinoflagellate, *Akashiwo sanguinea*, is responsible for the sea foam that gets whipped up by the pounding action of waves on the beach and may be harmful to birds but not to humans.[6]

Most phytoplankton, or microalgae, are called diatoms; they build skeleton structures out of silica that protect them from their bruising aquatic environment. About thirty-four thousand species of diatom are estimated to exist,[7] and they are so numerous that they account for almost half of the plant life, also called primary production, in the ocean;[8] the blanket of diatom shells on the seafloor can be a half-mile thick.[9] Alarmingly, diatomic biodiversity is decreasing around the globe (perhaps as much as 60% in the northern Pacific over the past one hundred years), which may result in a corresponding inability of the ocean to absorb greenhouse gases.[10]

Zooplankton can be all manner of tiny creatures, from those that spend their whole lives as tiny creatures, such as any one of the hundreds of species of radiolarians, to the small jellyfish, copepods, and crustaceans that often begin their lives small but then grow to larger forms. The collective weight of all these microorganisms—the single-celled algae, zooplankton, and bacteria, from production (photosynthesis) to decomposition—is roughly equivalent to 240 billion African elephants.[11]

The Coasts of California

Bull Kelp

06. All Creatures Great and Small

## 06.03 FROM BACTERIA TO SEA GRASS
*Regional primary producers of the kelp forests*

Look out from the shore along any number of California's coasts that harbor kelp forest habitat, and you can hardly detect the massive brew of life stirring just past the break of the waves on the beach. Most only see it as flotsam on the beach, the remnants of the great botanical world in the cold Pacific, but get out into it via scuba or snorkel, and delight in an arboreal habitat free from the bounds of gravity in a dense habitat space unlike any other.

damsel fish

Regional Distribution

S—*Southern California coasts*
C—*Central California coasts*
N—*Northern California coasts*

## Primary Producers of the Kelp Forests

*Dictyota* sp., Dictyota—S
*Eisenia* arborea, Eisenia—S
Order Corallinales, erect coralline algae—N, C
Order Corallinales, foliose red algae—N, C
*Laminaria farlowii*, kelp—S
*Laminaria setchellii*, kelp—N, C
*Macrocystis pyrifera*, giant kelp—S, C
*Nereocystis luetkeana*, bull kelp—N, C
*Pelagophycus porra*, elk kelp—S
*Pleurophycus gardneri*, Gardner's kelp—N
*Pterygophora californica*, winged kelp—N, C

## 06.04 FROM SUSPENSION FEEDERS TO GRAZERS
*Primary consumers of the kelp forests*

If kelp forms the overstory of this submarine forest, its understory is populated with animals and animal-like creatures that to the human eye are flower-like: anemones and other invertebrates that are stationary and radially symmetrical, unconstrained by the two-dimensional nature of the dry landscape. Here the strategy is to let the nutrients come to you. At this level of the trophic pyramid, the strategy of nutrient acquisition is either (1) to expose as much real estate as possible to catch the food that either falls or is in the water column, suspended and waiting to be caught, or (2) to employ a grazing strategy across rocky fields covered in green, rich sustenance.

Heterotrophs on the floor of the kelp forest come in three varieties: grazers, planktivores, and detritivores. Grazers are mobile, herbivorous invertebrates that use a variety of specially adapted organs to mow algal nutrients from rocky surfaces. Planktivores are predators that feed on microorganisms suspended in the water column. They can be mobile (e.g., rockfish), or stationary (e.g., anemone). Detritivores scavenge nutrients from decomposing plants and animals and their waste.

abalone

red fan gorgonian

## Grazers of the Kelp Forests

*Aplysia californica*, California sea hare (grazer)—S
*Balanus nubilus*, giant barnacle (planktivore)—N ,C
*Calliostoma gemmulatum*, gem top snail (grazer)—N, C
*Centrostephanus coronatus*, crowned urchin (grazer)—S
*Chromis* ssp., damsel fish (planktivore)—S
*Cryptochiton stelleri*, gumboot chiton (grazer)—N, C
*Haliotis fulgens*, green abalone (detritivore)—S
*Haliotis kamtschatkana*, northern abalone (detritivore)—N
*Haliotis rufescens*, red abalone (detritivore)—S, N, C
*Haliotis sorenseni*, white abalone (detritivore)—S
*Leptogorgia chilensis*, red fan gorgonian (planktivore)—S
*Lytechinus variegatus*, green urchin (grazer)—S
*Megastraea undosa*, wavy turban snail (grazer)—S
*Metridium* ssp., clonal plumose anemone (planktivore)—N
*Norrisia norrisii*, Norrisia snail (grazer)—N
*Oxyjulis californica*, señorita fish (planktivore)—S, C
*Parastichopus parvimensis*, warty sea cucumber (detritivore)—S
*Patiria miniata*, bat star (detritivore)—S, C, N
*Pugettia producta*, northern kelp crab (grazer)—C, N
*Sebastes mystinus*, blue rockfish (planktivore)—C, N
*Strongylocentrotus franciscanus*, red urchin (grazer)—S, C, N
*Strongylocentrotus purpuratus*, purple urchin (grazer)—S, C, N
*Styela clava*, rough sea squirt (planktivore)—C, N
*Tegula brunnea*, brown turban snail (grazer)—C, N
*Tethya aurantium*, golf ball sponge (planktivore)—C, N
*Urticina crassicornis*, mottled anemone (planktivore)—N

## 06.05 FROM PREDATORY SNAILS TO OTTERS
*Secondary consumers of the kelp forests*

Here the chain begins to resemble a web, and a rational, staircase-like pyramid of prey and predators breaks. By this categorization, predators such as the lobster and the otter, as niche occupants of the same trophic level, might be juxtaposed. When describing these degrees of separation, many different pathways or vectors in the prey-predator relationship are possible—thus the appearance of a web instead of a single chain. One such pathway within the web (which resembles a chain in this example) might draw a line from orca, *Orcinus orca*, an apex predator, seven trophic degrees away from phytoplankton: the orca might prey on harbor seals, who prey on yellow tail tuna, who prey on benthic fish, who prey on small jellies, who prey on copepods, who prey on phytoplankton.

Increased complexity within the ecosystem's food web corresponds to that ecosystem's ability to withstand disturbance and maintain homeostasis. When the food web simplifies, due to extirpation or any other stress that leaves a niche vacant, cascading effects can occur that threaten the integrity of the ecosystem. The kelp forests of California and around the world are currently in the grip of one such trophic cascade. In the past five years, the long absence of the overhunted sea otter, coupled with sea star wasting disease, have made way for urchin populations to explode across the bull kelp forests of Northern California. Urchins prey on kelp as otter and sea star (particularly the sunflower sea star, *Pycnopodia helianthoides*, now extirpated from California[12]) prey on urchin. Due to the urchin population explosion (and other significant stressors, including an ongoing marine heat wave[13]), over 90 percent of the bull kelp forests have been transformed into urchin barrens, and it will take many decades for the kelp canopy to recover.[14]

*Garibaldi*

## 06. All Creatures Great and Small

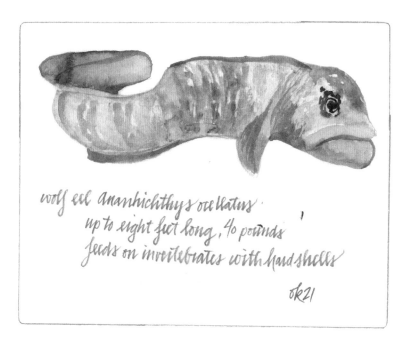

wolf eel *anarrhichthys ocellatus*
up to eight feet long, 40 pounds
feeds on invertebrates with hard shells

ok21

## Secondary Consumers of the Kelp Forests

*Anarrhichthys ocellatus*, wolf eel—N
*Ceratostoma foliatum*, hornmouth snail—C, N
*Enhydra lutris kenyoni*, northern sea otter—C
*Hexagrammos decagrammus*, kelp greenling—C
*Hexagrammos lagocephalus*, rock greenling—N
*Hypsypops rubicundus*, Garibaldi damselfish—S
*Kelletia kelletii*, Kellet's whelk snail—S
*Oxylebius pictus*, painted greenling—S, C
*Panulirus argus*, spiny lobster—S
*Pycnopodia helianthoides*, sunflower star—C, N
*Scorpaenichthys marmoratus*, scorpion fish—C
*Semicossyphus darwini*, Chilean sheepshead—S

## 06.06 FISH WHO EAT FISH WHO EAT FISH
*Tertiary consumers of the kelp forests*

Rockfish (genus *Sebastes*), sometimes called sea perch, have attained levels of biodiversity in the Southern California Bight that anoint them as a kind of royalty within their trophic niche. At least half of the world's 109 different species of predatory rockfish live in the kelp forests of California.[15]

Black rockfish

### Tertiary Consumers of the Kelp Forests

*Hemilepidotus hemilepidotus*, red Irish lord
*Ophiodon elongatus*, lingcod
*Paralabrax* ssp., rock bass
*Sebastes carnatus*, gopher sea perch
*Sebastes caurinus*, copper rockfish
*Sebastes chrysomelas*, black-and-yellow rockfish
*Sebastes guttata*, shortspine thornyhead
*Sebastes maliger*, quillback rockfish
*Sebastes melanops*, black rockfish
*Sebastes nebulosus*, China rockfish
*Sebastes serriceps*, treefish
*Solaster dawsoni*, morning sun star
*Synodus sciuticeps*, shorthead lizardfish

06. All Creatures Great and Small

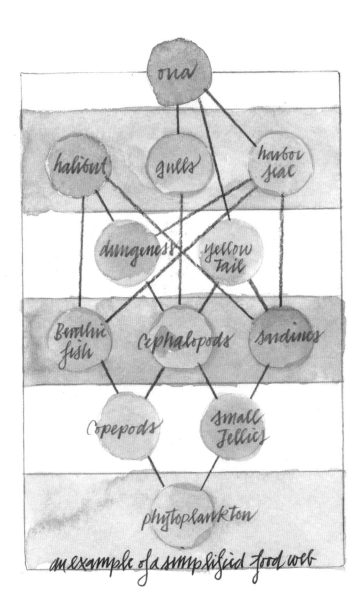

an example of a simplified food web

## 06.07 LIFE ON THE EDGE
*California's coastal endangered species*

In general, the species picked from the federal list of endangered species[16] for this particular grouping are determined by whether or not habitat for the species exists within sight of the coast. This list includes only species that are federally listed as endangered or threatened. All of California's endangered species, even those that find their habitat exclusively beyond the immediate reach of marine influence (in the Central Valley, the Sierra Nevada, and the deserts), depend on some service provided by California's proximity to the Pacific—especially the climate regimes influenced by the ocean, and the ways all life within the California Floristic Province has evolved in response. The remainder of this chapter provides a subjective selection of species, not an exhaustive survey of California wildlife conservation efforts.

DPS—distinct population segment
ESU—evolutionarily significant unit

### Invertebrates

*Apodemia mormo langei*, Lange's metalmark butterfly (San Francisco Bay Delta)
*Branchinecta conservatio*, conservancy fairy shrimp (Sonoma County)
*Branchinecta sandiegonensis*, San Diego fairy shrimp (San Diego County)
*Callophrys mossii bayensis*, San Bruno elfin butterfly (San Francisco Bay Area)
*Cicindela ohlone*, Ohlone tiger beetle (Santa Cruz County)
*Elaphrus viridis*, Delta green ground beetle (San Francisco Bay Delta)
*Euphilotes battoides allyni*, El Segundo blue butterfly (Los Angeles County)

ohlone tiger beetle

06. All Creatures Great and Small

*Euphilotes enoptes smithi*, Smith's blue butterfly (Monterey Bay area)
*Euphydryas editha bayensis*, Bay checkerspot butterfly (San Francisco Bay Area)
*Euphydryas editha quino*, Quino checkerspot butterfly (San Diego County)
*Glaucopsyche lygdamus palosverdesensis*, Palos Verdes blue butterfly (Los Angeles County)
*Haliotis cracherodii*, black abalone (Central and Southern California)
*Haliotis sorenseni*, white abalone (Southern California)
*Helminthoglypta walkeriana*, Morro shoulderband snail (San Luis Obispo County)
*Lycaena Hermes*, Hermes copper butterfly (San Diego County)
*Plebejus icarioides missionensis*, Mission blue butterfly (San Francisco Bay Area)
*Plebejus idas lotis*, lotis blue butterfly (Mendocino County)
*Polyphylla barbata*, Mount Hermon June beetle (San Cruz County)
*Pyrgus ruralis lagunae*, Laguna Mountains skipper (San Diego County)
*Speyeria callippe callippe*, Callippe silverspot butterfly (San Francisco County)
*Speyeria zerene behrensii*, Behren's silverspot butterfly (Sonoma County)
*Speyeria zerene hippolyta*, Oregon silverspot butterfly (Del Norte County)
*Speyeria zerene myrtleae*, Myrtle's silverspot butterfly (San Francisco Bay Area)
*Trimerotropis infantilis*, Zayante band-winged grasshopper (Santa Cruz County)

Fish

*Catostomus santaanae*, Santa Ana sucker (Los Angeles and Ventura Counties)
*Eucyclogobius newberryi*, Northern tidewater goby (Central and Northern California)
*Gasterosteus aculeatus williamsoni*, Unarmored threespine stickleback (Ventura County)
*Hypomesus transpacificus*, delta smelt (San Francisco Bay Delta)
*Oncorhynchus kisutch*, coho salmon (south of Punta Gorda, Humboldt County)
*Oncorhynchus mykiss irideus*, Steelhead/California Central Valley DPS
*Oncorhynchus mykiss irideus*, Steelhead/Central California Coast DPS
*Oncorhynchus mykiss irideus*, Steelhead/Northern California DPS
*Oncorhynchus mykiss irideus*, Steelhead/South Central California Coast DPS
*Oncorhynchus mykiss irideus*, Steelhead/Southern California DPS
*Oncorhynchus mykiss irideus*, Steelhead/summer run
*Oncorhynchus tshawytscha*, Chinook salmon/California Coastal ESU
*Oncorhynchus tshawytscha*, Chinook salmon/spring run of the Sacramento River drainage
*Oncorhynchus tshawytscha*, Chinook salmon/winter run
*Spirinchus thaleichthys*, longfin smelt (Southern, Central, and Northern California)

## Amphibians

*Ambystoma californiense*, California tiger salamander/Central California DPS
*Ambystoma californiense*, California tiger salamander/Santa Barbara County DPS
*Ambystoma californiense*, California tiger salamander/Sonoma County DPS
*Ambystoma macrodactylum croceum*, Santa Cruz long-toed salamander (Santa Cruz County)
*Rana draytonii*, California red-legged frog (Northern and Central California)

## Reptiles

*Caretta caretta*, loggerhead sea turtle/North Pacific DPS
*Chelonia mydas*, green sea turtle (Los Angeles County)
*Dermochelys coriacea*, leatherback sea turtle (Southern and Central California)
*Lepidochelys olivacea*, olive ridley sea turtle (Southern California)
*Masticophis lateralis euryxanthus*, Alameda whipsnake (Alameda County)
*Thamnophis sirtalis tetrataenia*, San Francisco garter snake (San Francisco Bay Area)

## Birds

*Artemisiospiza belli clementeae*, San Clemente sage sparrow (Southern California)
*Brachyramphus marmoratus*, marbled murrelet (Central and Northern California)
*Branta hutchinsii leucopareia*, Aleutian cackling goose (Northern California)
*Charadrius nivosus nivosus*, Western snowy plover (Central and Northern California)
*Empidonax traillii extimus*, Southwestern willow flycatcher (Southern and Central California)
*Falco peregrinus anatum*, American peregrine falcon (Northern California)
*Gymnogyps californianus*, California condor (Central and Southern California)
*Haliaeetus leucocephalus*, bald eagle (Northern California)
*Lanius ludovicianus mearnsi*, San Clemente loggerhead shrike (Southern California)
*Melospiza melodia graminea*, song sparrow (Southern and Central California)
*Pelecanus occidentalis californicus*, California brown pelican (Southern California)
*Phoebastria albatrus*, short-tailed albatross (Southern, Central, and Northern California)
*Polioptila californica californica*, coastal California gnatcatcher (Southern and Central California)
*Rallus obsoletus levipes*, light-footed Ridgway's rail (Central California)
*Rallus obsoletus obsoletus*, California Ridgway's rail (San Francisco Bay Area)
*Strix occidentalis caurina*, Northern spotted owl (Northern California)
*Vireo bellii pusillus*, Least Bell's vireo (Southern and Central California)

# Mammals

*Aplodontia rufa nigra*, Point Arena mountain beaver (Northern California)
*Arctocephalus townsendi*, Guadalupe fur seal (Southern California)
*Balaenoptera borealis*, sei whale (pelagic)
*Balaenoptera musculus*, blue whale (pelagic)
*Balaenoptera physalus*, fin whale (pelagic)
*Dipodomys heermanni morroensis*, Morro Bay kangaroo rat (Southern California)
*Dipodomys stephensi*, Stephens's kangaroo rat (Southern California)
*Enhydra lutris nereis*, Southern sea otter (Central California)
*Eschrichtius robustus*, gray whale/Eastern North Pacific DPS (pelagic)
*Eubalaena japonica*, North Pacific right whale (pelagic)
*Eumetopias jubatus*, Steller sea lion (Northern and Central California)
*Martes caurina humboldtensis*, Humboldt marten (Northern California)
*Megaptera novaeangliae*, humpback whale /Central America DPS (pelagic)
*Megaptera novaeangliae*, humpback whale/Mexico DPS (pelagic)
*Neotoma fuscipes riparia*, riparian woodrat (Northern, Central, and Southern California)
*Orcinus orca*, killer whale/Southern Resident DPS (pelagic)
*Perognathus longimembris pacificus*, Pacific pocket mouse (Southern California)
*Physeter macrocephalus*, sperm whale (pelagic)
*Reithrodontomys raviventris*, salt marsh harvest mouse (San Francisco Bay Area)
*Sylvilagus bachmani riparius*, riparian brush rabbit (Northern, Central, and Southern California)
*Urocyon littoralis catalinae*, Santa Catalina Island fox (Santa Catalina Island)
*Urocyon littoralis littoralis*, San Miguel Island fox (San Miguel Island)
*Urocyon littoralis santacruzae*, Santa Cruz Island Fox (Santa Cruz Island)
*Urocyon littoralis santarosae*, Santa Rosa Island Fox (Santa Rosa Island)
*Urocyon littoralis*, Island fox (Southern California)

Harbor seal pup

## 06.08 BIOSURVEY 01
*Amphibians*

*Source:* Data from "Reptiles and Amphibians of Coastal Southern California," CaliforniaHerps.com, http://www.californiaherps.com/identification/socalherps.html.

Across the globe, amphibian populations are struggling, and California is no exception. Due to anthropogenic stress across wetland ecosystems along California's coasts and inland, one in four species of amphibians is currently at risk of extinction.[17] Amphibians are ecologically considered indicator species, sometimes called sentinel species, because their bodies evolved to be sensitive to the chemistry of their habitat, and alterations to the delicate balance of that chemistry can result in their extirpation.[18] The indication then is the signaling of a tenacious cascade of pollutants that may extend to other trophic levels.

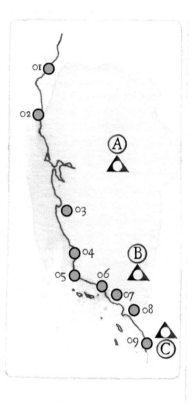

Taxonomic level: Family
Complete count (native and nonnative, coastal and inland)
Frogs and toads in California:[19]

Leiopelmatidae—tail-wagging frogs; 1 species
Bufonidae—true toads; 8 species
Hylidae—tree frogs; 4 species
Scaphiopodidae—spadefoots; 3 species
Ranidae—true frogs; 14 species
Leptodactylidae—thin-toed frogs; 1 species

Some notable coastal frogs and toads and their general ranges:

*Anaxyrus boreas halophilus*, California toad; south of Humboldt Bay (01)

*Anaxyrus californicus*, arroyo toad; San Diego County (09) and Transverse Ranges (B)

*Eleutherodactylus coqui*, common coqui, not native to California; south from Los Angeles County (08)

*Lithobates catesbeianus*, American bullfrog, not native to California; across all of coastal California

*Pseudacris cadaverina*, California treefrog; Santa Monica Mountains (07), Transverse (B) and Peninsular Ranges (C)

*Pseudacris hypochondriaca hypochondriaca*, Baja California treefrog; Point Conception (05) south to Baja

*Rana draytonii*, California red-legged frog; south from Point Arena (02) and the Sierra Nevada (A)

*Spea hammondii*, western spadefoot; Salinas River (03) and south from Morro Bay (04)

*Xenopus laevis*, African clawed frog, not native to California; south from Ventura County (06)

Baja California treefrog
*Pseudacris hypochondriaca hypochondriaca*

Taxonomic level: Family
Complete count (native and nonnative, coastal and inland)
Salamanders (order Caudata) in California:[20]

Ambystomatidae—mole salamanders; 6 species
Rhyacotritanidae—torrent salamanders; 1 species
Salamandridae—newts; 4 species
Plethodontidae—lungless salamander; 32 species

## Salamanders and their general ranges:

*Ambystoma mavortium mavortium*, barred tiger salamander,
  not native to California; Salinas River (03)

*Aneides lugubris*, arboreal salamander; south from Humboldt Bay (01)

*Batrachoseps major major*, garden slender salamander; San Diego County (09)

*Batrachoseps nigriventris*, black-bellied slender salamander;
  Central and Southern California

*Ensatina eschscholtzii eschscholtzii*, Monterey ensatina; south from Morro Bay (04)

*Taricha torosa*, California newt; Marin County to the Santa Ana Mountains (C)

Mount Diablo, Contra Costa County, and California newt, *Taricha torosa*

## 06.09 BIOSURVEY 02
*Nonmarine fish*

A. Humboldt County
B. San Francisco Bay Area
C. Monterey Bay
D. Los Angeles County

01. Russian River
02. Santa Clara County
03. Pajaro and Salinas watersheds
04. Point Conception
05. Ventura County
06. Santa Monica Mountains
07. Orange County
08. San Diego County

Of the 120 species of freshwater, anadromous, and euryhaline (nonmarine) fish currently extant in California, only about half, or exactly 67 species, are native.[21] Of that number of native fish species, less than half, or exactly 27 species, enjoy viable secure populations across California's diverse freshwater habitats.

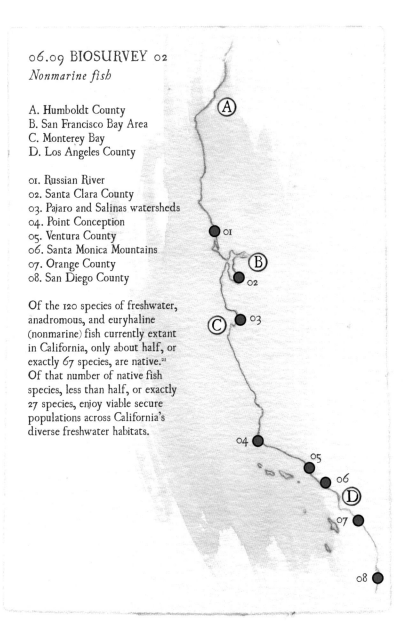

06. All Creatures Great and Small

Taxonomic level: Family
Complete count: 125 (native and nonnative, coastal and inland, extant and presumed extinct)
Freshwater, anadromous, and euryhaline fish in California:

Petromyzontidae—lampreys; 7 species
Representative coastal species: *Lampetra tridentata tridentata*, coastal Pacific lamprey; below dams in riverine Northern and Central California

Acipenseridae—sturgeons; 2 species
Representative coastal species: *Acipenser medirostris*, green sturgeon; Monterey Bay (C) and estuaries north[22]

Elopidae—tenpounders; 1 species
Representative coastal species: *Elops affinis*, Pacific ladyfish (invasive); shallow inshore waters south from Los Angeles County (D)

Clupeidae—minnows; 50 species and subspecies
Representative coastal species: *Lavinia exilicauda harengus*, Monterey hitch; Pajaro and Salinas (O3) riverine habitats

Catostomidae—suckers; 16 species and subspecies
Representative coastal species: *Catostomus occidentalis humboldtianus*, Humboldt sucker; watersheds of Humboldt County (A)

Cobitidae—loaches; 1 species
Representative coastal species: *Misgurnus anguillicaudatus*, Oriental weatherfish (invasive); watersheds of Orange County[23] (O7)

Monterey hitch

06. All Creatures Great and Small

Ictaluridae—catfish; 7 species
Representative coastal species: *Ameiurus catus*, white catfish (invasive); drainages of the San Francisco Bay (B) and inland

Esocidae—pikes; 1 species[24]
Representative coastal species: *Esox lucius*, northern pike (invasive); California eradication successful in 2007[25]

Osmeridae—smelts; 4 species
Representative coastal species: *Thaleichthys pacificus*, eulachon; Humboldt Bay (A) and north

Salmonidae—salmon and trout; 59 species
Representative coastal species: *Oncorhynchus tshawytscha*, Chinook salmon; California Coastal ESU Russian River fall run; Russian River (01)

Cyprinodontidae—pupfish; 10 species[26]
Exist only in inland, freshwater environments in the Mojave Desert

Fundulidae—killifishes; 2 species
Representative coastal species: *Fundulus parvipinnis*, California killifish; estuaries south of Monterey Bay (C)

California killifish

Eulachon

217

*Russian River tule perch*

Poeciliidae—livebearers; 3 species
Representative coastal species: *Poecilia latipinna*, sailfin molly (invasive); San Diego County (08)

Atherinopsidae—silversides; 2 species
Representative coastal species: *Menidia beryllina*, inland silverside (invasive); San Francisco Bay and creeksheds of Alameda and Santa Clara Counties (02)

Gasterosteidae—sticklebacks; 6 species
Representative coastal species: *Gasterosteus aculeatus williamsoni*, unarmored threespine stickleback; estuaries from Point Conception south (04)

Cottidae—sculpins; 17 species
Representative coastal species: *Cottus asper*, coastal prickly sculpin; estuaries from Ventura County north (05)

Moronidae—bass; 2 species
Representative coastal species: *Morone saxatilis*, striped bass (invasive); San Francisco Bay Delta (B)

Centrarchidae—sunfish, bass, crappies; 12 species
Representative coastal species: *Lepomis macrochirus*, bluegill (invasive); Klamath and Eel watersheds and estuaries from the Russian River (01) south

Percidae—perch; 2 species
Representative coastal species: *Perca flavescens*, yellow perch (invasive); Klamath River (A) and San Francisco Bay Area (B)

Embiotocidae—surfperch; 4 species
Representative coastal species: *Hysterocarpus traski pomo*, Russian River tule perch; Russian River watershed (01)

Cichlidae—cichlids; 4 species
Representative coastal species: *Oreochromis aureus*, Blue tilapia (invasive); estuaries in the Santa Monica Mountains (05) and south

Mugilidae—mullet; 1 species
Representative coastal species: *Mugil cephalus*, striped mullet (invasive); estuaries in the Santa Monica Mountains (05) and south

Gobiidae—goby; 6 species
Representative coastal species: *Acanthogobius flavimanus*, yellowfin goby; San Francisco Bay Area (B) and Los Angeles County (07) and south

Pleuronectidae—flounders; 1 species
Representative coastal species: *Platichthys stellatus*, starry flounder; estuaries north of Point Conception (04)

Point Conception, Santa Barbara County

# The Coasts of California

## 06.10 BIOSURVEY 03
### Pinnipeds

The word *pinniped* is Latin for "fin-foot"[27] and refers to a diverse group of semiaquatic marine mammals generally referred to as seals. In the California Current, six species of pinniped feed and haul out onto hundreds of sites along the entirety of California's rocky shore. There are four so-called eared seals (tagged ES on page 221), so named because they have small, externally visible ears, and two so-called true seals (tagged TS on page 221), the harbor seal and the elephant seal, who have internal ears. *Arctocephalus townsendi*, the Guadalupe fur seal, is the only seal in the California Current that doesn't have a major rookery site within the borders of the state of California. The Guadalupe fur seal breeds and gives birth on Guadalupe Island in Mexico.[28]

○ *Eumetopias jubatus*, northern (Steller) sea lion

○ *Phoca vitulina richardsi*, harbor seal

● *Mirounga angustirostris*, northern elephant seal

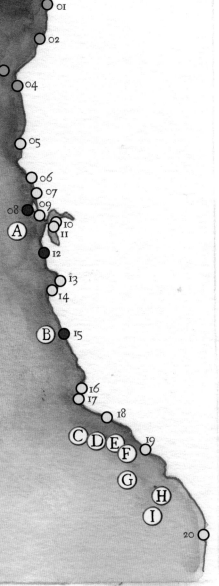

## 06. All Creatures Great and Small

*Zalophus californianus,*
California sea lion (ES)[29]

Major rookery sites:
    A. South Farallon Islands
    B. Año Nuevo Island
    C. San Miguel Island
    D. Santa Rosa Island
    E. Santa Cruz Island
    F. Anacapa Island
    G. Santa Barbara Island
    H. Santa Catalina Island
    I. San Clemente Island

*Eumetopias jubatus,*
northern (Steller) sea lion (ES)[30]

Major rookery sites:
    01. St. George Reef
    02. Sue-meg
    03. Sugar Loaf Island
    04. Sea Lion Gulch
    B. Año Nuevo Island
    C. San Miguel Island

Callorhinus ursinus,
northern fur seal (ES)[31]

Major rookery sites:
    A. South Farallon Islands
    C. San Miguel Island

*Phoca vitulina richardsi,*
harbor seal (TS)[32]

Major rookery sites:
    05. MacKerricher State Park
    06. Russian River
    07. Tomales Bay
    09. Bolinas Lagoon
    10. Castro Rock
    11. Yerba Buena Island
    13. Elkhorn Slough
    14. Point Lobos
    16. Vandenberg Air Force Base, Spur Road
    17. Vandenberg Air Force Base, First Cove
    18. Carpinteria
    19. Point Mugu Lagoon
    20. Casa Beach

*Mirounga angustirostris,*
northern elephant seal (TS)

Major rookery sites:
    08. Point Reyes
    12. Año Nuevo Coast Natural Preserve
    15. Point Piedras Blancas

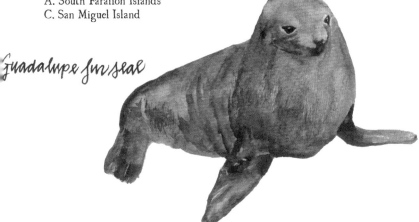

Guadalupe fur seal

# The Coasts of California

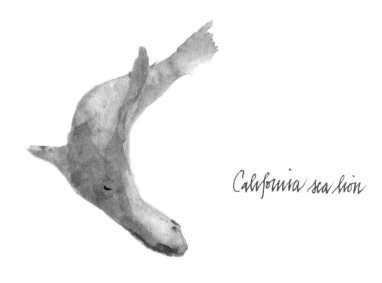

*California sea lion*

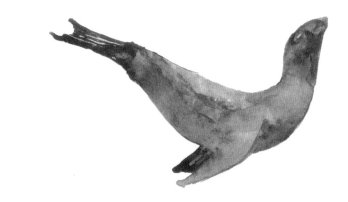

06. All Creatures Great and Small

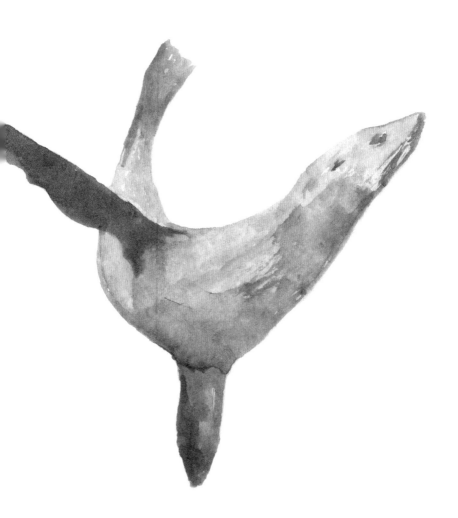

## 06.11 BIOSURVEY 04
*Shorebirds and waterfowl*

The Audubon Society, the stalwart organization dedicated to bird conservation, has identified fifty specific locales across California where more birds, both in species count and in individual numbers, congregate, for migratory rest or for nesting, than any other areas in the state.[33] These locations are used as measurements of inventory conservation by the Audubon Society and are simply called Important Bird Areas, or IBAs. Of the fifty top IBAs in the state, twenty-nine of them occur in relative proximity to the shore. Many of the IBAs boast annual visiting and nesting populations of tens of thousands of shorebirds, waterfowl, songbirds, and raptors.

What follows is a list of the shoreward IBAs with a small sample of unique bird species that are dependent on these locales, presented by their common name. (Conservation status varies.) There is a great deal of habitat overlap across California IBAs; this list emphasizes biodiversity, often omitting a more ubiquitous species in favor of including a species that may not be mentioned elsewhere in the survey.

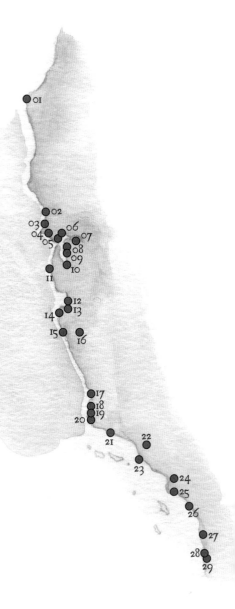

## 06. All Creatures Great and Small

01. Cape Mendocino grasslands
    Common murre, *Uria aalge*

02. Bodega Harbor
    Brant, *Branta bernicla*
    Black rail,
      *Laterallus jamaicensis coturniculus*
    Western snowy plover,
      *Charadrius alexandrinus nivosus*

03. Tomales Bay
    Dunlin, *Calidris alpina*
    Western sandpiper, *Calidris mauri*
    Yellow rail, *Coturnicops noveboracensis*
    Least bittern, Ixobrychus exilis

04. Bolinas Lagoon
    Great blue heron, *Ardea herodias*
    Great egret, *Ardea alba*
    Snowy egret, *Egretta thula*
    Black-crowned night heron,
      *Nycticorax nycticorax*

05. Richardson Bay
    Ruddy duck, *Oxyura jamaicensis*
    Clark's grebe, *Aechmophorus clarkii*
    Bufflehead, *Bucephala albeola*
    Greater scaup, *Aythya marila*

06. Corte Madera marshes
    California Ridgway's rail,
      *Rallus obsoletus*
    San Pablo song sparrow,
      *Melospiza melodia samuelsis*

07. Concord marshes
    American bittern,
      *Botaurus lentiginosus*
    Suisun song sparrow,
      *Melospiza melodia maxillaris*
    California least tern,
      *Sterna antillarum browni*
    Peregrine falcon, *Falco peregrinus*

08. Eastshore marshes
    California black rail,
      *Laterallus jamaicensis coturniculus*
    Burrowing owl, *Athene cunicularia*

09. Naval Air Station Alameda
    Least tern, *Sternula antillarum*
    Burrowing owl, *Athene cunicularia*

10. South San Francisco Bay
    California gull, *Larus californicus*
    Caspian tern, *Hydroprogne caspia*
    White-faced ibis, *Plegadis chihi*
    Marbled godwit, *Limosa fedoa*

Least bittern

The Coasts of California

11. Año Nuevo area
    Marbled murrelet,
      *Brachyramphus marmoratus*
    Vaux's swift, *Chaetura vauxi*
    Black swift, *Cypseloides niger*
    American dipper, *Cinclus mexicanus*

12. Elkhorn Slough
    Gadwall, *Mareca strepera*
    Northern pintail, *Anas acuta*
    Northern shoveler, *Spatula clypeata*
    Black skimmer, *Rynchops niger*

13. Upper Salinas River
    Western grebe,
      *Aechmophorus occidentalis*
    Clark's grebe, *Aechmophorus clarkii*
    Least Bell's vireo, *Bellii pusillus*

14. Point Lobos
    Elegant tern, *Thalasseus elegans*
    Little curlew, *Numenius minutus*
    Terek sandpiper, *Xenus cinereus*

15. Big Sur area
    Pigeon guillemot, *Cepphus columba*
    Ashy storm petrel,
      *Oceanodroma homochroa*
    Cassin's auklet,
      *Ptychoramphus aleuticus*
    Tufted puffin, *Fratercula cirrhata*

16. Lower Salinas River
    American white pelican,
      *Pelecanus erythrorhynchos*
    Long-billed curlew,
      *Numenius americanus*
    Loggerhead shrike,
      *Lanius ludovicianus*

17. Morro Bay
    Bell's sparrow, *Artemisiospiza belli*
    Western snowy plover,
      *Charadrius alexandrinus nivosus*
    Marbled godwit, *Limosa fedoa*

18. Santa Maria River Valley
    Warbling vireo, *Vireo gilvus*
    Swainson's thrush, *Catharus ustulatus*
    Rhinoceros auklet,
      *Cerorhinca monocerata*

19. Santa Ynez River Valley
    Southwestern willow flycatcher,
      *Empidonax traillii extimus*
    Least Bell's vireo, *Vireo bellii pusillus*
    Tricolored blackbird, *Agelaius tricolor*

20. Vandenberg Air Force Base
    Mountain plover,
      *Charadrius montanus*

Yellow-billed cuckoo

Caspian tern

06. All Creatures Great and Small

*Northern pintail*

*Western grebe*

Yellow-breasted chat, *Icteria virens*
Western snowy plover,
   *Charadrius alexandrinus nivosus*

21. Goleta shore
    White-tailed kite, *Elanus leucurus*
    Belding's Savannah sparrow,
       *Passerculus sandwichensis*
    Least bittern, *Ixobrychus exilis*

22. Santa Clara River Valley
    Long-eared owl, *Asio otus*
    Yellow-billed cuckoo,
       *Coccyzus americanus*
    Summer tanager, *Piranga rubra*

23. Point Mugu Lagoon
    Light-footed clapper rail,
       *Rallus longirostris levipes*
    Pacific golden plover,
       *Pluvialis fulva*
    Brown pelican, *Pelecanus occidentalis*

24. Ballona Valley
    California least tern,
       *Sterna antillarum browni*
    Black-bellied plover,
       *Pluvialis squatarola*
    Willet, *Tringa semipalmata*

25. Terminal Island
    Royal tern, *Thalasseus maximus*
    Caspian tern, *Hydroprogne caspia*
    Elegant tern, *Thalasseus elegans*

26. Orange Coast shoreline
    Forster tern, *Sterna forsteri*
    Marsh wren, *Cistothorus palustris*
    Cactus wren,
       *Campylorhynchus brunneicapillus*

27. Camp Pendleton
    California gnatcatcher,
       *Polioptila californica*
    California least tern,
       *Sterna antillarum browni*
    Long-eared owl, *Asio otus*

28. Northern San Diego lagoons
    Marsh wren, *Cistothorus palustris*
    Gadwall, *Mareca strepera*
    Redhead, *Aythya americana*

29. Tijuana River Reserve
    Gull-billed tern,
       *Gelochelidon nilotica*
    California gnatcatcher,
       *Polioptila californica*
    Southwestern willow flycatcher,
       *Empidonax traillii extimus*

# The Coasts of California

## 06.12 BIOSURVEY 05
*Sea turtles*

The five species of sea turtle that live in the North Pacific all visit California to feed in its nutrient-rich offshore currents. Some, including the Pacific leatherback, the largest and deepest-diving sea turtle species in the world, breed as far away as Indonesia and traverse the Pacific Ocean in an annual migration.[34] Due to being killed in fishing equipment, the poaching of their eggs, and the pernicious ingestion of marine plastic, sea turtles have experienced a decline in their worldwide population of as much as 90 percent in the last thirty years, and all species are threatened with extinction, perhaps as soon as within the next thirty years.[35]

*Pacific hawksbill sea turtle*

06. All Creatures Great and Small

01. Olive ridley sea turtle, *Lepidochelys olivacea*; Humboldt Bay, northern extent of sightings in California[36]

02. Green sea turtle, *Chelonia mydas*; Russian River, northern extent of sightings in California[37]

03. Pacific leatherback sea turtle, *Dermochelys coriacea*; Monterey Bay, most concentrated sightings in California[38]

04. Pacific hawksbill sea turtle, *Eretmochelys imbricata bissa*; Point Conception, northern extent of sightings in California[39]

05. Loggerhead sea turtle, *Caretta caretta*; Pacific Loggerhead Conservation Area[40]

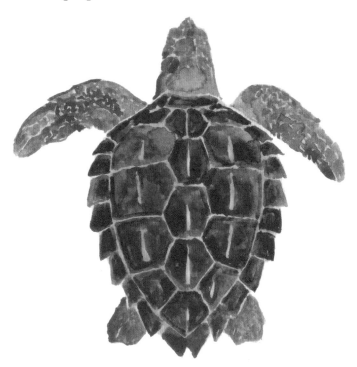

Loggerhead sea turtle

## 06.13 BIOSURVEY 06
*Sharks*

The elasmobranch group of marine predators (sharks and rays) contains over sixty species that feed and find habitat in the eastern Pacific of California and Mexico.[41] The ominously named Red Triangle is where the most abundant populations of California's most popular and feared shark, the great white, are commonly found, as it is a concentrated region for pinniped breeding (pinnipeds being the shark's preferred prey). Despite the great white's vicious reputation, attacks are extremely infrequent, and pale in comparison to the other mortal dangers of the coast, such as drowning. Sharks are found in all of California's benthic and pelagic ecosystems, as these apex predators are vital to the normal functioning of so many trophic systems, such as keeping pinniped populations in check, although nearly half of all species of sharks and rays are threatened with extinction.[42]

A. The Red Triangle[43]
  01. Bodega Bay; northern extent of the Red Triangle
  02. San Francisco Bay
  03. Monterey Bay
  04. Farallon Islands
  05. Point Sur; southern extent of the Red Triangle

06. All Creatures Great and Small

## Sharks of Monterey Bay National Marine Sanctuary, along with their conservation status[44]

Basking shark, *Cetorhinus maximus* (pelagic); vulnerable
Bat ray, *Myliobatis californica* (benthic); least concern
Blue shark, *Prionace glauca* (pelagic); near threatened
Brown smoothhound, *Mustelus henlei* (estuarine); least concern
Filetail catshark, *Parmaturus xaniurus* (benthic); least concern
Gray smoothhound, *Mustelus californicus* (estuarine); least concern
Leopard shark, *Triakis semifasciata* (estuarine); least concern
Prickly shark, *Echinorhinus cookei* (benthic); near threatened
Salmon shark, *Lamna ditropis* (pelagic); least concern
School shark, *Galeorhinus galeus* (benthic); vulnerable
Sevengill shark, *Notorynchus cepedianus* (benthic); data deficient
Sixgill shark, *Hexanchus griseus* (benthic); near threatened
Shortfin mako shark, *Isurus oxyrinchus* (pelagic); endangered
Spiny dogfish, *Squalus acanthias* (benthic); vulnerable
Thresher shark, *Alopias vulpinus* (pelagic); vulnerable
White shark, *Carcharodon carcharias* (pelagic); vulnerable

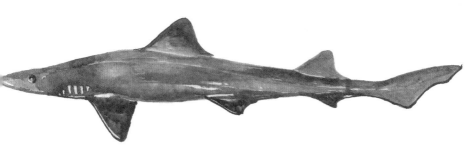

Gray smoothhound shark

## 06.14 BIOSURVEY 07
*Raptors and owls*

Ubiquitous in the sky across coastal California are the black silhouette of the scavenging turkey vulture, *Cathartes aura*, and the darting shape of the hunting red-tailed hawk, *Buteo jamaicensis*—perhaps the two most common coast raptor species. The raptor is an important predator with multiple responsibilities, including keeping rodent populations in check and keeping songbird populations strong. What follows is a list of special-status raptor species that find habitat within California; the map represents the range of five species that are indicative of raptor variety in geography and habitat type.

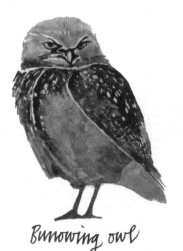

Burrowing owl

A—Coastal range of the Northern goshawk[45]
B—Coastal range of the California spotted owl[46]

Coastal range of the short-eared owl[47]
    Humboldt County (01)
    Santa Cruz County (03)

Coastal range of the burrowing owl[48]
    Alameda County (02)
    Orange County (04)
    San Diego County (05)

## Special-Status Raptor Species of California

Bald eagle, *Haliaeetus leucocephalus* (G5/S3)
Burrowing owl, *Athene cunicularia* (G4/S3)
California condor, *Gymnogyps californianus* (G1/S1)
California spotted owl, *Strix occidentalis occidentalis* (G3G4T2T3/S3)
Cooper's hawk, *Accipiter cooperii* (G5/S4)
Ferruginous hawk, *Buteo regalis* (G5/S3S4)
Flammulated owl, *Psiloscops flammeolus* (G4/S2S4)
Golden eagle, *Aquila chrysaetos* (G5/S3)
Great gray owl, *Strix nebulosa* (G5/S1)
Long-eared owl, *Asio otus* (G5/S3?)
Merlin, *Falco columbarius* (G5/S3S4)
Northern goshawk, *Accipiter gentilis* (G5/S3)
Northern harrier, *Circus hudsonius* (G5/S3)
Northern spotted owl, *Strix occidentalis caurina* (G5T3/S2S3)
Osprey, *Pandion haliaetus* (G5/S4)
Peregrine falcon, *Falco peregrinus anatum* (G4T4/S3S4)
Prairie falcon, *Falco mexicanus* (G5/S4)
Sharp-shinned hawk, *Accipiter striatus* (G5/S4)
Short-eared owl, *Asio flammeus* (G5/S3)
Swainson's hawk, *Buteo swainsoni* (G5/S3)
White-tailed kite, *Elanus leucurus* (G5/S3S4)

Peregrine falcon

The Coasts of California

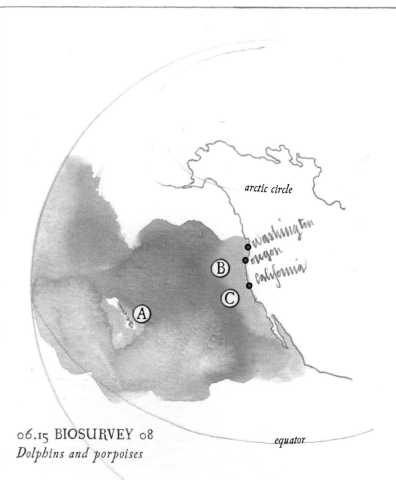

## 06.15 BIOSURVEY 08
### Dolphins and porpoises

There is more taxonomic crossover between a chimpanzee (family: Hominidae) and a human (family: Hominidae) than there is between a dolphin (family: Delphinidae) and a porpoise (family: Phocoenidae). These magnificently intelligent mammals, both from the order Cetacea, sometimes grow to large populations in the fish-laden California Current. All marine mammals are federally protected by the Marine Mammal Protection Act,[49] although

06. All Creatures Great and Small

too often, populations continue to decline due to the influence of human-caused stressors, including fishery destruction and overharvest, outright predation, illegal fishing practice, and pollution. There are eleven species of dolphin that inhabit the local area, generally defined as California, Oregon, and Washington, and two species of porpoise.[50] What follows is a census of these species within different regions, based on migratory and nonmigratory populations.

A—Hawai'i population
B—California, Oregon, and Washington population
C—California population

Short-beaked common dolphin, *Delphinus delphis* (B)
2016 estimated local population:[51] 969,861

Long-beaked common dolphin, *Delphinus capensis* (B)
2016 estimated local population: 68,432

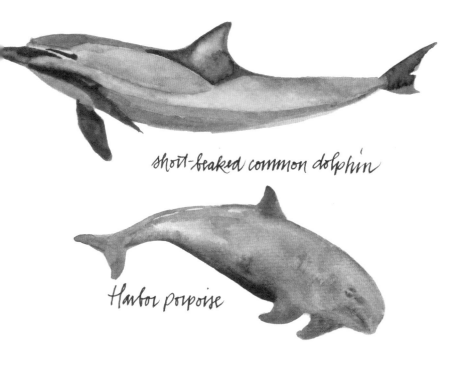

short-beaked common dolphin

Harbor porpoise

Short-finned pilot whale, *Globicephala macrorhynchus* (B)
2016 estimated local population: 816

Risso's dolphin, *Grampus griseus* (B)
2016 estimated local population: 6,336

Pacific white-sided dolphin, *Lagenorhynchus obliquidens* (B)
2016 estimated local population: 26,814

Northern right whale dolphin, *Lissodelphis borealis* (B)
2016 estimated local population: 26,556

Killer whale, *Orcinus orca* (C)
2017 estimated local population:[52] 512

False killer whale, *Pseudorca crassidens* (A)
2017 estimated local population:[53] 187

Pantropical spotted dolphin, *Stenella attenuata* (C)
2020 estimated local population:[54] greater than 2M

Striped dolphin, *Stenella coeruleoalba* (B)
2016 estimated local population: 29,211

Rough-toothed dolphin, *Steno bredanensis* (A)
2016 estimated local population:[55] 72,528

Common bottlenose dolphin, *Tursiops truncatus* (C)
2016 estimated local population:[56] 453

Dall's porpoise, *Phocoenoides dalli* (C)
2016 estimated local population: 27,750

Harbor porpoise, *Phocoena phocoena* (B)
2019 estimated local population:[57] 26,904

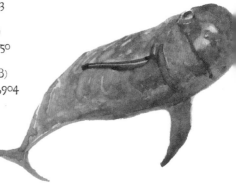

06. All Creatures Great and Small

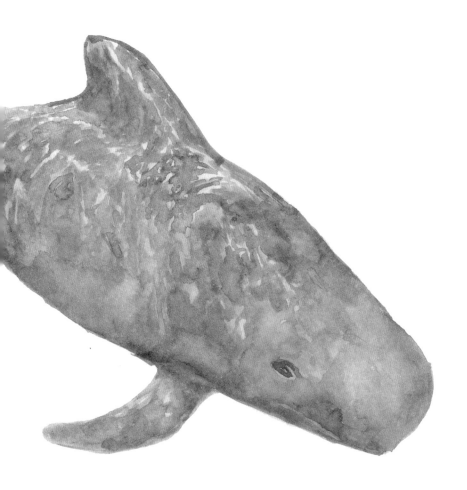

short-finned pilot whale

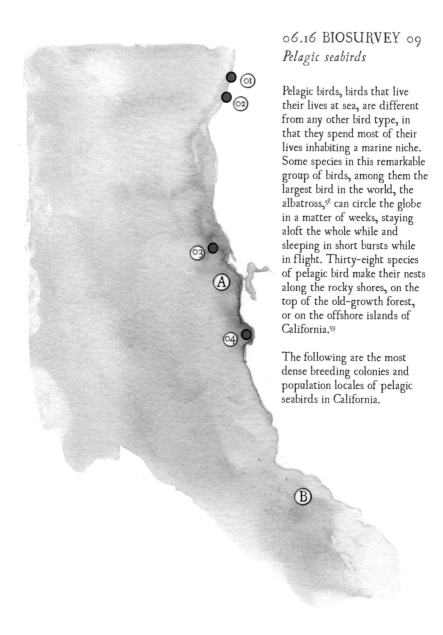

## 06.16 BIOSURVEY 09
*Pelagic seabirds*

Pelagic birds, birds that live their lives at sea, are different from any other bird type, in that they spend most of their lives inhabiting a marine niche. Some species in this remarkable group of birds, among them the largest bird in the world, the albatross,[58] can circle the globe in a matter of weeks, staying aloft the whole while and sleeping in short bursts while in flight. Thirty-eight species of pelagic bird make their nests along the rocky shores, on the top of the old-growth forest, or on the offshore islands of California.[59]

The following are the most dense breeding colonies and population locales of pelagic seabirds in California.

## 06. All Creatures Great and Small

A—Farallon Islands
B—Channel Islands

01. Castle Rock Reserve
02. Humboldt Bay Reserve
03. Cordell Bank
04. Monterey Bay

Most common pelagic bird types, with representative examples from California, and the conservation status by species:[60]

Albatrosses, family Diomedeidae
　Short-tailed albatross, *Phoebastria albatrus*
　(Vulnerable, G1/S1)

Cormorants, genus *Phalacrocorax*
　Brandt's cormorant, *Phalacrocorax penicillatus*
　(Least concern: population decreasing)

Frigatebirds, genus *Fregata*
　Magnificent frigatebird, *Fregata magnificens*
　(Least concern: population increasing)

Fulmars, genus *Fulmarus*
　Northern fulmar, *Fulmarus glacialis*
　(Least concern: population increasing)

Grebes, family Podicipedidae
　Western grebe, *Aechmophorus occidentalis*
　(Least concern: population decreasing)

Gulls, family Laridae
　Sabine's gull, *Xema sabini*
　(Least concern: population decreasing)

Loons, genus *Gavia*
　Pacific diver, *Gavia pacifica*
　(Least concern: population increasing)

Murres, genus *Uria*
　Common murre, *Uria aalge*
　(Least concern: population increasing)

Pelicans, genus *Pelecanus*
　Brown pelican, *Pelecanus occidentalis*
　(Least concern: population increasing, G4T3T4/S3)

Petrels, family Procellariidae
　Murphy's petrel, *Pterodroma ultima*
　(Threatened)

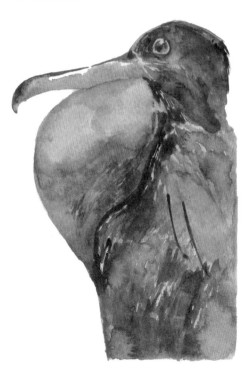

The Coasts of California

Phalaropes, genus *Phalaropus*
  Red phalarope, *Phalaropus fulicarius*
  (Least concern: population decreasing)

Puffins, genus *Fratercula*
  Tufted puffin, *Fratercula cirrhata*
  (Least concern: population decreasing, G5/S1S2)

Shearwaters, family Procellariidae
  Short-tailed shearwater, *Ardenna tenuirostris*
  (Least concern: population decreasing)

Storm petrels, genus *Hydrobates*
  Ashy storm petrel, *Hydrobates homochroa*
  (Endangered, G2S2)

Terns, subfamily Sterninae
  Arctic tern, *Sterna paradisaea*
  (Least concern: population decreasing)

Tropicbirds, genus *Phaethon*
  Red-billed tropicbird, *Phaethon aethereus*
  (Least concern: population decreasing)

Auklet, genus *Cerorhinca*
  Rhinoceros auklet, *Cerorhinca monocerata*
  (Least concern: population decreasing, G5/S3)

Skua, genus *Stercorarius*
Pomarine jaeger, *Stercorarius pomarinus*
(Least concern: population stable)

Magnificent Frigate Bird

06. All Creatures Great and Small

Loon skull (side)   Loon skull (top)

# The Coasts of California

## 06.17 BIOSURVEY 10
### Crustaceans and mollusks

The shelled invertebrate species of California's tide pools are dominated by the regularly recognizable crustaceans and the ubiquitous mollusks. If we were to consider just the crustaceans—crab, lobster, abalone, barnacles, copepods, water fleas, and shrimp—we would find hundreds of species in the tidal habitats of California. To be taxonomically correct, we should call them marine arthropods (phylum Arthropoda/subphylum Crustacea), recognize more than fifty thousand species around the globe, and pair them also with sea spiders (phylum Arthropoda/class Pycnogonida). Phylum Arthropoda includes the millions of species of terrestrial insect.

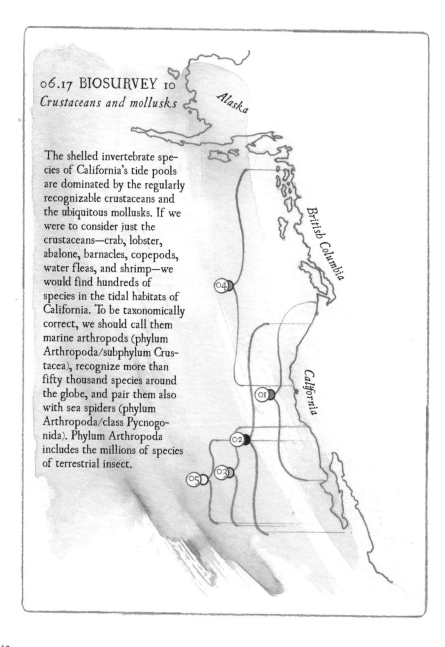

06. All Creatures Great and Small

Map 06.17 shows the special-status abalone species of California[61]

01. Pink abalone, *Haliotis corrugate* (G3?/S2?)
02. Black abalone, *Haliotis cracherodii* (G3/S1S2)
03. Green abalone, *Haliotis fulgens* (G3G4/S2)
04. Pinto abalone, *Haliotis kamtschatkana* (G3G4/S2)
05. White abalone, *Haliotis sorenseni* (G1/S1)

The following are the most common (and edible) species of crab in the genus *Cancer*:[62]

Dungeness crab, *Cancer magister*
Slender crab, *Cancer gracilis*
Rock crab, *Cancer antennarius*
Red crab, *Cancer productus*
Yellow crab, *Cancer anthonyi*

Mollusks (phylum Mollusca) are another group of organisms with incredible variety—about 110,000 species. The worldwide distribution of mollusk diversity is divided into four main classes[63]:

Bivalves (class Bivalvia): about 8,000 species
Gastropods (class Gastropoda): about 90,000 species
Cephalopods (class Cephalopoda): about 750 species
Chitons (class Polyplacophora): about 850 species

Dungeness crab

The Coasts of California

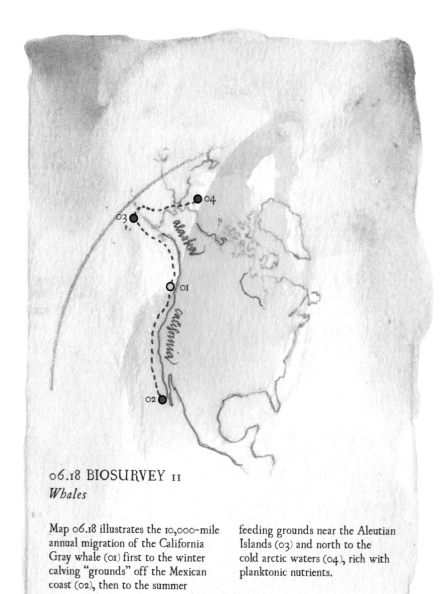

## 06.18 BIOSURVEY II
*Whales*

Map 06.18 illustrates the 10,000-mile annual migration of the California Gray whale (01) first to the winter calving "grounds" off the Mexican coast (02), then to the summer feeding grounds near the Aleutian Islands (03) and north to the cold arctic waters (04), rich with planktonic nutrients.

## 06. All Creatures Great and Small

> To share the planet, in this sliver of geologic time, with the largest animals to have ever existed and know that they are right now just offshore is among the great honors bestowed on our kind. Saving the whales from industrial exploitation is among the greatest achievements not only of the environmental movement but of modern society. It is monumentally important because it establishes a historical precedent that conservation activism, good policy, and economic brought to bear can alter the course of industrial momentum away from catastrophe.

There are nineteen true whales, order Cetacea, that can be found in the waters of the California Current.[64] They are listed here by family (six in all), along with their population status and adult average length.

### Eschrichtiidae

The gray whale is the only extant species in its family; it is not a rorqual whale (family Balaenopteridae) because of fundamental skeletal differences that indicate it had a different ancestor.

Gray whale, *Eschrichtius robustus*
(Least concern, population stable)
39'

### Balaenopteridae

This family of baleen whales comprises the most members, including the largest animals that have ever lived.

Six species can be found locally:

Blue whale, *Balaenoptera musculus*
(Endangered, population increasing)
82'

Bryde's whale, *Balaenoptera brydei*
(Least concern, population stable)
49'

Fin whale, *Balaenoptera physalus*
(Endangered, population trend uncertain[65])
63'

Humpback whale, *Megaptera novaeangliae*
(Least concern, population increasing)
50'

Minke whale, *Balaenoptera acutorostrata*
(Least concern, population increasing)
18'

Sei whale, *Balaenoptera borealis*
(Endangered, population trend uncertain[66])
60'

## Balaenidae

This family includes bowhead whales and right whales.

North Pacific right whale, *Eubalaena japonica*
(Endangered—population less than one hundred[67])
48'

## Kogiidae

This family includes two species, both of which are found in California; they are characterized by a facial feature that looks like a gill slit behind the cheek.[68]

Humpback whale

06. All Creatures Great and Small

Pygmy sperm whale, *Kogia breviceps*
(Least concern, population trend uncertain[69])
18'

Dwarf sperm whale, *Kogia sima*
(Least concern, population trend uncertain[70])
7'

## Physeteridae

The sperm whale is the only extant species in its family.

Sperm whale, *Physeter macrocephalus*
(Endangered, population decreasing)
40'

## Ziphiidae

These are the beaked and toothed whales found in California.

Blainville's beaked whale,
*Mesoplodon densirostris*
(Data insufficient to determine conservation status[71])
20'

Cuvier's beaked whale,
*Ziphius cavirostris*
(Least concern, population decreasing[72])
19'

Giant beaked whale,
*Berardius bairdii*
(Least concern, population trend uncertain[73])
36'

Ginkgo-toothed beaked whale,
*Mesoplodon ginkgodens*
(Data insufficient to determine conservation status[74])
16'

Hubbs' beaked whale,
*Mesoplodon carlhubbsi*
(Data insufficient to determine conservation status[75])
17'

Perrin's beaked whale,
*Mesoplodon perrini*
(Data insufficient to determine conservation status[76])
15'

Pygmy beaked whale,
*Mesoplodon peruvianus*
(Data insufficient to determine conservation status[77])
12'

Stejneger's beaked whale,
*Mesoplodon stejnegeri*
(Data insufficient to determine conservation status[78])
19'

The Coasts of California

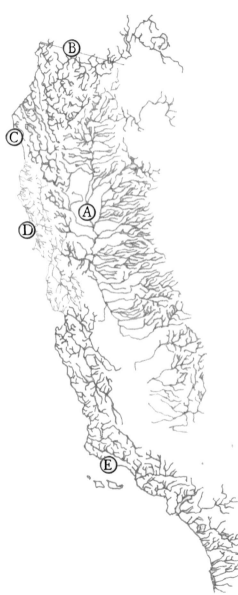

## 06.19 BIOSURVEY 12
*Anadromous fish*

Map 06.19 considers what have been called the recovery domains of California's salmon species.[79] The capillary-like, almost fractalized effect of the watercourses in this map represents a historical picture of the entirety of the range, free of impediment, when it was open spawning grounds for five of the six species that maintained populations in California and southern Oregon. Today there are only three species of wild salmon in California and eleven distinct population segments.

A—Central Valley
B—Southern Oregon/Northern California coast
C—Overlap of Northern California coast and north-central California coast
D—North-central California coast
E—South-central/Southern California coast

Genus *Oncorhynchus* with current or historical spawning grounds on the West Coast:

*Oncorhynchus gorbuscha*, pink salmon
    In California: historical spawning distribution only; no current population[80]

*Oncorhynchus keta*, chum salmon
    In California: historical spawning distribution only; no current population[81]

*Oncorhynchus kisutch*, coho salmon
    Central California coast coho (D); endangered
    Southern Oregon/Northern California coast coho (C); threatened

*Oncorhynchus mykiss*, steelhead
    Northern California steelhead (B, C); threatened
    California Central Valley steelhead (A); threatened
    Central California coast steelhead (D); threatened
    South-central California coast steelhead (E); threatened
    Southern California coast steelhead (E); endangered

*Oncorhynchus nerka*, sockeye salmon
    In California: no historical spawning populations[82]

*Oncorhynchus tshawytscha*, Chinook salmon
    Central Valley fall-run/late fall–run Chinook (A); species of concern
    Central Valley spring-run Chinook (A); threatened
    Sacramento River winter-run Chinook (A); endangered
    California Coastal Chinook (B, C, D); threatened

Sockeye salmon

# 07. A GOOD, LONG WALK
## *The California Coastal Trail*

There are moments on the trail that are joyfully lonely enough that I can remember a different kind of home, a home built in the ash of the old me that I burned to find this trail. This home becomes a sanctuary for the bits of me that survived the fire and that do not identify with human history. I become a machine of light and water. This is a proto-version of me that is broken off from the chaotic software of modernity. I forget how to paint. I forget how to write. It'll all be there for me to relearn when I return from this happy exile, but for now, every step I take is a step away from the bonfire I've made of all my work.

All the maps I make from the memory of this experience are maps back to this secret home. I'll share them with you. I'll share with you the great work that communities are doing to preserve these irreplaceable places, but I won't tell you where to go. Go find your own secret home. Find your place and either stake your ground and defend its natural workings, or pass through as the breeze, with respect and with no trace left. The earth will not remember you for anything but your legacy of leaving it undamaged.

# 07. A Good, Long Walk

Being about half completed, the California Coastal Trail (CCT) remains unrealized. When finished, the meandering route, which now crosses roads, and cuts from beach to bluff along California's twelve-hundred-mile shoreline, has the potential to be one of the nation's great walking trails. All such trails tell a story of the land they span—a bridge of natural and cultural history writ large across an expanse of geography revealed slowly in a long-distance walk, or a through-hike, as backpackers call it. Many of America's great through-hike opportunities—the Pacific Crest Trail, the Arizona Trail, the Rocky Mountain Trail, the Appalachian Trail—were built over the course of decades by various state agencies and nongovernmental organizations, but even these ambitious projects often did not have to negotiate the complex patchwork of property types that encumber the California shoreline. In the struggle to preserve and maintain California's coasts, completing the infrastructure for the CCT will be a milestone. Public access to the shore is the best antidote to the popular apathy that works to degrade its protection—the more that people know and love the shore, the greater their desire to protect it.

This chapter explores a generalized view of the world that the CCT runs through and is not a trail guide. Following from north to south, this survey includes geographic details from marine environments, intertidal and estuarine habitats, and the coastal uplands and ranges. Points of note include wildlife preserves, conservation refuges, parks and wilderness areas, ancillary hiking trails, sites of exceptional quality, and sanctuaries of essential value for marine, intertidal, avian, and terrestrial systems of life. Being somewhere between a thorough, if not entirely exhaustive, review of coastal conservation biogeography and a vision of California's coasts as an integrated whole is the guiding directive of this work.

# The Coasts of California

- Del Norte coast
- Redwood coast
- Humboldt coast
- Lost coast
- Sinkyone coast
- Mendocino coast
- Point Arena coast
- West Sonoma coast
- Point Reyes coast
- Golden Gate coast
- Halfmoon Bay coast
- Ano Nuevo coast
- Monterey coast
- Big Sur coast
- San Simeon coast
- Estero Bay coast
- San Luis Obispo coast
- Point Conception coast
- Santa Barbara coast
- Ventura coast
- Santa Monica coast
- San Pedro Bay coast
- San Clemente coast
- San Diego coast

*The waves crash through every human sense in this place of a billion sunsets where all parts are integral, and nothing is safe from the prismatic spray, and every bit is beautiful.*

Map 07.01

07. A Good, Long Walk

## 07.01 A MANY-FACETED DIAMOND
*The twenty-four coasts of California*

Organizing coastal California into twenty-four parts is an original contrivance to imagine the whole by analyzing the parts. A collection of maps presents a nonnarrative story that is apart from what is usually thought of as nature writing. This is a catalog that draws a happy albeit messy line between the objective and the subjective, between having an agenda and presenting information for information's sake. The cut diamond of twenty-four facets can be appreciated from any approach, and, reflecting this, the chapter proceeds as the trail does, from north to south, but may be used as a reference tool offering a holistic, nature-first vision of many different types of human and more-than-human coastal communities.

The content of each map is a fractalized inventory of threatened, precious places and projects that merit protection, interest, and stewardship. Every single point discussed could have an ancillary essay, an extended footnote addressing habitat restoration, connectivity, access, and justice; alas, that is not within the scope of this survey. The partial sentences presented throughout this chapter, indicative of the style of a field atlas, represent notes on the trail. What these maps add up to is a local's guide to coastal landmarks, not one of history but of ecology.

Humpback whale
*Megaptera novaeangliae*

255

The Coasts of California

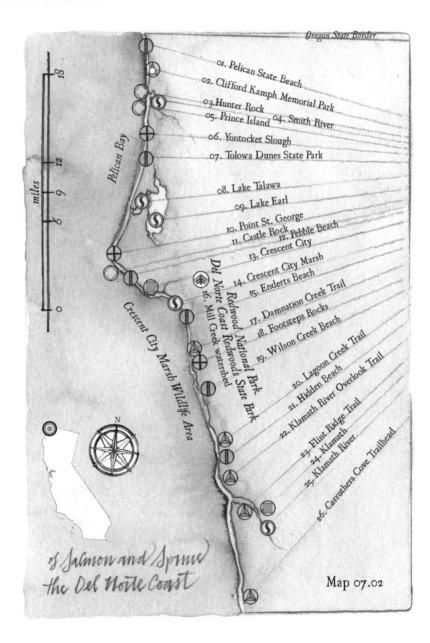

of Salmon and Spruce
the Del Norte Coast

Map 07.02

## 07.02 OF SALMON AND SPRUCE
*The Del Norte coast*

Map 07.02 depicts highlights from the 56 miles of Del Norte County's coastline.

The physiographic structure of the Del Norte coast is sculpted by a mix of forces that coalesce here to give this most northern corner of California its particular character. The rainy season hits this county harder than anywhere else in the state, potentially delivering more than seventy inches. Those potent clouds roll in from the west, then climb over the nearby Siskiyou Mountains and squeeze out a few dozen more inches of precipitation as they shrink in their eastward push. That rain falls into two main watersheds—the Smith and the Klamath, and proceeds to nourish some of the earth's largest trees, the redwoods that occupy the space between the mountains and the coast with more woody biomass than any other forest on the planet.[1]

This part of the coast, dotted with lagoon estuaries, grassy steppes, and long, gray-sand beaches decorated with masses of driftwood, is a place that despite its relative isolation, being so rural, is ecologically recovering from a century and a half of injurious resource extraction and industry.

01. Pelican State Beach; Pyramid Point State Marine Conservation Area; California's northernmost state beach; pelagic seabirds—fork-tailed storm petrel, *Oceanodroma furcata* (G5/S1), and tufted puffin, *Fratercula cirrhata* (G5/S1S2)—make a nest with a single egg.[2]

02. Clifford Kamph Memorial Park; long stretch of sand facing Pelican Bay; three cone-like sea stacks include Hunter Rock, Prince Island, and Pyramid Point; Cone Rock; small, tent-only campground.

03. Hunter Rock; nearly half of all nesting by shorebirds on coastal rocks in California happens here, on Hunter Rock and Prince Island in Del Norte County.[3] This site is an essential

> In California's last salmon stronghold, it is difficult but necessary to ponder whether these are the last decades of this great local biome or the bottleneck from where it resurges.

rookery for Brandt's cormorant, *Phalacrocorax penicillatus* (SNR); pelagic cormorant, *Phalacrocorax pelagicus* (SNR); western gull, *Larus occidentalis* (SNR); pigeon guillemot, *Cepphus columba* (SNR); and black oystercatcher, *Haematopus bachmani* (SNR).

04. Smith River; the entirety of the 300-mile-long watercourse network that makes up its drainage is protected by the Wild and Scenic Rivers Act; not compromised by impoundment anywhere along its length, a situation unique to all of California's major coastal rivers.[4] The coastal cutthroat trout, *Oncorhynchus clarkii clarkii* (G4T4/S3), seems to be holding on in this remote corner of its ancestral territory, as none of its populations in the US are considered threatened or endangered.[5]

05. Prince Island; near Pyramid Point, nesting cormorants dive to forty meters for rockfish, *Sebastes* sp. Other fish include the large sculpin called cabezon, *Scorpaenichthys marmoratus*; lingcod, *Ophiodon elongatus*; bocaccio, *Sebastes paucispinis*; halibut, *Hippoglossus stenolepis*; surf perch, family Embiotocidae; and sole, family Soleidae.

06. Yontocket Slough; historically, a drainage channel for the Smith River; important passage for anadromous fish, including the coastal cutthroat trout. Hundreds of Sitka spruce, *Picea sitchensis*, and red alder, *Alnus rubra*, were planted in the years before 2007 to restore the riparian ecosystem.[6]

07. Tolowa Dunes State Park. There are two sections of this 5,000-acre park, a northern and a southern half, that straddle the Lake Earl Wildlife Area; the result of tens of thousands of years of sediment accretion deposited by the Smith River;[7] cooperative restoration efforts, carried out between private, public, and tribal groups, include the recent removal of several old storm culverts that for many decades blocked fish access to what might be the highest-quality spawning habitat on the Smith River.[8]

08. Lake Talawa; the CDFW calls this smaller lobe of the Lake Earl Lagoon network Lake Talawa, sometimes spelled Tolowa; Lake Talawa is separated from the sea for most of the year only by a smallish, sandy beach, but when the channel flows, crossing this part of the beach on foot is impossible.

09. Lake Earl, with a perimeter of over 60 miles; the largest lagoon-habitat network in the lower forty-eight states. It supports one of the most important seabird sites in California, including the largest nesting populations of common murre, *Uria aalge* (SNR); Cassin's auklet, *Ptychoramphus aleuticus* (G4/S2S4); rhinoceros auklet, *Cerorhinca monocerata* (G5/S3); and tufted puffin.[9] This is habitat for 90% of California's population of Oregon silverspot butterfly, *Speyeria zerene hippolyta* (G5T1/S1).[10]

10. Point St. George; while heading north, the last, predominant hook

07. A Good, Long Walk

Northern spotted owl
*Strix occidentalis caurina*
(G3T3/S2S3)

along California's coast before Oregon's border.

11. Castle Rock; Castle Rock National Wildlife Refuge; in 1975, when the half-acre, steep-sloped island became federally protected, it was because of the discovery of a small, wintering population of the then presumed extinct Aleutian cackling goose, *Branta hutchinsii leucopareia* (G5T3/S3); habitat for hundreds of thousands seabirds.[11]

12. Pebble Beach; seasonal, sometimes tidal, littoral patterns dictate whether this mile-long stretch between Crescent City and Point St. George is sandy or rocky.

13. Crescent City; the 7-square-mile watershed of Elk Creek fans out through roughly 15 miles of creek habitat and empties to the sea through this village; restoration work on the watershed continues, in order to provide habitat for the Del Norte coast's litany of anadromous species of fish, including, most notably, coho salmon—southern Oregon/Northern California ESU, *Oncorhynchus kisutch*, pop. 2 (G4T2?/S2?);[12] habitat for Rocky Coast Pacific sideband, *Monadenia fidelis pronotis* (G4G5T1/S1S2).[13]

14. Crescent City Marsh; nearly 600 acres, threatened by the desiccating influence of nearby human development; home to rare old patches of Sitka spruce and California's largest population of the endangered western lily, *Lilium occidentale*.[14]

15. Enderts Beach; Crescent City Marsh Wildlife Area; recognized as one of the most important habitats for marine invertebrate biodiversity on the Northern California coast.[15]

16. Mill Creek Watershed; Highway 101 currently divides the coastal creeksheds of Cushing Creek, Nickel Creek, and Damnation Creek from the nearly 35,000-acre Mill Creek to the east; Mill Creek is a major tributary of the Smith River and is mostly encompassed and protected by the dually designated Redwood National Park and the Del Norte Coast Redwoods State Park; a massive restoration project is under way.[16]

17. Damnation Creek Trail; heavily forested trailhead; 2 miles to the beach.

18. Footsteps Rocks; at the northern end of False Klamath Cove; includes Sisters Rocks, False Klamath Rock, and Wilson Rock.

19. Wilson Creek Beach and Lagoon Creek Trail; coastal scrub forest; varied thrush, *Ixoreus naevius* (SNR), watching from the nearby alder tree, unleashes its sharp, one-note, three-second song.

20. Lagoon Beach Trail; the half-mile Yurok Loop Trail surrounds the namesake Lagoon Pond; once a dam site for logging operations, now restored as a wetland; a site for biotic research about tsunamis, their frequency and effect.[17]

21. Hidden Beach; massive driftwood poles and sea stacks painted white by the noisy parade of seabirds that together dwarf a lone human.

22. Klamath River Overlook Trail; 4 miles from the Lagoon Pond parking lot and 16 miles south of Crescent City; raven's view of the Klamath River's mouth as it unloads its vast freshwater content into the Pacific, 600 feet below; despite being California's second-largest river by volume discharge (after the Sacramento River), the Klamath's estuary is narrow; protected because of it from industrial pollution and development for nearly fifty years by a set of guidelines called the California Bays and Estuaries Policy.[18]

23. Flint Ridge Trail; might be the most beautiful coastal trail in Del Norte County; dark redwood groves; expansive hilltop views of the coast.

24. Klamath; heart of the Yurok culture, and an unincorporated municipality on its namesake river.

25. Klamath River; the mightiest of all lone rivers that empty directly into the Pacific along California's north coast. The Klamath River itself, like the people who have depended on it for thousands of years, like the forests that have thrived next to it for thousands of years, like the salmon that have migrated through it for thousands of years, has suffered massive injustices over the past century and a half since industrialized American culture has invaded; there currently is a plan, passed and ready to be enacted, for the largest dam removal in North American history: the removal of four impound-

ments not far from the Klamath's headwaters, 250 miles or so upstream; once this occurs and the river is allowed to heal, perhaps it will spur forest health, fishery health, and indeed health within the local communities of humans that will certainly benefit from such bold and compassionate action.

26. Carruthers Cove Trailhead; desolate and beautiful; gray-sand beach; it is as likely to be raining here in July as it is in November.

## 07.02a Stewarding Trees
*North coast forest restoration*

The science of applied forestry uses a particular vocabulary to describe various techniques of stewardship and habitat restoration.[19] Here are some of the terms:

Covering: the strategy of maintaining constant shade, either by using foliage or by artificial means, to prevent sun-loving seedlings from crowding the habitat space on the forest floor.

Crown manipulation: the treatment of the top portions of the arboreal habitat space by sawing or blasting to increase niche variety.

Flaming and torching: the specific application of fire to regulate the spread of invasive, simplified, and overcrowded conditions that affect forest stress.

Fuels reduction: the removal of a certain percentage of the overgrowth in the forest understory and the forest overstory to limit the capacity of wildfire to ladder up to the canopy.

Girdling: the complete removal of a strip of bark from around the midsection of a tree's trunk. This practice will kill the tree and is used to thin the forest.

Manual and mechanical vegetation removal: the removal of invasive or overcrowded individual plants to improve conditions in the forest understory.

Mowing: the annual clearing of grasses and grassy material on the forest floor.

Snag creation: supplying nesting and foraging space for animals through the identification of would-be snags, or dead trees, from conifers that are usually selected as such because of some existing deformation.

Solarization: the application of plastic sheeting to destroy the root crowns of invasive vegetation.

Thinning: the reduction of tree-stand density to mitigate fire damage by producing canopy holes and increasing light in the understory.

Tree planting: increasing forest diversity with the introduction of seedlings.

# The Coasts of California

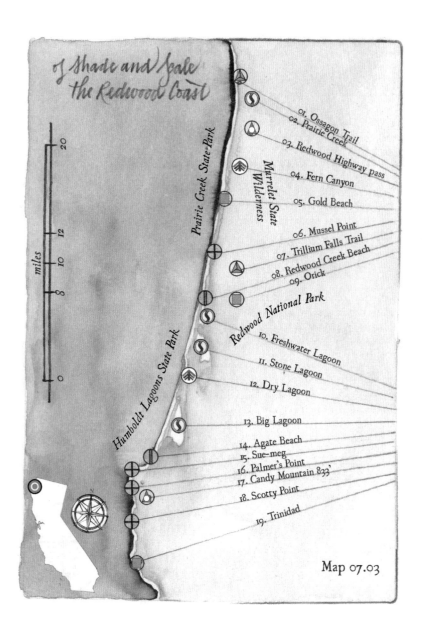

Map 07.03

## 07.03 OF SHADE AND SCALE
*The redwood coast*

Map 07.03 depicts approximately 30 miles of the northern Humboldt County coastline.

Across the several interagency park systems, the Redwood National and State Parks contain old-growth redwood forest habitat types and a vast quilt of diverse topographies, from expansive, coastal meadows where herds of elk spend their days among a prismatic spray of wildflowers, to lagoon wetlands full of waterfowl that are sheltered from the punishing sea by long, sandy spits. Offshore, rocky sea stacks and massive columns of weather-pitted stone make dozens of discrete sanctuaries for a vast range of diverse life, from migrating seabirds to complex tide-pool ecologies for a multitude of organisms.

All of it cumulates to a picture of a seashore that will never again exist as it is now; in the centuries to come, forests damaged by centuries of logging will begin to take on old-growth characteristics, and a rising sea will claim Humboldt Lagoons State Park, affecting avian life along the Pacific Flyway. One bird that may again claim its ancestral homeland in these forests is the California condor, *Gymnogyps californianus* (G1/S1), which the National Park Service announced it would reintroduce here in 2021.[1]

01. Ossagon Trail; the California Coastal Trail enters Humboldt County, Prairie Creek Redwoods State Park, and Redwood National Park near the Carruthers Cove Trailhead on the Del Norte County line; northern border of Murrelet State Wilderness; Humboldt County has just under 140 miles of coastline and has the longest coastline of California's fifteen coastal counties.

02. Prairie Creek; northernmost tributary of Redwood Creek; runs southerly from near the trailhead of the Hope Creek Trail along the Newton B. Drury Parkway; old-growth redwood forest; Elk Prairie; dozens of wild elk, *Cervus canadensis roosevelti* (SNR), roam.

---

*In the old-growth forests of the coast redwood, home to so many endangered species, the coastal fog is also endangered, and there is no legal protection of such disappearing phenomena.*

03. Redwood Highway pass at 1485'; nearly all the forest inside Murrelet State Wilderness is old growth.[2]

04. Fern Canyon; deep inside the old growth of Prairie Creek Redwoods State Park, one of California's first state parks (est. 1923). Five species of fern thickly adorn the 50-foot walls of the canyon corridor itself, including maiden hair fern, *Adiantum jordanii*; deer fern, *Struthiopteris spicant*; California polypody, *Polypodium californicum*; Licorice fern, *Polypodium glycyrrhiza*; and western sword fern, *Polystichum munitum*.

05. Gold Beach; although most of the California Coastal Trail in this area runs through Redwood National Park, there are no redwoods on the trail—it is too close to shore, and the big trees can't take the salinity in the air; under the tree-lined bluff, the campground is a morning's walk from the northern boundary of Humboldt County.

06. Mussel Point; the most inaccessible stretch of coastline in Redwood National Park; Skunk Cabbage Trail, named for the ubiquitous, redwood-forest plant *Lysichiton americanus*, known for its pungency.

Marbled murrelet
*Brachyramphus marmoratus*
(G3G4/S1)

07. Trillium Falls Trail; named for the western trillium, *Trillium ovatum*; trailhead is on the site of the old mill, where extensive logging of the old-growth forest was processed,[3] prior to the establishment of the redwoods park network; remaining old-growth redwood stand is approximately one-quarter of a mile wide, on both sides of the trail.

08. Redwood Creek Beach—a wide, sandy strand that supports many beach-based plant species including beach pea, *Lathyrus littoralis*; beach strawberry, *Fragaria chiloensis*; and sand verbena, *Abronia* spp.;[4] location of the Thomas H. Kuchel Visitor Center.

09. Orick, tourist community on Redwood Creek; nonnative settlement began in the mid-nineteenth century as a mining town.

10. Freshwater Lagoon; the smallest and least developed of three lagoons that make up Humboldt Lagoons State Park; winter storms break open the beaches of the park momentarily to create a unique ecosystem—sea water mixes with fresh water, and more than 50 species of bird make their permanent home; 100 species pass through on their migratory path along the Pacific Flyway.

11. Stone Lagoon; the three lagoons of Humboldt Lagoons State Park are among the largest lagoon networks in North America; provide brackish habitat; endangered by sea-level rise.

12. Dry Lagoon; meadowland; the hillock that is Dry Lagoon State Park, between Freshwater and Dry Lagoons, may be an island after sea levels rise.[5]

13. Big Lagoon; sequestered from the sea by Agate Beach; largest of Humboldt County's lagoon system and managed as a county park.

14. Agate Beach; 2-mile-long strand known for littoral deposits of semiprecious stones.

15. Sue-meg; see 07.03b; Sue-meg State Park; known site of the white-footed vole, *Arborimus albipes* (G3G4), known to inhabit only the old-growth forests of the north coast of California.[6]

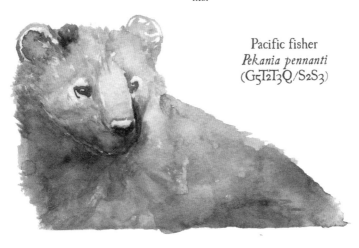

Pacific fisher
*Pekania pennanti*
(G5T2T3Q/S2S3)

16. Palmer's Point; southern edge of Sue-meg State Park; robust tide pools; 2-mile spur off the Coastal Trail.

17. Candy Mountain (833'); source of Beach Creek, which flows to the north to let out north of Sue-meg, and Burris Creek, which lets out near Scotty Point to the south.

18. Scotty Point; Seawood Cape Preserve. This is essential habitat for Pacific tailed frog, *Ascaphus truei* (G4); coastal cutthroat trout, *Oncorhynchus clarkii clarkii* (G4T4); and southern torrent salamander, *Rhyacotriton variegatus* (G3G4).

19. Trinidad, small town; Trinidad State Beach; Trinidad Head, the large bulb connected to the land by a narrow isthmus. Two special-status species of seabird make nesting colonies on the small island rocks near Trinidad Head; approximately 200 fork-tailed storm petrel, *Oceanodroma furcata* (G5/S1), nest on Little River Rock; a small population of tufted puffins, *Fratercula cirrhata* (G5/S1S2), make their nests on Puffin Rock; Cassin's auklet, *Ptychoramphus aleuticus* (G4/S2S4), can be found around Green Rock; nearly 10,000 Leach's storm petrel, *Oceanodroma leucorhoa* (SNR), nearly one-third of California's population, nests on these sea stacks.[7]

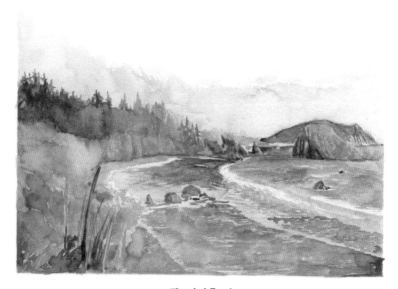

*Trinidad Beach*

07. A Good, Long Walk

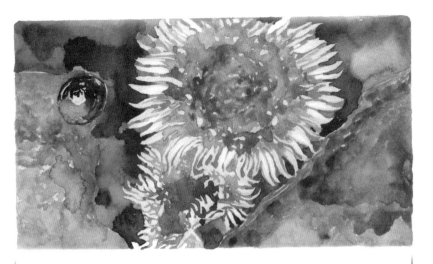

## 07.03a As Diverse as It Gets
*Invertebrate species of northern tide pools*

The delicate world of the Northern California tide pool is one of graceful complexity in both its species diversity and the variety of evolutionary strategies employed by its resident community of invertebrates. The grazing and predatory tools employed in this crowded intertidal community range from suspension feeding (limpets) to stinging tentacles that paralyze passing prey (anemones). The following is a list of common tide-pool invertebrates of Humboldt County:[8]

Aggregating anemone,
*Anthopleura elegantissima*
Black leather chiton,
*Katharina tunicata*
Black turban snail,
*Tegula funebralis*
California mussel,
*Mytilus californianus*
Flat porcelain crab,
*Petrolisthes cinctipes*
Hermit crabs, *Pagurus* spp.
Isopods, *Idotea* spp.
Limpets, *Lottia* spp.
Orange cup coral,
*Tubastraea coccinea*
Periwinkle snail, *Littorina scutulata*
Purple or ochre sea star,
*Pisaster ochraceus*
Purple shore crab,
*Hemigrapsus nudus*
White sea cucumber,
*Eupentacta quinquesemata*

# The Coasts of California

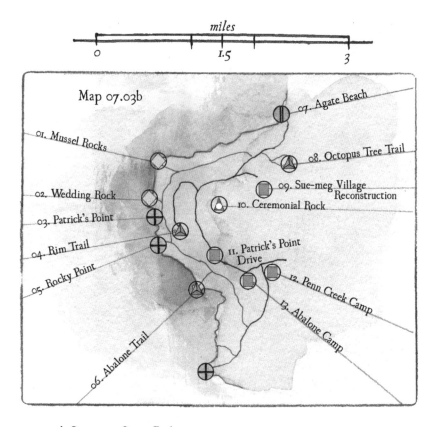

## 07.03b Sue-meg State Park

At 420 acres, Sue-meg State Park is a compact park; in addition to a deep assemblage of habitat types, it is the site of a Yurok village reconstruction that points to the deeper cultural significance this precious place once represented and still does represent. Out from the deep shade forest of Sitka spruce, *Picea sitchensis*; shore pine, *Pinus contorta* ssp. *contorta*; red alder, *Alnus rubra*; western hemlock, *Tsuga heterophylla*; and Douglas fir, *Pseudotsuga menziesii*, wildflower meadows spread through thickets of native berries, including thimbleberries, *Rubus parviflorus*; salmonberries, *Rubus spectabilis*; and huckleberries, *Vaccinium ovatum*—all coastal habitat for the California black bear.

# 07.04 OF OLD GROWTH AND OYSTERS
*The Humboldt coast*

Map 07.04 depicts 45 miles of the Humboldt County coastline.

Bookended by the Mattole River watershed in the south, and in the north by the Mad River outlet at Little River State Beach, the Humboldt coast is dominated by an expansive system of habitats within Humboldt Bay. Over the past century, 90 percent of the ecologically productive salt marshes within the larger network of the bay have been filled in by human development or overrun by invasive plants, shrinking the size of the ecosystem from 9,000 to 900 acres.[1]

The Humboldt Bay watershed includes the North (Arcata) Bay, and the South (Humboldt) Bay, which together drain an area of 288 square miles and include the old-growth redwood forests of Headwaters Forest Reserve, five miles up the Elk River, the bay's largest tributary.[2] Humboldt Bay is the second-largest estuary system in California behind the San Francisco Bay; and at three-and-a-half square miles, the Eel River estuary is the fourth-largest such habitat space.[3]

Surfsmelt *Hypomesus pretiosus*

> The fecund fish habitat of the wetlands isn't demonstrated only by the presence of the small adult species of osmerid fish but also by the small juvenile species, such as the rearing coho in the eelgrass.

# The Coasts of California

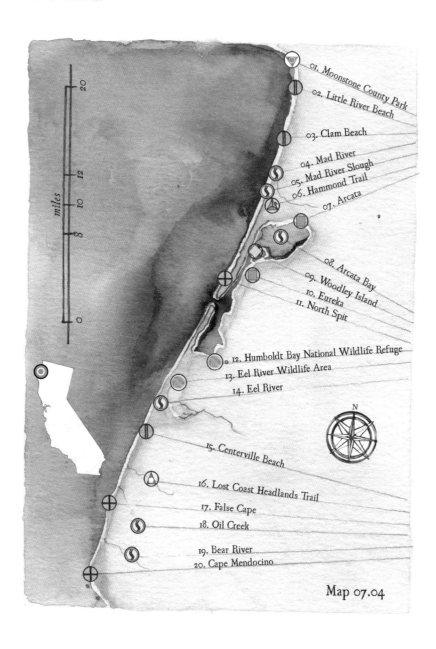

Map 07.04

## 07. A Good, Long Walk

01. Moonstone County Park; Trinidad Coast Land Trust manages a small conservation easement near this easily accessible beach; included in a collection of such properties along the coast south of Trinidad that will ultimately lead to the completion of the California Coastal Trail in this area.[4]

02. Little River State Beach; moving from the redwood coast to the Humboldt coast is one of the defining moments in the shifting topography; the coastline transforms from rocky terrain to the Humboldt Bay lowlands, where there are approximately 33 miles of sand dunes and spits, salt- and freshwater marshes, and estuary habitats.[5]

03. Clam Beach County Park; the McKinleyville Bluffs stretch to this beach across a dune field protected by riprap; noted for its bounty of the forageable Pacific razor clam, *Siliqua patula*, a delicious bivalve mollusk that may or may not contain dangerous levels of the toxin domoic acid.[6]

04. Mad River; running more than 100 miles inland; watershed covers nearly 500 square miles.[7] Two special-status osmerid species of fish may be present in the Mad River estuary: longfin smelt, *Spirinchus thaleichthys* (G5/S1); and eulachon, *Thaleichthys pacificus* (G5/S3); but neither have been observed in several years.[8]

05. Mad River Slough Wildlife Area; Mad River estuary; Humboldt Bay and Eel River estuary; invasive cordgrass, *Spartina densiflora*, has significantly contributed to degrading native eelgrass habitats and presents continued challenges to restoration efforts.[9]

06. Hammond Trail; 5-mile-long walking trail; part of the Coastal Trail that connects the lowlands of Arcata to Clam Beach Regional Park.

07. Arcata; Arcata Marsh and Wildlife Sanctuary; northern edge of Humboldt Bay; 307 acres. Habitat within and around Humboldt Bay includes over 220 terrestrial, marine, and aquatic plant species,[10] several hundred species of invertebrates and marine and anadromous fish;[11] and 73 nesting species of birds as well as more than 330 species of migrating birds.[12]

08. Arcata Bay; over 9,000 acres; the North Bay is Humboldt Bay's largest portion and harbors over half of the bay's total habitat area; a resting point for hundreds of thousands of migrating birds; nesting habitat for many special-status birds, including Caspian tern, *Hydroprogne caspia* (G5/S4), and California brown pelican, *Pelecanus occidentalis californicus* (G4T3T4/S3).

09. Woodley Island; the largest of five islands in the bay; three are visible at high tide, and two only become so at low tide.

10. Eureka, city; Humboldt Bay produces over half of the oysters for human consumption in California; the North Bay supports 287 acres of oyster mariculture habitat.[13]

11. North Spit; also called Samoa Peninsula; separated from the South Spit by the north and south jetties at the entrance of Humboldt Bay; an engineered project supported by hundreds of thousands of tons of introduced concrete and subsurface structures.[14]

12. Humboldt Bay National Wildlife Refuge; 3,000 acres of protected habitat within 5,000 acres of eelgrass, *Zostera marina*, vital nutrition for the tens of thousands of Pacific brant geese, *Branta bernicla nigricans* (G5/S2?), that visit the bay every spring;[15] Salmon Creek, Humboldt Bay's third-largest tributary, has recently been the target of a massive restoration project to support coho-rearing habitat[16] and salt marsh for pickleweed, *Salicornia virginica*; initial results were encouraging, and many endangered species, including the tidewater goby, *Eucyclogobius newberryi* (G3/S3), were found in the restoration area less than a year after project completion; four decades of restoration work at the sensitive Lanphere Dunes within the refuge are ongoing to halt the progress made by invasive European beach grass, *Ammophila arenaria*, and yellow bush lupine, *Lupinus arboreus*.[17]

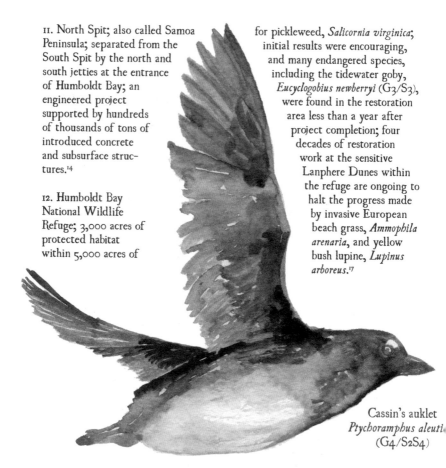

Cassin's auklet
*Ptychoramphus aleuti*
(G4/S2S4)

13. Eel River Wildlife Area; 2,600-acre patchwork of land designations; the Eel River estuary is geographically separated from Humboldt Bay by Table Bluff; diverse habitats include salt and brackish marsh, coastal scrub and meadows, and livestock pasture.

14. Eel River; at nearly 200 hundred miles in length, with a watershed over 3,600 square miles, the Eel is one of the North Coast Range's great rivers; with an average of nearly 4,500 tons of sediment per square mile of discharge, the Eel transports more sediment than any comparable watershed in the country.[18]

15. Centerville Beach; at this beach, the coastline south changes in character from the Humboldt lowlands to the rocky bluffs leading toward Cape Mendocino; the California Coastal Trail veers from the shore and follows Mattole Road out of Ferndale to Cape Mendocino Lighthouse.

16. Lost Coast Headlands Trail; the trail from Centerville Beach County Park to Guthrie Creek passes an immense slide area; what beaches do exist are small and rocky.

17. False Cape; hard to access; low marine terraces and extensive slumping cliffs round this rural farm community; near Capetown and Flyblow Gulch.

18. Oil Creek; a 3-mile watercourse that runs from Bunker Hill (2,464').

19. Bear River; Capetown, once a stagecoach stop, is the only vestige of settlement in this watershed that extends up to Mount Pierce, the tallest point along the nearby Bear River Ridge.

20. Cape Mendocino; westernmost point in California; formed from rock of the Franciscan Formation;[19] the cape is in close proximity to the convergence of three tectonic plates: the Pacific, the Gorda, and the North American Plates, at an offshore spot called the Mendocino Triple Junction.[20]

Tidewater goby
*Eucyclogobius newberryi*
(G3/S3)

## 07.04a Wastewater and Wildlife
*A new approach in Arcata*

The city of Arcata—2010 population, 17,231. Arcata's wastewater treatment system is as ecologically progressive as it is technologically innovative. The facility, inside the Arcata Marsh and Wildlife Sanctuary, uses the tidal action of the constructed wetlands to go through seven steps that, in the end, integrate the processed wastewater as a nutrient resource.[21]

Step 1—*Headworks*. Pumps lift the wastewater to make it flow through the first screens to remove visible debris.

Step 2—*Clarifiers*. Tanks allow organic solids to then separate and settle out.

Step 3—*Digesters*. Bacterial decomposers process the remaining sludge in an anaerobic environment that produces methane, used to heat the decomposers, which are spurred by the heat to do more work.

Step 4—*Sludge drying beds*. Digested sludge is dried and mixed with wood waste and composted.

Step 5—*Oxidation ponds*. Algae provides oxygen for bacteria to break down remaining waste from the clarifiers.

Step 6—*Treatment marshes*. Shade-producing reed plants prevent algae from growing and allow sediment pollutants to sink while providing wildlife habitat.

Step 7—*Chlorine contact basin*. Chlorine and sulfur dioxide remove any further pollutants in the water before discharge.

07.04a

# 07.05 OF THE REMOTE AND THE RUGGED
*The Lost Coast*

Map 07.05 covers 38 miles of southern Humboldt County.

It is arguable that the Lost Coast extends all the way from Centerville Beach (Map 07.05) to where Highway 1 veers inland, north of Rockport. If that is the case, its total length is over 80 miles and is certainly the longest stretch of undeveloped coastline in America, excluding Alaska.[1] Having proven impenetrable by roads, the craggy, steep terrain passingly resembles an exaggerated version of Big Sur's popular coastline, several hundred miles south. The brutal climate batters parts of the Lost Coast with over 100 inches of rain a year, but sea-facing forests are rare, and where they do exist, they don't contain redwood and Sitka spruce as elsewhere in Humboldt County, but rather tend toward an unusual association of Douglas fir and sugar pine.[2]

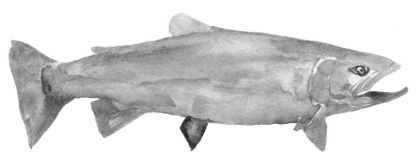

Steelhead *Oncorhynchus mykiss*

> The loveliest places are often the most beautiful and the most treacherous. The Coastal Trail through here is submerged at high tide, symbolic of everything modern humanity tries here, fleeting and impermanent.

# The Coasts of California

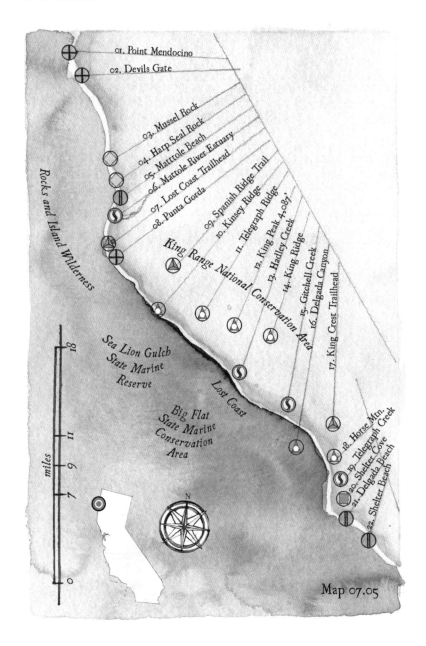

Map 07.05

## 07. A Good, Long Walk

01. Point Mendocino; near the convergence of three tectonic plates; Cape Mendocino; the King Range has experienced a rapid uplift of nearly 66 feet in six thousand years—an average that is twelve times faster than the rest of the California coast.[3]

02. Devils Gate; Black Sands Beach; South Cape Mendocino State Marine Reserve.

03. Mussel Rock; McNutt Gulch; Mattole Road turns east away from the coast toward Petrolia.

04. Hair Seal Rock. Regional pinnipeds include harbor seal, *Phoca vitulina* (SNR); Steller sea lion, *Eumetopias jubatus* (G3/S2); and California sea lion, *Zalophus californianus* (SNR).

05. Mattole Beach; trailhead and point; watershed degradation includes ecotype conversion from forest to pasture and erosion of the watercourse over several decades due to logging and development. Following this change, sediment increased along this treeless beach and into the marine reserve.[4]

06. Mattole River estuary; Mattole watershed; 1.5 miles of the estuary is proposed Wild and Scenic River;[5] habitat for juvenile salmon; restoration project includes the planting of 8,000 trees and 4,000 wetland plants to increase shade and decrease water temperature.

07. Lost Coast Trailhead; northern section; runs 24.6 miles to Shelter Cove.

08. Punta Gorda; historic decommissioned lighthouse; accessible from Cooskie Creek Trail, an 11-mile looping trail; like most trails across the King Range, lonely and steep.

09. Spanish Ridge Trail; looping trail that forms a 13-mile circuit when coupled with Kinsey Ridge Trail.

10. Kinsey Ridge; Smith-Etter Road follows this ridge, the only road in this remote country.

11. Telegraph Ridge; divide between the creek watersheds that drain into the Pacific and the Mattole River watershed.

12. King Peak (4,087'); highest peak on Highway 101 north of Monterey County.

13. Hadley Creek; where the creeks meet the ocean across the Lost Coast; significant habitat for an endemic bunchgrass, called reedgrass, *Calamagrostis foliosa*.

14. King Ridge; noted for its stand of Eastwood's manzanita, *Arctostaphylos crustacea* ssp. *Eastwoodiana*, the only such stand outside Santa Barbara County, 400 miles south.[6]

15. Gitchell Creek; steelhead habitat; three miles of the creek is currently proposed Wild and Scenic River;[7] close to Big Creek and Big Flat Creek.

16. Delgada Canyon; a large and deep submarine canyon that drops off suddenly to 600 feet in depth and reaches a depth of nearly 3,000 feet three miles from shore.[8]

17. King Crest Trailhead; Douglas fir and sugar pine dot forested sites above madrone chaparral.

18. Horse Mountain (1,920'); an example of the Lost Coast's steep incline from sea level; one-eighth of a mile from the shore; two miles north of Shelter Cove; Horse Mountain Creek Trail is the easiest route from the ocean to King Crest.[9]

19. Telegraph Creek. Arboreal, riparian habitat includes big-leaf maple, *Acer macrophyllum*; red alder, *Alnus rubra*; Oregon ash, *Fraxinus latifolia*; and California black cottonwood, *Populus trichocarpa*.

20. Shelter Cove, town 24 miles west of Garberville; town built on the steep hills; the bit of shelf that offers level ground is dedicated either to the airstrip or to the golf course; in 1965, a development plan included a potential population of 10,000, but was scrapped over fights about public access to the beach, among other issues;[10] population 700; only human community on the Lost Coast.

21. Delgada Beach; Point Delgada; a popular shore fishing spot for red abalone, *Haliotis rufescens* (SNR), the most abundant of California's six species of abalone; abalone fishing is stringently regulated and requires compliance with all applicable laws.[11]

22. Shelter Cove Beach; one of five parks in Shelter Cove; others are Black Sands Beach, Mal Coombs Park, Seal Rock Picnic Area, and Abalone Point.

California scrub jay
*Aphelocoma californica*

## 07.05a Rebuilding the Mattole River
*North coast estuary and riparian restoration*

Many ambitious organizations have aligned to restore habitat conditions at the mouth of the Mattole River. Thus a model for other communities has emerged to unite and repair salmon-rearing habitat where anadromous fish head out to sea.[12] This project—and other river estuary restoration work throughout salmon country—seeks to increase salmonid survival during low-flow summer months and enlarge available refugia for winter runs.[13]

Here are some of the strategies, further customized to the needs of the fish at different times:

1. Reinforce the stability of the channel banks against erosion using native vegetation along the watercourse as it approaches the estuary.

2. Increase the complexity of niche resource opportunities by restoring the instream habitat so that it mimics historically natural conditions.

3. Introduce enough native vegetation to promote riparian propagation.

4. Develop a wide variation of sediment-granule diameter along the streambed.

5. Promote diversity of the elevation of the surrounding riparian landscape.

6. Augment connectivity between other localized habitat types by removing physical obstacles such as fences and instream impoundments.

7. Reinforce food and nutrient resources available to target species.

Upon approval, the plan will take six years or so. The following timeline will not be executed in discrete time blocks but will overlap as one phase moves to the next.[14]

1. Seed collection—two years

2. Plant propagation—three years

3. Trenched willow baffle installation—two years

4. Containerized plant installation—six months

5. Broadcast seeding and mulching—six months

6. Maintenance—six months

7. Monitoring—three months

8. Invasive plant removal—one year

The Coasts of California

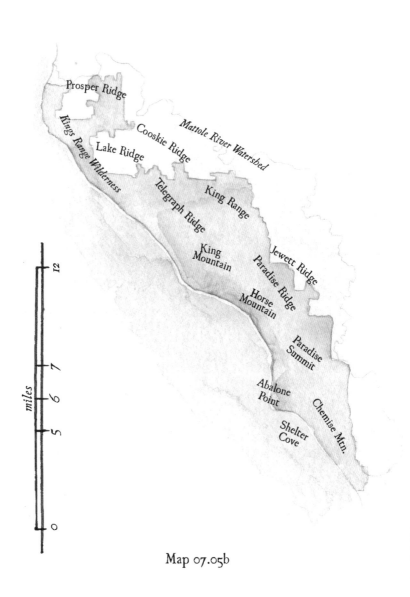

Map 07.05b

## 07.05b King Range National Conservation Area

It is a wilderness crown for California, this Lost Coast. No roads fragment its fire regime, so its steep, seaward cliffs burn as they did hundreds of years ago. The King Range's dynamic profile, the steepest rise in the shortest distance from sea level across the entirety of the California coast, keeps its secrets. There is a unique opportunity here, bolstered by the wild, remote character of the place: give it some time and the proper stewardship, and on the northern side of Telegraph Ridge, in the Mattole watershed—given its proximity to so much untouched shoreline—the leeward old growth will come back. It is an assumption—humanity has yet to see old-growth conditions return to a forest habitat space after it was dismantled—but if that assumption is correct, humanity may find some measure of reconciliation with wounds as yet unhealed.

# The Coasts of California

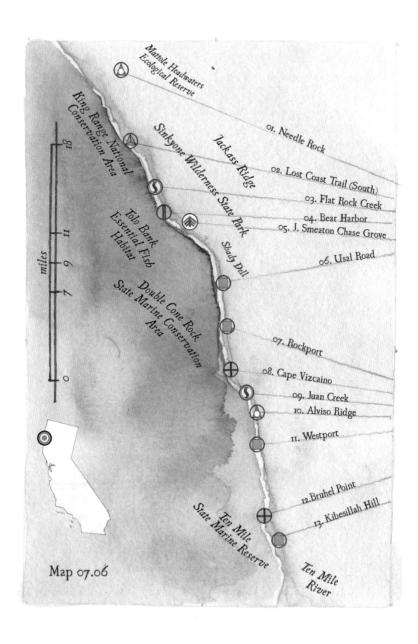

Map 07.06

## 07.06 OF STEPPE AND SOLITUDE
*The Sinkyone coast*

Map 07.06 describes 34 miles of the coastline of Mendocino County.

Along this length of the Coastal Trail, which includes the southern Lost Coast Trail between Shelter Cove and Usal Beach, Sinkyone Wilderness State Park runs twenty miles or so, defining the seaward side of Jackass Ridge, which divides it from the South Fork Eel River watershed beyond. Black bears and mountain lions explore deep, human-free terrain in their true wilderness, perhaps wondering where the recent, fecund salmon runs have gone and, more important, when they will be back. There are signs of humanity's effort everywhere, but it all seems to fade—all of it except for the scars. There was old growth, and roads were cut that now remain as trails; wharfs were built that are now being reclaimed by the sea; railroads were attempted and abandoned; and creeks were filled with sediment. Now the habitats exist, but as remnants of their former selves. Perhaps with an extended respite from human industry, these wild places can remember those former selves and invite back lost inhabitants.

01. Needle Rock; on the other side of Mattole River Ecological Reserve, a 1,400-acre, old-growth redwood forest; Needle Rock Visitor Center is accessible by car and is open year-round.

02. Lost Coast Trail (South); 22 miles of the Lost Coast Trail run through Sinkyone Wilderness State Park.

03. Flat Rock Creek. Amphibians of special status existing in this and adjacent creeksheds include foothill yellow-legged frog, *Rana boylii* (G3/S3); southern torrent salamander, *Rhyacotriton variegatus* (G3G4/S2S3); California giant salamander, *Dicamptodon ensatus* (G3/S2S3); and Pacific tailed frog, *Ascaphus truei* (G4/S3S4).[1]

04. Bear Harbor; School Marm Grove near Wheeler Beach; forest holds a different character of redwood tree

> In a second-growth forest, the trees survive, but the habitat does not. It is as if the forest can't remember itself. It is as if the forest has lost its mind.

than what you find over the ridge—the trees are blasted by wind to the edge of their tolerance for salt air.

05. J. Smeaton Chase Grove; one of three old-growth redwood groves left between Bear Harbor and Usal Beach; others are School Marm Grove and Sally Bell Grove, one creekshed south of Smeaton Chase.

06. Usal Road; Usal Beach, the only drive-in campground in the Sinkyone park; north of here, the California Coastal Trail is tough; Sinkyone is a pitiless wilderness, the topography is steep, and the wind and rain can be ceaseless for hours or days.

07. Rockport; former logging town that collapsed along with the region-wide industry of old-growth extraction in the first few decades of the twentieth century.

08. Cape Vizcaino; between steep ravines, hiding pockets of old-growth redwood, this area is a tumble of flat shelves of coastal steppe; restoration plans are being undertaken by Save the Redwoods League in the canyon around the cape to remediate the fuel load of excessive growth that the absence of a naturalized fire regime has permitted.[2]

School Marm old-growth grove, Sinkyone

## 07. A Good, Long Walk

Dark-eyed junco
*Junco hyemalis*

09. Juan Creek; at the beginning of the twentieth century, as logging extraction took hold, towns dotted this countryside, including around Juan Creek; nourished by surf fish, the people of that time enjoyed a tidal bounty that doesn't exist today.[3]

10. Alviso Ridge. Common spring wildflowers along this ridge are California poppy, *Eschscholzia californica*; Henderson's angelica, *Angelica hendersonii*; live-forever, *Dudleya farinosa*; golden yarrow, *Eriophyllum staechadifolium*; seaside daisy, *Erigeron glaucus*; broadleaf stonecrop, *Sedum spathulifolium*; and pearlwort, *Sagina procumbens*.

11. Westport; Westport–Union Landing State Beach; campground on 3-mile-long rocky beach. Grasslands inland from the beach are populated with a wide range of common native and invasive plant species, including California blue-eyed grass, *Sisyrinchium bellum*; Douglas iris, *Iris douglasiana*; red fescue, *Festuca rubra*; footsteps of spring, *Sanicula arctopoides*; yellow hairgrass, *Aira praecox*; and manycolored lupine, *Lupinus variicolor*.

12. Bruhel Point; Abalone Point; tide-pool habitat.

13. Kibesillah Hill (600'); Ten Mile River; within the southernmost range of the Roosevelt elk that were reintroduced to the King Range, their ancient range, in 1982; today the herd numbers about 60 individuals.[4]

## 07.06a Plants That Don't Use the Sun
*The fungus flowers of the Mendocino coast*

Fungus flower, mycotroph, and myco-heterotroph are three names for the same kind of plant, one that is different from all others. These plants don't use chlorophyll to produce energy, but rather feed through nutrient-delivery channels already in use between mycorrhizal communities and mutualistic vascular plants. This class of plant used to be referred to as a saprophyte, because they were mistakenly thought to rely on decaying matter; now they have been renamed to more accurately describe their life cycle.[5]

The mycotrophs are technically parasites, but they feed not on subterranean fungus but through them, profiting off an already occurring biological function.[6] Because they are not autotrophs and don't produce their own sugars from sunlight, fungus flowers come in a variety of nongreen colors and forms; they usually stand six to twelve inches tall, emerging from the soil on the forest floor. Extremely seasonal, fungus flowers tend to pop up only at the end of spring for a few weeks.[7]

Sugarstick
*Allotropa virgata*

Gnome plant
*Hemitomes congestum*

Spotted coral root
*Corallorhiza maculata*

Pink wintergreen
*Pyrola asarifolia*

Ghost plant
*Monotropa uniflora*

California pinefoot
*Pityopus californicus*

Sugarstick *Allotropa virgata*

## 07.07 OF TIDE POOLS AND TALL TREES
*The Mendocino coast*

Map 07.07 describes approximately 32 miles of the coast in Mendocino County.

When the Russian fur traders came down along this coast in the early half of the nineteenth century, they must have mused about the nature of these tiny forests. So close to the tallest forests on the planet, the terraced ecosystems here boast one of the biosphere's most diminutive forests. The light-colored soil under the topsoil provides the right kind of stress to make pygmy forests possible; it's called *podzol*, the Russian word for ash, though the Russian hunters themselves didn't use this name.[1]

Along the Mendocino coast, behind a dappled curtain of the larger bishop pine, *Pinus muricata*, with its branches often dripping with red Usnea, *Usnea rubicunda*, the pygmy forest hides in a tiny world all its own.[2] With its most common trees, the cypress, *Hesperocyparis pygmaea*, and the shore pine, *Pinus contorta* ssp. *bolanderi*, the unique habitat has many understory plants, including the endemic Fort Bragg manzanita, *Arctostaphylos nummularia*, and the pale Pacific reindeer lichen, *Cladonia portentosa* ssp. *pacifica*.

gray fox

*The earthen staircase rises quickly as a terrace, an open book over half a million years; meanwhile, the old pines grow a few feet in a century.*

# The Coasts of California

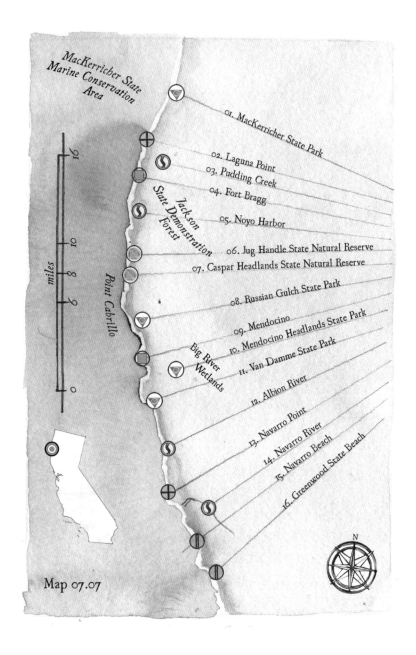

Map 07.07

01. MacKerricher State Park; park runs for 7 miles along the shoreline of a Marine Conservation Area; wintering and nesting sites (up to five mated pairs) of the western snowy plover, *Charadrius alexandrinus nivosus* (G3T3/S2S3);[3] site of Inglenook Fen–Ten Mile Dunes Nature Preserve.

Inglenook Fen is a 4,000-year-old groundwater-fed wetland, the southernmost of its kind of coastal fen in California;[4] the ecosystem of the dune complex, a nesting and migratory habitat for 90 species of birds, runs down to Laguna Point;[5] habitat for the largest population of the rare, dune-dwelling plant called the Mendocino spineflower, *Chorizanthe howellii*.[6]

02. Laguna Point; large tide-pool area in this dominant land feature; surrounded by tidal flats and rocky shores typical in MacKerricher State Park; public seal-watching platform; common grasses around the point and north and south along the dunes include velvet grass, *Holcus lanatus*, and sweet vernal grass, *Anthoxanthum odoratum*.

03. Pudding Creek; creekshed along the southern end of MacKerricher State Park; the other creeks in the park north from here, in order, are Pudding Creek, Virgin Creek, Mill Creek (Lake Cleone), Sandhill Creek, Inglenook Creek, and Ten Mile River at the northern end of the park.

04. Fort Bragg; a 10-mile paved extension of the California Coastal Trail was recently completed on the bluffs west of the town of Fort Bragg, from Glass Beach to Noyo Beach; at the beginning of the twentieth century, this was the site of a major timber operation, and the vegetative restoration and remediation the site finally received are as encouraging as they are extensive.[7]

05. Noyo Harbor; historically, one of the state's top ten fisheries; the community is adapting to depleted fishing stock and other environmental concerns, working with the Coastal Conservancy on enacting a detailed sustainability plan.[8]

conifer needle comparisons

> *Bay pipefish, Syngnathus leptorhynchus, six inches, lives in eelgrass beds*

06. Jug Handle State Natural Reserve; also site of the Hans Jenny Pygmy Forest Reserve;[9] perhaps the best site for observing the north coast marine terraces and their intact ecology; 2.5-mile trail up the staircase, rising across 300,000 years of geologic history through prairies, coastal redwood forest, and finally into the endemic pygmy forests on the topmost terrace.[10]

07. Caspar Headlands State Natural Reserve; within the dark shadows of this short, forested trail, a stand of Sitka spruce, *Picea sitchensis*, grows to define (along with western hemlock, *Tsuga heterophylla*) the southernmost end of one of the world's great biomes: the Pacific Northwest temperate coniferous rainforest.[11]

08. Russian Gulch State Park; Russian Gulch Creek runs inland under the charismatic bridge from a rocky shore, famous for a 100-foot, naturally eroded hole that, at high tide, echoes with the impact of thunderous waves; three lone Sitka spruce trees mark the southernmost extent of the species' range.[12]

09. Mendocino; Big River Estuary State Marine Conservation Area—8 miles in length; the inlet is the longest undeveloped estuary in California.[13] This is important habitat for many sensitive fish species at many different phases of their development, including a population of bay pipefish, *Syngnathus leptorhynchus*; cabezon, *Scorpaenichthys marmoratus*; copper rockfish, *Sebastes caurinus*; English sole, *Pleuronectes vetulus*; kelp greenling, *Hexogrammos decagrammus*; night smelt, *Spirinchus starski*; Pacific herring, *Clupea pallasii*; shiner surfperch, *Cymatogaster aggregata*; and tidepool sculpin, *Oligocottus maculosus*.[14] The Big River watercourse runs over 40 miles inland.

10. Mendocino Headlands State Park; the 347-acre park surrounds the town of Mendocino; Big River State Park, 7,334 acres, transferred as such by the Mendocino Land Trust to the California State Park system in 2002. The park includes habitat for the reintroduced golden beaver, *Castor canadensis subauratus* (SNR); river otter, *Lontra canadensis* (SNR); and mink, *Neovison vison* (SNR).[15]

11. Van Damme State Park; see 07.07b; 1,831 acres, 10 miles of trails from Little River, salmon spawning site, through fern canyons to 5 acres of notable pygmy forest;[16] Van Damme Cove; site of the northernmost nesting site of the ashy storm petrel, *Oceanodroma homochroa* (G2/S2).[17]

12. Albion River; an 18-mile, undammed river inside a 43-square-mile watershed that was once an expansive veldt of old-growth redwood forest and coho habitat. Today, the Albion is an impaired river surrounded by third- and fourth-growth forest; although it has no dams, it also enjoys little shade, leading to higher water temperatures that stress salmonid viability.[18]

13. Navarro Point; the 56-acre Navarro Point Preserve along with the Coastal Trail includes grassland habitat for many sensitive plant species, including coast lily, *Lilium maritimum*; Mendocino coast paintbrush, *Castilleja mendocinensis*; Point Reyes checkerbloom, *Sidalcea calycosa* ssp. *rhizomata*; and harlequin lotus, *Hosackia gracilis*; among others.[19]

14. Navarro River; Navarro River Estuary State Marine Conservation Area; 26-mile-long watercourse that runs from Anderson Valley; Navarro River Redwoods State Park and Paul M. Dimmick Campground are on the river, both within second-growth redwood forest; inland 20 miles is Hendy Woods State Park, home to a publicly accessible, old-growth redwood grove.

15. Navarro Beach; mouth of the Navarro River, north of Saddle Point; Arch of the Navarro visible from the beach; geologically, wave-eroded sea arches form quickly and don't last long.

16. Greenwood State Beach; also known as Elk Beach, on Greenwood Creek; near the coastal bluff town of Elk; wildflower meadows and pasturelands surround.

storm-petrel *Oceanodroma homochroa*

## 07.07a All the Tough Little Trees
*Stories from the terraced dune forest*

The pygmy shore pine, also called the Bolander pine, *Pinus contorta* ssp. *bolanderi*, is part of the larger genus of lodgepole pines (*P. contorta*) that can be found across the mountainous west. In just a few locations along California's northern coast, where millions of years of tectonic rearrangement, augmented by hundreds of thousands of years of blowing beach sand up the terraced landscape, habitat has evolved for a diminutive expression of the shore pine. Due to its environment, an eternally wet bog, and the limitations of the oxygen-poor soil (podzol), the tree is never able to even come close to the heights of the other members of its extended tree "family."[20] Often the century-old pines and cypress in the forest grow only three feet tall and just a couple of centimeters thick. Among squat rhododendron bushes; the bishop pine, *Pinus muricata*; the Mendocino cypress, *Cupressus pygmaea*; and its friend, the similarly adapted pygmy cypress, *Hesperocyparis pygmaea*, the pygmy shore pine has helped usher this uniquely Californian forest into being.

one-hundred-year-old six-foot Bolander pine

07. A Good, Long Walk

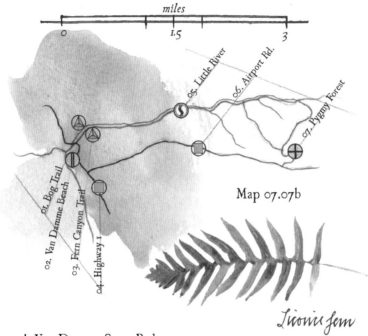

Map 07.07b

*Licorice fern*

## 07.07b Van Damme State Park

Van Damme State Park is among several sites along the Mendocino coast that exhibit the pygmy forest habitat within the context of a terraced staircase—the unique geologic formation of the inland coastal bluffs. The combination of uplift, erosion, and soil type creates niche conditions for a host of wildlife—the pinnipeds that lounge on the rocks offshore, shorebirds at their inland nesting sites, and, further inland, mammals, including the black bear, whose population in Mendocino county is now over two thousand individuals.[21]

Common ferns that densely compose the walls of the park's shaded and cool Fern Canyon Trail include the five-finger fern, *Adiantum aleuticum*; birdfoot cliffbrake, *Pellaea mucronata*; lady fern, *Athyrium filix-femina* var. *cyclosorum*; licorice fern, *Polypodium glycyrrhiza*; sword fern, *Polystichum munitum*; and the north coast's endemic species of deer fern, *Blechnum spicant*.[22] A five-mile round-trip trail crosses the Little River many times and leads to the pygmy forest, where there are sixty-year-old Mendocino cypress trees that, due to habitat, exist in stunted form at only a few feet in height.[23]

# The Coasts of California

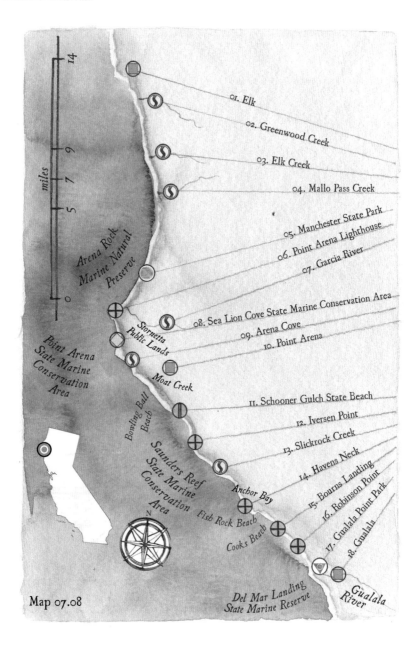

Map 07.08

# 07.08 OF LIGHTHOUSES AND LONG VIEWS
*The Point Arena coast*

Map 07.08 describes nearly 32 miles of the coastline in Mendocino County.

The hook that is Point Arena extends out from the westward sweep of Manchester Beach, creating a catch basin for driftwood and southward debris caught in the current moving clockwise around the Pacific; often junk from Japan will show up on the beach.[1] The climate near Point Arena is unique to coastal California in that it enjoys a relatively short frost season and, at three hundred days, an extraordinarily long growing season.[2] Arguably, Point Arena Lighthouse, with its long views and high vantage, is the best onshore whale-counting location on the north coast.

The area included on this map, from Mallo Pass Creek to Havens Neck, is the only habitat in the world for one of the world's oldest and most endangered rodents, the Point Arena mountain beaver.[3] Not to be confused with the dam-building, aquatic North American beaver with the slapping tail, the mountain beaver (of which the Point Arena variety is one of seven subspecies) lives underground in burrows.[4] Only sixteen population groups of between two and ten individuals are known to exist.[5]

01. Elk, coastal community; old logging town, remade as a tourist destination; migrating California tortoiseshell butterflies, *Nymphalis californica*, feed and lay their eggs on the many species of California lilac, *Ceanothus* spp., across the coastal steppe.[6]

02. Greenwood Creek; between the Garcia River, which exits into the sea at Point Arena, and Greenwood Creek,

the creek closest to the town of Elk, there is a ladder of four creeksheds: Elk Creek, Mallo Pass Creek, Alder Creek, and Brush Creek.

03. Elk Creek; a privately owned watershed of about 20 square miles; roughly the same size and shape of the other creeksheds in this heavily pastured landscape.

04. Mallo Pass Creek; the watercourse itself is hidden under a thick shrub canopy; the California Coastal Trail is the same as Highway 1 from Greenwood Beach to Manchester Beach; a side trail once existed close to the shore, but has since been weathered away.[7]

05. Manchester State Park; the wide, 4-mile-long, pristine beach includes 1,500 acres on land and 3,782 acres offshore; the park includes Lake Davis Wetlands and Coastal Dunes Natural Preserve; adjacent to the Brush Creek/Lagoon Lake Wetlands and Coastal Dunes Natural Preserve.

06. Point Arena Lighthouse; 150 years old; Point Arena–Stornetta Public Lands; 1,600 acres surround the lighthouse and are managed as part of the California Coastal National Monument; this area, an annex, was the first extension on to land of the marine-based monument;[8] thousands of human-planted daffodils, Narcissus, erupt from their bulbs every spring around the lighthouse.

07. Garcia River; 44-mile-long watercourse that follows the San Andreas Fault north from the river's headwaters south of Boonville; once an active salmonid habitat, the Garcia River may be so again, given the intense restoration effort under way—including the planting of 40,000 trees to fight river sedimentation and to sequester the pasture animals from the riparian habitat.[9]

08. Sea Lion Cove State Marine Conservation Area and Sea Lion Rocks; a quarter-square-mile protected habitat; abalone nursery for red abalone, *Haliotis rufescens*, and other species; harvest of invertebrates, algae, and other plants is prohibited.

09. Arena Cove; Moat Creek; rocky beach near the town of Point Arena, surrounded on all sides by tall cliffs; seeing a

*Douglas Iris*

gray whale in the coastal waters, right off the pier, is not uncommon in the winter months.[10]

10. Point Arena; 3 miles east of where the San Andreas fault enters the Pacific Ocean; the cliffs and rocks that make up the bluffs near the lighthouse are of the Pacific tectonic plate and are nearly 10 million years old.[11]

11. Schooner Gulch State Beach; above the sandy beach, close to Bowling Ball Beach; habitat for the endangered Behren's silverspot butterfly, *Speyeria zerene behrensii* (G5T1/S1)—coastal prairie that includes habitat for many plants the butterfly needs to recover, one of which is the western dog violet, *Viola adunca*, in whose leaves the butterfly lays her eggs.[12]

12. Iversen Point; Saunders Landing; Saunders Reef State Marine Conservation Area; home to some of the densest bull kelp, *Nereocystis luetkeana*, submarine forests in the world.[13]

13. Slickrock Creek; from Bowling Ball Beach, just south of Point Arena, the California Coastal Trail and Highway 1 are the same.

14. Havens Neck; Pelican Bluffs Preserve; coastal prairie and known site of Point Arena mountain beaver population. Common plants include everything that would be on the menu for the Point Arena mountain beaver:[14] bracken fern, *Pteridium aquilinum*; sword fern, *Polystichum munitum*; stinging nettles, *Urtica* spp.; thistles, *Cirsium* spp.; corn lily, *Veratrum* sp.; salal, *Gaultheria shallon*; foxglove, *Digitalis purpurea*; larkspur, *Delphinium* sp.; and skunk cabbage, *Lysichiton americanus*.[15]

15. Bourns Landing; between Bourns Landing and Gualala, the California Coastal Trail separates from Highway 1 and threads along the old coast highway.

16. Robinson Point; the southern Mendocino coast is whale-watching country; thousands of gray whales, *Eschrichtius robustus*, pass these bluffs in March on their way north to the Bering Sea, and pass this way again headed south on their annual migration in December.[16]

17. Gualala Point Regional Park; site of established offshore colony of Brandt's cormorant, *Phalacrocorax penicillatus* (SNR); approximately 75% of the world's population of Brandt's cormorant nest on the rocks off this coast.[17]

18. Gualala, town that sits on the boundary of Mendocino and Sonoma Counties. Common birds include northern flicker, *Colaptes auratus* (SNR); western bluebird, *Sialia mexicana* (SNR); the barn-dwelling violet-green swallow, *Tachycineta thalassina* (SNR); and the thistle-feeding American goldfinch, *Spinus tristis* (SNR). South of Gualala, on Del Mar Point, is Del Mar Landing State Marine Reserve—an Area of Special Biological Significance; .6 miles of coastline, 54 acres.[18]

## 07.08a Saving Elk Creek
*Data in the service of restoration*

Blasting past any one of the hundred-or-so creeks while driving up Highway 1 on the Mendocino coast, it is impossible to discern the importance of any single one of them. Yet every single one of them is potential habitat to an enormous wealth of biodiversity, indicated by several keystone species of salmonid fish that until very recently made good use of these coastal creeks in bountiful numbers. Elk Creek (not a unique creek, although precious nonetheless) is a creekshed that has undergone numerous studies to determine why it was historically excellent habitat for this richness of riverine and riparian life, and how it might be so again.

Compiling habitat inventory reports is the first step in a long campaign to what will eventually lead to the restoration of what has been forgotten, lost, compromised, or altered in this ecosystem. *The California Salmonid Stream Habitat Restoration Manual* offers the detailed information that restoration workers need to begin their efforts.[19] The analysis of Elk Creek in 2001 revealed the following highlights as existing habitat conditions:[20]

1. Water temperatures through the warm season are 59°–62°F, nearly too warm for the rearing of many local types of anadromous fish.

2. The three kinds of fish habitats are flatwater beds, pools, and riffles and were inventoried with the following existing percentages in the study area: 47%, 39%, and 14%, respectively, indicating habitat abundance for salmon redds (sites where eggs are laid).

3. The stream floor is 82% gravel substrate, excellent for fish spawning.

4. The mean percentage canopy density for Elk Creek is 87%. Canopy density is an indicator of the amount of shade on the watercourse, which can help lower water temperatures.

Although salmonid population numbers in Mendocino County over the past twenty years are spotty, many indicators suggest that a modest comeback of these important fish is under way, one that can be augmented with good science and investment.[21] The State of California has recently kicked off a new initiative to further the initial work done, called the Priority Action Coho Team, supporting the state-led stewardship of these habitats from Mendocino to Santa Cruz.

## 07. A Good, Long Walk

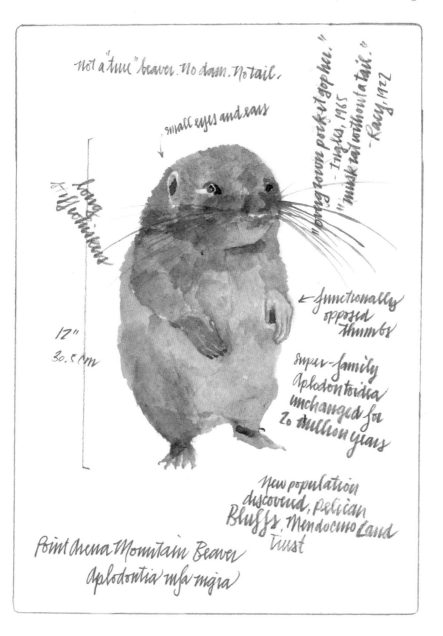

The Coasts of California

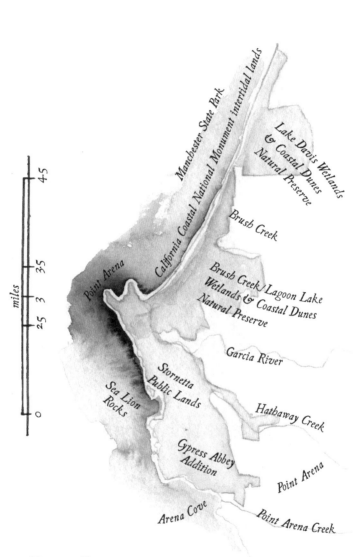

Map 07.08b

## 07.08b Stornetta Public Lands

Point Arena–Stornetta is famous in land-protection circles as having been the first land-based portion of the California Coastal National Monument (est. 2013). Within these twelve miles of state and federally protected coast, seabirds roost beside a thousand acres of precious northern coastal prairie. In shadowed alcoves across the stepped prairie, the regularly spotted flora include populations of alta fescue, *Festuca arundinacea*; Pacific blackberry, *Rubus vitifolius*; coast mugwort, *Artemisia suksdorfii*; coyote brush, *Baccharis pilularis*; red alder, *Alnus rubra*; salal, *Gaultheria shallon*; tufted hairgrass, *Deschampsia cespitosa*; and yellow bush lupine, *Lupinus arboreus*.[22] Less regularly seen but still present is the endangered Behren's silverspot butterfly, *Speyeria zerene behrensii* (G5T1/S1), nesting on its favorite food source, the western dog violet, *Viola adunca*, near patches of another rare flower found here, Contra Costa goldfields, *Lasthenia conjugens*.[23] Stornetta Public Lands, as the place is referred to, is also habitat to everyone's favorite endangered rodent, the Point Arena mountain beaver, *Aplodontia rufa nigra* (G5T2/S2).

guillemot

oystercatcher

Among the regular visitors and nesting species on the protected cliffs and rocks of the monument are black oystercatchers, *Haematopus bachmani*; pigeon guillemots, *Cepphus columba*; Laysan albatross, *Phoebastria immutabilis*; and ashy storm petrel, *Oceanodroma homochroa*.

The Coasts of California

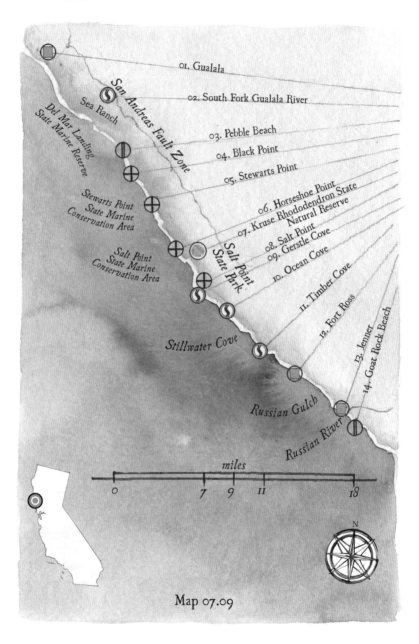

Map 07.09

## 07.09 OF WINE AND WILDFLOWERS
*The west Sonoma coast*

Map 07.09 depicts 34 miles of the coastline of Sonoma County.

When geologists visit the rocky beaches of the west Sonoma coast, they see something different than a casual tourist does. Where most people are only able to see and report the beaches as either rocky or sandy, the geologist might describe any given rocky beach south of Gualala as dominated by a sandstone-consolidated bedrock, among boulder fields on a cobble coast.[1] For many locals, the shoreline along Mendocino and Sonoma Counties merges into one continuous region called the Mendonoma coast.[2]

The particular nature of the climate, with its clear-skied winters, rainy springs, foggy summers, and blistering autumns, creates a great variety of ecological theater. Along this coast, natural habitat includes a spectrum from redwood riparia to wildflower prairie; meanwhile, along the nearby ridgelines, vintners find perfect conditions for their grapes, a bucolic scene that belies the continued fight to save this area's remnant natural refugia.

01. Gualala; behind the shops and between Highway 1 and the beach is the Gualala Bluff Trail at the mouth of the Gualala River—an easy vantage point for spotting such charismatic creatures such as seals, whales, river otters, and bald eagles; Bluff Trail is part of four local restoration and conservation projects stewarded by the Redwood Coast Land Conservancy, including two on the ocean (Hearn Gulch, Cooks Beach) and one on the Gualala River at Mill Bend.[3]

02. South Fork Gualala River; the fight is on over the proposed logging of 342 acres of mature redwood floodplain habitat on private land in the Gualala River watershed; Friends of

> all the building blocks of the previous world are still here; imagine the creeksheds, terraced landscapes of beaver lodges that hundreds of happy returning salmon climb like so many stairs back to their headwaters to fulfill their anadromous destiny.

the Gualala River and the Center for Biological Diversity have sued to prevent the logging of precious habitat for so many endangered species, including the red-legged frog, *Rana aurora* (G4/S3), and the northern spotted owl, *Strix occidentalis caurina* (G3T3/S2S3).[4]

03. Pebble Beach; habitat for 221 species of birds exists in the 10 miles between Gualala and Salt Point State Park; included in that number are 16 species of raptor and 6 species of owl. Among the special-status raptors are the white-tailed kite, *Elanus leucurus* (G5/S3S4); bald eagle, *Haliaeetus leucocephalus* (G5/S3); northern harrier, *Circus hudsonius* (G5/S3); Cooper's hawk, *Accipiter cooperii* (G5/S4); sharp-shinned hawk, *Accipiter striatus* (G5/S4); ferruginous hawk, *Buteo regalis* (G4/S3S4); golden eagle, *Aquila chrysaetos* (G5/S3); and merlin, *Falco columbarius* (G5/S3S4).[5]

04. Black Point; inside the larger development parcel called the Sea Ranch is the story of a 50-year-old war between public and private interests and, at the heart of the war—access, the touchstone that eventually led to the 1972 landmark legislation, the Coastal Zone Management Act; Sea Ranch was supposed to be twice as big as it currently is, having been originally planned for 5,200 homes, but now with only 2,500, and designed to keep the public off its beaches and out of its land; compromises were made on both sides; to this day, there is still only limited access through the development, and no trail that traverses the whole length of it.[6]

05. Stewarts Point; in 2017, Save the Redwoods League transferred an acquired inholding of 700 acres of healthy, second-growth redwood forest

Swamp harebell
*Campanula californic*

and 100 acres of coastal prairie to the perpetual management of the Sonoma County Agricultural Preservation and Open Space District.[7] Most of this parcel, which includes 1.7 miles of the Gualala River, will be managed as an old-growth restoration reserve; accelerated forestry techniques will be applied to return the forest to a virgin state.[8]

06. Horseshoe Point; northern end of Salt Point State Park. In early summer, marine mammals pass within sight of this point, including orca, *Orcinus orca*; humpback whale, *Megaptera novaeangliae*; and perhaps even a pod of more than a hundred Risso's dolphin, *Grampus griseus*.[9]

07. Kruse Rhododendron State Natural Reserve; among the reserve's namesake flowers are plentiful blooms of Calypso orchid, *Calypso bulbosa*[10]—the bright pink flower stands only a few inches above the vernal floor of the redwood forest.

08. Salt Point; Salt Point State Park; and Kashia Coastal Reserve;[11] all together, 6,000 acres, 6 miles of coastline, and 12 miles of trails; renowned as one of the few state parks to allow mushroom foraging—the per-person limit is three pounds per day; in February, the dampness brings blooms of delicious black trumpets, *Craterellus cornucopioides*, a prized delicacy.

09. Gerstle Cove; Gerstle Cove State Marine Reserve; Area of Special Biological Significance and also the site of a long-term study on the effects of ocean contaminants on bivalves—mussels, clams, and oysters;[12] .6 miles of coastline, adjacent to the Salt Point State Marine Conservation Area;[13] part of a network of protection designations—there is no legal harvesting of anything from within the reserve.

10. Ocean Cove; southern border of Salt Point State Park; Stillwater Cove Regional Park—210-acre county park with abundant redwood forest habitat along Stockhoff Creek; within this forest, a small and endemic blue flower lives, called the swamp harebell, *Campanula californica*[14]—considered threatened throughout its range and vulnerable to drought and to damage by logging and skidding of downed trees by the timber industry.[15]

11. Timber Cove; Windermere Point; site of a long-term diversity study of the ochre sea star, *Pisaster ochraceus*,[16] a ubiquitous species of sea star along the rocky shore of the eastern Pacific, from Alaska to Santa Barbara. In the warmer waters south of Santa Barbara, the species exists as *Pisaster ochraceus* ssp. *segnis*,[17] susceptible to sea star wasting disease (see 07.09a).

12. Fort Ross, state historical park; southernmost settlement of the Russian colonization into North America during the first half of the nineteenth century,[18] fueled economically by the harvest of fur from local mammals—beaver, fox, otter, seal, and others.[19]

13. Jenner; the only town for 40 miles north along Highway 1 before Gualala; home to the Jenner Headlands Preserve —5,630 acres of redwood forest and coastal prairie; known habitat for a number of special-status species, including the Sonoma tree vole, *Arborimus pomo* (G3/S3).

14. Goat Rock Beach; Russian River; Russian River State Marine Conservation Area. Goat Rock is a large, flat-topped sea stack that dominates the large sandy beach; it makes sense that you would find the largest colony of harbor seals in Sonoma County here in the largest estuarine habitat space at the mouth of its biggest river, the Russian River.[20]

northern harrier
Circus hudsonius
lives for 16 years
migratory bird of prey

## 07.09a Pathogen Incognita
*The mysterious tragedy of sea star wasting disease*

Since the late 1970s, a mysterious plague has afflicted over forty species of echinoderms, specifically sea stars, within California's rocky intertidal zone.[21] Called sea star wasting disease, it starts with white, blotchy lesions on the creature's skin, and within a few days, the hapless sea star utterly dissolves, having wasted away. Scientists had been studying the disease for several years before it came to California, as it did begin on the East Coast and took a while to make it to our local tide pools, and because of this advance study, there are good metrics about its devastating effect on the biome of our shoreline.[22] And devastating it has been—rendering locally extinct one population of sea star in the Channel Islands and decimating the populations of many others region wide.[23] Ecologically, the sea star is a keystone species (or, perhaps more precisely, a keystone predator), as it feeds on bivalve mollusks and thus prevents them from proliferating too much.[24] Without them, the trophic balance within the system is lost.

The disease has come and gone periodically over the decades, and the most recent and prolonged outbreak in Northern California hit in 2013, leaving most populations yet to fully recover.[25] The strangest thing about the disease is how little we know about it. It doesn't seem to be caused by any normal pathogen, it doesn't seem to be related to water temperature, and it doesn't seem to be spurred by oceanic acidification.[26] The latest research suggests that it is a virus that attacks the DNA of the invertebrate, and although some controlled-subject sea stars have responded positively to antibiotics, the exact cause of the sea star plague remains elusive.[27]

*Sunflower star, Pycnopodia helianthoides*

# The Coasts of California

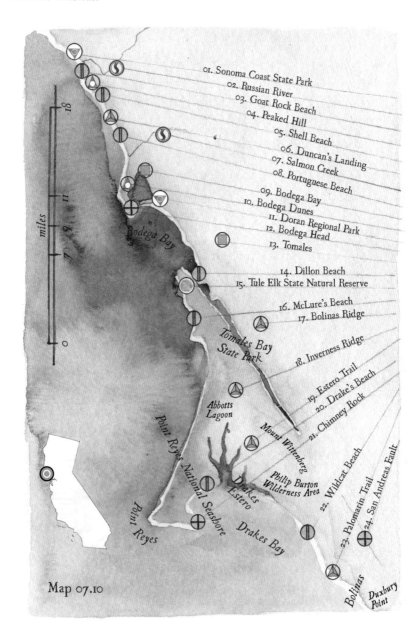

Map 07.10

## 07.10 OF PASTURE AND POETRY
*The Point Reyes coast*

Map 07.10 depicts a total of approximately 65 miles of the coastline of Marin and southern Sonoma Counties. That mileage includes Point Reyes, but does not include the shores of Tomales Bay.

According to archaeological evidence, humanity came to Point Reyes ten thousand years ago and found a much different place than it is today.[1] In this age, at the dawn of the Holocene, eight thousand years after the Last Glacial Maximum, there was still enough fresh water locked up in global ice that sea level was three hundred feet lower. At Point Reyes, the coastal steppe extended west thirty miles from where it stops today. Further north, into Sonoma Coast State Park, which includes much of the coast from Fort Ross to Bodega Bay, the coastal terrace, a massive wedge of tectonically influenced earth, had recently uplifted over the past hundred thousand years or so.[2] Noted for its exceptional biodiversity, the biome that is the Point Reyes coast, the boundary between the North American tectonic plate and the Pacific Plate is home to a number of vulnerable and endangered endemic species, including the ten-legged California freshwater shrimp, *Syncaris pacifica* (G2/S2), which only lives in seventeen creeks within Sonoma, Marin, and Napa Counties.[3]

01. Sonoma Coast State Park; the park's western boundary extends south from the mouth of the Russian River as a series of sandy beaches divided by rocky bluffs; the beach system runs for 17 miles, and includes Bodega Bay, south to Dillon Beach in Marin County.[4]

02. Russian River; the biggest river for 250 miles between San Francisco Bay and the Eel River, south of Humboldt Bay; the Russian River is 110 miles long and drains a watershed of approximately 1,500 square miles;[5] for Central California's distinct population segment of coast steelhead trout, *Oncorhynchus mykiss* (G5T2T3Q/ S2S3), there is no larger or more stable habitat than the Russian River;[6] the river's

---

*What do we want our parks to look like? What is the common good? Preservation is not a good word; it doesn't exist in the natural world.*

population of Chinook salmon, *Oncorhynchus tshawytscha* (G5/S1), seems to be widespread and stable as well;[7] coho salmon, *Oncorhynchus kisutch* (G4/S2), the river's least-populous salmonid, continues a year-over-year comeback from its 2004 low of only four adult fish returning to spawn; an estimated 800 adults returned in 2018, and coho will be removed from the endangered species list when they reach a total population of 10,100 returning individuals.[8]

03. Goat Rock State Beach; mouth of the Russian River; Russian River State Marine Conservation Area. Pinnipeds that regularly use the fish-rich estuary of the Russian River and the adjoining Goat Rock State Beach to rear their pups include the harbor seal, *Phoca vitulina richardsii*; California sea lion, *Zalophus californianus*; and northern elephant seal, *Mirounga angustirostris*. Pinniped population is at its highest during the April–June pupping season, and at its lowest in November.[9] Please

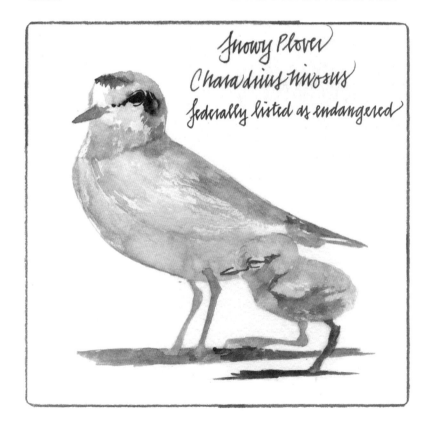

Snowy Plover
*Charadrius nivosus*
federally listed as endangered

note that if you see a harbor seal pup by itself, do not approach it; its mother is nearby, and the seal is in training to fend for itself.[10]

04. Peaked Hill (376'); between Arch Rock to the north, Gull Rock to the south, and Sunset Boulders to the east; the geologic melange that makes up this coastline is complex and includes Goat Rock, made from a quartz-rich sandstone known as graywacke, whereas most of the other stacks are composed of various Franciscan rocks whose original formation can date back 200 million years inside vastly different regional tectonic processes than those that exist today.[11]

05. Shell Beach; two trails begin at Shell Beach—the largely boardwalked Kortum Trail, which runs from Shell Beach to Goat Rock Beach (part of the California Coastal Trail), and Pomo Canyon Trail, which heads inland 3 miles for a total of 6 miles.

06. Duncan's Landing; Wright's Beach; the sea stack near Duncan's Landing is called Death Rock, apparently because the waves are responsible for the death of more than one unwary explorer of the beach.[12]

07. Salmon Creek; Carrington Ranch Preserve; 350 acres adjacent to Salmon Creek; the preserve, managed by Sonoma County Regional Parks and California State Parks, will soon be open to the public and will contain trails that connect this coastal space to the California Coastal Trail and the Kortum Trail to the north.[13]

08. Portuguese Beach; among the regular sightings of gray whale, many other cetacean species can be observed from this vantage, mostly from January to May, including fin whale, *Balaenoptera physalus*, and, appearing like a tiny blue whale, the minke whale, *Balaenoptera acutorostrata*.[14]

09. Bodega Bay; Coastal Prairie Trail; outside the town, Sonoma County's coastal prairie dominates the hilly country flora; native flora are still common among invasive grasses, including the ubiquitous coyote brush, *Baccharis pilularis*, and the bright-yellow coastal bush lupine, *Lupinus arboreus*; the coarse and rugged bracken fern, *Pteridium aquilinum*, lives beside Point Reyes ceanothus, *Ceanothus gloriosus*, beneath shrubby groves of Pacific wax myrtle, *Morella californica*.

10. Bodega Dunes; Bodega Dunes Beach and Salmon Creek Beach (07) are both designated protected habitat for the western snowy plover, *Charadrius alexandrinus nivosus* ($G_3T_3/S_2S_3$)—this diminutive, fluffy bird lays her eggs in plain sight, in beach sand from Washington to Baja. Aside from trampling by humans and, perhaps even worse, their dogs, along with the trash that often accompanies visits to the beach that might attract unwanted predators, two invasive species also threaten the snowy plover: European beach grass, *Ammophila arenaria*, and

*black-tailed deer*
*Odocoileus hemionus columbianus*
Native

the always pernicious eastern red fox, *Vulpes vulpes*.

11. Doran Regional Park; Doran Marsh; Bird Walk Coastal Access Trail. The tide reveals a vast mudflat, perfect foraging for a variety of special-status birds, including hundreds of brant geese, *Branta bernicla* (G5/S2?), who winter on Bodega Bay; the California black rail, *Laterallus jamaicensis coturniculus* (G3G4T1/S1); and the long-billed curlew, *Numenius americanus* (G5/S2).[15]

12. Bodega Head; a 4-mile-long piece of granite that sticks out from the southern Sonoma coast to create the natural harbor that is Bodega Bay;

## 07. A Good, Long Walk

the Sonoma coast can be a cold place, rarely getting higher than 60°F in September, although it also rarely freezes—from November through February, hurricane-like local storms can batter the exposed coastal terrace;[16] site of the UC Davis Bodega Marine Laboratory and the 362-acre Bodega Marine Reserve, the leading research facility working to save the last remaining coastal prairie habitats from invasive grasses.[17]

13. Tomales; in spring, across the pasturelands of northern Marin County, California poppy, *Eschscholzia californica*, blooms. Up on to the coastal terrace on a trek north, fields of lupine, *Lupinus* spp., skirted by orange monkeyflower, *Diplacus aurantiacus*, and dappled with Indian paintbrush, *Castilleja* spp., are joined in their floral composition by the tall streak of purple that is the unfolded Douglas iris, *Iris douglasiana*; as beautiful as it might be for us and the native bumble bee, *Bombus vosnesenskii*, that pollinates these fields, the thick mats that iris form prevent cattle feed from growing, to the consternation of ranchers.[18]

14. Dillon Beach; Stemple Creek finds Bodega Bay, just north of Dillon Beach at the southern end of the bay; Dillon Beach remains one of the only private beaches in California and is accessible only by paying a fee;[19] perhaps because of continuous private management over the past 60

Tule elk
*Cervus canadensis nannodes*

years, the large dune field behind Dillon Beach and near Lawson's Landing retains its original dynamic character. Dune habitat includes beach bursage, *Ambrosia chamissonis*; dune tansy, *Tanacetum camphoratum*; salt rush, *Juncus lesueurii*; and encroachment by the invasive gray-green European beach grass, *Ammophila arenaria*.[20]

15. Tule Elk State Natural Reserve; the tule elk herd at Point Reyes National Seashore has averaged a population

of 421 individual elk over the past 20 years;[21] Tomales Point is the northernmost end of the Point Reyes National Seashore; managed by the National Park Service, the park includes working ranches (leased from the park) over a landscape that is among the most consistently foggy places anywhere on the planet.[22]

16. McClures Beach; mile-long round-trip secluded trail near historic Pierce Point Ranch within the Tule Elk Preserve.

17. Bolinas Ridge; from the east side of Highway 1, which runs parallel to and in the immediate vicinity of the San Andreas Fault through Olema Valley, to the top of Bolinas Ridge, this area is managed as part the Golden Gate National Recreation Area in cooperation with the Golden Gate National Parks Conservancy; across woodland and riparian ecosystems, robust programs of volunteer-led restoration and invasive-plant-removal projects are constantly under way.[23]

18. Inverness Ridge; extends from Mount Wittenberg (1,407') north on the west side of Tomales Bay; to the west, pasturelands extend to Abbotts Lagoon; to the east, Tomales Bay State Park; Douglas fir, *Pseudotsuga menziesii*, is the most common conifer on the forested north end of the ridge, and toward the south end, the bishop pine, *Pinus muricata*. The overstory of the dry forest along the ridge includes a who's-who list of North Bay trees and includes coast live oak, *Quercus agrifolia*; California bay laurel, *Umbellularia californica*; and California buckeye, *Aesculus californica*. In the creek-fed valleys, the forests are primarily tanbark, *Notholithocarpus densiflorus*; Pacific madrone, *Arbutus menziesii*; and coast redwood, *Sequoia sempervirens*—which is not found on the other side of Tomales Bay, due to soil chemistry because of local tectonics. The understory shrubs of Tomales Bay State Park include Pacific poison oak, *Rhus diversiloba*; coyote brush, *Baccharis pilularis*; sticky monkeyflower, *Diplacus aurantiacus*, blueblossom; *Ceanothus thrysiflorus*, California sagebrush; *Artemisia californica*; coffeeberry, *Rhamnus californica*; and red-flowering currant, *Ribes sanguineum*.[24]

19. Estero Trail; Drakes Estero; the Estero Trail and the Abbotts Lagoon Trail are not part of the California Coastal Trail—which follows Inverness Ridge—but are ideal instances of Point Reyes wetland habitats; Point Reyes harbors four types of wetland, all of them endangered along the coast: salt, brackish, wet meadow, and seasonal ponds; four rodents are found in this area, including the federally listed salt-marsh harvest mouse, *Reithrodontomys raviventris*.[25]

20. Drake's Beach; breeding populations of northern elephant seal, *Mirounga angustirostris*, have steadily increased since their return to these beaches in the early 1970s;[26] elephant

seals spend most of their lives at sea, traversing the huge expanse of the eastern Pacific Ocean from Alaska to Mexico; along specific beaches on the mainland and the Channel Islands, these largest of the true seals gather between March and August to breed and give birth.[27]

21. Chimney Rock; Point Reyes, the furthest point west in the 70,000-acre Point Reyes National Seashore; over 400 species of migratory birds as well as over a dozen species of marine mammal pass by this point;[28] among them are many federally listed endangered species, such as the short-tailed albatross, *Phoebastria albatrus* (G1/S1), and the largest animal in the history of animal life on earth, the blue whale, *Balaenoptera musculus*.

22. Wildcat Beach; in 2020, the Woodward Fire scorched nearly 5,000 acres of Point Reyes parkland, from Mount Wittenberg to Wildcat Beach; these acres had not burned in more than 100 years, so the area had become a thick forest of dry fuel, allowing for intense, slow-moving fire.[29]

23. Palomarin Trail; northern end of the Bolinas Mesa; Crystal Lake, Pelican Lake, Bass Lake, Ocean Lake, and Wildcat Lake, coastal lakes formed by landslides; Alamere Falls—one of two "tidefalls" in California that flow directly into the ocean;[30] Pelican Lake and Double Point are protected Areas of Special Biological Significance due to the large population of harbor seals, *Phoca vitulina*, that use this rocky shore to breed and give birth.[31]

24. San Andreas Fault; in one lurch, the 1906 San Francisco earthquake pushed Point Reyes north 16 feet; Tomales Bay is a flooded rift valley between the North American and the Pacific tectonic plates.[32]

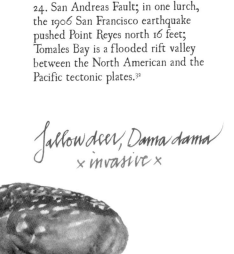

fallow deer, *Dama dama*
× invasive ×

## 07.10a Of Cows, Elk, Deer, and Oysters
*Conflicts of conservation at Point Reyes*

Point Reyes is a triangle of 71,028 acres (about 110 square miles) of land between Tomales Point in the north, Duxbury Point in the south, and the geographic locale that is Point Reyes to the east. Roughly thirty thousand acres within the national seashore are designated federal wilderness, called the Phillip Burton Wilderness. Surrounded by approximately twenty-two square miles of protected marine habitat within Point Reyes State Marine Reserve and Point Reyes State Marine Conservation Area, Point Reyes exists within a complicated web of management designations that bring an equal amount of contentious expectations. The story of cows, elk, deer, and oysters at Point Reyes is the story of our attempts to balance land protection with human ecology.

Ranching, the raising of cows for food and dairy, is a tradition on Point Reyes that is older than the state of California. When the national seashore was designated by President Kennedy in 1962 to be managed by the National Park Service, the ranchers sold their property to the federal government, but as part of their contract, they had the land leased back to them so that they could continue with that tradition. Today the total cow population in the park nears six thousand across fifteen of these legacy ranches, leased by twenty-four families.[33]

There are three herds of tule elk inside the national seashore: one that is fenced in near Tomales Point (with a population of 445 elk at the end of 2019); the other two, a free-roaming herd near the park's Limantour area of 163 elk, and one near Drake's Beach of 138 elk. Having been extirpated from this, their natural habitat, in the middle of the nineteenth century, they were reintroduced to Point Reyes in the late 1970s and have contended with cattle ranchers ever since. The exact population of elk fluctuates as environmental conditions change,[34] and periodically the park service decides to delay the kill of elk in accordance with management plans, but they may have resumed the killing as you are reading this—a decision that environmental activists meet often with fierce resistance.[35]

The future both of the elk and of ranching within the park—whether they can coexist—is a microcosm of California land management ethics as a whole. With the expelling of Drakes Bay Oyster Company in 2015, there is now a precedent within the national seashore of removing legacy commercial interests. Bowing to public interest after a decades-long, fierce debate about the oyster company's future, the National Park Service decided that the aquaculture of oyster farming within Drakes Bay was anathema to the vision of wilderness—a modern vision of wilderness that is land untouched by

## 07. A Good, Long Walk

human engagement—and despite no real scientific evidence of water degradation caused by the oysters, the oyster farm was removed.[36]

Another challenge to land management across Point Reyes is the control of two invasive species of deer: axis deer, *Axis axis*, and fallow deer, *Dama dama*. The two native species of ungulates on the point are elk and black-tailed deer, *Odocoileus hemionus columbianus*, and the presence of axis and fallow deer disrupts the native species' ability to proliferate as they've done for millennia. The last of the axis deer in Point Reyes were removed in 2009, and the last of the fallow deer have been sterilized by the National Park Service.[37]

axis deer, *Axis axis*
xinvasivex

# The Coasts of California

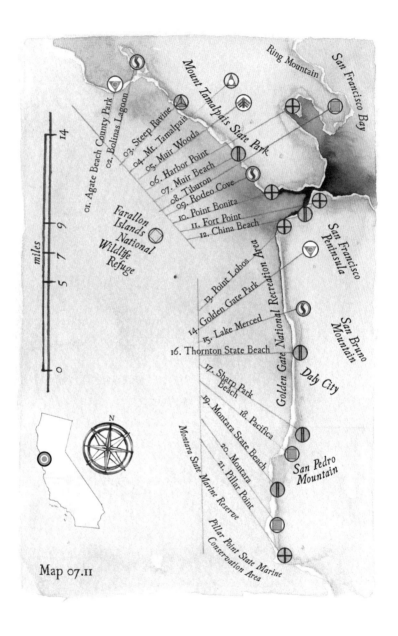

Map 07.11

## 07.11 OF PEAKS AND PENINSULAS
*The Golden Gate coast*

Map 07.11 depicts nearly 45 miles of the greater San Francisco area, across the Golden Gate Bridge and not including the entire San Francisco Bay.

Under San Francisco's iconic Golden Gate Bridge, the water from almost 40 percent of California's total land area—the combined flow from the Sacramento and the San Joaquin river valleys—passes as a powerful torrent through the narrow strait barely a mile wide. Before its nineteenth-century makeover, the northwest corner of San Francisco was a network of dunes and treeless bluffs, a native assemblage of dune scrub that included lupine, *Lupinus* spp.; sticky monkey-flower, *Diplacus aurantiacus*; coyote brush, *Baccharis pilularis*; and coffee-berry, *Rhamnus californica*. Being on an isolated peninsula means that many species of wildflowers in San Francisco have evolved to become endemic, flowers including San Francisco campion, *Silene verecunda*, and San Francisco spineflower, *Chorizanthe cuspidata*, among others. Today, you can find this plant community still existing within specific native garden sites across the landscape of the Presidio, including Lobos Creek Valley, North Baker Beach, and Balboa Natural Area, a restored dune community near Ocean Beach on the corner of Highway 1 and Balboa Street.[1]

01. Agate Beach County Park; southernmost extent of Point Reyes National Seashore; 20 miles from the Farallon Islands, which are visible on a clear day; partially within Duxbury Reef, a rocky intertidal zone with healthy tide pools.

02. Bolinas Lagoon; large estuary and home to Audubon Canyon Ranch, a nature center, and its affiliate, Cypress Grove Research Station; populations of up to 35,000 shorebirds and roughly 5,000 waterfowl visit or nest in the vicinity; avian and conservation science locally conducted by the Point Blue Conservation Science's Palomarin Field Station.[2]

> The most beautiful bridge in the world is not any piece of architecture but a temporal concept that links ancestral wisdom with ecological foresight.

03. Steep Ravine; 4-mile looping trail that begins at Pantoll Campground's parking lot; trail connects with Dipsea Trail or is walkable to the village of Stinson Beach; arguably the best creekside riparian redwood-forest trail in Marin—not like the big trees of Muir Woods National Monument just over the hill, but because of the steep elevation gain and loss of 900 feet, a dynamic scene.[3]

04. Mount Tamalpais (2,571'); the clear ridgeline is visible to the north of San Francisco; being at the tip of the peninsula, this mountain and more than 100 square miles of land surrounding it have enjoyed legal protection for almost a century and, thanks to that protection, remain a hotspot for rare plants and animals.

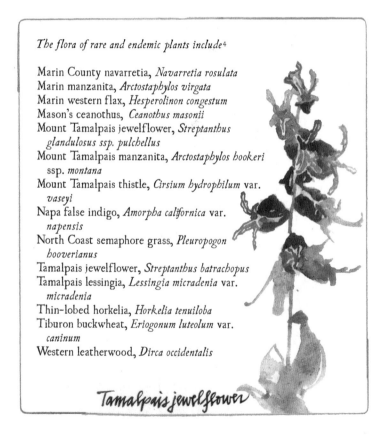

*The flora of rare and endemic plants include*[4]

Marin County navarretia, *Navarretia rosulata*
Marin manzanita, *Arctostaphylos virgata*
Marin western flax, *Hesperolinon congestum*
Mason's ceanothus, *Ceanothus masonii*
Mount Tamalpais jewelflower, *Streptanthus glandulosus ssp. pulchellus*
Mount Tamalpais manzanita, *Arctostaphylos hookeri ssp. montana*
Mount Tamalpais thistle, *Cirsium hydrophilum var. vaseyi*
Napa false indigo, *Amorpha californica var. napensis*
North Coast semaphore grass, *Pleuropogon hooverianus*
Tamalpais jewelflower, *Streptanthus batrachopus*
Tamalpais lessingia, *Lessingia micradenia var. micradenia*
Thin-lobed horkelia, *Horkelia tenuiloba*
Tiburon buckwheat, *Eriogonum luteolum var. caninum*
Western leatherwood, *Dirca occidentalis*

Tamalpais jewelflower

05. Muir Woods; in 1908, this old-growth redwood forest, called Muir Woods National Monument, was designated by President Roosevelt; the park is extremely popular—957,000 people visited Muir Woods in 2018, which is an average of 2,600 people per day; the park is open from 8 a.m. to 5 p.m., so at any given hour, that is an average of 288 people; the park is a total of 554 acres, of which 240 acres are old-growth forest; the tallest tree in Muir Woods is 258 feet high.[5]

06. Harbor Point; Richardson Bay; Richardson Bay Audubon Center and Sanctuary. Ring Mountain Preserve includes habitat for three endemic flowers listed as federally threatened: Tiburon mariposa lily, *Calochortus tiburonensis*; Tiburon jewelflower, *Streptanthus glandulosus niger*; and showy Indian clover, *Trifolium amoenum*.[6]

07. Muir Beach; site of a bold and charismatic restoration project where Redwood Creek runs past the tidal lagoon to the sea; from 2008 to its completion in 2015, the project focused on 1,700 linear feet of watercourse and reestablished the natural floodplain in order to benefit the local riparian and riverine diversity, including salmonid fish and amphibians; despite the effort, the number of returning adult salmon remains below expectations.[7]

08. Tiburon; the San Francisco Bay National Estuarine Research Reserve hosts the NOAA-implemented San Francisco Bay Coastal Training Program;[8] local habitat of the Tiburon micro-blind harvestman spider, *Microcina tiburona* (G1/S1).

09. Rodeo Cove; location of the Marine Mammal Center, which offers

the Golden Gate bridge from Point Bonita

Marin blind harvestman
*Calicina diminua*
(G1/S1)

rescue and rehabilitation for wounded or otherwise health-compromised mammals, including seals, sea lions, and whales—25,000 individual rescues since opening in 1975;[9] although the brackish Rodeo Lagoon is large enough to be churned by the wind, it is largely unaffected by the tide, and because of it is susceptible to eutrophication and the regular occurrence of fish die-off.[10]

10. Point Bonita; entrance to the Golden Gate; Marin Headlands; Hawk Hill; high raptor populations; local raptor sightings averaged 56 per hour over a 10-year study period.[11]

11. Fort Point; Presidio—1,446 acres of national park land includes 15 native plant communities and 15 species of endangered flora, including the endemic Presidio clarkia, *Clarkia franciscana*, and San Francisco lessingia, *Lessingia germanorum*; Crissy Marsh—40-acre restoration site of brackish wetland habitat,[12] only 10 percent of which is in its original state.[13]

12. China Beach; between Lands End and Baker Beach; Lands End Trail; Eagle's Point; the Presidio of San Francisco counts 16 species of mammal present in the area: one marsupial (possum), three canines (foxes and coyote), one weasel (skunk), one raccoon, six rodents (mouse, gopher, and vole), two insectivores (shrew and mole), and two bats (including the hoary bat, *Lasiurus cinereus*, G5/S4).[14]

13. Point Lobos; Sutro Baths; originally a treeless expanse of sand dunes; in the 1930s, thousands of Monterey pine and Monterey cypress were planted—these century-old trees are now part of a massive restoration and remediation plan that recognizes seven native-plant communities inside the project boundaries: central coast arroyo willow riparian forest, central coast riparian scrub, dune, freshwater seep, northern coastal bluff scrub, serpentine coastal bluff scrub, and unique floral assemblage[15]—an engineered yet native sanctuary of habitats.

Light-footed Ridgway's rail
*Rallus obsoletus levipes*
(G5T1T2/S1)

14. Golden Gate Park; San Francisco's iconic city park is a rectangular shape and measures 3 miles from east to west; unique convergence of cultural, natural, and scientific institutions and monuments include the Conservatory of Flowers, the San Francisco Botanical Garden, the California Academy of Sciences, and the Japanese Tea Garden.

15. Lake Merced; habitat for the California grizzly bear before the nineteenth century;[16] currently high levels of mercury have led to a fish-eating advisory; freshwater lake fed by an underwater spring; southern end of Ocean Beach, a 3.5-mile-long strand from Lands End.

16. Thornton State Beach; now closed to the public due to safety concerns regarding landslide danger from the steep bluffs;[17] part of the Ocean Beach network; south of Fort Funston and the Golden Gate National Parks Conservancy; location of the Yerba Buena Nursery native plant nursery, able to produce 25,000 plants per year for local parklands.[18]

17. Sharp Park Beach; Pacifica; Laguna Salada—critical wetland habitat for the San Francisco garter snake, *Thamnophis sirtalis tetrataenia* (G5T2Q/S2).[19]

18. Pacifica; Pacifica State Beach; Linda Mar Beach dune habitat is undergoing

extensive, volunteer-based restoration of native plant species for pollinators and shore-nesting birds.[20]

19. Montara State Beach; part of a network of sites from San Francisco to Half Moon Bay targeted for extensive restoration by the Pacific Beach Coalition, including six sites in Pacifica, among them Rockaway Beach, and three sites in Half Moon Bay, including Surfer's Beach.[21]

20. Montara; Gray Whale Cove State Beach; Devil's Slide; in Pacifica, the California Coastal Trail veers off Highway 1 and ascends San Pedro Mountain (1,050') via Old San Pedro Mountain Road; endemic flowers of adjacent McNee Ranch State Park include Hickman's potentilla, *Potentilla hickmanii*, and San Mateo thornmint, *Acanthomintha duttonii*; the only location in San Mateo County of the rare coastal chaparral habitat type that is defined by the three-part presence of manzanita (*Arctostaphylos* sp.), salal (*Gaultheria* sp.), and lupine (*Lupinus* spp.).[22]

21. Pillar Point; 220-acre park on coastal bluff; Ross Cove Beach; Fitzgerald Marine Reserve; Montara State Marine Reserve; nearby El Granada and Miramar beaches, starved of replenishing sands and subject to punishing waves from an ill-conceived Army Corps of Engineers breakwater in the mid-1960s.[23]

The Golden Gate bridge from Baker Beach

## 07.11a An Elite Class of Diversity
*The Golden Gate Biosphere Reserve*

UNESCO designated an area of 212,000 acres within Sonoma, Marin, San Francisco, and San Mateo Counties as being one of more than seven hundred global biosphere reserves—in its words, "learning places for sustainable development."[24] Eleven local, education, regional, and national agencies are responsible for the stewardship of this unique location,[25] and they are also responsible for the development of a sustainable interface between the local urban habitats and the existing cultural and biological diversity—a charge that will determine its success (and ours).[26]

The following is a list of qualifying UNESCO habitats in the Golden Gate Biosphere Reserve, a diverse inventory summarizing many region-wide plant association types, each exhibiting unique characteristics and habitat spaces worthy of stringent protections:

> Bishop pine forests
> Chaparral
> Coastal dune
> Coastal scrub
> Coastal strand
> Douglas fir forests
> Evergreen forests
> Grasslands
> Kelp forests
> Marshes
> Oak forests
> Redwood forests
> Tide pools
> Woodlands and savannas

*California tortoiseshell*
*Nymphalis californica*

# The Coasts of California

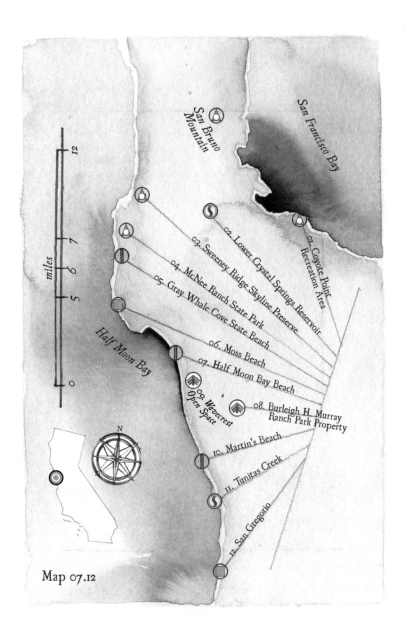

Map 07.12

# 07. A Good, Long Walk

## 07.12 OF INLETS AND INROADS
*The Half Moon Bay coast*

Map 07.12 depicts approximately 25 miles of the coastline within San Mateo County, 12 miles of which overlap Map 07.11.

The northwestern edge of the Santa Cruz Mountains also forms the southeastern basin restraint of San Francisco Bay. The entirety of the Half Moon Bay coast is protected as part of the Monterey Bay National Marine Sanctuary. From Pigeon Point north to Pillar Point, a series of a half-dozen, east–west-running creeksheds drain a few hundred square miles from a checkerboard of preserves and parks along the ridgeline of the Santa Cruz Mountains. These creeks provide essential habitat for a trio of regularly mentioned endangered species, each indicative of ecological health in this part of California: an evolutionarily significant unit of salmon (coho and steelhead), the tidewater goby, and the red-legged frog.[1] In addition, the ridgeline of redwood forest preserves holds potential habitat in the southernmost range of that particular and precious old-growth-nesting seabird, the marbled murrelet, *Brachyramphus marmoratus* (G3G4/S1).[2]

01. Coyote Point Recreation Area; 700-acre park, covered in eucalyptus trees; site of the Coyote Point Museum for Environmental Education; north of Bair Island and Don Edwards San Francisco Bay National Wildlife Refuge; the southern San Francisco Bay is essential bird habitat on the Pacific Flyway; tens of thousands of waterfowl and shorebirds from hundreds

> Because of their wide range and their potential for recovery, the four endangered animal species whose recovery will steer the future of development and restoration on California's coasts are a small sea bird (snowy plover), an anadromous fish (salmon), a tiny estuarine fish (goby), and a frog (red-legged frog).

of species find nesting habitat here as well as rest sites while on seasonal migrations; in this important bird area, 14 bird species of special status nest, as well as the entire population of the endemic Alameda song sparrow, *Melospiza melodia pusillula* (G5T2?/S2S3).³

Santa Cruz black salamander
*Aneides niger*
(G3/S3)

02. Lower Crystal Springs Reservoir; Upper Crystal Springs Reservoir; San Andreas Lake; San Mateo Creek watershed east of Montara Mountain (1,813'); inside the rift valley of the San Andreas Fault; occasional nesting habitat for bald eagles.⁴

03. Sweeney Ridge Skyline Preserve; trail from Mori Point, between Pacifica and San Bruno; sweeping views of coastal scrub habitat and marine chaparral; southernmost reach of the Golden Gate National Recreation Area; northernmost tip of the Santa Cruz Mountains ridgeline.

04. McNee Ranch State Park; San Pedro Valley County Park; Montara mountain scrub habitat—hazelnut-cream bush scrub association; locally characterized by the winter blooming of fetid adder's tongue, *Scoliopus bigelovii*, a relict population that rarely grows outside the redwood forest.⁵

05. Gray Whale Cove State Beach; near Devils Slide; Gray Whale Cove Trail; Montara; century-old, wind-sculpted Monterey cypress trees; offshore, feather-boa kelp forests; northern end of Half Moon Bay network of beaches, south of Point San Pedro.

06. Moss Beach; Mavericks Beach; Fitzgerald Marine Reserve; one of California's largest and most productive intertidal reefs;⁶ Seal Cove Cypress Tree Tunnel.

07. Half Moon Bay State Beach; Dunes Beach; Francis Beach; Elmar Beach—mouth of Pilarcitos Creek watershed; biodiverse watershed that contains Pilarcitos Dam, water storage for the local municipalities and agriculture.

08. Burleigh H. Murray Ranch State Park; historic ranch property with eucalyptus groves.

09. Wavecrest Open Space; important raptor wintering site, managed by the Coastside Land Trust;[7] Blufftop Coastal Park—coastal terrace prairie; habitat for white-tailed kite, *Elanus leucurus* (G5/S3S4), and an estimated 213 species of birds.[8]

10. Martin's Beach; mouth of Lobitos Creek; one of two creeks, the other being Purisima Creek, with headwaters inside Purisima Creek Redwoods Preserve.

11. Tunitas Creek; possible habitat for San Francisco forktail damselfly, *Ischnura gemina*;[9] possible habitat for Santa Cruz black salamander, *Aneides niger* (G3/S3).[10]

12. San Gregorio; San Gregorio State Beach; Pomponio State Beach; San Gregorio Creek watershed. Rare and threatened species of plants within the watershed include western leatherwood, *Dirca occidentalis*; Santa Cruz manzanita, *Arctostaphylos andersonii*; and Kings Mountain manzanita, *Arctostaphylos regismontana*.[11]

# The Coasts of California

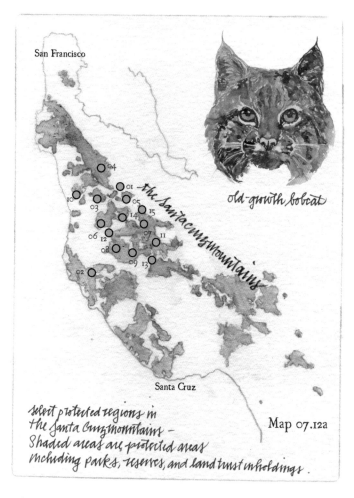

select protected regions in the Santa Cruz Mountains — Shaded areas are protected areas including parks, reserves, and land trust inholdings.

Map 07.12a

## 07.12a The Connected Forest
### *The Santa Cruz Mountains Stewardship Network*

Forming a largely connected chain of forest preserves across the northern Santa Cruz Mountains in San Mateo and Santa Cruz Counties,[12] the multiagency network of preserves could and should one day be consolidated as one enormous

entity focused on the conservation of redwood forest on the San Francisco peninsula.

01. Arastradero Preserve; 10 miles of hiking trails; managed by the City of Palo Alto; restoration projects organized by Grassroots Ecology[13]

02. Butano State Park; 4,728 acres; 315 acres of old-growth redwood forest on Little Butano Creek[14]

03. El Corte de Madera Creek Preserve; 2,906 acres; 1,800-year-old redwood trees;[15] managed by Midpeninsula Regional Open Space District (MROSD)

04. Huddart County Park; 974 acres; Douglas fir and redwood forest; County of San Mateo[16]

05. Jasper Ridge Biological Preserve; 1,193 acres; an exemplary site for biodiversity; contains examples of nearly all plant communities on the central coast;[17] managed by Stanford University

06. La Honda Creek Open Space Preserve; 6,142 acres; part of the Midpeninsula Regional Open Space District; habitat for San Francisco gartersnake, *Thamnophis sirtalis tetrataenia* (G5T2?/S2)[18]

07. Long Ridge Open Space Preserve; 13 miles of trail from Sanborn-Skyline County Park to the northern boundary of Russian Ridge Open Space Preserve[19]

08. Phleger Estate; 1,084 acres; southernmost portion of the Golden Gate National Recreation Area[20]

09. Pescadero Creek County Park; park complex of 8,020 acres, run by County of San Mateo; forests include Santa Cruz cypress, *Cupressus abramsiana*

10. Portola Redwoods State Park; 2,800 acres; home to the Old Tree—305' tall, 12' in diameter, and 1,200 years old[21]

11. Purisima Creek Redwoods Preserve; 4,711 acres; second-growth redwood forest; part of MROSD

12. Russian Ridge Open Space Preserve; 3,137 acres; high point, Borel Hill, 2,572'; exceptional habitat for raptors and wildflowers;[22] part of MROSD

13. Sam McDonald County Park; 867 acres; location of old-growth redwood habitat, Heritage Grove Redwood Preserve; run by County of San Mateo

14. Skyline Ridge Preserve; 2,143 acres; home of the David C. Daniels Nature Center; part of MROSD

15. Windy Hill Open Space Preserve; 1,355 acres; grasslands and oak ridge; part of MROSD

16. Wunderlich County Park; 942 acres; dense second-growth redwoods and meadows; run by County of San Mateo

The Coasts of California

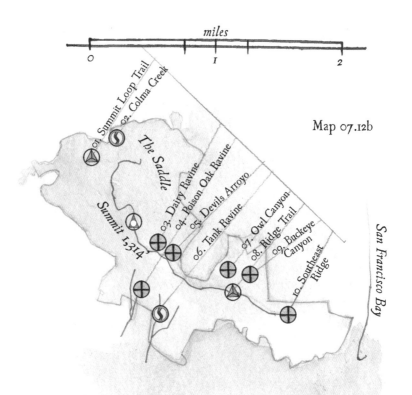

Map 07.12b

## 07.12b San Bruno Mountain State and County Park

Along this four-mile ridge in the southeastern corner of San Francisco County, a remnant piece of northern coastal scrub, striped by coastal riparian scrub, exists as San Bruno Mountain. Across its 2,416 acres, the park boasts habitat for 662 plant species, 42 butterflies, 195 birds, 5 bumblebees, 30 ant species, 24 mammals, 13 reptiles, and 6 amphibians.[23]

07. A Good, Long Walk

The following are some of the rare and endemic
plants and flowers on San Bruno Mountain:[24]

California lessingia, *Lessingia germanorum* (Asteraceae)
Central Coast iris, *Iris longipetala* (Iridaceae)
Choris's popcornflower, *Plagiobothrys chorisianus* var. *chorisianus* (Boraginaceae)
Coast rock cress, *Arabis blepharophylla* (Brassicaceae)
Diablo helianthella, *Helianthella castanea* (Asteraceae)
Montara manzanita, *Arctostaphylos montaraensis* (Ericaceae)
Pacific manzanita, *Arctostaphylos pacifica* (Ericaceae)
San Bruno Mountain manzanita, *Arctostaphylos imbricata* (Ericaceae)
San Francisco campion, *Silene verecunda* ssp. *verecunda* (Caryophyllaceae)
San Francisco collinsia, *Collinsia multicolor* (Plantaginaceae)
San Francisco gum plant, *Grindelia hirsutula* var. *maritima* (Asteraceae)
San Francisco spineflower, *Chorizanthe cuspidata* var. *cuspidata* (Polygonaceae)
San Francisco wallflower, *Erysimum franciscanum* (Brassicaceae)

The Coasts of California

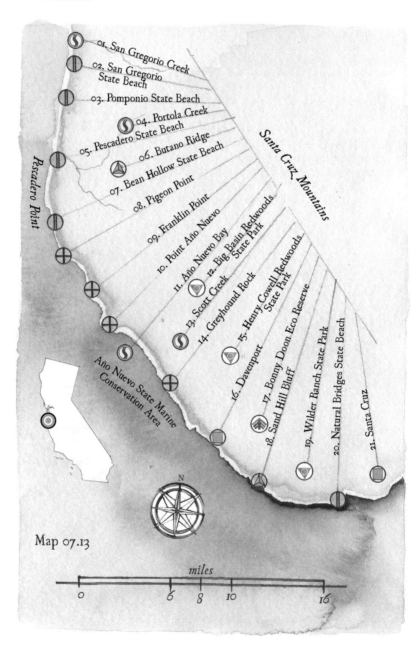

Map 07.13

## 07.13 OF SEALS AND SAGE
*The Año Nuevo coast*

Map 07.13 depicts approximately 38 miles of coastline in Santa Cruz County.

There are fifty watersheds in San Mateo and Santa Cruz Counties, which once flowed from tens of thousands of acres of old-growth redwood to support large populations of coho salmon. In 1995, a regional census of viable acreage found that only 1.5 percent of the total potential salmon-rearing sites still exist in only eleven streams and creeks.[1] Today, the estuarine fish found along the Año Nuevo coast may include Coastrange sculpin, *Cottus aleuticus*; coho salmon, *Oncorhynchus kisutch* (G4/S2); juvenile starry flounder, *Platichthys stellatus*; Pacific staghorn sculpin, *Leptocottus armatus*; prickly sculpin, *Cottus asper*; threespine stickleback, *Gasterosteus aculeatus*; and tidewater goby, *Eucyclogobius newberryi* (G3/S3).[2]

One of the unique islands of evolutionary diversity along the central coast exists only a few miles inland from Davenport. Just before the redwood forest, inside the liminal zone between the coast and the Santa Cruz Mountains, there are the dry, sandy soils of the inland sandhills. This is the land of the Santa Cruz kangaroo rat, *Dipodomys venustus venustus* (G4T1/S1), a long-lived native rat that is a keystone species within this specialized environment. (A five-year lifespan is a long time for a tiny mammal.) Where there were once thousands of acres in Santa Cruz's sandhill ecosystem, *D. venustus* now digs burrows, and caches and moves seeds, in a much smaller plot of about four hundred acres. Given the high number of endemic species that depend on this nearly extinct species, *D. venustus* should be federally designated as an endangered species along with its neighbors, the Zayante band-winged grasshopper, *Trimerotropis infantilis* (G1/S1), and the Mount Hermon June beetle, *Polyphylla barbata* (G1/S1).[3]

---

*Following a lightning storm, summer 2020 came with severe wildfires that scorched much of Big Basin's old growth forests. Watching them recover from the century's worst fire transforms us as much as these forests are transformed.*

01. San Gregorio Creek; site of the San Gregorio Creek Habitat Enhancement Project;[4] nearly a half-mile of the creek was rehabilitated in 2016 with the addition of large, woody debris—an important habitat opportunity for returning seabound anadromous fish, and their winter refuge;[5] restoration of the creek to fight sedimentation, pollution, and increased development continues to assist still-declining populations of coho and steelhead.[6]

02. San Gregorio State Beach; popular fishing spot; most common ocean fish taken are surfperch, *Embiotocidae* sp., and, occasionally, striped bass, *Morone saxatilis*.[7]

03. Pomponio State Beach; part of the network of San Mateo Coast State Beaches; Pomponio Creek; adding to the 55,000 acres of conserved land it manages in the Santa Cruz Mountains, the Peninsula Open Space Trust bought a conservation easement of 1,600 acres of ranchland in this watershed to help preserve and restore its natural character.[8]

04. Pescadero Creek; Butano Creek; site of the 2020 Butano Creek Channel Reconnection and Resilience Project;[9] priorities include improving habitat for migrating fish and helping prevent flooding in the Butano and Pescadero marshes and lagoons.

Northern elephant seal
*Mirounga angustirostris*

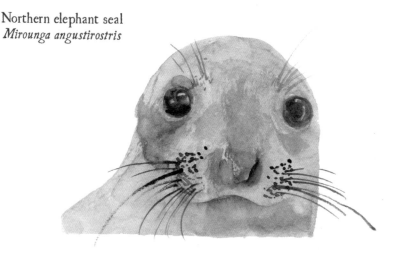

## 07. A Good, Long Walk

05. Pescadero State Beach; Pescadero Marsh Natural Preserve; wetland nesting habitat for over 60 bird species;[10] part of the Coastside State Parks Association.

06. Butano Ridge; from Tarwater Trail Camp in Butano State Park, the Butano Ridge Trail is 13 miles with a climbing elevation of almost 2,500 feet,[11] up from redwood, riparian habitat to meadowed, open ridgeline; one of the most remote trails in the Redwood State Parks network.

07. Bean Hollow State Beach; Pebble Beach, known for littoral deposits of semiprecious gemstones; site of a classic private–public battle for access that lasted a century and wasn't resolved until the mid-1980s, when the beach became a state park.[12]

08. Pigeon Point; Pigeon Point Light Station State Historical Park; Pigeon Point Bluffs.

09. Franklin Point; after a long and only partially successful campaign to eradicate the invasive ground plant gorse, *Ulex* sp., the state park now stewards the coastal bluffs in a manner consistent with, and informed by, local indigenous tradition, and performs a burn every other year; prescription fire benefits the native ecosystem of sedges and rush associations.[13]

10. Point Año Nuevo; Año Nuevo State Marine Conservation Area; in 2020, Save the Redwoods bought 564 acres of old-growth redwood forest in

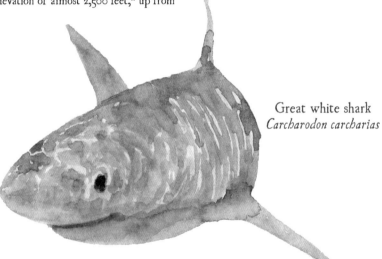

Great white shark
*Carcharodon carcharias*

Cascade Creek; donating the land to the California State Parks linked Año Nuevo to Big Basin Redwoods State Park.[14]

11. Año Nuevo Bay; home to one of the Pacific's largest breeding colonies of northern elephant seal, *Mirounga angustirostris*; Rancho del Oso Nature and History Center.

12. Big Basin Redwoods State Park; 18,000 acres, including 10,800 acres of old-growth redwood forest;[15] California's first state park and the largest old-growth forest south of Humboldt County; Waddell Creek watershed; in August 2020, the first major fire in 116 years swept through the heart of the old growth;[16] although it was a high-intensity and high-severity fire, the majority of the ecosystem will recover and may thrive due to the disturbance; redwood forests should exist in a normalized fire regime where low-intensity and low-severity fires return at regular intervals, and with this resetting fire, an opportunity presents itself to return patterns of such fire to the landscape.

13. Scott Creek; lagoon, marsh, and dune system; restoration site to increase the size of the floodplain by 20 acres and the wetland by 4 acres;[17] the Big Creek hatchery, on a tributary to Scott Creek, uses wild steelhead eggs and milt to ensure genetic diversity from wild sources.[18]

14. Greyhound Rock; Coast Dairies State Park—7 miles of undeveloped, protected land, coastal bluffs, and beaches that may be soon designated as part of the California Coastal National Monument;[19] Greyhound Rock State Marine Conservation Area.

15. Henry Cowell Redwoods State Park; 4,650 acres over two units, one in the San Lorenzo watershed and the other in Fall Creek; 200 acres of old-growth redwood forest;[20] near the park's entrance, all three species of redwood (coast, Sierra, and dawn) are planted together.

16. Davenport, small town on the coastal bluff; local sandy beaches, often difficult to access, but beautiful and lonely, include Bonny Doon, Laguna Creek, Panther, Shark Tooth, and Yellow Bank.

17. Bonny Doon Ecological Reserve; 552 acres; part of the Zayante Sandhills, a unique ecosystem that supports habitat for silverleaf manzanita mixed chaparral.[21] Endemic species of flora and fauna include Ben Lomond wild buckwheat, *Eriogonum nudum* var. *decurrens*; Bonny Doon manzanita, *Arctostaphylos silvicola*; Santa Cruz wallflower, *Erysimum teretifolium*; and Ben Lomond spineflower, *Chorizanthe pungens* var. *hartwegiana*.

18. Sand Hill Bluff; Red White and Blue Beach; archeological sites revealed the former presence of the flightless scoter, *Chendytes lawi*, a marine duck

that became extinct over two thousand years ago.[22]

19. Wilder Ranch State Park; Cave Gulch Trail; Moore Creek Preserve. This is habitat for Santa Cruz telemid spider, *Telema* sp. (G1G2/S1S2); Mackenzie's Cave amphipod, *Stygobromus mackenziei* (G1/S1); and Empire Cave pseudoscorpion, *Fissilicreagris imperialis* (G1/S1);[23] habitat for Ohlone tiger beetle, *Cicindela ohlone* (G1/S1).[24]

20. Natural Bridges State Beach; Natural Bridges State Marine Reserve; Monarch Butterfly Natural Preserve; essential migration habitat for the western monarch, *Danaus plexippus*, pop. 1 (G4T2T3/S2S3); monarch population is critically declining across the state; 1,997 monarchs were reported in 2020, a dramatic reduction from a count of 120,000 in 1997.[25]

21. Santa Cruz; University of California, Santa Cruz Natural Reserve;[26] UCSC arboretum; Younger Lagoon Reserve; Seymour Marine Discovery Center; San Lorenzo River watershed.

### 07.13a Save the Pollinators, Save the Plants
*Endangered bees of the Santa Cruz Mountains*

Of the four thousand bee species found in North America, nearly half are found west of the Sierra Nevada,[27] and the Santa Cruz Mountains, with its mix of climate and vegetation types, is the perfect place to get to know bees. Six species of furry, black-and-yellow bumble bees are species of special status in the state of California.

Blennosperma vernal pool andrenid bee, *Andrena blennospermatis* (G2/S2)[28]
Obscure bumble bee, *Bombus caliginosus* (G4?/S1S2)[29]
Crotch bumble bee, *Bombus crotchii* (G3G4/S1S2)[30]
Morrison bumble bee, *Bombus morrisoni* (G4G5/S1S2)[31]
Western bumble bee, *Bombus occidentalis* (G2G3/S1)[32]
Suckley's cuckoo bumble bee, *Bombus suckleyi* (G1/S1)[33]

European honey bee
also called western honeybee
*Apis mellifera*

## 07. A Good, Long Walk

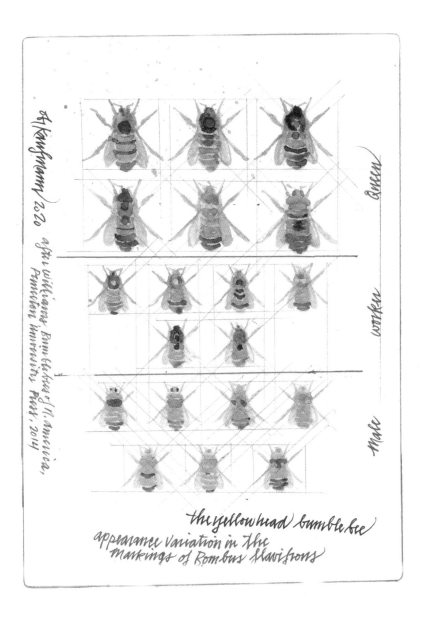

the yellow-head bumble bee
appearance variation in the markings of Bombus flavifrons

The Coasts of California

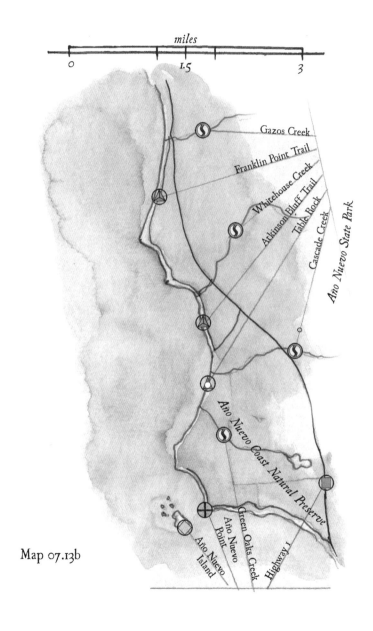

Map 07.13b

## 07. A Good, Long Walk

## 07.13b Año Nuevo Coast Natural Preserve

Along these bluffs, native grassland habitat persists and includes four hundred species of native and alien plants, including nine species of rush grass, among them San Francisco rush, *Juncus lescurii*. Commonly present are also beach strawberry, *Fragaria chiloensis*; yellow sand verbena, *Abronia latifolia*; American dune grass, *Leymus mollis*; European beach grass, *Ammophila arenaria*; purple needlegrass, *Nassella pulchra*; California oat grass, *Danthonia californica*; and tufted hair grass, *Deschampsia cespitosa*.[34]

Along the sandy beach, northern elephant seals have claimed birthing habitat after colonizing the area in 1961. Year after year since the first pup was delivered, the breeding population of northern elephant seals has increased. In 1995, more than two thousand pups were born at Año Nuevo. After a century of hunting that brought the species to the brink of extinction, there are now more than 160,000 northern elephant seals—all ancestors of that bottlenecked genetic pool.[35]

Año Nuevo Island Reserve is part of a network of natural reserves managed by the University of California.

sea lions of Año Nuevo

The Coasts of California

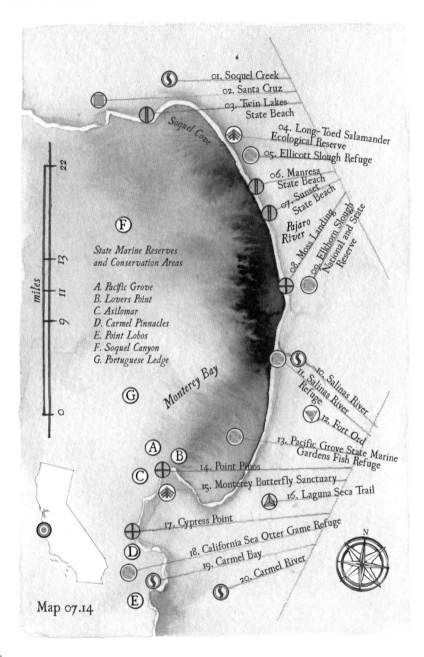

Map 07.14

## 07.14 OF MONARCHS AND MARSHLANDS
*The Monterey coast*

Map 07.14 depicts approximately 54 miles from Point Lobos north to the city of Santa Cruz and the entirety of Monterey Bay, including northern Monterey County and southern Santa Cruz County.

We are halfway. The round cup that is Monterey Bay is a hub for the equidistant spokes that stretch north to Oregon and south to Mexico. I sit on the beach outside Seaside and look west at the Monterey Peninsula, the birthplace of the state of California, or at least where the state constitution was signed in 1849, less than two years after gold was discovered in Sacramento, and I muse about where we've been and where we have to go.

Monterey Bay, a cold, oxygen-rich network of marine and intertidal ecosystems, supports so many endangered species and the precious beings that individually compose them. A cornucopia of charismatic mammals (to single out a particularly relatable group) rely on these local systems to sustain their numbers—humpback whales, orca, southern sea otter, dolphin, porpoise, seal, sea lion, and, up on land, the tremendously endangered and endemic Monterey shrew, *Sorex ornatus salarius* (G5T1?/S1), and Monterey vagrant shrew, *Sorex vagrans paludivagus* (G5T1/S1).

In this long trek down the coastal face of California, I know I've not done justice to the inventory I've set out to make. Every nook, every diamond-like niche where life has been able to evolve and become something uniquely tied to a set of conditions that may only exist for a geologic moment, a breath in the long history of earth—I know that I could write and paint about any one subject for the rest of my mortal days and still not do it justice.

---

*The Monterey pine is among the rarest wild plants on the planet, yet also one of the world's most common domesticated trees.*

01. Soquel Creek; watershed that supplies over 3,300 acre-feet for residential use throughout the local water district via groundwater pump;[1] Soquel Creek Restoration Project;[2] common site of foothill yellow-legged frog, *Rana boylii* (G3/S3),[3] and California newt, *Taricha torosa* (G4/S4).

04. Santa Cruz Long-Toed Salamander Ecological Reserve; Santa Cruz long-toed salamander, *Ambystoma macrodactylum croceum* (G5T1T2/S1S2); closed to the public to protect this critically endangered amphibian; the Buena Vista Unit of the reserve is part of the Ellicott Slough National Wildlife Refuge.

Monarch
*Danaus plexippus*

02. Santa Cruz; historic downtown suffered major damage from the 1989 Loma Prieta earthquake—epicenter 9 miles northeast of town, magnitude 6.9.[4]

03. Twin Lakes State Beach; Schwan's Lake birding trail; also listed as Schwan's Lagoon.[5]

05. Ellicott Slough National Wildlife Refuge. Besides the long-toed salamander, other amphibians of special status may include California tiger salamander, *Ambystoma californiense* (G3G3/S2S3); California giant salamander, *Dicamptodon ensatus* (G2/S2S3); and California red-legged frog, *Rana draytonii* (G2G3/S2S3).[6]

06. Manresa State Beach; snowy plover habitat; a broad and sandy strand beach, south all the way to the Pajaro River mouth.

07. Sunset State Beach; Pajaro River; Pajaro Dunes. At Monterey Bay National Marine Sanctuary, common dune plants include beach bur, *Ambrosia chamissonis*; beach salt bush, *Atriplex leucophylla*; beach wild rye, *Leymus mollis*; silky beach pea, *Lathyrus littoralis*; and yellow sand verbena, *Abronia latifolia*.[7]

08. Moss Landing; the twin stacks of the Moss Landing Power Plant, venting the generators powered by natural gas, are ubiquitous and dominant in the skyline around the bay; Moss Landing State Wildlife Area, west side of Elkhorn Slough; 872 acres; 2.64 miles south of Pajaro River mouth; pickleweed habitats and eelgrass bed.

09. Elkhorn Slough State and National Reserve; 1,438 acres; although only 23% of the salt marsh remains in Elkhorn Slough, as compared to levels 120 years ago, the levels remain inside the natural variant within a time scale going back one thousand years;[8] one of California's largest salt marshes outside San Francisco Bay; biodiversity profile includes habitat for 550 species of invertebrates, 100 species of fish, and 135 species of birds,[9] with an additional 170 species of bird using the slough during migration.[10]

10. Salinas River; watercourse that runs from the south, north to the Monterey Bay, over 175 miles long, and a watershed that is over 4,000 square miles;[11] Arroyo Seco and the Estrella River are the only two undammed tributaries, among a dozen now-impounded watercourses on the Salinas that hold imperiled but still extant populations of steelhead.[12]

11. Salinas River National Wildlife Refuge; 367 acres. This is habitat of the endangered and endemic Smith's blue butterfly, *Euphilotes enoptes smithi* (G5T1T2/S1S2); the Monterey sand gilia, *Gilia tenuiflora*; and the Monterey spineflower, *Chorizanthe pungens*.[13]

Monterey ornate shrew
*Sorex ornatus salarius*

12. Fort Ord National Monument; 15,000-acre decommissioned military base, now protected as wildflower habitat and parkland; among the open areas are flower fields that include blue-bonnet lupine, maritime chaparral, and oak woodland.

13. Pacific Grove State Marine Gardens Fish Refuge; rich with life, these 3 square miles of tidal ecosystems are protected by a series of designated sanctuaries, and they are close to the cities of Monterey and Pacific Grove; site of the Monterey Bay Aquarium.

14. Point Pinos; site of the Point Pinos Lighthouse; the point sticks out like a tooth on the lower jaw of the expansive maw of the Monterey Bay.

15. Monarch Butterfly Sanctuary; site of one of California's largest overwintering populations of monarchs, *Danaus plexippus* pop. 1 ($G_4T_2T_3/S_2S_3$); since 1980, the butterfly population at the grove has declined from several million to only 29,000 in 2019.[14]

16. Laguna Seca Trail; Laguna Seca Recreation Area; raptor country.

17. Cypress Point; the westernmost point of the Monterey peninsula; home of the famous Lone Cypress, *Hesperocyparis macrocarpa*.

18. California Sea Otter Game Refuge; designated to protect the endangered sea otter, *Enhydra lutris*; the sea otter has rebounded from near extinction 50 years ago to over 2,000 individuals today;[15] it has doubled its population in the past 10 years; sea otters are vital in the succession of the kelp forest and protect against ecological conversion of those forests into urchin barrens.[16]

19. Carmel Bay; Carmel Bay State Marine Conservation Area; Carmel Pinnacles State Marine Reserve; on the rocky shore of this bay, crowded into two sites are the only native wild locations of the Monterey cypress, *Cupressus macrocarpa*.[17]

20. Carmel River; Carmel River State Park; San Jose Creek.

Smith's blue butterfly
*Euphilotes enoptes smithi*
($G_5T_1T_2/S_1S_2$)

07. A Good, Long Walk

Monterey pine
*Pinus radiata*

## 07.14a Pickleweed
*Being a succulent in the salt marsh*

California's most common halophytic (salt-loving) plants in the coastal brackish wetlands are *Salicornia virginica* and *Salicornia pacifica*, two species of the globally distributed pickleweed genus.[18] This three-foot-high succulent turns red in the fall, not because it is deciduous, but because of an adaptation it employs to retain salt in the late summer months when water levels may be low. Pickleweed has adapted cells that chemically transport salt to the tips of its jointed scales, and when those tips can't hold any more, they turn red and fall off.[19] This tough plant is not endangered, but the habitat where it lives certainly is—almost 70 percent of California's tidal wetlands have been diked or filled in since 1920.[20]

Pickleweed
*Salicornia pacifica*

07. A Good, Long Walk

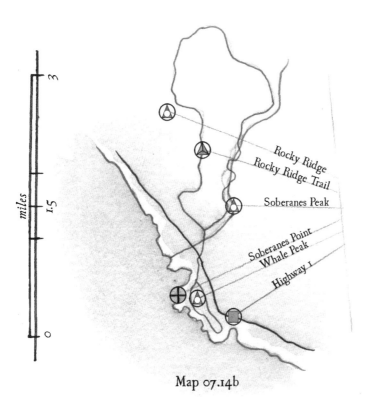

Map 07.14b

## 07.14b Garrapata State Park

Across nearly three thousand acres and including two miles of rocky shoreline, teeming with intertidal life at the base of sheer cliffs of granite and sandstone, Garrapata State Park sits between Monterey and Big Sur. Holding habitat for more than 110 species of bird and over 60 species of mammal, the park is a wildlife corridor between the coast and the Ventana Wilderness.[21] Soberanes Canyon, within the park, was the source of a 132,000-acre wildfire that roared through Monterey County in July 2016.[22]

# The Coasts of California

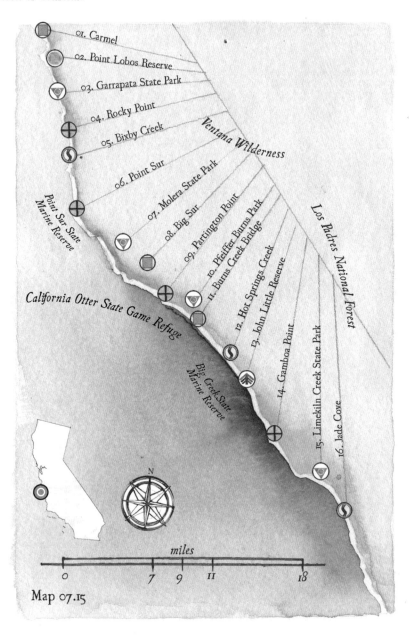

Map 07.15

07. A Good, Long Walk

## 07.15 OF CLIFFS AND CONDORS
*The Big Sur coast*

Map 07.15 depicts roughly 48 miles of the central California coastline in Monterey County.

Along California's central coast, a stretch of coastline offers no harbor to boats, and the human settlement of Big Sur feels perched perilously, as if the landscape regards humanity as a temporary phenomenon. This is the kingdom of the mountain lion and the condor, who hunt and scavenge the grassy marine steppe, and skirt through and around deep, dark ravines filled with coast redwood forests, the southernmost extent of the big trees' natural range. In 2016, the Soberanes Fire swept down from the north, scorching the mountain forests of the Ventana Wilderness, and then from the south, the Dolan Fire of 2020 moved in with similar ferocity. The waves of fire resemble the ocean waves themselves beating the shore at the base of the steep cliffs.

01. Carmel; Mission Trail Park; Carmel Valley, watershed of the Carmel River; Garland Ranch Regional Park.

02. Point Lobos State Natural Reserve; the restoration strategy for this peninsula, just over 5 square miles of land at the south edge of Carmel Bay, connecting the existing open space adjacent to the reserve, includes Garrapata State Park, Palo Corona Ranch, and the Santa Lucia Preserve. This plan maximizes habitat opportunities for corridor ecology between the inland mountains and the coast.[1]

03. Garrapata State Park; Map 07.14b.

04. Rocky Point; Garrapata Creek; Garrapata State Beach; Wildcat Canyon; near Palo Colorado Canyon, an unincorporated village that was largely destroyed by the Soberanes Fire.

*The California condor flying again over the redwoods of Big Sur is the greatest vision of hope I know.*

05. Bixby Creek; Bixby Creek Bridge, perhaps the most photographed bridge on the central coast; throughout the twentieth century, this area was exploited for its timber and lime (calcium carbonate) resources.[2]

06. Point Sur; lighthouse; state historic park between the Little Sur watershed to the north and Andrew Molera State Park to the south.

07. Andrew Molera State Park; location of the only known population of Arroyo Seco bush mallow, *Malacothamnus palmeri* var. *lucianus*, an endangered flower.[3]

08. Big Sur. The area is surrounded by coastal scrublands, maritime chaparral, and riparian creeksheds, all of which commonly include plant communities of California sagebrush, *Artemisia californica*; black sage, *Salvia mellifera*; California hedge nettle, *Stachys bullata*; and California mugwort, *Artemisia douglasiana*. Tall redwoods fill the steep canyons and begin a mile inland from the shore.

09. Partington Point; between Timber Top (3,120') to the north and Anderson Peak (4,099') to the south, the two peaks connected by the North Ridge Trail. Common plant communities include coyote bush, *Baccharis pilularis*; California coffeeberry, *Rhamnus californica*; blue blossom, *Ceanothus thyrsiflorus*; and Pacific poison oak, *Toxicodendron diversilobum*.

10. Julia Pfeiffer Burns State Park; the tallest redwoods in the Big Sur area are just under 200 feet tall and found in the Big Sur River watershed, which runs through this park;[4] McWay Falls, one of just a few California waterfalls that falls directly into the ocean.

11. Burns Creek Bridge; on the steep, rocky cliffs, plant communities include succulents—sea lettuce, *Dudleya caespitosa*, and sedum (stone crop), *Sedum spathulifolium*—tucked between patches of sea cliff buckwheat, *Eriogonum parvifolium*.

arroyo seco bush mallow
*Malacothamnus palmeri var. lucianus*

07. A Good, Long Walk

12. Hot Springs Creek; Esalen Institute; geothermally active area.

13. John Little State Natural Reserve; down from the Santa Lucia Range, endangered plants that may be found in the greater vicinity include canyon gooseberry, *Grossularia hystrix*, and Hickman sidalcea, *Sidalcea hickmanii* ssp. *hickmanii*.

14. Gamboa Point; Vicente Creek; Cone Peak (5,155'); habitat for the Santa Lucia fir, *Abies bracteata*, an endemic species.

15. Limekiln Creek State Park; toyon, *Heteromeles arbutifolia*, and manzanita, *Arctostaphylos* sp., spread across chaparral bluffs blooming with red flowers that include Indian paintbrush, *Castilleja affinis*, and scarlet bugler, *Penstemon centranthifolius*, alongside orange flowers such as Santa Lucia sticky monkeyflower, *Diplacus linearis*, and purple flowers such as yerba santa, *Eriodictyon californicum*.

16. Jade Cove; Willow Creek; Silver Peak Wilderness. The riparian plant community includes bigleaf maple, *Acer macrophyllum*; alder, *Alnus* sp.; western sycamore, *Platanus racemosa*; black cottonwood, *Populus trichocarpa*; and willow, *Salix* sp.

Bixby Bridge, Big Sur, California    OK 2021

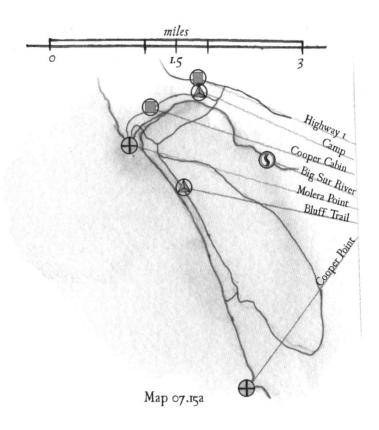

Map 07.15a

## 07.15a Andrew Molera State Park

On the mouth of the Big Sur River, and inland from waters protected as part of the Point Sur State Reserve and Marine Conservation Area, Andrew Molera State Park does not have the redwood forests you find south into the Big Sur area. In the forb-filled grasslands of the marine steppe that makes up most of the acreage of the park, kestrels, *Falco sparverius*, hunt pocket gopher, *Thomomys bottae*, and gopher snake, *Pituophis melanoleucus*. As with all the grasslands of Monterey County, the local grasslands of Big Sur count among the species present nearly half to be invasive and nonnative.[5]

07. A Good, Long Walk

the tallest forests in the world

The Coasts of California

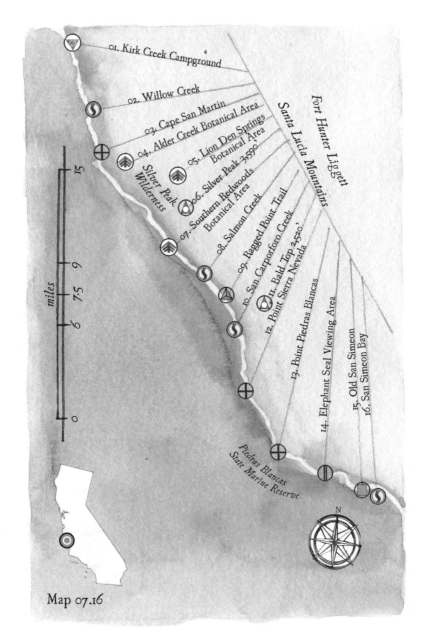

Map 07.16

## 07.16 OF CASTLES AND CASTILLEJA
*The San Simeon coast*

Map 07.24 depicts roughly 32 miles of California's central coast through Monterey and San Luis Obispo Counties.

Where the dark, steep canyons of Big Sur acquiesce to the broad, oak-dotted savanna of San Luis Obispo County, the bluffs over the San Simeon coast give the first southward views of the coasts of Southern California. Through the threshold, these new landscapes don't benefit from the regular patterns of coastal fog that the redwood belt enjoys, and the landscape is adapted to a more arid climate where sage and yucca gardens are common.

01. Kirk Creek Campground; Mill Creek; Chalk Peak (3,590'); Cone Peak Ridge divides the coastal watershed from the Nacimiento River watershed to the east.

02. Willow Creek; Silver Peak Wilderness; Alder Peak (3,744').

03. Cape San Martin; Jade Cove, named for deposits of California jade on the beach exposed during low tide; Pacific Valley Bluff Trailhead, exceptionally scenic.

04. Alder Creek Botanical Area; with deposits of serpentine—a substrate mineral that invites speciation within the plant community because of its isolation and unique chemistry; this area is known for rare plants such as the Palmer's monardella, *Monardella palmeri*.[1]

05. Lion Den Springs Botanical Area;[2] also called Lion Den Spring Special Interest Area; Silver Peak Wilderness; Alder Creek Botanical Area; Cruickshank Trail; home to cypress forests and the endemic flower Hardham's bedstraw, *Galium hardhamae*.

06. Silver Peak (3,590').

07. Southern Redwood Botanical Area; unmarked 17-acre preserve of the southernmost naturally occurring coast redwoods; not open to the public.

08. Salmon Creek; scenic Salmon Creek waterfalls; one the southernmost of Big Sur's drainages; burned by the 1970 Buckeye Fire and again by the Dolan Fire of 2020; adjacent to Alder Creek, the northernmost grove of Sargent's cypress in the Santa Lucia Mountains.[3]

---

*The recovery of the elephant seal on the California coast is a testament to the powerful combination of popularized political will and good policy.*

09. Ragged Point Trail; San Luis Obispo–Monterey County line; Mount Mars (2,674'); Black Swift Falls Trail; renowned scenic waterfall; the point is 400 feet above the water.

10. San Carpoforo Creek; wraps around the south of Bald Top and along the northwest corner of San Luis Obispo County; the ecological transition from the tree-laden Big Sur coast to the open grasslands and oak woodlands of the San Simeon coast.

11. Bald Top (2,550').

12. Point Sierra Nevada; Arroyo de la Cruz; 51,000-acre watershed; south of the Los Padres forests, these meadows expand above willow-lined riparian spaces, where birds known to the Audubon Society collectively as migrant passerines, or perching songbirds, gather on their migrations.[4]

13. Point Piedras Blancas; Piedras Blancas State Marine Reserve and Marine Conservation Area; trail runs along the highway, one mile south to seal-viewing site.

14. Elephant Seal Viewing Area; pinniped nursery for a year-over-year increasing population of northern elephant seals, *Mirounga angustirostris*; breeding populations on the beach can be over a thousand individuals; three peak seasons per year are January, April, and October; bellows echo inland from massive 16-foot-long seals that can weigh over half a metric ton.

15. Old San Simeon; entrance to the Hearst San Simeon State Historical Monument; Three Troughs Falls on San Simeon Creek, down from Black Oak Mountain (2,047'); Santa Rosa Creek Preserve; Pa-nu Cultural Preserve.

16. San Simeon Bay; Coastal Discovery Center at San Simeon Bay, run by the National Oceanic and Atmospheric Administration; San Simeon Natural Preserve—wintering site for the monarch butterfly.

Palmer's monardella
*Monardella palmeri*

07. A Good, Long Walk

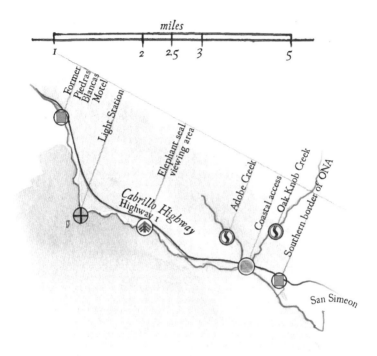

Map 07.16a

## 07.16a Piedras Blancas Light Station Outstanding Natural Area

This spot is where I mark the transition from Northern to Southern California. It doesn't exactly bisect the state, but there is a difference in ecological character from here, north to south. It has something to do with the redwoods that start their range just a few miles north over the Monterey County line. The northern Los Padres National Forest is separated from the southern through this swath of the Santa Lucia Range. The elephant seals seem drawn to this place—considering that they migrate over thirteen thousand miles a year, they found the perfect spot.[5]

# The Coasts of California

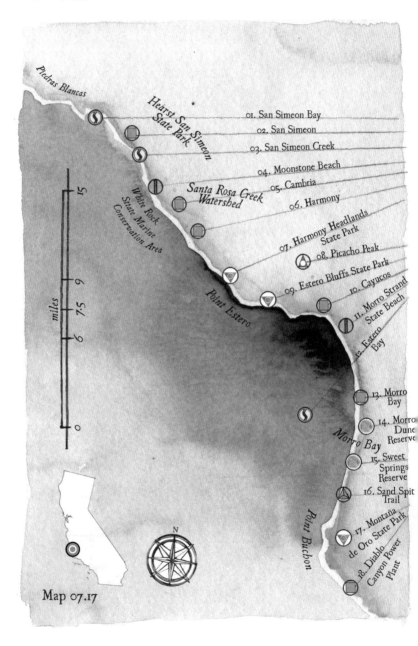

Map 07.17

# 07. A Good, Long Walk

## 07.17 OF BARNACLES AND BEACHES
### The Estero Bay coast

Map 07.17 depicts approximately 38 miles of the coastline along central California in San Luis Obispo County.

The annual grassland steppe that dominates this corner of coastal San Luis Obispo County is quiet. It isn't the loud and dynamic cliffs of Big Sur; it is a lonely prairie with woodlands tucked away. You might think you were somewhere like the Midwest if it wasn't for the ever-present blue line of the Pacific and the chaparral-covered ridgelines to the east. The chamise chaparral, scrub oak, serpentine manzanita, and buckbrush read as dark patches of vegetation from a few miles away. The creeks here are bordered by coastal scrub with black sage, ponderosa pine forest, and montane coast live oak hardwood, and foothill pine creeps in, shy of the ocean. The pinniped monarch of the Pacific, the elephant seal, claims its throne on this coast, and further south, Morro Bay offers the southernmost habitat for many north-coast, intertidal species associations. To the south, endangered species such as the Morro shoulderband snail, *Helminthoglypta walkeriana* (G1/S1E2), carry on despite ever-encroaching human development, and may have a shot at continued existence for the foreseeable future given the stringent plans being implemented for habitat conservation across the area.

01. San Simeon Bay; site of California's largest breeding and molting site of the northern elephant seal, the world's largest seal.

02. San Simeon, town; San Simeon Point Conservation Easement, 319 acres held by the California Department of Parks and Recreation; Pico Creek.

03. San Simeon Creek; San Simeon State Beach; William Randolph Hearst Memorial State Beach; Hearst Ranch Conservation Project; San Simeon Creek Groundwater Basin; Rocky Butte Botanical Area.

04. Moonstone Beach; Santa Rosa Creek, habitat for steelhead, south/central California coast (distinct population segment).[1]

05. Cambria, town; 2,500 acres of Monterey pine forest;[2] Cambria Pines Easement—1,450 acres held by the Nature Conservancy; Cambria mercury

---

*Out of the northern forest, we begin to uncover Southern California.*

mines continue to leak the toxic metal locally into Nacimiento Reservoir.[3]

06. Harmony, small town. Invasive grass species on the San Simeon coast include wild oats, *Avena fatua*; field mustard, *Brassica rapa*; ripgut grass, *Bromus diandrus*; Italian thistle, *Carduus pycnocephalus*; and yellow starthistle, *Centaurea solstitialis*.

07. Harmony Headlands State Park; 784 acres; grasslands, wetland, rocky shore. This is a habitat for many bird species of special concern, including brown pelicans, *Pelecanus occidentalis californicus* (G4T3T4/S3); white-tailed kites, *Elanus leucurus* (G5/S3S4); and long-billed curlews, *Numenius americanus* (G5/S2).

08. Picacho Peak; creekshed headwaters for Villa Creek and Cayucos Creek, 3 miles north of Estero Bay; habitat for California newt, *Taricha torosa* (G4/S4), and California red-legged frog, *Rana draytonii* (G2G3/S2S3).

09. Estero Bluffs State Park; 353-acre park of marine terrace; watersheds include San Geronimo Creek and Villa Creek; beach is habitat for resting and foraging sea otters and harbor seals.

10. Cayucos, town; surrounding watersheds are habitat for globose dune beetle, *Coelus globosus* (G1G2/S1S2), and Sandy Beach tiger beetle, *Cicindela hirticollis gravida* (G5T2/S2).

Globose dune beetle

11. Morro Strand State Beach; Cottontail Creek; strand, dune, and emerging wetland; removal of European beach grass and ice plant remains ongoing to defend habitat of beach sand verbena, *Abronia umbellata*, and Blochman's leafy daisy, *Erigeron blochmaniae*.[4]

12. Estero Bay; Ocean Shoreline Sensitive Resource Area and critical viewsheds; Morro Bay Sand Spit, another Sensitive Resource Area (according to the county's development plan), separates Estero Bay from Morro Bay.[5]

13. Morro Bay; Morro Bay State Park; Morro Bay State Marine Recreational Management Area; Chorro Creek bog thistle, *Cirsium fontinale* var. *obispoense*; Morro Bay Estuary; endangered Morro Bay blue butterfly, *Plebejus icarioides morroensis* (G5T2/S2); Baywood Peninsula is surrounded by a planted grove of Monterey cypress.

## 07. A Good, Long Walk

14. Morro Dunes Ecological Reserve; sensitive dune ecosystem with endemic, endangered species present; restoration project and removal of ice plant with glyphosate is ongoing; other restoration efforts include the installation of nearly three hundred bales of straw to protect against dune erosion.[6]

15. Sweet Springs Nature Preserve; Los Osos Creek watershed; Fairbank Point Property, nesting site for heron;[7] 1.7 square miles of habitat for the only population of Morro Bay kangaroo rat, *Dipodomys heermanni morroensis* (G3G4T2/S2); Los Osos Oaks State Natural Reserve, site of the El Morro Elfin Forest, coast live oaks that are stunted by habitat conditions;[8] existing freshwater marshes in Los Osos creekshed include Eto and Warden Lakes.

16. Sand Spit Trail; 4-mile trail through the Morro Dunes Ecological Reserve; in sight of the iconic Morro Rock, 578', that sits at the mouth of Morro Bay.

17. Montaña de Oro State Park; Map 07.17b.

18. Diablo Canyon Power Plant; the only operating nuclear power plant in California; generates 8.6% of California's energy and 23% of California's carbon-free energy;[9] the nuclear reservation is 900 acres and not accessible to the public; the reactors sit on the bluff, 85 feet above sea level, between two fault lines that were not known to exist at the time of construction;[10] the power plant is scheduled for decommissioning in 2025.[11]

White-tailed Kite

The Coasts of California

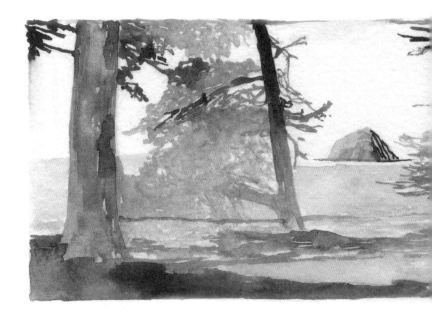

## 07.17a Of People and Pollutants
*Protecting Morro Bay*

Morro Bay is one of the most important, healthiest, and largest estuaries on the central coast. In order to keep it that way and to augment the services that the larger network of local ecosystems provides, the county has implemented a stringent conservation plan.[12] Covering an area of over twenty-three hundred acres, or just over 3.5 square miles, the estuary encompasses the mouths of both the El Chorro Creek and the Los Osos Creek watersheds. Among the tidal and freshwater habitats present is also significant acreage of coastal dune scrub habitat—one of the most endangered habitat types in California.[13] Any effort to conserve the healthy functioning of the estuary must account for the sizeable watershed it sits in—48,000 acres, or 75 square miles. The primary stressors and priorities impacting the future health of the estuary include seven identified issues:

1. Sedimentation—erosion problems in the upper watershed, from roads and from fire, increase sediment load in the delicate ecosystem of the estuary.

## 07. A Good, Long Walk

Morro Rock, a 580-foot-tall volcanic plug, an island that jets up out of Morro Bay, viewed through the trees, looking west.

2. Contamination—bacterial pollutants from storm runoff and improper disposal of human waste from boats overwhelm the brackish ecosystem.

3. Nutrient surplus—farm fertilizers and other nutrient chemicals deposited into the bay during seasonal flooding destroy the fertility of estuarine plant life.

4. Pollutants—a variety of toxic chemicals from the fishing and recreational boating industry and from the local urban environment destroy fecundity in the lower watershed.

5. Freshwater scarcity—freshwater delivery to the estuary is compromised by agricultural and urban usage, threatening desiccation across all wetland habitat types.

6. Preserving biodiversity—local conservation efforts must include connectivity between habitat spaces to buffer against (among other things) the impacts of climate breakdown and sea-level rise.

7. Balancing uses—compromise between environmental fecundity and human enterprise, as it manifests in resource extraction, is both an ever-evolving challenge and an unfolding opportunity. Future generations will benefit from a healthy, biodiverse Morro Bay—one that is robust in both the scope and capacity of its services.

# The Coasts of California

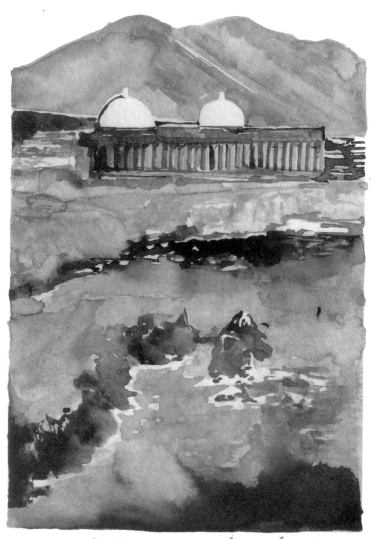

Diablo Canyon — the end of California's nuclear era

07. A Good, Long Walk

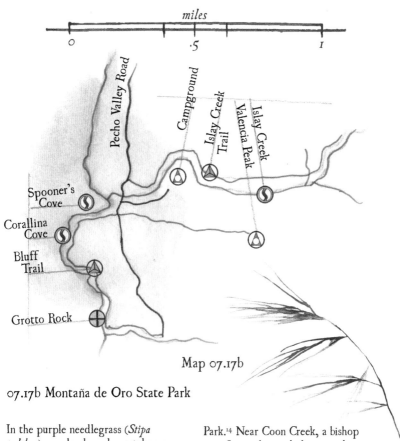

Map 07.17b

07.17b Montaña de Oro State Park

In the purple needlegrass (*Stipa pulchra*) grasslands and coastal sage scrub of Montaña de Oro State Park, down from the Irish Hills that separate Estero Bay to the north from San Luis Obispo Bay to the south, many rare and endemic organisms make their home in unique conditions. North of Islay Creek, Morro manzanita, *Arctostaphylos morroensis*, makes its only home in the fine sands of Baywood Park.[14] Near Coon Creek, a bishop pine forest that includes coast live oak supports one of the county's only native population of Carmel ceanothus, *Ceanothus thyrsiflorus* var. *griseus*.[15]

Purple needlegrass

369

# The Coasts of California

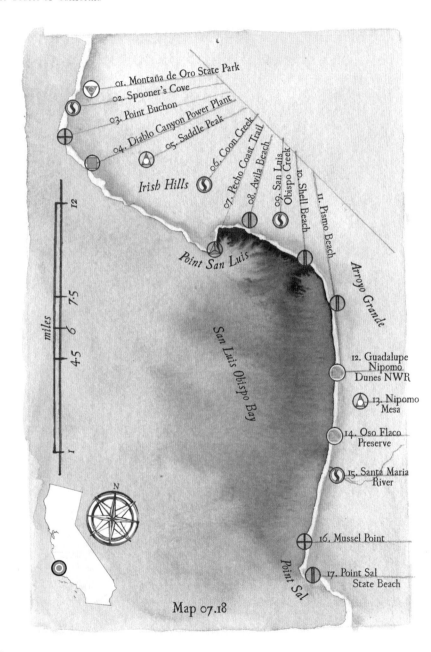

Map 07.18

# 07.18 OF DUNES AND DAISIES
*The San Luis Obispo Bay coast*

Map 07.18 depicts approximately 50 miles of coastline in central California within San Luis Obispo County.

Across the low hills, coastal dune fields, and scrub forests of San Luis Obispo County, Chumash culture evolved and flourished for at least ten thousand years. It is thought that this artistic and widespread people relied mainly on marine resources in the first few millennia of their residency, and later on acorn-based, terrestrial food sources as the climate warmed across the centuries.[1] Today, this temperate land of plenty that the indigenous people continue to know and love remains, in some points of relative isolation, intact. From Morro Bay to the Guadalupe-Nipomo Dunes, California society is rallying to defend the precious and stressed natural resources still extant by assembling complex action plans. From the city level to the county of San Luis Obispo to the state and even federal levels, the allied forces of restoration work locally to wrestle away the fate of once robust ecosystems from the deleterious and ever-encroaching consumption and extraction that modern California seems to require.

Blue rockfish
*Sebastes mystinus*

> For more than thirty-five years, we unwittingly leaked twelve million gallons of oil into one of the coast's most delicate environments. It is a wonder how this magnificence remains.

01. Montaña de Oro State Park; Map 07.17b.

02. Spooner's Cove; Spooner's Cove trailhead; flanked by Morro dune habitat within Montaña de Oro State Park; noted for fecund intertidal ecosystems; near the Point Buchon Trail, collapsed sea caves create sinkholes in the prairie as the steppe erodes from the tidal force below.

03. Point Buchon; Point Buchon State Marine Reserve and Marine Conservation Area; westernmost point of the Irish Hills peninsula. A recently completed long-term study of the local waters found that the most common species were blue rockfish, *Sebastes mystinus* (38% of the total research catch); gopher rockfish, *Sebastes carnatus* (27%); and black rockfish, *Sebastes melanops* (11%).[2]

04. Diablo Canyon Power Plant; California's last operating nuclear power plant; when it is decommissioned in 2025, the nuclear age of California will end with it; see Map 07.17.

05. Saddle Peak (1,819'), tallest peak in the Irish Hills.

06. Coon Creek; primary watershed within Montaña de Oro State Park; riparian corridor that contains serpentine outcrops with particular endemic flowers; one of the larger conifer forest groves in the county; see Morro Bay, Map 07.17.

07. Pecho Coast Trail; Point San Luis, San Luis Hill (705'); nearby Ruda Ranch contains some of the largest oak trees in the county.[3]

08. Avila Beach; Sycamore Springs; urban area along the coast extends through the cities of Pismo Beach and Grover Beach.

09. San Luis Obispo Creek; 84-square-mile watershed with a watercourse that runs from Cuesta Grade, northeast of the city of San Luis Obispo, to Avila Beach; habitat for southern steelhead despite numerous obstacles and impoundments; one of many sites in the county ready for beaver reintroduction, a move that might mitigate damage to watershed ecology and support efforts to combat the worst local effects of climate change.[4]

10. Shell Beach; Monarch Butterfly Grove Trail; one of five sites in California that has historically counted more than 10,000 overwintering monarch butterflies on their annual migration; 2016 count was more than 20,000, and 2020 count was under 3,000, in line with alarming statewide, rapidly diminishing butterfly counts.[5]

11. Pismo Beach; mouth of Pismo Creek; watershed of 47 square miles and includes Edna Valley; before it was channelized, Pismo Creek meandered to join Arroyo Grande Creek to find the ocean near the town of Oceano, 2 miles south of its present mouth;[6] species include sandy beach tiger

beetle, *Cicindela hirticollis gravida* (G5T2/S2), and western beach tiger beetle, *Cicindela latesignata latesignata* (G2G4T1T2/S1).

12. Guadalupe-Nipomo Dunes National Wildlife Refuge; 15,000 acres; ocean lagoon. Federally listed endangered plants include Pismo clarkia, *Clarkia speciosa* var. *immaculata*; Gambel's watercress, *Rorippa gambellii*; and marsh sandwort, *Arenaria paludicola*.

13. Nipomo Mesa (475'); Black Lake Canyon watershed, home to 25 diverse plant species and an influence on the greater Guadalupe-Nipomo Dunes ecosystem by feeding the watershed hydrology and providing acres of essential nearshore wildlife habitat.[7]

14. Oso Flaco Preserve; Oso Flaco Lake; part of Oceano Dunes State Vehicle Recreation Area; important riparian corridor habitat that includes silver dune lupine, *Lupinus chamissonis*, an important perennial shrub in the complex of dune ecosystems. Invasive plant species include purple veldt grass, *Ehrharta calycina*; European beach grass, *Ammophila arenaria*; jubata grass, *Cortaderia jubata*; slender-leaved ice plant, *Conicosia pugioniformis*; and sea figs, *Carpobrotus chilensis* and *Carpobrotus edulis*.[8]

15. Santa Maria River; flows to the coast for 24 miles from the confluence of the Cuyama and the Sisquoc Rivers; Twitchell Dam on the Cuyama is the only major impoundment in the watershed; the Sisquoc is a Wild and Scenic River that flows for 67 miles, from deep in the Los Padres National Forest; restoration of 150 acres of riparian habitat continues near the city of Santa Maria.[9]

16. Mussel Point; north of Point Conception, local fish biodiversity has been estimated at 500 species due to diverse habitat types from the rocky shore to pelagic depths.[10]

17. Point Sal State Beach; complex local wetland environment that supports an estimated 300 species of plant life, many at the northernmost or southernmost extent of their range.[11]

*Pismo clarkia*

## 07.18a Of Oil Fields and Dune Fields
*Cleaning up the Santa Maria River Estuary*

From 1955 to 1990, the sensitive ecosystem near the mouth of the Santa Maria River within what is now the Guadalupe-Nipomo Dunes National Wildlife Refuge was adjacent to the site of a major oil field. Several hundred wells were dug by the Union Oil Company; they pumped thousands of barrels of crude oil every day. Spills were a regular occurrence, and an estimated twelve million gallons of diluent (a kerosene-like hydrocarbon) were leaked into the sand over those decades. This contaminant might be dangerous for centuries to come, as it became part of the chemical composition of the westward-moving groundwater, climbing its way up the food chain.[12] A study done on California barred surfperch, *Amphistichus argenteus*, found toxic levels of TPH (total petroleum hydrocarbons) present from ingesting contaminated prey.[13]

Remediation of massive amounts of pollution and of the oil-field infrastructure continues to this day.[14] Over the past twenty years, more than one million cubic yards of contaminated soil were removed from the decommissioned oil field. There remains close to two million acres of contaminated soil in the ground.[15] The current plan is not to remove the poisoned earth but to cover it—buried in an eighteen-acre hole with a geosynthetic clay liner that may or may not work in the long term to keep the contamination sequestered from the groundwater.[16]

The tragedy has no obvious good solution; continuing to transport the contaminated soil from the site to the Santa Maria landfill via tens of thousands of trips in dump trucks is costly and does not address the core problem—the soil itself—it only moves it. Surface restoration will be ongoing for the foreseeable future—the legacy of the twentieth and twenty-first centuries. So far, 150 miles of pipeline have been removed, the oil rigs have been uninstalled, and twenty acres of invasive veldt grass have been replaced with native grass in an effort to restore the dune ecosystem.[17]

# The Coasts of California

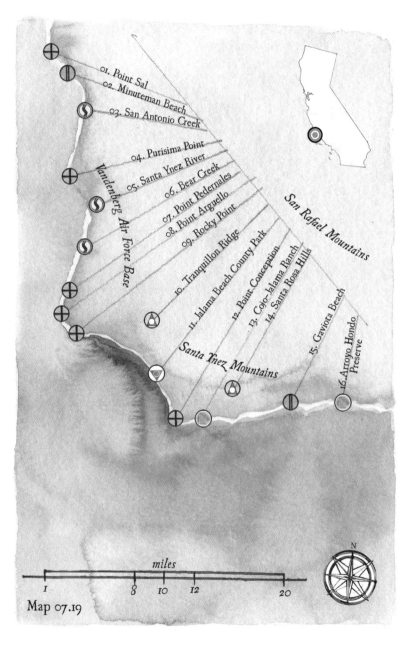

Map 07.19

## 07.19 OF OAKS AND OCEAN
*The Point Conception coast*

Unarmored three-spine stickleback

Map 07.19 depicts approximately 61 miles of the California coastline in Santa Barbara County.

At the risk of oversimplifying, we can say that California has three marine geographies: the north coast (from San Francisco Bay to the Oregon coast) and the central and south coasts, which are divided by the elbow of California, Point Conception. Here the orientation of the coastline shifts from running basically north–south to running west–east.

The Point Conception coast is dominated by Vandenberg Air Force Base. This military inholding of just less than one hundred thousand acres covers forty-five miles of coastline. Because it is removed from the realm of private and public development, the base has become de facto wilderness. The military has faithfully stewarded one of the highest local concentrations of threatened and endangered species in the nation.[1] Included in that promise is a comprehensive restoration plan to provide nesting habitat for nearly 20 percent of the Pacific population of western snowy plover, *Charadrius alexandrinus nivosus*.[2]

01. Point Sal State Beach; just under a thousand acres of public land managed by Santa Barbara County Parks and the Land Trust for Santa Barbara County; see 07.20.

02. Minuteman Beach; northern border of Vandenberg Air Force Base; access available only for residents of the base; habitat for the Point Conception Jerusalem cricket, *Ammopelmatus muwu* (G1/S1).

03. San Antonio Creek; begins its east–west flow 28 miles west of the Pacific; enters Vandenberg at Barka Slough; restoration of the stream bed of one mile of the watercourse near Highway 1 remains ongoing. This is habitat for federally listed endangered and threatened species including unarmored

*Some of California's most pristine coastline is also its most restricted.*

threespine stickleback, *Gasterosteus aculeatus williamsoni*; California red-legged frog, *Rana draytonii*; El Segundo blue butterfly, *Euphilotes battoides allyni*; and Gaviota tarplant, *Deinandra increscens* ssp. *villosa*.[3]

04. Purisima Point; inland from Burton Mesa Ecological Reserve; one of only nine known sites of Vandenberg monkey-flower, *Diplacus vandenbergensis*, a candidate for listing as an endangered species.[4]

Red-legged frog

05. Santa Ynez River; the east-west-running river is one of the biggest on the south coast; 92 miles long with a watershed of almost 900 square miles; impounded by three dams; historic beaver and steelhead habitat; native steelhead remain, but are unable to complete the anadromous life cycle due to impoundments.[5]

06. Bear Creek; 16-mile watercourse; watershed south of Lompoc.

07. Point Pedernales; mouth of Bear Creek; in 1997, the pipeline to the offshore oil rig, the northernmost platform in California, ruptured and released nearly 7,000 gallons of crude oil into the delicate ecosystem; it is a terrible irony that the offshore oil field is under the Channel Islands and Point Conception areas, both regions of extraordinary biological richness.

08. Point Arguello; the three oil platforms of the coast that currently extract oil from 500 feet below the ocean surface may soon be decommissioned; this move may or may not signal a key moment in the ending of the oil-mining era in and around the Santa Barbara channel.[6]

09. Rocky Point; as the Santa Ynez Mountains roll down to the coast, the character of the sage scrub changes on the now south-facing slopes—a pattern that continues across the Santa Barbara coast; the sage fields shift from black sage, *Salvia mellifera*, dominant to purple sage, *Salvia leucophylla*.[7]

10. Tranquillon Ridge (2,014'); highest point on Vandenberg Air Force Base; westernmost peak in the Santa Ynez Mountains; westernmost peak in the collective of mountain ranges called the Transverse Ranges.

11. Jalama Beach County Park; open to the public.

12. Point Conception; the transition zone; the orientation of the shoreline, from west-facing to south-facing, concentrates upwelling in marine ecosystems and supports large kelp beds that attract fish, birds, and a panoply of predator and prey species.

13. Cojo-Jalama Ranch; the Bixby Ranch and the Hollister Ranch were two enormous land holdings, remnants of the Spanish grant era that together cover 40,000 acres; the Bixby Ranch, also called the Cojo-Jalama Ranch, was sold to the Nature Conservancy through a single donation made by Jack and Laura Dangermond in 2017; a new preserve of 24,400 acres will bear their name; the Hollister Ranch was subdivided in 1965, and today about a hundred homes are scattered across the landscape; covering 8 miles of shoreline, the Dangermond preserve is a huge parcel of ecologically important coastal landscape;[8] oak woodland.

14. Santa Rosa Hills; Santa Rosa Park; floodplain of the Santa Ynez River; El Jaro Creek.

15. Gaviota State Park Beach; Nojoqui Falls County Park; ongoing eradication of artichoke thistle, *Cynara cardunculus*.[9]

16. Arroyo Hondo Preserve; just under 800 acres; sycamore riparian habitat through an idyllic canyon; restoration efforts continue focusing on the removal of invasive plants, including greater periwinkle, *Vinca major*, and onion weed, *Asphodelus fistulosus*.[10]

*Hollister Ranch Coast, Santa Barbara County*

# The Coasts of California

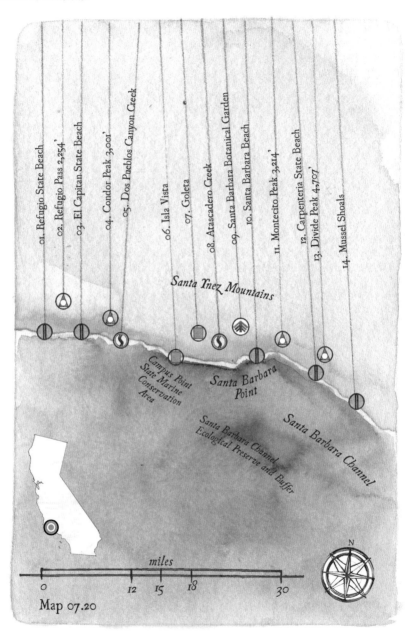

Map 07.20

## 07.20 OF SANDSTONE AND SKY
*The Santa Barbara coast*

Map 07.20 depicts nearly 45 miles of coastline in Santa Barbara County.

Belding's savannah sparrow

The litany of grievous injuries that industrialized culture has inflicted on the gorgeous riviera of the Santa Barbara coast is astounding, not only because the list is so long but also because the place still seems ecologically intact to the casual observer and continues to hold its unrivaled and uniquely beautiful, natural quality. Between the oil disasters, the catastrophic fires, the removal of habitat space (as much as 95 percent of steelhead habitat—see 07.20a), and the urban development, it is hard to conceive of the pollution in the idyllic environment that is Santa Barbara. Hardly in all the world is there a more perfect climate for the human animal. But it is all on a ticking clock, and the community may be waking up in time to reverse the trend toward total ecological dismantlement.

New awareness of how we might break the extractive chains of consumerism are emerging, and perhaps most emblematic of the ambitious local energy to get right with our behavior is the massive investment being put into a new waste-processing facility on top of the old landfill near Tajiguas beach, west of Refugio. The new facility recovers organic waste, reduces emissions, and is able to capture biomass energy and produce landscape nutrients from converted waste.

> In a context of tragic irony indicative of the human character, we enjoy the paradise of Santa Barbara while we continue to administer poison to its living systems.

Transforming the economy in this way, from production to stewardship and responsible management, is the ticket out of this mess and toward reconciliation with what we were given: the stewardship of paradise.[1]

01. Refugio State Beach; adjacent to the site of the 2015 pipeline leak that dumped more than 140,000 gallons (by volume, 140 twelve-by-twenty-four-foot swimming pools) of crude oil into the delicate ecosystems of the California coast's intertidal zone; the numbers reflect the travesty—1,500 acres of shoreline habitat directly affected, 2,200 acres of benthic subtidal habitat directly affected, hundreds and hundreds of birds from more than two dozen species killed, and hundreds of pinnipeds and cetaceans dead;[2] ongoing restoration will take decades.

02. Refugio Pass (2,254'); rural Santa Ynez Mountain pass; headwaters of Quiota Creek, a tributary of the Santa Ynez River.

03. El Capitan State Beach; El Capitan Creek—perennial creek with newly installed fish passage;[3] sycamore and oak riparian corridor.

04. Condor Peak (3,001'); Santa Ynez Peak (4,298'); Broadcast Peak (4,026'); fire analysis of local charcoal deposits indicates that over the past 500 years, major fires in excess of half a million acres occurred in these mountains every 50 years;[4] along the south coast, major fires were historically more common than along the north coast and inland montane woodland areas.

05. Dos Pueblos Canyon Creek; one of seven perennial, unimpaired creeksheds along the Gaviota coast watershed suitable for rainbow trout reintroduction.[5]

06. Isla Vista; Ellwood Creek; Coronado Butterfly Preserve, 9.3 acres on the Devereux creekshed; Goleta Butterfly Grove; Ellwood Shores coastal bluffs; Santa Barbara Shores County Park; the 1972 Coastal Zone Management Act protected monarch butterfly overwintering sites as Environmentally Sensitive Habitat Areas;[6] population continues to plummet across California, and locally, habitat degradation due to dying trees, loss of canopy, loss of wind protection, and loss of roosting branches exacerbates the problem.[7]

07. Goleta; Goleta Slough Ecological Reserve, 440 acres; habitat for eight species of endangered bird, including nesting sites for more than 100 Belding's savannah sparrows, *Passerculus sandwichensis beldingi* (G5T3/S3),[8] and visiting habitat for California brown pelican, *Pelecanus occidentalis californicus* (G4T3T4/S3).

08. Atascadero Creek; part of the Goleta Slough complex of creeks—San Jose Creek, San Pedro Creek, Maria Ygnacio Creek, San Antonio Creek, and Atascadero; six major barriers have been identified for removal to restore steelhead habitat.[9]

09. Santa Barbara Botanical Garden; community center and grounds for regional ecological restoration and stewardship; current work includes the mapping of over 300 miles of trails and roads affected by the Thomas Fire (2017, approximately 281,000 acres) and the Whittier Fire (2017, approximately 18,000 acres) across the Santa Ynez Mountains.[10]

10. Santa Barbara Beach; Santa Barbara Harbor; local tidal wetland includes the Laguna Channel and El Estero; heavy human traffic—site of the Garden Street Market Habitat Restoration Project for biological enhancement and the mitigation of future commercial projects. Grass species include California bulrush marsh, *Schoenoplectus californicus*; native southern cattail, *Typha domingensis*; arroyo willow, *Salix lasiolepis*; and western sycamore, *Platanus racemosa*.[11]

11. Montecito Peak (3,214').

12. Carpinteria State Beach; Carpinteria Salt Marsh Reserve; lagoon fed by two primary creeks, Santa Monica and Franklin Creeks; Carpinteria Salt Marsh Nature Park; northwestern geographic limit for light-footed clapper rail, *Rallus obsoletus levipes* (G5T1T2/S1).[12]

13. Divide Peak (4,707'); divides Santa Barbara and Ventura Counties.

14. Mussel Shoals; Rincon Point; Rincon Creek; Rincon Mountain (2,161').

*A bending of the creek in Arroyo Burro, Santa Barbara*

## 07.20a Of Streams and Steelhead
*Restoration of the Santa Barbara salmon*

Along the approximately fifty-eight miles from Point Conception to Rincon Point, the south-facing edge of Santa Barbara County, there are at least thirty-three creeks that historically held Southern California steelhead, a distinct population segment of *Oncorhynchus mykiss irideus*, pop. 10 (G5Ti?/S1). What a terrible failure of stewardship—where there were tens of thousands of returning salmon to the creeks only fifty years ago, now populations dwindle to just a few hundred, and of those thirty-three creeks, perhaps only fifteen still have populations at all.[13] Along this coast, between 5 and 31 percent of estimated remaining estuarine habitat—habitat vital to fish populations—exists.[14] The stresses to fish habitat here are mainly anthropogenic, and they're found across the state:[15]

Agricultural development
Dams and surface-water diversions
Flood-control infrastructure
Groundwater extraction
Levees and channelization
Nonnative species
Other passage barriers
Recreational facilities
Roads and other fragmentations
Urban development
Wildfires degrading riverine habitat

Listed here are the creeksheds from west to east, and whether they still have populations of steelhead (Y) or they don't (N) or if more data is needed (X), along with the stream length (in miles) of the associated watercourse (in parenthesis):[16]

Jalama Creek (X) (9.0)
Cañada del Cojo (X) (2.6)
Cañada del Sacate (X) (2.6)
Cañada de Santa Anita (Y) (3.4)
Cañada de la Gaviota (Y) (6.0)
Cañada San Onofre (X) (2.5)
Arroyo Hondo (Y) (2.2)
Arroyo Quemado (N—barrier) (3.1)
Tajiguas Creek (N—barrier) (4.4)
Cañada del Refugio (X) (5.5)
Cañada del Venadito (N—barrier) (3.5)
Cañada del Corral (Y) (4.9)
Cañada del Capitan (X) (4.9)
Gato Canyon (X) (5.1)
Dos Pueblos Canyon (Y) (6.4)
Eagle Canyon (X) (3.1)
Tecolote Creek (Y) (6.5)
Bell Canyon (N—barrier) (1.0)
Goleta Slough Complex (Y—five creeks) (34.0)
Arroyo Burro (Y) (4.0)
Mission Creek (Y) (7.8)
Montecito Creek (Y) (3.5)
Oak Creek (N—barrier) (2.7)
San Ysidro Creek (Y) (3.5)
Romero Creek (Y) (4.6)
Arroyo Paredon (Y) (5.3)
Carpinteria Salt Marsh Complex (N—barrier, two creeks) (8.0)
Carpinteria Creek (Y—four tributaries) (13.1)

07. A Good, Long Walk

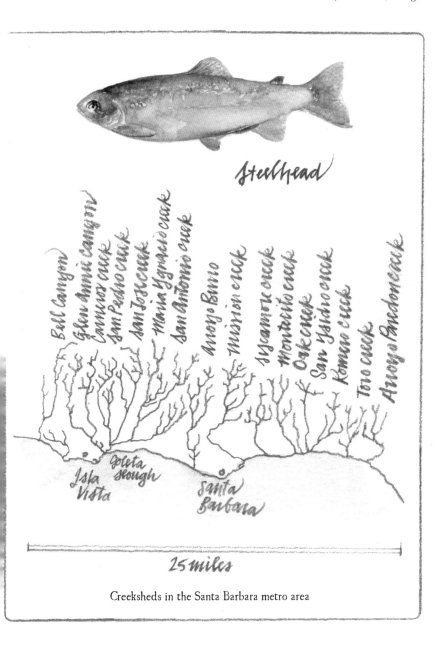

Creeksheds in the Santa Barbara metro area

The Coasts of California

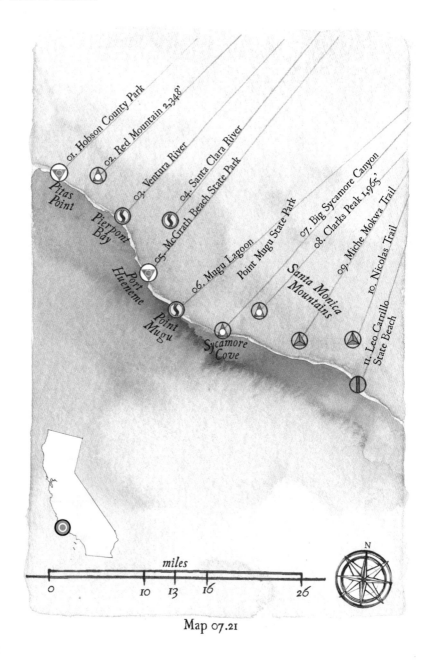

Map 07.21

## 07.21 OF SYCAMORES AND THE SANTA CLARA
*The Ventura coast*

Map 07.21 depicts approximately 34 miles of California coastline in Ventura County.

Cutting a meandering bead through the heart of Ventura County, the Santa Clara River is one of the most dynamic and largest watersheds on the south coast. Despite its incredible habitat for such endangered species as the south coast gartersnake, *Thamnophis sirtalis*, pop. 1 ($G_5T_1T_2/S_1S_2$), the wetlands of the Santa Clara are rivaled in depth of biodiversity by the Ventura River watershed, which includes the Matilija Canyon tributaries, and Mugu Lagoon, vital habitat for birds and pinnipeds.

Here old extractivist ways are increasingly challenged by a new conservationist mentality. There is a lot of oil here, and what to do with that oil, whether to leave it in the ground or to feed a fossil-fueled fantasy perpetuating the carbon economy, is the basis for this ethical conflict. Passing the many oil fields where derricks pump all day and all night just next to the freeway, you turn your head and count the offshore platforms marring the landscape and can't help but wonder at the decisions that are being made.

01. Hobson Beach County Park; Faria Beach County Park; Emma Woods State Beach; steep coastal bluffs line sandy beaches and rocky tide pools; three oil fields here and two major subterranean pipelines in what is called by the county the North Coastal Zone.[1]

02. Red Mountain (2,348') divides the Ventura River watershed and Lake Casitas (an off-river reservoir supplied via the Robles Canal) from the Santa Barbara Channel watershed.

03. Ventura River; stream length, 16.2 miles; the Ventura River Trail runs from its mouth to the town of Ojai, nearly 16 miles inland. Matilija Dam, a 70-year-old structure on one of the river's primary tributaries, is well beyond its active life and is 90% full of sediment; removing this dam is imperative to the survival of steelhead in the river and throughout the region of this distinct population segment.[2]

04. Santa Clara River; 83-mile watercourse; 1,600-square-mile watershed with three major tributaries—the Sespe, the Piru, and the Castaic from Ventura and Los Angeles Counties; watershed bounded on its southern side

*The Santa Clara River is certainly California's greatest river that the fewest people know about.*

by the Santa Monica Mountains; tributaries of the Santa Clara River with self-sustaining populations of rainbow trout, *Oncorhynchus mykiss*, include the Sespe River and Piru Creek;[3] before Euro-American settlement, this watershed was full of beaver[4] and antelope;[5] the water quality of the biologically valuable estuary is compromised;[6] in the estuary, currently "present" or "high potential" for being present are 9 plant, 18 bird, 0 amphibian, 4 reptile, 6 fish, and 4 invertebrate special-status species.[7]

05. McGrath Beach State Park; 2-mile sandy beach with campground.

06. Mugu Lagoon; between the Ormond Lagoon Waterway and the mouth of Calleguas Creek sit Ventura County's largest and most biologically important wetlands; home for hundreds of species of birds and a dozen

*The Santa Clara River*

different habitat types (see 07.21c); Naval Base Ventura County; Ormond Beach Generating Station; Point Mugu Game Reserve; Ventura County Game Preserve; site of the Ormond Beach Restoration Project, a joint venture between the Nature Conservancy, the City of Oxnard, and the State Coastal Conservancy.[8]

07. Big Sycamore Canyon; Santa Monica Mountains National Recreation Area; Boney Mountain State Wilderness Area; Point Mugu State Park; canyon between Boney Mountain (2,825') and La Jolla Peak (1,567').

08. Clarks Peak (1,965'), near the Ventura–Los Angeles county line.

09. Mishe Mokwa Trail; 3.5-mile looping trail; Carlisle Canyon and Balanced Rock; Split Rock Oak Grove.

10. Nicholas Trail; Leo Carrillo State Park; burned three times between 1919 and 1990, and in the Woolsey Fire of 2018, a massive fire that torched almost 24,000 acres.[9]

11. Leo Carrillo State Beach; 2,513 acres; 1.5-mile beach; restoration of the Arroyo Sequit, the creekshed, is ongoing, focused on fish habitat restoration and the removal of invasive plants (primarily cape ivy, *Delairea odorata*).[10]

American kestrel
*Falco sparverius*

## 07.21a Lessons Not Learned
*The legacy of oil in the Santa Barbara Channel*

At a depth of more than a half mile under the seabed in the Santa Barbara Channel is the Monterey Shale Formation—what could be the largest remaining oil deposit in the world.[11] The tension between the oil companies, who want the profit that would come from delivering that oil to the national economy, and the regional, state, and global communities that recognize the dire need to keep that carbon in its grave and to steward the delicate biodiversity in the local ecosystems, is coming to a dramatic head. As it stands, there are twenty-seven offshore platformed oil derricks on the water, in the channel between Point Conception and Huntington Beach in Orange County. Some of these platforms are over sixty years old.[12]

One catastrophic day in 1969, almost five million gallons of oil leaked from one of these platforms and eventually made a slick of seventy-five square miles—roughly the size of the Los Angeles Basin. The ecology of the Santa Barbara Channel was exposed to such catastrophe that echoes of the trauma still exist today. The disaster, to some degree, sparked the passing of a number of environmental laws in the 1970s and the world's first Earth Day a year later. Now, the third-largest offshore oil spill in our national history (behind the *Exxon Valdez* spill and the Deepwater Horizon disaster), the Santa Barbara spill seems to be a lesson we have largely failed to learn. In 2015, a leak of consequential size occurred on the Gaviota Coast (see 07.20), and although the emergency-response strategy has improved, the environmental effect remains inexcusable.[13]

There were a few more platforms built in the 1970s and a few more still in the 1980s—built using old leases. Following the 1969 spill, California (for the most part) put a moratorium on new oil leases. Everything is changing. The federal government under the Trump administration opened up forty-seven sites from Humboldt Bay to Orange County, most of the US coastal waters off California, to new leases.[14] This endeavor would have been the death knell for all the work California claims to be doing to transform the carbon-based economy. With the abhorrent plan under the Trump oil leasing regime, we could have seen a half-dozen oil platforms out from the Golden Gate—a threat that with one dreadful accident could wipe out half of California's seabird population as they nest on the Farallon Islands. Although the Biden administration has suspended this plan for federal leases of new oil platforms in US waters, the current government of California has some answering to do, as under the Newsom administration, the number of oil well and fracking leases is up across the board, despite the governor's insistence against giving such irresponsible permission.[15]

07. A Good, Long Walk

Despite the threat of new platforms, six of the now more than two dozen platforms off California's coast are scheduled for decommission or have already been decommissioned. What should be a celebration presents us with new conundrums. Over the past sixty years that these platforms have been in place, artificial reefs have developed around their bases and support several hundred species of fish and invertebrates.[16]

*Oil derricks off of the Santa Barbara coast*

# The Coasts of California

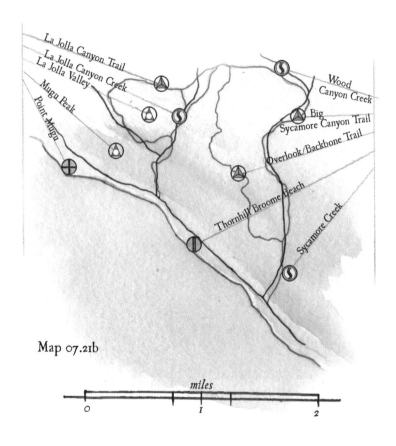

Map 07.21b

## 07.21b Point Mugu State Park

Three valleys and four peaks make up the geography of this 15,000-acre park. Chaparral-blanketed ridgelines fan out through oak woodlands down to oceanside tidal lagoons. Fifty miles of trail wind through pastoral dry grasslands where rabbits abound under yucca blooms, and where wildflower fields explode with vernal color from an idyllic wildflower habitat.

## 07.21C A Holdout for Diversity
*Habitat types at Mugu Lagoon*

Within the 4.3-mile long lagoon, just north of Point Mugu State Park and within Point Mugu Naval Air Station, are a number of large habitat areas at the estuary of Calleguas Creek.[17] This important site, a node of biodiversity, is stressed by the channelization of many of its tributaries that serve the local agricultural industry and deliver sediment to the fragile ecosystem.[18] The twelve identified habitat types found here are listed along with a couple of examples of indicative species associated with them.[19]

1. Beach/coastal strand
   a. Saltbush, *Atriplex leucophylla*
2. Coastal dunes
   a. Pink sand verbena, *Abronia umbellata*
   b. Beach bur, *Ambrosia chamissonis*
3. Dune swale wetlands
   a. Arctic rush, *Juncus arcticus*
   b. Salt grass, *Distichlis spicata*
4. Lagoon and open water
   a. Sea lettuce, *Ulva lactuca* and *U. intestinalis*
   b. Spiral ditch grass, *Ruppia cirrhosa*
4. Salt panne, hypersaline basin
   a. Brine flies, *Ephydridae* spp.
5. Salt marsh
   a. Pickleweed, *Salicornia pacifica*
   b. Sea lavender, *Limonium californicum*
6. Seasonal wetlands
   a. Coulter's saltbush, *Atriplex coulteri*
   b. Pacific saltbush, *A. pacifica*
7. Fresh-brackish wetland
   a. Saltmarsh bulrush, *Bolboschoenus maritimus*
   b. Saltmarsh baccharis, *Baccharis glutinosa*
8. Riparian
   a. Arroyo willow, *Salix exigua* and *S. lasiolepis*
9. Wetland–upland transition
   a. Brewer's saltbush, *Atriplex lentiformis* ssp. *breweri*
   b. Woolly seablite, *Suaeda taxifolia*
10. Upland
    a. Purple needlegrass, *Nassella pulchra*
    b. California brome, *Bromus carinatus*
11. Bioswales constructed/artificial wetlands (potential habitat for various species)

Sea lavender
*Limonium californicum*

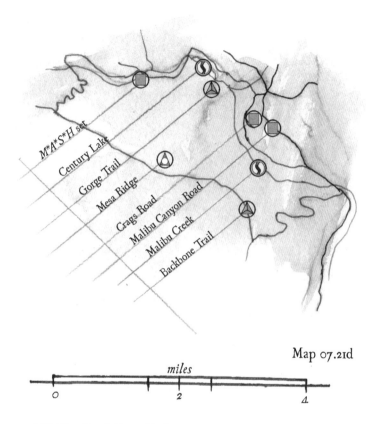

Map 07.21d

## 07.21d Malibu Creek State Park

Across this volcanic range that has been dormant for millions of years, parts of the chaparral and creekside riparian habitat of the 8,200-acre Malibu Creek State Park have burned thirty times in the last ninety years.[20] Along with Matilija Canyon on the Ventura River, Scott Dam on the Eel River, and the four dams on the Klamath River, Rindge Dam on Malibu Creek has been identified as one of the most important "deadbeat" dams that need to be removed immediately to free up access of salmon to the headwaters they need to progenerate their ailing species.[21] Rindge Dam was built in 1924 and is now completely full of sediment and scheduled for removal by 2025.[22]

07. A Good, Long Walk

*Malibu Creek*

# The Coasts of California

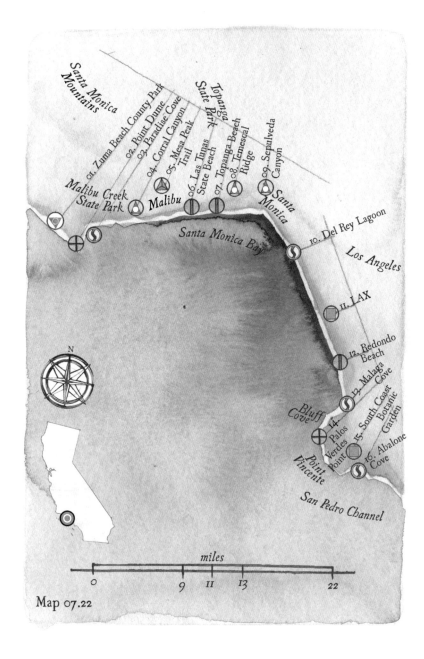

Map 07.22

# 07. A Good, Long Walk

## 07.22 OF CANYONS AND CREEKS
*The Santa Monica coast*

Map 07.21 depicts approximately 41 miles of coastline in Los Angeles County.

No stretch of the California coast is more heavily used, more transformed, and ultimately more exploited than the landscape that surrounds Santa Monica Bay. From wildland fire to the fires of industry, the natural world of this region has been shaped and burned beyond recognition by the collective overwhelming force that is the ever-growing fury of Los Angeles. Most recently, in 2018, the Woolsey Fire swept across one hundred thousand acres of the Santa Monica Mountains, a region already beleaguered by a deformed fire regime that has burned too much in recent decades.

Despite the constellation of modern stressors applied to the Santa Monica Bay microbiome, catastrophe is still avoidable as community after community takes responsibility for the slivers of sensitive habitat that keep the endemic wildlife systems on life support. Restoration projects in this area often include policies aimed at improved fish passage (for both the endangered southern steelhead and the tidewater goby), improved bird habitat (for the endangered light-footed Ridgway's rail), and for improved water quality. Across the southern part of the bay, a number of special-status species still find habitat in the fragmented El Segundo dune system, including the Santa Monica shield-back katydid, *Aglaothorax longipennis* (G1G2/S1S2); Lange's El Segundo dune weevil, *Onychobaris langei* (G1/S1); and the El Segundo blue butterfly, *Euphilotes battoides allyni* (G5T1/S1).

01. Zuma Beach County Park; wide and sandy beach; adjacent to Broad Beach; Trancas Creek outlet; due to sand erosion rates over the past 50 years, the shoreline has moved inland by 65 feet;[1] a sand nourishment restoration plan that involves the replacement of 300,000 cubic yards of sand to the beach, every 5 years, is ongoing.[2]

02. Point Dume; promontory at the western terminus of Santa Monica Bay; Point Dume Nature Preserve; 34-acre preserve; intact example of coastal bluff scrub.[3]

03. Paradise Cove; Escondido Canyon; Escondido Creek, a 2,300-acre watershed; site of the Escondido Canyon Park to Murphy Way Connector Project, part of a broader initiative to restore postfire habitat region wide.[4]

*We can't keep lighting the chaparral on fire.*

*Palos verdes butterfly*

04. Corral Canyon; Solstice Canyon, site of a perennial waterfall; Cameron Nature Preserve at Puerco Canyon, 700-acre preserve, a wildlife corridor between the ridge of Ladyface Peak (2,036') within Malibu Creek State Park and the coast of Dan Blocker County Beach.[5]

05. Mesa Peak Trail; Kaslow Natural Preserve, 1,900 acres; site of the rare Santa Susana tarplant, *Deinandra minthornii*, also named *Hemizonia minthornii*.[6]

06. Las Tunas State Beach; Tuna Canyon, 18,000 acres; Tuna Creek, intact coastal riparian habitat;[7] site of the Los Flores Canyon Creek and Park Restoration project, a native tree–planting campaign.[8]

07. Topanga Beach; Topanga Lagoon, site of a 15-acre wetland restoration project;[9] Malibu Lagoon Restoration Project, site of a 12-acre wetland restoration project.[10]

08. Temescal Ridge; Temescal Creek; Temescal Gateway Park, corridor parkland from Sunset Boulevard into the Santa Monica Mountains.

09. Sepulveda Canyon; transit corridor, Interstate 405; site of the Stone Canyon Reservoir system, providing drinking water for 400,000 people in northern Los Angeles County.[11]

10. Del Rey Lagoon; Ballona Wetlands Ecological Reserve—once 2,000 acres, now less than 600 (highly compromised) acres of habitat remain;[12] controversy around the restoration project is ongoing among environmentalists, as rare plants may have been discovered on the site and may be disturbed by a large-scale restoration project like the one described;[13] other local parks include Del Rey Lagoon Park, Titmouse Park, and Vista Del Mar Park.

11. LAX; Dockweiler State Beach; Hyperion Water Reclamation Plant, largest water-processing plant in Los Angeles County; El Segundo Butterfly Preserve, one of three known habitats for the El Segundo blue butterfly, *Euphilotes battoides allyni* (G5T1/S1), federally listed as endangered.[14]

07. A Good, Long Walk

12. Redondo Beach; site of the 20-acre Beach Bluffs Restoration Project, a plan to return native dune habitat; the El Segundo dune system once included extensive wetlands and vernal pools and extended from Ballona Creek across the southern Santa Monica Bay to Palos Verdes.[15]

13. Malaga Cove; Bluff Cove; Lunada Bay.

14. Palos Verdes Point, peninsula that divides Santa Monica Bay from San Pedro Bay; local habitat for Palos Verdes blue butterfly, *Glaucopsyche lygdamus palosverdesensis* (G5T1/S1).

15. South Coast Botanic Garden; 87-acre park in Palos Verdes; built in the 1960s on a landfill site.[16]

16. Abalone Cove; site of the Palos Verdes Reef Restoration Project, which includes the delivery of over 70,000 tons of rock to 40 acres of sandy ocean bottom within a 69-acre site to improve rocky-reef habitat.[17]

the charred Santa Monica Mountains

## 07.22a Saving the Mountain Lion
### *Connectivity at Liberty Canyon*

The potentially biggest threat to mountain lions in California is not their population but their access to genetic diversity.[18] From this position, highways are the biggest threat, not for the danger of collision with moving cars (average road-kill death of mountain lions is two per week[19]), but because of the habitat fragmentation they cause. Having a small population is already a crippling factor in the fight to save the mountain lion, but we are already seeing possible mutations show up in the big cats due to inbreeding and genetic drift caused by inaccessibility of a wider gene pool.[20] If we don't allow for greater mobility of mountain lions across their isolated habitat spaces, we may see the extirpation of these noble predators in the next fifty years.[21]

In late 2021, construction will begin on what is designed to be the largest highway wildlife crossing in the world—the Liberty Canyon Wildlife Crossing. The bridge will connect the isolated population of lions in the Santa Monica Mountains with those populations north of Highway 101, in the Santa Susana Mountains and the Los Padres National Forest. This single construction project represents not only an endeavor that could be species saving but a huge, symbolic willingness in the human community to maintain biodiversity and ecological functionality, as an expression of our responsibility toward stewardship and our shared destiny with the natural world.[22]

07. A Good, Long Walk

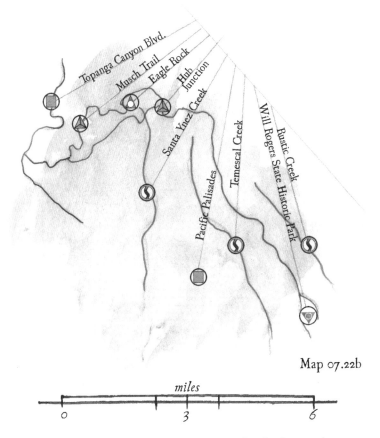

Map 07.22b

## 07.22b Topanga State Park

The 11,525-acre park is the biggest park in the Santa Monica Mountains and the biggest park in the Los Angeles city limits.[23] As part of a salmon-habitat restoration project, in 2014, a large berm, erected by locals several decades before to protect themselves from flood, was removed near Topanga Lagoon.[24] With this obstruction gone, endangered steelhead have access again to their headwaters that once supported a population of more than fifteen hundred fish.[25] Following Topanga Canyon Boulevard, Topanga Creek inhabits a watershed that covers eighteen square miles and harbors more biodiversity than any other watershed in the Santa Monica Mountains.[26] The lower reaches of Topanga Creek are within Topanga State Park.

The Coasts of California

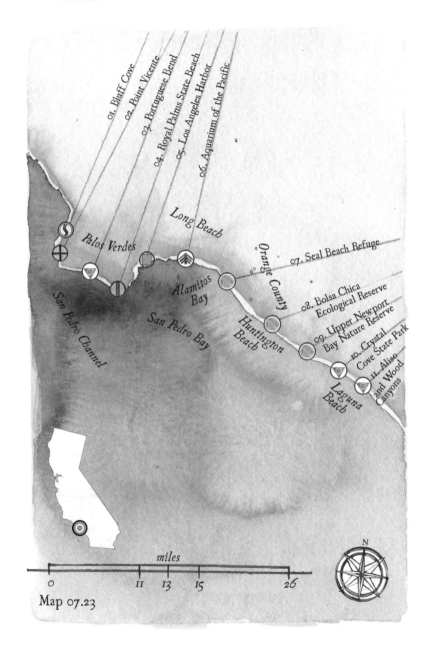

Map 07.23

07. A Good, Long Walk

## 07.23 OF CITIES AND SAGEBRUSH
*The San Pedro Bay coast*

Map 07.23 depicts approximately 50 miles of the coastline in Los Angeles and Orange Counties.

The municipality of Los Angeles surrounds, affects, and infiltrates all living systems in this section of the California coast. In protected pockets of wetlands, coastal sage scrub, cactus scrub, grassland, and oak habitat from Palos Verdes to Orange County, wildlife retains its foothold and still provides services. These networked, living communities work to filter and purify air and water, build soils and stabilize landscapes, absorb carbon dioxide, create a buffer against floods and high winds, and—perhaps most usefully—contribute to human well-being. Restored landscapes, and those in the process of restoration, provide nesting and breeding grounds for dozens of bird species, breeding and spawning habitat for hundreds of species of fish, the heterotrophic basis for complex food webs, and the only safe haven for many endangered and rare species.

So much of the remaining original, native biota—a sliver of what it once was, but a sliver nonetheless—was handed to us, a legacy of hard-fought late-twentieth-century environmental policy that recognized the fragile preciousness of these resources. As we marvel that any of it is left at all, we

Coastal cactus wren
*Campylorhynchus brunneicapillus sandiegensis*

wonder if we've saved enough to sustain these small numbers. We ask ourselves, and we present the challenge as the most pressing issue of our times: Can our cities live with nature or, more important, can they live without it?

*At the hub of the world economy, biodiversity remains assertive.*

01. Bluff Cove; Palos Verdes Estates Shoreline Preserve; Malaga Hills; Vista Del Norte Reserve, 14 acres; Lunada Canyon restoration of willow habitat in 2004 has yielded trees that are now more than 20 feet tall.[1]

02. Point Vicente; Vicente Bluff Reserve; Alta Vicente Reserve, site of a 23-acre restoration project of coastal sage scrub and cactus scrub habitat;[2] habitat of coastal cactus wren, *Campylorhynchus brunneicapillus sandiegensis* (G5T3?/S3).

03. Portuguese Bend; Portuguese Bend Reserve, part of a greenway managed by the Palos Verdes Peninsula Land Conservancy, which includes Three Sisters Reserve, Filiorum Reserve, and Forrestal Reserve.

04. Royal Palms State Beach; White Point Nature Preserve, 102 acres; San Ramon Reserve; Ocean Trails Reserve; across Palos Verdes, 1,400 acres of open-space preserve is planned for augmentation and restoration under a single plan designed to maximize connectivity and habitat regeneration for multiple species.[3]

05. Los Angeles Harbor; mouth of the Los Angeles River; the Port of Los Angeles and Long Beach together cover an area of more than 14,000 acres (half land, half water), and host more economic activity than any port in the United States;[4] despite over a hundred years of industry, the harbor maintains viable food webs that connect the intertidal with the pelagic and benthic communities through significant eelgrass and kelp bed habitats;[5] Terminal Island, within the harbor, supports 13% of the state's population of least tern, *Sternula antillarum browni* (G4T2T3Q/S2);[6] to truly restore the harbor, the first priority is to dismantle the obsolete 8-mile breakwater at the mouth of the harbor, which prevents circulation and keeps urban runoff close to shore.[7]

06. Aquarium of the Pacific; Long Beach shoreline; Alamitos Bay wetlands, mouth of the San Gabriel River; a restoration project is to begin soon over 18 square miles of East San Pedro Bay to support the local return of kelp, rocky reef, and eelgrass ecosystems.[8]

07. Seal Beach National Wildlife Refuge; 965 acres; the rich wetlands of Anaheim Bay once covered 5,000 acres; remnant saltwater marsh habitat is critical for migrating birds on the Pacific Flyway.

08. Bolsa Chica Ecological Reserve; together with the wetlands of Anaheim Bay, this wetland habitat is the largest of its kind to be found between Monterey Bay and the Tijuana Slough;[9] site of the most massive and expansive restoration project in the modern history of Southern California;[10] the scope of the project was to return tidal influence to the wetlands to mitigate the compromised, chemical nature of the polluted wetlands;[11] restoration was completed in 2008, although water quality remains impaired.[12]

## 07. A Good, Long Walk

Laguna beach

09. Upper Newport Bay Nature Reserve; 1,000-acre reserve, including habitat for a host of sensitive species including burrowing owl, *Athene cunicularia* (G4/S3);[13] ongoing restoration of local habitat includes reducing the number of pathways within the reserve, repairing ledge erosion, and replacing nonnative grasses with native varieties.[14]

10. Crystal Cove State Park; 4,000 acres; 3.2 miles of coastline; 1,400-acre Marine Protected Area; 10 acres of suitable habitat toward the south end of the park has recently been funded to become engineered "toad ponds" to support populations of western spadefoot, *Spea hammondii* (G3/S3).[15]

11. Aliso and Wood Canyons, major regional park; together, Aliso and Wood Canyons Regional Park (4,500 acres), Laguna Coast Wilderness Park (7,000 acres), Crystal Cove State Park (2,790 acres), city of Irvine open space (2,400 acres), Newport Beach open space (254 acres), the city of Laguna Woods (10 acres), and ancillary sites equal a "greenbelt" corridor of nearly 22,000 acres of open space—an inventory protected for more than 50 years as wilderness.[16]

California thrasher
*Toxostoma redivivum*

## 07.23a Rethinking Wastewater
*The key to Los Angeles's future*

Delivering water to the people of the Los Angeles area not only has always been a challenge but will always *be* a challenge. Water is made available to the city through major infrastructure projects—the California State Water Project, the Owens Valley Aqueduct, and the Colorado River Aqueduct—and all of these require huge amounts of energy to pump water from ecosystems as far away as the northern Sierra Nevada. The project can compromise or even destroy the watershed of origin, as was the case in the Owens Valley. Additional water is pumped from the aquifer under the Los Angeles basin; currently 11 percent of Los Angeles's usable water is sourced from groundwater.[17] More than a quarter of the state's human population lives in Los Angeles County, and the vast majority of the community exists solely because of imported water. In the era of climate breakdown, this situation will only grow more tenuous.

With considerable investment, Los Angeles's primary water treatment facility, Hyperion Sewage Treatment Plant, will be upgraded. The Hyperion plant, one of the largest water treatment plants in the world, discharges nearly 200 million gallons of water a day through a pipeline into Santa Monica Bay; under the new plan, that will stop, and those 200 million gallons will be made potable and then recycled into the water system of the city.[18]

As California's population grows from 40 million to 50 million people in the next twenty years,[19] these kinds of infrastructure projects—ones that acknowledge the closed loop of the hydrosphere and that recognize fresh water as a dwindling and precious resource—will get us through this bottleneck. Rising atmospheric temperatures and decreasing intervals between drought events are activating innovative solutions across California communities—including a major water recycling program already begun in Orange County, Santa Clara County, and others.[20] Only through conservationist thinking—the sort of visionary planning demonstrated by Los Angeles here—will California's municipalities sustain their prosperity through the coming decades of increased atmospheric aridity.

# The Coasts of California

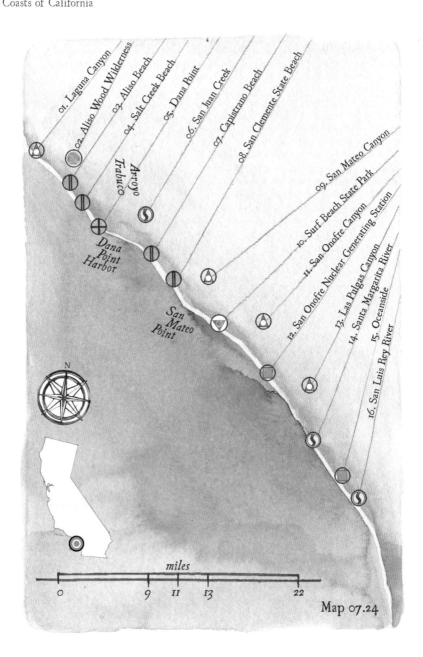

Map 07.24

## 07.24 OF VALLEYS AND VISTAS
*The San Clemente coast*

Map 07.24 depicts approximately 37 miles of coastline in Orange and San Diego Counties.

The extinct San Clemente Bewick's wren, *Thryomanes bewickii leucophrys* (G5TX/SX), and the Coastal California gnatcatcher, *Polioptila californica californica* (G4G5T2?/S2), are both endemic to the sage scrub of the San Clemente coast. Much of the remaining habitat is closed off to the public by Marine Corps Base Camp Pendleton in San Diego County. The ecologically precious community of local sage scrub is categorized by its regional varieties—Venturan coastal sage scrub, Diegan coastal sage scrub, succulent scrub, Riversidean alluvial fan scrub, and coastal sage chaparral scrub.[1] Each of these is identified by differing amounts and species varietals of sage (*Salvia* sp. and *Artemisia* sp.), cypress (*Cupressus* sp.), pine (*Pinus* sp.), and a bevy of shrub types. This categorization serves to underpin the sensitivity and importance of ecological biogeography and the overarching efforts of conservation biologists to save what is left of endangered coastal habitats.

01. Laguna Canyon; 2016 wildfire burned many parts of the ridgeline, and as part of firefighting, dozer trails were dug; site of native plant (cactus and shrub) restoration;[2] watershed extends from the coast at Laguna Beach northeast to the Santa Ana Mountains.

02. Aliso and Wood Canyons Wilderness Park; Aliso Creek watershed, 20-mile watercourse; runs through the fossilized remains of Pectin Reef, an ancient inland reef, now wetlands; the wilderness park contains 27 acres of wetland and riparian habitat and 70 miles of trails.

03. Aliso Beach, county park; separated from Aliso and Wood Canyons Wilderness Park by a private ranch;[3] Aliso Creek Estuary Restoration Project includes western and eastern estuary expansion across overflow parking lot, upland coastal sage scrub restoration, vegetated marsh restoration, and the improvement of wetland quality by reducing inflow from irrigation through watershed management.[4]

---

*A necklace of tidal wetlands offers opportunities for survival to so many in such a small area.*

04. Salt Creek Beach; one of three sites, including Crystal Cove and Laguna Cove, sited for the Orange County Giant Kelp Restoration Project;[5] giant kelp, *Macrocystis pyrifera.*

05. Dana Point; Dana Point Nature Interpretive Center; Dana Point Headlands, habitat for the federally listed endangered Pacific pocket mouse, *Perognathus longimembris pacificus* (G5T1/S1), one of the smallest mouse species on the continent.[6]

06. San Juan Creek; the study area of the local restoration plan is nearly 200 square miles, from Upper Trabuco Canyon to the western San Mateo Creek watershed;[7] near the border of Los Angeles and Orange Counties; includes Caspers Wilderness Park.

07. Capistrano Beach; because the sands of this beach are shifting, so-called stakeholders—meaning local business interests—are working with the municipality to adapt infrastructure to the change.[8]

08. San Clemente State Beach; the Oceanside littoral cell extends from Dana Point south across the entirety of San Diego County to La Jolla, and, because of its particular vulnerability to sea-level rise, is the subject of a major study about sea-level rise and its effect on local communities;[9] San Clemente is currently the site of a major project to return sand to the disappearing beach.[10]

09. San Mateo Canyon; massive restoration project in northern San Diego County across many different riparian habitats. The scope of the project includes a campaign to remove Arundo reed, other exotic plants, rangeland grasses, and alien forbs; to replace them with coastal sage scrub, chaparral, oak woodland, and sycamore; and to augment creek beds with other native plants.[11]

10. Surf Beach State Park; Trestles Wetlands Natural Preserve; 160 acres of willow scrub; between San Clemente Beach and San Onofre Beach.

11. San Onofre Canyon; inside Camp Pendleton, a military base; as with Vandenberg Air Force Base in Santa Barbara County, conditions for de facto wilderness develop over enough time on these massive military inholdings. Nineteen federally listed species find habitat on this training site that covers 125,000 acres, including San Diego fairy shrimp, *Branchinecta sandiegonensis* (G2/S2); Stephens's Kangaroo rat, *Dipodomys stephensi* (G2/S2); and San Diego button celery, *Eryngium aristulatum* var. *parishii.*[12]

12. San Onofre Nuclear Generating Station; as a major symbol of California leaving the age of nuclear power, both reactors at San Onofre were permanently shut down in 2012; during its heyday, 1980–2012, the power station supplied electricity for 20% of Southern California;[13] today, there remain over four tons of radioactive waste stored at the site.[14]

13. Las Pulgas Canyon; Las Flores View Point.

14. Santa Margarita River; one of the last free-flowing rivers on the south coast. The Wildlands Conservancy species count within this valuable watershed: 500 plant, 236 bird, 52 mammal, 43 reptile, and 24 aquatic invertebrate species, including 70 that are of special concern; of those, several are federally listed as endangered.[15]

15. Oceanside; Loma Alta Slough and Garrison Creek wetlands are in the midst of a 28-acre invasive plant removal and habitat restoration project;[16] the Oceanside restoration project at Buccaneer Beach is among the 46 projects nationwide funded in 2020 by the National Fish and Wildlife Foundation's Coastal Resilience Fund.[17]

16. San Luis Rey River; watercourse is 69 miles long; the last 7 miles of the watercourse are channelized; recently, 450 miles of the giant reed arundo was removed from the watershed to restore habitat in its lower reaches;[18] other extensive invasive problems include the same invasives plaguing so many watersheds on the south coast—salt cedar, *Tamarix* sp., and castor bean, *Ricinus communis*; bird species of special status in the lower reaches include least Bell's vireo, *Vireo bellii pusillus* (G5T2/S2), and the southwestern willow flycatcher, *Empidonax traillii extimus* (G5T2/S1). The California Society for Ecological Restoration identifies two types of ongoing restoration—passive and active; passive restoration involves the removal of invasive plants to promote native growth, and active restoration entails planting of native trees to improve habitat; over the project area, passive restoration began in 2006 over 100 acres, and active restoration began in 2014 over 30 acres.[19]

Stephens's kangaroo rat
*Dipodomys stephensi*
(G2/S2)

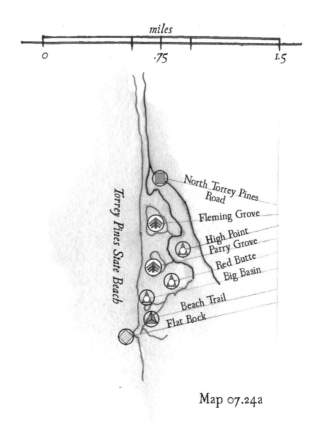

Map 07.24a

## 07.24a Torrey Pines State Natural Reserve

On this 337-acre reserve on a particular plot of wild coast, a very rare pine tree makes its home in one of only two places on earth. The Torrey pine, *Pinus torreyana*, population comprises only forty-five hundred individual trees here and, as a related subspecies, on Santa Rosa Island, 175 miles to the northwest.[20] The trees seem to exist here because of a climatic anomaly present in the offshore ocean current and the way that current delivers cold water through the process of upwelling. Without this upwelling, the regional coastal fog that occurs here more than elsewhere along the San Diego coast would not happen, and without it, the precious endemic trees would also go.[21]

## 07.25 OF CACTUS AND CLOUDS
*The San Diego coast*

Map 07.25 depicts approximately 54 miles of coastline in San Diego County.

As arid as this place may seem, water here defines everything with its preciousness. There are eleven hydrological units, or watershed networks, that define the coast of San Diego County. From north to south, these units are named San Juan, Santa Margarita, San Luis Rey, Carlsbad, San Dieguito, Penasquitos, San Diego, Pueblo San Diego, Sweetwater, San Diego Bay, Otay, and Tijuana.[1] The most prominent body of water along the coast is San Diego Bay. Even in this highly urbanized environment, remnant strands of six major plant communities struggle to survive: coastal strand, salt marsh, riparian scrub, coastal sage scrub, freshwater marsh, and mixed chaparral, each offering habitat to one of two special-status species—either the San Diego ringneck snake, *Diadophis punctatus similis* (G5T2T3/S2?), or the San Diego fairy shrimp, Branchinecta sandiegonensis (G2/S2).

The many habitats of San Diego's coast all wrestle with the trials and stressors imposed on them from ever-encroaching development. The wetlands in particular, where the most wildlife lives, continually fight increasing sedimentation, unseasonal flows of water from urban areas, invasive plant infestations, and poor water quality. Across the county, signs of hope are emerging from this catastrophe as community after community is lining up behind robust local restoration plans. At Buena Vista Lagoon, Agua Hedionda Lagoon, Batiquitos Lagoon, and other locations along the shore, wetland restoration plans are being implemented by private and municipal agencies that may just save the fragmented and degraded habitat from further collapse.

---

*One of our best bets for fighting the catastrophic toll on California's biodiversity from climate breakdown is the restoration and repair of San Diego's wetlands.*

# The Coasts of California

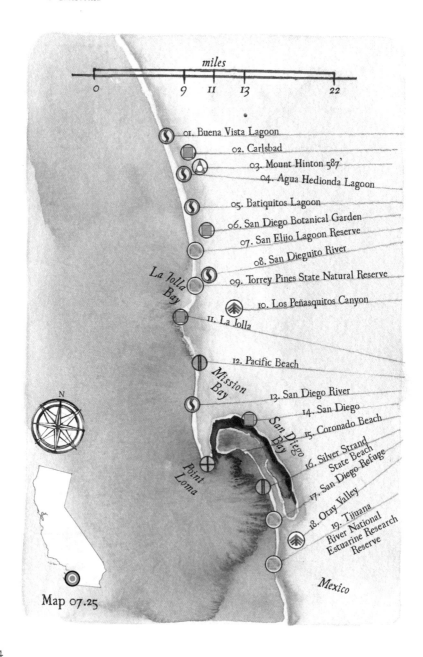

Map 07.25

# 07. A Good, Long Walk

01. Buena Vista Lagoon; nearly 80 years ago, a berm was installed at the end of the 220-acre lagoon, and after a decade of negotiation, the berm will be removed and the lagoon will be open again to saltwater intrusion—a vital necessity to the health of the lagoon;[2] northernmost lagoon in the Carlsbad hydrological unit.

02. Carlsbad; Encina Power Station; Carlsbad Desalination Plant; Carlsbad Lagoon (Agua Hedionda Lagoon) is the only lagoon in San Diego that offers recreation and industry—a fish hatchery and a shellfish aquafarming operation; sand dredged in the lagoon is moved to replenish nearby beaches; stewardship of the lagoon is the responsibility of the company that runs the desalination plant.[3]

03. Mount Hinton (587').

04. Agua Hedionda Lagoon; 31-square-mile watershed composed of two hydrologic subareas: Los Manos (Calavera Creek and La Mirada Creek) and Buena (Buena and Agua Hedionda); restoration plan priorities include watershed management to improve water quality, buffering of banks to prevent further erosion, return of arboreal habitat to riparian corridors, and reinforcing those natural systems, from river mouth to headwaters, most able to combat the effects of climate breakdown.[4]

05. Batiquitos Lagoon; 610-acre wetland in a watershed of 55,000 acres that functionally drains water from San Diego's largest municipalities; San Marcos Creek and Encinitas Creek; a dredging enhancement project of massive scope was undertaken in the mid-1990s and still works to keep the lagoon open from silt.[5]

06. San Diego Botanical Garden, a 37-acre garden in Encinitas.

07. San Elijo Lagoon Ecological Reserve; mouth at Cardiff State Beach; 979-acre

Tricolored heron
*Egretta tricolor*

estuary reserve; Escondido and La Orilla Creeks; 40% of all species of bird that live in North America have been counted in this place of essential habitat.[6]

08. San Dieguito River; 24-mile water course in a watershed of 346 square miles, the largest in San Diego County; the mouth of the river is a 150-acre lagoon near Del Mar; an extensive lagoon restoration plan includes the addition of 50 acres of restored tidal wetland and 15 acres of brackish wetland, which will mitigate urban runoff that has impaired water quality.[7]

09. Torrey Pines State Natural Reserve (see map 07.24).

10. Los Peñasquitos Canyon; 4,000-acre preserve inside both Peñasquitos and Lopez Canyons; included in this riparian corridor are the Carmel Mountain Preserve, Del Mar Mesa Preserve, and Canyon Hills Open Space; the Los Peñasquitos Lagoon Enhancement Plan covers a study area of 23 acres inside the 574-acre Los Peñasquitos State Marsh Natural Preserve;[8] this site suffers from legacy pollutants from decades of raw sewage dumping, train infrastructure that created a levee, a pooling effect that spawned a new floodplain, and the urbanization of the watershed; ongoing restoration by the Los Peñasquitos Lagoon Foundation has resulted, over the past decade, in habitat opportunities for dozens of endangered and special-status species, among them two rare and endangered flowering plants of special note—Coulter's goldfields, *Lasthenia glabrata* ssp. *coulteri*, and Nuttall's acmispon, *Acmispon prostratus*.[9]

11. La Jolla (see map 07.25b).

12. Pacific Beach; Mission Bay; just after World War II, San Diego decided to destroy 95% of the estuarine habitat at the mouth of the San Diego River to build the largest artificial water park in the country—Mission Bay;[10] a new plan calls for the rewilding of the northern portion of the bay—a multiphase project of passive and active restoration to expand bird habitat and to preserve the bay despite the predicted sea-level rise.[11]

13. San Diego River; Mission Trails Regional Park—at 7,220 acres, the largest municipally owned park in the state.[12] Priority species management includes San Diego thornmint, *Acanthomintha ilicifolia*; San Diego ambrosia, *Ambrosia pumila*; variegated dudleya, *Dudleya variegata*; willowy monardella, *Monardella viminea*; and coastal cactus wren, *Campylorhynchus brunneicapillus couesi*.[13]

14. San Diego; Balboa Park, a 1,200-acre urban park that includes the San Diego Zoo and the San Diego Natural History Museum.

15. Coronado Beach; Zuniga Jetty Shoal; on the jetty that creates San Diego Bay, the habitats that exist are coastal salt marsh, coastal strand, and wetland/mudflat.[14]

16. Silver Strand State Beach; ongoing restoration campaigns include the removal of the invasive sea fig, *Carpobrotus* sp.; in the mid-1990s, the native, endangered plant Brand's phacelia, *Phacelia stellaris*, returned following a year of such efforts[15]; Cabrillo State Marine Reserve.

17. San Diego Bay National Wildlife Refuge; Sweetwater Marsh; the only habitat in the world where Belding's savannah sparrow, *Passerculus sandwichensis beldingi* (G5T3/S3), is common;[16] the only habitat in the United States for a rare flowering plant in the heath family, the Palmer's frankenia, *Frankenia palmeri*.[17]

18. Otay Valley; 25-mile watercourse with 160-square-mile watershed; mouth at San Diego Bay; a 65-acre restoration project within the San Diego National Wildlife Refuge at Chula Vista is ongoing to benefit bird habitat.[18]

19. Tijuana River National Estuarine Research Reserve; called an intermittent estuary because of the extreme seasonal variance of flood to desiccation;[19] migration and nesting habitat for over 370 bird species;[20] site of the ambitious Tijuana Estuary Tidal Restoration Program, which will address the relentless stressors affecting the estuary's complex labyrinth of habitat types that wind through the reserve, including intertidal marsh, salt panne, mulefat scrub, sinuous slough channels, fresh- and saltwater wetlands, dunes, and maritime succulent scrub.[21]

Palmer's frankenia
*Frankenia palmeri*

## 07.25a A Mixed Blessing
*The promise and the reality of desalination*

The dream of desalination goes back to Aristotle, who, over twenty-four hundred years ago, proposed distilling sea water and collecting freshwater vapor.[22] Today, coastal communities across California are chasing this panacea by investing in desalination plants that are expensive and potentially ecologically devastating. The cost of desalination is enticing because it is currently only a bit more expensive than water recycling (see 07.23a); it's about double the cost of reservoir water, yet in many locales remains less expensive than importation.[23] The process has environmental challenges at every step: (1) taking in a massive amount of sea water can destroy a great deal of sea life, (2) the energy needed to osmotically remove the salt from the water is extremely energy intensive, and (3) the briny discharge that is left over is twice the salinity of ocean water and can cause dead spots where the local habitat is destroyed.[24]

The largest desalination plant in the Western Hemisphere opened in Carlsbad, San Diego County, in 2015. For necessary reasons, the facility operates within a larger context of a built environment—not only the physical context, beside the (now-retired) Encina Power Station (replaced by the Carlsbad Energy Center) and the Agua Hendionda Lagoon, but also the historical context, down the coast of the (now retired) San Onofre Nuclear Generating Station.[25]

As California leaves the era of nuclear and carbon power and begins to birth a new regime that redefines how we generate energy, how we use resources, and how we implement stewardship, the ethical question of desalination challenges the vision in a number of concerning ways. Are we not solving old problems of extraction and the exploitation of the natural world merely by transforming those old ways into new forms of waste and environmental corruption?

Ultimately, the Carlsbad Desalination Plant contributes 11 percent of San Diego's water, and given the litany of pending lawsuits brought on by environmental groups, whether the behemoth project will ultimately be worth its price tag remains in question.[26] Across California, there are currently seventeen desalination projects at different stages of design and construction.[27] The only other operating municipal-scale desalination plant is in Santa Barbara, which produces 30 percent of the city's water.[28]

07. A Good, Long Walk

The wild heart of Los Angeles

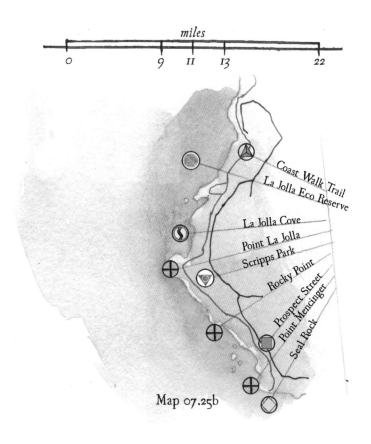

Map 07.25b

## 07.25b La Jolla Cove Walk

Just offshore are two Areas of Special Biological Significance: (1) San Diego–La Jolla Ecological Reserve and (2) San Diego–Scripps Coastal State Marine Conservation Area. Together, the two protected areas form the San Diego–La Jolla Underwater Park.

This "no-boat zone" is approximately six thousand acres in size and extends ten miles from La Jolla Cove to Torrey Pines Reserve. The La Jolla Shores coastal watershed is managed by the La Jolla Shores Coastal Watershed Management Plan.[29]

## 07. A Good, Long Walk

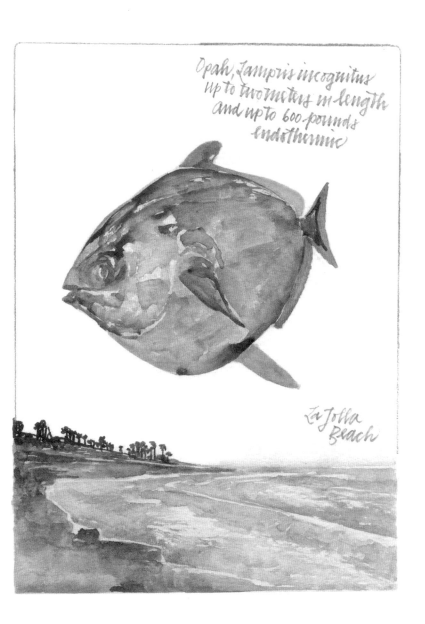

# 08. EACH A CHARACTER
## *The islands of California*

The Coasts of California

Within sight from the most densely populated corner of California is a lonely network of island spaces. The human population is small here, but the human effect is everywhere. For thousands of years, people found a sustainable balance and lived in and off the bounty of these singular places, but the colonizing forces of Europe and then America brought a legion of human-wrought stressors that invaded and degraded the islands' ecology. But even though Euro-American settlement has whittled down these islands' character, priceless original elements remain.

Each of the eight channel islands and the two northern islands highlighted in this chapter have ecological identities

> *Previous page:*
> Kelp bass
> *Paralabrax clathratus*

all their own. And despite so much waste and so much extinction, the trend in the twenty-first century is toward restoration. Under the stewardship of the National Park Service and increasingly effective measures by the US Armed Forces that occupy some of the islands, native plants are being managed to again dominate the landscape, oil prospects are either exhausted or prohibited, endangered species are rebounding, and the damage of invasive species in the ecosystem is actively mitigated.

The terrestrial environment of the islands themselves is rugged, and despite a frost-free climate, the ocean exposure is harsh. It is under the waves, in a kelp forest of world-class fecundity and biodiversity, that the complex wonder of the islands shine. Thousands of marine species depend on and thrive within this geographic anomaly where the cold current from the north spirals south around Point Conception and mixes with the warmer countercurrent of the California Bight moving in from the south. Nutrient-rich sea water sustains a robust marine food web that supports a wealth of life above the waves, including California's largest numbers of seabirds and marine mammals.

Western yellow-bellied racer
*Coluber constrictor mormon*

Plant associations and habitat types on these islands include coastal sage scrub, coastal bluff scrub, island chaparral, island woodland, riparian woodland, and coastal grassland.[1] The northern Channel Islands are less arid than the southern islands and also support closed-cone pine forests. Three trees are endemic to the Channel Islands: Catalina ironwood, *Lyonothamnus floribundus*; Catalina cherry, *Prunus lyonii*; and island oak, *Quercus tomentella*.[2] Because of their limited distribution and other stressors, at least one-third of the plants that are endemic to the islands are endangered. There are no native palm trees on the islands of California, except for Guadalupe palm, *Brahea edulis*.[3]

## Reptiles

The following are the native reptiles of the northern Channel Islands:

Four lizards: the island night lizard, *Xantusia riversiana* (on Santa Barbara, San Nicolas, and San Clemente Islands, G3/S3); the island fence lizard, *Sceloporus occidentalis becki* (NSR); the southern alligator lizard, *Elgaria multicarinata* (on San Miguel, Santa Rosa, and Santa Cruz Islands, NSR); and the side-botched lizard, *Uta stansburinia* (on Anacapa and Santa Cruz Islands, NSR)

One salamander: Channel Islands slender salamander, *Batrachoseps pacificus* (G4/S3S4)

One frog: Baja California treefrog, *Pseudacris hypochondriaca hypochondriaca* (on Santa Cruz, Santa Rosa, and Santa Catalina Islands, NSR)

Two snakes: western yellow-bellied racer, *Coluber constrictor mormon* (on Santa Cruz Island, NSR), and Santa Cruz Island gopher snake, *Pituophis catenifer pumilus* (on Santa Cruz and Santa Rosa Islands, G5T1T1/S1?)

## Birds

Forty-four species of land birds breed in the northern Channel Islands; thirteen of those species have differentiated into eighteen endemic subspecies,[4] including the Channel Islands song sparrow, *Melospiza melodia graminea* (on San Miguel and Santa Rosa Islands, G5T1/S1). The Santa Barbara Island song sparrow was declared extinct in 1983.[5] In a population of nearly 75,000 birds, including 28,000 Brandt's cormorants, fifteen seabird species rely on the northern Channel Islands for nesting habitat.[6]

Rhinoceros auklet
*Cerorhinca monocerata*

## Mammals

The native mammals on the Channel Islands include the island fox, *Urocyon littoralis* (and six island-endemic subspecies, G1T1/S1); the island deer mouse, *Peromyscus maniculatus santacruzae* (and five island-endemic subspecies, G5T1Q/S1); the island harvest mouse, *Reithrodontomys megalotis* ssp. (on Santa Cruz, Santa Catalina, and San Clemente Islands, G5T1?/S1); the Santa Catalina Island ground squirrel (*Spermophilus beecheyi nesioticus*, NSR); and the island skunk, *Spilogale gracilis amphialus* (on Santa Cruz and Santa Rosa Islands, G5T3/S3). Eleven species of bats are present on Santa Cruz and Santa Rosa Islands, including a colony of Townsend's big-eared bats, *Corynorhinus townsendii* (G3G4/S2).[7]

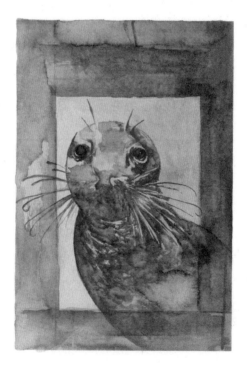

Harbor seal
*Phoca vitulina*

## Kelp

One-third of the kelp forest habitat area of California exists in the northern Channel Islands, where of the twenty-seven species of kelp (phylum Phaeophyta) in the world, nine are present.[8] The kelp forests are endangered, and their primary threats are a trophic cascade of urchin predation initiated a hundred years ago by the extirpation of the sea otter, and the looming disaster of a steadily warming sea spurred by the advent of climate breakdown.[9] Of the 150 species of fish in California, most can be found at some time in their life in a kelp forest.[10]

---

Common fish of the kelp forest

Blacksmith, *Chromis punctipinnis*
California sheephead, *Pimelometopon pulcher*
Garibaldi, *Hypsypops rubicundus*
Halfmoon, *Medialuna californiensis*
Kelp bass, *Paralabrax clathratus*
Opaleye, *Girella nigricans*
Rock wrasse, *Halichoeres semicinctus*
Señorita, *Oxyjulis californica*
Topsmelt, *Atherinops affinis*

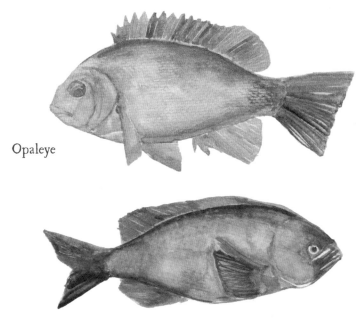

Opaleye

Blacksmith

# The Coasts of California

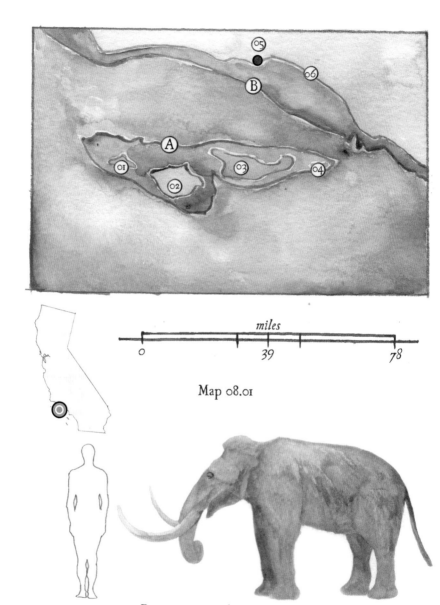

Map 08.01

Pygmy mammoth
*Mammuthus exilis*

## 08.01 SANTA ROSAE

Seventeen thousand years ago, during the Last Glacial Maximum, the sea level was about 125 feet lower than it is today.[11] The water level was so low that the offshore mountain range, the peaks of which are today's four northern Channel Islands, were connected above the waves as one island with four times the mass of today's islands and only five miles from shore. This was the closest these islands have ever been to the mainland in their five-million-year history.[12] The ancient island is today known to paleoscientists as Santa Rosae.

A. Santa Rosae Island
B. Coastline during the Last Glacial Maximum

01. San Miguel Island
02. Santa Rosa Island
03. Santa Cruz Island
04. Anacapa Island
05. The city of Santa Barbara
06. Modern coastline

The biogeography of all islands is defined by isolation, the ability of colonizing species to reach them, and the resources present on those islands (including the size of the island) to maintain populations of species already present.[13] It was during the age of the island of Santa Rosae, when the islands were close enough to land, that many species (some now extinct, some extant) began their evolutionary island identity. The forests of Santa Rosae were different than they are today on the islands and more closely resembled forest types that only exist today on the mainland, including ancient populations of Douglas fir and Gowen cypress, *Hesperocyparis goveniana*.[14]

### The Pygmy Mammoth

For thirty thousand years, the island of Santa Rosae was the land of one of the smallest mammoths in the fossil record: the pygmy mammoth, *Mammuthus exilis*. Forty thousand years ago, a few Columbian mammoths, *Mammuthus columbi*, the common, large-size mammoth of California, swam the short distance from the mainland and never went back. Over several centuries, the island effect of miniaturization (selection for smaller size based on limited resources) changed their evolved morphology. The pygmy mammoth stood only six feet tall and weighed two thousand pounds—half the height and one-tenth the weight of its mainland relatives. At the dawn of the Holocene, when megafaunal populations collapsed around the world, probably as a combined result of the coming of *Homo sapiens* and climate breakdown, the pygmy mammoth disappeared.

# The Coasts of California

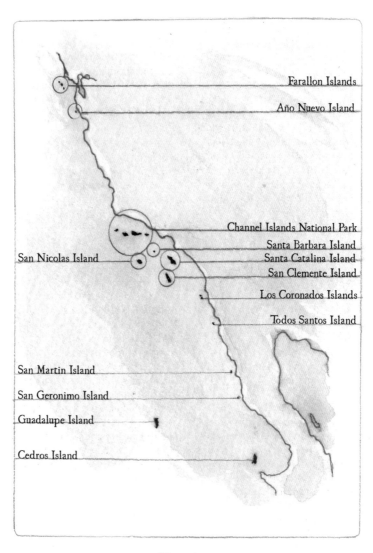

Map 08.02

## 08.02 THE ISLANDS OF CALIFORNIA

There are nearly eight hundred miles between 27.5° and 38° north latitude, the realm of the islands of California. The eighteen named islands between Cedros Island in Mexico and the Farallon Islands off the coast of San Francisco include the thirteen illustrated in Map 08.02 and the four islands of Channel Islands National Park (03) and the three Farallon Islands (01). This chapter includes Angel Island, the largest island in San Francisco Bay (08.11), and does not include a discussion of the islands of Mexico or Año Nuevo Island.

Although not highlighted in this chapter with a section of its own, Año Nuevo Island, a nine-acre rock in Santa Cruz County, is an important component in the Año Nuevo State Marine Conservation Area, and a breeding site for pinnipeds and seabirds. In recent years, a successful restoration project to protect the nest sites of pelagic birds from being crushed by sea lions involved installing clay structures the birds quickly accepted. In tandem with a plant-restoration program, this model is being applied to other islands where populations of rhinoceros auklets, *Cerorhinca monocerata* (G5/S3); Cassin's auklets, *Ptychoramphus aleuticus* (G4/S2S4); and pigeon Guillemots, *Cepphus columba* (NSR), are struggling with similar stressors.[15]

Short-tailed albatross
*Phoebastria albatrus*

## Invasive animals by island

*Source*: Data from H. Mooney, E. Zavaleta, and M. C. Chapin, eds., *Ecosystems of California* (Oakland: University of California Press, 2016), 759–60.

Key

SM, San Miguel
SR, Santa Rosa
SC, Santa Cruz
AN, Anacapa
SB, Santa Barbara
SN, San Nicolas
SCA, Santa Catalina
SCL, San Clemente
X, eradicated or removed, with date

Barbary sheep (SCA X 1970s)

Bison (SCA)

Black buck antelope (SCA X 2011)

Black rat (SM) (AN X 2002) (SCA) (SCL)

California vole (SCL)

Cat (SM X 1940s) (SR X 1930s) (SC X 1939) (AN X 1940s) (SB X 1978) (SN X 2010) (SCA) (SCL)

Cattle (SM X 1917) (SR X 1998) (SC X 1999) (SN X 1930s) (SCA X 1970s) (SCL X 1934)

Dog (SM X 1940s) (SR X 1993) (SC X 1980) (SN X 1940s) (SCA) (SCL X 1940s)

Elk (SR X 2011)

European sheep (SM X 1970s) (SR X 1960s) (SC X 2001) (AN X 1937) (SB X 1946) (SN X 1949) (SCA 1920s) (SCL X 1941)

European hare (AN X 1960s) (SB X 1930s)

European rabbit (SB X 1981) (SCA)

Goat (SM X 1890) (SR X 1900s) (SC X 1920) (SCA X 2005) (SCL X 1993)

Horse (SM X 1948) (SR) (AN X 2009) (SB X 1919) (SN X 1943) (SCA) (SCL X 1977)

House mouse (SCA) (SCL)

Mule deer (SR X 2015) (SCA) (SCL X 1990)

Mule/burro/donkey (SM X 1976) (SR X 1880) (SB X 1922) (SN X 1940s) (SCA X 1903) (SCL X 1930)

Norwegian rat (SCA)

Pig (SM X 1897) (SR X 1993) (SC X 2006) (SCA X 2004) (SCL X 1990)

Fallow deer (SR X 1949)

08. Each a Character

Island fox
*Urocyon littoralis*

# The Coasts of California

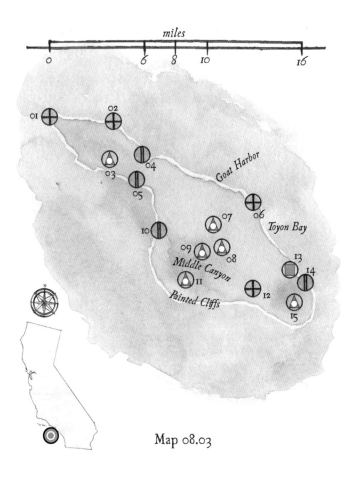

Map 08.03

## 08.03 SANTA CATALINA ISLAND

Twenty-five miles from Long Beach (Los Angeles County); land area, 48,000 acres (76 square miles); tallest peak: Mount Orizaba (08); plant species on Santa Catalina, 650; native plants by percentage, 66;[16] invertebrates—370 species of moth and butterfly (10 endemic);[17] native herpetofauna—five species of snake, three lizards, one frog, and two salamanders;[18] 37 species of land birds, two endemic: Catalina quail, *Callipepla californica catalinensis*, and Catalina Bewick's wren, *Thryomanes bewickii catalinae*.[19]

More reptiles and amphibians live on Santa Catalina island than on any of California's other islands, and fewer seabirds nest here.[20] The only breeding population of seabirds on Catalina Island is a population of about fifty pairs of western gulls, *Larus occidentalis*, on Bird Rock north of Isthmus Cove;[21] five species of native land mammals: one squirrel, two mice, a shrew, and a fox. Special-status endemic animal species include Santa Catalina lancetooth (snail), *Haplotrema catalinense* (G1/S1); Santa Catalina gartersnake, *Thamnophis hammondii*, pop. 1 (G4T1?/S1); Catalina Hutton's vireo, *Vireo huttoni unitti* (G5T2?/S2?); Santa Catalina shrew, *Sorex ornatus willetti* (G5T1/S1); and Santa Catalina Island fox, *Urocyon littoralis catalinae* (G1T1/S1).

01. West End
02. Arrow Points
03. Mount Torquemada (1,336')
04. Isthmus Cove
05. Catalina Harbor
06. Long Point
07. Black Jack Mountain (2,010')
08. Mount Orizaba (2,100')
09. Mount Banning
10. Little Harbor
11. Cactus Peak (1,560')
12. Silver Canyon
13. Avalon
14. Pebbly Beach
15. East Mountain (1,563')

Western gull
*Larus occidentalis*

# The Coasts of California

> Over the five hundred years since the Spanish arrived, the island commonly called Catalina has been ecologically transformed from its desolate original character to an extension of Los Angeles. Today, a million people a year visit this closest of California's southern islands, and more than three thousand people call this place home. Behind the imported eucalyptus trees and the alien fan palms, ancient Catalina remains in the native ironwood trees and the shrubby island mahogany. In the wake of climate breakdown as it unleashes its terrible wrath across the region, perhaps the island's endemic ecosystems, having largely survived the bottleneck of the first few centuries of Euro-American colonization, will be asked to endure another squeeze over the next several hundred years.

08. Each a Character

Potato Harbor, Santa Cruz Island

Where, not too long ago, forested canyons languidly flourished for thousands of years, now a wedge of wind and exotic grass still remembers, in slow-growing tiny clefts, certain bits of its ancient character, due to the stewarding efforts of an unlikely ally, the US Navy.

# The Coasts of California

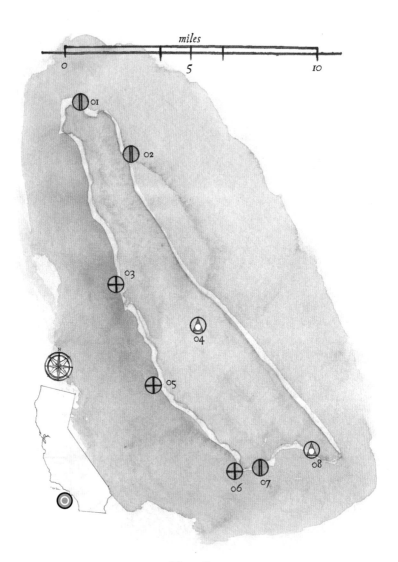

Map 08.04

## 08.04 SAN CLEMENTE ISLAND

Sixty miles from the city of San Clemente (San Diego County); land area, 36,500 acres (57 square miles); tallest point: Mount Thirst (04); owned and operated by the US Navy—no public land access; total plant species count, 382 (272 native). San Clemente Island has the most single-island-endemic plants of any of California's islands.[22] Special-status endemic animal species include San Clemente Island snail, *Micrarionta gabbi* (G1/S1); San Clemente Island coenonycha beetle, *Coenonycha clementina* (G1G2/S1S2); San Clemente loggerhead shrike, *Lanius ludovicianus mearnsi* (G4T1?/S1); San Clemente Island Bell's sparrow, *Artemisiospiza belli clementeae* (G5T1?/S1); San Clemente spotted towhee, *Pipilo maculatus clementae* (G5T1/S1S2); San Clemente deer mouse, *Peromyscus maniculatus clementis* (G5T1T2/S1S2); and San Clemente Island fox, *Urocyon littoralis clementae* (G1T1/S1).

01. Northwest Harbor
02. Wilson Cove
03. Eel Point
04. Mount Thirst (1,965')
05. Lost Point
06. China Point
07. Horse Cove
08. Pyramid Head

From 1875 to 1991 (when the last one was killed), imported goats wreaked havoc on the native flora of San Clemente Island. One of the only plant communities to remain intact is the maritime desert scrub, a thorny plant community able to resist a century of incessant grazing. The rocky cactus gardens of San Clemente Island are also home to more than 138 species of lichen. Some species, such as lace lichen, *Ramalina menziesii*, used to exist in the Santa Monica Mountains, but are now absent due to the one thing lichens can't take: air pollution.[23]

Wildlife management programs around San Clemente Island include nonlethal deterrents to prevent the predation of a special-status songbird called the Island loggerhead shrike, *Lanius ludovicianus anthonyi* (G4T1/S1)—a favored meal of island foxes—and a nursery program for thousands of native plants; successes include the potential removal of the island night lizard, *Xantusia riversiana* (G3/S3), from the California Department of Fish and Wildlife's Special Animals List.[24]

The Coasts of California

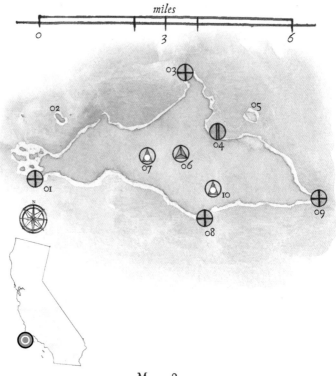

Map 08.05

## 08.05 SAN MIGUEL ISLAND

Twenty-seven miles south of Point Conception; area, 9,325 acres (14.5 square miles); 270 plant species on San Miguel, 74 percent of which are native; special-status endemic animal species include the San Miguel Island fox, *Urocyon littoralis littoralis* (G1T1/S1).

01. Point Bennett
02. Castle Rock
03. Harris Point
04. Cuyler Harbor
05. Prince Island
06. Caliche Forest
07. Green Mountain (817')
08. Crook Point
09. Cardwell Point
10. San Miguel Hill (831')

## 08. Each a Character

> At the heart of this wind-strafed, treeless island are the white bones of a particular kind of petrified forest. Hundreds of thousands of years ago, the wind began to bring the sand that encased the roots and trunks of ancient trees; the print of the long-gone wood remains as skeletons in the Caliche forest.

Island spotted skunk
*Spilogale gracilis amphialu*

San Miguel is an island of incredible animal wealth. It supports one-third of the total seabird population of the Channel Islands—tens of thousands of birds. In one of the world's largest pinniped breeding colonies, hundreds of thousands of seals and sea lions gather: northern elephant seal, harbor seal, Steller's sea lion, northern fur seal, Guadalupe fur seal, and approximately 90 percent of California's sea lion population.

The Coasts of California

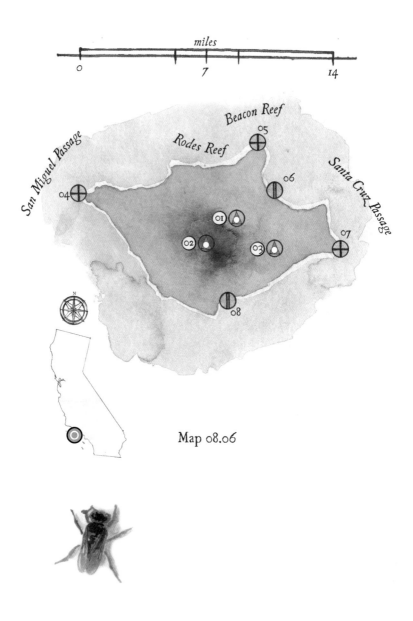

Map 08.06

## 08.06 SANTA ROSA ISLAND

Thirty miles southwest of the city of Santa Barbara; land area, 53,000 acres (82 square miles); 500 plant species, 80 percent of which are native. Endemic plants include Santa Rosa dudleya, *Dudleya blochmaniae* ssp. *insularis*; Santa Rosa manzanita, *Arctostaphylos confertiflora*; and Santa Rosa gilia, *Gilia tenuiflora* ssp. *hoffmannii*. Special-status endemic animal species include the Santa Rosa Island fox, *Urocyon littoralis santarosae* (G1T1/S1), and Channel Islands spotted skunk, *Spilogale gracilis amphiala* (Santa Rosa and Santa Cruz Islands, G5T3/S3).

01. Black Mountain (1,296')
02. Soledad Peak (1,574')
03. San Augustine Canyon
04. Sandy Point
05. Carrington Point
06. Bechers Bay
07. Skunk Point
08. South Point

The only grove of Torrey pine, *Pinus torreyana*, apart from the stands on the San Diego coast (see 07.24a), exists on Santa Rosa Island's north shore. In this small forest dwells the one insect known to exist only on this island, the island checkerspot, *Euphydryas editha insularis*.[25]

Channel islands sweat bee

The story of hope is written across the islands in the form of resiliency strategies. In studying how so many species survived our careless incursion, and as we awaken to our fundamental connection to diversity and its conservation, the lessons we learn might serve us well as we bear the brunt of what comes next.

The Coasts of California

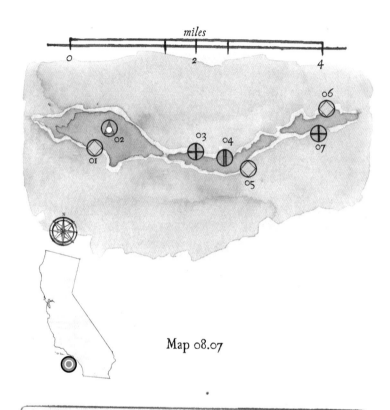

Map 08.07

On the jagged lip of Anacapa's precipitous Inspiration Point, a fragile braid of island habitat, humanity is invited to attend to its new urge, its new calling to stewardship, to active restoration, and to leaving be what should be left to its own ancient ways.

## 08.07 ANACAPA ISLAND

Twelve miles southwest of Port Hueneme (Ventura County); land area, 700 acres (1 square mile); 265 plant species, 72 percent of which are native. The north side of West Anacapa Island is located within the Anacapa Island State Marine Conservation Area, protecting nesting sites for the western United States' largest population of brown pelican, *Pelecanus occidentalis californicus* (G4T3T4/S3).[26]

01. West Anacapa
02. Summit Peak (936′)
03. Keyhole Rock
04. Winfield Scott Wreck
05. Middle Anacapa
06. East Anacapa
07. Inspiration Point

On Middle Anacapa, where no grazing animals have lived for decades, the thick-trunked shrub with bright, yellow flowers called giant coreopsis, *Leptosyne gigantea*,[27] grows to heights of nine feet or more, whereas mainland coreopsis rarely tops six feet.

The Coasts of California

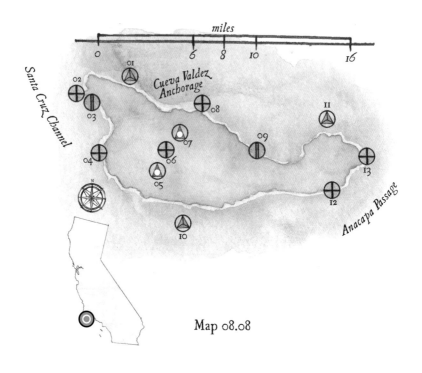

Map 08.08

The biggest island is its own country, Santa Cruz, empty of people, with time to recover — what will it do with all its wealth once it does so?

08. Each a Character

Southern alligator lizard
of Santa Cruz Island
*Elgaria m.multicarinata*

## 08.08 SANTA CRUZ ISLAND

Eighteen miles south of the city of Santa Barbara; land area, 62,000 acres (96 square miles); tallest peak: Devil's Peak (07); 680 plant species, 72 percent of which are native. Supports nesting sites for 50 percent (approximately 800 birds) of the Channel Islands population of ashy storm petrel, *Oceanodroma homochroa* ($G_2/S_2$).[28] Special-status endemic animal species include Santa Cruz Island shore weevil, *Trigonoscuta stantoni* ($G_1/S_1$); Santa Cruz Island gophersnake, *Pituophis catenifer pumilus* ($G_5T_1T_2/S_1?$); Santa Cruz Island rufous-crowned sparrow, *Aimophila ruficeps obscura* ($G_5T_2T_3/S_2S_3$); and Santa Cruz Island fox, *Urocyon littoralis santacruzae* ($G_1T_1/S_1$). Management of the island is divided between the National Park Service on the east side and the Nature Conservancy on the west, including the island's primary central valley.

01. Painted Cave State Marine Conservation Area; sea cave
02. Fraser Point
03. Forney's Cove
04. Kingston Point
05. Sierra Blanca (1,528')
06. Central Valley
07. Devils Peak (2,450')
08. Diablo Point
09. Platts Harbor
10. Gull Island State Marine Reserve
11. Scorpion State Marine Reserve
12. Sandstone Point
13. San Pedro Point

The largest island in Channel Islands National Park, Santa Cruz also supports the widest array of habitat types. This is the only place in the world for the island scrub jay, *Aphelocoma insularis* (G1/S1), a bird that is one-third larger than its mainland relatives. The bird is an example of island gigantism, a pattern that some species follow in adapting to isolation.[29] Another adaptive trait of island species is dwarfism, whereby species evolve to smaller sizes over time. Dwarfism on the Channel Islands has occurred in birds, mammals (including the pygmy mammoth), and many different reptiles.[30] This "island effect" occurs when mainland animals colonize islands and tends to result in large animals undergoing dwarfism and small animals experiencing gigantism.[31] Island gigantism usually results from the absence of predators and/or competition; "insular dwarfism" is probably triggered by lack of resources and territory.[32]

Santa Cruz Island supports the greatest variety of arboreal habitats of all the Channel Islands. Closed-cone bishop pine forests and maple/alder riparian corridors occupy habitats beside unique forests and woodlands that commonly include island mountain mahogany, *Cercocarpus betuloides* var. *blancheae*; toyon, *Heteromeles arbutifolia*; Catalina ironwood, *Lyonothamnus floribundus*; Catalina cherry, *Prunus lyonii*; coast live oak, *Quercus agrifolia*; MacDonald's oak, *Quercus macdonaldii*; and island oak, *Quercus tomentella*.[33] Pollinating the flowers of Santa Cruz and the northern Channel Islands are the native, special-status bees: the Channel Islands leaf-cutter bee, *Ashmeadiella chumashae* (G2?/S2?), and the Channel Islands sweat bee, *Lasioglossum channelense* (G1/S1).

08. Each a Character

Island scrub jay over Torrey pine, Santa Cruz Island

The Coasts of California

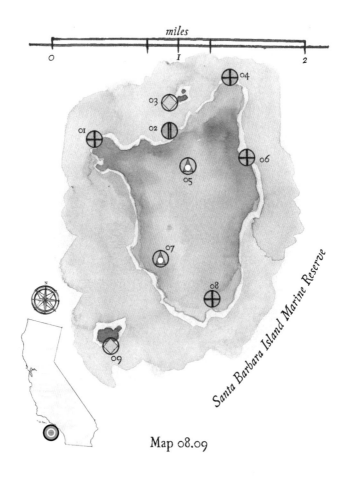

Map 08.09

450

# 08. Each a Character

## 08.09 SANTA BARBARA ISLAND

Forty miles southwest from Rancho Palos Verdes (Los Angeles County); land area, 640 acres (1 square mile); 135 plant species, 67 percent of which are native; largest colony of Scripps's murrelet, *Synthliboramphus scrippsi* (G3/S2), in the Channel Islands; special-status endemic animal species include the Santa Barbara island snail, *Micrarionta facta* (G1G2/S1S2), and the Santa Barbara shelled slug, *Binneya notabilis* (G1/S1).

01. Webster Point
02. Elephant Seal Cove
03. Shag Rock
04. Arch Point
05. North Peak (562')
06. Landing Cove
07. Signal Peak (634')
08. Cat Canyon
09. Sutil Island

Santa Barbara song sparrow
*Melospiza melodia graminea*
(extinct)

> The earring, the comma, the teardrop of the islands' national park; now silent, in its own way, for several decades since anyone has seen the Santa Barbara song sparrow and its was removed from the endangered species list by extinction; can the place ever be as it was?

# The Coasts of California

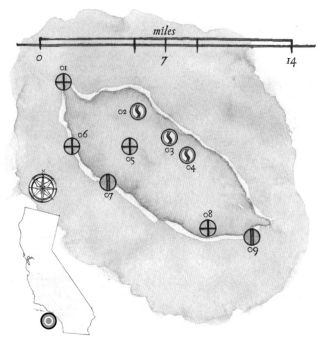

Map 08.10

> I have a dream of San Nicolas Island, out there, farthest from land, tough and vulnerable. It is a military base; I'll probably never go there. The forbiddance of the place calls to me in sleep.

## 08.10 SAN NICOLAS ISLAND

Seventy miles from Rancho Palos Verdes (Los Angeles County); land area, 21,000 acres (32 square miles); 277 plant species, 49 percent of which are native. Special-status endemic animal species include the San Nicolas Island fox, *Urocyon littoralis dickey* (G1T1/S1); San Nicolas Island snail, *Micrarionta feralis* (G1/S1); and the pricklypear island snail, *Micrarionta opuntia* (G1/S1), which lives only on the pricklypear cactus at the northeastern corner of the island.[34]

01. Vizcaino Point
02. Tule Creek
03. Mineral Creek
04. Celery Creek
05. Jackson Hill (909')
06. Cormorant Point
07. Seal Beach
08. Daytona Beach
09. Dead Corm Point

Yellowfin tuna

The Coasts of California

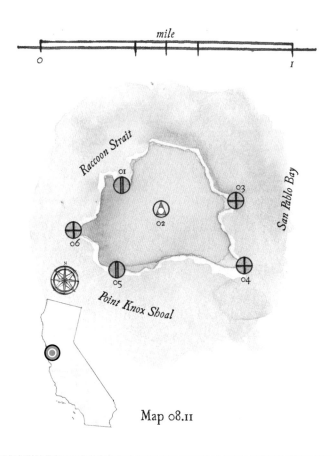

Map 08.11

*Angel Island always seemed to me like a drowned mountain; surely it has been submerged up to its knees for only a few thousand years at most.*

## 08.11 ANGEL ISLAND

Situated 0.65 miles from Peninsula Point (Marin County); land area, 756 acres (1.18 square miles); special-status endemic animal species include the Angel Island mole, *Scapanus latimanus insularis* (G5T1?/S1).

01. Ayala Cove
02. Mount Caroline Livermore (781')
03. Quarry Point
04. Point Blunt
05. Perle's Beach
06. Point Stuart

The Golden Gate Bridge from Angel Island

The Coasts of California

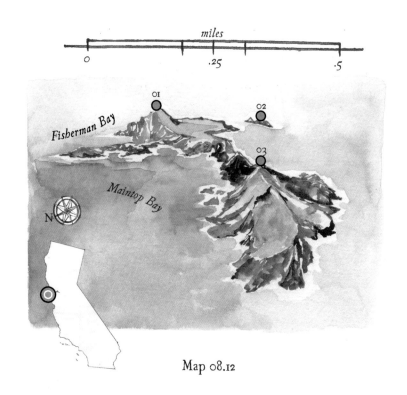

Map 08.12

Great white shark
*Carcharodon carcharias*

## 08.12 THE FARALLON ISLANDS

Twenty-eight miles west of San Francisco; land area of the group of four islands is 211 acres (.32 square miles); Farallon Islands National Wildlife Refuge; Farallon Islands/Fanny Shoal Essential Fish Habitat; Farallon Islands State Marine Conservation Areas, including the Southeast Farallon Island State Marine Conservation Area and the North Farallon Islands State Marine Reserve.

The Farallon Islands are owned by the City of San Francisco and are technically within city limits, which means that this designated wilderness area is among a tiny number of metropolitan areas around the globe that can boast such a thing. From a pre–gold rush population of over one million, the common murre (a type of auk), *Uria aalge*, was nearly wiped out at the Farallon Islands when demands for its eggs caused the population to plummet to 6,000 individuals. Today's population is about 150,000.

01. Southeast Farallon Island (357')
02. Seal Rock
03. Maintop Island

---

*The shark-tooth peaks, encircled by fat great whites, jut from the Pacific — seething and forbidding. The sea waves crash against the waves of life, tens of thousands of marine mammals and seabirds, in a turbid, living sway.*

# 09. POLICIES AND PROTECTIONS
## *Stewardship of the land and sea*

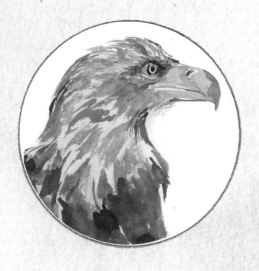

Let's lay out the legislative history of California's coasts so we can better understand how we got here, where we are, and where we need to go. The government of the State of California has a unique and far-reaching relationship to the state's shoreline. This relationship transcends the long strip of sand and sea and gets to the heart of California society. The legacy of our superlative coastal biodiversity depends on an activated citizenry being literate of the history of that relationship and being willing to engage with it. Listing some of the major laws, agencies, and coastal geographic designations that have been implemented over the nearly two hundred years since statehood, this chapter summarizes what we have as yet decided our responsibilities are to each other and to the natural world.

A fundamental question that dominates the philosophical investigation of environmental policy is where the line is drawn between public trust and private enterprise. Conservation and the wise use of natural space, for example, may be the most democratic effort of all because it supersedes personal freedoms to proclaim that the public good is our primary concern. The trajectory of state and federal environmental law toward increased protection of natural systems suggests the emergence of a way to regard nature that transcends its physicality, its rote material and utility. Examples include the Wilderness Act of 1964 and the California Coastal Act of 1972, which conceive of the landscape as something other than property and attempt to redefine it in terms of legacy. Nature becomes inherently, intrinsically valuable.

The legacy of twentieth-century ideology holds enormous sway over twenty-first-century conservation policy. Sequestering landscapes as parkland, enacting reactive legislation to address industrial pollution, relying on one species to represent a network of endangered life, and the hubristic policies of wildfire suppression are four hallmarks of this ideology that began with good intentions but may be well served by an upgrade. Through the incorporation of new scientific findings and a growing respect for the wise application of indigenous knowledge systems, many of the shortcomings of these iconic strategies are now blatant. As we move through the inflection

*Previous page:* Bald eagle
*Haliaeetus leucocephalus*

## 09. Policies and Protections

> A new vision of legal protection for California's endangered, living coasts transcends fragmented policies that are doomed to treat the symptoms and not the causes of so many problems. It draws a straight line from the quality of health in our marine ecosystems and coastal watersheds to the heart of human community.

point that is the twenty-first century, toward a new era of ecological abundance, societal priorities for what may endure as twenty-second-century policy emerge.

With reference to the four hallmarks presented in the previous paragraph as clear examples of the environmental ideology of the twentieth century, twenty-second-century policy might respond to each by (1) recognizing that sequestered and isolated landscapes require habitat corridors that connect them to sustain the bridged ecosystems; (2) enacting proactive legislation aiming toward a postcarbon future that establishes elements of what can be called a circular economy that works not unlike the adaptive cycle; (3) recognizing systems as being endangered—including habitats such as old-growth forest, or phenomena such as coastal fog—and therefore as being worthy of punitive protections; (4) acknowledging the history of anthropogenic stewardship of California's landscapes over the past several thousand years and by respecting indigenous sovereignty. With this latter approach, we could uncover pathways toward the normalization of so many ecological regimes that are now terribly wounded by climate breakdown and industrial extraction.

# The Coasts of California

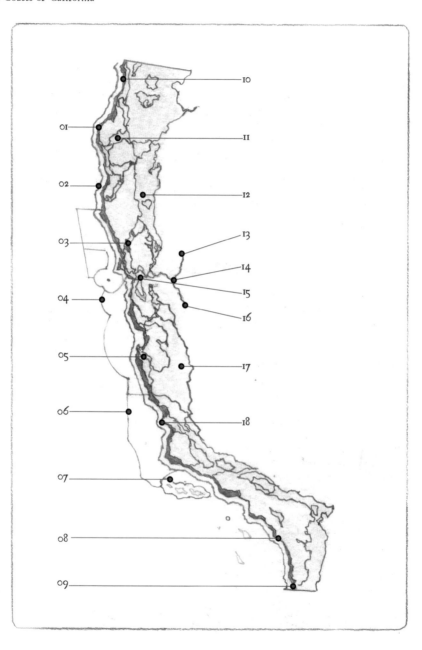

09. Policies and Protections

> *where once was a constellation, pinpoints of conservation, let's paint them together into one thick, uninterrupted line, a galaxy of protections.*

## 09.01 HOW WE GOT HERE AND WHAT OUR STRATEGY IS NOW

Written into the California Constitution of 1849 was the doctrine of public trust—the premise that the air, the rivers, the oceans, and the shoreline cannot be owned privately but are for public use. This doctrine, managed in trust by the state, directs many facets of society, from commerce to environmental law.

Map 09.01 describes the spatial relationships of some of the jurisdictions and primary points of interest, and the parent agency in charge of their management and stewardship.

01. California Coastal Zone—California Coastal Commission
02. California Coastal National Monument—Bureau of Land Management
03. Sonoma Land Trust
04. National Marine Sanctuaries—National Oceanic and Atmospheric Administration (NOAA)
05. Ventana Wilderness—US Forest Service (USFS)
06. Chumash Heritage National Marine Sanctuary (proposed)
07. Channel Islands National Park—National Park Service
08. South Coast Lagoon Wildlife Preserves—California Department of Fish and Wildlife (CDFW)
09. Tijuana Slough, US Fish and Wildlife Service (FWS)
10. Klamath River, dam removal (2023), *multiple agencies*
11. Humboldt Redwoods State Park, California State Parks
12. Mendocino National Forest, USFS, site of the August Complex fires (2020)
13. Sacramento River watershed
14. San Francisco–San Joaquin Delta Conservancy
15. San Francisco Bay Conservation and Development Commission
16. San Joaquin River Watershed, *multiple agencies*
17. Diablo Range, *multiple agencies*
18. Guadalupe-Nipomo Dunes, FWS

## A timeline of environmental policy and legislation

As long as growth is perceived as prosperous for human ecology, and as long as our economy is tied to an ever-increasing gross domestic product, our best conservation laws will run into the same problems: tensions between legal authority and regional business; mixed messages to regional agencies without additional funding; and disconnects between policies, their goals, and the tools used to meet those goals.

This survey is a story of how we've advanced between moments of inelegance and moments of genius to get to where we are now: a precarious present with an uncertain future. This survey is a cursory review and not a criticism of the history of coastal and environmental state and federal law. When a place in the timeline is marked "CA," it indicates a California statute, many of which predate federal versions of similar laws.

1849 — (CA) California Constitution
    *Establishes California's public trust doctrine and state lands*
1864 — (CA) Yosemite Valley Grant Act
    *Establishes Yosemite as the first publicly protected wilderness area in the US*
1872 — Yellowstone Act
    *Establishes the first national park*
1881 — (CA) Division of Forestry established
    *Established to manage and protect timber and watersheds*
    *Renamed Cal Fire in 1977*
1884 — (CA) *Woodruff v. North Bloomfield Gravel Mining Company*
    *Ends hydraulic gold mining in the Sierra Nevada*
1885 — (CA) California Board of Forestry established
    *The nation's first attempt at regulating logging practices*
1890 — (CA) By this year, three of the nation's four national parks are in California
    *Yosemite Valley, Mariposa Grove, and Sequoia*
1899 — Rivers and Harbors Act
    *First federal environmental law; restricts dumping in waterways*
1900 — Lacey Act
    *Prohibits illegal trade of animals and plants*
1902 — (CA) California State Parks established
    *Big Basin Redwoods becomes the first California state park*
1906 — Antiquities Act
    *Gives the president the authority to designate national monuments*

09. Policies and Protections

1913 — (CA) Water Commission Act
    *Establishes State Water Commission to oversee water rights*
1916 — National Park Service Organic Act
    *Establishes the National Park Service*
1918 — Migratory Bird Treaty Act
    *Protects 1,100 species of birds from poaching*
1946 — International Convention for the Regulation of Whaling
    *Eighty-nine nations sign an agreement to conserve whale populations*
1947 — (CA) Los Angeles Air Pollution Control District
    *Nation's first air pollution agency*
1951 — (CA) Department of Fish and Game established
    *Renamed Department of Fish and Wildlife in 2012*
1953 — Submerged Lands Act
    *Establishes state ownership of waters out to 3 miles*
1953 — Outer Continental Shelf Lands Act
    *Establishes federal ownership of seaward land 200*
    *nautical miles offshore*
1961 — (CA) The Resource Agency established
    *Renamed California Natural Resources Agency in 2009*
    *California Environmental Protection Agency formally established in 1991*

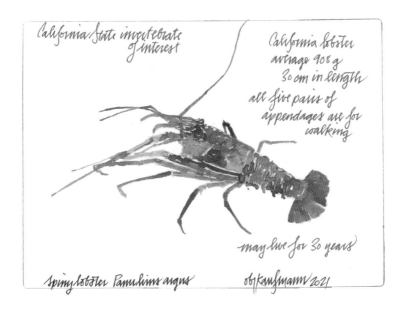

1963 — Clean Air Act
   *Amended 1965, 1966, 1967, 1969, 1970, 1977, and 1990*
1964 — Wilderness Act
   *Establishes federal wilderness areas*
1965 — (CA) McAteer-Petris Act
   *Protects San Francisco Bay from pollution*
1967 — (CA) California Air Resources Board
   *Sets emissions standards*
1967 — Fishermen's Protective Act
   *Protects US fish industry in accordance with international conservation efforts*
   *Amended 1971; the Pelly Amendment*
1969 — (CA) San Francisco Bay Conservation and Development Commission
   *First coastal protection agency in the US*
1970 — National Environmental Policy Act (NEPA)
   *Requires Environmental Impact Statements for projects*
   *Subsequent executive order creates the Environmental Protection Agency*
1970 — California Environment Quality Act (CEQA)
   *Requires mitigation of environmental impact from projects*
1970 — Reorganization Plan No. 4
   *Creates the National Oceanic and Atmospheric Administration (NOAA)*
1972 — Federal Water Pollution Control Act (Clean Water Act)
   *Amended 1977; Clean Water Act*
   *Amended 1987; Water Quality Act*
   *Amended 1996; Water Quality Standards and Pollution Act*
1972 — California Wild and Scenic Rivers Act
   *Protects rivers of extreme beauty*
1972 — California Coastal Zone Conservation Act
   *Implements coastal zone management plans*
1972 — Marine Protection, Research, and Sanctuaries Act
   *Regulates ocean dumping of polluting material*
1972 — Federal Insecticide, Fungicide, and Rodenticide Act
   *Regulates sale and use of pesticides*
1972 — Marine Mammal Protection Act
   *Prohibits the killing of all marine mammals*
1973 — Endangered Species Act
   *Establishes endangered species list*
1974 — (CA) Nejedly-Bagley-Z'berg Suisun Marsh Preservation Act
   *Protects 85,000 acres of the Suisun Marsh in the San Francisco Bay Delta*
1976 — Safe Drinking Water Act
   *Establishes guidelines for acceptable water quality*

## 09. Policies and Protections

1976 — Resource Conservation and Recovery Act
*Regulates hazardous waste from its creation to its disposal*
1976 — Toxic Substances Control Act
*Assesses and regulates new chemicals for commercial use*
1976 — (CA) California Coastal Act
*Prioritizes public access and establishes the Coastal Commission*
1976 — Magnuson-Stevens Fishery Conservation and Management Act (MSFCMA)
*Applies regional catch limits to fisheries*
1980 — Superfund (CERCLA)
*Mandates cleanup at sites of historical hazardous waste*
1982 — Nuclear Waste Policy Act
*Establishes national program for nuclear waste disposal*
1984 — Hazardous and Solid Waste Amendment Act (SARA)
*Amends CERCLA with more stringent site cleanup procedures*
1984 — California Wilderness Act
*Creates 23 federal wilderness areas in California*
1986 — Emergency Wetlands Resources Act
*Institutes National Wetlands Priority Conservation Plan*
1986 — (CA) Beverage Container Recycling and Litter Reduction Act
*Establishes large-scale statewide recycling program*
1987 — Driftnet Impact Monitoring, Assessment, and Control Act
*Requires the monitoring and regulated take of marine resources in US waters*
1990 — Oil Pollution Act
*Enforces remediation of oil disasters*
1991 — California Biodiversity Council
*Prioritizes interagency communication of biodiversity issues*
1999 — (CA) Marine Life Protection Act (MLPA)
*Establishes California's network of Marine Protected Areas*
1999 — (CA) Marine Life Management Act (MLMA)
*Requires sustainability evidence from fisheries*
2000 — Beaches Environmental Assessment and Coastal Health Act
*Requires EPA to monitor and notify public regarding water pollution and problems*
2000 — (CA) California Ocean Resources Stewardship Act (CORSA)
*Coordinates efforts between governmental agencies and marine science institutions*
2002 — (CA) California Bay Delta Authority
*Charged with protection and revitalization of the San Francisco Bay Delta*
2004 — (CA) California Ocean Protection Act (COPA)
*Creates the Ocean Protection Council to support 1999's MLMA*

2005 — Energy Policy Act
*Enables environmental law exemptions for fracking and nuclear power*
2006 — (CA) Global Warming Solutions Act
*Requires California to reduce greenhouses gas emissions to
1990 levels by 2020*
2014 — Water Quality, Supply, and Infrastructure Improvement Act
*Improves water infrastructure and species protections*
2014 — Intergovernmental Panel on Climate Change (IPCC) releases fifth report
*Sets the scientific stage for the Paris Climate Agreement*
2015 — Paris Climate Agreement
*International agreement to keep global warming to 1.5°C
over preindustrial levels*
2019 — The Klamath River is granted legal personhood by Yurok tribal court
*Establishes precedent for rights of nature in California*
2020 — (CA) 30 by 30 executive order
*California's governor commits to conserving 30 percent of state's land and
waters by 2030*
2020 — (CA) Carbon neutrality by 2045
*California's governor commits to making the state a negative carbon
emitter by 2045*
2021 — Protecting America's Wilderness and Public Lands Act
*Establishes new wilderness areas, restoration areas, and Wild and Scenic Rivers*

09. Policies and Protections

Sunset over the lone cypress, 17 Mile Drive, Pebble Beach, Monterey County

# The Coasts of California

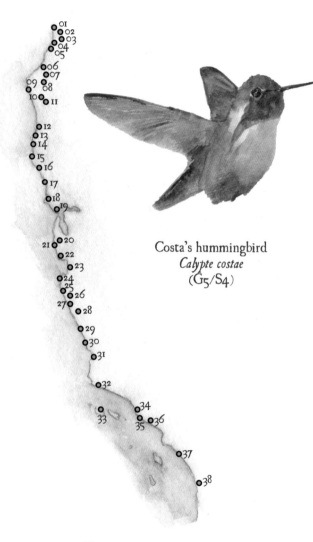

Costa's hummingbird
*Calypte costae*
(G5/S4)

Map 09.02

## 09.02 WITHIN SIGHT OF THE SEA
*Coastal parks and monuments*

01. Tolowa Dunes State Park
02. Jedediah Smith
    Redwoods State Park
03. Del Norte Coast
    Redwoods State Park
04. Redwood National Park
05. Prairie Creek Redwoods State Park
06. Humboldt Bay National
    Wildlife Refuge
07. Headwaters Forest Reserve
08. Humboldt Redwoods State Park
09. King Range Wilderness
10. Elkhorn Ridge Wilderness
11. South Fork Eel River Wilderness
12. MacKerricher State Park
13. Mendocino Headlands State Park
14. Van Damme State Park
15. Manchester State Park
16. Salt Point State Park
17. Sonoma Coast State Park
18. Point Reyes National Seashore
19. Muir Woods National Monument
20. Año Nuevo State Park
21. Big Basin Redwoods State Park
22. Henry Cowell Redwoods State Park
23. Elkhorn Slough National
    Estuarine Research Reserve
24. Point Lobos State Natural Reserve
25. Andrew Molera State Park
26. Ventana Wilderness
27. Julia Pfeiffer Burns State Park
28. Silver Peak Wilderness
29. Hearst San Simeon State Park
30. Morro Bay State Park
31. Rancho Guadalupe Dunes
    County Park
32. Gaviota State Park
33. Channel Islands National Park
34. Point Mugu State Park
35. Leo Carrillo State Park
36. Santa Monica Mountains
    National Recreation Area
37. Crystal Cove State Park
38. Torrey Pines State Natural Reserve

Map 09.01 does not include state beaches (see 04.09 and 04.10) and does not include the nearly eight thousand acres of public land of the six onshore units of the California Coastal National Monument: Trinidad Head (Humboldt County), Waluplh–Lighthouse Ranch (Humboldt County), Lost Coast Headlands (Humboldt County), Point Arena–Stornetta (Mendocino County), Cotoni–Coast Dairies (Santa Cruz County), and Piedras Blancas (San Luis Obispo County).

National parks directly on California's coastline include Redwood National Park (09.02.04), Point Reyes National Seashore (09.02.18), Golden Gate National Recreation Area (82,000 acres of noncontinuous parkland surrounding the San Francisco Bay Area, not indicated on map), Channel Islands National Park (09.02.33), and Cabrillo National Monument (southern tip of Point Loma Peninsula, 144 acres, not indicated on map). With the exception of Channel Islands National Park, the seaward boundary of coastal national park lands extends one thousand feet from shore.

The Coasts of California

Map 09.03

## 09.03 ENFORCEMENT AND ENHANCEMENT
*Protections and the agencies responsible*

A — North coast (09.04)
B — North central coast (09.05)
C — Central coast (09.06)
D — South coast (09.07)

Although the State of California owns all the lands and resources within three miles of the shore, the California Coastal National Monument extends out twelve miles and spans the entire coastline. The monument, managed by the Bureau of Land Management, is a federal designation that encompasses all islands, rocks, exposed reefs, and pinnacles off the coast above mean high tide.

In 1999, the Marine Life Protection Act (MLPA) mandated the creation of three different types of Marine Protected Areas (MPAs)[1] to preserve marine ecosystems. The three kinds of MPAs are (1) state marine reserves, (2) state marine parks, and (3) state marine conservation areas. The difference between the three is the degree of legal protection, which depends on the vulnerability of living and nonliving marine resources in the MPA and permittable extraction of those resources for a private or commercial interest. MLPA also instituted special closure policies for certain sensitive areas, and the establishment of state marine recreational management areas for human use. The California Department of Fish and Wildlife enforces and oversees the MPAs. Today, 124 MPAs protect 16 percent of the state's marine waters.[2]

## National Oceanic and Atmospheric Administration (NOAA)

NOAA is the federal agency with the most presence and management responsibility across California's coast. The research and resource-services arm of the Department of Commerce, NOAA is involved with establishing and monitoring MPAs. Within the National Estuarine Research Reserve System, three reserves in California are NOAA's long-term research responsibility: Elkhorn Slough, the Tijuana River, and San Francisco Bay. NOAA's National Marine Fisheries Services regulates and monitors fish, invertebrates, and marine mammals (other than sea otters) three to two hundred nautical miles off the coast.[3]

## National Agencies

The five federal agencies that have the most influence on the California coasts, as far as the scope of this chapter is concerned, are the Department of Commerce (NOAA, see previous section), the Department of the Interior (National Park System, Bureau of Land Management, and the Minerals Management Service), the Department

of Agriculture (US Forest Service), the Department of Defense, and the Environmental Protection Agency.

## National Marine Sanctuaries

Four of the nation's thirteen national marine sanctuaries are designated off the coasts of California: Channel Islands National Marine Sanctuary (CINMS), Greater Farallones National Marine Sanctuary (GFNMS), Cordell Bank National Marine Sanctuary (CBNMS), and Monterey Bay National Marine Sanctuary (MBNMS). The protections that national sanctuaries enjoy include the prohibition of oil prospecting and exploitation, the taking of organisms (although some fish permits are issued under particular conditions), discharge of any waste, and the removal of cultural resources (such as shipwrecks).

CINMS extends from mean high tide to six nautical miles offshore of each of the five northern Channel Islands in Channel Islands National Park and covers an ocean area of 1,470 square geographic miles.[4] GFNMS (outlined in map 09.05) extends from 39°N, south to 37°30'N (or along the coast from just north of Point Arena, down to just past Stinson Beach and then out to surround the Farallon Islands), with a total area of 3,295 square miles.[5] CBNMS protects 1,269 square miles of open sea and the Cordell Seamount, an undersea mountain whose summit is just more than one hundred feet below the surface.[6] MBNMS, the largest and deepest national marine sanctuary, covers 6,094 square miles and 276 miles of coastline from north of the Golden Gate Bridge to south of San Simeon. The biologically rich Davidson Seamount is also protected by the sanctuary.

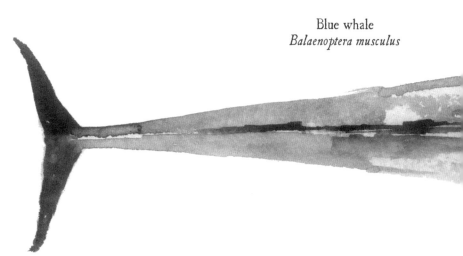

Blue whale
*Balaenoptera musculus*

09. Policies and Protections

## The California Coastal Act, Zone, and Commission

The California Coastal Zone was invented in 1976 under the California Coastal Act and extends down the entirety of the eleven-hundred-mile California shoreline, including all fifteen counties (except for San Francisco Bay, which is in part regulated by the Bay Conservation and Development Commission) and parts of fifty-nine coastal cities.[7] In some places, the zone may be only a hundred yards wide; in other places it goes miles inland. The California Coastal Commission is responsible for regulation of development within the California Coastal Zone. One of the primary responsibilities of the Coastal Commission (with its twelve voting members) is to maintain public access to the coast as originally discussed in the state's constitution, which may in essence be pitted against the capitalist notion of property rights as sacrosanct.

## The California Natural Resources Agency

Every citizen concerned with the intact quality and conserved beauty of California's coasts should arm themselves with at least a basic knowledge that the following departments, conservancies, and commissions exist. When we understand the network of our democratic institutions, and when we see how that network can help us carry out our responsibilities to the natural world, we critically interact with that system—as is our charge.

The cabinet-level umbrella agency we trust with California's coasts is the California Natural Resources Agency, which oversees every agency on this list. The description of each here is limited only to specific expectations with regard to the health and rights

475

of the natural environment and not its responsibilities to interagency communication (i.e., bureaucracy) or its duties toward recreation or other services directed at human ecology. The focus of the list is limited by the themes addressed in this book, and the entries are presented not in order of effectiveness but rather in alphabetical order.

In the future, as our responsibility toward stewardship becomes more acute, how will these institutions evolve? Will we have the Department of Adaptive Consciousness? The California Commission of Interdependent Ecology? The Conservancy of Watershed Personhood? We had probably better. The present-day ecosystem of governmental and academic groups involved in coastal and marine resources and who share responsibility for coastal vitality, research, development, and protection include the following:

A. Commissions: *councils and their supportive organizations responsible for the development of general policy, department policy guidelines, and representing of the state's interest. The twelve commissions that have direct influence on the coast's environment together have 105 decision-making, voting members. This list could have comprised fifteen commissions, which would include the Central Valley Flood Protection Board, the Mining and Geology Board, and the State Off-Highway Motor Vehicle Recreation Commission.*

1. Board of Forestry and Fire Protection: charged with developing policy for the protection and enhancement of state forest resources, including commercial and noncommercial timber; department—Cal Fire; eight members

2. Boating and Waterways Commission: charged with advising and commenting on all licensing, law enforcement, and loan/grant advice for the California State Parks Division of Boating and Waterways, including ecological issues related to boating: invasive aquatic species, beach erosion (restoration and sediment management), and clean boating laws; seven members

3. California Coastal Commission: charged with managing development within the coastal zone (see "The California Coastal Act, Zone, and Commission," earlier); twelve members

4. California Energy Commission: charged with developing California's energy policy, including hydroelectric power through the state's network of power-generating dams, which exerts enormous influence on California's hydrology and riverine/riparian ecosystems; a total power-generation portfolio of 62,000 megawatts;[8] oversees the California Climate Change Assessment;[9] five members

5. Delta Protection Commission: charged with the protection of agriculture, heritage, recreation, and natural resources present in the Sacramento–San Joaquin Delta, and the negotiated

extraction of those resources; members appointed from the State Lands Commission, the Department of Food and Agriculture, and the State Transportation Agency; eight members

6. Fish and Game Commission: charged with leading policy and partnership with the Department of Fish and Wildlife toward a California of healthy and biodiverse ecosystems; five members

7. Native American Heritage Commission: charged with identifying, cataloging, and protecting Native American cultural resources; nine members

8. Parks and Recreation Commission: charged with planning and classifying units in the state park system and establishing guidance policies for the director of California State Parks; nine members

9. San Francisco Bay Conservation and Development Commission: charged with the approval of permits and the funding of projects around San Francisco Bay with deference to enforcing the preservation of public access and of ecological diversity and health. Included are appointed members of local government and one each from the US Army Corps of Engineers; the US Environmental Protection Agency; and the state's secretary of business, transportation and housing; the director of finance; the secretary of resources; the State Lands Commission; and the Regional Water Quality Control Board; twenty-seven members

10. State Lands Commission: charged with the management of state-owned tidal and submerged lands to 3 nautical miles offshore, including the beds of navigable rivers and lakes; these lands include about 4 million acres; three members: the lieutenant governor, the state controller, and the governor's director of finance

11. State Water Resources Control Board: charged with allocating and adjudicating water rights, developing statewide water protection plans, establishing water quality standards, and providing policy guidance for the nine Regional Water Quality Control Boards; five members

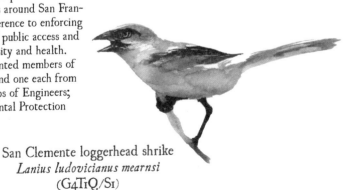

San Clemente loggerhead shrike
*Lanius ludovicianus mearnsi*
(G4T1Q/S1)

12. Wildlife Conservation Board: charged with purchasing power focused on acquisition and development of wildlife conservation areas; seven members, including the president of the Fish and Game Commission, the director of the California Department of Fish and Wildlife, the director of the Department of Finance, and four public members, two appointed by the legislature and two by the governor

B. Conservancies: *organizations responsible for the stewardship of a specific aspect of the natural world, often involving direct management of a specific area and projects.*

1. State Coastal Conservancy: trusted with protecting and improving coastal land through the direct purchase of land and the management of hundreds of conservation-based infrastructure projects in the coastal zone (see "The California Coastal Act, Zone, and Commission," earlier)

2. Sacramento–San Joaquin Delta Conservancy: charged with protecting the delta's 1,300 square miles and promoting what have been called the "coequal" goals of environmental and economic sustainability

3. San Diego River Conservancy: trusted with protecting San Diego's primary watershed by managing projects involving extensive wetland restoration, water quality protection, and monitoring runoff

4. San Gabriel and Lower Los Angeles Rivers and Mountains Conservancy: trusted with revitalizing rivers and restoring and protecting critical habitat in eastern Los Angeles County and western Orange County

5. Santa Monica Mountains Conservancy: trusted to run conservation efforts within the Santa Monica Mountains zone, which includes 75,000 acres of parkland in both wilderness and urban settings

C. Departments: *a principal division of government responsible for one focused area of interest, often with hundreds of employees and volunteers.*

1. Cal Fire: directs the fire protection and stewardship of one-third of the state's total land area (31 million acres—California's privately owned wildlands); formally called the Department of Forestry and Fire Protection

2. California Conservation Corps: directs targeted restoration and enhancement projects, including trail-building programs and watershed stewardship programs; provides emergency services

3. Department of Conservation: directs the California Geological Survey, the Division of Mine Reclamation, the Division of Land Resource Protection, the Geologic Energy Management Division, and the State Mining and Geology Board to develop safe and sustainable energy extraction

4. Department of Fish and Wildlife: directs hunting, fishing, licensing, and conservation enforcement; establishes wildlife and fishery management programs; identifies endangered and threatened species; oversees the Office of Oil Spill Prevention and Response; protects and manages more than 1.1 million acres of wildlife area and ecological reserves

5. Department of Parks and Recreation: directs resource protections for state parks and beaches for coastal recreation along 264 miles of ocean frontage, or about 24% of the California coastline

6. Department of Water Resources: operates the State Water Project; protects, conserves, develops, and manages California's water supplies and fishery resources of the bay and delta system

These are other state authorities that steward the California coasts:

1. California Environmental Protection Agency: coordinates the activities and policy direction for the Department of Pesticide Regulation, the Department of Toxic Substances Control, and the Office of Environmental Health Hazard Assessment, as well as for various state boards, including the Air Resources Board, CalRecycle, the State Water Resources Control Board, and the nine Regional Water Quality Control Boards

2. California Health and Human Services Agency: coordinates the monitoring and certification of shellfish-growing operations in marine waters; reports on biotoxin activity and toxigenic phytoplankton

3. University of California and California State University Systems: coordinate a network of academic research facilities across the University of California Natural Reserve System, including the Marine Laboratories/Marine Stations/Academic Consortia, the California Cooperative Oceanic Fisheries Investigation (CALCOFI), the Multi-Agency Rocky Intertidal Network (MARINe), the Partnership for Interdisciplinary Studies of Coastal Oceans (PISCO), and the Communication Partnership for Science and the Sea (COMPaSS)

Indo-Pacific blue marlin
*Makaira mazara*

The Coasts of California

## 09.04 NORTH COAST MARINE PROTECTED AREAS

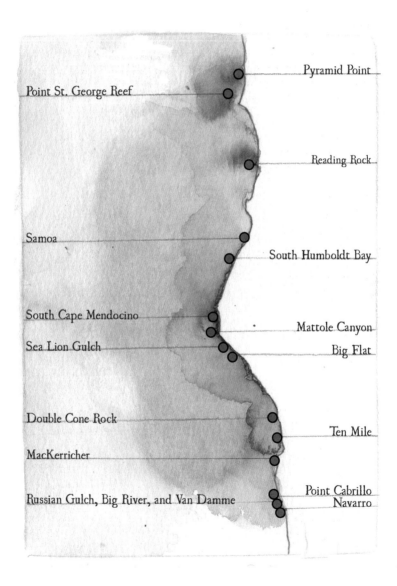

- Pyramid Point
- Point St. George Reef
- Reading Rock
- Samoa
- South Humboldt Bay
- South Cape Mendocino
- Mattole Canyon
- Sea Lion Gulch
- Big Flat
- Double Cone Rock
- Ten Mile
- MacKerricher
- Russian Gulch, Big River, and Van Damme
- Point Cabrillo
- Navarro

480

09. Policies and Protections

## 09.05 NORTH CENTRAL COAST MARINE PROTECTED AREAS

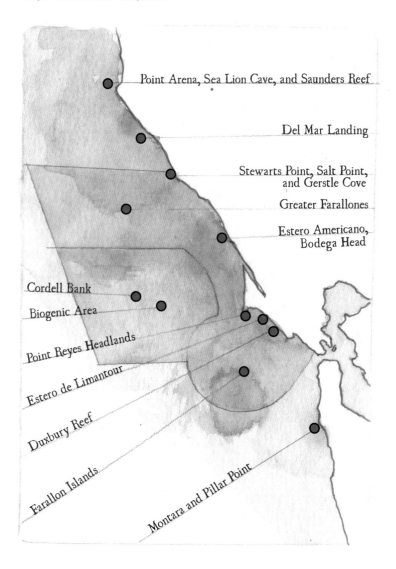

- Point Arena, Sea Lion Cave, and Saunders Reef
- Del Mar Landing
- Stewarts Point, Salt Point, and Gerstle Cove
- Greater Farallones
- Estero Americano, Bodega Head
- Cordell Bank
- Biogenic Area
- Point Reyes Headlands
- Estero de Limantour
- Duxbury Reef
- Farallon Islands
- Montara and Pillar Point

The Coasts of California

## 09.06 CENTRAL COAST MARINE PROTECTED AREAS

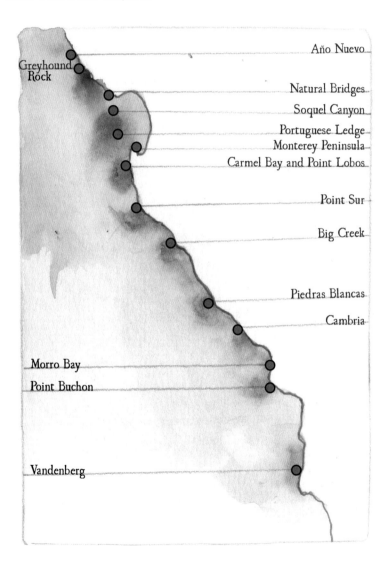

09. Policies and Protections

Black-footed albatross, *Phoebastria nigripes* (NSR, IUCN 3.1—nearly threatened), who nest in the Hawaiian Islands, routinely travel thousands of miles to Cordell Bank National Marine Sanctuary to forage for food.[10]

Black-footed albatross

California least terns, *Sternula antillarum browni* (G4T2T3?/S2), commonly called sea sparrows, were listed as an endangered species in 1970 when the nesting population was only 225 pairs. In 2004, the population reached 6,561 pairs and continues to climb, although the species remains vulnerable.[11]

California least tern

## 09.07 SOUTH COAST MARINE PROTECTED AREAS

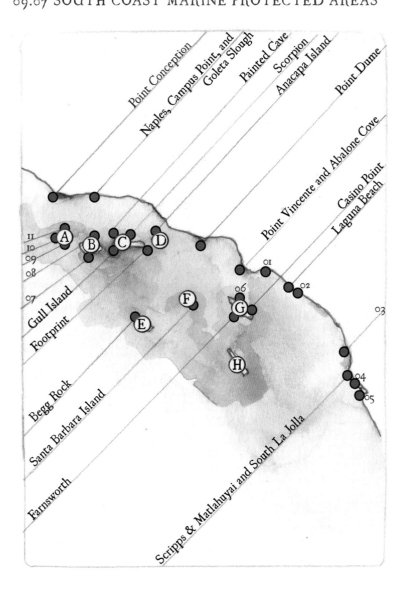

09. Policies and Protections

## South Coast Islands

A — San Miguel Island
B — Santa Rosa Island
C — Santa Cruz Island
D — Anacapa Island
E — San Nicolas Island
F — Santa Barbara Island
G — Santa Catalina Island
H — San Clemente Island

## Marine Protected Areas

01. Bolsa Bay and Bolsa Chica Basin, Upper Newport Bay
02. Crystal Cove and Dana Point
03. Batiquitos Lagoon, Swami, and San Dieguito
04. Famosa Slough and Cabrillo
05. Tijuana River Mouth
06. Sanctuaries of Santa Catalina Island: Arrow Point, Lion Head Point, Bird Rock, Blue Cavern, Long Point, Casino Point, Lover's Cove, Farnsworth, Cat Harbor
07. South Point and Skunk Point
08. Carrington Point
09. Judith Rock
10. Richardson Rock
11. Harris Point

Yontocket satyr butterfly
*Coenonympha tullia yontockett*
($G_5T_1T_2/S_1$)

The Coasts of California

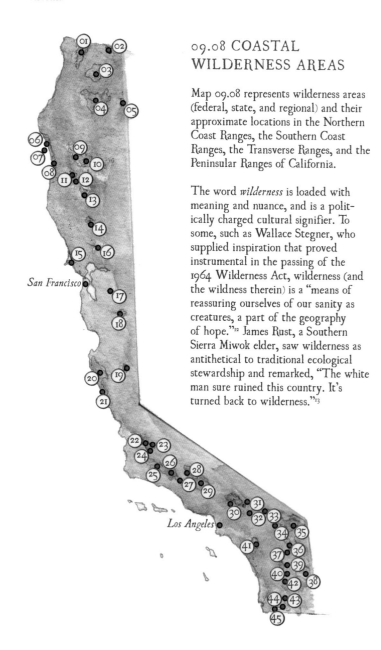

## 09.08 COASTAL WILDERNESS AREAS

Map 09.08 represents wilderness areas (federal, state, and regional) and their approximate locations in the Northern Coast Ranges, the Southern Coast Ranges, the Transverse Ranges, and the Peninsular Ranges of California.

The word *wilderness* is loaded with meaning and nuance, and is a politically charged cultural signifier. To some, such as Wallace Stegner, who supplied inspiration that proved instrumental in the passing of the 1964 Wilderness Act, wilderness (and the wildness therein) is a "means of reassuring ourselves of our sanity as creatures, a part of the geography of hope."[12] James Rust, a Southern Sierra Miwok elder, saw wilderness as antithetical to traditional ecological stewardship and remarked, "The white man sure ruined this country. It's turned back to wilderness."[13]

## 09. Policies and Protections

Federally designated wilderness is subject to the most stringent form of terrestrial land law afforded a piece of California's landscape. No roads, no engines, no power tools, no extraction, no harvest, and, for all intents and purposes, no resource management of any kind. The idea behind the strategy is that these areas' ecological health would wither with too much human interference or (to use the word from the Wilderness Act that invokes human influence) trammeling. And, in the modern context, it certainly would! Although the question remains: Has it done so anyway, with the advent of climate breakdown, pollution, invasive species, and lack of connective habitat? To what extent does our isolation of these places fundamentally prevent them from being healthy and whole? It can be argued that of all the legislative wisdom and of all the land policy we've inherited from the twentieth century, the idea that needs the most attention is the idea of wilderness.

USFS—US Forest Service
BLM—Bureau of Land Management
NPS—National Park Service

01. Siskiyou Wilderness; federal; USFS; 182,802 acres (285 square miles)
    Siskiyou, Klamath, and Six Rivers National Forests
02. Red Buttes Wilderness; federal; USFS; 19,940 acres (32 square miles)
    Klamath and Rogue River National Forests
03. Marble Mountains Wilderness; federal; USFS; 241,744 acres (378 square miles)
    Klamath National Forest
04. Trinity Alps Wilderness; federal; USFS; 535,627 acres (823 square miles)
    Shasta-Trinity, Klamath, and Six Rivers National Forests
05. Castle Crags Wilderness; federal; USFS; 12,232 acres (19 square miles)
    Shasta-Trinity National Forest
06. King Range Wilderness; federal; BLM; 42,585 acres (67 square miles)
    King Range National Conservation Area
07. Rocks and Islands Wilderness; federal; BLM; 19 acres (.03 square miles)
    King Range National Conservation Area
08. Sinkyone Wilderness State Park; state; CA State Parks; 7,250 acres (12 square miles)
09. North Fork Eel Wilderness; federal; USFS; 8,158 acres (13 square miles)
    Six Rivers National Forest
10. Yolla Bolly–Middle Eel Wilderness; federal; USFS; 180,877 acres (283 square miles)
    Mendocino National Forest
11. Yuki Wilderness; federal; USFS; 53,877 acres (84 square miles)
12. Sanhedrin Wilderness; federal; USFS; 10,571 acres (17 square miles)
    Mendocino National Forest

13. Snow Mountain Wilderness; federal; USFS; 60,076 acres (94 square miles)
    Mendocino National Forest
14. Cache Creek Wilderness; federal; BLM; 27,245 acres (43 square miles)
    Berryessa Snow Mountain National Monument
15. Phillip Burton Wilderness; federal; NPS; 33,373 acres (52 square miles)
    Point Reyes National Seashore
16. Cedar Roughs Wilderness; federal; BLM; 6,287 acres (10 square miles)
    Berryessa Snow Mountain National Monument
17. Ohlone Regional Wilderness; regional; 9,737 acres (15 square miles)
    East Bay Regional Parks
18. Orestimba Wilderness; state; CA State Parks; 22,000 acres (34 square miles)
    Henry W. Coe State Park
19. Hain Wilderness; federal; NPS; 15,985 acres (25 square miles)
    Pinnacles National Park
20. Ventana Wilderness; federal; USFS; 240,026 acres (375 square miles)
    Los Padres National Forest
21. Silver Peak Wilderness; federal; USFS; 31,555 acres (49 square miles)
    Los Padres National Forest
22. Santa Lucia Wilderness; federal; USFS and BLM; 20,241 acres
    (32 square miles)
    Los Padres National Forest
23. Machesna Mountain Wilderness; federal; USFS and BLM; 19,882 acres
    (31 square miles)
    Los Padres National Forest
24. Garcia Wilderness; federal; USFS and BLM; 14,100 acres (22 square miles)
    Los Padres National Forest
25. San Rafael Wilderness; federal; USFS; 191,104 acres (299 square miles)
    Los Padres National Forest
26. Dick Smith Wilderness; federal; USFS; 71,275 acres (111 square miles)
    Los Padres National Forest
27. Matilija Wilderness; federal; USFS; 29,270 acres (46 square miles)
    Los Padres National Forest
28. Chumash Wilderness; federal; USFS; 38,150 acres (60 square miles)
    Los Padres National Forest
29. Sespe Wilderness; federal; USFS; 219,700 acres (343 square miles)
    Los Padres National Forest
30. Magic Mountain Wilderness; federal; USFS; 11,938 acres (19 square miles)
    Angeles National Forest
31. Pleasant View Ridge Wilderness; federal; USFS; 26,839 acres (42 square miles)
    Angeles National Forest
32. San Gabriel Wilderness; federal; USFS; 35,738 acres (56 square miles)
    Angeles National Forest

33. Sheep Mountain Wilderness; federal; USFS; 43,182 acres (68 square miles)
    Angeles National Forest
34. Cucamonga Wilderness; federal; USFS; 13,007 acres (20 square miles)
    Angeles National Forest
35. San Gorgonio Wilderness; federal; USFS and BLM; 104,389 acres
    (163 square miles)
    San Bernardino National Forest
36. San Jacinto Wilderness; federal; USFS; 32,186 acres (50 square miles)
    San Bernardino National Forest
37. South Fork San Jacinto Wilderness; federal; USFS; 20,158 acres
    (32 square miles)
    San Bernardino National Forest
38. Santa Rosa Wilderness; federal; USFS and BLM; 78,576 acres
    (123 square miles)
    San Bernardino National Forest
39. Cahuilla Mountain Wilderness; federal; USFS; 5,575 acres (9 square miles)
    San Bernardino National Forest
40. Beauty Mountain Wilderness; federal; BLM; 15,628 acres (25 square miles)
41. San Mateo Canyon Wilderness; federal; USFS; 39,413 acres (62 square miles)
    Cleveland National Forest
42. Aqua Tibia Wilderness; federal; USFS; 17,975 acres (28 square miles)
    Cleveland National Forest
43. Pine Creek Wilderness; federal; USFS; 13,261 acres (21 square miles)
    Cleveland National Forest
44. Hauser Wilderness; federal; USFS; 6,919 acres (11 square miles)
    Cleveland National Forest
45. Otay Mountain Wilderness; federal; BLM; 16,893 acres (26 square miles)

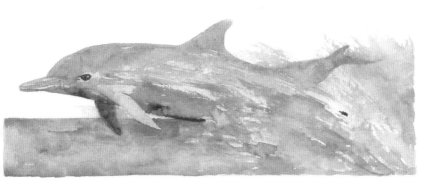

The Coasts of California

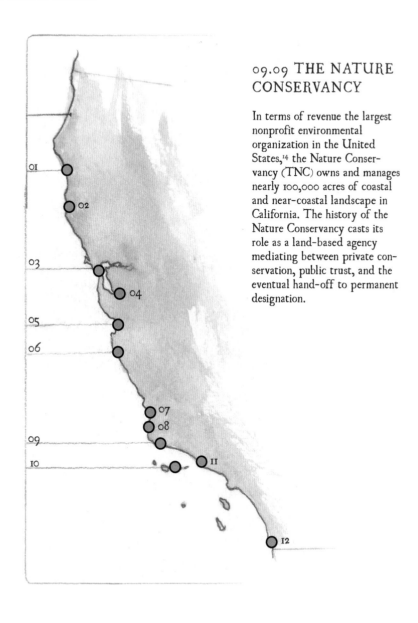

## 09.09 THE NATURE CONSERVANCY

In terms of revenue the largest nonprofit environmental organization in the United States,[14] the Nature Conservancy (TNC) owns and manages nearly 100,000 acres of coastal and near-coastal landscape in California. The history of the Nature Conservancy casts its role as a land-based agency mediating between private conservation, public trust, and the eventual hand-off to permanent designation.

## 09. Policies and Protections

01. Angelo Coast Range Reserve (1959–1994); historical acquisition; TNC and BLM grew the reserve to 7,500 acres; transferred to University of California's Natural Reserve System.

02. Garcia River (ongoing); the Garcia River Forest, 23,780 acres; partners: the Conservation Fund, California State Coastal Conservancy, and the Wildlife Conservation Board; property managed and held in trust by TNC.

03. Marin Headlands (1972–1975); historical acquisition; 2,100 acres of Marin Headlands were acquired by TNC and held in trust until the land became part of the Golden Gate National Recreation Area; the acquisition prevented the development of a small city, called Marincello, in the environmentally sensitive headlands.

04. Mount Hamilton (ongoing); over 100,000 acres across 1.5 million acres managed and held in trust; Santa Clara, San Benito, Alameda, Stanislaus, and Merced Counties.

05. Elkhorn Slough (1971–2012); historical acquisition; 5,000 acres; first conserved property in the 45,000-acre watershed; ownership transferred to the Elkhorn Slough Foundation.

06. Andrew Molera State Park (1968–1972); TNC was instrumental in the handover from private land to state park in 1972; Monterey County.

07. San Luis Obispo County (ongoing); 18,000 acres of corridor ecology; Cambria Pines; Irish Hills; Upper Salinas Oak Woodlands; Carrizo Plain National Monument; Salinas, Estrella, and San Juan Rivers

08. Guadalupe-Nipomo Dunes (ongoing); acquired approximately 3,100 acres; part of what is called the "largest intact coastal dune ecosystem on earth";[15] San Luis Obispo County.

09. Cojo-Jalama (ongoing); 24,000 acres; Jack and Laura Dangermond preserve; Santa Barbara County.

10. Santa Cruz Island (ongoing); ownership of the island is split between NPS (24%, or approximately 15K acres) and TNC (76%, or approximately 47K acres).

11. La Ventura (ongoing); project size, approximately 1,000 acres; restoring Ormond Beach habitat corridors at the Santa Clara River estuary; Ventura County.

12. San Diego County (ongoing); total project area, 35,000 acres; including San Diego National Wildlife Refuge, Santa Ysabel Open Space Preserve, Cañada de San Vicente Preserve, Ramona Grasslands Preserve, and San Diego County.

The Coasts of California

- Waukell Creek Wildlife Area
- Lake Earl Wildlife Area
- Big Lagoon Wildlife Area
- Eel River Wildlife Area
- Humboldt Bay Wildlife Areas (01)
- Headwaters Forests Ecological Reserve
- Mattole River Ecological Reserve
- Lake Sonoma Wildlife Area
- Mattole River Ecological Reserve
- Laguna Wildlife Area
- Atascadero Creek Marsh Ecological Reserve
- Tomales Bay Ecological Reserve
- Petaluma Marsh Wildlife Area
- San Pablo Bay Wildlife Area
- Corte Madera Marsh Ecological Reserve
- Marin Islands Ecological Reserve
- San Mateo Ecological Reserves (03)
- East Bay Ecological Reserves (02)
- Bair Island Ecological Reserve
- Bonny Doon Ecological Reserve
- Watsonville Slough Ecological Reserve
- Moss Landing Wildlife Area
- Elkhorn Slough Ecological Reserve
- Morro Bay Wildlife Area
- Morro Dunes Ecological Reserve
- Burton Mesa Ecological Reserve
- Goleta Slough Ecological Reserve
- Coal Canyon Ecological Reserve
- Bolsa Chica Ecological Reserve
- Upper Newport Bay Ecological Reserve
- Laguna Laurel Ecological Reserve
- San Diego County Lagoon Ecological Reserves (04)
- San Diego County Coast Mountain Ecological Reserves (05)

## 09.10 WILDLIFE AREAS AND ECOLOGICAL RESERVES

California's Department of Fish and Wildlife owns and manages hundreds of wildlife areas and ecological reserves across California. Each of these designated areas is highly regulated to balance private (noncommercial) human use (hiking, birdwatching, photography, hunting, angling, and more) with sustainable wildlife management. Visiting may require holding a daily or annual lands use pass.

01. Humboldt Bay Wildlife Areas include Mad River Slough Wildlife Area, Fay Slough Wildlife Area, Elk River Wildlife Area, and South Spit Wildlife Area.

02. East Bay Ecological Reserves include Albany Mudflats Ecological Reserve and Eden Landing Ecological Reserve.

03. San Mateo Ecological Reserves include San Bruno Mountain Ecological Reserve and Redwood Shores Ecological Reserve.

04. San Diego County Lagoon Ecological Reserves include Carlsbad Highlands Ecological Reserve, Buena Vista Lagoon Ecological Reserve, Agua Hedionda Lagoon Ecological Reserve, and San Elijo Lagoon Ecological Reserve.

05. San Diego County Coast Mountain Ecological Reserves include Blue Sky Ecological Reserve, Meadowbrook Ecological Reserve, Crestridge Ecological Reserve, Sycuan Peak Ecological Reserve, McGinty Mountain Ecological Reserve, Rancho Jamul Ecological Reserve, and Otay Mountain Ecological Reserve.

California black bear
*Ursus americanus californiensis*

# The Coasts of California

- Castle Rock NWR
- Humboldt Bay NWR
- San Pablo Bay NWR
- Farallon Islands NWR
- Marin Islands NWR
- Don Edwards SF Bay NWR
- Ellicott Slough NWR
- Salinas River NWR
- Guadalupe-Nipomo Dunes NWR
- Seal Beach NWR
- San Diego Bay NWR
- Tijuana Slough NWR

## 09.11 NATIONAL WILDLIFE REFUGES (NWRS)

The US Fish and Wildlife Service regulates the National Wildlife Refuge system of 568 inholdings across the United States. Each of the refuges serves "a statutory purpose that targets the conservation of native species dependent on those lands and waters."[16]

Castle Rock NWR—14 acres; sea stack

Humboldt Bay NWR—nearly 4,000 acres, primarily estuarine

San Pablo Bay NWR—13,190 acres; critical bird habitat on the Pacific Flyway; staging habitat for 11 species of anadromous fish; mudflats and wetlands

Marin Islands NWR—10.5 land acres over two small islands; total refuge size, 339 acres; bird and tideland habitat

Farallon Islands NWR—four groups of islands totaling 211 acres

Don Edwards San Francisco Bay NWR—30,000 acres; the nation's first urban wildlife refuge; 15 different habitat types from bay marsh to oak woodland

Ellicott Slough NWR—168 acres; closed to the public for preservation of endangered amphibians; Ellicott Unit, Calabasas Unit, and Harkins Slough Unit

Salinas River NWR—367 acres; dunes, coastal salt marsh at the mouth of the Salinas River

Guadalupe-Nipomo Dunes NWR—2,553 acres; dune habitat and sage scrub for an array of endangered animals, including many invertebrates

Seal Beach NWR—965 acres; remnant salt marsh in urban setting

San Diego Bay NWR—316 acres; urban refuge of submerged lands and intertidal habitats; eelgrass wetlands

Tijuana Slough NWR—1,072 acres; part of the 2,800-acre Tijuana River National Estuarine Research Reserve managed cooperatively with NOAA and California State Parks

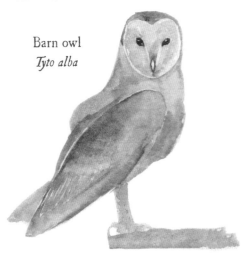

Barn owl
*Tyto alba*

The Coasts of California

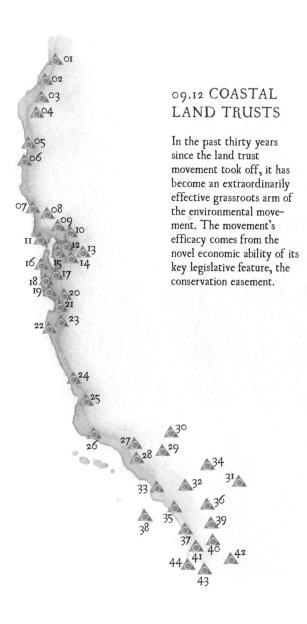

## 09.12 COASTAL LAND TRUSTS

In the past thirty years since the land trust movement took off, it has become an extraordinarily effective grassroots arm of the environmental movement. The movement's efficacy comes from the novel economic ability of its key legislative feature, the conservation easement.

496

09. Policies and Protections

A conservation easement is a category of land ownership that exists for the purposes of preserving some aspect of the physical landscape from future development. The character of the land that the easement contract describes is protected in trust by a private land management organization. The ability to realize conservation goals without change of ownership is appealing to many large-parcel landowners who also may realize some tax benefits for having sold or donated an easement. The voluntary decision of placing a conservation easement on the property is perpetual and will remain regardless of whether the property is sold in the future. Across California, land trusts are consolidating hundreds of thousands of acres inside wildlife corridors, essential acreage that becomes connective habitat between other protected spaces.

01. Redwood Coast Land Conservancy
02. McKinleyville Land Trust
03. Northcoast Regional Land Trust
04. Sanctuary Forest
05. InterTribal Sinkyone Wilderness Council
06. Mendocino Land Trust
07. Bodega Land Trust
08. Sonoma Land Trust
09. Napa Land Trust
10. Solano Land Trust
11. Marin Agricultural Land Trust and Marin Open Space Trust
12. John Muir Land Trust
13. Brentwood Agricultural Land Trust
14. Save Mount Diablo
15. Sogorea Te' Land Trust
16. Midpeninsula Regional Open Space District
17. Tri-Valley Conservancy
18. Peninsula Open Space Trust
19. Sempervirens Fund and Land Trust of Santa Cruz County
20. Amah Mutsun Land Trust
21. Elkhorn Slough Foundation
22. Big Sur Land Trust
23. Santa Lucia Conservancy
24. Cayucos Land Conservancy
25. Land Conservancy of San Luis Obispo County
26. Land Trust for Santa Barbara County
27. Ojai Valley Land Conservancy
28. Ventura Land Trust
29. Transition Habitat Conservancy
30. Tejon Ranch Conservancy
31. Mountains Restoration Trust
32. Fallbrook Land Conservancy
33. Los Angeles Neighborhood Land Trust
34. San Bernardino Mountains Trust
35. Mojave Desert Land Trust
36. Arroyos and Foothills Conservancy
37. Palos Verdes Peninsula Land Conservancy
38. Catalina Island Conservancy
39. Rivers and Lands Conservancy
40. California Cultural Resources Preservation Alliance
41. Irvine Ranch Conservancy
42. Anza Borrego Foundation
43. Kumeyaay-Digueño Land Conservancy
44. San Diego Habitat Conservancy

# 10. NAVIGATING A CHAOTIC SEA
*Modeling hope and peril*

Across the varied landscape, the millions of niche habitats, and the ecological complexities present on the thin slice of the globe where the North American continent meets the Pacific Ocean, an evolving and precarious drama is playing out. This drama, whose consequences reach around the globe, can progress in one of two ways: toward failure or toward success. Failure will be the collapse of biodiversity and the systems that biodiversity supports, among them the system of human ecology. Success will be the conservation of the world's wealth of species and could lead to the ushering in of a new era of abundance and justice realized. The will that brought on the panoply of anthropogenic stressors to the world's environment and relentlessly pushes the biosphere to catastrophe is the same will that can now choose between failure and success.

This chapter explores the primary drivers of biodiversity loss across California, how they are influenced, and some of the opportunities and challenges they represent. The chapter opens with a discussion of the ways that threats and disturbances can compound in our marine ecosystems. The chapter then moves through a few strategies that California (its government and its society) has for responding to threats from a warming future—from the philosophical (legal personhood of watersheds) to the infrastructural (desalination and water conveyance). Before closing with a consideration of California's future cartography, we'll explore how we might apply an ethic of justice to so many emerging challenges.

dolphin smile

10. Navigating a Chaotic Sea

In tandem with the maps and the supplemental material is a story (of sorts) pulled from my journals, called *Facing West*, a poetic narrative in fifteen parts that braids together the themes of this chapter.

### Facing West, part one: View from the shore

Sit by me at the campfire. It is a beautiful evening on the bluff, and although the crashing waves on the nearby beach are loud, we can hear each other using only soft voices. It's spring, and the fog will creep in soon. Venus, as the evening star, hangs over the horizon, and a coyote call carries on the slight breeze through the fading light. We've invited everyone we know, and tonight, so many millions of quiet and peaceful minds can hear our quiet whispers as if the stars themselves were dialed in to listen and are actively transmitting our heartfelt conversation to all those tuned in. This is an ancient scene. It was around this same fire that society, the basic tradition of essentialized community, began to become a reality to our ancestors, several hundreds of thousands of years ago. It was around this same fire that humans invented their most powerful, world-making tool: the story.

As the most important stories always are, our story tonight is about the opportunities of the future. We had to gather here at our coastal camp to tell this story. Let the ocean we hear roaring on the nearby beach represent that future, and on this cliff, the precipice is now. Having walked to the end of the westward trail, we have nowhere else to go. Tonight we are reckoning with the realization that, being unable to go back, it is here that we must rest. From here we can see clearly the future's broad horizon as a starlit mirror over the sea. All the world, everyone in attendance, the "we" who are referred to again and again, holds their breath waiting to hear tonight's tale. With eyes and hearts wide open, everyone is invited to participate as a storyteller and waits anxiously to see not only how well we tell this new story of the future but how well we listen to the voices of the past.

## 10.01 THE PATH OF RENEWAL
*The nature of disturbance*

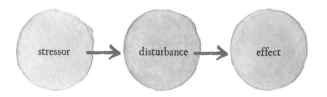

A *threat* is a particular stress on a system that can diminish, disrupt, or destroy the normal functioning of that system. A *disturbance* is a change agent within an ecosystem that spurs succession, the course that all living things take through the adaptive cycle of energy conservation, expenditure, and release. An example of a threat might be a source of pollution; a disturbance might be a wildfire that exists within a normalized fire regime.

The difference between a threat and a disturbance is in their outcome, not in the causal nature of their influence. A threat can be categorized as a disturbance when a phenomenon (such as fire) doesn't succeed in destroying the ecosystem past its own ability to

## 10. Navigating a Chaotic Sea

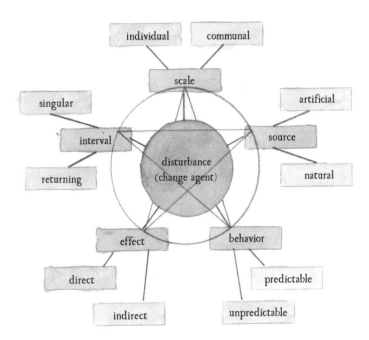

repair itself, because the system has a strategy to deal with the threat and incorporate the threat into its adaptive cycle. In the diagram above, parameters are set whereby a number of basic categories of threat/disturbance types are measurable by their scale, source, behavior, interval, and effect.

The acronym HIPPO describes what some researchers consider the five primary threats to biodiversity: habitat loss, invasive species, pollution, human population, and overharvesting. It has been rightly suggested that human population growth (the second *P* in the acronym) is an influencer and not a direct threat and that the acronym should be HIPCO with the addition of climate change associated with global warming as an ever-growing threat to world biodiversity.[1]

# The Coasts of California

one thing, all things
one being, all beings

## 10. Navigating a Chaotic Sea

### Facing West, part two: Starting with the end

Around our campfire, we've never been more safe. Here we are establishing a unity of mind in this age of entrenched divisiveness, contention, and despondency by beginning with a common vocabulary that sets the parameters. We must make sure we are all talking about the same thing. The narrative discourse in which we engage is persistent and strong, passionate and informed, and always relayed with a patient and metered tone that is open to nuance and amendment. We are not making an argument; we are fostering an opportunity.

The words we use to describe the future world are the waves against the beach. Although we can roughly measure the physical characteristics of each wave, our perspective is hopelessly individual. The context for the language we employ to tell this future story is the eroding shore. Prone to landslides and earthquakes, the narrative itself adapts to the landscape as it radically shifts in a moment. The history of our changing story, a parade of endless revolution between only fleeting moments of homeostasis, is a fast-crumbling cliff and a slow-rising mountain.

We are good at changing the story of who we are and who we've had to be. When a new idea ascends like an undeniable new sun, a revolution takes root, and we end the world as we knew it and are happy enough to begin again. One hundred thousand years ago, we did it at the dawn of modern humanity and the cognitive revolution. The Eurasians did it again twenty to ten thousand years ago, at the advent of the agricultural revolution. Civilizations around the world exist within their own adaptive cycle of birth, growth, death, and rebirth. We've gotten good at revolution. We need it. We thrive not despite but because of apocalypse. From the beginning of time, we've been telling stories about the end of the world.

As time and space are conjoined, there is necessarily a spatial aspect to the eschaton. The end of the world also exists as the edge of the world. On the coasts of California, we sit on that edge. Staring at the flickering campfire, we watch the flames at the end of the world, and from the ashes, the next story will begin.

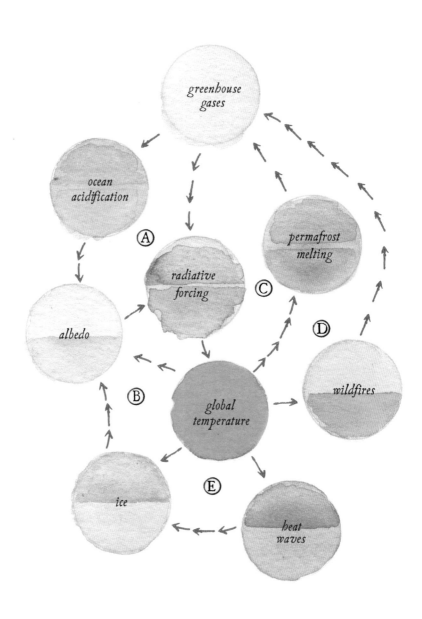

## 10.02 FEEDBACK CASCADES
*The drivers of climate breakdown*

The cascading development of positive feedback loops, or the compounding effect of climate breakdown, poses what is perhaps the greatest threat to ecosystems across the biosphere in several millennia. Diagram 10.02 depicts simplified versions of five feedback loops within the cavalcade of factors that can either prevent runaway climate chaos or contribute to it, depending on how these factors interact.

A. Ocean acidification. Phytoplankton emit sulphur compounds, which then seed clouds that increase albedo, or the reflectivity of the earth's surface. When greenhouse gases increase, the resulting ocean acidification kills phytoplankton.[2] Less phytoplankton means less albedo, spurring increased warming, further reducing phytoplankton biomass, establishing an augmenting feedback loop.

B. Radiative forcing. Radiative forcing is the heating effect caused by an imbalance of the sunlight energy absorbed and reflected from the earth's atmosphere. Warmer global temperature means less ice, which means less albedo, which means greater radiative forcing.

C. Permafrost melting. Arctic permafrost covers 9 million square miles and contains some of the planet's largest reservoirs of methane, a greenhouse gas with 25 times the potency of carbon dioxide.[3]

D. Wildfires, desertification, or rainforest drying. Heat negatively affects plant life in a variety of ways that all lead to greater concentrations of greenhouse gases.

E. Increased intervals between heatwave events lead to less ice, which leads to less albedo, which leads to greater radiative forcing, which leads to higher global temperatures, which leads to more heat waves.

Marbled godwit
*Limosa fedoa*

## Facing West, part three: Revolutions and paradigm shifts

The nineteenth and twentieth centuries were full of endings that marked beginnings, and the twenty-first century promises to follow suit. A steady flood of paradigm shifts within the Euro-American mind, spurred by a persistent rain of philosophical, literary, and scientific insights, dislodged the bedrock of what was once considered true. The industrial revolution, the invention of capitalism and modern democracy, the Romantic and Transcendentalist movements in literature, the Darwinian revolution, the Civil War of the United States, the ongoing genocide of indigenous people in the west, and the completion of the railroad across the North American continent—all represented moments in the nineteenth century when Western culture reframed what we once understood as the nature of the world.

In a similar way that the Copernican revolution of the fifteenth century unseated the earth as the center of the cosmos, the Darwinian revolution revealed that humanity was not the endgame of biological life. The establishment of the theory of evolution by natural selection provided the conceptual framework or what might have been an intellectual inflection point for the human species to reevaluate itself under the umbrella of a new, unifying paradigm of science and compassion. It may still be so, just delayed and nonlinear in its convoluted and often tragic emergence. The labyrinthine, braided watercourse drawn across the confused floodplain that was the twentieth century may have exhausted the false courses for the unstoppable flow from the headwaters of history that did not lead to the future sea of our story. Our narrative's promise is the discovery of the one, true course of justice's river that is the fertile estuary at the edge of the world.

## 10. Navigating a Chaotic Sea

A love story is a particular, thematic trope. I take it and unmoor it, and apply it to the nature book.

I am open to the deeply transformational aspect of it — Love, the thing.

Canada Geese
Branta canadensis
by obi kaufmann
Coasts of California
2021

love exists in my work as it does in the world — across many dimensions.

We can hold contradictions, it is okay. You can live in society and see the need for structural change at the same time.

I have hope,
I've earned it,
I'm hungry for it,
I also have terror, grief, and rage.

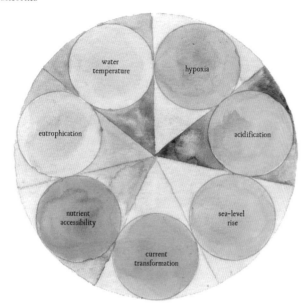

## 10.03 THE EFFECTS OF POLLUTION
*Vectors of climate-based ocean stress*

The ocean is the largest carbon sink on the planet. Pollution is changing earth's carbon chemistry, and the effects are hitting California's marine ecosystems in three ways: in the atmosphere from emissions, from below with changing cycles of upwelling, and in the collapse of the kelp forests and the loss of the sequestration service they provide.[4] The offshore ecosystems are absorbing one-third of all anthropogenic carbon emissions and up to 90 percent of the excess heat generated by radiative forcing, and the symptoms of this untenable affliction are manifesting in a host of deleterious conditions.

Acidification. The ocean off the California coast is acidifying at twice the average rate of the rest of the globe;[5] lower water pH levels are disastrous for California's calcifying species, such as mussels and coralline algae.

Current transformation. Changes in the California Current System and the functionality of the upwelling mechanism to deliver nutrients and cold, oxygen-rich water circulation produce rigid and exaggerated thermocline layers.[6]

Eutrophication. Harmful algal blooms triggered by an excess of nutrients (nitrogen and phosphorus) along coastal communities and inside estuaries are spurring dead-zones and fish-kill events.[7]

Hypoxia. Because of the strength of the California Current and its proximity to the effects of El Niño and La Niña events, the west coast of North America is among the most vulnerable ocean regions on the planet to hypoxia (lack of oxygen) and acidification;[8] a decrease of the dissolved oxygen could result in the collapse of the shellfish and herring industries in Southern California.[9]

Nutrient accessibility. An increase in greenhouse gases across the wind-driven California Current intensifies aspects of the upwelling phenomenon, which could result in the relocation of fish populations and species die-off.[10]

Sea-level rise. California's sea level has been rising by 0.1 inches per year over the past 30 years; sea-level rise is attributable to thermal expansion by a warming ocean, the melting of polar ice, and the subsidence of coastal land areas;[11] impacts include coastal flooding during storms, periodic tidal flooding, and increased coastal erosion.[12]

Water temperature. Across California's coasts, ocean temperatures up to 3,000 feet in depth have been increasing by 0.5°F each decade for the past 50 years, which could result in massive die-offs and even in the alteration of current patterns.[13]

*Facing West, part Four: Growth, unbounded and costly*

Waves have been pounding the edge of the world for as long as the earthly ocean of time has existed. We can let the ocean represent the future and the past, and the view would hold the same vastness. It is only close to the shore, through the clockwork of the wave, that we can detect with our basic senses the influence of time at a human scale. The span of time since life began on earth is so vast that a single wave, a single pulse of earth's oceanic heart, can, for our story tonight, represent a year, and a century might be the coming or going of a single tidal cycle. The twentieth century was one such rising tide, a tide larger and unlike any other span of comparable time in human history.

Mathematically, the unassailable force of the twentieth century fueled societal growth, for the first time in its long evolution and across every conceivable metric, from an arithmetic to a geometric trajectory. From a vector that was visualized as a ramp, steady and linear, to a curved upslope that now approaches verticality, the ratio of growth to time became the king of all tides, one that is changing not only our local shoreline but the configuration of the biosphere.

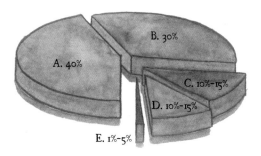

## 10.04 POISONING THE SEA
*Proportions and pollutants*

Any substance that detrimentally affects the atmosphere, the oceans, the water, or the soil is a pollutant. Chemical pollution into marine environments includes persistent organic pollutants (POPs), agricultural chemicals that are capable of bioaccumulation or perniciously passing from prey to predator. Pollutants also include chemicals that naturally occur in the environment but are considered a pollutant when anthropogenically sourced, such as carbon dioxide.

The ocean is being fed a slow, poisonous drip from human society, yet we seem not to have the will or even the ability to see that and react to it. The human mind, as it is linked to modern industry and the economy that feeds it, is able to conceive of disasters and how to respond to them, but not to systemic problems. When the big oil disaster occurred in 1969 off the coast of Santa Barbara, it helped kick off the so-called golden era of environmental legislation that gave us, among other excellent laws, the Endangered Species Act and the clean water and air acts. In a series of bold initiatives, California's government has set forth a plan to transform the state into a negative carbon emitter by 2045,[14] along with a plan to protect 30 percent of its land area by the year 2030.[15] By themselves, these two noble and ambitious policy goals have the potential to transform and propel California's economy into a new era and establish California as a world leader of climate innovation and biodiversity conservation.

Sources of global ocean pollution by percentage:[16]

A. Land-sourced runoff: nutrients, bacteria, and heavy metals; land-sourced emissions: airborne mercury and nitrous oxide
B. Dumping and garbage: trash, plastics, sewage
C. Chemical and oil spills; maritime transportation, shipping, and accidental emission
D. Industrial wastewater
E. Offshore oil and gas drilling; mining

# 10. Navigating a Chaotic Sea

## Facing West, part five: The cresting wave

Every species would do it if it could. A tactical advantage to unlock and profit from unbridled access to any given resource may inevitably lead to the overexploitation of that resource. The human advantages—the cognitive capacity to rend from the earth any manipulable energy, and the imaginative capacity to bend our growth potential toward the acquiring of that energy—are examples of this biological imperative. If growth due to resource exploitation is inevitable when some imbalance is detected and successfully capitalized on by a particular species, a corresponding collapse with the exhaustion of that resource always looms.

It may be some combination of cleverness, grace, wisdom, or luck that has so far prevented the rising tide of growth from its eventual, perhaps inevitable, retreat, or it may just be that an appropriate scale of data has yet to present itself. If the fate of humanity is ecologically set, the question could be asked: Is what the conservationists and the environmentalists are asking from human society, to keep growth and resource exploitation in check, not only useless but unscientific?

Kelp greenling, *Hexagrammos decagrammus*
all creatures in the kelp forest are now endangered

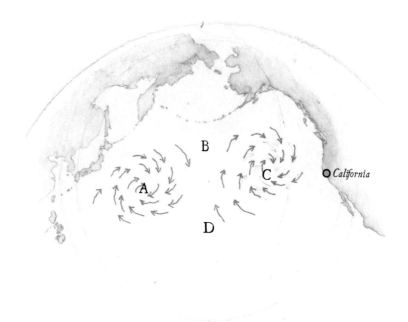

Map 10.05

## 10.05 NOTHING IS DISPOSABLE
*Plastic's insidiousness*

The amount of plastic products that continues to make its way to the ocean and threatens to transform the marine environment into a plastic soup is truly shocking. Nearly 14 million tons of plastic debris enter the ocean every year, and because most of it doesn't sink (but rather enters the water column, or descends to benthic depths), 80,000 tons of the nonbiodegradable poison have formed flotillas on the Pacific that cover an area several times the size of France.[17] The consumerist economy produces 381 million tons of plastic waste (most of it packaging) yearly, and that number is set to double by the middle of the decade,[18] when the physical weight of plastic in the ocean will exceed the total weight of all marine life. The plastic-induced mortality rate is on par with any other stressor in the biosphere, killing more

than one million seabirds and over one hundred thousand marine animals every year.[19]

Through a program strategy of prevention, removal, research, response, and outreach, the National Oceanic and Atmospheric Administration is working with California's Ocean Protection Council to tackle the huge problem, but it seems that nonprofit nongovernmental organizations (NGOs) are leading the charge to clean up the horrendous mess.[20] In 2020, the Ocean Voyages Institute reported that it collected over two tons of plastic waste per day in the Eastern Garbage Patch over the course of a bit less than two months, setting a new record for ocean cleanup.[21] Relying on the altruism of nonprofit agencies is not a viable path toward restoring ocean quality, however. The solution must be top down and must be guided by strict governmental pressure on market forces to change the way plastic is delivered to the economy.

A. Western Pacific Ocean; Kuroshio Current; Western Garbage Patch

B. Northern Pacific; Subtropical Convergence Zone

C. Eastern Pacific Ocean; California Current; Eastern Garbage Patch

D. Northern Equatorial Zone

Sea nettle jellyfish
*Chrysaora quinquecirrha*

*Facing West, part six: The bottleneck and the inflection point*

On the tide chart that is the ebb and flow of the adaptive cycle, two waveforms converge. Over time, one is an ascending measure of growth, while the other marks the dwindling amount of the available resource pool within the finite system. After the convergence of the two, the ability of the first line to continue its rising trajectory is based on the corresponding constraint of the second line. Inside a healthy adaptive cycle, any egregious imbalance within an ecosystem is corrected for by an inflection point forming at the crest of the first line and a bottleneck that forms at the trough of the second line, creating a rhythm of give and take between poles of growth and reduction. Within one system, population size, the system tends to autocorrect for skyrocketing growth with a sudden and massive diminution of that population.

The cold math can't account for the warmth of human genius. Hope exists because of the lack of any precedent for our storytelling mind in the fossil record. The situation is as auspicious as it is daunting. Just as we have evolved in a manner that no other creature has before, so too has the biosphere never been threatened by an agent of mass extinction that realizes its own agency to undo what has already been done.

## 10.06 THE SEA'S HARVEST
*Monitoring human predation*

A fishery is more than an area of the coast where a particular economy extracts fish and other marine resources. A fishery is a managed ecosystem where, to avoid collapses in any given species' population, a push and pull exists between regulation, societal understanding, and economic drive to produce sustainable practice.[22] A sustainable fishery works, in theory, by performing a balancing act between harvest taken and the ability for a harvest to grow back to its unfished state.[23]

Commercial fisheries account for the take of the majority of 200 species within a total count of 350 species of plants and animals harvested near California's shore.[24] Fisheries transform and endanger marine ecosystems in a number of ways that must always be accounted for in order to ensure sustainable practices. The nature of direct ecosystem disturbance by fishery type includes mixed-stock fisheries (whereby sequential depletion of species can occur due to harvest method—i.e., trawl, long line, and trapping[25]); bycatch (where nontarget species such as seabirds, marine mammals, and sea turtles are inadvertently killed in the fishing process); and degrading of physical habitat (dragging and set-line traps crushing biogenic habitat, such as deep-water corals and sponges[26]).

Historically, California fisheries have existed inside a boom-and-bust cycle, where management wasn't a consideration; now, the complex puzzle of balancing ecological resiliency and economic policy in the face of climate breakdown presents a new array of challenges for the industry. With the implementation of Marine Protected Areas (see 09.03), California policy is experimenting with a new set of tools to mitigate the interplay between extraction and replenishment in a commercial context.

Sablefish, or black cod
*Anoplopoma fimbria*

# The Coasts of California

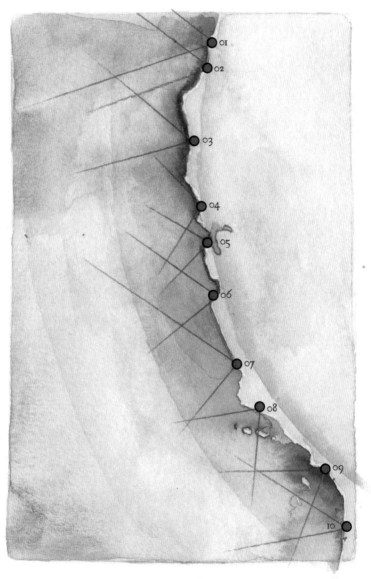

Map 10.06

10. Navigating a Chaotic Sea

Commercial fisheries and their primary harvest, as categorized by major ports:[27]

01. Crescent City—nearshore rockfishes, Dungeness crab, and ocean shrimp

02. Eureka—Petrale sole, Dover sole, sablefish, ocean shrimp, and albacore tuna

03. Fort Bragg—rockfish, sablefish, Dover sole, Chinook salmon, and red urchin

04. Bodega—Chinook salmon and Dungeness crab

05. San Francisco—Pacific herring, Chinook salmon, and Dungeness crab

06. Monterey—northern anchovy and Pacific sardine

07. Morro Bay—nearshore rockfish and sablefish

08. Santa Barbara—sea cucumber, market squid, white seabass, red urchin, and other invertebrates

09. San Pedro—Pacific mackerel, Pacific sardine, and a range of highly migratory species (HMS)

10. San Diego—spiny lobster, spot prawn, and HMS

Ocean shrimp (Pacific)
*Pandalus borealis*

Bluefin tuna, *Thunnus orientalis*, can grow to be ten feet long and weigh a thousand pounds, although individuals of that size have rarely been seen in recent years. Due to overharvesting, 90 percent of living bluefin tuna are thought to be juveniles, and this commercially valuable fish is thought to be at about 2 percent of its historical population.[28] In 2017, the Western and Central Pacific Fisheries Commission and the Inter-American Tropical Tuna Commission agreed to work together to rebuild that population to 20 percent of historical levels, a threshold for sustainable harvest.[29]

## 10. Navigating a Chaotic Sea

> *Facing West, part seven: Navigating the Future*
>
> Navigating the sea of the future, far from shore, is an exercise in probabilities. You can see the terrain of dancing variables from the shore: the turbulent tips and dips of the sea representing complexities inherent in the system. Each wave presents an opportunity or a challenge, a source or a sink. Because the nature of the ocean can't be changed, and emergent patterns can be only vaguely detected, safe passage is far from certain. What we can control is the design of our boat or the decision to stay on the shore.
>
> Designing a better boat represents our capacity for cleverness and the drive to innovate. The advocate for a better boat believes in the power of technology to overcome each wave that threatens to sink us. Deciding to stay on shore represents our propensity for wisdom and the quest for justice. The citizen who stays on shore believes in a deeper land ethic and the possibility of a compassionate society. *These two options do not need to be mutually exclusive.* In our working and creative community, we, like our ancestors, set sail in the morning and return in the evening. We operate inside a cyclical story of time and space that is fundamental to our worldview.

The Coasts of California

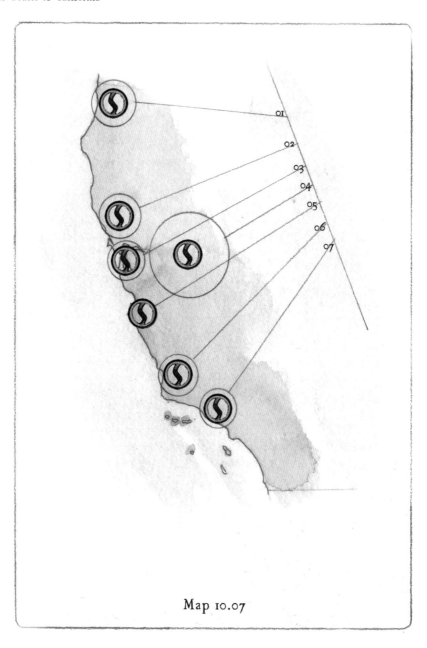

Map 10.07

## 10.07 THE RIGHTS OF RIVERS
*Polluted water, polluted bodies*

In a decisive move of leadership and prescient indigenous ecological knowledge, the Yurok Tribal Council voted unanimously in the spring of 2019 to give California's second-largest river, the Klamath, legal personhood.[30] Enshrining the rights of nature in this way fundamentally shifts how we think about the extractability of any given natural resource. It is also a means of confronting the injustices inflicted on the people who have revered the river for millennia.

Whether or not this precedent will have standing in state or federal court remains a question, but that might be beside the point. Despite being protected as a Wild and Scenic River, our nation's most powerful river protection law, south from the Iron Gate Dam (197 miles from the river mouth), the Klamath remains compromised. The Klamath irrigation project contains more than seven hundred miles of diverting canals, seven dams, and twenty-eight pumping stations, which together regularly reduce the Klamath to half of its natural flow.[31] In a major demonstration of what has been called restorative justice, four of the most obtrusive and debilitating dams in the upper reaches of the Klamath will be removed in a demolition project that is set to begin in 2023.[32]

Restorative justice begins with the human community, as a negotiation between indigenous communities and the governments of the United States and the State of California—though, if a precedent is set for the legal personhood of nonhuman persons, then justice begins to transcend that relationship, and through defining the rights of any entity in nature that meets certain ethical and ecological criteria, modern society profoundly reckons with its responsibilities and transforms because of it.

All watersheds and the watercourses that flow through them share a common physiographic anatomy. The complex, living body of a watershed begins with the structure of its main river. That watercourse acts as an artery, supplying the energy, whether nutritive or compromised by pollution, that feeds or corrupts, respectively, the ecosystem it supports. Every single one of California's inland water bodies are impaired and overtaxed. Addressing the chemical pollutants and the water-quality threat by type is the first empirical step in protecting the legacy of river systems, the circulatory structure of California's natural world. An analysis of some of California's most relied-on watersheds and the threats they face reveals their damaged nature:[33]

01. The Klamath River watershed: nutrient input (eutrophic agricultural chemicals such as nitrogen and phosphorus that feed algal blooms), low dissolved oxygen, ammonia, pH imbalance, and temperature[34]

02. The Russian River watershed: nutrient input, low dissolved oxygen, mercury, pathogens and indicator bacteria (including typhoid, dysentery, and *e. coli*) in sediment, pH imbalance, and temperature[35]

03. San Francisco Bay: nutrient input, legacy pollutants (chemicals still present due to past industry, including methylmercury and carcinogenic PCBs), pesticides, and CECs (chemicals of emerging concern, including flame retardants, pharmaceuticals, and personal care products)[36]

04. The Sacramento River and San Joaquin River watersheds: nutrient input (fertilizer), pesticides, methylmercury, microplastics, sewage overflow, boron, DDT, metals from historical mining operations (cadmium, copper, zinc, and mercury), selenium, invasive species, and salts[37]

05. The Salinas River watershed: nutrient input, chloride, pathogens, pesticides, nitrates, and pesticides[38]

06. The Santa Maria River and Santa Ynez River watersheds: nutrient input and sediment[39]

07. The Los Angeles River watershed: ammonia, cadmium, copper, lead, selenium, and zinc; Santa Ana River: salinity and pathogens[40]

*in the eyes of the California lion*

## 10. Navigating a Chaotic Sea

### Facing West, part eight: Circular time, space, and mind

Coastal redwoods have a complete tool box of adaptations that affords them a strategy to live for more than two thousand years; our lonely species is not the only one with a mind that contemplates and intelligently reacts to the nature of time, although it might be the only one that has constructed time as a linear concept rather than as a endless cycle of seasons. The horizon of the ocean is the only straight line in terrestrial nature that is perceptible to the naked eye and the naked mind alike, and it too is an illusion of scale. You can find it tonight, on this bluff, at the base of the star curtain and the shadowed sea. Ancient civilizations, the progenitors of Western philosophy from the Nile valley, were the first to recognize the mathematical power of geometry and the power that it could harness. Several millennia later, modern humans conceive of their life as frantic flight, pulling the individual along an unerring vector from the cradle to the grave.

Meanwhile, non-Western, indigenous thought often reflects a sustaining vision of time as reflected in space. Circles and spirals form an interface between human wisdom and patterns on the land. The natural world reveals straight lines to be pieces of larger arcs, a trick of perceived scale. The eagle builds its nest in a shape that mimics the horizon. The salmon lives entirely inside a circular map, claiming the place of death as the same of birth. All plants, from the smallest flower to the mightiest redwood, anticipate annual patterns inside a strategy of either bloom or seed. Across the biosphere, inside forests and across watersheds, we can observe a cooperative pulse that blinks with the seasons, feeding an immortal and evolving planetary physiology.

# The Coasts of California

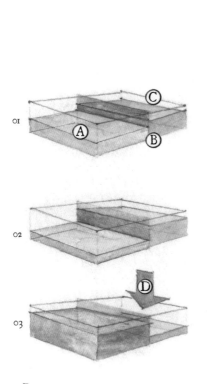

Figure 1

Osmosis and Reverse Osmosis Phenomena

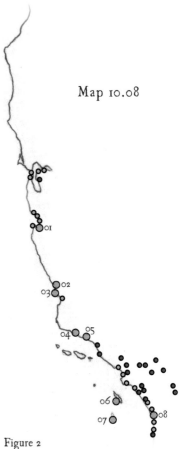

Map 10.08

Figure 2

Existing and Proposed Desalination Plants

- *Existing brackish desalination plant*
- *Existing marine desalination plant*
- *Proposed*

## 10.08 AN INFINITE SUPPLY
*Prospects and problems of desalination*

Access to fresh water has always been, and probably always will be, the primary constraining factor of human development across California's coasts. Most communities on the central coasts are not included in the California Water Project—the infrastructure conveyance of water from northern to southern California for urban and agricultural use—and are forced to get creative with a wide portfolio of water sources.

One of the most enticing prospects is to take water from the sea and remove the salt, or conduct desalination, as this process is called. The theory is good, but the practice, as executed so far, is wasteful and expensive. Not only are there significant environmental problems with sucking the water out of the sea in a way that doesn't destroy the marine ecosystem it's drawn from, but it also produces an abhorrent quantity of wastewater that, unless mixed with a large amount of diffusing fresh water, becomes a toxic disposal hazard. Further, the electrical cost is huge: in one small-scale plant in Monterey County, it reportedly takes $25,000 worth of electricity per month to make enough water for twelve hundred homes, certainly an unacceptable carbon footprint.[41] It may be that desalination is an idea ahead of its time, as there are clear, technologically solvable problems in regard to its large-scale implementation: (1) nondamaging uptake, (2) energy-dependent processing, and (3) waste disposal. If those three obstacles are overcome, the prediction that water will always be the constraining factor in our development and residency across arid lands everywhere might not become a reality.

Reverse-osmosis desalination is currently used as a supplemental source of water for California. There are twenty-three brackish-water (nonmarine water that still has too much salt to drink) desalination plants operating in California, and seventeen others are proposed.[42] The phenomenon of reverse osmosis (figure 1), which removes salt from sea water and brackish water, works because of the physical properties of liquid density and pressure. As shown in figure 1, osmosis (01) is the process by which, when separated by a partially permeable membrane (B), salt water (C) and fresh water (A) will generate osmotic pressure (02) in their efforts to equalize solution ratios. Reverse osmosis is then applying energy to counteract the osmotic flow, leaving behind a less concentrated water solution (03) that is separable from the highly saline wastewater, called the brine.[43]

Brackish-water desalination accounts for about enough water for four hundred

thousand people for a year[44]—not a lot, but reasonably good enough to support arid communities struggling with drought. Marine-sourced desalination plants can be made larger because of access to supply. There are currently twelve existing desalination facilities in California, including four in the Monterey area (01), two in Morro Bay (02), Diablo Canyon Power Plant (03), Gaviota Oil Heating Facility (04), Santa Barbara (05), Santa Catalina (06), San Nicolas Island (07), and the biggest facility in the country, Carlsbad (08), which accounts for roughly 10 percent of San Diego's supply of drinking water.[45]

turkey Vulture
Cathartes aura
lacks syrinx-bud vocal chords organ
Western Turkey vulture
C. a. meridionalis
11 million square mile range
Population - 4.5 million
oldest found fossil - 34 million years old
one of six species of New World vultures

## 10. Navigating a Chaotic Sea

### Facing West, part nine: Secrets of the arrow

Among archers, the straight-grained heartwood of the Port Orford cedar, *Chamaecyparis lawsoniana*, a conifer native to the coastal Siskiyou Mountains of northwest California and southwest Oregon, is said to make the best arrows. The wood will yield an arrow fashioned for strength, often with a slight taper to cut through the air in the truest manner. This ancient, predatory tool symbolizes more than the instrumental purpose of its design. The arrow, by the light of tonight's campfire, represents the trajectory of our species' domination in a global context. The arrow represents our personal ascendency, our alienation, and our burden of responsibility.

For more than one hundred thousand years, many human societies have been moving within, operating by, and struggling to overcome the parameters of the natural, physical systems that govern the growth of civilization. Innovation after innovation has liberated these societies from the constraints of local water, soil health, protein availability, and a legion of other limiting factors to transform the now global society into something unprecedented in the history of life. Our transformation is so complete that a sizable percentage of the American population currently believes themselves to be something other than animal, and nearly half doesn't believe in evolution by natural selection. For the past several thousand years, Western culture, the particular human society that has arguably been the world's foremost imperializing force, has driven what may ultimately be our biological imperative: the weaponizing of logic to unlock the resources our world. Could Western culture have made other decisions about its own trajectory, or was the arrow shot from somewhere in our collective, deep history, propelled with one possible trajectory, through time toward where we find ourselves now?

# The Coasts of California

Map 10.09

## 10.09 A CONTENTIOUS PLAN
*How the delta tunnel project would affect the bay*

There is an infrastructure proposal to build a water conveyance tunnel under the Sacramento–San Joaquin Delta, a project that would be scheduled for completion in 2035.[46] The tunnel, which has existed as a proposal in various forms for more than sixty years, is intended to support water resiliency across California in response to climate breakdown, rising sea levels, and seismic threats.[47] The project is also designed to manage water quality for the benefit of the 750 plant and animal species that rely on freshwater inflow from the Sacramento River.[48] In addition, the tunnel is promised to protect the rural communities of the area from flood threat and to bolster access to reliable water for communities in the San Joaquin Valley and beyond; thus the argument for the construction of the tunnel becomes an issue of water justice.[49]

With compromised fresh water coming into the delta, according to the latest Environmental Impact Report by the Department of Water Resources (2016), the salinity levels of the delta could increase by 60 percent, harmful algal blooms would become more regular, pesticides and human carcinogens would worsen and increase, methylmercury levels would be more than twice the exposure level prescribed by Environmental Protection Agency, and selenium levels would be high enough to be actively poisonous.[50] Given the delta's proximity to the coast, the degradation of the delta may have cascading effects up and down the coastline.

Each of the problems that the delta tunnel project attempts to address can be managed with more economical and less environmentally dangerous solutions. Alternative plans do exist and have been proposed by a number of organizations that believe that the jobs the tunnel is meant to do can be done by utilizing less expensive and less destructive technologies. An updated, sensible, and resilient water management approach for residential and agricultural usage in California includes enough efficiency upgrades (11 million acre-feet[51]), recycling (2 million acre-feet), stormwater capture (.5 million acre-feet), and groundwater management (2 million acre-feet[52]) at a cost much lower than uprooting the delta for the installation of a destructive piece of infrastructure.

01. Sacramento River
02. Proposed water intake
03. Proposed tunnel route
04. Clifton Court Forebay
05. State and federal pumps
06. South Bay Aqueduct
07. Existing aqueducts

## Facing West, part ten: The arrow misses its mark

In our story, the arrow represents a catch-all for the way Western thought has evolved: an inevitable tool of cosmic implications. The shape of the arrow represents linear concepts that govern our ideology, from the modeling of space/time to the modern world's current economic reality. The symbol that is the arrow can hold so much more. From one perspective, call it a material perspective, the arrow is only a tool and not responsible for how it is used. From another, call it a deterministic perspective, the arrow represents little but the potential for violence in a cultural context. The arrow represents the application and justification of power in the realm of science.

While the scientific method has provided humanity with a methodology for uncovering the universe's deep secrets, we must acknowledge that at the moment of its implementation as Western culture's dominant paradigm, an adjacent, shadowy deal was concurrently made. The arrow fired, brought with it rationalizations for what have been lately rightly called out as the sources of societal injustice that they certainly are: toxic masculinity, inequitable patriarchy, white supremacism, predatory capitalism, and the perversion of science to dominate and exploit the natural world and the indigenous cultures of the world.

10. Navigating a Chaotic Sea

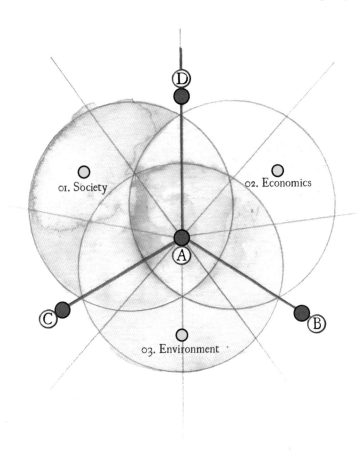

## 10.10 JUSTICE AND NATURE
*Human connectivity*

01. Society: quality of life, science education, opportunity
02. Economics: innovation, market forces, capitalism/regulation
03. Environment: resources, biodiversity, climate

A. Justice: the singular measure of equilibrium within human ecology
B. Environmental–economic: technology, incentives, subsidies
C. Social–environmental: policy, stewardship, values
D. Social–economic: ethics, rights, wages

*Why does there need to be a discussion of justice in a book about nature?*

When we talk about conserving, restoring, and preserving ecological services in terms of applied justice, we can make ethical arguments for the defense of nature. In an age of so much divisiveness in our popular discourse, the core desire for justice can be either a unifying or a divisive force. When we present the defense of nature as a human issue, as a way to assert the necessity of equitable access to a healthy and happy life, the denial of that access becomes commonly identifiable as an injustice. As climate breakdown, spurred by global warming, accelerates in the coming decades, the tenuous balance between societal, environmental, and economic pursuits must be in the forefront of our considerations. The Venn diagram 10.10 describes how justice can exist between three spheres of human ecology. Justice is a force that transcends personal or political agendas. It encompasses not only the relationship between people but also the relationship between humanity and the biosphere.

*"Justice is what love looks like in public."*
*Dr. Cornel West*

## 10. Navigating a Chaotic Sea

*Facing West, part eleven: Reckoning Day*

When California was colonized by the Spanish and later by the Americans, the pervading paradigm that motivated and guided the settlers' view of the cosmos, and the role that Western culture played in that cosmos, was dominated by religious dogma. From this righteous worldview came the genocide of California's indigenous populations and the ongoing dismantling and ecocide of California's natural world. Into the modern era, the same darkness spreads. The shadow deal that accompanies all that the arrow represents haunts every effort that originates from the colonial perspective to fix or heal California's collapsing endemic ecology.

Any plan that denies indigenous sovereignty, employs science that has been warped by a corporate agenda, or panders solely to pursuing an extraction-based economy will be unjust and is doomed. Even the idea of wilderness needs to be revised. Any policy that piecemeals California land to exile or to overexploitation is based in colonial thinking. Only by fundamentally integrating our responsibilities as knowledgeable stewards into all our rights as citizens can we invent an industry of sustainability, one that is able to both tend the wild and leave it to its own functionality. By contemplating the metaphor of the arrow and how linear and circular models of space, time, and mind transect, we can learn how to popularize and internalize this story.

# The Coasts of California

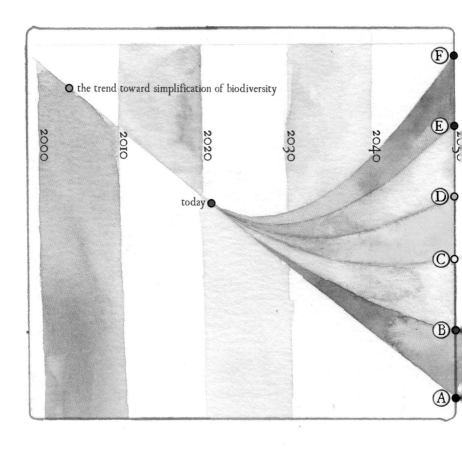

## 10.11 FOR THE LOVE OF JUSTICE
*Biodiversity's future*

A. The current trajectory: systematized injustice; rejection of climate and conservation science; predatory capitalism; carbon-based, linear economies; extractivist energy resources; quarterly profits; gross domestic product

B. Action network 1: racial justice. *Focus on the community*—indigenous management model; traditional ecological knowledge; indigenous resource management; massive community investment; health services; education services; unionized restoration as a trade skill

C. Action network 2: climate justice. *Reduce the footprint*—climate breakdown remediation; carbon neutrality; ecosystem connectivity (e.g., deadbeat dams, halting deforestation); land conservation prioritization; restoration of habitats and the cultural traditions necessary to maintain their functionality (e.g., fire-regime normalization)

D. Action network 3: water justice. *Reinforce nature's power*—water-quality policy; pollution control; strategic corridor ecology; salt remediation; agricultural reprioritization; watershed resiliency; legal personhood for watercourses; reintroduction of beaver and salmon

E. Action network 4: economic justice. *Build a circular economy*—sustainable production; fishery mediation; plastic elimination; economic restructuring and wealth distribution

F. Action network 5: ecological justice. *Tell the story of our connection to the world*—reduced consumption; transformation of watershed policy; beauty as a survival tool; citizen science; Encyclopedia of Life

This biodiversity is our legacy, and preserving it, repairing it, and strengthening it mean not only justice to remediate mistakes made in the past but justice to the future generations waiting to join the world. If the driver of the natural world of California is biodiversity, then biodiversity can be used to measure our success as stewards.

The five action networks prescribed in diagram 10.11, inspired by the United Nations Summit on Biodiversity and the California Natural Resources Agency's Biodiversity Initiative, focus on five spheres of justice that must simultaneously be enacted with great fervor and collective will. In so doing, we will not only find the natural world of California protected and strengthened but find ourselves also transformed—a heliotropic plant, face to the sun.

There is a postideology era coming. It is hard to see now, through the smoke of divisiveness that belabors every breath we take when talking about the future. Soon we will be ensconced in a new and bigger round of climate fires, a new and bigger round of drought events, and a new and bigger round of civil unrest. But we are forewarned and thus forearmed. Regardless of any individual events, the trajectory holds. We've got plans to make California carbon neutral in the next twenty-five years; we've got plans to restore 30 percent of California's natural habitat in the next two decades. We are transforming now inside a complex system, a terrain of dancing variables where catastrophic success is at least as probable as any other outcome.

For our purposes, let's double down on the word *justice*. There are other words that ecologically minded people use to discuss such things; most notably, the word *sustainability* is used to describe some practice or business-related aspect of adaptive capacity, and that is a good start, but it does not include the unifying, cosmopolitan yearning we have for harmony, for witness, for grace, and for love. The word *justice* does that. In the context of biodiversity, the word reveals a world where we let go of the scarcity myth—a myth that unregulated capitalism relies on in order to dismantle the working biosphere—and where we begin to see equity in diversity. In this world of inclusion and abundance, we are no longer being chased down the consumerist tunnel of the linear economy. Instead, we are held in a round basket, and we make ourselves within a world of replenishable resources—ones whose intrinsic value overrides their rote, utilitarian, disposable worth.

*Racial justice.* So often when we talk about restoration of California's natural world, we fail to realize that California's natural world is a landscape that for at least ten thousand years was intimately managed by indigenous Californians. Restoring California habitat space means engaging the active native Californian community and restoring those cultural traditions that the natural systems of California coevolved with. All of the other kinds of justice I am naming must get behind racial justice. There can be no environmental justice without racial justice, and in so many regards, the inverse is true as well: racial justice is environmental justice.

*Climate justice.* With the advent of a warming globe, California has been shocked by a number of environmental calamities that threaten so much of our daily life. The big one has got to be fire. Fire policy over the past one hundred years has been dictated by incomplete and overturned science, the timber industry, and colonial violence toward indigenous cultural practice. As fire transforms and resets the forest, we too are realizing our own capacity to transform and reset. Within the next five to ten years, we will have at least another year of terrible fire; there will be (more) towns lost across the west

slope of the Sierra Nevada. But it is not too late to begin to redress every one of our policies toward forest and land management, based on what we already know: pyrodiversity equals biodiversity, and saving the old trees means reintroducing healthy fire to make way for new trees.

*Water justice.* When you are talking about water in California, you are not talking about water—you are talking about worldview. You are talking about what is worth what. As we test our values against the eighty-year-old water infrastructure system, we find misalignments, we find injustice. Freedom, it turns out, is not being able to do whatever you want; freedom is having the agency to attend to your social responsibilities without a government entity dictating exactly what those responsibilities are. Our responsibility as Californians involves respect for water—water as a living relation, as a resource that transcends property—and if we were to honor it as such, if we were to restructure the story we tell ourselves about our relationship to it, we can align ourselves with a grander, more equitable vision of the future than the trajectory our current paradigm suggests.

*Economic justice.* Healthy coasts, strong with a good complement of their ancient biodiversity, provide a litany of invaluable services for the citizenry. Our coastal wetlands are polluted, desiccated, drained, diverted, and invaded. Our coastal forests are simplified, overcrowded, fragmented, stressed, and diseased. But the ambition to transform our habitat that made this mess in our forests is the same force that can clean it up. We should continue the economic transformation already begun by building restoration as a legitimate trade skill. To this end, we should enlist an army of young Californians and arm them with scientific knowledge and ancient wisdom to steward tomorrow's world.

*Ecological justice.* All the solutions to all the problems are on the table. The missing pieces on one level are expressed by actual geographic gaps, connectivity gaps between habitat spaces where private interest overruns public need, but on another level, the more important gaps are between members of our own species. As we recognize the disaster that a broken ecology demonstrates, as we feel the squeeze from missing species that play key roles in the health of functioning systems, as we begin to see climate breakdown for what it is—a disastrous act of self-robbery—we will reach for bold solutions. Some of these may be simple—for instance, with the dismantling of the four dams on the Klamath River, we are giving California salmon populations their best possible chance for continued survivability. Our course then is to couple that kind of initiative with a full campaign to reintroduce the beaver across the California Floristic Province. Increased biodiversity follows these industrious ecosystem engineers, once incredibly numerous but largely expelled from California before American settlement.

## Facing West, part twelve: The circular economy

So often, our daily diet of popular media asks us to absorb fatalistic, dystopian visions of the future and also technological panaceas that tease the perpetual, unfettered growth of the status quo. So often, we are asked to individually internalize an unfair share of the burden for what we sense are the necessary, systemic changes that our society needs to make in order to tackle the problems at hand. In a movement that has swelled over the past fifty years, concerned citizens who were told to reduce, reuse, and recycle were never given the economic tools to do any of those things to any consequential effect. Believing you are part of that movement, how do you reconcile that betrayal, that lie of personal agency over the well-being of the biosphere with the media's message from the hourly news that by consuming more and more, always more, you assist a nationalistic entity called the Economy, which is the measure of your worth as a citizen?

The genius of industrial society is its hyperefficient methods of creating disposability. Our extraction-based economy is built from the exploitation of capital resources, including human capital, and turning those resources into goods of temporary utility that then are labeled as garbage. Our ability to reconfigure the nature of our economy from a linear basis to a circle is metaphorically akin to learning how to curve the shot of the arrow from our proverbial bow; and in order to do that, you shoot the arrow far enough, with a big enough bow, to follow the curve of the earth.

# 10. Navigating a Chaotic Sea

## The Beaver and the Salmon

The historical density of California golden beaver, *Castor canadensis subauratus*, across California's coastal watersheds was far greater than we had thought for most of the twentieth century, and the beaver's role as an ecosystem engineer, including its relationship to anadromous fish, offers many services that are now desperately needed.[53] This scientific blind spot that the beaver is not a native animal of California has led to terrible policy decisions about its continued expulsion from across the California Floristic Province.

The beaver creates deep, cool pools and side channels throughout the watershed, where anadromous fish can rest and feed on their journey back and forth from the sea. The beaver dam and the reservoir it creates filters pollution; creates wetlands; aids in climate change adaptation by storing groundwater and mediating stream levels; prevents floods; stores carbon; and benefits a host of biodiverse life, including establishing habitat for migratory birds.[54] Salmon and other fish returning from the sea use beaver terraces as staircases to their spawning grounds; historically, at the completion of their life cycle, they have delivered hundreds of thousands of tons of calcium, phosphorus, and nitrogen per year to the watershed. This ancient and now fractured system of biological conveyance is an important component in the health of every ecosystem throughout every watershed, and restoring it has mediating implications for the biodiversity bottleneck we're witnessing across California's wildlands, along its coasts and beyond.

# The Coasts of California

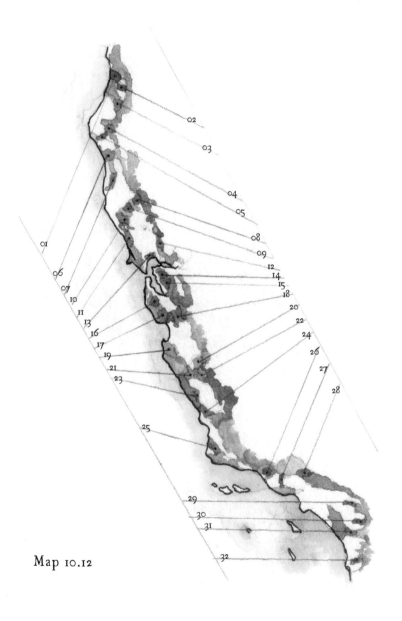

Map 10.12

## 10.12 FUTURE CALIFORNIA 001
*Keeping the circuit open*

Corridor ecology is the study of how wildlife uses space that connects habitat types, undeveloped areas, or natural landscape blocks for migration, foraging, and breeding. These wildlife corridors are bounded by imperative margins that insure genetic diversity and food availability while preventing overgrazing and a number of other deleterious effects that result from bounded terrestrial animal and plant populations. To maintain California's rich biodiversity, we must connect protected lands, and we must preserve key linkages within natural landscapes.

The green areas of map 10.12 represent areas of landscape across California's coastal ranges that remain relatively intact and free of overdevelopment, where abundant habitat space still exists and the land is afforded different levels of protection. The orange areas, listed here, are areas that have been identified as valuable wildlife corridors, unprotected and undeveloped.[55] The most able network of organizations to lead this fight today comprise the land trusts, and many have successfully worked pieces of these landscapes into their easement-management portfolios.

01. Blue Creek Mountain Ridge (Humboldt)
02. Bee Mountain (Humboldt)
03. Wire Grass Ridge; Redwood Creek watershed (Humboldt)
04. Chalk Mountains (Humboldt)
05. Elk Ridge; Mattole watershed (Humboldt)
06. Gibson Ridge; Benbow Lake area (Humboldt)
07. Elkhorn Ridge, south of Elkhorn Ridge Wilderness (Mendocino)
08. Hopland Corridor; Russian River watershed (Mendocino)
09. Gualala River headwaters (Sonoma)
10. Big Oat Mountain (Sonoma)
11. Cazadero Highway (Sonoma)
12. Vaca Mountains (Napa)
13. Wildcat Mountain (Sonoma)
14. San Pablo Ridge (Contra Costa)
15. Las Trampas Ridge (Alameda)
16. Mindego Hill (San Mateo)
17. Bear Creek (Santa Cruz)
18. Santa Clara Valley (Santa Clara)
19. Laureles Grade (Monterey)
20. Topo Ranch (Monterey)
21. Pine Canyon (Monterey)
22. San Lorenzo watershed (Monterey)
23. Cypress Mountain (San Luis Obispo)
24. Irish Hills (San Luis Obispo)
25. Santa Maria Valley (Santa Barbara)
26. Sulphur Mountain (Ventura)
27. Las Posas Hills (Ventura)
28. Highway 14 (Los Angeles)
29. Badlands (Riverside)
30. Black Hills (Riverside)
31. Tourmaline Queen Mountain (San Diego)
32. Starvation Mountain (San Diego)

If my painting could somehow past wildlife rendering, I would let it. If I could somehow satisfyingly communicate directly with the inherent beauty of pigment without the need of its translation, I'd jettison the artifice of trying to produce, in a physical way, a symbol or a sign that I hope develops, again, drawing closer and closer, an approximation.

Spring first 90

Protect and restore California wetlands

I spend my time exploring a better story — I do not work in future-present moment.

# 10. Navigating a Chaotic Sea

> *Facing West, part thirteen:*
> *The tide of revolution*
>
> In California, a globally significant economic force, there are many reasons to believe that the revolution aimed toward a postcarbon, circular economy is under way. Cooperative leading elements within the state and federal governments, indigenous communities, nongovernmental organizations, agricultural industry, big tech, local municipalities, and various scientific institutions hold a tenuous accord—an agreement that California can not only transform and adapt to the monumental challenges ahead but lead the world in showing how it is done. Yet the story we tell ourselves about our responsibility to the natural world and to the quality of our future society remains contentious.
>
> Divisiveness, spurred by interests that derive profits from discord, continues to dissuade the popular will from uniting behind this singular and yet all-encompassing issue. The divisiveness is so complete that we are often divided within ourselves, and even out here, in the beautiful evening air on this California bluff overlooking the sea, we are not at peace.

The Coasts of California

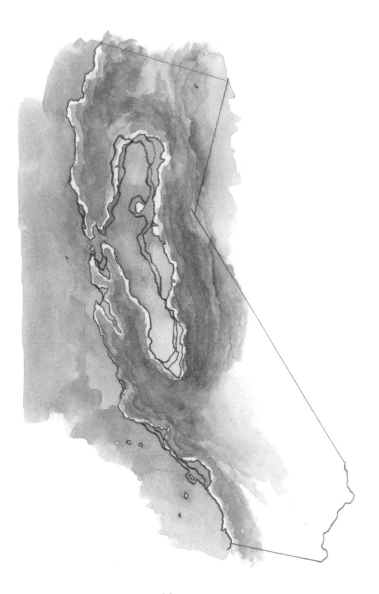

Map 10.13

## 10.13 FUTURE CALIFORNIA 002
*Unrecognizable*

Map 10.13 describes a situation where, directed by the runaway positive feedback loops of a warming earth that experiences an increase of between 4°C and 8°C over the next hundred years without the immediate curtailment of anthropogenic greenhouse gas emissions, California radically transforms: the Pacific inundates the Central Valley, the forests desiccate, the Mediterranean climate and the California Current are destroyed. This is a worst-case scenario and by no means our fate. We are grappling with the greatest conundrum that humanity has ever had to consider: Are we able to quickly redefine prosperity and veer from a carbon-based, industrialized society into a net-zero, postcarbon era in a matter of only a few decades?

The year 1776 was a very interesting one, and one worthy of consideration as we unravel the sources of our industrial conundrum. Not only was it an interesting year for humanity, being the year America declared its independence from England and established the world's first modern constitutional democracy, but it was the year when the coal-powered steam engine became commercially available, ostensibly beginning the industrial revolution. It was also the year that the Scottish economist Adam Smith published *The Wealth of Nations*, which gave us the blueprint for the free-market system.

Since that time, humanity has been profiting from the devil's deal that was made for great prosperity at nature's expense, for what will probably be only a finite period of time. Since that time, humans have been giving their lives for the carbon economy. In 2015, one in six human deaths was caused by air, water, or soil pollution brought on by industrial and consumerist activity.[56] We rationalize the horror, and we carry on thinking that while it may be the free market that got us here, it is also the free market that will save our modern lifestyle.

We stand at a beautiful and terrible crossroads. We wonder whether the energy used to create sentient life (modern humanity) is commensurate with an energy input into the biosphere that destroys the conditions for that life to exist. We wonder at the axiomatic nature of extinction as being the ultimate course of every species, and we marvel at the folly of so many of our decisions. There is more carbon in the atmosphere now than there has been in tens of millions of years, and every year we record the astonishing speed with which the world's frozen poles warm, retreat, and spill into the rising sea. New evidence suggests that if we turn off the emissions, if we will ourselves away from our plastic culture and immediately embrace a different manner of economic abundance, we may be able to avoid grim truths about what a disastrously warmed world would mean for California, the globe, and the human species.[57]

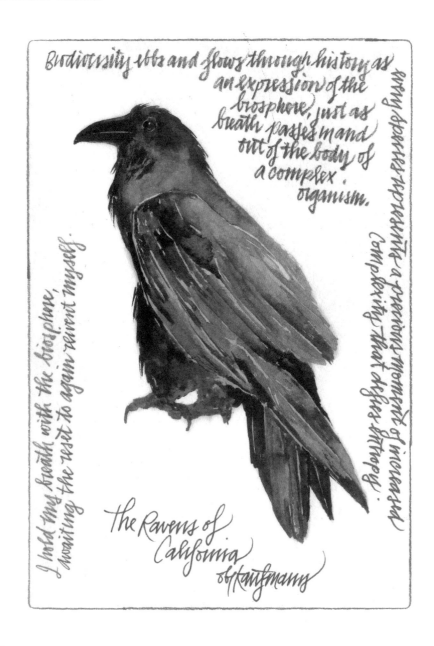

# 10. Navigating a Chaotic Sea

## Facing West, part fourteen: The innovation of memory

How we get through this next century, through the next decade, will determine the quality of our residency within the biosphere over the next several thousand years. We are going to get through this, but we are not going to get through this unchanged. Our grandchildren will see a world and be in a world much different from our own. How we treat and regard one another and the more-than-human world will be radically different. The coasts of California as they are today will not be as they will be then.

Only threads of all of this beautiful geography will exist, just as only bits of our society will continue to work for us as they did when we based economic growth on nonreplenishing resources. All of this is reflected in our relationship to our ancestors and our descendants, iterations of what has come before and what comes next. New insights will be discovered and new truths will be written, both of which often only proving what has been known all along, forgotten yet accessible: how to live in accord with the world.

The Coasts of California

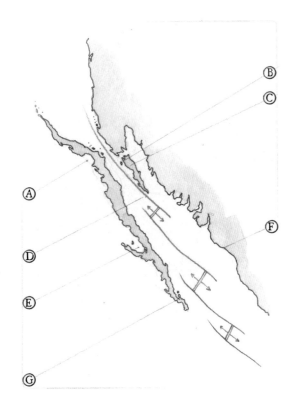

## 10.14 FUTURE CALIFORNIA 003
*Islands in deep time*

Global warming events brought on by tremendous carbon loads in the atmosphere are disastrous for many ecosystems, most acutely for marine ecosystems, but the fossil record suggests that new opportunities do arise from such calamity. During the last great warming period following the extinction of all nonavian dinosaurs, primates evolved on a much warmer earth, when there were redwoods in Greenland and tropical rain forests in Antarctica.

Map 10.14 depicts what California will look like 10 million years into the future, when the Baja peninsula becomes the island of Baja and will

have moved north to become a suburb of the archipelago of San Francisco. Ten million years is not a tremendously long time for a mammal species to survive, and it is impossible to say whether *Homo sapiens* will still exist. Given the branching speed with which hominid species in the past evolved into new iterations, it is unlikely that we will have very much in common with humanity on that time scale in the future. In all likelihood, the biosphere will be recovering from the sixth mass extinction and inventing new forms of life that we can't possibly imagine. The biodiversity on the island of Baja, the evolutionary island of California, will be bountiful, strange, and depthlessly beautiful, as it is today.

A. Los Angeles
B. San Francisco
C. The archipelago of San Francisco
D. San Andreas fault zone
E. Vizcaino Bay
F. West slope of the Sierra Nevada

---

*Facing West, part fifteen: This is where we begin*

Hope, justice, and love cannot yet be scientifically investigated as having physical qualities. Just as our own consciousness exists only in philosophical debate as something we understand to exist, we have yet to adequately invent scientific experiments to prove its objective reality, so many of our most basic convictions about our relationship to the known universe remain speculative. Science, along with humanity, remains in its infancy regarding its potential. In tomorrow's California, it is as likely as any other undeniable conclusion we arrive at that outer reality mirrors our internal feeling and that the mind of nature and the mind of our humanity are one and the same.

As our story comes to a close, as the fire has turned to dying coals and the full moon is overhead, we dream about tomorrow, hiking the coasts of California. We will count the butterflies and the wildflowers; we will explore the tide pools; we will marvel at the dolphins, otters, and seabirds; we will laugh as we run from the waves on the beach; and we will ponder with great delight what an honor it is to appreciate our precious moment here at the edge of the world.

# ACKNOWLEDGMENTS

A book like this only comes into being with patient care and consistent trust funneled from a large community toward its author. The community responsible for making it possible includes an enormous collection of family, friends, collectors, patrons, colleagues, bookstores, scientists, artists, citizens, collaborators, correspondents, volunteers, makers, and, ultimately, engaged readers like you. I must begin and probably end with my editor, Emmerich Anklam, my publisher, Steve Wasserman, and my co-designer, Ashley Ingram; along with the rest of the team at Heyday, who provide both a constant wind at my back and a channel that always manages to deftly direct my creative flood. Here I've collected a partial list of some of the professionals who have had a direct influence on making this book a reality, and to whom I am forever in debt for it.

Adina Merenlender / UC Climate Stewards

Ali Dunn / State Water Resources Control Board

Allison Titus / Laguna de Santa Rosa Foundation

Antonia Adezio / Marin Art & Garden Center

April Austin / Santa Clara Valley Audubon Society

April Higashi / Shibumi Gallery

Blake Matheson / Monterey Audubon

David Bess / CDFW Law Enforcement Division

Dillon Brook / American River Conservancy

Doug McConnell / *OpenRoad*

Dup Crosson / California Wilderness Coalition

Eamon O'Byrne / Sonoma Land Trust

Elissa Robinson / Contra Costa Resource Conservation District

Gail Taylor / UC Davis, Department of Plant Sciences

Gary Griggs / UC Santa Cruz, Earth and Planetary Sciences Department

Hilary Hodge / City of Grass Valley

Hildie Spautz / CDFW Watershed Restoration Grants Branch

Jared and Julia Drake / Wildbound PR

Acknowledgments

Jeff Depew / Friends of the River
Jess Swigonski / Wild & Scenic Film Festival
Lanny Kaufer / Herb Walks
Liebe Patterson / Blue Dot Farm
Lindsie Bear / Humboldt Area Foundation
Liv O'Keefe / California Native Plant Society
Lynn Rodriguez / Watersheds Coalition of Ventura County
Malcom Margolin / California Institute for Community, Art, and Nature
Mari Beltran / Watershed Progressive
Mark Cederborg / Hanford ARC
Mark Medeiros / Peninsula Open Space Trust
Mats Andersson / Indigofera
Matt Decker / Premium Tattoo
Matthew Shaffer / Sempervirens Fund
Michael Fried / Planet Earth Arts
Mike Splain / Ventana Wilderness Alliance
Pamela Biery / Thumbler Digital Agency
Rebecca Jung / Belvedere Tiburon Library
Redgie Collins / California Trout
Richard Miller / MindBodyHealthPolitics.org
Rodrigo Corona / Santa Lucia Conservancy
Sabrina Jacobs / KPFA Berkeley
Sara Aminzadeh / Pisces Foundation
Sarah Seiter / Exploratorium
Siobhan Cassidy / San Francisco Zen Center
Tabitha Wadsworth / Lindsay Wildlife Experience
Wade Crowfoot / California Natural Resources Agency

# GLOSSARY

**Apex predator.** An animal at the highest trophic level within an ecosystem and not prey for any natural predator.

**Aquaculture.** The rearing of aquatic animals (salmon, mollusks, crustaceans, etc.) or the cultivation of aquatic food from plants (algae).

**Autotroph.** An organism that makes its own food, most commonly through photosynthesis—i.e., plants and phytoplankton.

**Benthic.** Referring to anything associated with or occurring on the bottom of a body of water.

**Bight.** Referring to the bend in the coastline around Point Conception, responsible for an eddy effect in the California Current.

**Bioswale.** Engineered, artificial wetland habitat.

**Bottleneck.** The reduction of resources that can lead to population loss.

**Brackish.** Describes wetland habitat that contains varying levels of salinity.

**Complexity.** In systems modeling, the trend away from simplification toward emergent phenomenon and associated resiliency against disturbing agents.

**Conservation easement.** A property managed for preservation of cultural or natural value.

**Corridor.** Connective space providing migration and territorial range between habitat types.

**Disturbance.** A stressor that alters homeostasis within a system.

**Ecosystem engineer.** A species that creates habitat for a network of other species, whether through physically building that habitat (e.g., beaver) or through autogenesis (e.g., kelp), where the body of the individual organism provides habitat for other organisms.

**Endemic.** Describing a species that exists only in one region, watershed, locale, or habitat.

**Estuary.** A coastal river-mouth habitat space that is influenced by the tide.

**Eugeosyncline.** Rocks from an ancient ocean basin with a thick layer of sediment and some igneous intrusion.

**Euryhaline.** Able to tolerate different levels of water salinity.

**Fire severity.** A measure of the destructive potential inside a fire event.

**Genetic drift.** The loss of genetic diversity over time when there is a small population of animals.

# Glossary

**Glaciation.** The trapping of fresh water in the form of mountain ice during ages of global cooling.

**Inflection point.** The point at which a curved graph changes trajectory from descending to ascending, or vice versa.

**Inholding.** A property managed by a public or private agency.

**Lagoon.** An isolated, shallow body of water adjacent to the shoreline or a river mouth. A lagoon and an estuary share characteristics and differences. Whereas lagoons may receive seasonal inflows of fresh and salt water, estuaries have regular inflow of fresh water and may be influenced by the tide.

**Land trust.** A nonprofit organization that manages conservation easements and other inholdings.

**Last Glacial Maximum.** The period between 26,500 and 19,000 years ago when glacial ice sheets reached their greatest extent.

**Littoral drift.** The movement of sand, directed by tide and current, to build and destroy beaches. The California Current directs the littoral drift southward.

**Orogeny.** The process of tectonic geology that forms a mountain range.

**Osmerid.** Smelt; freshwater smelt, of the family *Osmeridae*.

**Pacific Flyway.** The migration corridor for hundreds of bird species between Alaska and Mesoamerica.

**Pangaea.** Paleozoic supercontinent.

**Pelagic.** Relating to the open sea.

**Peninsular Ranges.** Most of the generally north-to-south-running mountains in Los Angeles, Orange, and San Diego Counties; major orogenies include the Santa Ana Mountains and those ranges within the Cleveland National Forest.

**Phenology.** The study of seasonally based biological phenomena.

**Reclamation.** Usually in reference to freshwater bodies or water resources, whereby human utilization is the primary concern and involves transforming an ecosystem for resource extraction, often destroying it in the process.

**Recruitment.** A measure of successful growth from seed to plant of any given plant or tree species in a given area.

**Regime.** Any normalized pattern that exists as a rhythm of influence on an ecosystem.

**Restoration.** Managing a habitat for resiliency based on historical integrity, whether passive (removing pollution to encourage native recruitment) or active (altering the landscape and repairing ecological functionality).

# Glossary

**Rewilding.** Managed implementation of indigenous processes at scale.

**Riprap.** Installed material, such as loose stone or piling, to form a breakwater or other defensive structure within a riparian or coastal feature subject to erosion.

**Sand spit.** The barrier, attached to the shore at one end, that forms at a river mouth or some other coastal freshwater body.

**Sea stack.** A visible offshore rock or towering geologic feature suitable as a small island habitat.

**Second growth.** A forest that has grown back following timber harvest.

**Serpentine.** A mineral substrate of unique chemistry found in isolated patches of northern California and responsible for many endemic plant types.

**Simplification.** The trend toward less biodiversity.

**Stewardship.** The active management strategy when engaging a habitat space with the intent of restoring or augmenting local ecological processes.

**Stressor.** Any system input that has the potential to create a disturbance.

**Taxonomic binomial.** The two-part scientific name of a species that includes its genus and its species designation.

**Tidal prism.** The ecological area between the low and the high tide in a wetland habitat.

**Transverse Ranges.** The mountain ranges from Point Conception to San Gorgonio; major orogenies include those ranges within the Southern Los Padres National Forest and the San Gabriel and San Bernardino Ranges.

**Trophic level.** The ecological niche terraces describing predator and prey relationships in a food chain or web.

**Water column.** Any given area of space within a pelagic ecosystem.

**Watershed.** A geographical entity between ridgelines that defines a drainage-basin area.

# NOTES

Internet sources were accessed in 2020 and early 2021.

## INTRODUCTION

*1.* "Natural Diversity Database, Endangered and Threatened Animals List," California Department of Fish and Wildlife (CDFW), 2019, https://wildlife.ca.gov/Data/CNDDB/Plants-and-Animals.
*2.* "A Summary of the California Environmental Quality Act (CEQA)," CDFW, https://wildlife.ca.gov/Conservation/CEQA/Purpose.
*3.* "Natural Diversity Database, CDFW.

## 01. SYMMETRY AND SUCCESSION

*1.* I. Abrahamson, "*Arctostaphylos manzanita*," USDA Forest Service, Fire Effects Information System, 2014, https://www.fs.fed.us/database/feis/plants/shrub/arcman/all.html.
*2.* S. Yagoda, "*Pycnopodia helianthoides*," Animal Diversity Web, https://animaldiversity.org/accounts/Pycnopodia_helianthoides.
*3.* "Impacts on Kelp Forests," National Marine Sanctuaries, https://sanctuaries.noaa.gov/visit/ecosystems/kelpimpacts.html.
*4.* "Biodiversity Hotspots," Conservation International, https://www.conservation.org/priorities/biodiversity-hotspots.
*5.* B. Buma, J. Krapek, and R. Edwards, "Watershed-Scale Forest Biomass Distribution in a Perhumid Temperate Rainforest as Driven by Topographic, Soil, and Disturbance Variables," *Canadian Journal of Forest Research* 46, no. 6 (2016): 844–54, https://doi.org/10.1139/cjfr-2016-0041.
*6.* "California Floristic Province," Critical Ecosystem Partnership Fund, https://www.cepf.net/our-work/biodiversity-hotspots/california-floristic-province.
*7.* "Hotspot: California on the Edge," California Academy of Sciences, 2005, https://www.nps.gov/goga/learn/management/upload/-1214-HOTSPOT-California-On-The-Edge-1.pdf.
*8.* P. Noble and P. Renne, "Paleoenvironmental and Biostratigraphic Significance of Siliceous Microfossils of the Permo-Triassic Redding Section, Eastern Klamath Mountains, California," *Marine Micropaleontology* 15, no. 3–4 (1990): 379–91, https://doi.org/10.1016/0377-8398(90)90021-D.

Notes

9. R. Hilton, *Dinosaurs and Other Mesozoic Reptiles of California* (Berkeley: University of California Press, 2003), appendix.

10. Hilton, *Dinosaurs*, 102.

11. K. A. Schierenbeck, "Historical Processes That Shaped California," in *Phylogeography of California* (Berkeley: University of California Press, 2019), https://doi.org/10.1525 /9780520959248-003.

12. B. Peecook and C. Sidor, "The First Dinosaur from Washington State and a Review of Pacific Coast Dinosaurs from North America," *PLOS One* 10, no. 5 (2015): e0127792, https://doi.org/10.1371/journal.pone.0127792.

13. Hilton, *Dinosaurs*, 46.

14. Hilton, *Dinosaurs*, 114.

15. S. Walsh, "Middle Eocene Mammal Faunas of San Diego County, California," in *The Terrestrial Eocene-Oligocene Transition in North America*, edited by D. R. Prothero and R. J. Emry, 74–114 (Cambridge, United Kingdom: Cambridge University Press, 2013).

16. T. Nyborg and V. Santucci, *Death Valley National Park Paleontological Survey* (Lakewood, CO: National Park Service, Geological Resources Division, 1999), http://npshistory.com/publications/deva/grdtr-99-01.pdf.

17. M. Woodburne, R. Tedford, and R. Swisher, "Lithostratigraphy, Biostratigraphy, and Geochronology of the Barstow Formation, Mojave Desert, Southern California," *Geological Society of America Bulletin* 102, no. 4 (1990): 459–77, https://doi .org/10.1130/0016-7606(1990)102<0459:LBAGOT>2.3.CO;2.

18. C. Bell, E. Lundelius, A. Barnosky, R. Graham, E. Lindsay, E. Ruez, H. Semkem, et al., "The Blancan, Irvingtonian, and Rancholabrean Mammal Ages," in *Late Cretaceous and Cenozoic Mammals of North America: Biostratigraphy and Geochronology*, edited by M. O. Woodburne, 232–314 (New York: Columbia University Press, 2004).

19. P. Remeika, I. W. Fischbein, and S. A. Fischbein, "Lower Pliocene Petrified Wood from the Palm Spring Formation, Anza Borrego Desert State Park, California," *Review of Palaeobotany and Palynology* 56, no. 3–4 (1988): 183–98, https://doi.org/10.1016 /0034-6667(88)90057-7.

20. S. F. Cook, S. T. Brooks, and H. E. Ezra-Cohn, "Histological Studies on Fossil Bone," *Journal of Paleontology* 36, no. 3 (1962): 483–94, https://www.jstor.org /stable/1301081.

21. Bell et al., "Blancan, Irvingtonian, and Rancholebraen Mammal Ages."

22. J. Johnson, T. Stafford, H. Ajie, and D. Morris, "Arlington Springs Revisited," in *Proceedings of the Fifth California Islands Symposium*, vol. 2, edited by D. R. Browne, K. L. Mitchell, and H. W. Chaney, 541–45 (Santa Barbara, CA: Santa Barbara Museum of Natural History, 2002).

23. S. M. Fitzpatrick, T. C. Rick, and J. M. Erlandson, "Recent Progress, Trends, and Developments in Island and Coastal Archaeology," *Journal of Island and Coastal Archaeology* 10, no. 1 (2015): 3–27, https://doi.org/10.1080/15564894.2015.1013647.

24. M. R. Waters and T. W. Stafford Jr., "Redefining the Age of Clovis: Implications for the Peopling of the Americas," *Science* 315, no. 5815 (2007):1122–26, https://doi.org/10.1126/science.1137166.

25. L. Raab and T. Jones, "The Rediscovery of California Prehistory," in *Prehistoric California: Archaeology and the Myth of Paradise*, edited by L. Raab and T. Jones, 1–10 (Salt Lake City: University of Utah Press, 2004).

26. T. Blackburn and K. Anderson, *Before the Wilderness: Environmental Management by Native Californians* (Menlo Park, CA: Ballena Press, 1993).

27. S. Stine, "Extreme and Persistent Drought in California and Patagonia during Mediaeval Time," *Nature* 369 (1994): 546–49, https://doi.org/10.1038/369546a0.

28. S. Stephens, R. Martin, and N. Clinton, "Prehistoric Fire Area and Emissions from California's Forests, Woodlands, Shrublands, and Grasslands," *Forest Ecology and Management* 251, no. 3 (2007): 205–16, https://doi.org/10.1016/j.foreco.2007.06.005.

29. "A Roadmap for Protecting the State's Natural Heritage," California Biodiversity Initiative, 2018, https://www.californiabiodiversityinitiative.org/pdf/california-biodiversity-action-plan.pdf.

30. "Building a Network of Restored Habitat in the Klamath River Watershed," NOAA Fisheries, October 23, 2020, https://www.fisheries.noaa.gov/feature-story/building-network-restored-habitat-klamath-river-watershed.

31. "Snowy Plovers at Point Reyes," in "Point Reyes National Seashore California," National Park Service, https://www.nps.gov/pore/learn/nature/birds_snowyplover.htm.

32. "Western Snowy Plover: *Charadrius nivosus nivosus*," US Fish and Wildlife Service, Arcata Fish and Wildlife Office, https://www.fws.gov/arcata/es/birds/wsp/plover.html.

33. "2019 Snowy Plover Breeding Season Underway at Point Reyes," National Park Service, https://www.nps.gov/articles/2019-snowy-plover-breeding-season-underway-at-point-reyes.htm.

34. M. Singh, "Delta Smelt: The Tiny Fish Caught in California's War with Trump," *Guardian*, December 22, 2019, https://www.theguardian.com/environment/2019/dec/22/delta-smelt-fish-trump-california-aoe.

35. D. B. Marshall, "Status of the Marbled Murrelet in North America: With Special Emphasis on Populations in California, Oregon, and Washington" (Washington, DC: US Department of the Interior, Fish and Wildlife Service, 1988), https://apps.dtic.mil/dtic/tr/fulltext/u2/a322715.pdf.

36. P. Halbert and S. Singer, eds., *Marbled Murrelet Landscape Management Plan for Zone 6* (Felton: California Department of Parks and Recreation, Santa Cruz District, 2017), https://www.parks.ca.gov/pages/29882/files/Z6-Plan_FINAL_MASTER_V14_07-17.pdf.

37. "Drought Stressor Monitoring Case Study: Santa Cruz Long-toed Salamander Survival Monitoring," California Department of Fish and Wildlife, https://wildlife.ca.gov/Drought/Projects/Santa-Cruz-Long-toed-Salamander.

Notes

38. "California Condor Recovery Program: 2019 Annual Population Status," US Fish and Wildlife Service, https://www.fws.gov/cno/es/calcondor/PDF_files/2020/2019_California_Condor_Population_Status.pdf.

39. E. Pelton, "Monarch Population in California Spirals to Another Record Low," Xerces Society for Invertebrate Conservation, November 30, 2020, https://xerces.org/blog/monarch-population-in-california-spirals-to-another-record-low.

40. "Mountain Lions in California," California Department of Fish and Wildlife, https://wildlife.ca.gov/Conservation/Mammals/Mountain-Lion.

41. "Mountain Lions in the State of California," Mountain Lion Foundation, https://mountainlion.org/us/california.

42. A. M. Phillips, "As U.N. Warns of Widespread Extinction, California Is Already Losing Species," *Los Angeles Times*, May 7, 2019, https://www.latimes.com/politics/la-na-pol-california-united-nations-extinction-report-20190507-story.html.

43. "Wildlife Crossing at Liberty Canyon," Resource Conservation District of the Santa Monica Mountains, https://www.rcdsmm.org/what-we-do/wildlife-crossing-at-liberty-canyon.

44. "Endangered Species Facts: Tidewater Goby, *Eucyclogobius newberryi*," Environmental Protection Agency, https://www.epa.gov/sites/production/files/2013-08/documents/tidewater-goby.pdf.

45. "Tidewater Goby, *Eucyclogobius newberryi*," US Fish and Wildlife Service, Arcata Fish and Wildlife Office, https://www.fws.gov/arcata/es/fish/goby/goby.html.

## 02. FAULT-LINE SYMPHONY

1. G. Griggs, K. Patsch, and L. Savoy, eds., *Living with the Changing California Coast* (Berkeley: University of California Press, 2005), 14.

2. J. E. Tierney, J. Zhu, J. King, S. B. Malevich, G. J. Hakim, and C. J. Poulsen, "Glacial Cooling and Climate Sensitivity Revisited," *Nature* 584 (2020): 569–73, http://doi.org/10.1038/s41586-020-2617-x.

3. "Farallon Plate," United States Geological Survey, May 5, 1999, https://pubs.usgs.gov/gip/dynamic/Farallon.html.

4. A. Mulch, S. Graham, and P. Chamberlain, "Hydrogen Isotopes in Eocene River Gravels and Paleoelevation of the Sierra Nevada," *Science* 313, no. 5783 (2006): 87–89, http://doi.org/10.1126/science.1125986.

5. G. Slack, "Voice of the Volcano," *Bay Nature*, April 1, 2005, https://baynature.org/article/voice-of-the-volcano.

6. B. P. Luyendyk, M. Kamerling, and R. Terres, "Geometric Model for Neogene Crustal Rotations in Southern California," *GSA Bulletin* 91, no. 4 (1980): 211–17, http://doi.org/10.1130/0016-7606(1980)91%3C211:GMFNCR%3E2.0.CO;2.

7. W. J. Nokleberg, D. L. Jones, and N. J. Silberling, "Origin and Tectonic Evolution of the Maclaren and Wrangellia Terranes, Eastern Alaska Range, Alaska," *Geological Society of America Bulletin* 96, no. 10 (1985): 1251–70, http://doi.org/10.1130/0016-7606(1985)96<1251:OATEOT>2.0.CO;2.

8. S. Israel, L. Bernanek, R. Friedman, M. Richard, and J. Crowley, "New Ties between the Alexander Terrane and Wrangellia and Implications for North America Cordilleran Evolution," *Lithosphere* 6, no. 4 (2014), 270–76, http://doi.org/10.1130/L364.1.

9. P. L. Smith and T. Howard, "Plate Tectonics and Paleobiogeography: Early Jurassic (Pliensbachian) Endemism and Diversity," *PALAIOS* 1, no. 4 (1986): 399–412, http://doi.org/10.2307/3514477.

10. E. Centeno-Garcia, M. Guerrero-Suastegui, and O. Talavera-Mendoza, "The Guerrero Composite Terrane of Western Mexico: Collision and Subsequent Rifting in a Supra-Subduction Zone," in *Formation and Applications of the Sedimentary Record in Arc Collision Zones*, edited by A. E. Draut, P. D. Clift, and D. W. Scholl (Boulder, CO: Geological Society of America, 2008), http://doi.org/10.1130/2008.2436(13).

11. M. G. Wilmarth, "Selected Geologic Names Committee Remarks (ca. 1930) on Rocks of California," in *Lexicon of Geologic Names of the United States (Including Alaska)*, edited by M. G. Wilmarth (Washington, DC: United States Geological Survey, 1938), http://doi.org/10.3133/b896.

12. D. D. Alt and D. W. Hyndman, *Roadside Geology of Northern and Central California* (Missoula, MT: Mountain Press, 2000), 176.

13. "California Earthquake Risk Map and Faults by County," California Earthquake Authority, https://www.earthquakeauthority.com/California-Earthquake-Risk/Faults-By-County.

14. R. W. Durrenberger with R. B. Johnson, *California Patterns in the Land* (Palo Alto, CA: Mayfield, 1976).

15. S. S. Schulz and R. E. Wallace, "The San Andreas Fault," United States Geological Survey, November 30, 2016, https://pubs.usgs.gov/gip/earthq3/safaultgip.html.

16. C. Smith, "Abstract and Bio," Census of Diversity of Abyssal Marine Life (CeDAMar), Office of Ocean Exploration & Research, National Oceanic and Atmospheric Administration.

17. L. A. Levin and G. W. Rouse, "Giant Protists (Xenophyophores) Function as Fish Nurseries," *Ecology* 101, no. 4 (2020): e02933, http://doi.org/10.1002/ecy.2933.

18. "The Living Ocean," *NASA Science*, https://science.nasa.gov/earth-science/oceanography/living-ocean.

19. "Exploring California's Seamounts," Marine Conservation Institute, June 17, 2020, https://storymaps.arcgis.com/stories/8315a3654bce41bfbf4704f4f74a1a06.

20. K. Stocks and P. Hart, "Biogeography and Biodiversity of Seamounts," in *Seamounts: Ecology, Fisheries, and Conservation* (Hoboken, NJ: Blackwell, 2007), 255–81.

21. S. Georgian, "Gumdrop and Pioneer Seamounts—Offshore Seabird Havens,"

Mission Blue Sylvia Earle Alliance, April 17, 2019, https://mission-blue.org/2019/04/gumdrop-and-pioneer-seamounts-offshore-seabird-havens.

22. E. J. Burton and L. Lundsten, *Davidson Seamount Taxonomic Guide*, Office of National Marine Sanctuaries, December 2008, https://sanctuaries.noaa.gov/science/conservation/taxonomic.html.

23. T. E. Chase, P. Wilde, W. R. Normark, G. I. Evenden, C. P. Miller, B. A. Seekins, J. D. Young, et al., "Map Showing Bottom Topography of the Pacific Continental Margin, Cape Mendocino to Point Conception," US Geological Survey, 1992, https://pubs.usgs.gov/imap/2090/c/images/i2090c.pdf.

24. C. K. Paull, R. Gwizada, and E. Lundsten, "Monterey Canyon: Stunning Deep-Sea Topography Revealed," Monterey Bay Aquarium Research Institute, https://www.mbari.org/science/seafloor-processes/geological-changes/mapping-sections.

25. Durrenberger with Johnson, *California Patterns*.

26. P. Stoffer, "Rocks and Geology in the San Francisco Bay Region," US Geological Survey, Bulletin 2195 (2002), http://doi.org/10.3133/b2195.

27. J. Maxson, "Geology of the Western Siskiyou Mountains," PhD dissertation, California Institute of Technology, 1931, http://doi.org/10.7907/D9XJ-NG92.

28. W. Irwin and E. Mankinen, "Rotational and Accretionary Evolution of the Klamath Mountain, California and Oregon, from Devonian to Present Time," US Geological Survey, open-file report 98-114 (1998), http://doi.org/10.3133/ofr98114.

29. B. Schneider, E. Moores, J. Moores, M. Hoshovsky, and P. Schiffman, *Exploring the Berryessa Region* (Bayside, CA: Backcountry Press, 2020), 26.

30. D. Sweetkind, J. Rytuba, V. Langenheim, and R. Fleck, "Geology and Geochemistry of Volcanic Centers within the Eastern Half of the Sonoma Volcanic Field, Northern San Francisco Bay Region, California," *Geosphere* 7, no. 3 (2011): 629-57, http://doi.org/10.1130/GES00625.1.

31. K. Than, "The Hidden Hazards of the Santa Cruz Mountains," *Stanford Earth*, November 18, 2013, https://pangea.stanford.edu/news/hidden-hazard-santa-cruz-mountains.

32. "Santa Monica Mountains, Geologic History," National Park Service, https://www.nps.gov/samo/learn/nature/geologicformations.htm.

33. American Association of Petroleum Geologists, "Brief Description of the Geology of the Santa Ana Mountains," in *Geologic Guide of San Onofre Nuclear Generating Station and Adjacent Regions of Southern California* (Thousand Oaks, CA: Pacific Station AAPG, 1979), C-5-C-7.

## 03. ELEMENTAL RHYTHMS

1. T. Garrison, *Oceanography: An Invitation to Marine Science*, 6th ed. (Belmont: Thomson Brooks/Cole, 2007), 298.

2. "Equator," *National Geographic*, https://www.nationalgeographic.org/encyclopedia/equator.

3. "Tides and Water Levels," National Oceanic and Atmospheric Administration, https://oceanservice.noaa.gov/education/tutorial_tides/welcome.html.

4. "Tsunamis," National Oceanic and Atmospheric Administration, https://www.noaa.gov/education/resource-collections/ocean-coasts/tsunamis.

5. "Tsunami," California Department of Conservation, https://www.conservation.ca.gov/cgs/tsunami.

6. J. R. Petit, J. Jouzel, D. Raynaud, N. I. Barkov, J.-M. Barnola, I. Basile, M. Bender, et al., "Climate and Atmospheric History of the Past 420,000 Years from the Vostok Ice Core, Antarctica," *Nature* 399 (1999): 429–36, https://doi.org/10.1038/20859.

7. I. Schroeder, B. Black, W. Sydeman, S. Bograd, E. Hazen, J. Santora, and B. Wells, "The North Pacific High and Wintertime Pre-Conditioning of California Current Productivity," *Geophysical Research Letters* 40, no. 3 (2013): 541–46, https://doi.org/10.1002/grl.50100.

8. Schroeder et al., "North Pacific High."

9. B. Robison, R. Sherlock, and K. Reisenbichler, "The Bathypelagic Community of Monterey Canyon," *Deep Sea Research Part II: Topical Studies in Oceanography*, no. 16 (2010): 1551–56, https://doi.org/10.1016/j.dsr2.2010.02.021.

10. J. Zwolinski, K. Demer, G. Byers, J. Cutter, T. Sessions, and B. Macewicz, "Distributions and Abundances of Pacific Sardine (*Sardinope sgax*) and Other Pelagic Fishes in the California Current Ecosystem during 2006, 2008, and 2010, Estimated from Acoustic-Trawl Surveys," *Fishery Bulletin* 110, no. 1 (2012): 110–22, https://spo.nmfs.noaa.gov/sites/default/files/zwolinski.pdf.

11. R. D. Brodeur, W. G. Pearcy, and S. Ralston, "Abundance and Distribution Patterns of Nekton and Micronekton in the Northern California Current Transition Zone," *Journal of Oceanography* 59 (2003): 515–35, https://doi.org/10.1023/A:1025548801541.

12. L. D. Zeidberg, W. M. Hamner, N. P. Nezlin, and A. Henry, "The Fishery for California Market Squid, *Loligo Opalescens* (*Cephalopoda myopsida*), from 1981 through 2003." *Fishery Bulletin* 104 (2006): 46–59, https://spo.nmfs.noaa.gov/sites/default/files/pdf-content/2006/1041/zeidberg.pdf.

13. J. Mauchline and J. Gordon, "Oceanic Pelagic Prey of Benthopelagic Fish in the Benthic Boundary Layer of a Marginal Oceanic Region," *Marine Ecology Progress Series* 74, no. 2/3 (1991): 109–15, https://www.jstor.org/stable/24825817.

14. H. A. Mooney and E. Zavaleta, eds., *Ecosystems of California* (Berkeley: University of California Press, 2016), 292–93.

15. L. Osborn, "Ocean Temperatures across the California Coast in Summer," 2021, https://www.currentresults.com/Oceans/Temperature/pacific-ocean-temperature-california-summer.php.

16. E. Rasmussen and T. Carpenter, "Variations in Tropical Sea Surface Temperature and Surface Wind Fields Associated with the Southern Oscillation/El Niño," *Monthly*

*Weather Review* 110, no. 5 (1982): 354–84. https://doi.org/10.1175/1520-0493(1982)110<0354:VITSST>2.0.CO;2.

17. S. Philander, *El Niño, La Niña, and the Southern Oscillation* (San Diego, CA: Academic Press, 1990).

18. National Oceanic and Atmospheric Administration, "El Niño/Southern Oscillation (ENSO) Diagnostic Discussion," NOAA National Weather Service Climate Prediction Center, March 5, 2015, https://www.cpc.ncep.noaa.gov/products/analysis_monitoring/enso_disc_mar2015/ensodisc.html.

19. K. Redmond and R. Koch, "Surface Climate and Streamflow Variability in the Western United States and Their Relationship to Large-Scale Circulation Indices," *Water Resources Research* 27, no. 9 (1991): 2381–99, https://doi.org/10.1029/91WR00690.

20. J. R. King, V. N. Agostini, C. J. Harvey, G. A. McFarlane, M. G. G. Foreman, J. E. Overland, E. Di Lorenzo, et al., "Climate Forcing and the California Current Ecosystem," *ICES Journal of Marine Science* 68, no. 6 (2011): 1199–216, https://doi.org/10.1093/icesjms/fsr009.

21. R. R. Rykaczewski and D. M. Checkley Jr., "Influence of Ocean Winds on the Pelagic Ecosystem in Upwelling Regions," *Proceedings of the National Academy of Sciences* 105, no. 6 (2015): 1965–70, https://doi.org/10.1073/pnas.0711777105.

22. N. Diffenbaugh, M. Snyder, and L. Sloan, "Could $CO_2$-Induced Land-Cover Feedbacks Alter Near-Shore Upwelling Regimes?" *Proceeding of the National Academy of Sciences* 101, no. 1 (2004): 27–32, https://doi.org/10.1073/pnas.0305746101.

23. D. A. Koweek, C. Garcia-Sanchez, P. G. Brodrick, P. Gassett, and K. Caldeira, "Evaluating Hypoxia Alleviation through Induced Downwelling," *Science of the Total Environment* 719, 1 June 2020 (2020), https://doi.org/10.1016/j.scitotenv.2020.137334.

24. X. Canbo, W. Fan, Y. Qiang, Z. Xu, P. Yiwen, and C. Ying, "A Tidal Pump for Artificial Downwelling: Theory and Experiment," *Ocean Engineering* 151 (March 1, 2018): 93–104. https://doi.org/10.1016/j.oceaneng.2017.12.066.

25. "Chlorophyll along U.S. West Coast," NASA Earth Observatory, https://earthobservatory.nasa.gov/images/14015/chlorophyll-along-us-west-coast.

26. "Upwelling on the Central California Coast," Sanctuary Integrated Monitoring Network, July 17, 2004, https://sanctuarysimon.org/2004/07/upwelling-on-the-central-california-coast.

27. B. Buhler, "What Lurks Beneath," *Bay Nature*, February 8, 2016, https://baynature.org/article/what-lurks-beneath.

28. A. Thomas, R. Mendelssohn, and R. Weatherbee, "Background Trends in California Current Surface Chlorophyll Concentrations: A State-Space View," *Journal of Geophysical Research Oceans* 118, no. 10 (2013): 5296–311, https://doi.org/10.1002/jgrc.20365.

29. D. Hornbeck and P. Kane, *California Patterns: A Geographical and Historical Atlas* (Mountain View, CA: Mayfield, 1983).

30. A. Borunda, "'Rivers in the Sky' Are Why California Is Flooding," *National Geographic*, March 1, 2019, https://www.nationalgeographic.com/environment/2019/03/atmospheric-river-flood-rain-california-explainer.

31. F. M. Ralph, P. J. Newman, G. A. Wick, S. I. Gutman, M. D. Dettinger, D. R. Cayan, and A. B. White, "Flooding on California's Russian River: Role of Atmospheric Rivers," *Geophysical Research Letters* 33, no. 13 (2006): 285–301, https://doi.org/10.1029/2006GL026689.

32. R. Beatty, "The Definition of the Mediterranean Climate: A Californian Perspective," Gardening in Mediterranean Climates Worldwide, http://www.gimcw.org/climate/definition_CA_RussBeatty.cfm.

33. M. Blumler, "Three Conflated Definitions of Mediterranean Climates," *Middle States Geographer* 38 (2005): 52–60, http://msaag.aag.org/wp-content/uploads/2013/05/8-Blumler.pdf.

34. J. Johnstone and T. Dawson, "Climatic Context and Ecological Implications of Summer Fog Decline in the Coast Redwood Region," *Proceedings of the National Academy of Sciences* 107, no. 10 (2010): 4533–38, https://doi.org/10.1073/pnas.0915062107.

35. "GRACE: California Central Valley," American Museum of Natural History, https://www.amnh.org/learn-teach/curriculum-collections/grace/grace-tracking-water-from-space/california-central-valley.

36. D. DiPietro, "Overview of Projected Change in the California Central Valley," California Landscape Conservation Partnership, July 2017, http://climate.calcommons.org/article/central-valley-change.

37. A. Sheeler, "Central Valley Could See More 'Dangerously Hot' Days from Climate Change. Here's How Many," *Sacramento Bee*, July 16, 2019, https://www.sacbee.com/news/local/environment/article232733222.html.

38. "California Coastal Steppe, Mixed Forest, and Redwood Forest Province," US Forest Service, https://www.fs.fed.us/land/ecosysmgmt/colorimagemap/images/263.html.

39. Johnstone and Dawson, "Climatic Context."

40. R. Butz, S. Sawyer, and H. Safford, *A Summary of Current Trends and Probable Future Trends in Climate and Climate-Driven Processes for the Mendocino National Forest*, USDA Forest Service report, 2015, https://doi.org/10.13140/RG.2.1.3496.9123.

41. M. B. Kirkham, *Principles of Soil and Plant Water Relations*, 2nd ed. (New York: Academic Press, 2014), 501–14.

42. Y. Liu, P. Di, S. Chen, X. Chen, J. Fan, J. DaMassa, and J. Avise, "Climatology of Diablo Winds in Northern California and Their Relationships with Large-Scale Climate Variabilities," *Climate Dynamics* 56 (2020): 1335–56, https://doi.org/10.1007/s00382-020-05535-5.

43. "JetStream Max: Addition Köppen-Geiger Climate Subdivisions," National Weather Service, https://www.weather.gov/jetstream/climate_max.

44. C. Potter, "Understanding Climate Change on the California Coast: Accounting for Extreme Daily Events among Long-Term Trends," *Climate* 2, no. 1 (2014): 18–27, https://doi.org/10.3390/cli2010018.

45. "California Phenology Project," National Phenology Network, https://cpp.usanpn.org.

46. F. Sun, D. Walton, and A. Hall, "A Hybrid Dynamical–Statistical Downscaling Technique. Part II: End-of-Century Warming Projections Predict a New Climate State in the Los Angeles Region," *Journal of Climate* 28, no. 12 (2015): 4618–36, https://doi.org/10.1175/JCLI-D-14-00197.1.

47. "Climate—San Diego, California," World Climate Guide, https://www.climatestotravel.com/climate/united-states/san-diego.

48. "Climate Change and Regional Planning," University of California, San Diego, https://www.sandiego.edu/soles/hub-nonprofit/initiatives/dashboard/climate-impacts.php.

49. "Precipitation," California Office of Environmental Hazards, https://oehha.ca.gov/epic/changes-climate/precipitation.

50. M. Dettinger, M. Ralph, T. Das, and P. Neiman, "Atmospheric Rivers, Floods and the Water Resources of California," *Water* 3, no. 2 (2011): 1102–16, https://doi.org/10.3390/w3020445.

51. "Observed Precipitation," NOAA California Nevada River Forecast Center, https://www.cnrfc.noaa.gov/rainfall_data.php.

52. P. Duginski, "Diablo Winds Can Feed Northern California Fires. Here's How They Form," *Los Angeles Times*, October 24, 2019, https://www.latimes.com/california/story/2019-10-24/what-are-diablo-winds.

53. A. Vaziri, "The Diablo Winds Are Coming. California Fires Could Get Even Worse When They Do," *San Francisco Chronicle*, September 30, 2020, https://www.sfchronicle.com/california-wildfires/article/California-wildfires-are-devastating-Diablo-15607783.php.

54. C. Burt, "Big Winds in the West, Possible Wind Gust Record in California," Weather Underground, December 2, 2011, https://www.wunderground.com/blog/weatherhistorian/big-winds-in-the-west-possible-wind-gust-record-in-california.html.

55. J. Guzman-Morales and A. Gershunov, "Climate Change Suppresses Santa Ana Winds of Southern California and Sharpens Their Seasonality," *Geophysical Research Letters* 46, no. 5 (2019): 2772–80, https://doi.org/10.1029/2018GL080261.

56. M. Hayes and M. Warner, "Wildfires Rage in Northern California," CNN, August 20, 2020, https://www.cnn.com/us/live-news/california-wildfires-08-19-2020/index.html.

57. C. Kaur, "California Fire Is Now a 'Gigafire,' a Rare Designation for a Blaze That Burns at Least a Million Acres," CNN, October 6, 2020, https://www.cnn.com/2020/10/06/us/gigafire-california-august-complex-trnd/index.html.

58. A. P. Williams, J. T. Abatzoglou, A. Gershunov, J. Guzman-Morales, and D. A. Bishop, "Observed Impacts of Anthropogenic Climate Change on Wildfire in California," *Earth's Future* 7, no. 8 (2019): 892–910, https://doi.org/10.1029/2019EF001210.

59. H. Safford and K. Van de Water, "Using Fire Return Interval Departure (FRID) Analysis to Map Spatial and Temporal Changes in Fire Frequency on National Forest Lands in California," US Forest Service, research paper PSW-RP-266, 2014, https://doi.org/10.2737/PSW-RP-266.

60. "Type Conversion—The Impact of Excessive Fire," California Chaparral Institute, https://www.californiachaparral.org/threats/too-much-fire.

61. A. Taylor and C. Skinner, "Fire History and Landscape Dynamics in a Late-Successional Reserve in the Klamath Mountains, California, USA," *Forest Ecology and Management* 111, no. 2–3 (1998): 285–301, https://doi.org/10.1016/S0378-1127(98)00342-9.

62. J. Stuart, "Fire History of an Old-Growth Forest of *Sequoia sempervirens* (Taxodiaceae)," *Madroño* 34, no. 2 (1987): 128–41, https://www.jstor.org/stable/41424623.

63. "Fire in Chaparral Ecosystems," US Forest Service, https://www.fs.fed.us/psw/topics/fire_science/ecosystems/chaparral.shtml.

64. J. Greenlee and J. Langenheim, "Historic Fire Regimes and Their Relation to Vegetation Patterns in the Monterey Bay Area of California," *American Midland Naturalist* 124, no. 2 (1990): 239–53, https://doi.org/10.2307/2426173.

65. "Fire in Our Region," Los Padres Forest Watch, https://lpfw.org/fire.

66. M. Wells, J. O'Leary, J. Franklin, J. Michaelsen, and D. E. McKinsey, "Variations in a Regional Fire Regime Related to Vegetation Type in San Diego County, California," *Landscape Ecology* 19 (2004): 139–52, https://doi.org/10.1023/B:LAND.0000021713.81489.a7.

67. K. McKelvey and K. Busse, "Twentieth Century Fire Patterns on Forest Service Lands," in *Sierra Nevada Ecosystem Project: Final Report to Congress, vol. 2, Assessments and Scientific Basis for Management Options* (Davis: University of California, Centers for Water and Wildland Resources, 1996).

68. "Chart: 14 of California's 20 Largest Wildfires Burned since 2000," Climate Signals, https://www.climatesignals.org/resources/chart-14-californias-20-largest-wildfires-burned-2000.

69. F. K. Lake, "Trails, Fires and Tribulations: Tribal Resource Management and Research Issues in Northern California," *Occasion: Interdisciplinary Studies in the Humanities* 5 (2013), https://arcade.stanford.edu/sites/default/files/article_pdfs/OCCASION_v05i01_Lake_050613_0.pdf.

## 04. SAND AND RIVERS

1. D. R. Cayan, P. D. Bromirski, K. Hayhoe, M. Tyree, M. D. Dettinger, and R. E. Flick, "Climate Change Projections of Sea Level Extremes along the California Coast," *Climatic Change* 87 (2008): 57–73, https://doi.org/10.1007/s10584-007-9376-7.

Notes

2. "What Is an Estuary?" California Department of Water Resources, https://emp.baydeltalive.com/wiki/13265.

3. L. S. Brophy, C. Greene, V. Hare, B. Holycross, A. Lanier, W. Heady, K. O'Connor, et al., "Insights into Estuary Habitat Loss in the Western United States Using a New Method for Mapping Maximum Extent of Tidal Wetlands," *PLOS One* 14, no. 8 (2019): e0218558, https://doi.org/10.1371/journal.pone.0218558.

4. D. W. Pritchard, "What Is an Estuary: Physical Viewpoint," in *Estuaries* (Washington, DC: American Association for the Advancement of Science, 1967), 3–5.

5. S. V. Smith, R. M. Chambers, and J. T. Hollibaugh, "Dissolved and Particulate Nutrient Transport through a Coastal Watershed Estuary," *Journal of Hydrology* 176, no. 1–4 (1996): 181–203, https://doi.org/10.1016/0022-1694(95)02781-5.

6. W. N. Heady, K. O'Connor, J. Kassakian, K. Doiron, C. Endris, D. Hudgens, R. Clark, et al., *An Inventory and Classification of U.S. West Coast Estuaries* (Arlington, VA: Nature Conservancy).

7. G. Griggs, K. Patsch, and L. Savoy, eds., *Living with the Changing California Coast* (Berkeley: University of California Press, 2005), 15.

8. "What Is a Watershed?" Santa Cruz Mountains Bioregional Council, http://www.scmbc.org/what-is-a-watershed.

9. V. Cabello, B. Willaarts, M. Aguilar, and L. del Moral, "River Basins as Social-Ecological Systems: Linking Levels of Societal and Ecosystem Water Metabolism in a Semiarid Watershed," *Ecology and Society* 20, no. 3 (2015): 20, https://doi.org/10.5751/ES-07778-200320.

10. "Open Ocean," Oceana International, https://oceana.org/marine-life/marine-science-and-ecosystems/open-ocean.

11. S. Gaines and S. Airame, "Upwelling," National Oceanic Atmospheric Administration, 2018, http://oceanexplorer.noaa.gov/explorations/02quest/background/upwelling/upwelling.html.

12. "Open Ocean: MBNMS," Sanctuary Integrated Monitoring Network, https://sanctuarysimon.org/monterey-bay-nms/open-ocean.

13. M. Margolin, *The Ohlone Way* (Berkeley, CA: Heyday, 1978).

14. "Bay Formation," in *The Bay Model Journey*, US Army Corps of Engineers, https://www.spn.usace.army.mil/Missions/Recreation/Bay-Model-Visitor-Center/The-Bay-Model-Journey/Bay-Formation.

15. A. A. Whipple, R. M. Grossinger, D. Rankin, B. Stanford, and R. A. Askevoid, *Sacramento–San Joaquin Delta Historical Ecology Investigation: Exploring Patterns and Process* (Richmond, CA: San Francisco Estuary Institute—Aquatic Science Center, 2012).

16. "San Francisco Bay Estuary," San Francisco Bay Development and Conservation Division, https://www.bcdc.ca.gov/bay_estuary.html.

17. A. Okamoto, "Reflowing the Sierra to the Sea," *Estuary News*, December 2018, https://www.sfestuary.org/estuary-news-reflowing-sierra-to-sea.

18. B. F. Atwater, "Distribution of Vascular-Plant Species in Six Remnants of Intertidal Wetland of the Sacramento–San Joaquin Delta, California," United States Geological Survey, open-file report 80-883 (1980), https://doi.org/10.3133/ofr80883.

19. P. Fimrite, "New Maps Show How Little Is Left of West Coast Estuaries," *San Francisco Chronicle*, August 17, 2019, https://www.sfchronicle.com/environment/article/New-maps-show-how-little-is-left-of-West-Coast-14339398.php.

20. M. Graham, B. Halpern, and M. Carr, "Diversity and Dynamics of Californian Subtidal Kelp Forests," in *Food Webs and the Dynamics of Marine Benthic Ecosystems*, edited by T. R. McLanahan and G. R. Branch (Oxford: Oxford University Press, 2008), https://doi.org/10.1093/acprof:oso/9780195319958.003.0005.

21. W. Leet, C. Dewees, R. Klingbeil, and E. Larson, eds., *California's Living Marine Resources: A Status Report* (Sacramento: California Department of Fish and Wildlife, 2001), 536.

22. "Sea Otter," Defenders of Wildlife, https://defenders.org/wildlife/sea-otter.

23. "Geologic Activity," in "Point Reyes National Seashore," National Park Service, https://www.nps.gov/pore/learn/nature/geologicactivity.htm.

24. "Fog," *Science Daily*, https://www.sciencedaily.com/terms/fog.

25. J. Evens, "Crowning Glories: Celebrating the Landscapes of Point Reyes," *Bay Nature*, 2012, https://baynature.org/product/crowning-glories-celebrating-the-landscapes-of-point-reyes.

26. "Coastal Dune Habitat Restoration Projects: Why Is Dune Restoration Important?," in "Point Reyes National Seashore," National Park Service, February 28, 2015, https://www.nps.gov/pore/learn/management/planning_dunerestoration_importance.htm.

27. A. Alden, "Finding Stories in a Few Grains of Northern California Beach Sand," *Bay Nature*, July 2016, https://baynature.org/article/stories-in-sand.

28. M. Slagel and G. Griggs, "Cumulative Losses of Sand to the California Coast by Dam Impoundment," *Journal of Coastal Research* 24, no. 3 (2008): 571–84, https://doi.org/10.2112/06-0640.1.

29. Griggs et al., *Changing California Coast*, 51.

30. B. Cowan, "Protecting and Restoring Native Dune Plants," *Fremontia* 3, no. 2 (1975): 3–7.

31. M. G. Barbour, M. Theodore, and A. F. Johnson, "Synecology of Beach Vegetation along the Pacific Coast of the United States of America: A First Approximation," *Journal of Biogeography* 3, no. 1 (1976): 55–69, https://doi.org/10.2307/3038099.

32. "Beach Grass," in "Redwood National and State Parks," National Park Service, http://www.nps.gov/redw/beach-gr.htm.

33. "Menzies's Wallflower (*Erysimum menziesii*)," US Fish and Wildlife Service Environmental Conservation Online System, https://ecos.fws.gov/ecp/species/2935.

34. "Nipomo Mesa Lupine," California Department of Fish and Wildlife, https://wildlife.ca.gov/Conservation/Plants/Endangered/Lupinus-nipomensis.

35. "Sand Dunes," in "Golden Gate National Recreation Area," National Park Service, https://www.nps.gov/goga/learn/nature/sanddunes.htm.

36. "Liquefaction Hazard Maps," Earthquake Hazards Program, US Geological Survey, https://earthquake.usgs.gov/hazards/urban/sfbay/liquefaction.

37. A. Santos, A. Frederick, B. Higgins, A. Carrillo, A. Carter, K. Dickson, D. German, and M. Horn, "The Beach-Spawning California Grunion *Leuresthes tenuis* Eats and Digests Conspecific Eggs," *Journal of Fish Biology* 93, no. 2 (2018): 282–89, https://doi.org/10.1111/jfb.13734.

38. "California Grunion Facts and Expected Runs," California Department of Fish and Wildlife, https://wildlife.ca.gov/fishing/ocean/grunion.

## 05. AS ABOVE, SO BELOW

1. K. E. Mayer and W. F. Laudenslayer Jr., eds., *A Guide to Wildlife Habitats of California* (Sacramento: State of California, Department of Fish and Game Resources Agency, 1988), https://wildlife.ca.gov/Data/CWHR/Wildlife-Habitats.

2. E. Bakker, *An Island Called California* (Berkeley: University of California Press, 1971), 101.

3. S. C. Sillett, R. Van Pelt, A. L. Carroll, J. Campbell-Spickler, and M. E. Antoine, "Aboveground Biomass Dynamics and Growth Efficiency of *Sequoia sempervirens* Forests," *Forest Ecology and Management* 458 (2020): 117740, https://doi.org/10.1016/j.foreco.2019.117740.

4. "The Lost Coast Rivers," Save the Redwoods, 2020, https://www.savetheredwoods.org/wp-content/uploads/mp_j_lostcoast.pdf.

5. "The Mattole River Watershed," Sanctuary Forest, 2020, http://sanctuaryforest.org/about/mattole-lost-coast-map.

6. "Watershed Plan: The Mattole Integrated Coastal Watershed Management Plan," Mattole Watershed Council, 2020, https://www.mattole.org/about/watershed-plan.

7. R. H. Waring and J. F. Franklin, "Evergreen Coniferous Forests of the Pacific Northwest," *Science* 204, no. 4400 (1979): 1380–86, https://doi.org/10.1126/science.204.4400.1380.

8. "Mattole Integrated Coastal Watershed Management Plan: Foresight 2020," Mattole River and Range Partnership, August 31, 2009, 43, https://www.mattole.org/wp-content/uploads/2014/08/WatershedPlan_Final_w_Cover.pdf.

9. "Mattole Integrated Coastal Watershed Management Plan."

10. P. Williams, L. Messinger, and S. Johnson, eds., *Habitats Alive! An Ecological Guide to California's Diverse Habitats* (El Cerrito: California Institute for Biodiversity, and Claremont, CA: Rancho Santa Ana Botanic Garden, 2009), 412.

11. M. Bettleheim, "Presumed Extinct: On a Wing and a Prayer," *(Bio)accumulation*, March 4, 2012, https://bioaccumulation.wordpress.com/tag/lotis-blue-butterfly.

12. Williams et al., *Habitats Alive!* 84, 92.

13. D. Fong, *Fisheries Assessment for Bolinas Lagoon Tributaries within the Golden Gate National Recreation Area, 1995–2000* (Sausalito, CA: NPS Golden Gate National Recreation Area, Division of Natural Resource Management and Research, 2002), http://www.krisweb.com/biblio/southmarin_nps_fong_2002_bolinas.pdf.

14. "Green Crab Removal Project," Greater Farallones National Marine Sanctuary, 2017, https://farallones.noaa.gov/eco/bolinas/greencrab.html.

15. "Kent Island Project," Greater Farallones National Marine Sanctuary, 2017, https://farallones.noaa.gov/eco/bolinas/kentisland.html.

16. "Bolinas Lagoon Ecosystem Restoration Project," Gulf of the Farallones National Marine Sanctuary, 2008, https://nmsfarallones.blob.core.windows.net/farallones-prod/media/archive/eco/bolinas/pdf/finalplanoptnov.pdf.

17. "Muir's Hairstreak, *Callophrys muiri* (Hy. Edwards, 1881)," Butterflies and Moths of North America, https://www.butterfliesandmoths.org/species/Callophrys-muiri.

18. "Ramsar Fact Sheet," US State Fish and Wildlife Service, 2017, https://www.fws.gov/international/pdf/factsheet-ramsar.pdf.

19. S. Singer, "Old-Growth Forests of the Santa Cruz Mountains: A Rare and Valuable Resource," Santa Cruz Mountains Bioregional Council, 2012, http://www.scmbc.org/old-growth-forests-of-scmtns.

20. G. Waldron, "Resource Inventory: Animal Life," Big Basin Redwoods State Park, 2001, 7, https://www.parks.ca.gov/pages/21299/files/wildlife.pdf.

21. Waldron, "Resource Inventory," 12.

22. N. Riggio, "Big Basin on Fire," Sierra Club, 2020, https://www.sierraclub.org/sierra/slideshow/big-basin-santa-cruz-california-czu-complex-fire#2.

23. G. F. Gause, *The Struggle for Existence* (Baltimore, MD: Williams & Wilkins, 1934).

24. Waldron, "Resource Inventory," 13.

25. A. Kitajima and A. Gillespie, *Morro Bay National Estuary Program's Implementation Effectiveness Program for the Morro Bay Watershed* (Morro Bay, CA: Morro Bay National Estuary Program, 2012), https://www.mbnep.org/wp-content/uploads/2014/12/2012_Data_Summary_Report.pdf.

26. "California Condor Rehabilitation Report," Ventana Wildlife Society, 2020, https://www.ventanaws.org/california-condors.html.

27. Kitajima and Gillespie, *Morro Bay*.

28. S. Hudson, B. Carey, D. Christensen, and M. Kubran, "County of Santa Barbara Local Coastal Program Amendment No. LCP-4-STB-16-0067-3 (Gaviota Coast Plan)," California Coastal Commission, April 24, 2018, https://documents.coastal.ca.gov/reports/2018/5/th19c/th19c-5-2018-report.pdf.

29. Hudson et al., "Local Coastal Program Amendment."

30. C. Groves et al., *Designing a Geography of Hope: A Practitioner's Handbook to Ecoregional Conservation Planning*, 2nd ed., vol. 2 (Ventura, CA: Nature Conservancy, 2000).

Notes

31. AMEC Earth and Environmental, *Santa Clara River Enhancement and Management Plan*, prepared for the Ventura County Watershed Protection District and the Los Angeles County Department of Public Works, 2005, http://parkway.scrwatershed.org/wkb/scrbiblio/scrempfinal/attachment_download/SCREMP2005Final.pdf.

32. S. Matsumoto and E. J. Remson, *Santa Clara River Upper Watershed Conservation Plan* (Ventura, CA: Nature Conservancy, 2006), https://www.cerc.usgs.gov/orda_docs/DocHandler.ashx?task=get&ID=1315.

33. Matsumoto and Remson, *Santa Clara River*.

34. "Conserved Lands," Palos Verdes Peninsula Land Conservancy, https://pvplc.org/conserved-lands.

35. "Rancho Palos Verdes Natural Communities Conservation Planning Subarea Plan," City of Rancho Palos Verdes, July 29, 2004, https://pvplc.org/wp-content/uploads/2020/01/NCCP.pdf.

36. "Terrestrial Habitats," in "Channel Islands National Park," National Park Service, https://www.nps.gov/chis/learn/nature/terrestrial-habitats.htm.

37. A. Shoennherr, C. R. Feldmeth, and M. Emerson, *Natural History of the Islands of California* (Berkeley: University of California Press), 212.

38. Shoennherr, *Natural History*, 196–242.

39. "Comprehensive Management Plan," Tijuana River National Estuarine Research Reserve, 2010, https://coast.noaa.gov/data/docs/nerrs/Reserves_TJR_MgmtPlan.pdf.

40. R. Potts and A. K. Behrensmeyer, "Late Cenozoic Terrestrial Ecosystems," in *Terrestrial Ecosystems through Time*, edited by A. K. Behrensmeyer, J. D. Damuth, W. A. Dimichele, R. Potts, H. D. Sues, and S. L. Wing, 418–541 (Chicago: University of Chicago Press, 1992).

41. Feather boa kelp, *Egregia menziesii*, is also capable of forming canopies, but is not included in the range map 05.03.

42. "Giant Kelp Forest: Explore a Forest under the Ocean," Birch Aquarium, Scripps Institute of Oceanography, https://aquarium.ucsd.edu/visit/exhibits/giant-kelp-forest.

43. M. H. Carr, "Effects of Macroalgal Assemblages on the Recruitment of Temperate Zone Reef Fishes," *Journal of Experimental Marine Biology and Ecology* 126, no. 1 (1989): 59–76, https://doi.org/10.1016/0022-0981(89)90124-X.

44. D. Krause-Jensen, "Marine Forests—Nature's Own Carbon Capture and Storage," *Science Nordic*, September 18, 2018, https://sciencenordic.com/climate-change-climate-solutions-denmark/marine-forests---natures-own-carbon-capture-and-storage/1458305.

45. E. Bryce, "What Kelp Forests Can Do for the Climate," *Yes!*, July 1, 2020, https://www.yesmagazine.org/environment/2020/07/01/climate-carbon-oceans-kelp.

46. J. Browning, "5 Reasons to Protect Kelp, the West Coast's Powerhouse Marine

47. K. Leitzell, "New Research to Address Kelp Forest Crisis in California," Sea Grant California, July 6, 2020, https://www.pewtrusts.org/en/research-and-analysis/articles/2020/05/27/5-reasons-to-protect-kelp-the-west-coasts-powerhouse-marine-algae.

48. T. Woody, "California's Critical Kelp Forests Are Disappearing in a Warming World. Can They Be Saved?" *National Geographic*, April 2020, https://www.nationalgeographic.com/science/2020/04/california-critical-kelp-forests-disappearing-warming-world-can-they-be-saved.

49. M. A. Snyder, L. C. Sloan, N. S. Diffenbaugh, and J. L. Bell, "Future Climate Change and Upwelling in the California Current," *Geophysical Research Letters* 30, no. 15 (2003): 1823, https://doi.org/10.1029/2003GL017647.

50. M. S. Foster and D. R. Sheil, *The Ecology of Giant Kelp Forests in California: A Community Profile* (Washington, DC: US Fish and Wildlife Service, 1985).

51. M. Gleason, E. Fox, S. Ashcraft, J. Vasques, E. Whiteman, P. Serpa, E. Saarman, et al., "Designing a Network of Marine Protected Areas in California: Achievements, Costs, Lessons Learned, and Challenges Ahead," *Ocean and Coastal Management* 74 (2013): 90–101, https://doi.org/10.1016/j.ocecoaman.2012.08.013.

52. J. T. Carlton, ed., *The Light and Smith Manual: Intertidal Invertebrates from Central California to Oregon* (Berkeley: University of California Press, 2007).

53. J. E. Howard, E. Babij, R. Griffis, and B. Helmuth, "Oceans and Marine Resources in a Changing Climate," *Oceanography and Marine Biology* 51 (2013): 71–192, https://www.researchgate.net/publication/245025185_Oceans_and_Marine_Resources_in_a_Changing_Climate.

54. S. Frazier, *Ramsar Sites Overview: A Synopsis of the World's Wetlands of International Importance* (Wageningen, the Netherlands: Wetlands International, 1999), https://www.wetlands.org/publications/overview-of-ramsar-sites.

55. "What Are Coastal Wetlands?" UC Davis Science & Climate, https://climatechange.ucdavis.edu/climate-change-definitions/coastal-wetlands.

56. K. McLaughlin, M. Sutula, L. Busse, S. Anderson, J. Crooks, R. Dagit, D. Gibson, et al., *Southern California Bight 2008 Regional Monitoring Program, vol. 8, Estuarine Eutrophication* (Costa Mesa: Southern California Coastal Water Research Project, 2012), https://doi.org/10.13140/RG.2.2.26834.09923.

57. "Estuary Facts," Association of National Estuary Programs, https://nationalestuaries.org/estuary-facts.

58. S. Seitzinger, J. A. Harrison, J. K. Böhlke, A. F. Bouwman, R. Lowrance, B. Peterson, C. Tobias, and G. Van Drecht, "Denitrification across Landscapes and Waterscapes: A Synthesis," *Ecological Applications* 16, no. 6 (2006): 2064–90, https://doi.org/10.1890/1051-0761(2006)016[2064:DALAWA]2.0.CO;2.

59. D. Stralberg, M. Brennan, J. C. Callaway, J. K. Wood, L. M. Schile, D. Jongsomjit, M. Kelly, et al., "Evaluating Tidal Marsh Sustainability in the Face of Sea Level Rise: A Hybrid Modeling Approach Applied to the San Francisco Bay," *PLOS One* 6, no. 11 (2011): e27388, https://doi.org/10.1371/journal.pone.0027388.

60. S. R. Miles and C. B. Goudey, "Ecological Subregions of California: Section and Subsection Descriptions" (San Francisco: USDA Forest Service, Pacific Southwest Region, 1997).

61. T. J. Belzer, *Roadside Plants of Southern California* (Missoula, MT: Mountain Press, 1984).

62. California Department of Fish and Game (CDFG), "List of California Terrestrial Natural Communities Recognized by the California Natural Diversity Database," September 2003 ed. (Sacramento: CDFG, Wildlife and Habitat Data Analysis Branch, 2003).

63. W. E. Westman, "Xeric Mediterranean-Type Shrubland Associations of Alta and Baja California and the Community/Continuum Debate," *Vegetatio* 52, no. 1 (1983): 3–19.

64. J. R. Griffin, "Maritime Chaparral and Endemic Shrubs of the Monterey Bay Region, California," *Madroño* 25, no. 2 (1978): 65–81, https://www.jstor.org/stable/41424135.

65. T. L. Hanes, "California Chaparral," in *Terrestrial Vegetation of California*, edited by M. G. Barbour and J. Majors, 417–70 (Hoboken, NJ: Wiley, 1977).

66. Hanes, "California Chaparral."

67. J. Hart, "Berryessa Snow Mountain: Northern California's New National Monument," *Bay Nature*, May 2016, https://baynature.org/article/berryessa-snow-mountain-northern-californias-new-national-monument.

68. M. G. Barbour, T. Keeler-Wolf, and A. A. Schoenherr, eds., *Terrestrial Vegetation of California*, 3rd ed. (Los Angeles: University of California Press, 2007), 324.

69. Barbour et al., *Terrestrial Vegetation*, 347.

70. J. S. Fried, C. L. Bolsinger, and D. Beardsley, "Chaparral in Southern and Central Coastal California in the mid-1990s: Area, Ownership, Condition, and Change," US Forest Service, 2004, https://doi.org/10.2737/PNW-RB-240.

71. Barbour et al., *Terrestrial Vegetation*, 353.

72. Barbour et al., 330.

73. Barbour et al., 321.

74. Barbour et al., 327.

75. T. C. Foin and M. Hektner, "Secondary Succession and the Fate of Native Species in a California Coastal Prairie Community," *Madroño* 33, no. 3: 189–206, https://www.jstor.org/stable/41424593.

76. J. Sawyer and T. Keeler-Wolf, *A Manual of California Vegetation* (Sacramento: California Native Plant Society, 1995).

77. T. Gaman and J. Firman, "Oaks 2040: The Status and Future of Oaks in California," California Oaks Foundation, 2006, https://www.fs.fed.us/psw/publications/documents/psw_gtr217/psw_gtr217_603.pdf.

78. N. Myers, R. A. Mittermeier, C. G. Mittermeier, G.A.B. da Fonseca, and J. Kent, "Biodiversity Hotspots for Conservation Priorities," *Nature* 403 (2000): 853–58, https://doi.org/10.1038/35002501.

79. T. Kroeger, F. Casey, P. Alvarez, M. Cheatum, and L. Tavassoli, *An Economic Analysis of the Benefits of Habitat Conservation on California's Rangelands*, Conservation Economics White Paper, Conservation Economics Program (Washington, DC: Defenders of Wildlife, 2010), https://defenders.org/sites/default/files/publications/an_economic_analysis_of_the_benefits_of_habitat_conservation_on_california_rangelands.pdf.

80. F. W. Davis and M. Moritz, "Mechanisms of Disturbance," in *Encyclopedia of Biodiversity*, edited by S. A. Levin, 153–60 (New York: Academic Press, 2001).

81. M. Geniella, "Towering Tree on Fetzer Ranch Has Inspired Awe for Centuries," *Press Democrat*, March 2006, https://www.pressdemocrat.com/article/news/towering-tree-on-fetzer-ranch-has-inspired-awe-for-centuries.

82. M. Parker, "The Wild Diversity of Sonoma County's Oaks," Sonoma County Parks, August 2016, http://parks.sonomacounty.ca.gov/Learn/Blog/Articles/The-Wild-Diversity-of-Sonoma-County-Oaks.

83. G. Slack, "The Essential Tree," *Bay Nature*, October 1, 2003, https://baynature.org/article/the-essential-tree.

84. "Mitteldorf Preserve, Carmel Valley," Big Sur Land Trust, https://bigsurlandtrust.org/mitteldorf-preserve-carmel-valley.

85. "Los Osos Oaks State Natural Reserve," California State Parks, https://www.parks.ca.gov/?page_id=597.

86. N. Masters, "The Oak Trees of Southern California: A Brief History," KCET, February 7, 2013, https://www.kcet.org/shows/lost-la/the-oak-trees-of-southern-california-a-brief-history.

87. M. E. Kauffmann, *Conifers of the Pacific Slope* (Arcata, CA: Backcountry Press, 2013).

88. Kauffmann, *Conifers*, 112.

89. S. E. Haas, M. B. Hooten, D. M. Rizzo, and R. K. Meentemeyer, "Forest Species Diversity Reduces Risk in Generalist Plant Pathogen Invasion," *Ecology Letters* 14, no. 11 (2011): 1108–16, https://doi.org/10.1111/j.1461-0248.2011.01679.x.

90. Guy Kovner, "Extent of Sudden Oak Death Spread in California Unexpected in Dry Year," *Press Democrat*, November 15, 2020, https://www.pressdemocrat.com/article/news/extent-of-sudden-oak-death-spread-in-california-unexpected-in-dry-year.

91. Kauffmann, *Conifers*, 120.

92. Kauffmann, 110.

93. Not to be confused with the Department of Water Resources, which is responsible for water usage and water delivery across California's water infrastructure.

94. "About the Water Board," California Water Boards, https://www.waterboards.ca.gov/about_us. From the webpage: "The State and Regional Water Boards have regulatory responsibility for protecting the water quality of nearly 1.6 million acres of lakes, 1.3 million acres of bays and estuaries, 211,000 miles of rivers and streams, and about 1,100 miles of exquisite California coastline."

95. "State Water Quality Protection Areas—Areas of Special Biological Significance," California Water Boards, July 8, 2020, https://www.waterboards.ca.gov/water_issues/programs/ocean/asbs.html.

## 06. ALL CREATURES GREAT AND SMALL

1. "California Current: Species at Risk," Oceana, https://usa.oceana.org/california-current-species-risk.

2. M. B. Yinon, R. Phillips, and R. Milo, "The Biomass Distribution on Earth," *National Academy of Sciences* 115, no. 25 (2018): 6506–11, https://doi.org/10.1073/pnas.1711842115.

3. "How Much Oxygen Comes from the Ocean?" National Ocean Service, https://oceanservice.noaa.gov/facts/ocean-oxygen.html.

4. Ohio State University, "Plankton Key to Origin of Earth's First Breathable Atmosphere," *ScienceDaily*, February 22, 2011, www.sciencedaily.com/releases/2011/02/110221163052.htm.

5. *Scripps News*, "Everything You Wanted to Know about Red Tides," Scripps Institute of Oceanography, April 28, 2020, https://scripps.ucsd.edu/news/everything-you-wanted-know-about-red-tides.

6. R. Kudela, "Ask the Naturalist: Sea Foam—How Much Is Too Much?" *Bay Nature*, October 22, 2015, https://baynature.org/article/ask-the-naturalist-seafoam-how-much-is-too-much.

7. M. D. Guiry, "How Many Species of Algae Are There?" *Journal of Phycology* 48, no. 5 (2012): 1057–63, https://doi.org/10.1111/j.1529-8817.2012.01222.x.

8. P. Tréguer, C. Bowler, B. Moriceau, S. Dutkiewicz, M. Gehlen, O. Aumont, L. Bittner, et al., "Influence of Diatom Diversity on the Ocean Biological Carbon Pump," *Nature Geoscience* 11 (2018): 27–37, https://doi.org/10.1038/s41561-017-0028-x.

9. P. Assmy, V. Smetacek, M. Montresor, C. Klaas, J. Henjes, V. H. Strass, J. M. Arrieta, et al., "Thick-Shelled, Grazer-Protected Diatoms Decouple Ocean Carbon and Silicon Cycles in the Iron-Limited Antarctic Circumpolar Current," *PNAS* 110, no. 51 (2013): 20633–38, https://doi.org/10.1073/pnas.1309345110.

10. C. S. Rousseaux and W. Gregg, "Recent Decadal Trends in Global Phytoplankton Composition," *Global Biogeochemical Cycles* 29, no. 10 (2015): 1674–88, https://doi.org/10.1002/2015GB005139.

11. "Marine Food Chains and Biodiversity," *National Geographic*, https://www.nationalgeographic.org/activity/marine-food-chains-and-biodiversity.

12. J. Steinbauer, "Bringing Back Kelp," *Bay Nature*, June 21, 2020, https://baynature.org/article/bringing-back-kelp.

13. L. Rogers-Bennett and C. A. Catton, "Marine Heat Wave and Multiple Stressors Tip Bull Kelp Forest to Sea Urchin Barrens," *Scientific Reports* 9 (2019): 15050, https://doi.org/10.1038/s41598-019-51114-y.

14. R. Aguilar and M. Razazan, "Why Has California Lost 90% of Its Kelp Forests?" KALW, November 24, 2019, https://www.kalw.org/post/one-planet-why-has-california-lost-90-percent-its-kelp-forests.

15. M. S. Love, P. Morris, M. McCrae, and R. Collins, *Life History of 19 Rockfish (Scorpaenidae: Sebastes) from the Southern California Bight* (Washington, DC: US Department of Commerce, 1990), https://spo.nmfs.noaa.gov/sites/default/files/tr87opt.pdf.

16. "State and Federally Listed Endangered and Threatened Animals of California," California Department of Fish and Wildlife, Biogeographic Data Branch, California Natural Diversity Database, November 10, 2020, https://wildlife.ca.gov/Data/CNDDB/Plants-and-Animals.

17. J. Loda, "Four Rare Amphibians in California Move Closer to Endangered Species Act Protection," Center for Biological Diversity, June 30, 2015, https://www.biologicaldiversity.org/news/press_releases/2015/california-amphibians-06-30-2015.html.

18. "Ecology and Conservation of Amphibians in Northern California," US Geological Survey, Western Ecological Research Center, https://www.usgs.gov/centers/werc/science/ecology-and-conservation-amphibians-northern-california.

19. "Complete List of Amphibian, Reptile, Bird and Mammal Species in California," State of California Natural Diversity Database, California Department of Fish and Wildlife, May 2016, https://wildlife.ca.gov/Data/CNDDB.

20. "Complete List," California Natural Diversity Database.

21. P. B. Davis and L. H. Davis, "A List of Freshwater, Anadromous, and Euryhaline Fishes of California," *California Department of Fish and Game* 86, no. 4 (2000): 244–58, https://watershed.ucdavis.edu/library/list-freshwater-anadromous-and-euryhaline-fishes-california.

22. "Green Sturgeon Ranges," NOAA Fisheries, https://www.calfish.org/portals/2/Fish/images/GreenSturgeonRangeNew_1200.jpg.

23. "Oriental Weatherfish (*Misgurnus anguillicaudatus*) Ecological Risk Screening Summary," US Fish and Wildlife Service, August 21, 2012, https://www.fws.gov/fisheries/ans/erss/highrisk/Misgurnus-anguillicaudatus-WEB-8-21-12.pdf.

24. *Esox lucius*, the northern pike, is the only species in this family and only exists inland and is thus not included on the list of representative species. More information on the northern pike at "California's Invaders: Northern Pike," California Department of Fish and Wildlife, https://wildlife.ca.gov/Conservation/Invasives/Species/Northern-Pike.

25. "California's Invaders," California Department of Fish and Wildlife.

26. Every species in this family (pupfish) exists inland and is thus not included on the list of representative species.

27. J. S. Elias, *Science Terms Made Easy: A Lexicon of Scientific Words and Their Root Language Origins* (Westport, CT: Greenwood, 2007), 157.

28. K. D. Hanni, D. J. Long, R. E. Jones, P. Pyle, and L. E. Morgan, "Sightings and Strandings of Guadalupe Fur Seals in Central and Northern California, 1988–1995," *Journal of Mammalogy* 78, no. 2 (1997): 684–90, https://doi.org/10.2307/1382920.

29. "Seal and Sea Lion Viewing," National Park Service, https://www.nps.gov/chis/planyourvisit/seal-and-sea-lion-viewing.htm.

30. D. J. Tollit, M. A. Wong, and A. W. Trites, "Diet Composition of Steller Sea Lions (*Eumetopias jubatus*) in Frederick Sound, Southeast Alaska: A Comparison of Quantification Methods Using Scats to Describe Temporal and Spatial Variabilities," *Canadian Journal of Zoology* 93, no. 5 (2015): 361–76, https://doi.org/10.1139/cjz-2014-0292.

31. "Northern Fur Seal," NOAA Fisheries, https://www.fisheries.noaa.gov/species/northern-fur-seal.

32. "California Pinniped Map," NOAA Fisheries via ArcGIS, https://www.arcgis.com/home/webmap/viewer.html?webmap=2ff3fabe20cf4c83959cae1597500b09; "California Mainland Pinniped Rookeries," Seal Conservancy, https://sealconservancy.org/documents/California_Mainland_Pinniped_Rookeries_Map.pdf.

33. "Important Bird Areas," Audubon California, https://ca.audubon.org/important-bird-areas-9.

34. "Meet the Turtles," SWOT, https://www.seaturtlestatus.org/meet-the-turtles.

35. A. C. Broderick, R. Frauenstein, F. Glen, G. C. Hays, A. L. Jackson, T. Pelembe, G. D. Ruxton, and B. J. Godley, "Are Green Turtles Globally Endangered?" *Global Ecology and Biogeography* 15, no. 1 (2006): 21–26, http://www.jstor.org/stable/3697653.

36. T. Steiner and R. Walder, "Two Records of Live Olive Ridleys from Central California, USA," *Marine Turtle Newsletter*, 2005, http://www.seaturtle.org/mtn/archives/mtn107/mtn107p9.shtml.

37. "Southern California Sea Turtles," Sportfishing Association of California, June 30, 2016, https://www.californiasportfishing.org/single-post/2016/06/30/Southern-California-Sea-Turtles.

38. R. C. Stebbins and S. M. McGinnis, *Field Guide to Amphibians and Reptiles of California: Revised Edition*, California Natural History Guides (Berkeley: University of California Press, 2012).

39. J. L. Behler and F. W. King, *The Audubon Society Field Guide to North American Reptiles and Amphibians* (New York: Knopf, 1992).

40. B. Elliott, "Loggerhead Sea Turtles Gain Protection with Swordfish Drift Gillnet Fishery Restriction," *Oceana*, July 25, 2014, https://oceana.org/blog/loggerhead-sea-turtles-gain-protection-swordfish-drift-gillnet-fishery-restriction.

41. L. Saldana Ruiz, E. Garcia-Rodriguez, J. Pérez-Jiménez, J. Tovar-Ávila, and E. Tellez, "Biodiversity and Conservation of Sharks in Pacific Mexico," *Advances in Marine Biology* 83 (2019): 11–60, https://doi.org/10.1016/bs.amb.2019.08.001.

42. P. Kyne, N. Bax, and N. Dulvy, "Biodiversity: Sharks and Rays in Peril Too," *Nature* 518, no. 167 (2015), https://doi.org/10.1038/518167e.

43. P. Grieve, "Great White Sharks Spotted near Half Moon Bay," *San Francisco Chronicle*, July 12, 2019, https://www.sfchronicle.com/bayarea/article/Great-white-sharks-spotted-at-Half-Moon-Bay-14090988.php.

44. "The Sharks of the Monterey Bay," Pelagic Shark Research Foundation, http://www.pelagic.org/montereybay/index.html.

45. W. D. Shuford and T. Gardali, *California Bird Species of Special Concern: A Ranked Assessment of Species, Subspecies, and Distinct Populations of Birds of Immediate Conservation Concern in California* (Camarillo, CA: Western Field Ornithologists; Sacramento: California Department of Fish and Game, 2008).

46. Shuford and Gardali, *California Bird Species of Special Concern*.

47. Shuford and Gardali.

48. Shuford and Gardali.

49. "Laws and Policies: Marine Mammal Protection Act," NOAA Fisheries, https://www.fisheries.noaa.gov/topic/laws-policies#marine-mammal-protection-act.

50. J. Barlow, K. A. Forney, P. S. Hill, R. L. Brownell, Jr., J. V. Caretta, D. P. DeMaster, F. Julian, et al., *U.S. Pacific Marine Mammal Stock Assessments: 1996* (La Jolla, CA: NOAA Southwest Fisheries Science Center, 1997), https://repository.library.noaa.gov/view/noaa/3025.

51. "Cetaceans—Dolphins," in "Marine Mammal Stock Assessment Reports by Species/Stock," NOAA Fisheries, https://www.fisheries.noaa.gov/national/marine-mammal-protection/marine-mammal-stock-assessment-reports-species-stock#cetaceans---dolphins. NOAA Fisheries annually prepares marine mammal stock assessment reports for all marine mammals in US waters.

52. "Killer Whale, West Coast Transient," in "Marine Mammal Stock Assessment Reports by Species/Stock," NOAA Fisheries, https://www.fisheries.noaa.gov/national/marine-mammal-protection/marine-mammal-stock-assessment-reports-species-stock#cetaceans---small-whales.

53. "False Killer Whale, Hawaiian Islands Stock Complex," in "Marine Mammal Stock Assessment Reports by Species/Stock," NOAA Fisheries, https://www.fisheries.noaa.

gov/national/marine-mammal-protection/marine-mammal-stock-assessment-reports-species-stock#cetaceans---small-whales.

54. "Pantropical Spotted Dolphin," NOAA Fisheries, https://www.fisheries.noaa.gov/species/pantropical-spotted-dolphin.

55. "Rough-Toothed Dolphin, Hawaii," in "Marine Mammal Stock Assessment Reports by Species/Stock," NOAA Fisheries, https://www.fisheries.noaa.gov/national/marine-mammal-protection/marine-mammal-stock-assessment-reports-species-stock#cetaceans---dolphins.

56. "Pacific Bottlenose Dolphin, California Coastal," in "Marine Mammal Stock Assessment Reports by Species/Stock," NOAA Fisheries, https://www.fisheries.noaa.gov/national/marine-mammal-protection/marine-mammal-stock-assessment-reports-species-stock#cetaceans---dolphins.

57. "Harbor Porpoise," in "Marine Mammal Stock Assessment Reports by Species/Stock," NOAA Fisheries, https://www.fisheries.noaa.gov/national/marine-mammal-protection/marine-mammal-stock-assessment-reports-species-stock#cetaceans---porpoises. Monterey Bay population, 3,455; Morro Bay, 4,255; Northern California–Southern Oregon, 11,670; San Francisco–Russian River, 7,524.

58. M. Van Hedler, "Scientists Finally Have Evidence That Frigatebirds Sleep While Flying," Audubon, August 11, 2016, https://www.audubon.org/news/scientists-finally-have-evidence-frigatebirds-sleep-while-flying.

59. "Our Seabirds and Important Seabird Areas," Audubon California, https://ca.audubon.org/our-seabirds-and-important-seabird-areas.

60. "IUCN Red List of Threatened Species," International Union for Conservation of Nature, https://www.iucn.org/resources/conservation-tools/iucn-red-list-threatened-species.

61. G. Anderson, "Abalone Species Diversity," *Marine Science*, July 29, 2018, https://www.marinebio.net/marinescience/06future/abspdiv.htm.

62. "Dungeness Crab of California and Its Close Relatives," California Department of Fish and Wildlife, https://wildlife.ca.gov/Fishing/Ocean/Dungeness-Crab.

63. K. Hennessy, ed., *Natural History: The Ultimate Visual Guide to Everything on Earth* (New York: Penguin Random House, 2010).

64. "Species Directory," NOAA Fisheries, https://www.fisheries.noaa.gov/species-directory.

65. G. N. Meredith and R. R. Campbell, *COSEWIC Status Report on the Fin Whale*, Balaenoptera physalus, *in Canada* (Ottawa, Ontario: Committee on the Status of Endangered Wildlife in Canada [COSEWIC], 1987).

66. COSEWIC, *COSEWIC Assessment and Status Report on the Sei Whale* Balaenoptera borealis *in Canada* (Ottawa, Ontario: COSEWIC Secretariat, 2003), https://wildwhales.org/wp-content/uploads/2017/06/sr_sei_whale_e.pdf.

67. "North Pacific Right Whale," NOAA Fisheries, https://www.fisheries.noaa.gov/species/north-pacific-right-whale.

68. Fiona Reid, *A Field Guide to the Mammals of Central America and Southeast Mexico*, 2nd ed. (Oxford: Oxford University Press, 2009), 301.

69. "Pygmy Sperm Whale, *Kogia breviceps*," Aquarium of the Pacific, https://www.aquariumofpacific.org/onlinelearningcenter/species/pygmy_sperm_whale.

70. J. Kiszka and G. Braulik, "*Kogia sima*, Dwarf Sperm Whale," in *IUCN Red List of Threatened Species*, 2020, https://www.researchgate.net/publication/342919353.

71. "Blainville's Beaked Whale," NOAA Fisheries, https://www.fisheries.noaa.gov/species/blainvilles-beaked-whale.

72. J. E. Moore and J. P. Barlow, "Declining Abundance of Beaked Whales (Family Ziphiidae) in the California Current Large Marine Ecosystem," *PLOS One* 8, no. 1 (2013): e52770, https://doi.org/10.1371/journal.pone.0052770.

73. "Giant Beaked Whale, *Berardius bairdii*," Alaska Department of Fish and Game, https://www.adfg.alaska.gov/static/education/wns/bairds_beaked_whale.pdf.

74. M. L. Dalebout, C. Scott Baker, D. Steel, K. Thompson, K. M. Robertson, S. J. Chivers, W. F. Perrin, et al., "Resurrection of *Mesoplodon hotaula* Deraniyagala 1963: A New Species of Beaked Whale in the Tropical Indo-Pacific," *Marine Mammal Science* 30, no. 3 (2014): 1081–108, https://doi.org/10.1111/mms.12113.

75. T. A. Jefferson, S. Leatherwood, and M. A. Webber, *Marine Mammals of the World* (Rome, Italy: United Nations Environment Programme, Food and Agriculture Organization of the United Nations, 1993).

76. J. G. Mead, S. Baker, A. Baker, and A. Von Helden, "A New Species of Beaked Whale *Mesoplodon perrini* (Cetacea: Ziphiidae) Discovered through Phylogenetic Analyses of Mitochondrial DNA Sequences," *Marine Mammal Science* 18, no. 3 (2002): 577–608, https://doi.org/10.1111/j.1748-7692.2002.tb01061.x.

77. J. Urban-Ramirez and D. Aurioles-Gamboa, "First Record of the Pygmy Beaked Whale *Mesoplodon peruvianus* in the North Pacific," *Marine Mammal Science* 8, no. 4 (2006): 420–25. http://doi.org/10.1111/j.1748-7692.1992.tb00058.x.

78. Moore and Barlow, "Declining Abundance."

79. L. G. Crozier, M. M. McClure, T. Beechie, S. J. Bograd, D. A. Boughton, M. Carr, T. D. Cooney, et al., "Climate Vulnerability Assessment for Pacific Salmon and Steelhead in the California Current Large Marine Ecosystem," *PLOS One* 14, no. 7 (2019): e0217711, https://doi.org/10.1371/journal.pone.0217711.

80. X. Augerot, *Atlas of Pacific Salmon* (Berkeley: University of California Press, 2005), 73.

81. Augerot, *Atlas*, 69.

82. Augerot, 77.

## 07. A GOOD, LONG WALK

*Notes for 07.02 and 07.02a*

1. "Redwood Forest Biomass," Save the Redwoods League, https://www.savethered woods.org/forest_fact/redwood-forest-biomass.
2. P. D. Boersma and M. C. Silva, "Fork-Tailed Storm-Petrel," Cornell Lab of Ornithology, Birds of the World, January 1, 2001, https://birdsoftheworld.org/bow/species/ftspet/cur/introduction.
3. US Army Corps of Engineers, *Explore 1: The California Coastline, Oregon Border to Klamath River Mouth* (San Francisco: US Army Corps of Engineers, 1980), 6.
4. "Smith River, California," National Wild and Scenic Rivers System, https://www.rivers.gov/rivers/smith.php.
5. P. J. Connolly, T. H. Williams, and R. E. Gresswell, eds., *The 2005 Coastal Cutthroat Trout Symposium: Status, Management, Biology, and Conservation* (Portland: Oregon Chapter of the American Fisheries Society, 2008), http://sccp.ca/sites/default/files/species-habitat/documents/CCTS_12-31-2008%20Complete.pdf.
6. M. Love and Associates, *Yontocket Slough Fish Passage and Habitat Enhancement Planning Project*, funded by the California Department of Fish and Game, Smith River Alliance, Five Counties Salmonid Conservation Program, and California Coastal Conservancy, 2006, https://www.5counties.org/docs/projects/yontocket_final.pdf.
7. P. Vaughan, *Age Estimation for Landforms at Tolowa Dunes State Park* (Eureka: California Department of Parks and Recreation North Coast Redwoods District, 2016), https://lccnetwork.org/resource/age-estimation-landforms-tolowa-dunes-state-park-report.
8. "Project Highlights: Fish Passage Restoration within Yontocket Slough at Tolowa Dunes State Park," Pacific Coast Fish, Wildlife & Wetlands Restoration Association, https://www.pcfwwra.org/projects.
9. "Del Norte Coast," Audubon, https://www.audubon.org/important-bird-areas/del-norte-coast.
10. "Del Norte Coast."
11. D. Jacques, *Castle Rock National Wildlife Refuge Information Synthesis, Final Report* (US Fish and Wildlife Service Humboldt Bay National Wildlife Refuge Complex, 2007), 82.
12. National Marine Fisheries Service, *Final Recovery Plan for the Southern Oregon/Northern California Coast Evolutionarily Significant Unit of Coho Salmon (Oncorhynchus kisutch)* (Arcata, CA: National Marine Fisheries Service, 2014), https://repository.library.noaa.gov/view/noaa/15985. See also https://smithriveralliance.org/elk-creek-fish-restoration.
13. "*Monadenia fidelis pronotis*," iNaturalist, https://www.inaturalist.org/taxa/150855-Monadenia-fidelis-pronotis.
14. G. Leppig, M. van Hattem, and W. Maslach, "North Coast Fens: Biodiversity Hotspots of Great Botanical Richness," *Fremontia* 46, no. 2 (2018): 14–20, https://www

.cnps.org/wp-content/uploads/2019/11/Fremontia_V46_N2_Wetlands_LR.pdf.
15. US Army Corps of Engineers, *Explore 1*, 6.
16. Redwoods Rising, *Greater Mill Creek Ecosystem Restoration Project: Draft Initial Study/Negative Declaration and Environmental Assessment*, April 2019, https://www.parks.ca.gov/pages/980/files/GMC_ISEA_PublicDraft_040519-508_GMCERP.pdf.
17. C. E. Garrison-Laney, "Diatom Evidence for Tsunami Inundation from Lagoon Creek, a Coastal Freshwater Pond, Del Norte County, California," master's thesis, Humboldt State University, 1998, https://scholarworks.calstate.edu/downloads/mc87ps54p.
18. "Water Quality Control Policy for the Enclosed Bays and Estuaries of California," State of California, State Water Resources Control Board, 1974, https://www.waterboards.ca.gov/board_decisions/adopted_orders/resolutions/1974/rs74_043.pdf.
19. Redwoods Rising, *Ecosystem Restoration Project*.

*Notes for 07.03, 07.03a, and 07.03b*

1. "Condor Videos," National Park Service, https://www.nps.gov/redw/learn/photosmultimedia/condorvideos.htm.
2. P. Welch and Center for Integrated Spatial Research, "Distribution of Redwood (*Sequoia sempervirens*) Indicating Locations of Old-Growth Stands," in *Ecosystems of California*, edited by H. Mooney and E. Zavaleta, 538 (Oakland: University of California Press, 2016).
3. Backcountry Press, "Trillium Falls Trail," *Backcountry Press* (blog), January 25, 2020, https://backcountrypress.com/2020/01/trillium-falls-trail.
4. "Plants," in "Redwood National and State Parks," National Park Service, https://www.nps.gov/redw/learn/nature/plants.htm.
5. "Humboldt Lagoons State Park," California State Parks, https://www.parks.ca.gov/?page_id=416.
6. P. Fimrite, "Search Is On for Mysterious White-Footed Vole near Redwoods," *SFGATE*, September 13, 2014, https://www.sfgate.com/science/article/Search-is-on-for-mysterious-white-footed-vole-5754041.php.
7. D. Cooper, *Important Bird Areas of California* (Pasadena, CA: Audubon, 2004), 272.
8. "Tidepool Animals," in "Redwood National and State Parks," National Park Service, https://www.nps.gov/redw/learn/nature/tidepool-animals.htm.

*Notes for 07.04 and 07.04a*

1. "Humboldt Bay Sea Level Rise Adaptation Plan," California State Coastal Conservancy, October 18, 2012, 4, https://scc.ca.gov/webmaster/ftp/pdf/sccbb/2012/1210/20121018Board11_Humboldt_Bay_SLR.pdf.

Notes

2. "Nature and Science: Humboldt Bay: Physical Geography," Friends of the Dunes, 2012, http://www.friendsofthedunes.org/nature/humboldt-bay.shtml.

3. S. Schlosser and A. Eicher, *Humboldt Bay and Eel River Estuary Benthic Habitat Project* (San Diego: California Sea Grant College Program, 2012), https://caseagrant.ucsd.edu/publication/humboldt-bay-and-eel-river-estuary-benthic-habitat-project.

4. "Map and Guide," Trinidad Coastal Land Trust, https://www.trinidadcoastallandtrust.org/map-and-guide.html.

5. G. Griggs, K. Patsch, and L. Savoy, *Living with the Changing California Coast* (Berkeley: University of California Press, 2005), 177.

6. "Razor Clams," Washington Department of Fish and Wildlife, http://wdfw.wa.gov/fish/shelfish/razorclm/domacid.htm.

7. E. G. Gudde and W. Bright, *California Place Names: The Origin and Etymology of Current Geographical Names* (Berkeley: University of California Press), 223.

8. K. Osborn, "Seasonal Fish and Invertebrate Communities in Three Northern California Estuaries," master's thesis, Humboldt State University, 2017, https://digitalcommons.humboldt.edu/etd/101.

9. "Invasive Spartina in Humboldt County," US Fish and Wildlife Service, http://www.fws.gov/humboldtbay.

10. "Humboldt Bay," US Fish and Wildlife Service, https://www.fws.gov/refuge/Humboldt_Bay/wildlife_and_habitat/wildlife_and_habitat.html.

11. S. Schlosser and A. Eicher, "Humboldt Bay and Eel River Estuary Benthic Habitat Project" (San Diego: California Sea Grant College Program, 2009), 20, http://ca-sgep.ucsd.edu/sites/ca-sgep.ucsd.edu/files/files/Humboldt_Habitats.pdf.

12. "Map & Guide: Arcata Marsh & Wildlife Sanctuary," Arcata Marsh Interpretive Center, Environmental Services Department, City of Arcata.

13. C. Pomeroy, C. J. Thomson, and M. M. Stevens, *California's North Coast Fishing Communities Historical Perspective and Recent Trends: Final Report to the California State Coastal Conservancy* (La Jolla: California Sea Grant College Program, 2010).

14. S. P. O'Hara and G. Graves, *Saving California's Coast: Army Engineers at Oceanside and Humboldt Bay* (Spokane, WA: Arthur H. Clark, 1991), 277.

15. "Pacific Brant," US Fish and Wildlife Service, https://www.fws.gov/refuge/Humboldt_Bay/wildlife_and_habitat/PacificBrant.html.

16. "Salmon Creek Restoration," US Fish and Wildlife Service, Humboldt Bay National Wildlife Refuge, https://www.fws.gov/refuge/humboldt_bay/wildlife_and_habitat/salmoncreekrestoration.html. Restoration partners include Pacific Coast Fish, Wildlife & Wetlands Restoration Association; USFWS Coastal Program; California Department of Fish and Wildlife; California Conservation Corps; Ducks Unlimited; and National Fish and Wildlife Foundation.

17. "Dune Restoration—Humboldt Bay," US Fish and Wildlife Service, Humboldt Bay National Wildlife Refuge, March 30, 2020, https://www.fws.gov/refuge/Humboldt_Bay/wildlife_and_habitat/DunesRestoration.html.

18. B. A. Ogle, *Geology of Eel River Valley Area, Humboldt County, California* (San Francisco: California Department of Natural Resources, Division of Mines, 1953).

19. G. Griggs, K. Patsch, and L. Savoy, *Living with the Changing California Coast* (Berkeley: University of California Press, 2005), 185.

20. K. P. Furlong and R. Govers, "Ephemeral Crustal Thickening at a Triple Junction: The Mendocino Crustal Conveyor," *Geology* 27, no. 2 (1999): 127–30, https://doi.org/10.1130/0091-7613(1999)027<0127:ECTAAT>2.3.CO;2.

21. "Map & Guide."

## Notes for 07.05, 07.05a, and 07.05b

1. B. Lorentzen and R. Nichols, *Hiking the California Coastal Trail: Volume One* (Mendocino, CA: Bored Feet, 1998), 95.

2. M. Kauffmann, "Sugar Pines of the King Range Wilderness," July 4, 2014, https://www.michaelkauffmann.net/2014/07/sugar-pines-king-range-wilderness.

3. R. McLaughlin, S. B. Ellen, M. C. Blake Jr., A. Jayko, W. Irwin, K. Aalto, G. Carver, and S. Clarke Jr., "Geology of the Cape Mendocino, Eureka, Garberville, and Southwestern Part of the Hayfork 30 x 60 Minute Quadrangles and Adjacent Offshore Area, Northern California," US Geological Survey, 2000, https://pubs.usgs.gov/mf/2000/2336.

4. Mattole Restoration Council, "North Coast Resource Partnership, 2018/2019 IRWM Project Application: Lower Mattole River and Estuary Enhancement Phase II," https://northcoastresourcepartnership.org/site/assets/uploads/2019/03/19-Mattole-Restoration-Council-Lower-Mattole-River-Estuary-Enhancement-Phase-II.pdf.

5. "King Range Proposed WSRs," California Wilderness Coalition, https://www.calwild.org/portfolio/kingrange-wsrs.

6. "*Arctostaphylos crustacea eastwoodiana*," Las Pilitas Nursery, https://www.laspilitas.com/nature-of-california/plants/85--arctostaphylos-crustacea-eastwoodiana.

7. "Gitchell Creek," Northwest California's Mountains & Rivers, https://mountainsandrivers.org/gitchell-creek.

8. M. Schwartz, ed., *Encyclopedia of Marine Science* (New York: Springer, 2005), 413.

9. M. Kauffmann, *Hiking Humboldt*, vol. 1 (Eureka, CA: Backcountry Press, 2016), 84.

10. R. Burns, "In Shelter Cove, Cultures Collide on Either End of a Disputed Coastal Trail," *Lost Coast Outpost*, May 16, 2015, https://lostcoastoutpost.com/2015/may/16/shelter-cove-cultures-collide-either-end-coastal-t.

11. "California Recreational Ocean Fishing Regulations: Invertebrate Fishing Regulations," California Department of Fish and Wildlife, March 8, 2021, https://wildlife.ca.gov/Fishing/Ocean/Regulations/Sport-Fishing/Invertebrate-Fishing-Regs.

12. "Mattole Restoration Council," Trees Foundation, https://treesfoundation.org/partner-groups/mattole-restoration-council. Groups include the Mattole Restoration

Council, the Mattole Salmon Group, Sanctuary Forest, the Mill Creek Watershed Conservancy, the Upper Mattole River and Forest Cooperative, and the Mattole River and Range Partnership.
13. "Mattole Restoration Council."
14. "Mattole Restoration Council."

*Notes for 07.06 and 07.06a*

1. "Sinkyone Wilderness State Park: Science and Nature," California State Parks, https://www.parks.ca.gov/?page_id=28167.
2. "Cape Vizcaino Restoration," Save the Redwoods League, https://www.savetheredwoods.org/project/cape-vizcaino-restoration.
3. "Juan Creek," Mendocino Coast Historical Society, https://www.mendorailhistory.org/1_towns/towns/juan_creek.htm.
4. G. Wengert, "Demography, Range, Habitat, Condition and Parasites of the Roosevelt Elk *(Cervus elaphus roosevelti)* of Sinkyone Wilderness State Park, Mendocino County, California," report for California State Parks, 2000, http://www.iercecology.org/wp-content/uploads/2012/06/Wengert-2000-Elk-CA_State_Park.pdf.
5. M. Bidartondo, B. Burghardt, G. Gebauer, T. Bruns, and D. Read, "Changing Partners in the Dark: Isotopic and Molecular Evidence of Ectomycorrhizal Liaisons between Forest Orchids and Trees," *Proceedings of the Royal Society B* 271, no. 1550 (2004): 1799–806, https://doi.org/10.1098/rspb.2004.2807.
6. S. Wicke and J. Naumann, "Molecular Evolution of Plastid Genomes in Parasitic Flowering Plants," *Advances in Botanical Research* 85, no. 1 (2018): 315–47, https://doi.org/10.1016/bs.abr.2017.11.014.
7. "Mycotrophic Wildflowers," US Forest Service, https://www.fs.fed.us/wildflowers/beauty/mycotrophic.

*Notes for 07.07 and 07.07a*

1. O. Spaargaren, "Podzols," in *Encyclopedia of Soil Science*, edited by W. Chesworth, 580–81 (Dordrecht, Netherlands: Springer, 2008).
2. "Science and Nature," in "Jug Handle SNR," California State Parks, https://www.parks.ca.gov/29497.
3. D. S. Cooper, *Important Bird Areas of California* (Pasadena, CA: Audubon, 2004), 150.
4. "Diversity of Fens in the Mountains of California," US Forest Service, fs.fed.us/wildflowers/beauty/California_Fens/diversity/index.shtml.
5. J. Havlena, "MacKerricher State Park: Northern Section Laguna Point, Lake Cleone, Ten Mile Beach," Mendocino Audubon Society, https://www.mendocinocoastaudubon.org/mcas_birding_MacKerricher.html.

6. Chorizanthe howellii *(Howell's spineflower)* 5-*Year Review: Summary and Evaluation* (Arcata, California: US Fish and Wildlife Service, Arcata Fish and Wildlife Office, 2011), https://www.fws.gov/arcata/es/plants/howellsSpineflower/documents/2011%20 Howells%20spineflower%205YR%20Status%20Review.pdf.

7. M. Jones, *Fort Bragg Coastal Restoration and Trail Project Phase II, Mendocino County, California: Subsequent Environmental Impact Report* (Fort Bragg, CA: City of Fort Bragg, 2014), https://city.fortbragg.com/DocumentCenter/View/4154/2014-Coastal-Trail -Phase-II---Subsequent-EIR-PDF.

8. "Noyo Harbor Community Sustainability Plan," Coastal Conservancy, November 30, 2017, https://scc.ca.gov/webmaster/ftp/pdf/sccbb/2017/1711/20171130Board03D_ Noyo_Harbor_Community_Sustainability_Plan.pdf.

9. "Hans Jenny Pygmy Forest Reserve," University of California Natural Reserve System, https://ucnrs.org/reserves/hans-jenny-pygmy-forest-reserve.

10. W. Fox, "Pygmy Forest: An Ecological Staircase," *California Geology* 29, no. 1 (1976): 1–24, https://maps.conservation.ca.gov/cgs/cgs_magazine.html.

11. M. Kauffmann, *Conifers of the Pacific Slope* (Kneeland, CA: Backcountry Press, 2013), 85.

12. J. R. Griffin and W. Critchfield, *The Distribution of Forest Trees in California* (Berkeley, CA: US Forest Service, 1972), 24.

13. "Big River Estuary: Expansive Conservation, Enormous Fun," Visit Mendocino, https://visitmendocino.com/big-river-estuary-expansive-conservation-enormous-fun.

14. K. Osborn, "Seasonal Fish and Invertebrate Communities in Three Northern California Estuaries" master's thesis, Humboldt State University, 2017, https:// digitalcommons.humboldt.edu/etd/101.

15. F. W. Sheridan and E. D. Wilcox, eds., *Big River: The Natural History of an Endangered Northern California Estuary* (Santa Cruz: University of California, 1981).

16. J. Lowell, "Charlotte M. Hoak Memorial Pygmy Forest," http://pygmy-forest.com /CMHPF.htm.

17. D. S. Cooper, *Important Bird Areas of California* (Pasadena, CA: Audubon, 2004), 150.

18. "Albion Coho Defense Community: Description and Location," Albion River Watershed Protection Association and Friends of Salmon Creek, http://www.rcwa.us /albion/history.html.

19. T. Sholars, "Navarro Point Vascular Plants," California Native Plant Society, Dorothy King Young Chapter, 2007, https://www.dkycnps.org/plant_lists/NavarroPt -Plants_2007.pdf; "Native Flora Locations in Our Area," California Native Plant Society, Dorothy King Young Chapter, https://www.dkycnps.org/locations.html.

20. T. Sholars, 1998. "Jug Handle State Natural Reserve: The Ecological Staircase," California State Parks, https://www.parks.ca.gov/pages/441/files/Jughandle _Brochuretas2016A.pdf.

21. M. Krauth, "Living with the California Black Bear," *Ukiah Daily Journal*, January 9, 2009, https://www.ukiahdailyjournal.com/2009/01/20/living-with-the-california -black-bear.

Notes

22. "Deer Fern, *Blechnum spicant*," Calscape, https://calscape.org/Blechnum-spicant-(Deer-Fern).
23. J. McKinney, *Day Hiker's Guide to California's State Parks* (Sacramento: California State Parks Foundation, 2011), 302.

## Notes for 07.08, 07.08a, and 07.08b

1. "Manchester State Park," California State Parks, https://www.parks.ca.gov/437.
2. "Point Arena Mountain Beaver," Encyclopedia.com, https://www.encyclopedia.com/environment/science-magazines/point-arena-mountain-beaver.
3. *Point Arena Mountain Beaver (Aplodontia rufa nigra) 5-Year Review: Summary and Evaluation* (Arcata, California: US Fish and Wildlife Service, Arcata Fish and Wildlife Office, 2009), https://www.fws.gov/arcata/es/mammals/mtnbeaver/documents/5yearReview.pdf.
4. T. L. Newell, "*Aplodontia rufa*: mountain beaver," Animal Diversity Web, 2002, https://animaldiversity.org/accounts/Aplodontia_rufa.
5. W. J. Zielinski, F. V. Schlexer, T. L. George, K. L. Pilgrim, and M. K. Schwartz, "Estimating Abundance and Survival in the Endangered Point Arena Mountain Beaver Using Noninvasive Genetic Methods," *Northwest Science* 87, no. 2 (2013): 126–39, https://doi.org/10.3955/046.087.0205.
6. B. Cornelius, "*N. californica* Population Explosion," email, May 27, 2005, https://mailman.yale.edu/pipermail/leps-l/2005-May/009535.html.
7. B. Lorentzen and R. Nichols, *Hiking the California Coastal Trail: Volume One* (Mendocino, CA: Bored Feet, 1998), 155.
8. "California Coastal National Monument," Bureau of Land Management, https://www.blm.gov/programs/national-conservation-lands/california/california-coastal.
9. J. Larke, "Garcia River: A Watershed Is Restored," *Mendocino Beacon*, August 23, 2018, https://www.mendocinobeacon.com/2008/07/17/garcia-river-a-watershed-is-restored.
10. J. Jackson, "Two Juvenile Gray Whales Pay Several Visits to the Point Arena Pier," Mendonoma Sightings, January 9, 2013, https://www.mendonomasightings.com/2013/01/09/two-juvenile-gray-whales-pay-several-visits-to-the-point-arena-pier.
11. C. E. Shaw, "California Coastal National Monument Geologic Characterization," Bureau of Land Management, 2007, 17, https://www.mendocino.edu/sites/default/files/ca_coastal_national_monument_geology.pdf.
12. D. V. McCorkle and P. C. Hammond, "Observations on the Biology of *Speyeria zerene hippolyta* (Nymphalidae) in a Marine Modified Environment," *Journal of the Lepidopterists' Society* 42, no. 3 (1988): 184–95, https://images.peabody.yale.edu/lepsoc/jls/1980s/1988/1988-42(3)184-McCorkle.pdf.

13. R. Hohman, S. Hutto, C. Catton, and F. Koe, *Sonoma-Mendocino Bull Kelp Recovery Plan*, Greater Farallones National Marine Sanctuary and California Department of Fish and Wildlife, 2019, 6, https://farallones.org/wp-content/uploads/2019/06/Bull-Kelp-Recovery-Plan-2019.pdf.

14. "Point Arena Mountain Beaver," Mendocino Land Trust, https://www.mendocinolandtrust.org/explore/explore-our-lands/pelican-bluffs/point-arena-mountain-beaver.

15. D. T. Steele, *Recovery Plan for the Point Arena Mountain Beaver* Aplodontia rufa nigra (Rafinesque) (Portland, OR: US Fish and Wildlife Service, 1998).

16. "Gray Whales, *Eschrichtius robustus*," Noyo Center for Marine Science, https://noyocenter.org/marine-mammals/gray-whales.

17. R. LeValley, "Brandt's Cormorant Reproductive Efforts on Gualala Point Island, Sonoma County, and Fish Rocks," Mad River Biologists, March 23, 2010, http://www.npshistory.com/publications/blm/california-coastal/brandts-cormorant-repro-2010.pdf.

18. "California's Critical Coastal Areas: Del Mar Landing," California Coastal Commission, June 8, 2006, https://www.coastal.ca.gov/nps/Web/cca_pdf/ncoastpdf/CCA17DelMarLanding.pdf.

19. G. Flosi, S. Downie, J. Hopelain, M. Baird, R. Coey, and B. Collins, *California Salmonid Stream Habitat Restoration Manual*, 4th ed. (State of California, Resources Agency; California Department of Fish and Game, Wildlife and Fisheries Division, 2010), available at https://wildlife.ca.gov/Grants/FRGP/Guidance.

20. B. Finlayson and J. Nelson, "Stream Inventory Report: Elk Creek," California Department of Fish and Game, Fisheries Inventory, 2001, nrm.dfg.ca.gov; PDF download link.

21. "Salmon Restoration Association Grant Request Details," Salmon Restoration Association, 2011, https://salmonrestoration.com/project/mendocino-high-school-sonar-program.

22. J. O. Sawyer and T. Keeler-Wolf, *A Manual of California Vegetation* (Sacramento: California Native Plant Society, 1995).

23. "Initial Study, Manchester Subsea Cables Project," California State Lands Commission, 2019, https://www.slc.ca.gov/wp-content/uploads/2019/04/MND.pdf.

## Notes for 07.09 and 07.09a

1. P. Raimondi, "Windermere Point," Multi-Agency Rocky Intertidal Network (Marine), University of California, Santa Cruz, 2019, https://marine.ucsc.edu/sitepages/windermerepoint.html.

2. J. A. Jackson, *Mendonoma Sightings throughout the Year* (Gualala, CA: Mendonoma Sightings Publishing, 2018).

3. "Gualala Bluff Trail," Redwood Coast Land Conservancy, https://www.rclc.org/gualala-bluff-trail-2.

4. P. Galvin and C. Ivor, "Lawsuit Challenges Logging Threat to Endangered Wildlife in Northern California Redwoods," Friends of the Gualala River, September 15, 2020, http://gualalariver.org/news/lawsuit-challenges-logging-threat-to-endangered-wildlife-in-northern-california-redwoods.

5. D. Martinez, "Gone to the Birds: Bird Watching at Sea Ranch," Sea Ranch Abalone Bay, September 9, 2013, https://searanchabalonebay.com/activities/bird-watching-at-sea-ranch.

6. B. Lorentzen and R. Nichols, *Hiking the California Coastal Trail: Volume One* (Mendocino, CA: Bored Feet, 1998), 175.

7. "Wandering the Coastal Wonderland of Stewarts Point," Save the Redwoods League, 2017, https://www.savetheredwoods.org/redwoods-magazine/autumn-winter-2017/wandering-coastal-wonderland-stewarts-point.

8. "Stewards Point Stewardship Project," Save the Redwoods League, 2017, https://www.savetheredwoods.org/project/stewarts-point-stewardship-project.

9. Jackson, *Mendonoma Sightings*, 85.

10. C. Russell, "Kruse Rhododendron State Natural Reserve," May 21, 2018, https://wildflowers.russellramblings.com/2018/05/kruse-rhododendron-state-natural-reserve.

11. "Kashia Coastal Reserve," Trust for Public Land, https://www.tpl.org/our-work/kashia-coastal-reserve.

12. "Surface Water Ambient Monitoring Program—Mussel Watch Program," California Water Boards, February 4, 2019, https://www.waterboards.ca.gov/water_issues/programs/swamp/mussel_watch.html.

13. "California's Critical Coastal Areas: Gerstle Cove," California Coastal Commission, June 8, 2006, https://www.coastal.ca.gov/nps/Web/cca_pdf/ncoastpdf/CCA18GerstleCove.pdf.

14. "Stillwater Cove Trails," Sonoma County Regional Parks, http://parks.sonomacounty.ca.gov/Visit/Stillwater-Cove-Regional-Park/Trails.

15. B. Valentine, T. Nelson, C. Golec, L. Clare, and S. Martinelli, "The Response of Swamp Harebell (*Campanula californica*) to Timber Harvest: A Case Study," in *Coast Redwood Science Symposium—2016: Past Successes and Future Direction*, R. B. Standiford and Y. Valachovic, technical coordinators, 295–305 (Albany, CA: US Department of Agriculture, Forest Service, Pacific Southwest Research Station, 2017), https://www.fs.fed.us/psw/publications/documents/psw_gtr258/psw_gtr258_295.pdf.

16. Raimondi, "Windermere Point."

17. V. Humphreys, "The Biogeography of the Purple Ochre Sea Star (*Pisaster ochraceus*)," Geography 316: Biogeography, San Francisco State University, fall 2003, http://online.sfsu.edu/bholzman/courses/Fall%2003%20project/oseastar.htm.

18. "Fort Ross State Historical Park," California State Parks, https://www.parks.ca.gov/449.

19. T. Blok, "The Russian Colonies in California: A Russian Version," *California Historical Quarterly* 12, no. 3 (1933): 189–90, https://doi.org/10.2307/25178215.

20. "Marine Mammals," Sonoma Water, 2011, https://www.sonomawater.org/marine-mammals.

21. M. Miner, R. Gaddam, and M. Douglas, "Sea Star Wasting Disease," Multi-Agency Rocky Intertidal Network, University of California, Santa Cruz, March 29, 2021, https://marine.ucsc.edu/data-products/sea-star-wasting.

22. C. Mah, "Starfish Wasting Disease!" *Echinoblog*, September 10, 2013, http://echinoblog.blogspot.com/2013/09/starfish-wasting-disease.html.

23. G. L. Eckert, J. M. Engle, and D. J. Kushner, "Sea Star Disease and Population Declines at the Channel Islands," *Proceedings of the Fifth California Islands Symposium* (2000): 390–93, https://marine.ucsc.edu/data-products/sea-star-wasting/eckertetal_sswd_channel_islands_symposium_1999.pdf.

24. R. T. Paine, "Food Web Complexity and Species Diversity," *American Naturalist* 100, no. 910 (1966): 65–75, https://www.jstor.org/stable/2459379.

25. C. Miner, J. Burnaford, R. F. Ambrose, L. Antrim, H. Bohlmann, C. Blanchette, J. Engle, et al., "Large-Scale Impacts of Sea Star Wasting Disease (SSWD) on Intertidal Sea Stars and Implications for Recovery," *PLOS One* 13, no. 3 (2018): e0192870, https://doi.org/10.1371/journal.pone.0192870.

26. M. E. Eisenlord, M. L. Groner, R. M. Yoshioka, J. Elliott, J. Maynard, S. Fradkin, M. Turner, et al., "Ochre Star Mortality during the 2014 Wasting Disease Epizootic: Role of Population Size Structure and Temperature," *Philosophical Transactions of the Royal Society of London B* 371, no. 1689 (2016): 20150212, https://doi.org/10.1098/rstb.2015.0212.

27. I. Hewson, J. B. Button, B. M. Gudenkauf, B. Miner, A. L. Newton, J. K. Gaydos, J. Wynne, et al. "Densovirus Associated with Sea-Star Wasting Disease and Mass Mortality," *Proceedings of the National Academy of Sciences of the United States of America* 111, no. 48 (2014): 17278–83, https://doi.org/10.1073/pnas.1416625111.

*Notes for 07.10 and 07.10a*

1. H. Gilliam, *Island in Time: The Point Reyes Peninsula* (San Francisco: Sierra Club, 1962).

2. D. Sloan, "Goat Rock State Beach: Rising Land and Crashing Waves on the Sonoma Coast," *Bay Nature* 1, no. 3 (2001), 8–9, 22–23.

3. J. W. Martin and M. K. Wicksten, "Review and Redescription of the Freshwater Atyid Shrimp Genus *Syncaris* Holmes, 1900, in California," *Journal of Crustacean Biology* 24, no. 3 (2004): 447–62, https://doi.org/10.1651/C-2451.

4. "Discover Sonoma County's Marine Wildlife at Goat Rock Beach," Sonoma County, California, https://www.sonomacounty.com/articles/discover-sonoma-countys-marine-wildlife-goat-rock-beach.

## Notes

5. "Russian River," US Geological Survey, US Board on Geographic Names, https://geonames.usgs.gov/apex/f?p=138:3:::NO:3:P3_FID,P3_TITLE:267200,Russian%20River.

6. K. Deiner, J. C. Garza, R. Coey, and D. J. Girman, "Population Structure and Genetic Diversity of Trout (*Oncorhynchus mykiss*) above and below Natural and Man-Made Barriers in the Russian River, California," *Conservation Genetics* 8 (2007): 437–54, https://doi.org/10.1007/s10592-006-9183-0.

7. S. D. Chase, D. J. Manning, D. G. Cook, and S. K. White, "Historic Accounts, Recent Abundance, and Current Distribution of Threatened Chinook Salmon in the Russian River, California," *California Fish and Game* 93, no. 3 (2007): 130–48, https://www.researchgate.net/publication/279540140_Historic_accounts_recent_abundance_and_current_distribution_of_threatened_Chinook_salmon_in_the_Russian_River_California.

8. Z. Reinstein, "Russian River Coho Salmon Continue Their Comeback," Sea Grant California, August 24, 2018, https://caseagrant.ucsd.edu/blogs/russian-river-coho-salmon-continue-their-comeback.

9. A. Pecharich and J. Martini-Lamb, *Russian River Estuary Management Project Marine Mammal Protection Act Incidental Harassment Authorization Report of Activities and Monitoring Results—January 1 to December 31, 2019* (Albuquerque, NM: National Marine Fisheries Service, Office of Protected Resources and Southwest Regional Administrator, 2020), https://docplayer.net/201594540-Russian-river-estuary-management-project.html.

10. "Share the Shore with Harbor Seals," NOAA Fisheries, https://www.dnr.wa.gov/publications/amp_na_woodardbay_babyseal.pdf.

11. Sloan, "Goat Rock State Beach," 8–9, 22–23.

12. B. Lorentzen and R. Nichols, *Hiking the California Coastal Trail: Volume One* (Mendocino, CA: Bored Feet, 1998), 192.

13. "Carrington Ranch Preserve," Sonoma County, https://sonomacounty.ca.gov/Parks/Planning/Carrington-Ranch-Preserve.

14. M. Luna and A. Mapes, *Whale Watch Docent Manual* (Guerneville, CA: Stewards of the Coast and Redwoods, 2003).

15. D. S. Cooper, *Important Bird Areas of California* (Pasadena, CA: Audubon, 2004), 55.

16. C. Cornwall, S. Moore, D. DiPietro, S. Veloz, L. Micheli, L. Casey, and M. Mersich, *Climate Ready Sonoma County: Climate Hazards and Vulnerabilities* (Santa Rosa, CA: North Bay Climate Adaptation Initiative, 2014), http://rcpa.ca.gov/wp-content/uploads/2016/03/Climate-Ready_Hazards_Vulnerabilities-FINAL.pdf.

17. "Bodega Marine Reserve," UC Davis Coastal and Marine Science Institute, https://marinescience.ucdavis.edu/bml/bmr.

18. "Douglas Iris," California Native Plant Society, https://calscape.org/Iris-douglasiana-().

19. "The Best Beaches You Can't Visit," California Beaches, https://www.californiabeaches.com/map/best-beaches-youll-never-see-california.

# Notes

20. J. Evens, "Shifting Sands," *Bay Nature*, April 1, 2008, https://baynature.org/article/shifting-sands.
21. "Tule Elk," in "Point Reyes National Seashore," National Park Service, https://www.nps.gov/pore/learn/nature/tule_elk.htm.
22. G. Migiro, "The Foggiest Places on Earth," *World Atlas*, February 23, 2018, https://www.worldatlas.com/articles/foggiest-places-on-earth.html.
23. "Bolinas Ridge," Golden Gate National Parks Conservancy, https://www.parksconservancy.org/parks/bolinas-ridge.
24. A. J. Galloway, "Vegetation," in *Geology of the Point Reyes Peninsula, Marin County, California* (Sacramento: California Division of Mines and Geology, 1977).
25. D. Schirokauer and A. Parravano, "Enhanced Wetlands Mapping and Inventory in Point Reyes National Seashore and Golden Gate National Recreation Area," *Park Science* 23, no. 1 (2005): 34–40, https://irma.nps.gov/DataStore/DownloadFile/615785.
26. "Viewing Elephant Seals," in "Point Reyes National Seashore," National Park Service, https://www.nps.gov/pore/planyourvisit/wildlife_viewing_elephantseals.htm.
27. "Northern Elephant Seal," NOAA Fisheries, https://www.fisheries.noaa.gov/species/northern-elephant-seal.
28. R. Krasna, "Spring into Migration!" Mission Blue: Sylvia Earle Alliance, March 7, 2019, https://mission-blue.org/2019/03/spring-into-migration.
29. B. Cartwright, "Woodward a Glimpse into Fiery Future," *Point Reyes Light*, September 16, 2020, https://www.ptreyeslight.com/article/woodward-glimpse-fiery-future.
30. J. Cheng, "Alamere Falls," World of Waterfalls, https://www.world-of-waterfalls.com/waterfalls/california-alamere-falls.
31. *Double Point, Marin County: California Marine Waters Areas of Special Biological Significance Reconnaissance Survey Report* (Sacramento: California State Water Resources Control Board, Surveillance and Monitoring Section, 1979), https://www.waterboards.ca.gov/publications_forms/publications/general/docs/asbs_doublepoint_may.pdf.
32. S. Fletcher, "Marin History: Remembering the 1906 Earthquake," *Marin Independent Journal*, April 1, 2019, https://www.marinij.com/2019/04/01/marin-history-1906-earthquake.
33. National Park Service, *General Management Plan Amendment: Final Environmental Impact Statement* (Point Reyes National Seashore, CA: NPS Point Reyes National Seashore, 2020), https://parkplanning.nps.gov/document.cfm?documentID=106632.
34. "Tule Elk at Tomales Point FAQ," in "Point Reyes National Seashore," National Park Service, https://www.nps.gov/pore/learn/nature/tule_elk_tomales_point_faq.htm.
35. G. Wuerthner, "Welcome to Point Reyes National Cattle Ranch," *Wildlife News*, September 30, 2020, https://www.thewildlifenews.com/2020/09/30/welcome-to-point-reyes-national-cattle-ranch.

Notes

36. L. A. Watt, *The Paradox of Preservation: Wilderness and Working Landscapes at Point Reyes National Seashore* (Berkeley: University of California Press, 2017), 194–99.
37. "Non-Native Deer," in "Point Reyes National Seashore," National Park Service, https://www.nps.gov/pore/learn/nature/nonnativespecies_deer.htm.

*Notes for 07.11 and 07.11a*

1. "Coastal Dune Scrub Community," National Park Service, https://www.nps.gov/prsf/learn/nature/coastal-dune-scrub-community.htm.
2. Audubon Canyon Ranch, Cypress Grove Research Station, https://egret.org/cypress-grove-research-center; Point Blue Conservation Science, www.pointblue.org.
3. "Dipsea and Steep Ravine," Redwood Hikes, http://www.redwoodhikes.com/Muir/SteepRavine.html.
4. J. Herrmann, M. Murphy, and D. Smith, "Rare and Endangered Plants of Mt. Tamalpais," Friends of Mt Tam, 2007, https://www.friendsofmttam.org/wp-content/uploads/rareendemicsfinal-cb.pdf.
5. "Muir Woods National Monument," National Park Service, https://www.nps.gov/muwo/index.htm.
6. "Saving Rare Native Plants from Extinction on Ring Mountain," Marin County Parks, January 20, 2021, https://www.marincountyparks.org/projectsplans/land-and-habitat-restoration/rare-plant-research-ring-mountain.
7. "Third Redwood Creek Coho Salmon Release a Success," National Park Service, January 2018, https://www.nps.gov/articles/third-redwood-creek-coho-salmon-release-a-success.htm.
8. "Coastal Training Technical Assistance," San Francisco Bay National Estuarine Research Reserve, https://sfbaynerr.sfsu.edu/node/47.
9. "About Us," Marine Mammal Center, https://www.marinemammalcenter.org/about-us.
10. A. J. Szeri, "Langmuir Circulations in Rodeo Lagoon," *American Meteorological Society Monthly Weather Review* 124, no. 2 (1996): 341–42, https://doi.org/10.1175/1520-0493(1996)124<0341:LCIRL>2.0.CO;2.
11. "Raptor-Sightings in the Marin Headlands during 2015," *Pacific Raptor Report* 37 (2015), 13, https://www.parksconservancy.org/sites/default/files/PacificRaptor37.pdf.
12. K. Ward and M. Ablog, *Crissy Field Restoration Project Summary of Monitoring Data 2000–2004* (San Francisco: Golden Gate National Recreation Area, 2006), https://www.nps.gov/goga/learn/management/upload/-1441-crissy-marsh.pdf.
13. B. Lorentzen and R. Nichols, *Hiking the California Coastal Trail: Volume One* (Mendocino, CA: Bored Feet, 1998), 234.
14. "Mammals," in "Presidio of San Francisco," National Park Service, https://www.nps.gov/prsf/learn/nature/mammals.htm.

15. M. Loran, *Coastal Trail at Lands End: Habitat Restoration and Enhancement and Trail Management and Maintenance Strategy, Golden Gate National Recreation Area* (San Francisco: Golden Gate National Parks Conservancy, 2005), https://www.nps.gov/goga/learn/management/upload/-1430-Final-Report-Coastala-Trail-at-Lands-End.pdf.

16. A. K. Brown, trans. and ed., *With Anza to California, 1775–1776: The Journal of Pedro Font, O.F.M.* (Norman: Arthur H. Clark Co., University of Oklahoma Press, 2011).

17. D. Sloan, "Down to the Sea Again," *Bay Nature*, January 1, 2005, https://baynature.org/article/down-to-the-sea-again.

18. "Fort Funston Nursery," Golden Gate National Parks Conservancy, https://www.parksconservancy.org/programs/fort-funston-nursery.

19. "Sharp Park Beach, Pacifica," Pacific Beach Coalition, https://www.pacificbeachcoalition.org/take-action/monthly-adopt-a-beach-cleanups/sharp-park-beach-cleanup.

20. "Linda Mar Beach Restoration, Pacifica," Pacific Beach Coalition, https://www.pacificbeachcoalition.org/take-action/linda-mar-habitat-restoration.

21. Pacific Beach Coalition, https://www.pacificbeachcoalition.org.

22. C. Kozak, "Native Plants of Montara Mountain," McNee Ranch State Park, 1998, http://plants.montara.com/mrsp.html#plants.

23. R. Mena-Werth, "Local Resident Works to Save Threatened Surfer's Beach near Half Moon Bay," *Peninsula Press*, July 11, 2016, http://peninsulapress.com/2016/07/11/sand-savior.

24. "Biosphere Reserves," UNESCO, https://en.unesco.org/biosphere.

25. Audubon Canyon Ranch, University of California, National Oceanic and Atmospheric Administration, US Fish and Wildlife Service, National Park Service, Stanford University, Marin Municipal Water District, California Department of Parks and Recreation, San Francisco Public Utilities Commission, Point Reyes Bird Observatory, and Presidio Trust.

26. Golden Gate Biosphere Reserve," in "Point Reyes National Seashore," National Park Service, https://www.nps.gov/pore/learn/nature/golden_gate_biosphere_reserve.htm.

## Notes for 07.12, 07.12a, and 07.12b

1. C. Cox and E. Soderstrom, *San Gregorio Creek Watershed Management Plan* (San Francisco: Natural Heritage Institute, 2010), http://www.sanmateorcd.org/SanGregorioWMP_final.pdf.

2. "Portola Redwoods State Park," Sempervirens Fund, https://sempervirens.org/portola-redwoods-state-park.

3. D. S. Cooper, *Important Bird Areas of California* (Pasadena, CA: Audubon, 2004), 217.

4. T. Stienstra, "In Bay Area and Beyond, Bald Eagles Steal the Show," *San Francisco Chronicle*, October 13, 2019, https://www.sfchronicle.com/outdoors/stienstra/article/In-Bay-Area-and-beyond-bald-eagles-steal-the-show-14518866.php.

5. M. Vasey, "Of Hazelnuts and Adder's Tongue," *Bay Nature*, April 1, 2001, https://baynature.org/article/of-hazelnuts-and-adders-tongue.

6. A. M. Brown, *Nature Hot Spots in California* (New York: Firefly Books, 2019), 70.

7. "Wavecrest Open Space Trail," Coastside Land Trust, August 2, 2020, http://www.coastsidelandtrust.org/our-blog/2020/8/2/wavecrest-open-space-trail.

8. "Blufftop Coastal Park, Half Moon Bay," Sequoia Audubon Society, http://birding.sequoia-audubon.org/description.php?loc=97.

9. T. N. Pollak, "Population Status of the Endemic San Francisco Damselfly (*Inschura gemina*)," master's thesis, San Francisco State University, 2016, https://scholarworks.calstate.edu/downloads/m039k6477.

10. "Santa Cruz Black Salamander," iNaturalist.com, https://www.inaturalist.org/observations?taxon_id=520461.

11. "Inventory of Rare and Endangered Plants of California" (online ed., v8-03 0.39), California Native Plant Society, Rare Plant Program, http://www.rareplants.cnps.org.

12. Santa Cruz Mountains Stewardship Network, http://scmsn.net. From the organization's website: "The Stewardship Network is comprised of 21 organizations including local, state, and federal agencies, nonprofits, academia, business, community, and tribal groups."

13. Grassroots Ecology, https://www.grassrootsecology.org.

14. P. VanEyll, "A First Encounter with Redwood Grandeur," Save the Redwoods League, February 16, 2017, https://www.savetheredwoods.org/blog/first-encounter-redwood-grandeur.

15. "El Corte de Madera Preserve," Midpeninsula Regional Open Space District, https://www.openspace.org/preserves/el-corte-de-madera-creek.

16. "Huddart: A San Mateo County Park," San Mateo County Parks, November 2018, https://parks.smcgov.org/sites/parks.smcgov.org/files/HuddartBrochure-Nov2018-FINAL-web.pdf.

17. C. K. Lunch, "Primary Production at Jasper Ridge Biological Preserve, in *Jasper Ridge Biological Preserve State of the Preserve Assessment*, edited by N. Chiariello, Jasper Ridge Biological Preserve, Stanford University, 2009, https://jrbp.stanford.edu/sites/default/files/primary_production_SOP.pdf.

18. M. Robertson, "Sprawling Nature Preserve, a Haven for Jesse James Outlaws and Threatened Frogs, Opens in Bay Area," *SFGATE*, November 29, 2017, https://www.sfgate.com/bayarea/article/la-honda-nature-preserve-jesse-james-ken-kesey-12392751.php.

19. "Long Ridge Preserve," Midpeninsula Regional Open Space District, https://www.openspace.org/preserves/long-ridge.

20. "Maps," in "Golden Gate National Recreation Area," National Park Service, https://www.nps.gov/goga/planyourvisit/maps.htm.

21. "Portola Redwoods State Park," Sempervirens Fund, https://sempervirens.org/portola-redwoods-state-park.
22. "Russian Ridge Preserve," Midpeninsula Open Space District, https://www.openspace.org/preserves/russian-ridge.
23. "Plantlife on San Bruno Mountain," San Bruno Mountain Watch, https://www.mountainwatch.org/plants.
24. "Plantlife on San Bruno Mountain."

*Notes for 07.13, 07.13a, and 07.13b*

1. K. R. Anderson, *A Status Review of the Coho Salmon (Oncorhynchus kisutch) in California South of San Francisco Bay* (Sacramento: California Department of Fish and Game, 1995).
2. M. H. Bond, S. A. Hayes, C. V. Hanson, and R. B. MacFarlane, "Marine Survival of Steelhead (*Oncorhynchus mykiss*) Enhanced by a Seasonally Closed Estuary," *Canadian Journal of Fisheries and Aquatic Sciences* 65, no. 10 (2008), https://doi.org/10.1139/F08-131.
3. J. McGraw, with M. Freeman, R. Arnold, and C. Bean, *The Sandhills Conservation and Management Plan: A Strategy for Preserving Native Biodiversity in the Santa Cruz Sandhills* (Santa Cruz, CA: Land Trust of Santa Cruz County, 2004), http://www.sccoplanning.com/Portals/2/sandhills%20conservation%20and%20management%20plan.pdf.
4. "San Gregorio Restoration Project," San Mateo Resources Conservation District, http://www.sanmateorcd.org/project/sgcreeklwd.
5. "Rehabilitation of San Gregorio Creek," San Mateo Resources Conservation District, http://www.sanmateorcd.org/project_category/water.
6. "Health of San Gregorio Creek Studied at Forum," *Half Moon Bay Review*, April 13, 2000, https://www.hmbreview.com/news/health-of-san-gregorio-creek-studied-at-forumhalf-moon-bay-review-april-13-2000/article_6ac692b5-5c7c-531f-80e8-05d474afd4b1.html.
7. "Category: Recreational Fishing Sites San Mateo County 236," RecFIN, http://wiki.recfin.org/index.php/Category:Recreational_Fishing_Sites_San_Mateo_County_236.
8. J. Hart, "San Mateo Coast," *Bay Nature*, January 1, 2006, https://baynature.org/article/san-mateo-coast.
9. "Butano Creek Reconnection Project," San Mateo Resources Conservation District, http://www.sanmateorcd.org/wp-content/uploads/2020/05/As-Built-Designs.pdf.
10. "Pescadero Marsh Natural Preserve," Coastside State Parks Association, https://www.coastsidestateparks.org/pescadero-marsh-natural-preserve.
11. "Butano Ridge," Redwood Hikes, http://www.redwoodhikes.com/Portola/Butano.html.

Notes

12. J. Clifford, "Before Martins Beach, There Was Pebble Beach," *San Mateo Daily Journal*, November 20, 2017, https://www.smdailyjournal.com/news/local/before-martins-beach-there-was-pebble-beach/article_20b4a268-cd82-11e7-a3ae-7706e9e453fd.html.
13. N. Seltenrich, "Franklin Point Offers a Unique Look at the San Mateo Coast," *Bay Nature*, January 1, 2007, https://baynature.org/article/franklin-point-offers-unique-look-san-mateo-coast.
14. P. Rogers, "Redwood Forest in Santa Cruz Mountains Preserved in $9 Million Deal, 564-Acre Cascade Creek Property Links Big Basin and Año Nuevo State Parks," *Santa Cruz Sentinel*, January 31, 2020, https://www.santacruzsentinel.com/2020/01/31/redwood-forest-in-santa-cruz-mountains-preserved-in-9-million-deal-2.
15. C. L. Bolsinger and K. L. Waddell, "Area of Old-Growth Forests in California, Oregon, and Washington" (Portland, OR: USDA Forest Service, Pacific Northwest Research Station, 1993), https://doi.org/10.2737/PNW-RB-197.
16. D. Verardo and J. Verardo, "Echoes of the Past [The Great 1904 Fire]," *Mountain Echo*, accessed at Santa Cruz Public Libraries, Local History, https://history.santacruzpl.org/omeka/items/show/88#?c=0&m=0&s=0&cv=0&xywh=-1425%2C-1%2C3376%2C2073.
17. "RTC Receives Grant for Scotts Creek Lagoon and Marsh Restoration Planning," Santa Cruz County Regional Transportation Commission, 2019, https://sccrtc.org/rtc-receives-grant-for-scotts-creek-lagoon-and-marsh-restoration-planning.
18. "Hatchery," Monterey Bay Salmon and Trout Project, https://mbstp.org/hatchery.
19. "Cotoni–Coast Dairies National Monument," Sempervirens Fund, https://sempervirens.org/protect-redwoods/cotoni-coast-dairies-national-monument.
20. Bolsinger and Waddell, "Area of Old-Growth Forests," 16.
21. D. Bulger and C. Bean, "Santa Cruz Kangaroo Rat's Decline Indicates a Plant Community at Risk," Sierra Club, Ventana Chapter, 2003, http://www.ventanasierraclub.org/back_issues/0302/krat.shtml.
22. M. Moratto, *California Archaeology* (New York: Academic Press, 1984).
23. "Cave Gulch/Wilder," UCSC Campus Natural Reserve, https://ucsccampusreserve.ucsc.edu/maps-habitats-organisms-stewardship/habitats-and-geography/cave-gulch.html.
24. R. Freitag, D. H. Kavanaugh, and R. Morgan, "A New Species of *Cicindela* (*Cicindela*) (Coleoptera: Carabidae: Cicindelini) from Remnant Native Grassland in Santa Cruz County, California," *Coleopterists Bulletin* 47, no. 2 (1993): 113–20, https://www.jstor.org/stable/4008856.
25. L. M. Krieger, "Is This the End of Western Monarch Butterflies? New Data Shows Another Terrible Year for Insect Populations," *Mercury News*, January 23, 2020, https://www.mercurynews.com/2020/01/23/is-this-the-end-of-western-monarch-butterflies.
26. "Birding at Younger Lagoon, Santa Cruz Bird Club, https://santacruzbirdclub.org/birding-in-santa-cruz/birding-at-younger-lagoon.

27. G. Frankie, R. Thorp, J. Hernandez, M. Rizzardi, B. Ertter, J. Pawelek, S. Witt, et al., "Native Bees Are a Rich Natural Resource in Urban California Gardens," *California Agriculture* 63, no. 3 (2009): 113–20, https://doi.org/10.3733/ca.v063n03p113. Total bee species in North America is about 4,000, and in California the number is close to 1,600.

28. J. M. Leong, R. P. Randolph, and R. W. Thorp, "Observations of the Foraging Patterns of *Andrena* (*Diandrena*) *blennospermatis* Thorp (Hymenoptera: Andrenidae)," *Pan-Pacific Entomologist* 71, no. 1 (1995): 68–71, https://www.biodiversitylibrary.org/item/252098.

29. Q. S. McFrederick, "Guide to the *Bombus* of San Francisco," San Francisco State University Bee Inventory Plot, http://userwww.sfsu.edu/sfbee/pdfs/GUIDE_TO_THE_BOMBUS_OF_SAN%20FRANCISCO___.pdf.

30. R. G. Hatfield and G. LeBuhn, "Patch and Landscape Factors Shape Community Assemblage of Bumble Bees, *Bombus* spp. (Hymenoptera: Apidae), in Montane Meadows," *Biological Conservation* 139, no. 1–2 (2007): 150–58, https://doi.org/10.1016/j.biocon.2007.06.019.

31. R. W. Thorp, D. S. Horning, and L. L. Dunning, "Bumble Bees and Cuckoo Bumble Bees of California (Hymenoptera: Apidae)," *Bulletin of the California Insect Survey* 23 (1983): viii.

32. K. K. Garvey, "The Buzz: Protecting Our Bumble Bees," UCANR Bug Squad, February 20, 2020, https://ucanr.edu/blogs/blogcore/postdetail.cfm?postnum=39397.

33. Garvey, "Buzz."

34. N. Seltenrich, "Franklin Point Offers a Unique Look at the San Mateo Coast," *Bay Nature*, January 1, 2017, https://baynature.org/article/franklin-point-offers-unique-look-san-mateo-coast.

35. "Northern Elephant Seals," California Department of Recreation, https://www.parks.ca.gov/?page_id=1115.

## Notes for 07.14, 07.14a, and 07.14b

1. "Facts, Figures, and Maps," Soquel Creek Water District, https://www.soquelcreekwater.org/who-we-are/facts-figures-and-maps.

2. Soquel Creek Restoration Project, https://www.facebook.com/SoquelCreekRestoration.

3. "Sensitive and Poorly-Known Amphibian Species in the Santa Cruz Mountains Bioregion," Santa Cruz Mountains Bioregional Council, http://www.scmbc.org/amphibian-species.

4. "M6.9 October 17, 1989 Loma Prieta Earthquake," US Geological Survey, https://www.usgs.gov/natural-hazards/earthquake-hazards/science/m69-october-17-1989-loma-prieta-earthquake.

Notes

5. "Schwan Lagoon," AllTrails, https://www.alltrails.com/trail/us/california/schwan-lagoon.
6. "Sensitive and Poorly-Known Amphibian Species."
7. "Coastal Dunes II. Coastal Dune Community," Monterey Bay National Marine Sanctuary, https://montereybay.noaa.gov/sitechar/coast2.html.
8. K. A. Griffith, *Pickleweed: Factors That Control Distribution and Abundance in Pacific Coast Estuaries and a Case Study of Elkhorn Slough, California* (Royal Oaks, CA: Elkhorn Slough Foundation, 2010), http://library.elkhornslough.org/research/bibliography/Griffith_Salicornia_technicalreport_2010.pdf.
9. "Elkhorn Slough National Estuarine Research Reserve," NOAA National Estuarine Research Reserves, https://coast.noaa.gov/nerrs/reserves/elkhorn-slough.html.
10. "Moss Landing Nature Area," California Department of Fish and Wildlife, https://wildlife.ca.gov/Lands/Places-to-Visit/Moss-Landing-WA.
11. D. J. Funk and A. Morales, *Upper Salinas River and Tributaries Watershed Fisheries Report and Early Actions* (Atascadero, CA: Upper Salinas–Las Tablas Resource Conservation District, 2003), https://us-ltrcd.specialdistrict.org/files/335ec4a34/Watershed_Fisheries_Report.pdf.
12. "Ventana Wild Rivers Campaign: Arroyo Seco River, Tassajara Creek & Church Creek," Ventana Wilderness Alliance's Wild Rivers Campaign, 2010. See also *Ventana Wilderness Watch* 15, no. 4, http://docplayer.net/53158352-Ventana-wilderness-watch.html.
13. US Fish and Wildlife Service, *Salinas River National Wildlife Refuge Comprehensive Conservation Plan Summary* (Sacramento: US Fish and Wildlife Service, California/Nevada Refuge Planning Office, 2002), https://www.fws.gov/uploadedFiles/Final_CCP.pdf.
14. C. Conrad, "Congressman Jimmy Panetta Introduces Monarch Act in Pacific Grove," KSBW, February 21, 2020, https://www.ksbw.com/article/congressman-jimmy-panetta-introduces-monarch-act-in-pacific-grove/31028768.
15. "California Sea Otters in Big Sur," Big Sur Chamber of Commerce, https://www.bigsurcalifornia.org/seaotter.html.
16. J. Morton, "Balancing Act: Otters, Urchins and Kelp," KQED, February 25, 2014, kqed.org/quest/67124/balancing-act-otters-urchins-and-kelp.
17. C. M. Hogan and M. P. Frankis, "Monterey Cypress: *Cupressus macrocarpa*," *iGoTerra*, GlobalTwitcher, 2009, archived September 6, 2019, at the Wayback Machine, https://web.archive.org/web/20170906035305/http://www.globaltwitcher.com/artspec_information.asp?thingid=62524.
18. "Pickleweed," Nature Collective, https://thenaturecollective.org/plant-guide/details/pickleweed.
19. "Pickleweed," Aquarium of the Pacific, https://www.aquariumofpacific.org/onlinelearningcenter/species/pickleweed.

20. Griffth, *Pickleweed*.

21. "Garrapata State Park," California State Parks, 2012, https://www.parks.ca.gov/pages/579/files/GarrapataSPWeb2012Rev.pdf.

22. "Soberanes Fire Updates," Cal Fire Incident Information, http://calfireinformation.weebly.com/soberanes-fire-updates.html.

## Notes for 07.15 and 07.15a

1. *Existing Conditions and Resources Inventory Report: Point Lobos State Natural Reserve* (Sacramento: California State Parks and AECOM, 2013), https://www.parks.ca.gov/pages/21299/files/PLSNR_Existing%20Conditions_rev12-17.pdf.

2. R. Newland, "Bixby Creek Bridge," Monterey County Historical Society, 1996, http://www.mchsmuseum.com/bixbycr.html.

3. P. Henson and D. J. Unser, *The Natural History of Big Sur* (Berkeley: University of California Press, 1993), 90.

4. Henson and Unser, *Natural History*, 133.

5. Henson and Unser, 284.

## Notes for 07.16 and 07.16a

1. D. Slakey, "Rare Plants on the Central Coast," California Native Plant Society, December 1, 2013, https://www.cnps.org/education/rare-plants-on-the-central-coast-6807.

2. *Land Management Plan: Part 2 Los Padres National Forest Strategy* (Vallejo, CA: USDA Forest Service, Pacific Southwest Region, 2005), 100, https://www.fs.usda.gov/Internet/FSE_DOCUMENTS/stelprdb5337817.pdf.

3. P. Henson and D. J. Unser, *The Natural History of Big Sur* (Berkeley: University of California Press, 1993), 391.

4. "A. North Coast," Morro Coast Audubon, https://www.morrocoastaudubon.org/p/bfg-section-a.html.

5. "Lifestyle," in "Diving the Deep: Elephant Seals," *Earthguide*, Scripps Institute of Oceanography, June 24, 2013, http://earthguide.ucsd.edu/elephantseals/lifestyle.

## Notes for 07.17, 07.17a, and 07.17b

1. M. Roest, "Steelhead Thrive in Santa Rosa, San Simeon Creeks," *San Luis Obispo Tribune*, March 9, 2016, https://www.sanluisobispo.com/news/local/community/cambrian/cambrian-opinion/article64997887.html.

# Notes

2. P. Bonello, T. R. Gordon, and A. J. Storer, "Systemic Induced Resistance in Monterey Pine," *Forest Pathology* 31, no. 2 (2001): 1–8, https://doi.org/10.1046/j.1439-0329.2001.00230.x.

3. C. Rigley, "Mercury Rising: Inactive Mines Have Left a Mess Behind," *San Luis Obispo New Times*, July 29, 2009, https://www.newtimesslo.com/sanluisobispo/mercury-rising/Content?oid=2939978.

4. "Morro Strand State Beach," California State Parks, 2015, https://www.parks.ca.gov/pages/593/files/MorroStrandSBFinalWebLayout042115.pdf.

5. County of San Luis Obispo, *Estero Area Plan* (San Luis Obispo, CA: County of San Luis Obispo, 2009), https://www.slocounty.ca.gov/Departments/Planning-Building/Forms-Documents/Plans-and-Elements/Area-Plans/Coastal-Zone/Estero-Area-Plan.pdf.

6. "Morro Dunes Restoration Project—Final Report: Morro Dunes Restoration Project Ice Plant Removal and Coastal Dune Restoration," California Department of Fish and Wildlife, searchable online with "CDFW Grant P1775001."

7. County of San Luis Obispo, *Estero Area Plan*.

8. "Pygmy Coast Live Oak Elfin Forest," Morro Bay National Estuary Program, April 26, 2019, https://www.mbnep.org/2019/04/26/photograph-friday-native-trees-around-the-morro-bay-estuary/coast-live-oak-elfin-forest-7.

9. P. Mayeda and K. Riener, *Economic Benefits of Diablo Canyon Power Plant* (San Francisco: Pacific Gas & Electric Company, 2013), https://www.pge.com/includes/docs/pdfs/shared/edusafety/systemworks/dcpp/PGE_Economic_Impact_Report_Final.pdf.

10. "Diablo Canyon Power Plant, Unit 1," US Nuclear Regulatory Commission, https://www.nrc.gov/info-finder/reactors/diab1.html.

11. "PG&E Accepts Diablo Canyon Decision," *World Nuclear News*, February 13, 2018, https://www.world-nuclear-news.org/C-PGE-accepts-Diablo-Canyon-decision-1302187.html.

12. *Morro Bay National Estuary Program: Comprehensive Conservation and Management Plan* (Morro Bay, CA: Morro Bay National Estuary Program, 2012), https://www.mbnep.org/wp-content/uploads/2014/12/MB_CCMP.pdf.

13. H. A. Mooney, "Southern Coastal Scrub," in *Terrestrial Vegetation of California*, edited by M. G. Barbour and J. Major, 471–89 (Hoboken, NJ: Wiley, 1977).

14. "*Arctostaphylos morroensis* Wies. & Schreib., Morro manzanita," USDA Natural Resources Conservation Service, Plants Database, https://plants.usda.gov/core/profile?symbol=ARMO2.

15. "*Ceanothus thyrsiflorus* Eschsch. var. griseus," Calflora, https://www.calflora.org/app/taxon?crn=11492.

*Notes for 07.18 and 07.18.a*

1. J. C. Carr, "An Environmental and Historical Study of the Nipomo Mesa Region," senior project, California Polytechnic State University, San Luis Obispo, Department of Anthropology, 2013, https://digitalcommons.calpoly.edu/socssp/112.
2. J. S. Petterson, *California's Central Coast Marine Protected Areas* (San Diego: California Sea Grant, 2008), https://caseagrant.ucsd.edu/sites/default/files/CC_MPA.pdf.
3. County of San Luis Obispo, *Land Use and Circulation Elements of the San Luis Obispo County General Plan, San Luis Bay Area Plan: Coastal* (San Luis Obispo, CA: County of San Luis Obispo, 2009), 59, https://www.slocounty.ca.gov/Departments/Planning-Building/Forms-Documents/Plans-and-Elements/Area-Plans/Coastal-Zone/San-Luis-Bay-Coastal-Area-Plan.pdf.
4. S. C. Suplick, "Beaver (*Castor canadensis*) of the Salinas River: A Human Dimensions–Inclusive Overview for Assessing Landscape-Scale Beaver-Assisted Restoration Opportunities," senior project, California Polytechnic State University, San Luis Obispo, Natural Resources Management and Environmental Sciences Department, 2019, https://digitalcommons.calpoly.edu/nrmsp/57.
5. "Pismo Beach Monarch Butterfly Grove," Experience Pismo Beach, https://www.experiencepismobeach.com/beach-and-outdoors/monarch-butterflies.
6. Central Coast Salmon Enhancement, *Arroyo Grande Creek Watershed Management Plan Update* (Sacramento: California Department of Fish and Game, 2009), https://creeklands.org/wp-content/uploads/2020/02/Arroyo-Grande-Creek-Watershed-Management-Plan-Update.pdf.
7. T. Duff (project manager), "Black Lake Canyon Enhancement Plan: Rossi Acquisition," Coastal Conservancy, May 18, 2005, https://www.scc.ca.gov/webmaster/ftp/pdf/sccbb/2005/0505/0505Board16_Black_Lake_Canyon_Enhancement.pdf.
8. "Oso Flaco Lake—A California State Park," Guadalupe–Nipomo Dunes Center, http://dunescenter.org/visit-the-dunes/points-of-interest/oso-flaco-lake.
9. "The Restoration of Santa Maria River," City of Santa Maria, January 22, 2020, https://www.cityofsantamaria.org/Home/Components/News/News/12315/18?arch=1&npage=6.
10. T. DeRocco, "MMS Issues Second Multi-Sale Call for Gulf of Mexico Sales," January 30, 1997, https://www.boem.gov/sites/default/files/boem-newsroom/Press-Releases/1997/70010.pdf.
11. "Point Sal Santa Maria Area," Land Trust for Santa Barbara County, https://www.sblandtrust.org/portfolio-item/point-sal-santa-maria-area.
12. K. C. Holston, "Evidence for Community Structure and Habitat Partitioning in Coastal Dune Stiletto Flies at the Guadalupe-Nipomo Dunes System, California," *Journal of Insect Science* 5, no. 1 (2005): 42, https://doi.org/10.1093/jis/5.1.42.
13. Hagler Bailly Services, "Evaluation of Petroleum Hydrocarbon Residues in Fish," data and literature review, 1997.

Notes

14. Levine Fricke, *Remedial Action Plan Beach Project Guadalupe Oil Field San Luis Obispo County, California* (Emeryville, CA: Levine Fricke, 1994).

15. K. Bubnash, "Proposed Restoration Plan in the Guadalupe Oil Field Could Limit Harmful Emissions and Save Chevron Millions," *San Luis Obispo New Times*, November 17, 2019, https://www.newtimesslo.com/sanluisobispo/proposed-restoration-plan-in-the-guadalupe-oil-field-could-limit-harmful-emissions-and-save-chevron-millions.

16. "DRC2019-00069 Union Oil of California," San Luis Obispo County Planning Commission, April 26, 2019, https://agenda.slocounty.ca.gov/IIP/sanluisobispo/file/getfile/131201.

17. D. Sneed, "Another Ten Years: Guadalupe Dunes Still Recovering from Oil Spill," *San Luis Obispo Tribune*, June 27, 2015, https://www.sanluisobispo.com/news/local/environment/article39542613.html.

*Notes for 07.19*

1. "Environmental Restoration, Installation: Vandenberg AFB," Secretary of Defense: Environmental Awards, 2018, https://denix.osd.mil/awards/previous-years/2018secdef/environmental-restoration-installation/vandenberg-air-force-base-california.

2. L. Hill, "Vandenberg Air Force Base Helps Plover Recovery Take Off," US Fish and Wildlife Service, *Endangered Species*, Fall 2015, https://www.fws.gov/endangered/news/episodes/bu-Fall2015/story1/index.html.

3. ManTech SRS Technologies, *Final Environmental Assessment: San Antonio Creek Restoration at Vandenberg Air Force Base, California* (Vandenberg Air Force Base, CA: Department of the Air Force, 30th Space Wing, 2008), https://apps.dtic.mil/dtic/tr/fulltext/u2/a631015.pdf.

4. US Fish and Wildlife Service, "Endangered and Threatened Wildlife and Plants; Endangered Status for Vandenberg Monkeyflower," *Federal Register*, October 29, 2013, https://www.federalregister.gov/documents/2013/10/29/2013-25397/endangered-and-threatened-wildlife-and-plants-endangered-status-for-vandenberg-monkeyflower.

5. Santa Ynez River Technical Advisory Committee, *Adult Steelhead Passage Flow Analysis for the Santa Ynez River* (Santa Barbara, CA: Santa Ynez River Consensus Committee, 1999), https://www.waterboards.ca.gov/waterrights/water_issues/programs/hearings/cachuma/phase2/exhibits/ccrbid1_226c.pdf.

6. J. Yamamura, "Three Offshore Oil Platforms to Shut Down—Sixty-Two Wells off Coast of Santa Barbara County Set to Be Plugged," *Santa Barbara Independent*, February 5, 2020, https://www.independent.com/2020/02/05/three-offshore-oil-platforms-to-shut-down.

7. "Generalized Vegetation Map of Southern Vandenberg Air Force Base, Santa Barbara County, California," in San Diego State University Center for Regional Environmental

Studies, *Ecological Assessment of Vandenburg Air Force Base, California*, vol. 1: *Evaluation and Recommendations* (Los Angeles Air Force Station, CA: Headquarters Space and Missile Systems Organization, 1976), 98, https://apps.dtic.mil/sti/pdfs/ADA025800.pdf.

8. A. Charlton, "Thanks to $165 Million Gift, Nature Conservancy Purchases Jalama Cojo Ranch," *Noozhawk*, December 22, 2017, https://www.noozhawk.com/article/thanks_to_gift_nature_conservancy_gets_jalama_cojo_ranch.

9. C. Fisher, "Invasive and Noxious Weeds of Rangeland in Santa Barbara County," County of Santa Barbara Agricultural Commissioner's Office, presentation to the Livestock and Land Program, October 22, 2011, https://livestockandland.org/PDF/Rangeland_Weeds.pdf.

10. "Ongoing Projects in Santa Barbara County," Channel Islands Restoration Network, https://cirweb.org/habitat-restoration#gc.

## Notes for 07.20 and 07.20a

1. B. Holland, "Tajiguas Landfill Project on Track to 'Fundamentally Redefine' Waste Recovery," *Noozhawk*, May 31, 2019, https://www.noozhawk.com/article/tajiguas_resource_recovery_project_at_landfill_20190531.

2. Refugio Beach Oil Spill Trustees, *Refugio Beach Oil Spill: Draft Damage Assessment and Restoration Plan/Environmental Assessment*, prepared by the California Department of Fish and Wildlife, California State Lands Commission, California Department of Parks and Recreation, Regents of the University of California, US Department of the Interior, US Fish and Wildlife Service, and National Oceanic and Atmospheric Administration, https://nrm.dfg.ca.gov/FileHandler.ashx?DocumentID=178526&inline.

3. El Capitan Creek," Land Trust of Santa Barbara, https://www.sblandtrust.org/portfolio-item/el-capitan-creek.

4. S. Mensing, J. Michaelsen, and R. Byrne, "A 560-Year Record of Santa Ana Fires Reconstructed from Charcoal Deposited in the Santa Barbara Basin, California," *Quaternary Research* 51, no. 3 (1999), 295–305, https://doi.org/10.1006/qres.1999.2035.

5. D. Ashbury, "Figure 12. Anchor and Other Important Watersheds of Southern Santa Barbara County, California," Center for Ecosystem Management and Restoration Cartographer, 2010. Data sources: CEMAR, National Hydrography Dataset, CalFish PAD, CA DOC, TeleAtlas, ESRI, National Geographic TOPO!, and CalWater 2.2.1.

6. City of Goleta Planning and Environmental Review Department, *Final Ellwood Mesa/Sperling Preserve Open Space Monarch Butterfly Habitat Management Plan* (Goleta, CA: City of Goleta, 2019), https://www.cityofgoleta.org/home/showdocument?id=21867.

7. B. Holland, "Monarch Butterfly Populations Drop Dramatically in Goleta Grove, across the State," *Noozhawk*, January 16, 2019, https://www.noozhawk.com/article/monarch_butterfly_population_drop_goleta_ellwood_grove_across_california.

8. R. Zembal, S. M. Hoffman, and R. T. Patton, *A Survey of the Belding's Savannah Sparrow (Passerculus sandwichensis beldingi) in California, 2015* (Sacramento: California Department of Fish and Wildlife, Nongame Wildlife Program, 2015), downloadable as a PDF online.

9. "Atascadero and Maria Ygnacio Steelhead Restoration Design," Southern California Wetlands Recovery Project, https://scwrp.org/projects/atascadero-and-maria-ygnacio-steelhead-restoration-design.

10. "Fire Recovery & Community Science," Santa Barbara Botanic Garden, https://www.sbbg.org/conservation-research/fire-recovery-community-science.

11. M. Carroll, W. Ferren, and G. McGowan, *Garden Street Market Habitat Restoration Plan* (San Luis Obispo, CA: Arcadis US, 2017), https://www.santabarbaraca.gov/SBdocuments/Advisory_Groups/Planning_Commission/Archive/2019_Archives/04_Staff_Reports/2019_07_18_July_18_2019_Item_III_301_E_Yanonali_Street_Staff_Report_Exhibit_I_Habitat_Restoration_Plan_by_Arcadis.pdf.

12. "Carpinteria Salt Marsh Reserve; Part I: Carpinteria Salt Marsh: Background and Natural History," University of California Natural Reserve System, https://carpinteria.ucnrs.org/setting.html.

13. NOAA, "Listing of Several Evolutionary Significant Units (ESUs) of West Coast Steelhead," *Federal Register*, August 18, 1997, https://www.federalregister.gov/documents/1997/08/18/97-21661/endangered-and-threatened-species-listing-of-several-evolutionary-significant-units-esus-of-west.

14. National Marine Fisheries Service, *Southern California Steelhead Recovery Plan* (Long Beach, CA: NOAA Southwest Regional Office, National Marine Fisheries Service, 2012), table 4-2, https://repository.library.noaa.gov/view/noaa/15988.

15. National Marine Fisheries Service, *Southern California Steelhead Recovery Plan*, table 4-1.

16. National Marine Fisheries Service, *Southern California Steelhead Recovery Plan*, table 2-1.

*Notes for 07.21, 07.21a, 07.21b, 07.21c, and 07.21d*

1. "Ventura County General Plan," Ventura County Planning Division, 2017, https://vcrma.org/ventura-county-general-plan.

2. "Restoring the Ventura River," California Trout, https://caltrout.org/our-work/steelhead-salmon/ventura-river-restoration.

3. J. R. Stephenson and G. M. Calcarone, *Southern California Mountains and Foothills Assessment: Habitat and Species Conservation Issues* (Albany, CA: Pacific Southwest Research Station, USDA Forest Service, 1999), 318, https://doi.org/10.2737/PSW-GTR-172.

4. J. P. Harrington, "Chumash Field Notes," Harrington Papers microfilm edition: Volume 3, Reel 85, Frame 0305–0307, National Anthropological Archives, Smithsonian Institution.

5. Father Pedro Font, "Journal of the Colonizing Expedition," 1776, https://www.jstor.org/stable/481033?seq=1.

6. *Santa Clara River Watershed Section WCVC IRWM Plan Update 2014* (Santa Paula, CA: Santa Clara River Conservancy, 2014), https://santaclarariver.org/wp-content/uploads/2017/07/scrw_irwm_update-52114_final.pdf.

7. CBEC, WRA, and M. Podlech, *Santa Clara River Estuary Habitat Restoration and Enhancement Feasibility Study Existing Conditions Technical Report* (Malibu, CA: Wishtoyo Foundation and Wishtoyo Foundation's Ventura Coastkeeper Program, 2015), https://static1.squarespace.com/static/5459dd35e4b0eb18b9b5599b/t/56414ee5e4b00a9a1605d69c/1447120613685/SCRE_Existing+Conditions+Technical+Report_low+res.pdf.

8. ESA, *Ormond Beach Restoration and Public Access Project: Preliminary Restoration Plan* (Oxnard: California State Coastal Conservancy, Nature Conservancy, and City of Oxnard, 2019), https://www.oxnard.org/wp-content/uploads/2019/06/ORMOND-BEACH-RESTORATION-AND-PUBLIC-ACCESS-PROJECT-Preliminary-Restoration-Plan-Final.pdf.

9. K. W.-H. Radtke, A. Arndt, and R. Wakimoto, "Fire History of the Santa Monica Mountains," in *Proceedings of the Symposium on Dynamics and Management of Mediterranean-Type Ecosystems, June 22–26, 1981, San Diego, CA* (Berkeley, CA: USDA Forest Service, Pacific Southwest Forest and Range Experiment Station, 1982), https://www.fs.fed.us/psw/publications/documents/psw_gtr058/psw_gtr058_6a_radtke.pdf.

10. Heal the Bay, Neighbor, "Habitat Restoration at Leo Carrillo State Park," *Patch*, September 12, 2013, https://patch.com/california/santamonica/habitat-restoration-at-leo-carrillo-state-park_d84395a.

11. "Information about the Monterey Shale," *Natural Gas Intelligence*, 2020, https://www.naturalgasintel.com/information-about-the-monterey-shale.

12. T. Curwen, "A Historic Oil Platform off of Santa Barbara turns into a Rusty Ghost Ship," *Los Angeles Times*, March 14, 2019, https://www.latimes.com/projects/la-me-platform-holly.

13. J. Hamilton, "How One of the Nation's Worst Oil Spills Turned Our Beaches Black and Our Nation Green," National Public Radio, January 28, 2019, https://www.npr.org/2019/01/28/688219307.

14. K. Ferrar, "The Feds Trump California's State Ban on Offshore Oil Drilling," Fractracker Alliance, November 5, 2018, https://www.fractracker.org/2018/11/california-offshore-drilling.

15. D. Montgomery and S. Holder, "Why Is California Approving So Many New Oil Wells?" *Bloomberg*, November 18, 2019, https://www.bloomberg.com/news/articles/2019-11-18/under-newsom-oil-well-approvals-are-going-up.

16. Plains Exploration & Production Company, *Revisions to the Platform Hidalgo Development and Production Plan to Include Development of the Western Half NW/4 of Lease OCS-P*

Notes

0450: *Accompanying Information Volume Biological Evaluation of Threatened and Endangered Species* (Camarillo, CA: Bureau of Ocean Energy Management, Pacific OCS Region, 2012), https://www.boem.gov/sites/default/files/oil-and-gas-energy-program/Leasing/Regional-Leasing/Pacific-Region/Arguello-DPP/Biological-Evaluation-of-TE-Species.pdf.

17. R. Patrick, *Rivers of the United States*, vol. 1: *Estuaries* (Hoboken, NJ: Wiley, 1994), 126.

18. URS, *2010 Ventura County Hazard Mitigation Plan: Final* (Oxnard, CA: County of Ventura, 2011), http://www.vcfloodinfo.com/pdf/Ventura%20County%20HMP_031411.pdf.

19. ESA, *Ormond Beach Restoration*.

20. M. Stiles, R. Menezes, and J. Schleuss, "Malibu's Wildfire History," *Los Angeles Times*, December 12, 2018, https://www.latimes.com/projects/la-me-malibu-wildfire-history.

21. "Top 5 California Dams Out," *California Trout*, 2019, https://caltrout.org/damsout.

22. US Army Corps of Engineers, *Malibu Creek Ecosystem Restoration: Final Integrated Feasibility Report (IFR) with Environmental Impact Statement/Environmental Impact Report and Appendices* (Los Angeles: US Army Corps of Engineers, Los Angeles District, 2019), https://www.spl.usace.army.mil/Missions/Civil-Works/Projects-Studies/Malibu-Creek-Study.

## Notes for 07.22, 07.22a, and 07.22b

1. Moffat & Nichol, *Broad Beach Restoration Project: Coastal Development Permit Project Description* (Malibu, CA: Trancas Property Owners Association, 2011), https://www.malibucity.org/DocumentCenter/View/1223/Project-Description.

2. "Broad Beach Restoration Project," Rincon Consultants, 2015, https://www.rinconconsultants.com/project/broad-beach-restoration-project.

3. "Point Dume State Beach and Natural Preserve," California State Parks, https://www.nps.gov/samo/planyourvisit/upload/PtDumeBrochure.pdf.

4. Wood Environment & Infrastructure Solutions, *Draft Initial Study and Mitigated Negative Declaration: Escondido Canyon Park to Murphy Way Connector Project* (Mountain Recreation & Conservation Authority, 2018), https://mrca.ca.gov/wp-content/uploads/2019/01/Draft-MND.pdf.

5. "Cameron Nature Preserve at Puerco Canyon," Mountain Recreation and Conservation Authority, https://mrca.ca.gov/parks/park-listing/cameron-nature-preserve-at-puerco-canyon.

6. "Malibu Creek State Park," California State Parks, 2018, https://www.parks.ca.gov/pages/614/files/MalibuCreekSPFinalWebLayout2018.pdf.

# Notes

7. "Tuna Canyon Park," Mountain Recreation and Conservation Authority, https://mrca.ca.gov/parks/park-listing/tuna-canyon-park.

8. "Las Flores Canyon Creek & Park Restoration," City of Malibu, https://www.malibucity.org/668/Las-Flores-Canyon-Creek-Park-Restoration.

9. "Topanga Lagoon Restoration Planning Phase 1," Southern California Wetlands Recovery Project, https://scwrp.org/projects/topanga-lagoon-restoration-and-facilities-management-plan.

10. "Malibu Lagoon Restoration," Bay Foundation, https://www.santamonicabay.org/explore/wetlands-rivers-streams/malibu-lagoon.

11. "Stone Canyon Water Quality Improvement Project," Governor's Office of Planning and Research, September 27, 1994, https://ceqanet.opr.ca.gov/1993091066/2.

12. "Ballona Wetlands Ecological Reserve," Bay Foundation, https://www.santamonicabay.org/explore/wetlands-rivers-streams/ballona-wetlands-ecological-reserve.

13. L. Sahagun, "A Rare Plant and a Renegade Environmental Activist Could Derail Ballona Wetlands Restoration," *Los Angeles Times*, November 23, 2017, https://www.latimes.com/local/california/la-me-ballona-rare-plant-20171123-story.html.

14. T. Ochoa, "The El Segundo Butterfly Reserve," *Atlas Obscura*, https://www.atlasobscura.com/places/the-el-segundo-butterfly-preserve-los-angeles-california.

15. A. Dalkey and T. Longcore, *Beach Bluffs Restoration Project Master Plan* (Redondo Beach, CA: Beach Bluffs Restoration Project Steering Committee, 2005), https://www.urbanwildlands.org/Resources/BBRPmasterplan.pdf.

16. "History," South Coast Botanic Garden, https://southcoastbotanicgarden.org/history-mission.

17. "Palos Verdes Reef," OXY: Occidental College, 2020, https://www.oxy.edu/academics/vantuna-research-group/palos-verdes-reef.

18. C. Carlson, "Ventura County Mountain Lions Face Extinction," *Ventura County Star*, August 30, 2016, https://www.vcstar.com/story/news/special-reports/outdoors/2016/08/30/ventura-county-mountain-lions-face-extinction/89546834.

19. C. Katz, "Roadkill Rates Fall Dramatically as Lockdown Keeps Drivers at Home," *National Geographic*, June 26, 2020, https://www.nationalgeographic.com/animals/2020/06/decline-road-kill-pandemic-lockdown-traffic.

20. C. Carlson, "Mountain Lion Found in Santa Monica Mountains Might Be First with Physical Abnormalities," *Ventura County Star*, September 9, 2020, https://www.vcstar.com/story/news/special-reports/outdoors/2020/09/09/cougar-genetic-abnormalities-discovered-santa-monica-mountain-lions-p-81/5761841002.

21. J. F. Benson, P. J. Mahoney, T. W. Vickers, J. A. Sikich, P. Beier, S. P. D. Riley, H. B. Ernest, and W. M. Boyce, "Extinction Vortex Dynamics of Top Predators Isolated by Urbanization," *Ecological Applications* 29, no. 3 (2019): e01868, https://doi.org/10.1002/eap.1868.

Notes

22. A. B. Cholo, "NPS Biologists Report First Abnormalities Linked to Inbreeding Depression in Mountain Lions," National Park Service, September 9, 2020, https://www.nps.gov/samo/learn/news/first-abnormalities-linked-to-inbreeding-depression.htm.

23. "Topanga State Park General Plan," California State Parks, https://www.parks.ca.gov/?page_id=25956.

24. "Topanga Creek Restoration Project," Southern California Wetlands Recovery Project, https://scwrp.org/projects/topanga-creek-restoration-program.

25. V. De Turenne, "20-Year-Old Berm to Be Removed from Topanga Creek," Los Angeles Times, August 11, 2008, https://latimesblogs.latimes.com/lanow/2008/08/20-year-old-ber.html.

26. "Topanga Creek Watershed," Los Angeles County Public Works, https://dpw.lacounty.gov/wmd/watershed/topanga/index.

## Notes for 07.23 and 07.23a

1. "Agua Amarga Reserve," Palos Verdes Peninsula Land Conservancy, https://pvplc.org/wp-content/uploads/2020/01/AgAmarga-update-2018.pdf.

2. "Alta Vincente Reserve," Palos Verdes Peninsula Land Conservancy, https://pvplc.org/wp-content/uploads/2020/01/Alta-Vicente-Reserve-2018.pdf.

3. "Benefits of the Natural Community Conservation Plan (NCCP or Plan)," Palos Verdes Peninsula Land Conservancy, https://pvplc.org/wp-content/uploads/2020/01/NCCP-Frequently-Asked-Questions.pdf.

4. T. D. Johnson, Los Angeles and Long Beach Harbor Habitat: Our Biological Treasures (San Pedro, CA: Port of Los Angeles, 2013), https://kentico.portoflosangeles.org/getmedia/7527c4b7-4041-4afc-8fb8-69a3c597d9cc/Harbor-Habitat-Brochure-2013/.

5. Science Applications International Corporation, 2008 Biological Surveys of Los Angeles and Long Beach Harbors (San Pedro, CA: Port of Los Angeles, Environmental Management Division, April 2010), https://kentico.portoflosangeles.org/getmedia/328825ec-4975-4576-bd69-496b4ra66429/biobaseline2008.

6. "Pier 400 Tern Colony (formerly Terminal Island)," Audubon, https://www.audubon.org/important-bird-areas/pier-400-tern-colony-formerly-terminal-island.

7. "Long Beach Breakwater," Surfrider Foundation, https://longbeach.surfrider.org/breakwater.

8. "East San Pedro Bay Ecosystem Restoration Feasibility Study," US Army Corps of Engineers, 2019, https://www.spl.usace.army.mil/Missions/Civil-Works/Projects-Studies/East-San-Pedro-Bay-Ecosystem-Restoration-Study.

9. "Bolsa Chica Information," Bolsa Chica Conservancy, http://bolsachica.org/the-wetlands/ecology.

10. D. Schoch, "Bolsa Chica Restoration Cost Soars," *Los Angeles Times*, September 9, 2000, https://www.latimes.com/archives/la-xpm-2000-sep-09-mn-18274-story.html.

11. "USA: California: Restoring Bolsa Chica Wetlands," Society for Ecological Restoration, https://www.ser-rrc.org/project/usa-california-restoring-bolsa-chica-wetlands.

12. "Bolsa Chica Critical Coastal Area," California Coastal Commission, 2019, https://documents.coastal.ca.gov/assets/water-quality/ccc-factsheets/South-Coast/CCA%20I4%20Bolsa%20Chica%20Factsheet%2012-17-19.pdf.

13. "Upper Newport Bay Nature Reserve," OC Parks, https://www.ocparks.com/parks/newport.

14. "Bayview Restoration Project," Newport Bay Conservancy, https://newportbay.org/projects/bayview-project.

15. L. Nguyen, "Coastal Commission Approves 8 Toad Pools and Habitat Restoration at Crystal Cove State Park," *Daily Pilot, Los Angeles Times*, December 12, 2019, https://www.latimes.com/socal/daily-pilot/news/story/2019-12-12/coastal-commission-approves-eight-toad-pools-and-habitat-restoration-at-crystal-cove-state-park.

16. "About," Laguna Greenbelt, https://lagunagreenbelt.org/about-3.

17. "Los Angeles Water Issue: Why It's Not Just the Drought," USC Viterbi School of Engineering, 2019, https://viterbi.usc.edu/water.

18. R. Glennon, "Los Angeles Needs to Reclaim What We Used to Consider 'Wastewater,'" *Los Angeles Times*, March 5, 2019, https://www.latimes.com/opinion/op-ed/la-oe-glennon-water-sewage-recycling-los-angeles-20190305-story.html.

19. M. H. Lopez and J. M. Krogsted, "Will California Ever Become a Majority-Latino State? Maybe Not," Pew Research Center, June 4, 2015, https://www.pewresearch.org/fact-tank/2015/06/04/will-california-ever-become-a-majority-latino-state-maybe-not.

20. D. Gorn, "Nation's Largest Water Recycling Plant Expanding in Orange County," KQED, December 14, 2016, https://www.kqed.org/news/11218554/nations-largest-water-recycling-plant-expanding-in-orange-county.

*Notes for 07.24 and 07.24a*

1. "Frequently Asked Questions about Critical Habitat & the Coastal California Gnatcatcher," US Fish and Wildlife Service, https://www.fws.gov/pacific/news/gnatcatcher/faqtext.htm.

2. "Laguna Ridge Trail Restoration," Laguna Canyon Foundation, https://lagunacanyon.org/work/conservation.

3. Driftwood Properties, "History of Aliso Canyon," Athens Group, 2009, http://www.alisocreekinnupdate.com/Main.

4. "Aliso Creek Estuary Restoration Plan Public Meeting," Laguna Ocean Foundation, October 12, 2017, https://www.lagunaoceanfoundation.org/wp-content/uploads/2017/10/Aliso_Creek_Estuary_Restoration_Public_Meeting.pdf.

# Notes

5. N. Caruso and D. Burcham, "Orange County Giant Kelp Restoration Project: Data Summary for the Stakeholders of the Marine Life Protection Act," Aquarium of the Pacific, April 2009, https://www.aquariumofpacific.org/images/mcri_uploads/kelp_restoration_project.pdf.

6. "Dana Point Headlands Conservation Area and Trail System," Headlands Conservation Area, https://www.danapoint.org/home/showpublisheddocument?id=8793.

7. R. D. Smith and C. V. Klimas, *Riparian Ecosystem Restoration Plan for San Juan Creek and Western San Mateo Creek Watersheds: General Design Criteria and Site Selection* (Vicksburg, MS: US Army Engineer Research Development Center, Environmental Laboratory, Waterways Experiment Station, 2004), https://www.spl.usace.army.mil/Portals/17/docs/regulatory/Projects/SAMP/Riparian_Ecosystem_Restoration_Plan_for_SJCWSMC_Watershed.pdf.

8. L. Bartlett, "Capistrano Beach Park Master Plan," OC Parks, February 26, 2020, https://www.ocparks.com/civicax/filebank/blobdload.aspx?BlobID=112575.

9. Moffatt & Nichol, *City of San Clemente Sea Level Rise Vulnerability Assessment* (San Clemente: California Coastal Commission, 2019), https://www.san-clemente.org/home/showdocument?id=54174.

10. "Agenda Report: San Clemente City Council Meeting," City of San Clemente, March 15, 2016, https://www.san-clemente.org/Home/ShowDocument?id=26972.

11. Smith and Klimas, *Riparian Ecosystem Restoration Plan*, 21.

12. "Federally Listed Threatened, Endangered, Terrestrial Wildlife and Plant Species and Ecosystem Affinities at Camp Pendleton," Marine Corps Base Camp Pendleton, https://www.pendleton.marines.mil/Portals/98/Docs/Environmental/Natural%20Resources/Federally_Listed_Threatened_Endangered_Species_List%20Updated%20Nov%202020.pdf?ver=yMVFoJmswjxOFUEZYCNGjg%3D%3D.

13. A. Sewell, "If San Onofre Nuclear Plant Is Restarted, Who Pays?" *Los Angeles Times*, August 22, 2012, https://www.latimes.com/archives/la-xpm-2012-aug-22-la-me-0823-san-onofre-20120823-story.html.

14. "Irvine Leaders Recommend Shutting Down San Onofre Power Plant," *Orange County Register*, March 28, 2012, https://www.ocregister.com/2012/03/28/irvine-leaders-recommend-shutting-down-san-onofre-power-plant.

15. "Santa Margarita Trail Preserve," Wildlands Conservancy, https://www.wildlandsconservancy.org/preserve_santamargarita.html.

16. "Watershed Protection Program," City of Oceanside, https://www.ci.oceanside.ca.us/gov/water/services_programs/clean/default.asp.

17. P. Diehl, "Oceanside Gets $175,000 for Wetlands Enhancement," *San Diego Union Tribune*, November 28, 2020, https://www.sandiegouniontribune.com/communities/north-county/oceanside/story/2020-11-28/oceanside-gets-175-000-for-wetlands-enhancement.

18. "San Luis Rey Recovery Program," Southern Wetlands Recovery Program, https://scwrp.org/projects/san-luis-rey-river-arundo-removal.

19. K. M. Palmer, "San Luis Rey Flood Risk Management," *California Society of Ecological Restoration 26*, no. 4 (2016): 8–9, https://static1.squarespace.com/static/558d9dd9e4b097e27b791a1f/t/59762f4d20099e96a3a31fa/1500917585501/sercal16ivecesis.pdf.

20. A. Farjon, "Torrey Pine, *Pinus torreyana*," IUCN Red List of Threatened Species (2013): e.T42424A2979186, https://doi.org/10.2305/IUCN.UK.2013-1.RLTS.T42424A2979186.en.

21. "Climate and Ocean," Torrey Pines State Natural Reserve, https://torreypine.org/nature-center/seashore.

## Notes for 07.25, 07.25a, and 07.25b

1. "The Watersheds of San Diego County," San Diego County Department of Public Works, https://www.sandiegocounty.gov/content/sdc/dpw/watersheds/Watersheds.html.

2. P. Diehl, "Decades in the Making, Buena Vista Lagoon Restoration Plan Finally Approved," *San Diego Union Tribune*, May 30, 2020, https://www.sandiegouniontribune.com/communities/north-county/story/2020-05-30/decades-in-the-making-buena-vista-lagoon-restoration-plan-finally-approved.

3. P. Diehl, "Desal Plant Operator Assumes Maintenance of Carlsbad Lagoon," *San Diego Union Tribune*, May 13, 2019, https://www.sandiegouniontribune.com/communities/north-county/story/2019-05-13/desal-plant-operator-assumes-maintenance-of-carlsbad-lagoon.

4. Tetra Tech, *Agua Hedionda Watershed Management Plan* (Vista, CA: City of Vista, 2008), https://nrs.ucsd.edu/_files/agua-hedionda-watershed-management-plan.pdf.

5. "About Batiquitos Lagoon," Batiquitos Lagoon Foundation, http://www.batiquitosfoundation.org/about.

6. "Bird Counts," Nature Collective, https://thenaturecollective.org/reports/bird-counts.

7. "San Dieguito Lagoon W-19 Wetland Restoration," San Dieguito River Park, http://www.sdrp.org/wordpress/portfolio/w-19-restoration.

8. "Los Penasquitos Lagoon Restoration Design and Feasibility Study," Southern California Wetlands Recovery Project, https://scwrp.org/projects/los-penasquitos-lagoon-restoration-planning.

9. "Sensitive Species," Los Peñasquitos Lagoon Foundation, http://www.lospenasquitos.org/conservation/sensitive-species.

10. "Our Bay," ReWild Mission Bay, https://rewildmissionbay.org/place.

11. Everest International Consultants, *ReWild Mission Bay: Wetlands Restoration Feasibility Study Report* (San Diego, CA: San Diego Audubon Society, Coastal Conservancy, US Fish and Wildlife Service, 2018), https://missionbaywetlands.fileswordpress.com/2018/12/rewild-mb_feasibility-study-report_final-december-2018_with-preface-and-es.pdf.

Notes

12. "The Park," Mission Trails Regional Park, https://mtrp.org/the-park-2.
13. RECON Environmental, *Natural Resources Management Plan for Mission Trails Regional Park, San Diego, California* (San Diego, CA: City of San Diego, 2019), https://www.sandiego.gov/sites/default/files/nrmp_mtrp_020819.pdf.
14. City of Coronado, *City of Coronado: Coastal Program Local Coastal Program Land Use Plan* (Coronado, CA: City of Coronado, 2005), https://www.coronado.ca.us/UserFiles/Servers/Server_746006/File/government/departments/comm%20dev/building/1373656741_71747.pdf.
15. K. Clark, "The Remnant Coastal Dunes of Southern California," *Proceedings of the CNPS Conservation Conference, 17–19 Jan 2009* (2011): 20–27, https://www.researchgate.net/publication/327845491.
16. "San Diego Bay," US Fish and Wildlife Service, https://www.fws.gov/refuge/San_Diego_Bay/About_the_Complex.html.
17. "*Frankenia palmeri*," California Native Plant Society, http://www.rareplants.cnps.org/detail/815.html.
18. "Otay Delta Restoration Moves Ahead, Thanks to Funders," River Partners, 2011, https://www.riverpartners.org/the-journal/otay-delta-restoration-moves-ahead-thanks-to-funders.
19. "Tijuana Slough Nature Preserve Point of Interest," California State Parks, https://www.parks.ca.gov/?page_id=669.
20. "Discover Over 370 Species of Birds," Tijuana River Estuary National Research Center, October 29, 2010, https://trnerr.org/discover-over-370-species-of-birds.
21. "Tijuana Estuary Tidal Restoration Program II: Phase I Restoration Design," Southern California Wetlands Recovery Project, https://scwrp.org/projects/tijuana-estuary-tidal-restoration-program-ii-phase-restoration-design.
22. R. J. Forbes, *A Short History of the Art of Distillation: From the Beginnings Up to the Death of Cellier Blumenthal* (Leiden, Netherlands: E. J. Brill, 1948).
23. H. Cooley and N. Ajami, *Key Issues in Seawater Desalination in California: Costs and Financing*, Pacific Institute, November 2012, https://pacinst.org/publication/costs-and-financing-of-seawater-desalination-in-california.
24. H. Cooley, N. Ajami, and M. Heberger, *Key Issues in Seawater Desalination in California: Marine Impacts*, Pacific Institute, December 2013, https://pacinst.org/publication/desal-marine-impacts.
25. S. Puterski, "After 64 years, Encina Power Plant Goes Dark," *Coast News Group*, December 13, 2018, https://thecoastnews.com/after-64-years-encina-power-plant-goes-dark.
26. E. Anderson, "Drinking Water Starts Flowing from Carlsbad Desalination Plant: Water Official Answers Five Questions about the $1 Billion Project," KPBS, December 14, 2015, https://www.kpbs.org/news/2015/dec/14/what-you-need-to-know-about-carlsbad-desalination.

27. K. Fagan, "Desalination Plants a Pricey Option If Drought Persists," *SFGATE*, February 15, 2014, https://www.sfgate.com/news/article/Desalination-plants-a-pricey-option-if-drought-5239096.php.

28. "Charles E. Meyer Desalination Plant," City of Santa Barbara, February 10, 2020, https://www.santabarbaraca.gov/gov/depts/pw/resources/system/sources/desalination/default.asp.

29. Scripps Institution of Oceanography, *The La Jolla Shores Coastal Watershed Management Plan* (San Diego: University of California San Diego, City of San Diego, and San Diego Coastkeeper, 2008), https://www.sandiego.gov/sites/default/files/0802ljwmp.pdf.

## 08. EACH A CHARACTER

1. A. Schoenherr, C. Feldmeth, and M. Emerson, *Natural History of the Islands of California* (Berkeley: University of California Press, 1999), 154–77.

2. "Coastal Land Use Plan," County of Santa Barbara, 2019, https://cosantabarbara.app.box.com/s/cx95k0r4hnfo58hg29ifi5gzf5rrdurd.

3. B. Lauri, "*Brahea edulis*," San Diego Natural History Museum, https://www.sdnhm.org/oceanoasis/fieldguide/brah-edu.html.

4. "Landbird Monitoring," National Park Service, https://www.nps.gov/im/medn/landbird-monitoring.htm.

5. "Santa Barbara Song Sparrow, *Melospiza melodia graminea*," Environmental Conservation Online System, US Fish and Wildlife Service, https://ecos.fws.gov/ecp/species/5513. This subspecies has been delisted due to extinction.

6. D. S. Gilmer, ed., *Breeding Populations of Seabirds in California, 1989–1991*, vol. 1 (Dixon, CA: US Fish and Wildlife Service, Northern Prairie Wildlife Research Center, 1992).

7. "Terrestrial Mammals," National Park Service, https://www.nps.gov/chis/learn/nature/terrestrial-animals.htm.

8. "Kelp Forest," National Park Service, https://www.nps.gov/chis/learn/nature/kelp-forests.htm.

9. E. Anderson, "Researchers Warn a Warming Ocean Threatens Giant Kelp Forests," KPBS, August 4, 2020, https://www.kpbs.org/news/2020/aug/04/warmer-ocean-threatens-giant-kelp.

10. Schoenherr et al., *Natural History*, 107.

11. R. G. Fairbanks, "A 17,000-Year Glacio-Eustatic Sea Level Record: Influence of Glacial Melting Rates on the Younger Dryas Event and Deep-Ocean Circulation," *Nature* 342 (1989): 637–42, https://doi.org/10.1038/342637a0.

12. "Geologic Formations of the Channel Islands," National Park Service, https://www.nps.gov/chis/learn/nature/geologicformations.htm.

13. R. Macarthur and E. O. Wilson, *The Theory of Island Biogeography* (Princeton, NJ: Princeton University Press, 1967).

14. J. S. Tweet, V. L. Santucci, K. Convery, J. Hoffman, and L. Kirn, *Channel Islands National Park: Paleontological Resource Inventory (Public Version)* (Fort Collins, CO: National Park Service, 2020), https://doi.org/10.36967/nrr-2278664.

15. E. Coletta, J. Beck, R. Carle, and M. Hester, "Año Nuevo State Park Seabird Conservation and Habitat Restoration: 2017," unpublished report to the California Department of Parks and Recreation, Año Nuevo State Park, 2018.

16. Channel Islands National Park, *Final General Management Plan/Wilderness Study/Environmental Impact Statement* (Ventura, CA: National Park Service, Channel Islands National Park, 2014), available online as a PDF.

17. J. A. Powell, "Biogeography of Lepidoptera on the California Channel Islands," in *The Fourth California Islands Symposium Update on the Status of Resources*, edited by W. L. Halvorson and G. J. Maender, 449–64 (Santa Barbara, CA: Santa Barbara Museum of Natural History, 1994).

18. "Santa Catalina Island," CaliforniaHerps.com, http://www.californiaherps.com/islands/pages/santacatalinaisland.html.

19. W. D. Shuford and T. Gardali, eds., *California Bird Species of Special Concern: A Ranked Assessment of Species, Subspecies, and Distinct Populations of Birds of Immediate Conservation Concern in California* (Camarillo, CA: Western Field Ornithologists; Sacramento: California Department of Fish and Game, 2008).

20. "Animal Species," Catalina Island Conservancy, https://www.catalinaconservancy.org/index.php?s=wildlife&p=animal`species.

21. C. A. Harper, "Breeding Biology of a Small Colony of Western Gulls (*Larus occidentalis wymani*) in California," *Condor* 73, no. 3 (1971): 337–41, https://doi.org/10.2307/1365760.

22. P. H. Raven, "A Flora of San Clemente Island, California," *Aliso: A Journal of Systematic and Evolutionary Botany* 5, no. 3 (1963): 289–347, https://doi.org/10.5642/aliso.19630503.08.

23. P. Bowler, W. Weber, and R. Riefner, "A Checklist of the Lichens of San Clemente Island, California," *Bulletin of the California Lichen Society* 3, no. 2 (1996), https://ucjeps.berkeley.edu/rlmoe/cals3_2.html.

24. L. Perez, "Endangered Species: San Clemente Island," in *Conserving Biodiversity on Military Lands: A Guide for Natural Resources Managers*, edited by N. Benton, J. D. Ripley, and F. Powledge (Arlington, VA: NatureServe, 2008), http://www.dodbiodiversity.org/case_studies/ch_6_2.html.

25. T. Emmel and J. Emmel, "*Euphydryas editha insularis*," *Journal of Research on the Lepidoptera* 13, no. 2 (1974): 131–34, https://www.lepidopteraresearchfoundation.org/backissues/Vol%2013-14%20(1974-1975).pdf.

26. "Northern Channel Islands," Audubon Society, https://netapp.audubon.org/iba/Reports/193.

27. "Giant Coreopsis," CSU Channel Island Native Plants, https://nativeplants.csuci.edu/leptosyne-gigantea.htm.

28. W. R. McIver, A. L. Harvey, and H. R. Carter, *Monitoring and Restoration of Ashy Storm-Petrels at Santa Cruz Island, California, in 2008*, unpublished report, US Fish and Wildlife Service, Arcata, California; Channel Islands National Park, Ventura, California; and Carter Biological Consulting, Victoria, British Columbia, 2009, https://www.montroserestoration.noaa.gov/wp-content/uploads/2011/08/MontroseSeabirdRestoration_ASSP_2008Report_Final.pdf.

29. L. Caldwell, V. J. Bakker, T. S. Sillett, M. A. Desrosiers, S. A. Morrison, and L. M. Angeloni, "Reproductive Ecology of the Island Scrub-Jay," *Condor* 115, no. 3 (2013): 603–13, https://doi.org/10.1525/cond.2013.120028.

30. A. M. Sparkman, A. D. Clark, L. J. Brummett, K. R. Chism, L. C. Combrink, N. M. Kabey, and T. S. Schwartz, "Convergence in Reduced Body Size, Head Size, and Blood Glucose in Three Island Reptiles," *Ecology and Evolution* 8, no. 12 (2018): 6169–182, https://doi.org/10.1002/ece3.4171.

31. P. Raia and S. Meiri, "The Island Rule in Large Mammals: Paleontology Meets Ecology," *Evolution* 60, no. 8 (2006): 1731–42, https://doi.org/10.1111/j.0014-3820.2006.tb00516.x.

32. G. Burness, J. Diamond, and T. Flannery, "Dinosaurs, Dragons, and Dwarfs: The Evolution of Maximal Body Size," *PNAS* 98, no. 25 (2001): 14518–23, https://doi.org/10.1073/pnas.251548698.

33. "Coastal Land Use Plan," County of Santa Barbara, 2019, https://cosantabarbara.app.box.com/s/cx95kor4hnfo58hg29ifi5gzf5rrdurd.

34. "*Micrarionta opuntia*—Roth, 1975," Integrated Taxonomic Information System, taxonomic serial no. 77804, https://www.itis.gov/servlet/SingleRpt/SingleRpt?search_topic=TSN&search_value=77804#null.

## 09. POLICIES AND PROTECTIONS

1. "MPA Founding Legislation (MLPA/MMAIA)," California Department of Fish and Wildlife, https://wildlife.ca.gov/conservation/marine/MPAS.

2. *Strategic Plan to Protect California's Coast and Ocean 2020–2025*, California Ocean Protection Council, https://www.opc.ca.gov/webmaster/ftp/pdf/2020-2025-strategic-plan/OPC-2020-2025-Strategic-Plan-FINAL-20200228.pdf.

3. "National Estuarine Research Reserves," NOAA Office for Coastal Management, https://coast.noaa.gov/nerrs.

4. "Channel Islands National Marine Sanctuary," Office of National Marine Sanctuaries, channelislands.noaa.gov.

5. "Greater Farallones National Marine Sanctuary," National Ocean Service, 2015,

https://nmsfarallones.blob.core.windows.net/farallones-prod/media/archive/manage/pdf/expansion/maps/Expansion_150514_v17.pdf.

6. "Cordell Bank," NOAA, https://cordellbank.noaa.gov/about.

7. J. Gurish, *Overview of California Ocean and Coastal Laws with Reference to the Marine Environment* (Sacramento: California Ocean Protection Council, 2019), 33.

8. California Code, Public Resources Code 25302(a), https://codes.findlaw.com/ca/public-resources-code/prc-sect-25302.html.

9. California's Fourth Climate Change Assessment, https://www.climateassessment.ca.gov.

10. "Seabirds of Cordell Bank," NOAA, https://cordellbank.noaa.gov/about/seabirds.html.

11. "California Least Tern," Center for Biological Diversity, https://www.biologicaldiversity.org/campaigns/esa_works/profile_pages/CaliforniaLeastTern.html.

12. W. Stegner, "Coda: Wilderness Letter," in *The Sound of Mountain Water* (Lincoln: University of Nebraska Press, 1985), 145.

13. M. K. Anderson, *Tending the Wild* (Berkeley: University of California Press, 2005), 3.

14. "America's Top Charities List," *Forbes*, 2020, https://www.forbes.com/lists/top-charities.

15. "Guadalupe Nipomo Dunes," Nature Conservancy, https://www.nature.org/en-us/get-involved/how-to-help/places-we-protect/guadalupe-nipomo-dunes.

16. "FAQ," US Fish and Wildlife Service, https://www.fws.gov/refuges/about/faq.html.

## 10. NAVIGATING A CHAOTIC SEA

1. C. Harvey, "Climate Change Is Becoming a Top Threat to Biodiversity," *Scientific American*, March 28, 2018, https://www.scientificamerican.com/article/climate-change-is-becoming-a-top-threat-to-biodiversity.

2. R. J. Charlson, J. E. Lovelock, M. O. Andreae, and S. Warren, "Oceanic Phytoplankton, Atmospheric Sulphur, Cloud Albedo and Climate," *Nature* 326 (1987): 655–61, https://doi.org/10.1038/326655a0.

3. C. Welch, "Arctic Permafrost Is Thawing Fast. That Affects Us All," *National Geographic*, August 2019, https://www.nationalgeographic.com/environment/2019/08/arctic-permafrost-is-thawing-it-could-speed-up-climate-change-feature.

4. R. Xia, "California Coastal Waters Rising in Acidity at Alarming Rate, Study Finds," *Los Angeles Times*, December 16, 2019, https://www.latimes.com/california/story/2019-12-16/ocean-acidification-california.

# Notes

5. E. B. Osborne, R. C. Thunell, N. Gruber, R. A. Feely, and C. R. Benitez-Nelson, "Decadal Variability in Twentieth-Century Ocean Acidification in the California Current Ecosystem," *Nature Geoscience* 13 (2020): 43–49, https://doi.org/10.1038/s41561-019-0499-z.

6. D. M. S. Palacios, S. J. Bograd, R. Mendelssohn, and F. B. Schwing, "Long Term and Seasonal Trends in Stratification in the California Current, 1950–1993," *Journal of Geophysical Research: Oceans* 109, no. C10 (2004), https://doi.org/10.1029/2004JC002330.

7. "Eutrophication," Southern California Coastal Research Project, https://www.sccwrp.org/about/research-areas/eutrophication.

8. F. Kessouri, D. Bianchi, L. Renault, J. C. McWilliams, H. Frenzel, and C. A. Deutsch, "Submesoscale Currents Modulate the Seasonal Cycle of Nutrients and Productivity in the California Current System," *Global Biogeochemical Cycles* 34, no. 10 (2020), https://doi.org/10.1029/2020GB006578.

9. J. L. Sarmiento, T.M.C. Hughes, R. J. Stouffer, and S. Manabe, "Simulated Response of the Ocean Carbon Cycle to Anthropogenic Climate Warming," *Nature* 393 (1998): 245–49, https://doi.org/10.1038/30455.

10. K. McGee, "Assessing the Impacts of Greenhouse Gasses on Upwelling and Surface Temperature in the California Current System," PhD dissertation, Loyola Marymount University, 2020, https://digitalcommons.lmu.edu/etd/904.

11. A. Voiland, "California's Rising and Sinking Coast," NASA Earth Observatory, https://earthobservatory.nasa.gov/images/147439/californias-rising-and-sinking-coast.

12. G. Griggs, D. Cayan, C. Tebaldi, H. A. Fricker, J. Árvai, R. DeConto, and R. E. Kopp, *Rising Seas in California: An Update on Sea-Level Rise Science*, California Ocean Protection Council Science Advisory Team Working Group, California Ocean Science Trust, April 2017, http://www.opc.ca.gov/webmaster/ftp/pdf/docs/rising-seas-in-california-an-update-on-sea-level-rise-science.pdf.

13. "Coastal Ocean Temperature," California Office of Environmental Health Hazard Assessment, February 11, 2019, https://oehha.ca.gov/epic/impacts-physical-systems/coastal-ocean-temperature.

14. E. G. Brown Jr., "Executive Order B-55-18 to Achieve Carbon Neutrality," State of California, Executive Department, September 10, 2018, https://www.ca.gov/archive/gov39/wp-content/uploads/2018/09/9.10.18-Executive-Order.pdf.

15. "Governor Newsom Launches Innovative Strategies to Use California Land to Fight Climate Change, Conserve Biodiversity, and Boost Climate Resilience," Office of Governor Gavin Newsom, October 7, 2020, https://www.gov.ca.gov/2020/10/07/governor-newsom-launches-innovative-strategies-to-use-california-land-to-fight-climate-change-conserve-biodiversity-and-boost-climate-resilience.

16. E. L. Johnston and D. A. Roberts, "Contaminants Reduce the Richness and Evenness of Marine Communities: A Review and Meta-Analysis," *Environmental Pollution* 157, no. 6 (2009): 1745–52, https://doi.org/10.1016/j.envpol.2009.02.017.

17. "The Great Pacific Garbage Patch," Ocean Cleanup, https://theoceancleanup.com/great-pacific-garbage-patch.

18. "Ocean Pollution: 11 Facts You Need to Know," Conservation International, https://www.conservation.org/stories/ocean-pollution-11-facts-you-need-to-know.

19. "Ocean Plastics Pollution: A Global Tragedy for Our Oceans and Sea Life," Center for Biological Diversity, https://www.biologicaldiversity.org/campaigns/ocean_plastics.

20. "About the California Ocean Litter Strategy & Agency Needs," California Ocean Protection Council, https://opc.ca.gov/programs-summary/marine-pollution/ocean litterstrategyproject/about.

21. S. Hirsh, "An Ocean Cleanup Crew Just Collected a Record Amount of Ocean Plastic from the GPGP," July 17, 2020, https://www.greenmatters.com/p/ocean-plastic-cleanup.

22. A. F. McEvoy, "Historical Interdependence between Ecology, Production, and Management in California Fisheries," in *Sustainability Issues for Resource Managers*, edited by D. Bottom, G. Reeves, and M. Brookes, 45–53 (Corvallis, OR: USDA Forest Service, Pacific Northwest Research Station, 1996), https://www.fs.fed.us/pnw/pubs/pnw_gtr370.pdf.

23. "Sustainable Seafood: What We Do," Monterey Bay Aquarium, https://www.montereybayaquarium.org/act-for-the-ocean/sustainable-seafood/what-we-do.

24. W. Leet, C. Dewees, R. Klingbell, and E. Larson, *California's Living Marine Resources: A Status Report* (Sacramento: California Department of Fish and Game, 2001), https://wildlife.ca.gov/Conservation/Marine/Status/2001.

25. J. M. Cope, J. Devore, E. Dick, K. Ames, J. Budrick, D. Erickson, J. Grebel, et al., "An Approach to Defining Stock Complexes for U.S. West Coast Groundfishes Using Vulnerabilities and Ecological Distributions," *North American Journal of Fisheries Management* 31, no. 4 (2011): 589–604, https://doi.org/10.1080/02755947.2011.591264.

26. S. Thrush and P. Dayton, "Disturbance to Marine Benthic Habitats by Trawling and Dredging: Implications for Marine Biodiversity," *Annual Review of Ecology and Systematics* 33 (2002): 449–73, https://www.jstor.org/stable/3069270.

27. Data collected by PacFIN database maintained by the Pacific State Marine Fisheries Commission, and presented in H. Mooney and E. Zavaleta, eds., *Ecosystems of California* (Berkeley: University of California Press, 2016), 790.

28. F. Harvey, "Overfishing Causes Pacific Bluefin Tuna Numbers to Drop 96%," *Guardian*, January 9, 2013, https://www.theguardian.com/environment/2013/jan/09/overfishing-pacific-bluefin-tuna.

29. C. Leschin-Hoar, "Countries Pledge to Recover Dwindling Pacific Bluefin Tuna Population," NPR, September 1, 2017, https://www.npr.org/sections/thesalt/2017/09/01/547903557/countries-pledge-to-recover-dwindling-pacific-bluefin-tuna-population.

30. Yurok Tribe general counsel Amy Cordalis, in conversation with Lulu Garcia-Navarro, "Tribe Gives Personhood to Klamath River," NPR, September 29, 2019, https://www.npr.org/2019/09/29/765480451/tribe-gives-personhood-to-klamath-river.

31. M. D. Nascimento, "Reclaiming the Klamath," Earthjustice, 2020, https://earthjustice.org/features/klamath-salmon-yurok-tribe.

32. J. Burns, "Plan Revived for Dam Removal on Klamath River in Oregon, California," Oregon Public Broadcasting, November 17, 2020, https://www.opb.org/article/2020/11/17/klamath-river-dam-removal-oregon-california.

33. C. Chappelle and E. Hanak, "California's Water Quality Challenges," Public Policy Institute of California, 2014, https://www.ppic.org/publication/californias-water-quality-challenges.

34. "Water-Quality Monitoring and Modeling of the Keno Reach of the Klamath River," US Geological Survey Oregon Water Science Center, https://or.water.usgs.gov/proj/keno_reach.

35. "Common Pollutants," Russian River Watershed Association, https://www.rrwatershed.org/project/common-pollutants.

36. "Toxic Pollutants and Chemicals of Concern," San Francisco Baykeeper, https://baykeeper.org/our-work/toxic-pollutants-and-chemicals-concern.

37. D. E. Hinton, "Multiple Stressors in the Sacramento River Watershed," in *Fish Ecotoxicology*, edited by T. Braunbeck, D. E. Hinton, and B. Streit (Basel: Birkhäuser, 1998), https://doi.org/10.1007/978-3-0348-8853-0-9; "Proposed Strategy for San Joaquin River Basin Water Quality Monitoring and Assessment," Environmental Protection Agency, 2010, https://www.epa.gov/sites/production/files/documents/draftpropwqmonitorstratsjrbasin3-3-10.pdf.

38. B. Anderson, J. Hunt, B. Phillips, P. Nicely, K. Gilbert, V. de Vlaming, V. Connor, et al., "Ecotoxicologic Impacts of Agricultural Drain Water in the Salinas River, California, USA," *Environmental Toxicology and Chemistry* 22, no. 10 (2003): 2375–84, https://doi.org/10.1897/02-427.

39. "Water Quality," Water Wise in Santa Barbara County, Santa Barbara County Water Agency, http://www.waterwisesb.org/quality.wwsb.

40. N. Ashoori, D. A. Dzombak, and M. J. Small, "Water Supply for Los Angeles, California: Sources, Stressors, and Sustainability," *Water Resources Impact* 17, no. 1 (2015): 13–16, https://www.jstor.org/stable/wateresoimpa.17.1.0013?seq=1.

41. D. Potter, "Why Isn't Desalination the Answer to All California's Water Problems?" KQED, December 18, 2015, https://www.kqed.org/science/28668/why-isnt-desalination-the-answer-to-all-californias-water-problems.

42. D. G. Bansal, "Desalination of Aquifers Offers Drought-Weary California New Hope," *Mercury News*, February 6, 2017, https://www.mercurynews.com/2017/02/05/desalination-of-salty-aquifers-offers-drought-weary-california-new-hope.

43. "Understanding Reverse Osmosis," Puretec Industrial Water, https://puretecwater.com/reverse-osmosis/what-is-reverse-osmosis.

44. "Why Desalination Can Help Quench California's Water Needs," CalDesal, https://www.caldesal.org/post/why-desalination-can-help-quench-californias-water-needs.

45. A. R. de Righi, "Existing Seawater Desalination Facilities," California Water Boards, 2019, https://www.waterboards.ca.gov/water_issues/programs/ocean/desalination/docs/170105_desal_map_existing.pdf.

46. E. Berardi, "California Moves Forward with Delta Tunnel," *Engineering News-Record*, January 17, 2020, https://www.enr.com/articles/48538-california-moves-forward-with-delta-tunnel.

47. "Delta Conveyance," California Department of Water Resources, https://water.ca.gov/deltaconveyance.

48. Associated Press, "Newsom Restarts Project to Build Underground Tunnel to Pump Billions of Gallons of Water to SoCal," KTLA, January 15, 2020, https://ktla.com/news/local-news/newsom-restarts-project-to-build-underground-tunnel-to-pump-billions-of-gallons-of-water-to-socal.

49. G. Kremen, "A Social Justice Perspective of the Delta Tunnel Project," *Cal Matters*, June 20, 2020, https://calmatters.org/commentary/my-turn/2020/06/a-social-justice-perspective-of-the-delta-tunnel-project.

50. "2016 Final Environmental Impact Report/Environmental Impact Statement (EIR/EIS)," State Water Resources Control Board, March 7, 2018, https://www.waterboards.ca.gov/waterrights/water_issues/programs/bay_delta/california_waterfix/exhibits/exhibit102/index.html.

51. P. Gleick with H. Cooley, K. Poole, and E. Osann, "The Untapped Potential of California's Water Supply: Efficiency, Reuse, and Stormwater," Pacific Institute and Natural Resources Defense Council, June 2014, https://pacinst.org/wp-content/uploads/2014/06/ca-water-capstone.pdf.

52. California Department of Water Resources, *Conjunctive Management and Groundwater: A Resource Management Strategy of the California Water Plan* (Sacramento: California Department of Water Resources, 2016), https://water.ca.gov/-/media/DWR-Website/Web-Pages/Programs/California-Water-Plan/Docs/RMS/2016/08_ConjMgt_GW_Storage_July2016.pdf.

53. C. W. Lanman, K. Lundquist, H. Perryman, J. Eli Asarian, B. Dolman, R. B. Lanman, and M. M. Polloc, "The Historical Range of Beaver (*Castor canadensis*) in Coastal California: An Updated Review of the Evidence," *California Fish and Game* 99, no. 4 (2013): 193–221, https://nrm.dfg.ca.gov/FileHandler.ashx?DocumentID=78018&inline=1.

54. B. Goldfarb, *Eager: The Surprising, Secret Life of Beavers and Why They Matter* (Chelsea, VT: Chelsea Green, 2018), 221–45.

55. W. D. Spencer, P. Beier, K. Penrod, K. Winters, C. Paulmann, H. Rustigian-Romsos, J. Strittholt, et al., *California Essential Habitat Connectivity Project: A Strategy for Conserving a Connected California* (Sacramento: California Department of Transportation, California Department of Fish and Game, and Federal Highways Administration, 2010), https://wildlife.ca.gov/Conservation/Planning/Connectivity/CEHC.

56. P. J. Landrigan, R. Fuller, N.J.R. Acosta, O. Adeyi, R. Arnold, N. Basu, A. B. Balde, et al., "The Lancet Commission on Pollution and Health," *Lancet* 391, no. 10119 (2017), https://www.thelancet.com/commissions/pollution-and-health.

57. B. Berwyn, "Many Scientists Now Say Global Warming Could Stop Relatively Quickly after Emissions Go to Zero," *Inside Climate News*, January 3, 2021, https://insideclimatenews.org/news/03012021/five-aspects-climate-change-2020.

# SELECTED BIBLIOGRAPHY

A selection of supplemental works, without which *The Coasts of California* would not exist.

Alden, P., and F. Heath. *1998. Field Guide to California.* National Audubon Society. New York: Knopf.

Allaby, M. *1994. The Concise Oxford Dictionary of Ecology.* New York: Oxford University Press.

Anderson, M. K. *2005. Tending the Wild: Native American Knowledge and the Management of California's Natural Resources.* Berkeley: University of California Press.

Baker, L. N. *1969. Wild Peninsula: The Story of Point Reyes National Seashore.* New York: Atheneum.

Bakker, E., and G. Slack. *1971. An Island Called California: An Ecological Introduction to Its Natural Communities.* Berkeley: University of California Press.

Baldwin, B. G., D. H. Goldman, D. J. Keil, R. Patterson, T. J. Rosatti, and D. H. Wilken, eds. *2012. The Jepson Manual: Vascular Plants of California.* 2nd ed. Berkeley: University of California Press. (The Jepson eFlora, the Jepson Herbarium, University of California, Berkeley, https://ucjeps.berkeley.edu/eflora.)

Barbour, M. G., T. Keeler-Wolf, and A. A. Schoenherr. *2007. Terrestrial Vegetation of California.* 3rd ed. Berkeley: University of California Press.

Barbour, M. G., and J. Major, eds. *1977. Terrestrial Vegetation in California.* Hoboken, NJ: Wiley.

Barbour, M. G., B. Pavlik, F. Drysdale, and S. Lindstrom. *1993. California's Changing Landscapes: Diversity and Conservation of California Vegetation.* Sacramento: California Native Plant Society.

Barnes, R. S., and K. H. Mann. *1980. Fundamentals of Aquatic Ecosystems.* Oxford: Blackwell Scientific Publications.

Beck, W. A., and Y. D. Haase. *1974. Historical Atlas of California.* Norman: University of Oklahoma Press.

Behrensmeyer, A. K., J. D. Damuth, W. A. DiMichele, R. Potts, H.-D. Sues, and S. L. Wing. *1992. Terrestrial Ecosystems through Time: Evolutionary Paleoecology of Terrestrial Plants and Animals.* Chicago: University of Chicago Press.

# Selected Bibliography

Berger, J., ed. 1990. *Ecological Restoration in the San Francisco Bay Area*. Berkeley, CA: Restoring the Earth.

British Columbia Ministry of Forests and British Columbia Ministry of Environment, Land and Parks. 1995. *Biodiversity Guidebook*. Victoria: BC Forest Practices Code.

Buchmann, S. 2015. *The Reason for Flowers: Their History, Culture, Biology, and How They Change Our Lives*. New York: Scribner.

California Department of Fish and Game. 2005. *California Wildlife: Conservation Challenges, California's Wildlife Action Plan*. Edited by D. Bunn, A. Mummert, M. Hoshovsky, K. Gilardi, and S. Shanks. Davis: UC Davis Wildlife Health Center.

California Department of Fish and Wildlife. 2015. *California State Wildlife Action Plan, 2015 Update: A Conservation Legacy for Californians*. Edited by A. G. Gonzales and J. Hoshi. https://www.wildlife.ca.gov/SWAP/Final.

California Department of Fish and Wildlife. n.d. "Wildlife Habitats—California Wildlife Habitat Relationships System." https://www.wildlife.ca.gov/Data/CWHR/Wildlife-Habitats.

California Interagency Wildlife Task Group. 2005. *Habitat Classification Rules, California Wildlife Habitat Relationships System*. California Department of Fish and Game. https://nrm.dfg.ca.gov/FileHandler.ashx?DocumentID=65851&inline.

"California Natural Community List," California Department of Fish and Wildlife. https://www.wildlife.ca.gov/Data/VegCAMP/Natural-Communities.

Carle, D. 2004. *Introduction to Water in California*. California Natural History Guides. Berkeley: University of California Press.

Carle, D. 2008. *Introduction to Fire in California*. California Natural History Guides. Berkeley: University of California Press.

Carle, D. 2010. *Introduction to Earth, Soil and Land in California*. California Natural History Guides. Berkeley: University of California Press.

Carson, R. 1955. *The Edge of the Sea*. Boston: Houghton Mifflin.

Cheng, S., ed. 2004. *Forest Service Research Natural Areas in California*. Gen. Tech. Rep. PSW-GTR-188. Albany, CA: Pacific Southwest Research Station, US Department of Agriculture, US Forest Service.

Cooper, D. 2004. *Important Bird Areas of California*. Pasadena: Audubon California.

# Selected Bibliography

Critser, G. 2000. *California: National Geographic Traveler.* Washington, DC: National Geographic.

Cunningham, L. 2010. *A State of Change: Forgotten Landscapes of California.* Berkeley, CA: Heyday.

Dale, N. 1986. *Flowering Plants: The Santa Monica Mountains, Coastal and Chaparral Regions of Southern California.* California Native Plant Society. Santa Barbara, CA: Capra.

Didion, J. 2003. *Where I Was From.* New York: Random House.

DiTomaso, J. M., G. B. Kyser, S. R. Oneto, R. G. Wilson, S. B. Orloff, L. W. Anderson, S. D. Wright, et al. 2013. *Weed Control in Natural Areas in the Western United States.* UC Davis Weed Research and Information Center. Davis: University of California Agriculture and Natural Resources.

Durrenberger, R. W., and R. B. Johnson. 1976. *California: Patterns on the Land.* California Council for Geographic Education. Palo Alto, CA: Mayfield.

Faber, P. M., ed. 1997. *California's Wild Gardens: A Guide to Favorite Botanical Sites.* Berkeley: University of California Press.

Farmer, J. 2017. *Trees in Paradise: The Botanical Conquest of California.* Berkeley, CA: Heyday.

Ferguson, G. 2017. *Land of Fire.* Portland, OR: Timber Press.

Fewster, H., and C. Hallinan. 2019. *The Ecology Book.* New York: Random House.

Finson, B., ed. 1983. *Discovering California.* San Francisco: California Academy of Sciences.

Fleischner, T. L., ed. 2011. *The Way of Natural History.* San Antonio, TX: Trinity University Press.

Forest Climate Action Team. 2018. *California Forest Carbon Plan: Managing Our Forest Landscapes in a Changing Climate.* Sacramento. https://resources.ca.gov/wp-content/uploads/2018/05/California-Forest-Carbon-Plan-Final-Draft-for-Public-Release-May-2018.pdf.

Fradkin, P. L. 1995. *The Seven States of California: A Natural and Human History.* Berkeley: University of California Press.

Griggs, G. 2010. *Introduction to California's Beaches and Coast.* Berkeley: University of California Press.

# Selected Bibliography

Gudde, E. G. 1949. *California Place Names: The Origin and Etymology of Current Geographical Names.* Berkeley: University of California Press.

Harden, D. 1992. *California Geology.* New York: Pearson.

Hart, J. D. 1975. *Hiking the Bigfoot Country: The Wildlands of Northern California and Southern Oregon.* San Francisco: Sierra Club.

Hart, J. D. 1978. *San Francisco's Wilderness Next Door.* San Rafael, CA: Presidio.

Hart, J. D. 1987. *A Companion to California.* Berkeley: University of California Press.

Henson, P., and D. J. Usner. 1993. *The Natural History of Big Sur.* Berkeley: University of California Press.

Hilty, J. A., A. T. H. Keeley, W. Z. Lidicker, and A. M. Merenlender. 2019. *Corridor Ecology: Linking Landscapes for Biodiversity Conservation and Climate Adaptation.* 2nd ed. Washington, DC: Island.

Holing, D. 1988. *California Wild Lands: A Guide to the Nature Conservancy Preserves.* San Francisco: Chronicle Books.

Holland, R. F. 1986. *Preliminary Descriptions of the Terrestrial Natural Communities of California.* Sacramento: California Department of Fish and Game.

Holland, V. L., and D. J. Keil. 1987; 1995. *California Vegetation.* San Luis Obispo, CA: El Corral, California Polytechnic State University (1987); Dubuque IA: Kendall Hunt (1995).

Hornbeck, D., and P. S. Kane. 1983. *California Patterns: A Geographical and Historical Atlas.* Palo Alto, CA: Mayfield.

Hutchinson, J., J. Lutjeharms, B. McMillan, J. Musick, and B. Stonehouse, 2017. *Concise Encyclopedia of the Ocean.* London: Red Lemon Press.

Iselin, J. 2019. *The Curious World of Seaweed.* Berkeley, CA: Heyday.

Jenks, M. A. 2011. *Plant Nomenclature.* West Lafayette, IN: Department of Horticulture and Landscape Architecture, Purdue University.

Jensen, H. A. 1947. *A System for Classifying Vegetation in California.* Sacramento: California Department of Fish and Game.

The Jepson eFlora, the Jepson Herbarium, University of California, Berkeley, https://ucjeps.berkeley.edu/eflora.

Johnson, P. *1970. Pictorial History of California.* New York: Bonanza.

Johnston, V. R. *1998. Sierra Nevada: The Naturalist's Companion.* Berkeley: University of California Press.

Kareiva, P., H. Tallis, T. Ricketts, G. Daily, and S. Polasky. *2011. Natural Capital: Theory and Practice of Mapping Ecosystem Services.* New York: Oxford University Press.

Karuk Tribe Department of Natural Resources. 2019. *Karuk Climate Adaptation Plan.* https://karuktribeclimatechangeprojects.files.wordpress.com/2019/10/reduced-size_final-karuk-climate-adaptation-plan.pdf.

Kauffman, E. *2003. Atlas of Biodiversity of California.* Sacramento: State of California, Resources Agency, Department of Fish and Game.

Kauffman, S. *1995. At Home in the Universe: The Search for Laws of Self-Organization and Complexity.* New York: Oxford.

Kauffmann, M. E. *2013. Conifers of the Pacific Slope: A Field Guide to the Conifers of California, Oregon, and Washington.* Kneeland, OR: Backcountry.

Keator, G. *2009. California Plant Families West of the Sierran Crest and Deserts.* Berkeley: University of California Press.

Keeley, J. E. *2006. Fire in California's Ecosystems.* Berkeley: University of California Press.

Kimmerer, R. W. *2013. Braiding Sweetgrass.* Minneapolis, MN: Milkweed.

Klein, N. *2019. On Fire: The (Burning) Case for a Green New Deal.* New York: Simon & Schuster.

Kolbert, E. *2014. The Sixth Extinction: An Unnatural History.* New York: Picador.

Kolbert, E. *2021. Under a White Sky: The Nature of the Future.* New York: Crown.

Kress, W. J., and J. K. Stine. *2017. Living in the Anthropocene: Earth in the Age of Humans.* Washington, DC: Smithsonian Books.

Lanner, R. *1999. Conifers of California.* Los Olivos, CA: Cachuma.

Laws, J. M. *2007. The Laws Field Guide to the Sierra Nevada.* California Academy of Sciences. Berkeley, CA: Heyday.

Lentz, J. E. *2013. A Naturalist's Guide to the Santa Barbara Region.* Berkeley, CA: Heyday.

## Selected Bibliography

Leopold, A. S. *1985. Wild California: Vanishing Lands, Vanishing Wildlife.* Berkeley: University of California Press.

Locklin, L., ed. *1981. California Coastal Access Guide.* California Coastal Commission. Berkeley: University of California Press.

Lopez, B., ed. *2007. The Future of Nature.* Minneapolis, MN: Milkweed.

Lopez, B., and D. Gwartney. *2006. Home Ground: A Guide to the American Landscape.* San Antonio, TX: Trinity University Press.

Lorentzen, B., and R. Nichols. *1998. Hiking the California Coastal Trail: A Guide to Walking the Golden State's Beaches and Bluffs from Border to Border. Volume One: Oregon to Monterey,* and *Volume Two: Monterey to Mexico.* Mendocino, CA: Bored Feet.

Lyons, K., and M. B. Cuneo-Lazaneo. *1988. Plants of the Coast Redwood Region.* Soquel, CA: Shoreline.

MacArthur, R. H. *1972. Geographical Ecology: Patterns in the Distribution of Species.* Princeton, NJ: Princeton University Press.

MacArthur, R. H., and E. O. Wilson. *1967. The Theory of Island Biogeography.* Princeton, NJ: Princeton University Press.

Malarkey, T. *2019. Stronghold: One Man's Quest to Save the World's Wild Salmon.* New York: Spiegel & Grau.

Margolin, M. *1974. The East Bay Out: A Personal Guide to the East Bay Regional Parks.* Berkeley, CA: Heyday.

Margolin, M. *1978. The Ohlone Way: Indian Life in the San Francisco–Monterey Bay Area.* Berkeley, CA: Heyday.

Marianchild, K. *2014. Secrets of the Oak Woodlands: Plants and Animals among California's Oaks.* Berkeley, CA: Heyday.

Mark, J. *2015. Satellites in the High Country: Searching for the Wild in the Age of Man.* Washington, DC: Island Press.

Mayer, K. E., and W. F. Laudenslayer Jr., eds. *1988. A Guide to Wildlife Habitats in California.* Sacramento: California Department of Forestry and Fire Protection. (Updated online as California Department of Fish and Wildlife, "Wildlife Habitats—California Wildlife Habitat Relationships System," https://www.wildlife.ca.gov/Data/CWHR/Wildlife-Habitats.)

McAuley, M. *1985. Wildflowers of the Santa Monica Mountains*. Canoga Park, CA: Canyon.

McKibben, B. *1989. The End of Nature*. New York: Random House.

McKinney, J. *2011. Dayhiker's Guide to California State Parks*. Santa Barbara, CA: Trailmaster.

McPhee, J. *1993. Assembling California*. New York: Farrar, Straus and Giroux.

Messinger, L., et al., eds. *2009. Habitats Alive! An Ecological Guide to California's Diverse Habitats*. Cal Alive! Exploring Biodiversity Teachers Resource Guide. El Cerrito: California Institute for Biodiversity; Claremont, CA: Rancho Santa Ana Botanic Garden.

Miller, C. S., and R. S. Hyslop. *1983. California: The Geography of Diversity*. Mountain View, CA: Mayfield.

Mooney, H., E. Zavaleta, and M. C. Chapin, eds. *2016. Ecosystems of California*. Berkeley: University of California Press. https://www.jstor.org/stable/10.1525/j.ctv1xxzp6.

Morton, T. *2007. Ecology without Nature: Rethinking Environmental Aesthetics*. Cambridge, MA: Harvard University Press.

Mott, W. P. *1960. California Historical Landmarks*. Sacramento: California Landmarks Advisory Committee.

Muir, J. *1894; 1988. The Mountains of California*. San Francisco: Sierra Club.

Munz, P. A., and D. D. Keck. *1959. A California Flora*. Berkeley: University of California Press.

Naess, A. *2008. The Ecology of Wisdom*. Berkeley, CA: Counterpoint.

Neely, N. *2016. Coast Range: A Collection from the Pacific Edge*. Berkeley, CA: Counterpoint.

Nixon, S. *1966. Redwood Empire*. New York: Galahad.

Ornduff, R., P. M. Faber, and T. Keeler-Wolf. *2003. Introduction to California Plant Life*. California Natural History Guides. Berkeley: University of California Press.

Palmer, T. *1993. California's Threatened Environment: Restoring the Dream*. Washington, DC: Island Press.

Pavlik, B. M. *2008. The California Deserts: An Ecological Rediscovery*. Berkeley: University of California Press.

Pavlik, B. M., P. M. Muick, S. G. Johnson, and M. Popper. *1991. Oaks of California.* Los Olivos, CA: Cachuma.

Penrose, R. *1994. Shadows of the Mind: A Search for the Missing Science of Consciousness.* New York: Oxford University Press.

Peterson, B. *1993. California: Vanishing Habitats and Wildlife.* Wilsonville, OR: Beautiful America.

Phillips, D., and H. Nash, eds. *1981. The Condor Question: Captive or Forever Free?* San Francisco: Friends of the Earth.

Pickett, E. R. *1971. Birds of Central California.* Sacramento, CA: reprinted from the *Sacramento Bee.*

Polakovic, G. *1999.* "Channel Island Woman's Bones May Rewrite History." *Los Angeles Times.* https://www.latimes.com/archives/la-xpm-1999-apr-11-mn-26401-story.html.

Powers, R. *2018. The Overstory.* New York: Norton.

Pratt-Bergstrom, B. *2016. When Mountain Lions Are Neighbors: People and Wildlife Working It Out in California.* Berkeley, CA: Heyday.

Press, D. *2002. Saving Open Space: The Politics of Local Preservation in California.* Berkeley: University of California Press.

Preston, R. *2008. The Wild Trees: A Story of Passion and Daring.* New York: Random House.

Pyne, S. *2019. Fire: A Brief History.* Seattle: University of Washington Press.

Quammen, D. *1996. Song of the Dodo: Island Biogeography in the Age of Extinctions.* New York: Scribner.

Quammen, D. *2008. Natural Acts: A Sidelong View of Science and Nature.* New York: Norton.

Quinn, R. D., and S. C. Keeley. *2006. Introduction to California Chaparral.* California Natural History Guides. Berkeley: University of California Press.

Reisner, M. *1986. Cadillac Desert: The American West and Its Disappearing Water.* New York: Penguin.

Reisner, M. *2003. A Dangerous Place: California's Unsettling Fate.* New York: Penguin.

Riegert, R. 1988. *Hidden Coast of California: Including San Diego, Los Angeles, Santa Barbara, Monterey, San Francisco, and Mendocino*. Berkeley, CA: Ulysses.

Riegert, R. 1990. *California: The Ultimate Guidebook*. Berkeley, CA: Ulysses.

Ritter, M. 2011. *A Californian's Guide to the Trees among Us*. Berkeley, CA: Heyday.

Ritter, M. 2018. *California Plants: A Guide to Our Iconic Flora*. Berkeley, CA: Pacific Street.

Sanford, B. 1994. *The San Joaquin, the Sierra, and Beyond*. Santa Cruz, CA: Western Tanager.

Sawyer, J. O., T. Keeler-Wolf, and J. Evens. 2009. *A Manual of California Vegetation*. 2nd ed. Sacramento: California Native Plant Society. https://www.cnps.org/vegetation/manual-of-california-vegetation; vegetation.cnps.org.

Schoenherr, A. A. 1992. *A Natural History of California*. Berkeley: University of California Press.

Schonewald-Cox, C. M., S. M. Chambers, B. MacBryde, and W. L. Thomas, eds. 1983. *Genetics and Conservation*. Menlo Park, CA: Benjamin/Cummings.

Sheldrake, M. 2020. *Entangled Life: How Fungi Make Our Worlds, Change Our Minds & Shape Our Futures*. New York: Random House.

Slododkin, L. B. 2003. *A Citizen's Guide to Ecology*. New York: Oxford University Press.

Smith, D. 1978. *Condor Journal: The History, Mythology, and Reality of the California Condor*. Santa Barbara, CA: Capra.

Snyder, G. 1995. *A Place in Space: Ethics, Aesthetics, and Watersheds*. New York: Counterpoint.

Snyder, G. 1996. *Mountains and Rivers without End*. Berkeley, CA: Counterpoint.

Spencer, W. D., P. Beier, K. Penrod, K. Winters, C. Paulman, H. Rustigian-Romsos, J. Strittholt, M. Parisi, and A. Pettler. 2010. *California Essential Habitat Connectivity Project: A Strategy for Conserving a Connected California*. Prepared for the California Department of Transportation, California Department of Fish and Game, and Federal Highways Administration. https://wildlife.ca.gov/Conservation/Planning/Connectivity/CEHC.

Stamets, P. 2005. *Mycelium Running: How Mushrooms Can Help Save the World*. Berkeley, CA: Ten Speed Press.

Stanley, S. M., ed. *Ecological Restoration Implementation Plan*. 2013. US Department of Agriculture, US Forest Service, Pacific Southwest Region. R5-MB-249. https://www.frames.gov/catalog/15758.

## Selected Bibliography

Starr, K. *2005. California: A History.* New York: Modern Library.

Stegner, W. *1946. The Sound of Mountain Water.* New York: Dutton.

Stegner, W. *1953. Beyond the Hundredth Meridian: John Wesley Powell and the Second Opening of the West.* Cambridge, MA: Riverside Press.

Stienstra, T. *2000. California Wildlife: A Practical Guide.* Emeryville, CA: Foghorn Outdoors, Avalon.

Stiling, P. *1999. Ecology: Theories and Applications.* 3rd ed. Upper Saddle River, NJ: Prentice Hall.

Storer, T. I., and R. L. Usinger. *2004. Sierra Nevada Natural History.* Rev. ed. California Natural History Guides. Berkeley: University of California Press.

Telander, T. *2012. Birds of California.* Falcon Field Guides. Helena, MT: Rowman and Littlefield.

Timbrook, J. *2007. Chumash Ethnobotany: Plant Knowledge among the Chumash People of Southern California.* Santa Barbara Museum of Natural History. Berkeley, CA: Heyday.

van Wagtendonk, J. W., N. G. Sugihara, S. L. Stephens, A. E. Thode, K. E. Shaffer, and J. A. Fites-Kaufman, eds. *2006. Fire in California's Ecosystems.* Berkeley: University of California Press.

Vries, de C. *1978. Grand and Ancient Forest: The Story of Andrew P. Hill and Big Basin Redwood State Park.* Fresno, CA: Valley.

Waite, H. *1999. Calling California Home.* Berkeley, CA: Wildcat Canyon.

Wallace, D. R. *1983. The Klamath Knot: Explorations of Myth and Evolution.* Berkeley: University of California Press.

Wallace, D. R. *2014. Articulate Earth: Adventures in Ecocriticism.* Kneeland, OR: Backcountry.

Wallace, D. R. *2015. Mountains and Marshes: Exploring the Bay Area's Natural History.* Berkeley, CA: Counterpoint.

Watkins, T. H. *1973. California: An Illustrated History.* Great West Series. Palo Alto, CA: American West.

White, D. J., and N. J. Hagens. *2019. The Bottlenecks of the 21st Century.* Las Vegas, NV: Earth Trust.

Whittaker, R. H. *1975*. *Communities and Ecosystems*. 2nd rev. ed. New York: Macmillan.

Wilczek, F. *2015*. *A Beautiful Question: Finding Nature's Deep Design*. New York: Random House.

Williams, T. T. *2019*. *Erosion: Essays of Undoing*. New York: Picador.

Wilson, E. O. *1998*. *Consilience: The Unity of Knowledge*. New York: Random House.

self portrait by Kaufmann
the Coast of California

# ABOUT THE AUTHOR

Obi Kaufmann's earliest memory is of putting his thumb on a small map of California near his beloved Mount Diablo, near San Francisco where he grew up, and stretching his little finger to the Oregon border, then tracing a circle with his hand down to the border of Mexico. Growing up the son of two scientists, challenging the epistemological nature of their scientific temper, Obi decided at some point while attending the University of California, Santa Barbara, that his career was going to be based on uniting the humanities with empirical data to tell the story of our species' relationship with the natural world. He has been working on that ever since.

*The Coasts of California* is the third Field Atlas, and Obi's fourth book. *The California Field Atlas* (Heyday, 2017) was followed by *The State of Water: Understanding California's Most Precious Resource* (Heyday, 2019). *The Forests of California: A California Field Atlas* was published by Heyday in 2020. *The Deserts of California: A California Field Atlas* and *The State of Fire: How, Where, and Why California Burns* are forthcoming.